ROMANTICS
REALISTS
REVOLUTIONARIES

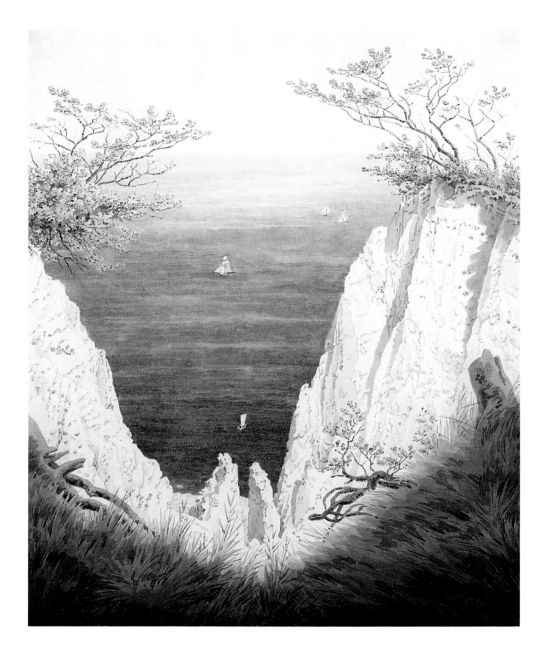

ROMANTICS
REALISTS
REVOLUTIONARIES

Masterpieces of 19th-Century German Painting
from the Museum of Fine Arts, Leipzig

Edited by Edgar Peters Bowron

With an essay by Helmut Börsch-Supan

and contributions by:
Helga Kessler Aurisch
Karl-Heinz Mehnert
Susanne Petri
Dietulf Sander
Andreas Stolzenburg

Prestel

Munich · London · New York

This volume was first published on the occasion of the exhibition held at:
The Museum of Fine Arts, Leipzig (June 29–August 20, 2000)
The Museum of Fine Arts, Houston (October 22, 2000–January 28, 2001)

The exhibition *Romantics, Realists, Revolutionaries: 19th-Century German Masterpieces from the Museum of Fine Arts, Leipzig* was organized by the Museum of Fine Arts, Houston, and the Museum der bildenden Künste Leipzig. The exhibition is supported by an indemnity from the Federal Council on the Arts and the Humanities.

Funding for the exhibition in Houston was provided by:
Houston Endowment Inc.
Caroline Wiess Law
E. J. Hudson, Jr., and Lynne James
Tassie and Constantine Nicandros Foundation
Mr. Fayez Sarofim
Goldman, Sachs & Co.
Mr. and Mrs. Peter R. Coneway
Mr. and Mrs. Robert B. Tudor III

Front cover:
Caspar David Friedrich, *Stages of Life*, c. 1834 (detail), see cat. no. 23
Adolph von Menzel, *Gustav Adolf Greets his Wife outside Hanau Castle in January 1632*, 1847 (detail), see cat. no. 49
Arnold Böcklin, *The Island of the Dead V*, 1886 (detail), see cat. no. 66

Back cover:
Gustav Adolph Hennig, *Reading Girl*, c. 1828, see cat. no. 30

Frontispiece:
Caspar David Friedrich, *The Chalk Cliffs on the Island of Rügen*, 1825–26, see cat. no. 20

Translated from the German by Elizabeth Clegg, London (catalogue entries); Elizabeth Schwaiger, Toronto (essay by Helmut Börsch-Supan); Stephen Telfer, Edinburgh (entry for cat. no. 33 and the "Welcome" by Wolfgang Tiefensee)

Editorial direction: Diane Lovejoy, Houston
Manuscript edited by Jennifer Lawrence, Houston

Library of Congress Card Number: 00–102988
Die Deutsche Bibliothek – CIP-Einheitsaufnahme
Cataloging data is available

© Prestel Verlag, Munich · London · New York, 2000
© for the illustrations: Museum of Fine Arts, Leipzig

Photo Credits: see p. 223

Prestel books are available worldwide.
Visit our website www.prestel.com
or contact one of the following
Prestel offices for further information:

Head Office: Mandlstrasse 26 · 80802 Munich
Tel. +49 (89) 381709–0, Fax +49 (89) 381709–35
e-mail: sales@prestel.de

Prestel London: 4 Bloomsbury Place · London WC1A 2QA
Tel. +44 (20) 7323 5004, Fax +44 (20) 7636 8004
e-mail: sales@prestel-uk.co.uk

Prestel New York: 175 Fifth Avenue, Suite 402, New York, NY 10010
Tel. +1 (212) 995 27 20, Fax +1 (212) 995 2733
e-mail: sales@prestel-usa.com

Designed by Maja Kluy
Typography and lithography by LVD GmbH, Berlin
Printed by Jütte Druck, Leipzig
Bound by Kunst- und Verlagsbuchbinderei, Leipzig

Printed in Germany

ISBN 3-7913-2380-6

Contents

Welcome

International communication is a result mainly of understanding – of oneself and others, of one's own and others' past and of the present as experienced by oneself and others, too. The rapid development of means of transport and telecommunications has made the task of understanding easier and, for many people, has transformed the world into a global village. What holds true for some people, however, does not hold true for everyone, but it certainly is true that telecommunications will never take the place of meeting people face-to-face. This is why it gives me great pleasure that Leipzig's Museum der bildenden Künste, with its exhibition entitled *Romantics, Realists, Revolutionaries: 19th-Century German Masterpieces from the Museum of Fine Arts, Leipzig* is, for the first time, to exhibit in Houston as the guest of the city's Museum of Fine Arts.

The Houston exhibition takes place immediately after the one in Leipzig. I like to regard it as an expression and a result of the successful collaboration between our two cities in their still recent twinning agreement. More than that for me, however, this exhibition also represents a way to *strengthen* those new links because it and the related program of cultural events allow those of you who have as yet been unable to visit Leipzig to get to know our museum and our city better.

Leipzig's Museum der bildenden Künste is among the oldest and most important of Germany's public collections and is delighted to exhibit here 84 masterpieces from the 19th century. Like the world-famous Gewandhaus Orchestra, the equally-renowned Thomanerchor and numerous other cultural institutions, the Museum der bildenden Künste contributes to Leipzig's reputation as a center both with a rich cultural heritage and a vibrant cultural scene today. I *do* hope, therefore, that you will regard this exhibition as an invitation to come to Leipzig, a city that, as a center of trade and industry, of science and culture, resembles Houston in many respects, and yet is a very different place. It is, I would say, the differences that add excitement to any partnership.

We look forward to visiting Houston, extend warmest thanks to all those who have made our visit possible, and look forward to meeting you.

WOLFGANG TIEFENSEE
Mayor of the City of Leipzig

Statement from the Mayor of the City of Houston

On behalf of the city of Houston, I would like to express our sincere appreciation to the Museum of Fine Arts in Leipzig, Germany, for selecting the Museum of Fine Arts, Houston, as the venue to introduce German painting to the people of Texas. We welcome this rare opportunity to view eighty-four masterworks from the Leipzig museum's acclaimed permanent collection. The exhibition is yet another example of the ongoing cultural exchange that began when Houston and Leipzig became sister cities in 1993.

Houston and Leipzig have much in common. Like Houston, Leipzig is a large city that plays a leading role in world trade. Leipzig is a vital link between Eastern and Western Europe, just as Houston is a major port and vital link between Latin and North America. Both cities are prominent centers for academic and technological research. Trade, medicine, science, culture, and a "can-do" spirit are among the bonds that tie these two vibrant cities together.

Now, our city can experience firsthand the most renowned works from Leipzig's Museum of Fine Arts. This exhibition represents a major step in our goal of fostering artistic exchanges between two cities that have discovered the many benefits of international understanding and cultural appreciation. We hope that seeing these cultural treasures from Leipzig will inspire you to visit our sister city.

LEE P. BROWN
Mayor of the City of Houston

Preface

Despite the large number of German immigrants who came to America in the nineteenth and twentieth centuries, there is not a single major collection of nineteenth-century German painting in this country. In addition, despite the fact that nearly one-fifth of the twenty million residents of Texas claim German ancestry, there never has been a major survey of nineteenth-century art in the state.

Now, thanks to the kindness of our colleagues at the Museum der bildenden Künste in Leipzig, Houston becomes a perfect venue for an exhibition of masterpieces never before shown as a group in the United States. It is a fitting collaboration because Leipzig and Houston have been sister cities since 1993. We hope that museums in both cities will develop an ongoing exchange program to enrich both our cultures. Showcasing Leipzig's treasured artworks in this exhibition marks a significant beginning to future efforts.

The great artists in this exhibition are not household names in America. Many of us may be familiar with Caspar David Friedrich but less widely known are Carl Blechen, Lovis Corinth, Max Klinger, and Wilhelm Leibl. These nineteenth-century German masters form the core of the permanent collection of the Museum der bildenden Künste Leipzig. As that museum prepares to move into a new building, the paintings, sculpture and works on paper in the exhibition *Romantics, Realists, Revolutionaries: 19th-Century German Masterpieces from the Museum of Fine Arts, Leipzig* will provide our city a rare opportunity to learn about these works and to understand how German artists influenced American art.

From 1840 to 1880, Germany had a profound impact on artistic life in America.

The Düsseldorf Academy, for a period of about twenty years beginning in 1840, attracted numerous American artists early in their careers. The Düsseldorf Academy emphasized drawing that served genre painters such as Richard Caton Woodville, John Whetten Ehninger, and Eastman Johnson. But the academy's ultimate goal was to train history painters. The most famous American to reach this plateau was Emanuel Leutze whose *Washington Crossing the Delaware* (1851) is an icon of American art.

The tight drawing style of Düsseldorf lost out in the late 1860s to vibrantly rich paintings that echoed the works of Renaissance artists as well as those of Spaniards such as Velazquez. Some of this new style came out of the Royal Bavarian Academy in Munich, but most scholars argue that it was the great painting collections in Munich and the profound interest of the study of art history there that inspired artists to pursue new directions in their work. Two of the most famous Americans to study in Munich were Frank Duveneck, who studied under Wilhelm Leibl, and William Merritt Chase, who evolved his realistic style into a style that succeeded in evoking the atmosphere of a place. The Americans who studied in Munich eventually helped to form organizations that mirrored their experiences abroad. These include The Art Students League (1875) and the Society of American Artists (1877).

By the late 1870s, more and more artists viewed Paris as the place to be. Between 1870 and 1950, the City of Light was the major destination.

Yet, the simple fact remains that from 1840 to 1880, Germany significantly influenced artistic life in America. This exhibition from Leipzig carries on that tradition.

PETER C. MARZIO
Director
The Museum of Fine Arts, Houston

HELMUT BÖRSCH-SUPAN

Diversity within Unity?

Nineteenth-century German painting
in the context of the collection at the Museum of Fine Arts, Leipzig

French painting was centered in Paris, English painting in London. No such center exists in Germany because its many states were not unified until 1871. Vienna, the grand old imperial city at the edge of the Empire, never fulfilled quite the same role as Paris and London, no matter how hard it tried. In the nineteenth century, Austrian painting followed a path all its own. It is interesting to note that while Romanticism had a profound influence on music in the old monarchy, it never took hold in the visual arts there.

Anyone with the desire to fully understand German painting must therefore visit many cities. Studying the eventful history of the country's numerous regions helps clarify the rise and fall of the different schools of art. Cities such as Nuremberg and Augsburg—centers of German Renaissance and Baroque art—slipped into obscurity in later years. In merchant cities, cultural life was governed by rules different from those in cities where a prince or regional potentate established his principal residence. Cities and their culture differed, too, in the Catholic South and in the Protestant North, where words carried more weight than images. The confusing web of city histories makes it difficult for Germans themselves to understand the diversity of their artistic heritage. How much more difficult then for anyone from "outside"! There is only one possible key to a better understanding: history in the context of the country's diverse geography.

The very fact that some of the most important works of nineteenth-century German painting were produced in Rome speaks volumes for the conditions in Germany at that time. Asmus Jakob Carstens, often credited with having breathed new life into German painting, provided the decisive impulse during the brief period when he worked in Rome from 1792 until his death in 1798. Jakob Philipp Hackert, who had already moved to Rome in 1768, revitalized landscape art. His unbounded productivity created the foundations for Romanticism in landscape painting, no matter how much the younger generation insisted on distancing itself from the openness and diligence of this influential and internationally renowned artist. Even as late as the 1870s and 1880s, another "reformer of painting" would settle in Rome: Hans von Marées. In Rome, it seemed, one could simply be a German, while "back home," identities were more complex—one was seen as a Saxon, or a Bavarian or yet a Prussian, and then a German.

Germans were far more unified by their literary heritage than by the visual arts, because literature delivered the national sentiment they so desired. The classic era of German playwrights and novelists such as Klopstock, Lessing, Wieland, Herder, Goethe, and Schiller experienced a flourishing period from approximately 1760 onward. Literature, it would seem, could provide the model for the visual arts. In the Romantic era, poetry dominated and had a powerful influence on painting. Wilhelm Schadow's *Mignon* (see cat. no. 28) based on a character from a novel by Goethe, the very embodiment of the Romantic poet, aptly shows the link between literature and the visual arts. However, these close ties to literature served only to demarcate national boundaries even more clearly, especially against France, which had had such a strong influence on Germany's culture during the eighteenth century.

Asmus Jakob Carstens
Melancholic Ajax
with Termessa and Eurysachas
Watercolor, c. 1791
Kunstsammlung zu Weimar

The renewal of the visual arts in Germany preceded the change from the eighteenth to the nineteenth century by a full generation and accelerated dramatically in the wake of the turmoil caused by Napoleon's field campaigns in Germany.

In Catholic southern Germany, one clearly observes how the spirit of the Enlightenment and Neoclassicism coincided with the decline in the 1780s of a great art founded in religious feeling, practiced by many talented artists and widely spread even into the smallest villages. A similar fate

Jakob Philipp Hackert
Riverscape with Mercury and Paris
1785
Museum der bildenden Künste
Leipzig

befell the tradition of courtly portraiture, which had flourished especially in the Protestant North. Anton Graff was the last German painter of note who continued to devote himself almost exclusively to portraiture. His confident treatment of the human figure and face, combined with a lively presentation such as in the late self-portrait from 1809 (see cat. no. 7), gradually gave way to a style that focused on carefully documenting individual characteristics. Objectivity became the new ideal. Years later, in the era of Historicism and a well-to-do bourgeois milieu, Franz Lenbach once again took up the role of society portraitist (see cat. no. 59).

As Baroque culture began to fade, the seeds were planted for a generation of artists who believed in art's capacity for renewal.

Academies and drawing studios became the training ground for this expansion. These institutions were usually founded or reorganized by members of the aristocracy, as in Mannheim (1756), Stuttgart (1761), Dresden and its affiliated academy in Leipzig (1764), Munich (1770), Düsseldorf (1773), Kassel (1778), and Berlin (1786).

At the opulent court of the Elector of the Palatinate Karl Theodor, artistic life ground to a halt in 1777 when he moved his residence to Munich after having been granted the same office and title over Bavaria. Mannheim's foremost artists, among them the Kobell family, followed the prince to Munich.

Stuttgart, a town of only 20,000 and the seat of the Duchy of Wurthemberg, saw the emergence in the 1780s of a Neoclassical style influenced by its proximity to France and the stewardship of Jacques Louis David. For two decades, the small city became the center of the most modern art movement in Germany. This period of artistic flourish came to an abrupt end with the French occupation in 1796. The Stuttgart art scene would never again attain a similar radiance and impact as during the era of Neoclassicism.

In addition to portraits, historical images based on Antiquity and landscapes were the main themes, the latter particularly in the work of Joseph Anton Koch (see cat. nos. 8 and 9). Philipp Friedrich von Hetsch, Eberhard Wächter, and Gottlieb Schick were the leading historical and portrait painters of the time. As is typical of classic movements in art, sculpture flourished as much as

Gottlieb Schick
Apollo Surrounded by Shepherds
1806
Staatsgalerie Stuttgart

painting, with Heinrich Dannecker and others as the main representatives. Finally, it is important to remember how profoundly this era was inspired by the genius of Friedrich Schiller, whose revolutionary early work *The Robbers* was published in 1781. The playwright fled from the despotic rule of Duke Karl Eugen in the following year.

The influence of Stuttgart's Neoclassicism extended above all to the artistic communities in Rome, Vienna, Dresden, and Berlin. Koch, who saw himself as a successor to Carstens, worked in Rome from 1795 until his death in 1839. Schick was closely linked to Koch from 1802 to 1811 before his untimely death in 1812 at the age of thirty-six. Through Caroline von Humboldt, he exerted a strong influence on painting in Berlin. Ferdinand Hartmann brought the Stuttgart style to Dresden, while Heinrich Füger, originally from Heilbronn in Swabia, directed the Vienna Academy from 1795 until his death in 1818.

In the nineteenth century, the academies came into their own as did the practice of major, organized exhibitions, above all in Dresden, Berlin, Munich, and Düsseldorf. In each case, one can justifiably speak of a "school," that is, a cohesive style of art with a specific and unique character. Patrons, too, contributed to this trend by founding yet more institutions, such as in Karlsruhe in 1854 where Edmund Kanoldt and Hans Thoma (see cat. nos. 63 and 78) were active, or in Weimar in 1858 where Karl Buchholz and Friedrich Preller the Elder (see cat. nos. 58 and 55) were based. Another academy had been founded as early as 1845 in Königsberg, Prussia, as an adjunct to the Berlin academy to bolster the somewhat impoverished artistic life in Germany's east.

Increasingly, art exhibitions were instrumental in elevating the quality of the exponents of new movements through criticism and competition, and also in opening new markets for art.

The academies churned out a steady stream of artists who relied on the support of the artists' associations, which were founded in all major German cities after 1818. This growing population of new artists ensured that interest in art became more widespread, penetrating even into remote areas. In doing so however, academies also promoted a kind of mediocrity, as they were perhaps too readily influenced by the dictates of the "marketplace" in the interest of survival. Being an artist was an alluring professional choice because it offered the opportunity to leap across social barriers—to rise to a higher position in society than one may have been granted by birth alone. Few dwelled on the fact that only a handful of exceptionally talented artists ever succeeded, while others, no matter how gifted, failed.

The aristocracy and the church no longer inspired artists to create their greatest works. Caspar David Friedrich's landscapes, although spiritual in nature, were created outside of the fold of the Protestant church (see cat. nos. 21, 22, 23). King Ludwig I of Bavaria, who reigned from 1825 to 1848, was one of the few monarchs still able to uphold the traditional link between court and art. Gathering artists like Peter Cornelius, Julius Schnorr von Carolsfeld (see cat. no. 10), and Carl Rottmann (see cat. nos. 18 and 19) around him, he basked in the reflected glow of their artistry. Overall however, fewer works were created on commission and more were "produced" for a specific market with the artist often absorbing the risk of working on an ambitious, large-scale painting for naught if he was unable to sell it. This was particularly true of large works on historical themes, whose scarcity was generally bemoaned.

However, some painters saw it as their duty to educate society; by sheer dedication they seemed to rise above such adversity and unerringly followed their own path. Today, an almost heroic aura surrounds this group of artists, comprised, at the beginning of the nineteenth century, of the core group of Romantics and, at the close of the same century, of the forerunners of modern art, such as Max Liebermann, who incurred the displeasure of Kaiser Wilhelm II for his efforts (see cat. nos. 60, 61, 62).

As a result, many major artists emerged outside of the academies or even in direct opposition. Some worked in complete isolation, devoted only to their own artistic conscience. Others sought out a circle of like-minded colleagues, and yet others, such as the Nazarenes, looked to the distant past for inspiration while some, like Philipp Otto Runge (see cat. nos. 3, 4, 5, 6) and Caspar David Friedrich, explored innovative and uncharted areas.

Peter von Cornelius
Joseph Interpreting Dreams
Fresco on plaster, 1816–17
Staatliche Museen zu Berlin,
Nationalgalerie, Berlin

The Nazarenes—a derogatory nickname coined because of their hairstyle reminiscent of traditional Christ images—formed into a recognizable school of artists from 1810 onward in Rome where they led a monastic life. The core of the group was the so-called Lukas-club founded in 1809 by Lübeck artist Friedrich Overbeck (see cat. no. 16) and his Frankfurt colleague Franz Pforr in protest against the teaching methods at the Vienna Academy, with four other painters joining in. Their goal was to create art from the source of a morally pure lifestyle, with the act of creating art as a kind of sacrament and the profession of the artist a kind of priesthood. Their models were Rafael, Dürer, and the classic Italian painters. Initially only Pforr, who died in 1812, Overbeck, and the Swiss Ludwig Vogel went to Rome. Others began to join them after 1811, among them Peter Cornelius from the Rhineland—the most colorful figure of the group—and Berlin's Wilhelm Schadow, the son of the leading Classical sculptor.

The school's style was characterized by a highly disciplined skill in drawing and emphasized contours, with similarities to the work of Carstens and John Flaxman from England, who had distilled drawing down to a perfect shorthand. Anything that revealed the artist's hand or his individuality was avoided as artistic vanity.

Their love of traditional Italian prompted the group to revive the art of fresco painting. In 1816, Overbeck, Schadow, Philip Veit (also from Berlin and grandson of philosopher Moses Mendelssohn), and Peter Cornelius collaborated on a fresco depicting the story of Joseph in the Roman residence of Prussian Consul General Jakob Salomon Bartholdy. It was hoped that this work would have a lasting influence also in Germany where everyone anticipated a renewal of the arts in the wake of the victory over Napoleon in 1815. However, the only reaction was one commission in 1817 for frescoes with motifs based on the poetry of Dante, Ariosto, and Tasso, for the Casino Massimo, a commission whose completion took until 1829.

The allure of Rome and the Nazarene ideal continued to grow. However, the dogmatic approach of Overbeck, whose logical and personal conclusion prompted him to convert to Catholicism in 1813, was not for everyone; many other splinter groups developed.

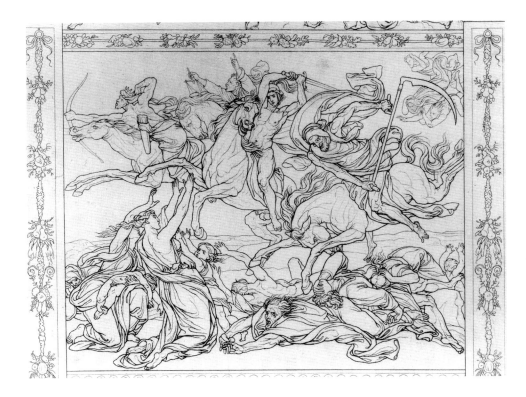

Peter von Cornelius
The Four Riders of the Apocalypse
1846
Staatliche Museen zu Berlin,
Nationalgalerie, Berlin (destroyed)

Carl Philipp Fohr
Schriesheim
Watercolor, 1813–14
Museum der bildenden Künste
Leipzig

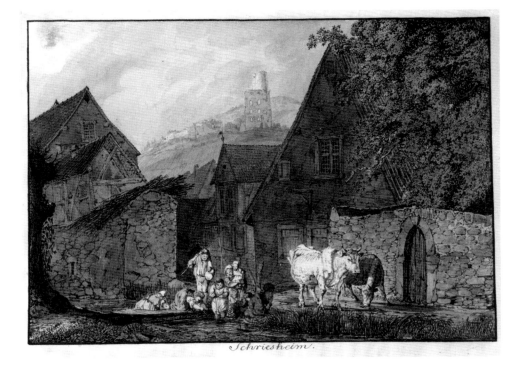

Carl Philipp Fohr and Franz Horny, two genial landscape draftsmen, arrived on the scene in 1816. Shortly thereafter, in 1818, Horny drowned in the Tiber River and Fohr succumbed to tuberculosis in 1824. In 1817, Julius Schnorr von Carolsfeld came to Rome. In Vienna, he had just finished a masterpiece in the Nazarene style, titled *Saint Roch Distributing Alms* (see cat. no. 10). Von Carolsfeld continued to pursue this style in Munich in 1827 and in Dresden in 1847. In 1818, Friedrich Olivier traveled to Rome from Dessau, a center, even then, of enlightened studies in art. Landscape as a theme in painting and drawing introduced genrelike motifs into Nazarene art. The rustic Tyrolian artist Joseph Anton Koch was the mentor of these young landscape artists. His famous work, from 1811, titled *The Schmadribach Waterfall in the Lauterbrunnen Valley* (see cat. no. 8) clearly expresses Koch's view of the world as a mountainous environment in which the mountains themselves were symbols of an even grander architecture created by God. Koch felt so closely connected to the Nazarenes, in fact, that he commissioned Peter Cornelius to paint an image of Jacob's homecoming into one of his own landscapes some five years later (see cat. no. 9).

The Nazarene style spread from Rome to all major German cities. Cornelius, director of the Munich Academy since 1825, led the movement in the Bavarian capital. Heinrich Maria von Hess's *The Visitation* (see cat. no. 35), from 1829, is a perfect example of this pious artistic style. And, when Wilhelm Schadow was appointed director of the Düsseldorf Academy in 1826, he cultivated an elegant, technically accomplished variation of the Nazarene style with a small circle of student followers. Philipp Veit took on the directorship of the Städelsche School of Art in Frankfurt am Main in 1830, where he also promoted the Nazarene style. Suddenly three —and with Schadow student Eduard Bendemann's appointment to the Dresden Academy in 1838, even four—major art institutions were led by representatives of a movement that had originated in opposition to the academies. By its very nature, the Nazarene style with its "nostalgia" for an art of the distant past, was limited as a movement, and the gradual impoverishment and demise that followed were inevitable as other, Realism-based movements overtook it.

In 1841, Cornelius was called to Berlin, where he sketched some grandiose designs for frescoes, none of which were ever executed, while Aldoph Menzel, whose genius was known to only a very few at that time,

was already creating historical images in a very different manner. Both were probably Germany's most significant artists of the day, after the death of Caspar David Friedrich and Carl Blechen in 1840. But their paths could not have been more different and they had no contact with each other; on the other hand, both were also limited as to their sphere of influence. This circumstance casts a stark light on the paralysis, which had set in for German painting by the mid-nineteenth century, once the invigorating energy that followed the wars of liberation had ebbed.

Menzel was captivated by the power of history, whose impact he experienced in daily life. Whenever he studied the past he was looking at the present. His goal was to represent less the divine than the all-too-human forces in the world; he wanted to do so with a sober, disillusioning glance, albeit not without admiration for the great figures in history (see cat. no. 49). Thus, Menzel became a constant and incorruptible observer of his surroundings and of human activity. The result was an impressive oeuvre in which acute observation, a sharp intelligence, and virtuosity in drawing combined to reveal the individuality of the objects he portrayed, while maintaining their integrity (see cat. nos. 50 and 51). These works offer a foretaste of our contemporary, insatiable appetite for pictures and our belief in the authenticity of the photographic snapshot.

In the first half of the nineteenth century, many artists were highly attuned to emotional subtexts even in landscape; the result was a proliferation of drawings whose unique rhythm and style clearly communicate a love of the object (see cat. nos. 12, 20, 27). Some draftsmen focused exclusively on this intimate art form with little public impact. This high culture of the drawing ceased in the second half of the century and Menzel alone stands out in this regard.

When two historically detailed works by Belgian artists were exhibited in Berlin in 1842— Edouard de Biefve's *Compromise of the Dutch Nobility* (1566) and Louis Gallait's *Abdication of Karl V to the benefit of his son Philipp II* (1555)—it became evident that the chasm between idealistic, religious figurative painting and realistic, historical painting had become insurmountable. Realism won the day and henceforth it was unanimously agreed that the highest achievement in art was the ability to create a suggestive rendering of great historic moments. Progress in this genre consisted of increasing the scientific detail in the depiction. Many works from this period no longer exist because the development was later condemned. Biblical themes, too, were treated in this manner.

In a famous painting by Fritz von Uhde, created in Munich in 1884 and titled *"Suffer Little Children to Come Unto Me"* (see cat. no. 64), the Nazarene maxim of inspiring a feeling of solemn piety was successfully combined with a realistic rendering, even though the biblical scene was depicted in a contemporary setting to emphasize the eternal validity of Christ's word. The immediacy conveyed in this painting is closely linked to the innovations achieved through modern Impressionistic painting.

The majority of paintings created in nineteenth-century Germany depicted landscapes, imagined or real, that captured a specific location. There were others that encapsulated, anonymously as it were, the aesthetic interest of a piece of nature, a certain cast of light or similar phenomena, as well as a whole range of other mixed forms of landscape painting.

The early Romantic landscape artists espoused a very different philosophy from the Nazarenes, although most representatives of both groups hailed from the North. Caspar David Friedrich was born in Greifswald in Pomerania and the iconography in his images—dividing the space into a worldly foreground and an otherworldly background—sprang from the artist's personal experience of the coastal landscape (see cat. nos. 20, 21, 22). The other major figure in early Romanticism was Philipp Otto Runge, who came from Wolgast, a town near Greifswald. He died in 1810. Toward the end of his life, Runge worked in Hamburg, later home to a bourgeois artistic community whose works were highly realistic and unique. Runge tried to show landscape as a cosmos ordered by God, depicting less an excerpt of nature than a complex and imaginative allegory in which the painterly composition mirrored the divine order (see cat. nos. 3, 4, 5, 6).

Yet both artists experienced their most important period in Dresden, where Friedrich lived until his death in 1840.

The capital had become a celebrated center of the arts in Germany thanks to the generous patronage of the Electors of Saxony and the attractive landscape that surrounded it. In approximately 1800, Dresden also became a center of early Romantic literature. One of the unique characteristics of Saxony was the invigorating symbiotic relationship between courtly Dresden and Leipzig—the latter with its venerable university and established trade fairs and considered a more bourgeois city where private collectors and the adjunct branch to the Dresden Art Academy promoted a more serious art production.

The natural environs of Dresden, especially the area along the Elbe River, had been a popular site for landscape art as far back as the mid-eighteenth century, when such works aimed at arousing patriotic sentiment. The landscape motif was commonly shown in drawing and engraving. The cityscapes by Venetian artist Bernardo Bellotto made Dresden the cradle of German architectural art, which blossomed in the nineteenth century, especially in Berlin.

At the turn of the eighteenth century, Johann Christian Klengel was the leading landscape painter in Dresden. His work bridges the gap between the sensitive, emotive, and often Arcadian eighteenth-century landscapes and the clarity expressed in early Romanticism. His *A Lake in Moonlight* (1804) evokes a feeling that is difficult to define (see cat. co. 1), while Friedrich's *Seascape in Moonlight* (1826–27)—a ship on a wide-open sea in the light of a moon half-obscured by clouds—is clearly allegorical (see cat. no. 22).

Only a few artists continued in Friedrich's tradition of treating the landscape as a parable for religious ideas. To Ferdinand Olivier—who lived in Dresden from 1804–6 and in Vienna from 1811–30—the hikers in the foreground of his *Landscape near Berchtesgaden* (see cat. no. 11), from 1817, were an allegory for a Christian way of life, as he stated in a letter to his friend Wilhelm von Gerlach. When Norwegian painter Johan Christian Dahl arrived in Dresden in 1817, he was strongly influenced by Friedrich—from 1820 onward they lived in the same house—but instead of adopting his colleague's philosophy on depicting nature, he espoused a more naive view of landscape. In keeping with his lively temperament, he applied the paint in rapid gestures, which captured the natural elements and movement and also allowed for tremendous productivity (see cat. no. 17), earning him a large following.

Carl Gustav Carus, a physician and painter friend of Friedrich, adopted the latter's symbolic vocabulary, without, however, ever achieving the same clarity (see cat. nos. 32, 33, 34).

The same can be said of Ernst Ferdinand Oehme, who began his career by emulating Friedrich. Later, however, he arrived at a quite different perception of landscape along with Ludwig Richter with whom he spent several years in Italy. They worked there under the influence of Koch. This influence is particularly evident in the panel titled *Mountainous Landscape with a Group of Trees and a Chapel, with the Borschen in the Background* (see cat. no. 38), painted in memory of Oehme's journey to Bohemia with Richter in 1841. In this image people live in harmony with a detailed and lovingly rendered landscape. Such images, more even than any created by Richter, inspire the viewer to enjoy life and appreciate the beauty of nature. A darker, more threatening side of nature—as much a part of it as beauty—is captured in Ludwig Richter's *Approaching Storm at Schreckenstein* (see cat. no. 25). The scene shows a storm about to break and country folk running for shelter. It would be a mistake to look upon these paintings as representing bucolic idylls. The painters were all too aware of the dangers that came with rapid urban expansion and industrialization, and the poverty and misery of the working classes. Their images warn of these dangers and praise the virtues of a simple life in harmony with nature. Richter became one of Germany's most popular artists, especially because of his work as an illustrator.

Such concerns about negative trends in society were also a result of the economic hardship in Saxony in the wake of the "wars of liberation." Saxony had been Napoleon's ally right to the end, and consequently paid the price of defeat by having to yield large tracts of land to Prussia. Dresden lost its status as Germany's leading center of art and seemed more bound to tradition in the decades that followed. By the end of the century, when Impressionism finally came to Dresden through

Lübeck artist Gotthardt Kuehl, who had trained in Paris, the Dresden style seemed somehow tamer, more contemplative (see cat. no. 82).

The Leipzig painter, draftsman, etcher, and sculptor Max Klinger, by contrast, had a profound influence. His cosmopolitan experiences in Berlin and Paris inspired the artist to develop a visual language that fed the imagination and provided psychological insight (see cat. nos. 70, 71, 72, 73). In his etching cycles he illustrated major dramatic epics, and he also sought to create analogies between art and music, with Beethoven as his greatest hero (see cat. no. 74). There seems to be a straight line from Klinger to another great Leipzig painter: Max Beckmann. Klinger's world is the very world Ludwig Richter had warned against.

Saxony's political loss was Prussia's gain. More than that, because the Rhineland and Westphalia, too, were absorbed into Prussia. Berlin—already a major center during the Enlightenment and literary Romanticism—now became Germany's center of science after the founding of its university in 1810. Prussia's supremacy began to make itself felt and was powerfully reinforced during the second half of the century. In art, this was particularly evident in sculpture, with Johann Gottfried Schadow as the leading artist and founder of an influential school from which Christian Daniel Rauch emerged, ultimately outranking his erstwhile teacher. And in Karl Friedrich Schinkel, Berlin had the most inspired, productive, and visionary architect of nineteenth-century Germany, an enormous benefit for the city's development in the years after the wars of liberation. The Berlin painting of those years, however, never matched the political stature of the capital, despite many respectable talents and Schinkel's own attempts as a painter. Another reason may well have been the conscious and intelligent decision to avoid centralization and to promote the arts in the provinces. Thus, Wilhelm Schadow moved to the Düsseldorf Academy in 1826, as the head of a group of Berlin's foremost painters.

Still, Berlin did produce two excellent artists in Carl Blechen and Adolph Menzel. On the surface they seemed to have much in common because of the vigorous manner in which they applied paint to canvas, but each pursued a very different philosophy (see cat. nos. 39, 49, 50, 51). Blechen was a Romantic in an era when hopes that Romanticism would by artistic intervention help to

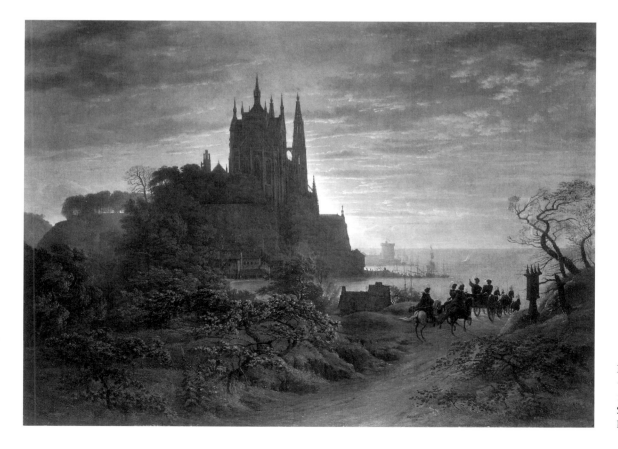

Karl Friedrich Schinkel
Gothic Church on a Cliff
1815
Staatliche Museen zu Berlin,
Nationalgalerie, Berlin

build a more humane society had already begun to fade. The fallout of the 1830 July Revolution in Paris came as a great shock in Germany because fifteen years prior to these events, everyone had believed that the specter of revolution had been banished for good. Increased emigration to America was only one of many symptoms of a growing unease.

The infectious energy in Blechen's art arose from a sense of danger, which the artist tried to escape but which erupted again and again with explosive force in his paintings and drawings whose spontaneity sets them apart from the majority of the other graphic works in the Romantic style. A journey to Italy in 1828–29 seemed to lift the artist's melancholy at first, but in the end he succumbed to it nonetheless. Mentally ill from 1836 onward, he died in 1840. His work titled *Valley with a Mill near Amalfi* (see cat. no. 39), from 1831, exaggerates the steep angles of mountain slopes, houses, and trees, and the oppressive narrowness of the gorge. The two slender trees, to which the figures relate in the composition, seem to signal how easily they can be felled, a frailty underscored by a tree stump nearby. The drama in the painting is not merely one of nature observed, but also of the conflict between the sturdy robustness of progressive Berlin society and the artist's own vulnerability.

Still, most artists were quite capable of adapting to fashionable trends in order to survive. Throughout the 1830s, artists poured into Berlin. Journeys to Italy for the purpose of painting the local landscapes and creating genre images were *de rigueur* among the Berlin crowd, far more so than in Dresden, Düsseldorf, and Munich. This trend was no doubt linked to the Classicist tenor in Berlin art—an attempt to transplant southern style to the North—and also to the austerity of the northern landscape, whose unique charms, especially of the waterscapes, were not discovered by landscape painters until the late nineteenth century. Like Blechen's, Menzel's work was one of opposition, but he was tougher and more resilient and thus better equipped to survive a long period of obscurity until he finally achieved fame in the 1860s. The Berlin style was characterized above all by a sober objectivity and a sparse elegance. These characteristics were at their best in architectural painting and in portraiture. The former genre, especially, profited from the heightened awareness in the city of architecture through the work of Schinkel and his successors. Eduard Gaertner was the foremost artist of this genre because he went beyond objective documentation. He sought to achieve

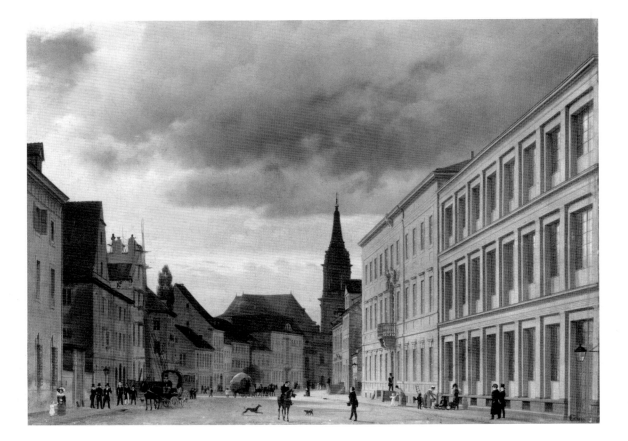

Eduard Gaertner
Klosterstrasse
1830
Staatliche Museen zu Berlin,
Nationalgalerie, Berlin

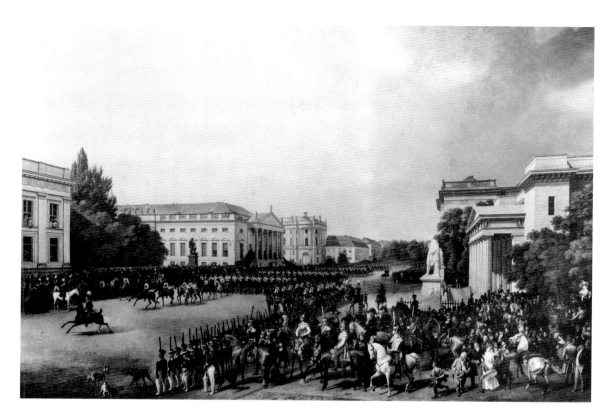

Franz Krüger
Parade on the Opernplatz in Berlin
1824–1830
Staatliche Museen zu Berlin,
Nationalgalerie, Berlin

minute nuances in color, and his compositions and settings successfully demonstrated how the character of a city is formed by the people who build and inhabit it. The ascendancy of photography made this kind of glittering representation redundant.

The same applies to portraiture which, although popular, was not widely represented in Berlin. Instead, drawings were often held to be sufficient, such as those by Franz Krüger, who was adept at creating them quickly and with tremendous accuracy. He stands out among the other portraitists of his day. His monumental depictions of Berlin society at special events, parades, and Friedrich Wilhelm IV's tribute in 1840, are unique achievements that typify the Berlin of the era.

From an objective contemporary perspective, one can, in hindsight, draw a straight line from Krüger to Menzel. But this line also continues on to Anton von Werner, a talented and influential painter at the beginning of the Kaiser era in 1871, and who is all too easily dismissed today. Werner was bitterly opposed to modernity, putting his talents entirely at the disposal of the state and seeking to document important political events in detailed historical paintings. There is, however, also a direct link from Menzel to Max Liebermann, who best captured the essence of life in Berlin during the last third of the nineteenth and the beginning of the twentieth century. The painting *The Preserve Makers* (1879) is among his early works in which he gave artistic dignity to the pace of an oppressive world of labor through a style full of nuance and insight (see cat. no. 60). Sixteen years later he would paint an exhausted Dutch farmer taking a break: in the composition the figure occupies but a tiny space in an immense, albeit nondescript, dune landscape. Without pathos, the farmer is an expression of anonymous greatness that cannot be measured by societal values (see cat. no. 61). In his mature years and at the height of his

Anton von Werner
Crown-Prince Friedrich at a Court Ball
1895
Staatliche Museen zu Berlin,
Nationalgalerie, Berlin

Oswald Achenbach
Rocca d'Arci
1877
Museum der bildenden Künste
Leipzig

success, Liebermann came to appreciate the respectability of a bourgeois existence. The self-portrait from 1929 shows the artist, then president of the Prussian Academy of Art, at more than eighty years of age (see cat. no. 62).

At the beginning of the Kaiser era, the Berlin Gallery had little stature. Munich was still considered to be the center of German art. This dominance changed as a result of a countermovement in the arts that was more receptive toward international trends, leading to the foundation of the Berlin Secession in 1899 with Max Liebermann at its head. When Lovis Corinth (see cat. no. 81) from Eastern Prussia and, one year later, the Bavarian Max Slevogt (see cat. no. 83) moved to Berlin, the metropolis was home to the three most important representatives of German Impressionism, and thus became the center of German art.

During this period, the Düsseldorf School exerted little influence. Still, at the turn of the century the Achenbach brothers continued to work and paint in Düsseldorf: Andreas Achenbach (see cat. no. 54), born in 1815, the same year as Menzel and surviving Menzel by five years, and Oswald Achenbach, born in 1827, who died in 1905, also the year of Menzel's death. Both were passionate and productive landscape painters, the elder more interested in the northern landscape and the sea, and the younger more drawn to Italy.

The Düsseldorf School first came to prominence in 1826, when Wilhelm Schadow was appointed director of the academy. He was joined by Eduard Bendemann, Julius Hübner, and Carl Sohn from Berlin, all talented figurative artists working in the Nazarene style, as well as Karl Friedrich Lessing, a solid landscape artist and great-nephew of the poet and playwright, who also painted historic works that contained critical commentaries of the present (see cat. no. 48). This fairly homogenous, Prussian group was joined by Johann Wilhelm Schirmer (see cat. no. 46) from the Rhineland, a landscape artist, who was mainly influential as a teacher. The Düsseldorf group quickly gained recognition and it was generally held that this success was symptomatic of a new era in German painting after Prussia's victory over France. Schadow's *Mignon* (see cat. no. 28) was among the enthusiastically celebrated works of this school, but soon after 1830 the first skeptical voices were raised, not least of all as part of the general unrest that characterized this time. The dissenters found sympa-

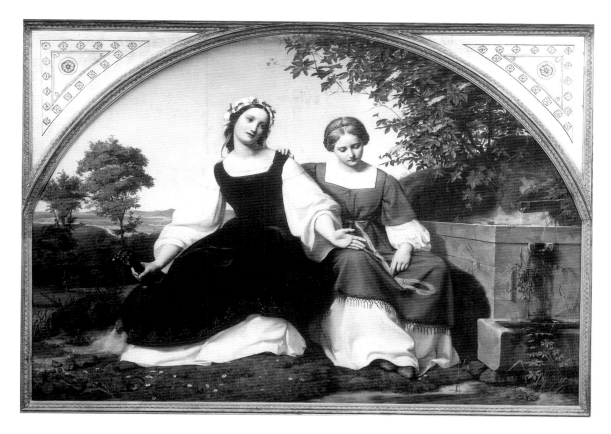

Eduard Bendemann
Two Maidens
1833
Kunstmuseum im Ehrenhof,
Düsseldorf

thies in the Rhineland, which was more democratically inclined and dissatisfied with Prussia's su-premacy. This mood is evident in Wilhelm Joseph Heine's painting *A Service at the Penitentiary Church (Criminals at Church)* (see cat. no. 44), from 1837. The picture is psychologically revealing and openly sympathetic to the prisoners, thereby questioning the validity and structure of state power. During this time, many talented, young artists left the academy in protest, beginning with Andreas Achenbach in 1835, followed by Alfred Rethel in 1836. Rethel was the most individualistic histori-cal painter of the Düsseldorf School, who sided with the conservatives in the 1848 revolution and warned of a coup by way of producing a gripping series of woodcuts, which were very much in the tradition of Dürer and which he called *Also a Dance of Death*.

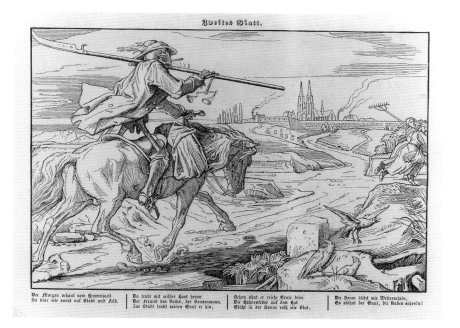

Alfred Rethel
Death on Horseback
Sheet 2, woodcut, from:
Also a Dance of Death, 1849

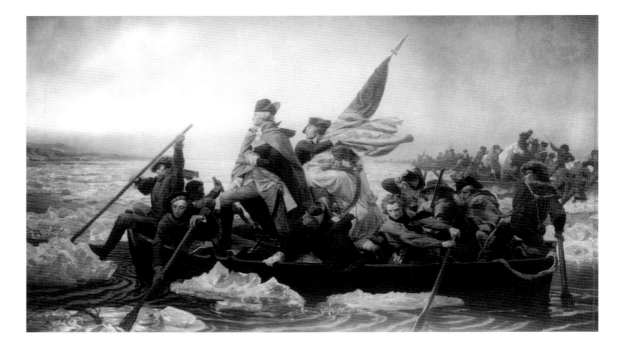

Emanuel Leutze
Washington Crossing the Delaware
1851
formerly in the Kunsthalle Bremen
(destroyed in 1943)

Despite such crises, the academy in Düsseldorf attracted many students from Scandinavia, Russia, and America. Among this group the German-American Emanuel Leutze, who resided in Düsseldorf from 1841 to 1859, was the most famous.

Relatively speaking, this small city was home to a large number of artists. As a means of economic survival, they organized a kind of "picture factory" in which they turned out competent landscape and genre works that appealed to the taste of a broad public and were mainly geared toward export. Thus an art dealership was founded in 1849 in New York specializing in the sale of art from the Düsseldorf School, whose pathos appealed to collectors in America who valued a pioneer spirit and appreciated spectacular landscape views. The works of other German schools were not nearly so sought after in America.

But these economic constraints stood in the way of a much-needed artistic renewal, and gradually Düsseldorf's reputation began to suffer. When an academy was founded in Karlsruhe in 1854, Johann Wilhelm Schirmer moved to the capital of Baden Baden as its new director. Lessing and Adolph Schrödter, a talented genre painter, followed in 1858 and 1859, respectively.

In Karlsruhe, Hans Thoma was the most popular painter. A student of Schirmer, he had also been strongly influenced by Gustave Courbet in Paris. From 1876 to 1899, he was based in Frankfurt am Main, the traditional bourgeois center of southwest Germany, which was more open toward modern French art than other areas in Germany. His *Landscape along the Main River* (see cat. no. 78), from 1893, combines idyllic studio elements with a lofty composition based on simple motifs, founded in solid drawing. There is something of the spirit of the early Romantics, especially Runge, although—naturally—without the optimistic perspective of that earlier time.

Next to Frankfurt, Munich had become the second gateway to modern French Realism in landscape painting since the 1860s. During the second quarter of the nineteenth century, King Ludwig I had given the city a complete facelift with elaborate buildings. He also commissioned outstanding artists such as Peter Cornelius, Heinrich Maria von Hess, and Julius Schnorr von Carolsfeld, to provide new interpretations of ancient, Christian and modern literature as tangible expressions of his theory of absolutism. Most of these works were executed as large wall panels or frescoes. In architecture, Munich's answer to Berlin's Schinkel was Leo von Klenze, who, like the former, was also active as a painter. His architectural vision is expressed in a painting titled *Italian Landscape* (see cat. no. 36) from 1829, characterized by the clarity in the composition of the landscape elements and also in the integration of the mountain face and castle ruins. Even in decay, he seems to say, the majesty

of architecture dominates nature. In Carl Rottmann, an artist from Heidelberg, this tendency to-ward the grandiose combined with a fascination with the past, took on a tragic note. In *Ruins of Sikyon with Mount Parnassus* (see cat. no. 19), from 1839, ancient Greece, whose revival was being attempted in Munich, is represented as irrevocably lost, overpowered by the natural power of the cosmos.

In addition to such academic styles, another, more folkloric, narrative, but well-crafted genre flourished in Munich. Heinrich Bürkel's *Mountain Village* (see cat. no. 41), from 1834, is a perfect example. In terms of architectural painting, Domenico Quaglio (see cat. no. 40) was the leading artist in Munich. And Carl Spitzweg combined a new, gently satirical tone in genre painting with a sensitive palette, giving him enduring popularity to this day (see cat. no. 52). The Viennese Moritz von Schwind, only slightly senior to Spitzweg, remained an outsider in Munich. More aloof and probing, his drawing style was still very much in the Romantic tradition. Schwind, more than any other German painter, made the world of fairy tales and sagas the theme of his work (see cat. no. 47).

Munich particularly favored genre painting of country life that was unabashedly nationalistic. The Alps as a motif always garnered admiration, although other artists such as Josef Wenglein (see cat. nos. 67 and 68) and Ludwig Dill (see cat. no. 80) discovered beauty in less dramatic landscapes. This latter aesthetic connected at the turn of the century with the formal intent of Art Nouveau, which originated in Munich, among other cities. Among the genre painters of peasant life, Franz von Defregger (see cat. no. 57) was especially popular, keeping alive the myth of the brave, loyal peasant folk of Tyrol—a myth that had evolved during the Napoleonic era. In Munich, successful painters enjoyed a high social standing. Many were granted titles, as was the case for Cornelius, the historic painters Wilhelm Kaulbach and Carl Piloty, Defregger, Lenbach, and Franz Stuck. Munich gave rise to the phenomenon of the *Kunstfürst*, or "prince of art," celebrating the artist's stature in society and giving it external expression in grand villas and residences.

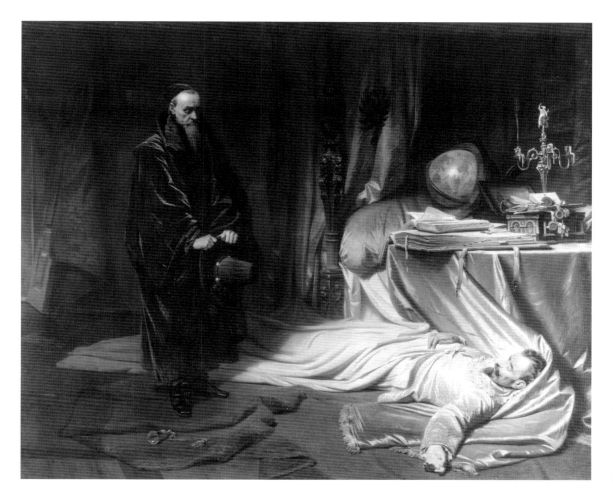

Carl von Piloty
Seni Standing in front of the Dead Wallenstein
1855
Bayerische Staatsgemäldesamm-lungen, Neue Pinakothek, Munich

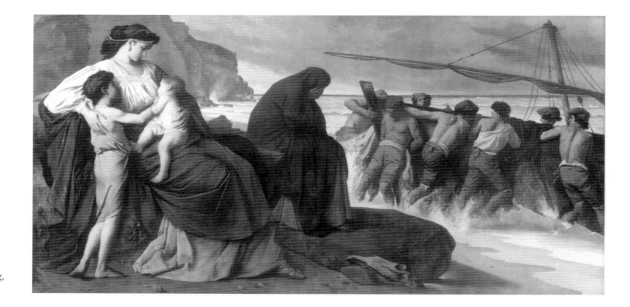

Anselm Feuerbach
Medea
1870
Bayerische Staatsgemäldesammlung,
Neue Pinakothek, Munich

The so-called *Deutschrömer*, or literally "Germans in Rome," had much closer ties to Munich than to the North. These were Arnold Böcklin, Anselm Feuerbach, and Hans von Marées, all born between 1827 and 1837. From a feeling of unease that characterized this period, all three strove for a renewal of German art and looked to the culture of the Mediterranean for inspiration. Yet, unlike the Nazarenes two decades earlier, they were not looking for the roots of Christian life, but for a harmony between life and nature that reached back to Antiquity. This was a movement of rebirth, not of departure toward a modern era. The reality of Germany's present was simply pushed aside.

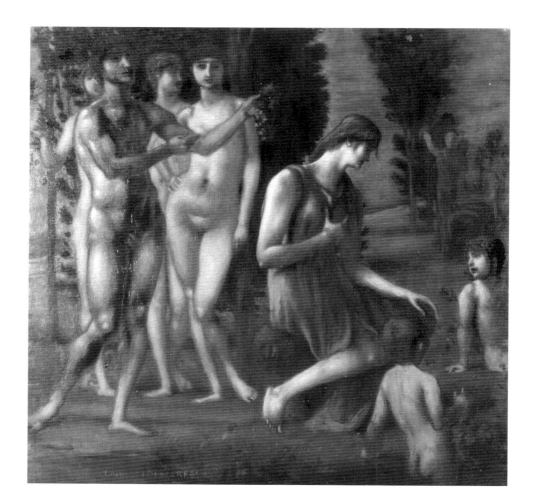

Hans von Marées
In Praise of Modesty II
1885
Museum der bildenden Künste
Leipzig

Anselm Feuerbach worked in a Neoclassical style inspired by literature. Marées sought to translate the intensity of human expression, a goal with which he struggled terribly. Of the group, he had the most enduring influence on twentieth-century artists. The Swiss Böcklin, more robust than his two companions, the eldest of the group and the one who would live longest, until 1901, knew how to bring myths and legends to life. After many years of being relegated to the sidelines, he finally received enthusiastic accolades toward the end of his life. *The Island of the Dead V* (see cat. no. 66), from 1886, the latest of altogether five versions, distilled nature's eternal essence. The theatrical solemnity and monumentality of the work seeks to offer consolation for human mortality. Yet what was perceived as modern and daring at the turn of the century, would soon be considered superannuated, or even lacking in artistic value, because of its Symbolist tendency.

With a premonition of the political catastrophe that arrived with World War I and whose full impact we are perhaps just beginning to comprehend, Modernism quickly gained ground in Germany in the years immediately after 1900. Even before 1914, many other styles emerged to rival Impressionism, which appeared as a unifying international movement. The result was a pluralism of expressive styles and a leveling of local differences.

THE MASTERPIECES

Plates

The Authors

HKA Helga Kessler Aurisch
KM Karl-Heinz Mehnert
SP Susanne Petri
DS Dietulf Sander
AS Andreas Stolzenburg

I Johann Christian Klengel

1751–1824

A Lake in Moonlight

1804

Oil on canvas, 93.8 x 119.5 cm
Signed on the back: Klengel 1804
Inv. no. 1351

Provenance: acquired in 1942 from the art dealer Gustav Werner, in Leipzig,
with funds intended for the legal foundation of state museums

Klengel, the first truly significant painter from Saxony who trained at the Dresden Academy of Art, succeeded in liberating landscape painting from the conventions of Dutch and French art. In so doing, he paved the way for the Romantic approach to landscape subjects that was to become associated with Dresden.

Having received traditional academic training under Christian Wilhelm Ernst Dietrich, Klengel was impressed by the picturesque landscape fantasies produced by artists such as Johann Heinrich Roos. He also broadened his historical range by making copies of the work of seventeenth-century Dutch masters. Characteristic of Klengel's activity is a painting in the Leipzig Museum, *Landscape with Cowherds and Cattle*,[1] which is a copy after the *Landscape with Figures and Cattle* of 1658 by Frederik Moucheron and Adriaen van de Velde.[2]

Through his acquaintance with the painter Adrian Zingg, who taught at the Dresden Academy, Klengel was inspired to pursue a more individual and more realistic approach to landscapes. (It was, however, Klengel himself who, as a draftsman, "discovered" the characteristic features of the Saxon landscape—and in particular the sandstone rock formations along the Elbe not far north of Dresden—as a subject for artists.) Zingg drew Klengel's attention to the work of the Swiss poet, painter, and etcher Salomon Gessner. Influenced by the writings of Jean-Jacques Rousseau and the ideas of the eighteenth-century Enlightenment, Gessner had succeeded in giving fresh but also carefully observed form to his vision of nature as an idyll. Nonetheless, Klengel's attraction to the early classicism of Gessner, as reflected in the former's *Arcadian Landscape*, in the collection of the Leipzig Museum,[3] represents only a phase in his development.

Klengel turned increasingly to motifs from the country around Dresden, rendering these objectively in an unaffected manner and paying particular attention to light effects and mood. Because of his rural upbringing, Klengel had always felt in close contact with nature and the land. By around 1785 his observations began to find expression in small-scale rural genre scenes—landscapes including peasants at work—that are especially notable for their sensitive response to light. We may presume that these scenes of Saxony included the *Landscape with Figures*.[4]

A tireless observer of light at various times of the day and the year, Klengel imbued his pictures with a particularly compelling atmosphere. By the early 1800s, works such as this moonlit landscape, which was included in the Dresden Academy's annual exhibition in 1805, already evince an intensity that approaches a distinctively Romantic, spiritual interpretation of nature. At the same time, numerous features—the composition as a whole, the grouping of trees around a Classical-style monument half-hidden in deep shadow, and the mildly stereotyped treatment of the foliage—testify to Klengel's academic training. The powerful groups of trees framing the calm lake contribute as effectively to the compact character of the whole as does the predominantly dark green and brown tonality. Moonlight, penetrating the white-gray cloud and scattering across the lightly ruffled water surface, brings enchantment to this silent world. After 1800, Klengel focused almost entirely on producing such freely composed landscapes in moonlight, dusk, or sunrise. DS

1 Inv. no. 2995; acquired in 1998 from a private collection in Leipzig. In 1930 Klengel's *Landscape with a Herd of Cattle*, a copy after Berchem, inv. no. 7, was deaccessioned by the Leipzig Museum.
2 Formerly in the collection of Colonel Hayward, then in that of Sir Prior Goldney.
3 Inv. no. 1529, acquired in 1956 from the Kühl Collection, Dresden.

4 This picture is in the Maximilian Speck von Sternburg Stiftung within the collection of the Museum der bildenden Künste Leipzig, inv. no. 1744; see Herwig Guratzsch, ed., *Maximilian Speck von Sternburg. Ein Europäer der Goethezeit als Kunstsammler* (exh. cat., Leipzig 1998), no. 1/161, pp. 376ff., fig. on p. 377.

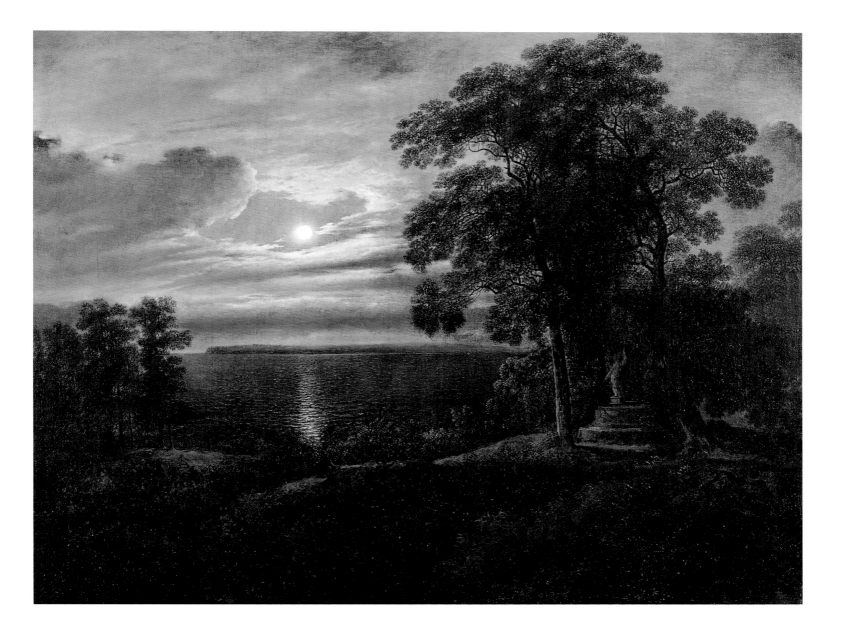

2 Johann Christian Reinhart

1761–1847

Landscape with Mercury, Argus and Io

1805

Oil on canvas, 116 x 111.5 cm
Unsigned
Inv. no. 189

Provenance: commissioned by Ernst Blümner, of Frohburg; acquired by the Leipzig
Museum in 1946 from the Krug von Nidda Collection, Frohburg, during the postwar
process of nationalization; in 1997 returned to the owners' heirs; in 1998 acquired from
Friedrich-Carl Krug von Nidda und von Falckenstein, of Bad Homburg

This painting prompted the artist's biographer Otto Baisch to comment, "Reinhart, … who took great care to execute his pictures, wherever possible, *alla prima*, worked slowly and devoted only his best hours to painting. As ever, he reserved a substantial part of his time for the study of landscape and for sketching excursions, during which … he took in the impressions of all that he observed in order to store these up in his mind."[1] There was usually a long interval between Reinhart's receiving a commission for a painting and then delivering the finished work. As a result, it has not been possible to establish whether Reinhart responded to a commission that had perhaps not stipulated a specific theme by submitting a previously elaborated composition. Inge Feuchtmayr has, however, demonstrated that the treatment of the foliage in this landscape recalls that seen in paintings produced before 1800, and the foliage is quite distinct from treatments seen after 1810.

The figures from Classical mythology depicted here come from the Roman poet Ovid. In the first book of his *Metamorphoses*, Ovid tells the story of the beautiful Io: Mercury, recognizable in the painting from his winged sandals and *petasos* (a light, flat traveling cap), was born in Arcadian Cyllene from the union of Jupiter and Maia, one of the daughters of Atlas, who bore the Heavens on his shoulders. Mercury is the nimble Messenger of the Gods and the God of Communication and Roads. He is also protector of thieves and merchants. Io, one of the daughters of Imachus, had been sought out by the amorous Jupiter, and was then transformed by Jupiter's enraged consort, Juno, into a cow tended by Argus, traditionally portrayed as a well-meaning giant with one, four, or even a hundred eyes.

These two stories come together in the scene depicted by Reinhart —a scene that has a bloody outcome (albeit for Jupiter a happy one).

Mercury is shown reaching cautiously for his sword and is about to murder Argus, whom he had put to sleep with his music. Jupiter is thus able to have his way with Io; the fruit of their union is Epaphus. Juno, once again infuriated, rages over the entire earth until finally coming to rest in Egypt, where she is released from her anger and subsequently worshipped as the goddess Isis.

In his choice of subject, his rendering of the landscape, and his painterly use of color, Reinhart has achieved an Arcadian idyll of blissful calm and harmony. According to Feuchtmayr, he must have derived direct inspiration for his motif from the work of Claude Lorrain, in which can be found, for example, similar "close-up" views of figures and parallel types of figural grouping concentrated in one half of a composition.[2] In Reinhart's picture, the landscape has a paradisiacal purity. The work is characterized by the powerful forms of the trees that tower over the place of captivity, simultaneously concealing and protecting, and enlivened by the presence of a waterfall.

Through his landscape studies, Reinhart acquired a deeper understanding of nature in all its manifestations. One of these studies of sycamore trees was made in 1792 at the start of Reinhart's Italian period. He may have referred to this study to produce the present painting. The study appeared on the art market in Warsaw in 1996.[3] Nonetheless, this painting, which Reinhart created based on a variety of his studies, and in which he incorporates invented as well as true-to-life depictions of landscape, is entirely traditional in its execution. This approach is in keeping with Reinhart's Classicism, even though Hans Joachim Neidhart rightly detects in the picture "a presentiment of the Romantic feeling for the complex 'soul' of the forest."[4]

DS

1 Otto Baisch, Joahann Christian Reinhart und sein Kreise. Ein Lebens- und Culturbild. Nach Originalquellen dargestellt (Leipzig 1882), p. 185.
2 Inge Feuchtmayr, Johann Christian Reinhart. 1761–1847. Monographie und Werkverzeichnis (Munich 1975), p. 85.

3 For related works, see Anna Kozak, "Landscape mit Platanen. Ein neuentdecktes Bild von Johann Christian Reinhart", in Weltkunst 56/88 (April 15, 1996), p. 896 and fig. 1.
4 Hans Joachim Neidhart, Deutsche Malerei des 19. Jahrhunderts (Leipzig 1990), fig. 12, p. 84.

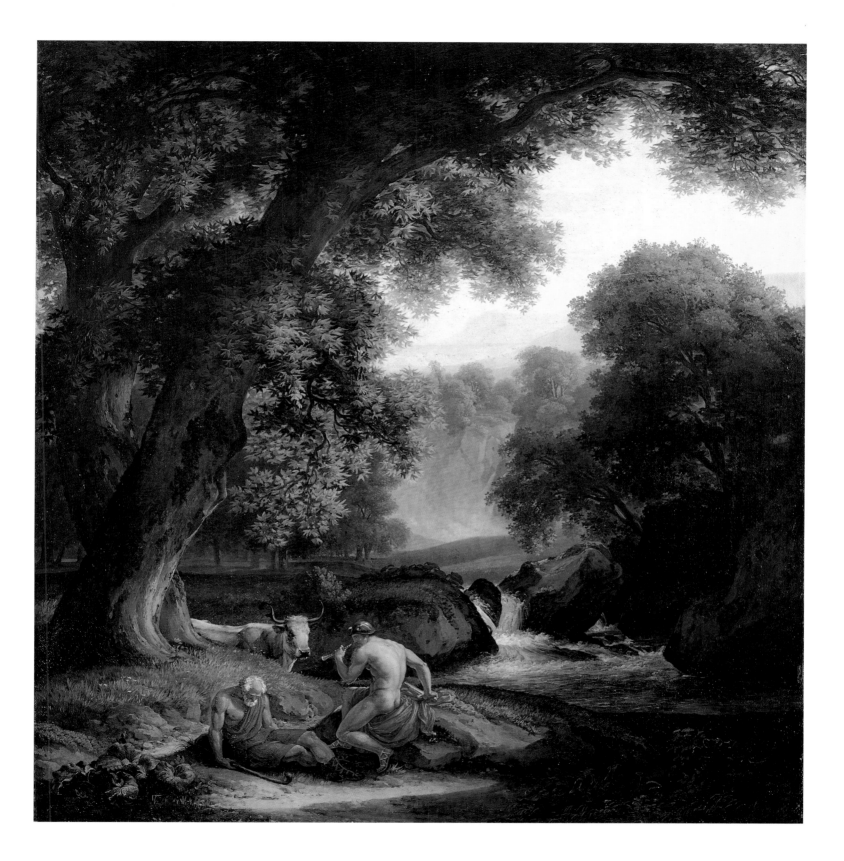

3 Philipp Otto Runge

1777–1810

The Four Times of the Day (Second edition)
Morning

1807

Etching, 70.7 x 47.4 cm
Inscribed on the plate at the lower left: Vier Zeiten [Four Times], and at the center:
MORGEN [Morning]; signed at the lower right: von Philipp Otto Runge
Inv. no. I. 2756 a

Provenance: transferred in 1914 to the Leipzig Museum from the Leipzig *Kunstverein*

In the summer of 1803, Philipp Otto Runge completed the drawings for *The Four Times of the Day* that he had begun in late 1802.[1] When these were published in Dresden in 1805, in the form of etchings by the engravers Johann Adolf Darnstedt, Ephraim Gottlieb Krüger and Johann Gottlieb Seyfert,[2] connoisseurs of such work reacted enthusiastically to the four large compositions. Johann Wolfgang von Goethe, who had the four sheets (sent to him by Runge on April 26, 1806) hung in his music room, was fascinated by their formal grace and their inspired combination of motifs, as he explained in 1807 in a text in the *Jenaische Allgemeine Zeitung*.

Encouraged by the initial reception of Runge's *Four Times of the Day* in the German art world, the Hamburg publisher Ludwig Perthes took the risk of issuing a second, much larger edition in 1807 (this edition is assumed to have numbered around two hundred and fifty copies). The set now in the collection of the Leipzig Museum derives from this second edition.

In a letter of January 30, 1803, to his brother Daniel, Runge provided a detailed description of the precise drawings (partially executed with a pair of compasses) that were to serve as the models for the printmakers working in 1805 and 1807.[3] Runge also indicated the coloring that he envisioned for his painted version of these compositions: "The first one: In the lower part of the composition there is a light mist, out of which there grows a tall, upright lily. Four budding lily flowers sprout from the central stem, their stalks forming evenly spaced arches, and on each arch there sits a child playing a musical instrument; the buds

open and roses and other flowers emerge from out of the mist, tinting it with their own colors. At the center of the picture a lily flower in full bloom and bright as a light sits atop a stalk that rises vertically; and on each of its petals there sits a child; the two closest to us are embracing and they gaze into each other's eyes; the pair to the left look deeply and contemplatively into the calyx of the lily; and those to the right gaze at the filaments that rise above them, and on which a further trio of children stand, these too in an embrace, holding aloft the lily's pistil, upon which Venus the Morning Star is seated; this figure will be gilded. The upper part of the sky is entirely dark blue in tone, but it gradually becomes brighter toward the horizon and loses its color as it meets the mist, so that the lily and the children appear like a great light. To left and right there are stacks of clouds, their edges brilliantly lit. Beneath them the sky takes on an ever richer glow, that of the imminent sunrise. Light here is embodied in the lily; and, as posed, the three groups [of children] are related to the notion of the Trinity. Venus is the pistil, or the midpoint of the light, and I was therefore eager to give this no other shape and form than that of a star."

Concerning the meaning of the four images as a series, Runge explained: "Morning is the unbounded illumination of the universe. Day is the boundless creation of the creatures that fill the universe. Evening is the boundless destruction of all that comes into existence with the origin of the universe. Night is the boundless depth of the knowledge of the indestructible existence of God. These are the four dimensions of the created spirit. But God is at work in them all."[4] AS

1 See Jörg Traeger, Philipp Otto Runge und sein Werk. Monographie und kritischer Katalog (Munich 1975), nos. 280–83 (with bibliography); see also Jörg Traeger, *Philipp Otto Runge oder die Geburt einer neuen Kunst* (Munich 1977), pp. 24–27, figs. 23–26. On the formal and iconographic tradition of the "Four Times of the Day," see Ewa Chojecka, "Philipp Otto Runges 'Vier Tageszeiten'—zum Nachleben eines alten ikonographischen

Konzepts," in *Philipp Otto Runge im Umkreis der deutschen und europäischen Romantik*, 2. Greifswalder Romantik-Konferenz, Lauterbach/Putbus, May 1–May 5, 1977 (Greifswald 1979), pp. 21–24.
2 The etchings were published in an edition of twenty-five. On this first edition, cf. *Runge in seiner Zeit* (exh. cat., Hamburg 1977), pp. 115 ff., nos. 65–68; see also *Philipp Otto Runge—Caspar David

Friedrich. Im Lauf der Zeit* (exh. cat., Amsterdam 1995), p. 95, nos. 7–10.
3 Runge's studies for *The Four Times of the Day* are now in the collection of the Kunsthalle, Hamburg; cf. Hanna Hohl, "Philipp Otto Runge. Die Zeiten—Der Morgen," (exh. cat., Hamburg and Stuttgart 1997); cf. *Philipp Otto Runge—Caspar David Friedrich*, p. 94, nos. 3–6.

4 On Philipp Otto Runge's writings, see Johann Daniel Runge, ed. *Philipp Otto Runge, Hinterlassene Schriften* (2 vols., Hamburg 1840–41), cited in Traeger, *Philipp Otto Runge*, pp. 28–33.

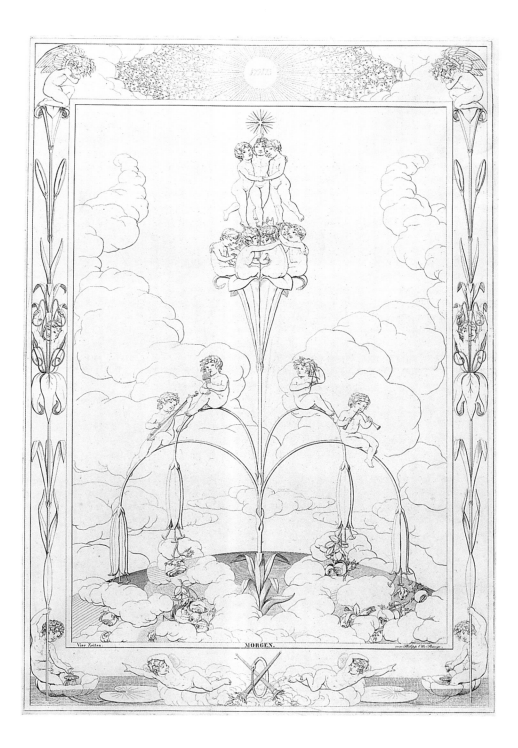

4 Philipp Otto Runge
1777–1810

The Four Times of the Day (Second edition)
Day

1807

Etching, 70.7 x 47.4 cm
Inscribed on the plate at the lower left: Vier Zeiten [Four Times], and at the center:
TAG [Day]; signed at the lower right: von Philipp Otto Runge
Inv. no. I. 2756 b

Provenance: transferred in 1914 to the Leipzig Museum from the Leipzig *Kunstverein*

In a letter of January 30, 1803, to his brother Daniel, Philipp Otto Runge spoke of his as yet unfinished composition *Day*: "In *Day* I use the lily again [see cat. no. 3], but this time without figures, because it is only at morning and evening that we can see into the sun, that is to say at times when the earth is colored red by its light."[1] Shortly thereafter—on February 22, 1803—the fourth, and last, finished drawing for *Day* was completed. Runge described this work too in a letter to his brother in Hamburg: "I've now inserted the lily within a wreath of cornflowers; during the day [i.e., in full sunlight] we do not see the sun, we are ourselves in the picture and we enjoy the vitality of our dear Mother Earth and all her bounty. So [in my picture] a mother is seated in a niche made out of apricots, cherries, black currants, plums, and bunches of grapes. At her feet water bubbles up from a spring. In front of her the male and female figures separate, devoting themselves, respectively, to work and to life; but between them there bloom two forget-me-nots, which are here intended to embody this moment of separation; to each side of these figures I have placed nettles, and one of a pair of figures bends down to pick a violet, turning to look at the other as they do so; there is also a large thistle and, in front of this, on one side a bluebell and on the other a hyacinth, each accompanied by a standing child as if to draw attention to the motif. In the background, a blue iris grows on each side of the arbor, their long leaves curving to meet at the center, where they support two children who sit to take their midday meal. Beyond grow a flax plant on the 'female' side, and a stalk of corn on the 'male' side."[2]

AS

1 On Philipp Otto Runge's writings, see Johann Daniel Runge, ed., *Philipp Otto Runge. Hinterlassene Schriften* (2 vols., Hamburg 1840–41), cited in Jörg Traeger, *Philipp Otto Runge oder die Geburt einer neuen Kunst* (Munich 1977), pp. 28–33.
2 Cited in Traeger, *Philipp Otto Runge*, pp. 33–35.

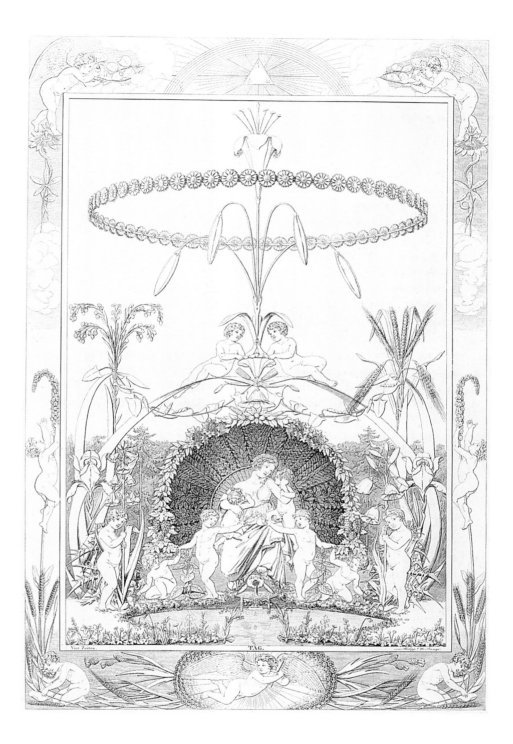

7　Anton Graff

1736–1813

Self-portrait at the Easel

1809

Oil on canvas, 199.5 x 118 cm
Signed within the composition on the back of the stretched canvas standing on the easel:
anton Graff/geb. zu Winterthur 1736./Sich selbst gemalt 1809.
Inv. no. 850

Provenance: presumed to have come into the possession of the landscape painter Johan
Christian Clausen Dahl, in Dresden, along with other works formerly owned by Graff's
son, the landscape painter Carl Anton Graff; after Dahl's death in 1857, it was acquired by
the Saxon Envoy, Carl Friedrich von Savigny; in 1906, it was purchased from the latter's
heirs by the City of Leipzig for presentation to the Leipzig Museum

The work of Anton Graff has its roots in the Baroque Era but also is
linked to the beginnings of the Age of Romanticism. His oeuvre, with
its wealth of portraits and its few late landscapes, keeps pace with the
social and intellectual upheaval that occurred in Europe as a response to
the ideals of the Enlightenment and the French Revolution.

The rising urban bourgeoisie found in Graff its most suitable por-
traitist for his realistic approach both accommodated and influenced the
middle class's demand for self-representation. Graff's unassuming style
and his tendency to eschew the sort of affectation that was then scorned
led him to emphasize the character and individuality of the sitter, rather
than his or her social rank and title. Graff's skills as a painter were such
that even his most aristocratic sitters appeared in their portraits as essen-
tially bourgeois in both bearing and dress. Graff increasingly reduced his
portraits to busts or half-figures, concentrating expression in the faces and
the hands, and paying little or no attention to costume or attributes.

While this artist from Winterthur had effectively announced his
presence in Dresden with an earlier full-length, self-portrait (1794–95),[1]
it appears that the production of this second large-scale image,[2] the sta-
tus and evolution of which have been established by Susanne Heiland,[3]
was motivated by very personal reasons. This picture is also one of the
most important works of the approximately eighty self-portraits pro-
duced by Graff.[4] The Leipzig Museum possesses the last, a painterly and
very psychologically penetrating work of 1813.[5]

A composition study (1809)[6] and preparatory studies of both the
head and the right arm (both 1809)[7] have survived, demonstrating that
the artist arrived at his final painted image by way of numerous steps.
The painting is impressive because of the interplay of its balanced com-
position, its evidence of the simplifying style of Graff's old age, and its
subdued coloring. Also to be admired are its psychological precision
and its superb encapsulation of earlier studies.

Anton Graff tempers the dignity of the standing pose adopted by
his own life-size, full-length figure by casually resting his knee on the
leather-covered seat of a stool. Chalk-holder in hand, the artist is shown
sketching his selected subject on a prepared canvas. Graff thus also sup-
plies a fascinating insight into the working methods of the aging artist.
For the last time Graff also depicts himself wearing glasses; in the fol-
lowing years he would protect his eyes, already attacked by cataracts,
with an eyeshade. Graff is shown here in the studio of his Dresden house
on the southern side of the Old Market near the Kreuzkirche (Church
of the Holy Cross). Only cursorily indicated and sparsely furnished, this
space offers few clues to Graff's identity or profession. In the composi-
tion sketch, however, a portrait of Graff's father-in-law, the philosopher
Johann Georg Sulzer, appears on the wall at the upper left.

This imposing work was in all likelihood intended exclusively for
Graff's own family and was rarely exhibited in public. Graff's other
self-portraits were also probably made for members of his family or at
the request of one of his numerous friends and patrons. These, in the
Renaissance tradition of educated art lovers, reflect a desire to have a
portrait of the artist to admire for perpetuity.　　　　　　　　　DS

1　Dresden, Staatliche Kunstsammlungen,
Gemäldegalerie Neue Meister, gallery no. 2167.
See Ekhart Berkenhagen, *Anton Graff. Leben und
Werk* (West Berlin 1967), no. 511, p. 158 with
illustration.
2　See Berkenhagen, no. 504, p. 164, fig. 163.
3　On the evolution of the painting, see Susanne

Heiland, "Anton Graff geb. zu Winterthur 1736.
sich selbst gemalt 1809," in *Meisterwerke aus dem
Museum der bildenden Künste Leipzig. Dokumentation
& Interpretation 2* (Leipzig 1986), pp. 7–16.
4　See Berkenhagen, nos. 473–553, pp. 151–67.
5　Inv. no. 1776; see Berkenhagen, no. 547, p. 165
with illustration.

6　Leipzig, Museum der bildenden Künste,
Graphische Sammlung, inv. no. I 2711; see
Berkenhagen, no. 538, p. 163 with illustration.
7　Weimar, Goethe-Nationalmuseum; see Berken-
hagen, no. 537, p. 163 with illustration, and no.
539, p. 164; also Leipzig, Museum der bildenden
Künste, Graphische Sammlung, inv. no. I 2712.

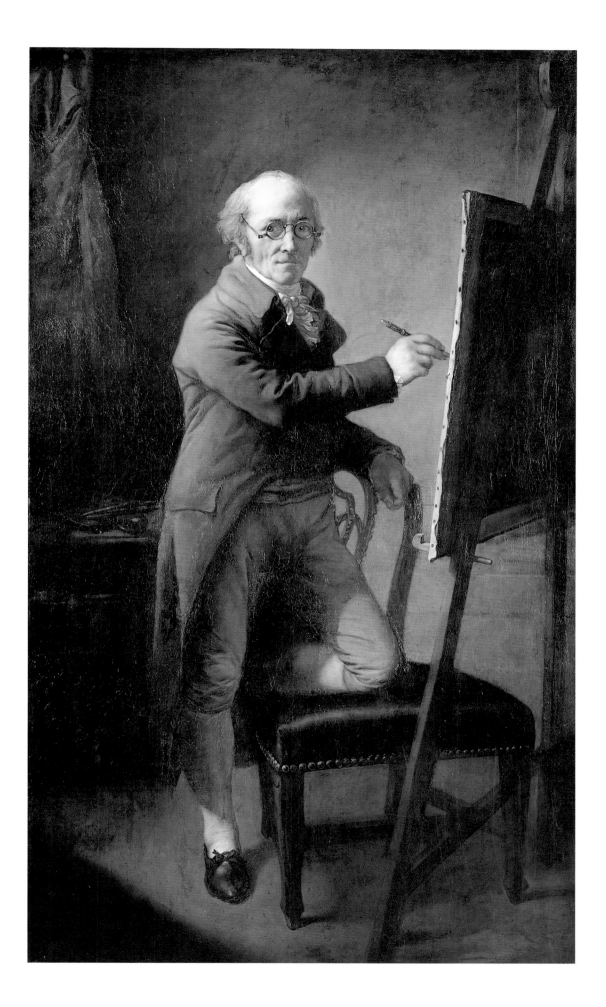

8　Joseph Anton Koch

1768–1839

The Schmadribach Waterfall in the Lauterbrunnen Valley

1811

Oil on canvas, 123 x 93.5 cm
Signed: G. Koch fece/1811
Inv. no. 121

Provenance: acquired in 1812, directly from the artist, by a Herr Honneker, of Bremgarten, Switzerland; subsequently in the collection of the Leipzig artists' association, the *Kunstverein*; purchased in 1865 by the Leipzig Museum with funds provided by the landscape painter Joseph Zelger

In the late eighteenth century, a coterie of intellectuals and artists began their "discovery" of the Alps. Inspired by the legacy of the Enlightenment, they sought to reveal their new understanding of the relationship between man and nature. This relationship was anticipated in literature, notably in Jean-Jacques Rousseau's novel *Julie, ou la Nouvelle Héloise* (1761). Among artists, however, Joseph Anton Koch was the first to succeed in producing images that rose above the level of the views painted as travelers' souvenirs. Koch's *Schmadribach Waterfall* marks a high point in the evolution of paintings depicting the Alpine landscape.

With his painting of the Schmadribach Waterfall, Koch became the first among German landscape painters to translate, on an imposing scale, the newly awakened appreciation for the natural forms of the Alps. To a degree, this approach was matched only about a century later in the work of the Swiss artist Ferdinand Hodler. As Christian von Holst has demonstrated,[1] Koch had already recorded the Schmadribach Waterfall around 1805 in a markedly vertical composition.[2]

In this work, the viewer takes the artist's perspective of looking down, from Steckelberg, at the Alps. We see the Grosshorn and the Breithorn, and, lying beneath them, the snow fields of the Schmadri and the Breithorn Glaciers, from which there gush the thundering Schmadribach Waterfall and its tributary, the Krummbach. The painting reveals Koch's understanding of the primeval quality of the Alpine landscape, for its wild grandeur and for the natural forces visibly at work within it.

The Alpine setting is organized into clear, boldly colored and structurally discrete zones; together these constitute a characteristic and geologically accurate image of the Alps. Starting from the fresh green of the valley meadow, the eye is drawn across the shady forested slopes to the cool region of rocks with the powerful funnel into which the waters tumble, and then up to the zone of the mountain peaks with its powerful contrast of white and intense blue sky. Linked by the surging waterfall, these distinct regions merge into a harmonious whole that the spectator, in spite of the "wide-angle" effect, finds himself unable to embrace in a single glance.

The significance of this painting lies, above all, in Koch's ability to convey his vision of nature and, in doing so, to create an enduring, Romantic symbol of sublime grandeur. As von Holst has argued, "Koch's work is characterized by geologically very precise observation and its translation into correspondingly precise pictorial compositions. He uses the observed and recorded landscape view as a starting point, as an image which he then condenses into the sort of work of art that will allow insights into the essence of natural processes and their interconnections, and in a way that [the fruit of] pure observation could never do."[3]

Koch's second painted version of the Schmadribach Waterfall was produced in 1821/22[4] (a study for it is now in the collection of Georg Schäfer, in Euerbach),[5] and it was acquired in 1829 by King Ludwig I of Bavaria. This second painting corresponds to the one in the Leipzig Museum in its overall arrangement, but it is more imposing because of greater clarity of forms and more radiant coloring. In addition, the figure of the hunter found in the valley in the Leipzig painting is replaced by a more realistic group of shepherds. This difference reflects Koch's increasing concern, in his later landscapes, for overcoming the conflict between man and nature.　DS

1　Christian von Holst, "Unbekannte und wieder aufgetauchte Werke Joseph Anton Kochs," in *Pantheon* 49 (1991), pp. 149 ff. Holst refers to an article entitled *"Künstlerleben,"* which appeared in the *Zeitung für die elegante Welt* on July 17 and 19, 1806.
2　It is presumed that this was identical to the painting of the Schmadribach Waterfall completed in 1806, at the latest, and now in the Casita del Infante of the Escorial, outside Madrid. Hilmer Frank, *Joseph Anton Koch. Der Schmadribachfall. Natur und Freiheit* (Frankfurt am Main 1995), pp. 50–53, fig. on p. 51.
3　Christian von Holst, ed., *Joseph Anton Koch. 1768–1839. Ansichten der Natur* (exh. cat., Stuttgart 1989), p. 146.
4　Munich, Bayerische Staatsgemäldesammlungen, Neue Pinakothek, inv. no. WAF 449; see Otto von Lutterotti, *Joseph Anton Koch. 1768–1839. Mit Werkverzeichnis und Briefen des Künstlers* (Berlin 1940), no. G 53, pp. 215 ff.
5　Otto R. von Lutterotti, *Joseph Anton Koch. 1768–1839. Leben und Werk. Mit einem vollständigen Werkverzeichnis* (Vienna and Munich 1985), no. Z 1095, p. 360.

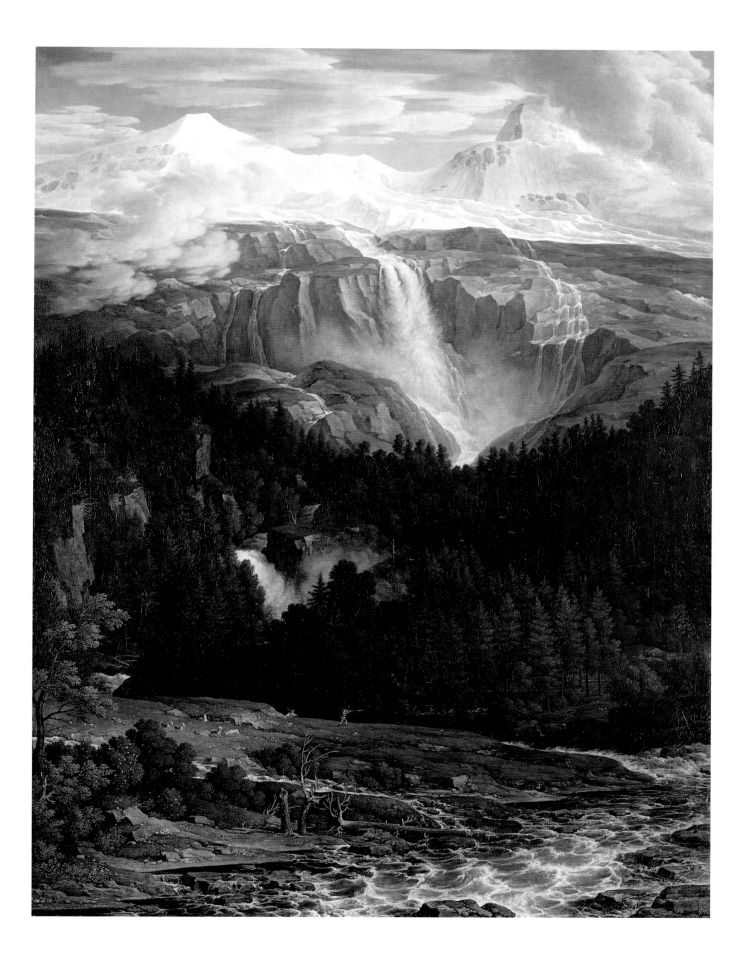

9 Joseph Anton Koch

1768–1839

Ideal Landscape with Jacob's Homecoming

1816

Oil on canvas, 74.5 x 98 cm
Signed within the composition on the stone panel at the lower right:
I. KOCH/Tirolese f./1816
Inv. no. 120

Provenance: initially in the possession of the Danish sculptor Bertel Thorwaldsen, in Rome and Copenhagen; after his death it was acquired in 1844 by Johann Gottlob von Quandt, in Dresden; in 1868 it was acquired from his collection by the Leipzig Museum

In January 1816, Koch wrote to Robert von Langer, "At the moment I'm working on a picture that shows a region derived from my etched sheets of Olevano and Civitella. But I'm treating this picture less as an imitation of nature and more as a product of my imagination. What I've done is to show the journey made by the patriarch Jacob out of Haran, accompanied by his wives, his children and all he possessed in the way of camels, sheep, cattle and so on. This composition is perhaps newer and more original than anything else that I've done."[1] Koch took elements of his painted composition from his landscape etching of 1810, *Between Civitella and Olevano*, from the series of *Roman Views*. Writing to Freiherr von Uexküll he recounted "[…] a landscape full of joy. This picture will be one of the most charming that I've ever made."[2]

The painting in the Leipzig Museum shows Jacob's return from Haran to Canaan with his two wives Leah and Rachel, his sons, the serving maids Silpa and Bilha, and all the possessions that he had amassed while away. As demonstrated by reference to Koch's pen-and-ink drawing *The Return of Jacob with his Family, Cattle and Flocks*,[3] it is evident that the figures in the Leipzig painting were of the artist's own devising. Louise Seidler[4] reports that, when calling on Bertel Thorwaldsen to bid farewell in 1823, she saw in his collection two excellent landscapes by Koch, in which the figures had been painted by Peter von Cornelius. This revelation would lead us to conclude that Cornelius had been involved only in the execution of the paintings (as opposed to their conception and planning). While Cornelius's involvement is perhaps detectable in a certain cold brightness, the work as a whole (as essentially that of Koch) evinces a sturdiness and solidity in its form and a brilliance in its color that are altogether new for both artists.

While Jacob's procession fills out the entire drawing, with the landscape relegated to the background, in the painting it is subordinate to the superb rendering of what Koch suggests is the region around Olevano. It should, however, be noted that, according to Christian von Holst, the landscape shown in the drawing has little connection to this specific area, and derives from an earlier phase of Koch's landscape style, dating to approximately 1806, when Koch first decided to embark on a composition on this theme.[5]

Koch's etching of 1810 shows the region above the famous oak grove of Serpentara, called *Le sbarre* (the barriers). From this spot a path led in one direction up to the hilltop town of Civitella and in the other direction down to Subiaco. The country around Olevano was of particular significance for Koch's work from around 1804. The landscape seen in the painting is closest to that found in the etching, if we overlook the additional exotic element of the palm tree. This beautiful setting is further enlivened by the clear light, the saturated colors, and the powerfully accented tones found in the drapery. Koch was evidently deeply absorbed in rendering the procession and the stones, plants, and animals.

A joy in narrative and in life itself characterizes this work, which appears not to have been painted in response to a commission. We may perhaps detect the artist's jubilation at his return to Italy. Holst, indeed, speaks of a "semi-autobiographical Jacob's Homecoming."[6] The value that Koch himself attached to this painting is confirmed by the variety and balance to be found among its figures and the landscape motifs, and by the effect of both coloring and light. DS

1 Letter of January 31, 1816, to Robert von Langer, in Munich, cited in Otto R. von Lutterotti, *Joseph Anton Koch, 1768–1839, Mit Werkverzeichnis und Briefen des Künstlers* (Berlin 1940), p. 81, with note 220. Since 1807, Koch had been a friend of the son of the Munich Professor Johann Peter von Langer through whom he was to obtain several commissions.

2 Letter of February 16, 1816, cited in Christian von Holst, ed., *Joseph Anton Koch, 1768–1839, Ansichten der Natur* (exh. cat., Stuttgart 1989), p. 253.
3 Innsbruck, Tiroler Landesmuseum, Ferdinandeum; cf. Otto R. von Lutterotti, *Joseph Anton Koch. 1768–1839. Leben und Werk. Mit einem vollständigen Werkverzeichnis* (Vienna and Munich 1985), no. Z 359, p. 339.

4 *Erinnerungen und Leben der Malerin Louise Seidler [...] Aus handschriftlichem Nachlass zusammengestellt und bearbeitet von Hermann Uhde* (2nd ed., Berlin 1875), p. 311.
5 See Holst, p. 253.
6 See Holst, p. 17.

10 Julius Schnorr von Carolsfeld

1794–1872

Saint Roch distributing Alms

1817

Oil on canvas, 94 x 129 cm
Signed within the composition, at the right on the stone post: 18 JS [in the form of a monogram] 17
Inv. no. 223

Provenance: acquired in January or February 1818 by the art and antiquarian book dealer, publisher, and university official, Johann August Gottlob Weigel, in Leipzig; bequeathed by Weigel in 1847 to the Leipzig Museum

This technically dazzling work is regarded as an early masterpiece of Nazarene art, the ideals of which had inspired the young artist in Vienna when he came under the influence of Joseph Anton Koch and Ferdinand Olivier.

The composition relates to an earlier design for a composition initially to be titled *The Pilgrimage*, in which Schnorr had written in 1814 of his encounter with a procession of pilgrims to Heiligenkreuz in the Vienna Woods: "Close by Heiligenkreuz the path drops sharply and one enters the valley. Heiligenkreuz, with its monastery and church lay unexpectedly before us … The beautiful landscape setting, together with the pilgrims and the monks, formed in my mind into an image that I sketched at the time in watercolor on canvas and that I now undertook to execute in oils, before I embarked on my journey to Italy, as a subject corresponding to my inclination and mood."[1]

In a series of masterly pen-and-ink drawings, the earliest dating from 1815, Schnorr had evolved his own approach to nature. His distinctive approach makes the treatment of the landscape setting in the picture of Saint Roch one of the most beautiful achievements of German Romantic painting. The small church with cemetery and adjoining house is an impressionistic reminiscence of Salzburg, perhaps indeed of the graveyard of the church of Saint Peter and the chapel of Saint Margaret.

In early November 1817, Schnorr von Carolsfeld renamed his composition after the short story by Johann Wolfgang von Goethe, *The Festival of Saint Roch at Bingen*, a traveler's tale published earlier that year. Roch, who was born in Montpellier in the late thirteenth century, distributed his possessions among the poor and, in his pilgrimage to Rome, cared for those infected with the plague. The distribution of alms was among the most frequently illustrated scenes in the life of this saint.

Drawing also on examples of Medieval and Early Renaissance German art, Schnorr combines the depiction of several actions within a narrow stage placed strictly parallel with the picture plane. Particularly striking, here, is that the decorative elements do not overpower the narrative. Also noteworthy are the sureness of Schnorr's approach and the subdued coloring. He sought to assemble the figures in two essentially static and unconnected main groups, each more or less self-contained. Every part of the composition, however, is positioned in relation to the figure of the saint as the spiritual center of the depicted event. To Schnorr, the element of genre painting in such a subject was even more important than concentration on the symbolic central idea[2] (the latter would clearly have removed the depicted event from the realm of everyday life). This is especially evident in the stone figure of Saint John, at the extreme left of the picture, who, in a conscious analogy with the role of Saint Roch, embodies an allusion to the invisible Christ Child.[3] According to Ellen Spickernagel,[4] the historically costumed figures seen here represent the primordial simplicity that was characteristic of the common people, the *Volk*. The young Schnorr von Carolsfeld was a master at rendering such figures, and his work became a model for the religious painting of the Nazarenes.

Several of the believers shown devoutly observing the depicted event are, in fact, portraits; including these types of portraits is characteristic of the work of the German artists in Rome. The young bearded man half-hidden by the tree on the right is Schnorr's friend, the painter Friedrich Olivier. The child staring out of the picture at the left bears the features of Olivier's ten-year-old stepdaughter, Maria Heller, whom Schnorr came to know in 1814 and whom he was to marry in 1827, shortly after his return from Italy. According to Kornelius Fleischmann,[5] the priest behind the figure of the saint may be presumed to be a portrait of the celebrated monk and priest Klemens Maria Hofbauer, who was very close to the German Romantic Circle of Friedrich and Dorothea Schlegel in Vienna. DS

1 Franz Schnorr von Carolsfeld, ed., *Künstlerische Wege und Ziele. Schriftstücke aus der Feder des Malers Julius Schnorr von Carolsfeld* (Leipzig 1909), pp. 7, 35.
2 Helmut Börsch-Supan, *Die Deutsche Malerei von Anton Graff bis Hans von Marées 1760–1870* (Munich 1988), p. 235.

3 Annemarie Wengenmayer, "Julius Schnorr von Carolsfeld: 'Die Hochzeit von Kanaan' der Hamburger Kunsthalle. Zum Italienerlebnis der Nazarener," in *Niederdeutsche Beiträge zur Kunstgeschichte*, vol. 11 (Munich and West Berlin 1972), p. 252.

4 Ellen Spickernagel, "'Das Innerste erschüttern und bewegen'. Zur religiösen Tafelmalerei der Nazarener," in *Die Nazarener* (exh. cat., Frankfurt am Main 1977), p. 115.
5 Letter of May 28, 1986, to the Museum der bildenden Künste Leipzig, in the Museum archive.

11 Johann Heinrich Ferdinand Olivier

1785–1841

Landscape near Berchtesgaden

1817

Oil on canvas, 78.5 x 56 cm
Signed on left, on the tree trunk: FO (monogr.)/1817
Inv. no. 1161

Provenance: 1927 from R. Steinhausen, Frankfurt am Main

Johann Heinrich Ferdinand Olivier painted *Landscape near Berchtesgaden* after his second trip to Salzburg and its vicinity in 1817. He had sketched throughout the summer with his brother Woldemar Friedrich Olivier and used these sketches as the basis for several of his highly finished oil paintings, considered his finest works.[1] The Olivier brothers, together with their other painter friends, among them Philipp Veit and Joseph Anton Koch, were the first to discover the beauty of the Austrian Alps and the charms of Salzburg. In this work, Ferdinand Olivier goes beyond a mere description of the magnificent topographical setting and transposes it into a "spiritual landscape" through the addition of several figures in the foreground. The three men dressed in medieval garb, who have just reached a fountain after a steep climb, are much more than mere incidental genre figures. Their strenuous climb can be interpreted as man's struggle in life—their longing for water as man's natural need for sustenance. The man in the shadow who continues upward undeterred, is the one who, according to Olivier, "follows a different shepherd, seeking salvation in the water of life."[2]

In the attempt to depict man as a harmonious part of nature, Olivier followed the teachings of Friedrich Schlegel.[3] The serene atmosphere that pervades everything from sun-dappled meadows to peaceful glaciers invites contemplation of man's interaction with nature. The fences point to man's cultivation rather than destruction of nature while the vast expanse of the mountains remains untouched and untamed. Stylistically Olivier was strongly influenced by the Italian and German Renaissance masters. From Dürer, he borrowed certain compositional devices, while the beautifully detailed trees are particularly reminiscent of Raphael. Olivier's technique, akin to that of the Old Masters, and the use of historicizing costumes characterize this work as a Romantic and Revivalist painting. Olivier's spirituality is different from that of Caspar David Friedrich or Philipp Otto Runge, but his landscapes nonetheless express his Franciscan love of all things.[4] HKA

1 Klaus Gallwitz, ed., *Die Nazarener in Rom* (München: Prestel, 1981), p. 140.
2 Ibid., p. 269.
3 Gallwitz, *Die Nazarener in Rom*, p. 140.

4 Gert Schiff, ed., *German Masters of the Nineteenth Century, Paintings and Drawings from the Federal Republic of Germany*. exh. cat. (New York: The Metropolitan Museum of Art, 1981), p. 18.

12 Johann Heinrich Ferdinand Olivier

1785–1841

The Garden of the Capuchin Monastery in Salzburg

1820

Pen and black ink over pencil, 59 x 49.4 cm
Inscribed at the lower left: 18 FO [in the form of a monogram] 20
Inv. no. I. 5715

Provenance: in the collections of the Dukes of Anhalt, in Dessau (sold in 1927 by the art
dealer K.E. Henrici, in Berlin); acquired in 1927 through the art dealer C.G. Boerner,
in Leipzig

This large drawing by Ferdinand Olivier, showing a view of the garden
of the Capuchin monastery in Salzburg, is without doubt among the
greatest achievements of the Nazarene Circle artists who produced
works on paper. The viewer encounters a gentle slope, at the end of
which stand the extensive buildings of the monastery, surrounded by a
well-tended garden in which a monk can be seen working. The fore-
ground of the composition is dominated by an image of "untamed" na-
ture, but the eye is drawn to a simple path that leads directly into the
monastery garden. This path, coming into view at the lower edge of
the painting, then pushing deep into the pictorial space and bordered
by walls shown in sharp recession, exerts a strong pull on the imagina-
tion and effectively draws the viewer into the meditative calm of the
unworldly monastery. The boundary between an inner and an outer
world, between the unrestrained bustle of humanity and the inner
communion of the monastery, is signaled by the figure of a monk who
stands by the edge of the path.

Every detail of the landscape, the garden, and the monastery build-
ings in the background is rendered with utmost precision, with exquis-
itely even use of hatching and distribution of lit passages, and a masterly
sense of tonality and composition. Olivier used incisive pen-and-ink
strokes for those sections of the composition closest to the foreground,
and a light pencil line for the more distant features.

This drawing was made in 1820 at the end of two walking tours
that Olivier made with Philipp Veit (in 1815) and with Julius Schnorr
von Carolsfeld and Carl Ludwig Frommel (in 1817) in the Salzburg re-
gion. In this image, the combination of closely observed landscape and
figures representing the Church—in this case the significant figure of
the monk—is characteristic of the work of the German artists of the
Brotherhood of Saint Luke that formed around Friedrich Overbeck,
and of which Olivier was a member from 1811.[2]

In 1826, Olivier made a painting in oil on wood, based on his
drawing of 1820, and this work too is in the collection of the Leipzig
Museum.[3] Acquired as early as 1868, the painting repeats the drawing in
almost every respect with the exception of a few details—for example,
some additional cloud formations and a simple wooden table placed in
the right foreground at the edge of the path.

In 1938, Ludwig Grote published a monograph on Ferdinand
Olivier, in which he described the painted version of this composition
in words that might also be understood to apply to the drawn version,
with the exception of allusions to the coloring: "The Garden of the
Capuchins in the Museum der bildenden Künste in Leipzig is a Roman-
tic song of the peace of evening. Here we find no stupendous blazing
sunset, but the sun's gentle retreat to its heavenly home. Dark-robed
Capuchins, symbols of humanity at peace with God, are working in
their garden. The church, the monastery, and the garden—this is the
lovingly tended sphere of their life, a realm that will never be troubled
by any form of turbulence."[4] AS

1 Klaus Gallwitz, ed., *Die Nazarener* (exh. cat.,
Frankfurt am Main 1977), p. 196, no. E 27, with
illustration on p. 226; Dieter Gleisberg and Karl-
Heinz Mehnert, *Meisterzeichnungen. Museum der
bildenden Künste Leipzig* (Leipzig 1990), no. 99;
Herwig Guratzsch, ed., *Von Lucas Cranach bis
Caspar David Friedrich* (exh. cat., Leipzig 1994),
p. 267, no. 138.

2 Cf. Peter Märker, "'Selig sind die nicht sehen
und doch glauben'. Zur nazarenischen Landschaft-
sauffassung Ferdinand Oliviers", in *Städel-Jahrbuch*,
new series 7 (1979), p. 179, fig. 10.
3 Inv. no. 168. Cf. Ludwig Grote, *Die Brüder
Olivier und die deutsche Romantik* (Berlin 1938),
p. 208, and fig. 124 on p. 213.
4 See Grote, p. 208.

13 Friedrich Philipp Reinhold

1779–1840

Monastery on the Kapuzinerberg near Salzburg

1818

Oil on paper mounted on canvas, 35 x 31 cm
Unsigned
Inv. no. 1163

Provenance: acquired in 1927 from the Toula Collection, Vienna

In his view of the *Monastery on the Kapuzinerberg near Salzburg*, Reinhold has followed the inspiration of Ferdinand Olivier, who had traveled to Salzburg in 1815.[1] Olivier himself had made a large, meticulous pen-and-pencil drawing as well as an oil painting of the same monastery (see cat. no. 12), choosing as his subject the monastery garden located on the other side of the wall that in Reinhold's painting appears at the left of the composition. Unlike Olivier, whose carefully drawn works depict a part of monastic life, Reinhold has chosen a much more incidental view. The footpath, curving and dipping along the outside of the monastery wall, leads to an architecturally unremarkable building group in the middle ground. A small figure in a tall hat and yellow-and-black coat is shown from the back, sitting in the middle of a grassy bank between the wall and the path. In the background, the peak of the Untersberg is visible, set off against high, towering white clouds in a brilliant blue sky.

The brushwork, especially that of the grass, the tree, and even the beautifully differentiated expanse of the wall, is very open, the paint applied with quick, short strokes. The colors, dominated by greens and grays, are subtly nuanced and juxtaposed with great finesse. The sitting figure, which may well be a fellow artist sketching the same view, has none of the significance that Caspar David Friedrich's *Rückenfiguren* (figures seen from the back). Reinhold has dispensed with any Classicistic or Romantic elements and created a work that is outstanding for its time in its realistic rendition of nature. HKA

1 Ulrich Thieme and Felix Becker, eds., *Allgemeines Lexikon der Bildenden Künste, Von der Antike bis zur Gegenwart*, vol. 28, Hans Vollmer, ed. (Leipzig: Seemann, 1934), pp. 130–31.

14　Carl Wagner

1796–1867

A Moonlit Night

1820

Oil on canvas, 59.5 x 51 cm
Signed at the lower right: C.Wagner fec. 1820
Inv. no. 1284

Provenance: donated to the Leipzig Museum in 1937 by Professor Dr. Karolus,
of Grossdeuben near Leipzig

As is so often the case with nineteenth-century German art, we can learn about the painters of this period by reading published memoirs. The late Romantic painter, draftsman, and printmaker Adrian Ludwig Richter provided a detailed picture of Carl Wagner, an artist highly esteemed by his contemporaries: "One day my father brought a slim and handsome young man into our studio; he was studying at the Forestry College at Tharandt and wanted to profit from the proximity of Dresden in order to improve the skill he employed in his favorite occupation—sketching landscape—through taking some lessons. We pupils soon took a liking to him for he had something fresh and stimulating about him, he was superior to us in general education, and my father believed him to be extremely talented. His cheerful character and physical vivacity were reminders that he had a drop of French blood in his veins, for his mother was French. His father was the writer Wagner, well known and much loved in Meiningen for his novels *The Travelling Painter, Isidore,* and *Willibald's Views on Life.*"[1]

In Italy, Wagner and Richter became close companions and embarked on many walking and sketching tours together. The fresh and realistic drawings made by Wagner at the start of his career had enchanted the young Richter because they derived exclusively from a direct study of nature. Further, they were not inhibited by the academic rules about art that were taught frequently in Germany. It was, in fact, on this account that Wagner spontaneously abandoned his studies under Richter's father, the engraver Carl August Richter, when he met Johan

Christian Clausen Dahl in 1819 and, through him, the Dresden circle around Caspar David Friedrich.

Until embarking on his journey to Italy in 1822, Wagner worked in a manner that revealed his response to the work of Dahl and Friedrich, two masters of the Romantic landscape. Wagner produced works such as his *Rising Moon* of 1821,[2] his masterpiece as a painter. In this context Wagner mainly produced moonlit night scenes transfigured by stillness, such as the picture in the Leipzig Museum, which in particular illustrates his sensitivity to rendering atmosphere and his expertise in creating "luministic" effects. Of his two "masters," however, Wagner gravitated toward the "popular" Romanticism of Dahl rather than the "spiritualized" Romanticism of Friedrich.

Unlike many other German artists of the Romantic era, who were "rediscovered" in the epoch-making Centennial Exhibition held in Berlin in 1906, it was not until the early 1920s that a broader German public became aware of Wagner. In 1935, Otto H. Förster[3] succeeded in establishing Wagner as one of the great painters of German Romanticism. Since that time the two paintings by Wagner in the Leipzig Museum (these only acquired in the 1930s, even though the "*Moonlit Landscape* of the artist's own invention, painted in oils by C. Wagner of Meiningen," had been included in the Dresden Academy exhibition of 1820),[4] have been regarded as treasures among its small but very precious Romantic collection.　　　　　DS

1　Erich Marx, ed., *Ludwig Richter, Lebenserinnerungen eines deutschen Malers. Nebst Tagebuchaufzeichnungen und Briefen* (Leipzig 1950), pp. 48 ff.
2　Cologne, Wallraf-Richartz Museum, inv. no. WRM 1320.

3　Otto H. Förster, "Der Maler Carl Wagner," in *Zeitschrift des Vereins für Kunstwissenschaft*, vol. 2 (1935), pp. 274–83.
4　According to Moritz Wullen, "Zeichenstunden im Palazzo Caffarelli. Ein Beitrag zu Wirkungsgeschichte Schnorrs von Carolsfelsd," in Gerd-Helge

Vögel, ed., *Julius Schnorr von Carolsfeld und die Kunst der Romantik. Publikation der Beiträge zur VII. Greifswalder Romantikkonferenz in Schneeberg, veranstaltet vom Caspar-David-Friedrich-Institut der Universität Greifswald vom 30. September bis zum 3. Oktober 1994* (Greifswald 1996), note 6, p. 36.

15 Woldemar Friedrich Olivier

1791–1859

Ideal Landscape with Horseman

c. 1822

Oil on canvas, 61.8 x 74.2 cm
Unsigned
Inv. no. 1250

Provenance: 1934 from the estate of Paul Lohse, Leipzig through the art dealer
Willy Franke, Leipzig

Ideal Landscape with Horseman was the last painting Olivier completed before he returned to Vienna from Rome, where he had lived between 1818 and 1823. During his extended stay, he joined the Nazarene painters, completely absorbing their teachings of religious and Romantic Revivalism.[1] In preparation for this work, Olivier made a large landscape sketch, dated April 1822, which includes the woman and child but not the horseman. In a typical gesture of artistic support and personal comradeship, Julius Schnorr von Carolsfeld, a fellow Nazarene, sketched a horseman with a lance at the right side of the drawing. Olivier followed his suggestion, opting however for a less martial appearance by eliminating the lance.[2]

Stylistically this Italian landscape was inspired by the Florentine Renaissance painters, especially by Raphael. The motif of the castle on a hill, flanked by a group of Renaissance-style buildings, is picturesque rather than dramatic. The vertical architectural elements, emphasized by the slender trees that punctuate the scene, are painted very much in the manner of Perugino or Raphael. Like his brother Ferdinand, Woldemar Friedrich sought to suggest religious meaning through his landscapes. In this painting, however, the first impression of a Holy Family does not hold up on close inspection. Although the woman in her devotional attitude has certain characteristics of a Madonna, she is characterized as a peasant by the scythe in her right hand. Furthermore, she has turned her back on the naked infant, an inconceivable attitude for a Madonna. The horseman, although turning in the direction of the woman and child, looks over their heads to the horizon in the manner of a disinterested passerby. This enigmatic lack of interaction between the figures may have been inspired by the works of Giorgione or Titian.

Woldemar Friedrich Olivier's ideal landscapes did not achieve the same expression of devotion found in his brother's "spiritual landscapes," but this painting is a very fine example of his personal lyricism. HKA

1 William Vaughan, *German Romantic Painting*
(New Haven: Yale University Press, 1980), p. 186.
2 Herwig Guratzsch, ed., *Von Lucas Cranach bis
Caspar David Friedrich*, exh. cat. (Stuttgart: Hatje,
1994), p. 281.

16 Johann Friedrich Overbeck

1789–1869

The Miracle of the Roses of Saint Francis of Assisi

1829

Oil on canvas, 70 x 85.5 cm
Unsigned
Inv. no. 170

Provenance: from 1830 in the collection of Johann Gottlob von Quandt, of Dresden;
in 1868 acquired by the Leipzig artists' association, the *Kunstverein*, and subsequently by
the Leipzig Museum

The fresco painted by Johann Friedrich Overbeck in 1829 on the pediment of the Portiuncula Chapel owes its existence to the fulfilment of a vow made in the artist's youth "to dedicate my best picture to the Lord in the form of a gift for a church."[1] The chapel is located within the Church of Santa Maria degli Angeli, attached to the Franciscan monastery at Assisi, which was established by Saint Francis as a site for his spiritual exercises.

Saint Francis was born in Assisi in 1182, the son of a rich cloth merchant. As a result of severe illness and consequent long periods of isolation, he underwent a profound spiritual transformation. In prayer and in his visions, he came to recognize that he was destined for a life of poverty, charity, and preaching.

In 1823, Overbeck met Fra Luigi Ferri di Bologna, who later became Father Superior at the Franciscan Monastery in Assisi. It was with his understanding and agreement that the artist arranged to execute a fresco. He intended to depict a vision that Saint Francis had had in 1216, in which the "perfect indulgence" (the Portiuncula Indulgence) was bestowed on him by Christ and his Mother for all those who, after making a penance, visited this little church of grace. The oil sketch shown here, which it appears had already been requested, in advance of its completion, by the Leipzig-born art collector Johann Gottlob von Quandt,[2] was made by Overbeck shortly after his return from Assisi to Rome.

In the spring of 1829, the artist and his family moved into the monastery at Assisi. In May, the cartoon (the full-scale preparatory drawing for the fresco) had already been "satisfactorily affixed in the sanctuary and everything set in order so that I shall perhaps be able to embark on the painting within two or three days."[3] Eduard Jakob von Steinle, who, like many other artists, visited Overbeck at the monastery, also helped him for a time with the decorative details that surround the main scene. The work was completed in December. Like almost no other work by Overbeck, it embodies his intent to put his art at the service of God, entirely in the spirit of the Medieval masters. After Overbeck's murals based on the Story of Joseph for the Casa Bartholdy (1816–17) and his frescoes on themes from Tasso in the Villa Massimo (1817–27), the fresco in Assisi is Overbeck's last important work in this medium that he and Peter von Cornelius sought to revive.

Despite its title, Overbeck's Assisi fresco does not depict the Miracle of the Roses, but rather the vision that had followed this event. To shield himself from the temptations of unchaste thoughts and deeds, Saint Francis had thrown himself into a thicket of thorns. In the pain, he believed that he could see red and white thorns radiating a heavenly light.[4] Like the fresco, the painting in the Leipzig Museum connects the two events, while the cartoon itself concentrates entirely on the apparition of the saints accompanied by a choir of angels. In this composition, the influence of Giotto's Assisi frescoes in the Church of San Francesco, the work of Fra Angelico, and above all the early work of Raphael are happily united with the graphic and geometric beauty that distinguish Overbeck's design. DS

1 Letter of July 31, 1811, to Joseph Sutter; cited in Franz Binder, ed., *Friedrich Overbeck. Sein Leben und Schaffen. Nach seinen Briefen und anderen Documenten des handschriftlichen Nachlasses geschildert von Margaret Howitt*, vol. 1 (Freiburg im Breisgau 1886), p. 500.

2 See Binder, p. 514.
3 Letter of May 11, 1829, to Johannes Veit; cited in Binder, p. 501.
4 Cf. Andreas Blühm and Gerhard Gerkens, eds., *Johann Friedrich Overbeck, 1789–1869, Zur zweihundertsten Wiederkehr seines Geburtstages* (exh. cat., Lübeck 1989), p. 136.

17 Johan Christian Clausen Dahl

1788–1857

Megalithic Grave in Winter

1825

Oil on canvas, 75 x 106 cm
Signed within the composition at the center of the stone:
JD [letters intertwined] ahl/1825
Inv. no. 1734

Provenance: acquired from the artist in 1825 by Maximilian Speck von Sternburg, in Lützschena; in 1945 transferred to the Leipzig Museum during the postwar process of nationalization; in 1996 in the museum collection as part of the Maximilian Speck von Sternburg Stiftung

Johan Christian Clausen Dahl, while based in Dresden, devoted himself almost exclusively to painting the landscape of his native Norway. In the resulting pictures, his characteristic Romantic Realism complemented the deeply emotional and often melancholy approach to nature seen in the work of Caspar David Friedrich. Dahl's artistic contribution profoundly enriched the Romantic landscape painting tradition of Dresden.

Dahl's penchant for historical landscape and his interest in the surviving traces of the pre-Christian past may be associated, according to Hans Joachim Neidhart,[1] with the "Nordic Renaissance"—the bourgeois and national mood of awakening among the Scandinavian peoples. As a means of reinforcing the history and traditions of Scandinavia, Dahl always deliberately added menhirs, mound tombs, and stave churches to his Norwegian landscapes.

He was first attracted to such features during a sketching trip he made to southern Sweden in September 1817 with his friend Christian Jürgensen Thomsen, the Danish archaeologist and well-informed art lover, who was one of the founders of Norwegian archaeology. The painting illustrated here, like almost all of the Norwegian scenes painted after 1826, is probably based on drawn studies that Dahl made, for example, during the summer months of the period 1814–17 around Vordingborg on the island of Seeland. Among the paintings based on such drawings is the *Dolmen near Vordingborg in Winter* of 1824.[2] Later Norwegian scenes reflect Dahl's response to works such as Friedrich's prehistoric *Megalithic Grave in the Snow* (c. 1807)[3] and other such pictures showing the originally earth-covered mound graves, or dolmen, of the late fourth and early third centuries B.C., that Friedrich invested with visionary metaphorical significance.

It is precisely in Dahl's treatment of such motifs that the distinction between his approach and that of Friedrich becomes apparent—for Friedrich, who was profoundly influenced by his experience of the Napoleonic campaigns and then by the Wars of Liberation fought in 1813–14, saw the megalithic graves above all as a symbol "of a primeval Germany, still untouched by civilization and alien influences."[4]

Dahl's painting is much more varied and lively than those by Friedrich in terms of composition, the rendering of space, and the registering of details. According to Geismeier,[5] the Romantic strain in Dahl prompted him to treat his principal motif heroically and to fully convey the significance of the depicted season or the atmosphere and the character of the landscape. While the well-established symbols of vanity—the oaks, the grave itself, and the covering of snow already pierced by green shoots of grass—still accord with the Romantic understanding of the allegorical relation between nature and humanity, the oaks here no longer symbolize death. They are, rather, "living beings, leafless but full of health and sap, a constituent part of the landscape."[6]

Dahl's painting is in fact closer in temperament to the invigorating breadth of seventeenth-century Dutch landscapes and to the drama of nature as captured by Jacob Isaacksz. van Ruisdael. Dahl used the motif of the megalithic grave to give a particular mood to a winter scene and to juxtapose the contemporary life depicted with the remains of a much earlier era. Dahl skillfully renders an overcast winter's day with heightened sensitivity to color.

Immediately after its completion, the picture was acquired by the well-known Leipzig collector Maximilian Speck von Sternburg. In the inventory of his collection, made in 1840, Speck von Sternburg even provided a contemplative annotation: "Do not cling only to the earth, in the end it has nothing for you but a grave./This painting, full of truth, poetry, and a beautiful sense of color and completion, is one of this artist's best works."[7] DS

1 Hans Joachim Neidhart, *Deutsche Malerei des 19. Jahrhunderts* (Leipzig 1990), no. 34, p. 106.
2 Marie Lodrup Bang, *Johan Christian Clausen Dahl. 1788–1857. Life and Work* (Arlöv 1987), vol. 2, pp. 153 ff., no. 441; and vol. 3, fig. 441, plate 177.
3 Dresden, Staatliche Kunstsammlungen, Gemäldegalerie Neue Meister, gallery no. 2196. In 1845, Dahl acquired this picture at a Leipzig auction, owning it until his death.
4 Marianne Frodl, in *Der Traum vom Glück, Die Kunst des Historismus in Europa* (exh. cat., Vienna 1996), vol. 2, pp. 335–36.
5 Willi Geismeier, *Die Malerie der deutschen Romantiker* (Dresden 1984), p. 222.
6 Hans Joachim Neidhardt, *Die Malerei der Romantik in Dresden* (Leipzig 1976), p. 167.
7 Maximilian Speck von Sternburg, *Verzeichnis der Gemäldesammlung des Freiherrn v. Speck-Sternburg* (Leipzig 1840), p. 59.

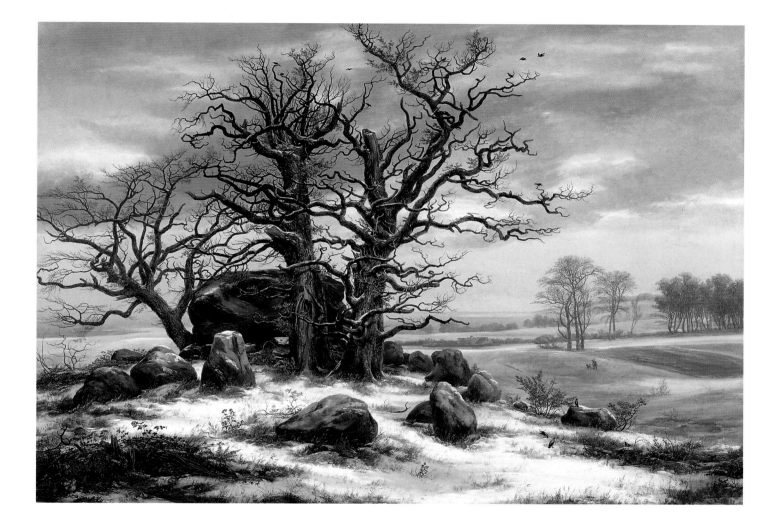

18 Carl Rottmann

1797–1850

The Valley of the Inn near Brannenburg

1825–26

Oil on canvas, 35 x 52 cm
Unsigned
Inv. no. 679

Provenance: bequest of Eduard Moritz Mayer, Leipzig

The Italian and Greek landscape cycles are the cornerstones of Rottmann's artistic achievement (see cat. no. 19), even though he also painted a considerable number of landscapes of the Bavarian and Austrian Alps. In the summers of 1822 and 1825, Rottmann went on extended sketching tours in this area, which had been overlooked by the earlier generation of painters of the Munich school. The awesome grandeur of the Alps impressed Rottmann immensely, forcing him to return repeatedly to the same themes.[1] This oil study of the Inn Valley corresponds closely to a watercolor study of the same site from 1823. On stylistic grounds, however, the oil study is dated a few years later.[2] Rottmann has chosen a somewhat elevated point of view from which he painted the Inn River as it curves out from between the high Alps at a point where the valley opens up into a wide expanse. As in the later Greek cycle, Rottmann's painting is unpeopled, and even the few buildings scattered throughout the valley blend into the landscape. Man and his creations are insignificant in comparison to the majestic beauty of the mountains, which constitute the focal point of the work. Although

Rottman left the foreground unfinished, he concentrated on characterizing the mountains.

In comparison with the watercolor study of 1823, Rottmann's style has undergone a decisive change. While the earlier work is meticulously detailed, the later study in oil shows Rottmann's tendency toward a more summary style. Rottmann's tendency to reduce the topography to simple, even flattened shapes and contours can already be felt here, although this manner of rendering the tectonic elements of a landscape is not fully developed until a decade later in his Greek cycle. The palette also has changed from cooler light greens that dominate the foreground and middle ground of the watercolor, to richer and darker colors in the oil version. Because of the unfinished parts in the foreground, it may be that this study was done directly from nature.[3] It may have served as a preparatory study for an oil painting of the same motif, dated 1825. This work, mentioned in an art publication in 1826, unfortunately has been lost.

HKA

1 Andreas Hahn, "Motive aus Deutschland und dem Alpenraum," in *Landschaft als Geschichte, Carl Rottmann, 1797–1850, Hofmaler König Ludwigs I.* ed. Christoph Heilmann and Erika Rödiger-Diruf (München: Hirmer, 1998), p. 95.

2 Erika Bierhaus-Rödiger, *Carl Rottmann, 1797–1850, Monographie und Werkverzeichnis* (München: Prestel, 1978), p. 175.

3 Ibid., p. 176.

21 Caspar David Friedrich

1774–1840

Cemetery in Snow

1826–27

Oil on canvas, 31 x 25.3 cm
Dated on the wooden cross on the right: 1826
Inv. no. 1733

Provenance: painted on commission for Maximilian Speck von Sternburg, Leipzig/
Luetzschena; transferred in 1945 in accordance with the land reform to the Museum der
bildenden Künste Leipzig; in 1996 part of the Maximilian Speck von Sternburg-Bequest
to the Museum der bildenden Künste Leipzig

This painting of a segment of a snow-covered cemetery is the only dated work by Friedrich.[1] The year 1826 is clearly legible on the largest of the wooden crosses, but no signature is decipherable. Since it was mentioned in the catalogue of the collection of Baron Speck von Sternburg in 1826–27, it has been assumed that he had commissioned it.[2] It is probably a commemorative work, but it is unclear in whose memory it was painted.

The dilapidated state of the crosses would indicate an old and forgotten graveyard. The newly dug grave in the foreground, in which the gravediggers seem to have left their shovels temporarily, however, contradicts that assumption. On first impression, it is a picture of complete hopelessness. The colors of winter—white, gray, browns, and black—are without any warmth. Snow and cold have extinguished all signs of life, the ground is frozen, and the leafless branches of the shrubs are reminiscent of Christ's crown of thorns. But for Friedrich, who once described snow as "the essence of purity whereby nature prepares itself for a new life," it meant renewal.[3] The few green blades of grass pushing through the snow are indeed small signs of hope and resurrection. The open gate is another of Friedrich's symbols of hope of salvation, even if it can be reached only through the grave.

Throughout his career, Friedrich painted many scenes of graveyards,[4] an intrinsically romantic subject, and symptomatic of Friedrich's preoccupation with death throughout his life. "One must submit oneself many times to death in order to attain life everlasting," Friedrich once said.[5] The quest to express his hope of salvation permeates and defines Friedrich's entire oeuvre. HKA

1 Jens Christian Jensen, *Caspar David Friedrich* (Köln: Dumont, 1999), p. 211.
2 Herwig Guratzsch, ed., *Maximilian Speck von Sternburg, Ein Europäer der Goethezeit als Kunstsammler* (Leipzig: Seemann in der Dornier Medienholding GmbH, 1998), p. 219.

3 Helmut Börsch-Supan, Hans Joachim Neidhardt, and William Vaughan, *Caspar David Friedrich: 1774–1840; Romantic landscape painting in Dresden*, exh. cat. (London: Tate Gallery, 1972), p. 89.
4 Jensen, *Caspar David Friedrich*, p. 207.

5 Gert Schiff, *German Masters of the Nineteenth Century, Paintings and Drawings from the Federal Republic of Germany*, exh. cat. (New York: The Metropolitan Museum of Art, 1981), p. 15.

22 Caspar David Friedrich

1774–1840

Seascape in Moonlight

c. 1830/35

Oil on canvas, 25.2 x 31.2 cm
Unsigned
Inv. no. 1732

Provenance: from the collection of Maximilian Speck von Sternburg, Leipzig/Luetzschena; transferred in 1945 in accordance with the land reform to the Museum der bildenden Künste Leipzig; in 1996 part of the Maximilian Speck von Sternburg-Bequest to the Museum der bildenden Künste Leipzig

Friedrich concentrates here on the powerful image of a single ship on the open sea, with no sign of life as far as the eye can reach. The loneliness of man, even if he deems himself to be master of his fate, is clearly the implied message. The interpretation of this work is much less enigmatic than that of many other of Friedrich's works, in which he seems to use a hieroglyphical language as a means of expressing himself. According to Börsch-Supan, the ship represents man's journey through life, and the moonlight that glistens in the wake of the ship represents Christ. Friedrich lights the ship's course even in adversity, symbolized by the windswept clouds.[1]

This is one of Friedrich's most poignant works from a purely painterly point of view. The ship, placed in the center of the canvas, is unequivocally the focal point of the work. The moon casts its silver light around it; yet the ship is seen only as a dark silhouette. The ship's emphatic verticals pierce the strong horizontals of sea and sky, creating a visual link between them. The sea is completely still, only the clouds traversing the somber sky in a strong diagonal provide a sense of movement. In total harmony with the focus on a single object, Friedrich reduces his palette to the shades of a single color. The painting is a monochrome of grays; yet there is so much variety in the nuances that the entire canvas is animated. In this moving image of a ship, alone in the dark between sea and sky, Friedrich expresses most poignantly that underlying feeling of *Sehnsucht*, or yearning, which is a defining element of German Romanticism.

HKA

1 Helmut Börsch-Supan, Hans Joachim Neidhardt, and William Vaughan, *Caspar David Friedrich, 1774–1840; Romantic landscape painting in Dresden*, exh. cat. (London: Tate Gallery, 1972), p. 99.

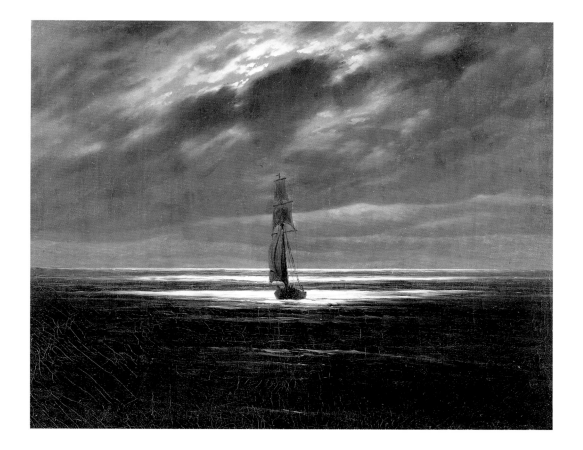

23 Caspar David Friedrich

1774–1840

Stages of Life

c. 1834

Oil on canvas, 73 x 94 cm
Unsigned
Inv. no. 1217

Provenance: probably in the possession of Johann Heinrich Friedrich, the brother of the artist; 1905 in the possession of the daughter-in-law of the former; gift to Sophie Siemsen, Greifswald, who sold it to the Museum der bildenden Künste Leipzig through the Galerie Nathan of Zurich in 1931

Stages of Life[1] is in many ways a remarkable painting. The group of five people depicted here is unusually large for Friedrich, who generally painted single figures, often seen from the back, or groups of no more than two or three people. The group is gathered on the seashore, interacting with one another and watching five sailing ships of different sizes approaching the shore. The identity of the people is not completely clear, but Börsch-Supan suggests that this work was painted as a memento to Friedrich's own family.[2] Accordingly, Friedrich has shown himself as an old man seen from the back, his often-used device of the *Rückenfigur*. The young man gesturing toward him is probably his nephew Heinrich, who later owned this painting. The small boy holding the flag is probably Friedrich's son Gustav Adolph and the little girl his daughter Agnes. The identity of the young woman is somewhat problematic, but she may be Friedrich's older daughter, Emma.

As in almost all of Friedrich's works, *Stages of Life* is filled with symbols of death and salvation, giving a deep and solemn meaning to this family gathering. An overturned boat lies on the rocks in the foreground, a device Friedrich uses repeatedly to symbolize a coffin.[3] A further symbol of death and salvation is the cross-shaped marker that was used by fishermen to indicate the location of their nets,[4] while the

three dead branches, used to dry fishing nets, may be seen as a symbol of the Trinity. Ships in Friedrich's pictorial language symbolize man's journey through life. Since the number of people corresponds exactly to the number of sailboats, the identification of one group with the other seems obvious.[5] The smaller, nonseaworthy boats represent the children, while the largest ship must represent the old man, who like the ship, is closest to completing his voyage of life. The other larger vessels representing the young man and young woman are still in full sail, their journeys still holding unfulfilled promises.

Friedrich's symbolism even permeates the composition and the color harmonies. The pyramidal arrangement of the figures is underscored by the rocky shoreline. It, too, stands for the Trinity. The symbol is repeated in the even larger triangle of the three large ships that leads the eye from the dark shore, across the sea, and up into the luminous sky. The horizon that divides the composition into two nearly equal halves also divides the grays and greens of shore and sea from the golden yellow of the sky. While the somber colors characterize the realm of human activity and human plight, the bright and warm colors represent the glories of heaven toward which, according to Friedrich's beliefs, man should be journeying all his life. HKA

1 Herwig Guratzsch, ed., *Von Lucas Cranach bis Caspar David Friedrich*, exh. cat. (Stuttgart: Hatje, 1994), p. 255.
2 Helmut Börsch-Supan, *Caspar David Friedrich* (München: Prestel, 1990), p. 172.
3 Ibid.
4 Ibid.
5 Jens Christian Jensen, *Caspar David Friedrich* (Köln: DuMont, 1999), p. 198.

24 Adrian Ludwig Richter

1803–1884

Valley near Amalfi with a View of the Gulf of Salerno

1825/26

Oil on canvas, 100 x 138 cm
Signed at the lower right: L.R. Roma 1826.
Inv. no. 200

Provenance: purchased by the Saxon artists' association, the *Kunstverein*, in 1828; acquired by a Herr von Minkewitz, of Dresden, when the *Kunstverein* collection was dispersed; subsequently in the collection of Dr. Hillig, of Leipzig; auctioned in 1862 by the Leipzig art dealer Rudolph Weigel; in the collection of M. von Zahn, then in that of Eduard Cichorius, in Leipzig; donated by Cichorius in 1862 to the Leipzig Museum

The Leipzig Museum has one of the best collections of works by Adrian Ludwig Richter, generally known as Ludwig Richter, to be found outside Dresden. The museum owns six paintings, more than one hundred drawings and watercolors, and numerous prints, portfolios, and illustrated books.[1] Within this collection, the painting *Valley near Amalfi with a View of the Gulf of Salerno* is one of the most significant of Richter's early works.[2]

Richter began working on this composition after returning to Rome from Civitella in 1825. He referred to studies made during a three-day stop in Amalfi when en route from Rome to Naples the previous spring. He also was inspired by the art of Renaissance masters, notably Bellini's painting *Bacchanal* (1514); the landscape portion of the work was completed, after Bellini's death, by Titian.[3] Richter had seen this picture in the Camuccini Collection in Rome and it had made a deep and lasting impression upon him.

As in Richter's earlier landscape compositions, *Mount Watzmann* (1824)[4] and *The Rocca Santo Stefano in the Sabine Hills* (1824/25),[5] here he once again sought to achieve a greater compositional simplicity. Accordingly, he eschewed the classicizing approach to form characteristic of his esteemed model Joseph Anton Koch. Instead, Richter adopted something of the Romantic and idyllic mood as seen in the work of his friend Julius Schnorr von Carolsfeld. A further innovation for Richter was the greater attention to the treatment of the figures. In fact, Richter sought the assistance of Schnorr von Carolsfeld for this aspect of the composition, a move likely because Richter considered himself little versed in figure drawing: "As he [Schnorr von Carolsfeld] had recently promised to let me have one of his own drawings when the chance arose, he proposed the following plan: I should supply an outline version of my figures, he would then provide a fully worked out version of these and make a corrected drawing based on this. After eight days he brought along a drawing in pen and ink and wash based on my figures but so exquisitely executed, correctly drawn and overflowing with charm in every line that I couldn't believe my luck to be in possession of such a treasure … I couldn't stop looking at it, and each time I came back home the very first thing I did was to get out this drawing in order to look at it as carefully as possible and, where possible, to learn something from its excellence."[6]

In addition to the ink drawing made by Schnorr von Carolsfeld on the basis of Richter's design,[7] a fragment of Richter's original tracing has also survived.[8] The latter shows Richter's pencil outlines and the corrections added by Schnorr von Carolsfeld in pen and ink. Also in connection with the painting of 1825/26, Richter made a pen-and-ink drawing with both ink wash and watercolor, *Italian Peasants in a Mountainous Landscape* (c. 1826),[9] and a composition drawing in pencil,[10] the latter serving as a model for the etching *View of the Gulf of Salerno from a Valley near Amalfi*,[11] which Richter prepared in 1828 for the illustrated volume published by the Saxon artists' association, the *Bilderchronik des Sächsischen Kunstvereins*. SP

1 Cf. *Ludwig Richter. Zeichnungen, Aquarelle, Gemälde: Kataloge der Graphischen Sammlung* vol. 6, (Leipzig 1984).
2 Karl Josef Friedrich, *Die Gemälde Ludwig Richters* (Berlin 1937), text vol. p. 35, no. 17; illustration vol. plate on p. 19, fig. 29.
3 Washington, D.C., National Gallery of Art, inv. no. 597.
4 Munich, Bayerische Staatsgemäldesammlungen, Neue Pinakothek, inv. no. 8983; see Friedrich, text vol. p. 33, no. 12; illustration vol. plate on p. 15, fig. 24.
5 Leipzig, Museum der bildenden Künste, inv. no. 195; see Friedrich, text vol. p. 34, no. 14; illustration vol. plate on p. 16, fig. 25.
6 Heinrich Richter, ed. *Lebenserinnerungen eines deutschen Malers. Selbstbiographie nebst Tagebuchaufzeichnungen und Briefen von Ludwig Richter* (10th ed., Frankfurt am Main 1901), p. 238.
7 Julius Schnorr von Carolsfeld, *Italian Landscape* (1826), private collection in northern Germany; formerly in the Heumann Collection, Chemnitz (Lugt 2148 a); cf. *Julius Schnorr von Carolsfeld. 1794–1872* (exh. cat., Leipzig 1994), p. 210, no. 57, fig. 122.
8 Erlangen, Universitätsbibliothek, inv. no. L I, A 533; cf. von Carolsfeld, pp. 210ff., no. 57, fig. on p. 210.
9 Budapest, Szépmüvészeti Múzeum, inv. no. 1935–2872.
10 Leipzig, Museum der bildenden Künste, Graphische Sammlung, inv. no. I. 1591.
11 Karl Budde, ed., *Johann Friedrich Hoff: Adrian Ludwig Richter. Maler und Radierer. Verzeichnis seines gesamten graphischen Werkes* (2nd ed., Freiburg im Breisgau 1922), p. 53, no. 185.

25 Adrian Ludwig Richter

1803–1884

Approaching Storm at Schreckenstein

1835

Oil on canvas, 88 x 115.3 cm
Signed at the lower left: L. Richter./1835
Inv. no. 199

Provenance: purchased by the Saxon artists' association, the *Kunstverein*, in 1835; entered
the collection of the Oberforstrat Cotta, in Tharandt when the *Kunstverein* collection
was dispersed; subsequently acquired by the Dresden art dealer Johann Christoph Arnold,
who sold it to Eduard Cichorius, in Leipzig; donated in 1862 to the Leipzig Museum

After spending three years in and around Rome from 1823 to 1826, Richter at first did not find it easy to readjust to Germany or to find inspiration there for his work. "My longing … for this ideally beautiful and splendid landscape almost took on the proportions of an illness, and perhaps the more so in that, on account of my limited possibilities, I could foresee no chance of ever again being able to set foot on this territory, which for me had now assumed the character of a sacred realm. The landscapes I found in my immediate surroundings, on the contrary, appeared to me impoverished and lacking in form …"[1] At last in the autumn of 1834, when he made a trip through Bohemia, Richter was able to emerge from this crisis and see his homeland in a new light. Writing to Wilhelm von Kugelgen, he declared: "I've now started to turn away from my ties to Italy and have taken the Bohemian villages to my heart as a painter."[2]

Still, relying on a composition completed five years earlier, *Storm on Monte Serone in the Sabine Hills*,[3] Richter succeeds in his *Approaching Storm at Schreckenstein* with rendering a more familiar landscape. This landscape provided the starting point for an entire series of pictures focused on the same striking and myth-laden motif: a rocky outcrop on the River Elbe, near Aussig (now Ústí nad Labem, Czech Republic), eighty meters in height, accessible only from one side and topped by a ruined castle.

In these works, Richter was able to draw on the impressions gained on his travels in Bohemia, and keenly recorded in two sketchbooks. One of these is almost exclusively devoted to figure studies,[4] but the other, known as the "Bohemian Sketchbook,"[5] contains swift sketches of motifs encountered en route, landscape studies, and composition drawings that supply a record of the points at which Richter stopped during his journey. It is probable that the pencil study in this sketchbook served as a model for the Leipzig painting of 1835. The drawing shows a view of Schreckenstein from the north and makes it clear that the water mill appearing at the right in the painting was an invented feature added later.

A comparison between painting and drawing also shows Richter's desire to achieve a dramatic treatment of the landscape by depicting an approaching storm, thereby somewhat suppressing some of the closely observed drawn detail. Furthermore, a slight alteration in the relative scale of the individual elements in the painting ensures that the Schreckenstein itself, already a visual focus both graphically and chromatically, becomes the dominant feature of the composition; the surrounding mountain landscape recedes into the background. The abrupt drop to the river below is formally interrupted by the presence of an overgrown tree and the previously mentioned water mill. These help to lead the eye across the Elbe meadows and the river itself, and to the chain of mountains with its highest point formed by the peak of the Stauden visible in the distance. The slightly raised foreground is dominated by a group of figures driving their cattle and clearly hastening to seek shelter from the approaching storm. Their progress into the middle distance leads the eye back, via this sloping ground, to the main motif towering above it.[6]

The Schreckenstein was a popular subject for several generations of painters and draftsmen. A poem by Theodor Körner extolled what was probably the most imposing ruin to be found in the entire Elbe Valley; many other writers testified to their fascination with this location. It is said that the composer Richard Wagner, who often traveled through Bohemia in his Dresden period, found inspiration in Schreckenstein when he was at work on his opera *Tannhäuser*. SP

1 Heinrich Richter, ed. *Lebenserinnerungen eines deutsches Malers. Selbstbiographie nebst Tagebuchaufzeichnungen und Briefen von Ludwig Richter* (10th ed., Frankfurt am Main 1901), p. 316.
2 See Richter, p. 211.
3 Frankfurt am Main, Städelsches Kunstinstitut, inv. no. 1093; Karl Josef Friedrich, *Die Gemälde Ludwig Richters* (Berlin 1937), text vol. p. 44, no. 31; illustration vol. plate on p. 32, fig. 50.
4 Ludwig-Richter-Skizzenbuch no. 70; Dresden, Staatliche Kunstsammlungen, Kupferstich-Kabinett, inv. no. C 1941–93.
5 Ludwig-Richter-Skizzenbuch no. 12; Dresden, Staatliche Kunstsammlungen, Kupferstich-Kabinett, inv. no. C 1941–35.
6 Cf. Winfried Werner, "Die Schreckenstein-Bilder," pp. 30–33.

26 Adrian Ludwig Richter

1803–1884

Evening Prayers (Evening Bells)

1842

Oil on canvas, 70 x 105 cm
Signed at upper right: L. Richter 1842
Inv. no. 201

Provenance: purchased in 1842 by the Saxon artists' association, the *Kunstverein*; subsequently in the collection of Johann Gottlob von Quandt, in Dresden; after his death acquired in 1868 by the Leipzig Museum

After 1836, Ludwig Richter devoted almost all of his attention to book illustration. Until the mid-1860s, he produced very few paintings, though several rank among the artist's masterpieces. One of these is *Evening Prayers*, in the Leipzig Museum.[1] This work is impressive not only for its painterly qualities but also for its appealing treatment of the coexistence of man and nature. Here, the landscape engaged Richter less than the group of figures because the landscape serves principally as a "stage set" for the real subject of the picture. The figural group provides the focus of the composition.

In front of a devotional image attached to the trunk of a powerful oak, a small group of women and children, having come directly from their day's work in the fields (their sheaves of harvested corn lie nearby), has gathered for evening prayers. The group stands out clearly against the gleaming western sky. To the right, a monk sounds the little bell that hangs from a branch of the tree. In the foreground, we find several children reclining calmly on the forest floor with sheep, lambs, and a dog. Others, however, play boisterously in the hollow trunk of the vast oak.[2] Both the narrative element in the scene and the deft handling of the interplay of light and shadow—one of the most important expressive tools available in the technique of the woodcut—show Richter's skill as a book illustrator.

While earlier critics assumed that the landscape setting seen here was based on Richter's study of the feature known as the Ostrage Hege near Dresden,[3] it has more recently been suggested that a landscape motif discovered during Richter's travels in Bohemia may have served as inspiration.[4] One starting point may have been the pencil drawing of an *Oak near Ossegg in Bohemia*,[5] which already contains figures. Another drawing, *Edge of a Wood with Oak Trees near Ossegg*,[6] shows the same oak from another view. The similarity with the oak in the painting of 1842 appears all the more significant in that a dead tree with the remains of a metal tabernacle was found in Ossegg (now Osék, Czech Republic); in addition, there are striking similarities in the overall landscape. Moreover, in Richter's time the tradition of holding outdoor evening prayers was no longer common in the area around Dresden, yet it was still maintained in Catholic Bohemia.

Several preparatory drawings for this painting have survived: a composition sketch,[7] a study for the figure of a kneeling girl,[8] a pen-and-ink drawing,[9] and—probably the most important preparatory work—a careful study from life for figures in the principal group,[10] which differs only slightly from the painted version. In 1842, Richter also painted a watercolor that resembles the painting of this year,[11] and this work served as a model for Wilhelm Witthöft's etching of this subject.[12] Richter himself used a slightly altered version of the group of women and children seen in his painting for his woodcut of 1866, *The Harvester's Prayer of Thanks*.[13]

SP

1 Karl Josef Friedrich, *Die Gemälde Ludwig Richters* (Berlin 1937), text vol. p. 63, no. 66; illustration vol. plate on p. 62, fig. 102.
2 Cf. Winfried Werner, "Ludwig Richter als Landschafter in Böhmen und Schlesien" (B.A. diss., Leipzig 1982), pp. 58 ff.

3 Cf. Friedrich, text vol. p. 63.
4 Cf. Werner, p. 60.
5 Nuremberg, Germanisches Nationalmuseum, inv. no. Hz. 3204.
6 Dresden, Staatliche Kunstsammlungen, Kupferstich-Kabinett, inv. no. C 1892–363.
7 Dresden, Staatliche Kunstsammlungen, Kupferstich-Kabinett, Ludwig-Richter-Skizzenbuch no. 23, inv. no. C 1941–46, sheets 29 b and 30.
8 Dresden, Staatliche Kunstsammlungen, Kupferstich-Kabinett, inv. no. C 1908–1206.
9 Untraced; cited in Friedrich, text vol. p. 63.
10 Leipzig, Museum der bildenden Künste, Graphische Sammlung, inv. no. r I. 1593.

11 Karl Budde, ed., *Johan Friedrich Hoff: Adrian Ludwig Richter. Maler und Radierer. Verzeichnis seines gesamten graphischen Werkes* (2nd ed., Freiburg im Breisgau 1922), p. 384, no. 3542.
12 See Budde, p. 305, no. 2981.
13 See Budde, p. 119, no. 541.

27 Adrian Ludwig Richter

1803–1884

Summer's Joy

1844

Watercolor over pencil, 15.5 x 24.4 cm
Signed at the lower left: L.R. 1844
Inv. no. NI. 927

Provenance: acquired in 1865 as part of a bequest from Christian Heinrich Demiani,
in Leipzig

The watercolor *Summer's Joy* is one of four hundred and ninety-six sheets that entered the collection of the Leipzig Museum as a bequest from Christian Heinrich Demiani (1794–1865). This Leipzig merchant and passionate art collector had encouraged Adrian Ludwig Richter to paint watercolors when the artist was working at the Drawing School of the porcelain factory at Meissen, and Demiani was the first patron to commission a watercolor from Richter.

In his memoirs, Richter recalled this period in some detail: "As I have spoken of my own work and that of my friends in the time when I was in Meissen, I'd also like to pay tribute to a man who has remained in my memory of this phase in my life … In addition to these works there were also … a number of drawings and watercolors. I started work on these last —because I had never earlier tried to work in this medium—when I recognized that I ought to make better use of the free time after the class in which drawings were corrected, and which I had usually passed in reading or in chatting with my colleagues … When Demiani, a Leipzig art lover and the owner of an extensive collection of watercolors, expressed a desire to have one of these from my hand, I made a composition of a harvest procession in the Campagna, executing this in the Drawing School. This was the first watercolor that I ever painted."[1]

Sadly, this sheet with a "Harvest Procession in the Campagna," presumably painted around 1828/29, is now untraced. It is not known for certain whether Richter's watercolor of 1844, now in Leipzig, was commissioned by Demiani, nor exactly when the collector acquired this sheet. The brightly colored and animated composition shows a group of young women and children walking along the edge of a field. They are carefree and laughing, singing and making music. At the edge of the path sits an older woman; surrounded by her grandchildren, she has settled in a shady spot to refresh herself with water and fruit. Beyond, in the background, a journeyman—probably a laborer on his way to the nearest town, which appears in the form of a distant silhouette on the horizon—casts a benevolent glance at this manifestation of high spirits.

The "folksy" character of this watercolor bears a close connection to Richter's work as an illustrator, which dominated his artistic activity from the late 1830s. It is assumed that the composition of the watercolor derives from that of an unfinished painting;[2] and three related studies in pencil were auctioned by C.G. Boerner in Leipzig in 1928.[3] Two further preparatory drawings[4] were made for the lithograph version of this subject, which was executed in 1852 by Georg Christian Hahn as a gift for the members of the Saxon artists' association in Dresden, the *Kunstverein*.[5]

SP

1 Heinrich Richter, ed., *Lebenserinnerungen eines deutschen Malers. Selbstbiographie nebst Tagebuch-aufzeichnungen und Briefen von Ludwig Richter* (Frankfurt am Main 1901), pp. 309 ff.
2 Summer's Joy (sketch), oil on canvas, 39.5 x 42 cm, Nuremberg, Museen der Stadt; cf.

Karl Josef Friedrich, *Die Gemälde Ludwig Richters* (Berlin 1937), text vol., p. 65, no. 70; illustrations vol. p. 65, fig. 107.
3 Sale no. 159, cat. no. 49; cf. Karl Josef Friedrich, p. 65.
4 Catalog for sale no. 159, C.G. Boerner, Leipzig, nos. 47, 48; cf. Karl Josef Friedrich, p. 65.

5 Karl Budde, ed., *Johann Friedrich Hoff: Adrian Ludwig Richter. Maler und Radierer. Verzeichnis seines gesamten graphischen Werkes* (Freiburg i. Br. 1922), pp. 339 ff., no. 3228.; cf. p. 373, no. 3441 and p. 135, no. 653.

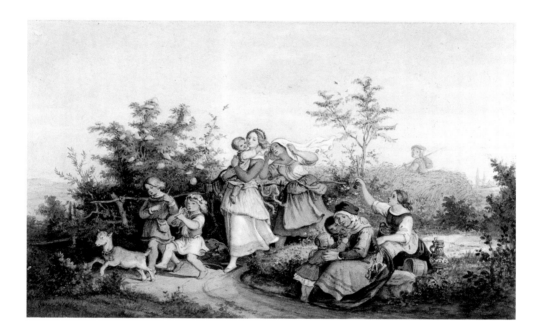

28 Wilhelm von Schadow

1788–1862

Mignon

1828

Oil on canvas, 119 x 92 cm
Unsigned
Inv. no. 1714

Provenance: painted in 1825 on commission for Maximilian Speck von Sternburg, Leipzig/Luetzschena; transferred in 1945 in accordance with the land reform to the Museum der bildenden Künste Leipzig; in 1996 part of the Maximilian Speck von Sternburg-Bequest to the Museum der bildenden Künste Leipzig

In 1825, Baron Maximilian Speck von Sternburg commissoned Wilhelm von Schadow to paint a Mignon, a figure from the novel *Wilhelm Meisters Lehrjahre* by Johann Wolfgang von Goethe. The completion was delayed until 1828 because of von Schadow's lengthy illness and a move to Düsseldorf, where he had been appointed director of the art academy.[1] The figure of Mignon, according to Goethe, is the incarnation of poetry, yet von Schadow's work is more than an allegorical or "phantasy portrait."[2] He sought to express his philosophy of poetry as the "intermediary between the divine and the earthly."[3]

Von Schadow rendered *Mignon* as a serene young woman whose large golden wings characterize her as a heavenly being. The angelic appearance is further enhanced by the classical white dress, with accents of gold in the sash around her slender waist and the fillet circling her dark curls. Her purity is further symbolized by the lily at her right, a flower usually associated with the Madonna. Mignon is depicted at the moment when she has just finished her song with the words, "so let me seem until I am."[4] The inspiration for this stylistically refined and highly finished work—with its classical composition, balanced proportions, and luminous colors—lies obviously in Raphael's work, which von Schadow admired greatly. Already on his trip to Rome he had seen the master's *Sistine Madonna* in Dresden, and borrowed from it the use of curtains to denote a sacred space. Despite a number of differences, Raphael's *Poetry* in the Stanza della Segnatura in the Vatican undoubtedly served as von Schadow's immediate inspiration. But whereas Raphael's *Poetry* is full of energy, caught in an animated pose with her wings outspread as though about to take flight, von Schadow's *Mignon* is completely passive. The classical accessories used by Raphael—laurel wreath and lyre—have been replaced by lily and guitar, moving the figure out of the antique and into the Christian context. This significant difference is symptomatic of von Schadow's affiliation with the Nazarenes, whose emphasis on religion von Schadow embraced in his art as well as in his personal life.

Stylistically, von Schadow stands between the Classicism of his father, who had made a chalk drawing of Marianne Schlegel as *Mignon* in 1802,[5] and the Romantic and Revivalist teachings of the Nazarenes. First and foremost, however, for von Schadow was his own desire to depict the inspiration from which both painting and poetry flows. For him a painting was nothing less than "a poem in form and color."[6] HKA

1 Herwig Guratzsch, ed., *Maximilian Speck von Sternburg, Ein Europäer der Goethezeit als Kunstsammler* (Leipzig: Seemann in der Dornier Medienholding GmbH, 1998), p. 236, cat.no.I/177.
2 Barbara Camilla Tucholski, "Friedrich Wilhelm von Schadow, 1789–1862, Künstlerische Konzeption und Poetische Malerei" (Ph.D. diss., Univ. Bonn), 1980, p. 143.
3 Helmut Börsch-Supan, "Das Frühwerk Wilhelm von Schadows und die berlinischen Voraussetzungen der Düsseldorfer Schule," in *Die Düsseldorfer Malerschule*, ed. Wend von Kalnein (Mainz/Rhein: von Zabern, 1979), p. 63.
4 Herwig Guratzsch, ed., *Maximilian Speck von Sternburg*, p. 236.
5 Ibid., p. 238.
6 Geraldine Norman, *Nineteenth-Century Painters and Painting: A Dictionary* (Berkeley and Los Angeles: University of California Press, 1977), p. 188.

29 Wilhelm von Schadow
1788–1862

Girl, reading

Probably 1831/32

Oil on canvas, 46 x 37 cm
Unsigned
Inv. no. 1713

Provenance: acquired from the First Exhibition of the Art Association *(Kunstverein)* of
Leipzig by Maximilian Speck von Sternburg, Leipzig/Luetzschena; transferred in 1945 in
accordance with the land reform to the Museum der bildenden Künste Leipzig; in 1996
part of the Maximilian Speck von Sternburg-Bequest to the Museum der bildenden
Künste Leipzig

This undated painting is mentioned by Baron Maximilian Speck von
Sternburg in his catalogue in 1840 as "A girl reading in a landscape, …
her head covered with a white cloth, reading in devoted manner in a
prayer book which she holds with both hands."[1] The young girl, char-
acterized by her historical costume and her serene expression as a Virgin
Mary, has been placed very close to the foreground, the lower frame
serving almost as a ledge behind which she is sitting. The small devo-
tional manuscript is opened to reveal a medieval illustration and letter-
ing, underscoring the allusion to a Renaissance-style painting. This ref-
erence is carried out in the background landscape, which is reminiscent
of those found in the Madonnas of Raphael. Imitating the Renaissance
master, von Schadow balances the strong colors of the Virgin's dress
with the soothing greens and blues of the background.

Von Schadow, who had converted to Catholicism in 1814 during
his association with the Nazarene painters in Rome, considered reli-
gious painting of utmost importance. In his thematic hierarchy, paint-
ings of the Madonna ranked immediately after depictions of the life of
Christ.[2] If the contemplation of the portrait of the Madonna, of her
majesty and beauty could lift the soul of the beholder even for a brief
moment, then such a painting stood above all others, von Schadow
wrote as late as the 1850s, almost thirty years after leaving the Nazarenes
in Rome.[3] The stylistic requirements necessary to inspire the viewer to
contemplation and true devotion were quiet outlines, balanced shapes,
suppression of details, and an emphasis on clear colors, according to von
Schadow. His *Girl, reading* illustrates his teachings beautifully and in
many ways expresses his deeply felt religious convictions better than his
larger and more elaborate works. HKA

1 Dietulf Sander, "A Girl Reading," unpublished
catalogue notes, Museum der bildenden Künste
Leipzig.
2 Barbara Camilla Tucholski, "Friedrich Wilhelm

von Schadow, 1789–1862, Künstlerische Konzep-
tion und Poetische Malerei" (Ph.D. diss., Univ.
Bonn, 1980), pp. 32–33.
3 Ibid., p. 33.

30 Gustav Adolph Hennig

1797–1869

Reading Girl

c. 1828

Oil on canvas, 42.5 x 36.5 cm
Unsigned
Inv. no. 1086

Provenance: 1916 gift of Max Heilpern, Leipzig

For a long time, this painting was referred to as *Reading Madonna*.[1] The difficulty in determining the correct title is due to the fact that this portrait of a young girl embodies many elements of Nazarene painting, where the line between religious works and portraiture is often blurred. Hennig had been part of the Nazarene movement during his stay in Rome from 1823 to 1826, but it is Overbeck and Pforr who are credited with having developed this type of portrait. Many of their portraits as well as a number of self-portraits not only show the sitters in medieval costumes but also include religious symbolism and devotional aspects.[2] Other members of this group, such as Julius Schnorr von Carolsfeld, often include portraits of their friends in their religious paintings (see cat. no. 10).[3]

The young girl portrayed by Hennig, with her severely parted dark hair and simple orange-red dress, has a timeless quality that could place her in a biblical context as well as in a contemporary one. In both hands, she holds a small book in which she reads with total concentration. Her downcast eyes permit no access to her thoughts, but the stillness of her delicate features in their slightly foreshortened view indicates meditation or prayer.

Hennig follows the Nazarene teachings of a linear style and emphasizes the outline of the whole figure as seen against a neutral background. His palette also corresponds to the Nazarene predilection of strong local colors, but is very controlled, reduced to five or six colors. The quiet yet warm tonality underlines the pensive and serene mood of the subject. The strength of this refined work lies in the subtle balance of different geometric shapes such as the oval of the face and the trapezoid of the neckline, and in the interplay of the delicate lines within the strong outline. The figure's contained silhouette corresponds harmoniously to the introverted expression of the face. Hennig, although not one of the leading figures of the Nazarene school, has certainly earned himself a place of honor with this remarkable depiction of a reader completely absorbed in a book. HKA

1 Ulrich Thieme and Felix Becker, eds. *Allgemeines Lexikon der Bildenden Künste, Von der Antike bis zur Gegenwart*, vol. 16, Hans Vollmer, ed. (Leipzig: Verlag von Wilhelm Engelmann, 1923), pp. 401–2, and Herwig Guratzsch, ed., *Von Lucas Cranach bis Caspar David Friedrich*, exh. cat. (Stuttgart: Hatje, 1994), p. 297.

2 Ulrich Finke, *German Painting from Romanticism to Expressionism* (Boulder, Colo.: Westview Press, 1975), pp. 51, 62.
3 Herwig Guratzsch, *Von Lucas Cranach bis Caspar David Friedrich*, pp. 283–85, cat. no. 148.

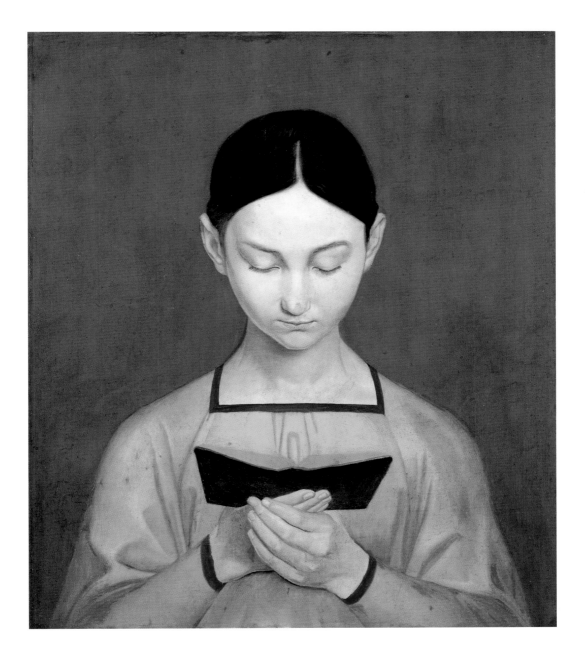

31 Gustav Adolph Hennig

1797–1869

The Artist's Daughters on the Way to School

1851

Oil on canvas, 134 x 105.5 cm
Signed lower left: GAH(lig.)enig. p./1851
Inv. no. 1210

Provenance: acquired in 1930 from the art dealer Beyer and Son, with funds from the
donation by Hacker

Hennig painted his daughters Margarethe and Elisabeth in this nearly life-size double portrait when he was at the height of his career. The two girls, one about eight years of age and the other around six years of age, are holding each other by the hand as they are setting out on their way to school. Their simple dresses and book bags are certainly appropriate for a school day. While the older girl's clothes are somewhat somber in color, consisting of a gray cloak over a long-sleeved green dress which in turn is sensibly covered by a gold-brown apron, the little girl's bright red dress, under which a pair of white pantalets are peeping out, constitutes the coloristic highlight of this painting. Hennig subtly differentiated the expressions on his daughters' faces. The older girl seems confident, but the younger one has a pensive, slightly anxious expression, indicating that it may be her first day of school.[1] The girls are standing in front of a nondescript dark wall; the narrow street opening up on the right background, however, is a recognizable street in Leipzig.[2]

In this painting, Hennig has moved away from his more linear style as documented by his *Reading Girl* (see cat. no. 30), and given his figures more fullness, more plasticity through deeper shading. The detailed accessories like the carefully drawn book bags are also a new element in his work. The colors are no longer the bright local colors of the Nazarenes, but more subdued and more harmonious. All in all, Hennig has abandoned the stylization of his earlier works in favor of a more realistic interpretation. In this respect, his work corresponds to the general trend in German painting around the middle of the nineteenth century, an influence often attributed to the success of the Düsseldorf Academy of Art. HKA

1 Herwig Guratzsch, ed., *Von Lucas Cranach bis Caspar David Friedrich*, exh. cat. (Stuttgart: Hatje, 1994), p. 298.
2 It has been suggested that the girls are standing in front of a buttress on the north side of the church of St. Nikolai, the scene in the background being St. Nikolai Square, but it may also be a view of the former "Georgenhaus"; see Herwig Guratzsch, ed., *Von Lucas Cranach bis Caspar David Friedrich*, p. 298.

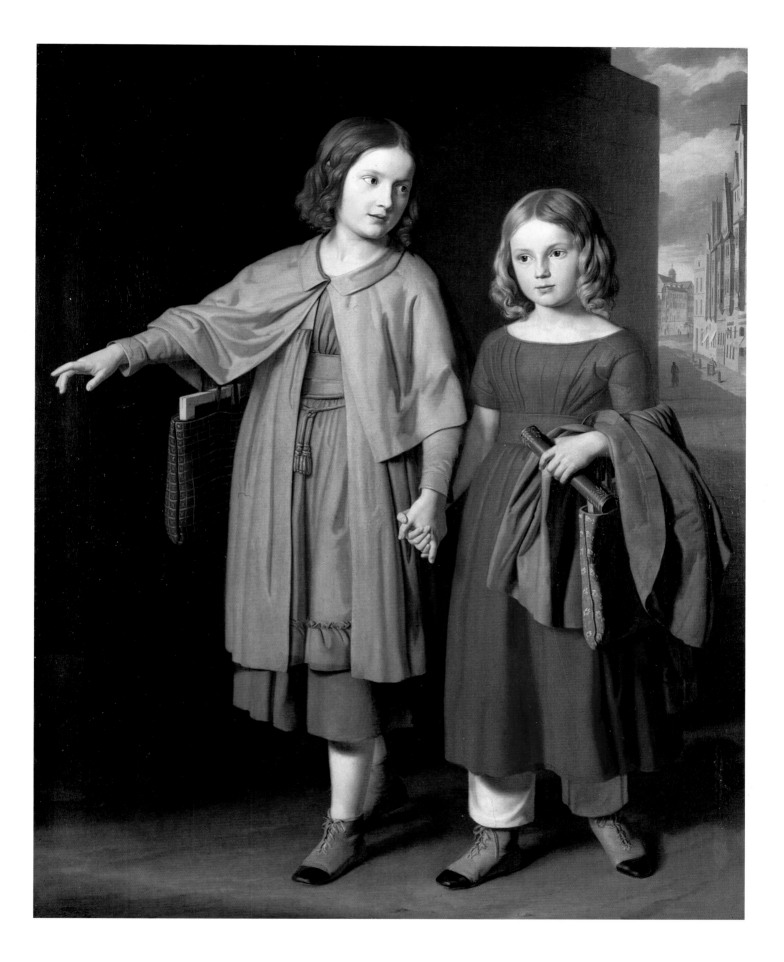

32 Carl Gustav Carus

1789–1869

Cemetery on Mount Oybin

1828

Oil on canvas, 67.5 x 52 cm
Unsigned
Inv. no. 1099

Provenance: acquired in 1917 from Charlotte Rietschel, the artist's great-granddaughter, in Zittau

Successful and active in many fields, Carl Gustav Carus embodies "the Romantic tendency toward the unity and integration of all the intellectual and cultural energies. His far-reaching talents make it difficult to consider his achievements as a painter and as a draftsman to the exclusion of his contribution in many other fields. For his work as an artist drew on the same sources of inspiration as did his philosophical, scientific, and art-historical research."[1]

Carus's early artistic work already testifies to a fresh response to reality and a sensitive treatment of landscape motifs. From the time he settled in Dresden until about 1828, the profound influence of Caspar David Friedrich's personality and work on Carus's own artistic production is quite evident. Until 1828, Carus produced numerous winter and evening landscapes depicting the ruins of monasteries and churches, or graves and cemeteries, in the manner of Friedrich. Because of his close contact with Friedrich, Carus evolved his own aesthetic, which he elaborated on in his *Nine Letters on Landscape Painting*, written between 1815 and 1824 and published in 1831. In these texts, he succeeded in establishing a thorough theoretical foundation and a literary justification for early Romantic landscape painting. Carus was concerned, above all, with conveying the "truth" of a landscape. Carus considered the principal task of landscape painting "the clear rendering and interpretation of any of the so endlessly various moods of life on earth."

The work in the Leipzig Museum is regarded as the high point of Carus's series of landscapes with ruins that the artist painted in the style of Caspar David Friedrich. This picture is so close to its revered model, in subject, composition, and technique that Grashoff, writing in 1926, deemed it typical of Friedrich in its "overall arrangement."[2] In fact, Grashoff ascribed it to this artist. Indeed, that has been the unwitting fate of many pictures by Carus.

While Carus usually consulted his landscape sketches to help create his paintings, here he did not make direct use of the drawings he had done on Mount Oybin in August 1820 while exploring the Riesenge-birge on foot. Among these was a drawing, *Ruined Monastery on Mount Oybin, the Window*, dated August 11, 1820,[3] and now in Dresden. The double window on the longer north side of the monastery building facing the west entrance to the church (where, according to Marianne Prause,[4] the window allowed light into the former two-story porch), rises above an openwork, first-floor window with an arched canopy. Carus viewed his motif from the steep slope running along the entire length of the north wall of the church. The cemetery itself was located along the north wall of the choir, thus allowing Carus to achieve in his painting an effective new combination of the architectural and the natural.

The picturesque ruin, located on Mount Oybin in the Lausitz Mountains, was the Gothic church of a former Celestine monastery. Around 1800, the ruin was "discovered" by many Romantic artists and writers, who recognized its potential as a highly attractive motif. Carus first saw the ruin in August 1820 during the aforementioned walking trip in which "Mount Oybin, with its extremely Romantic ruins, made a great impression on me and prompted me to make several drawings."[5] Carus subsequently produced three paintings based on this motif, all datable to approximately 1828.[6]

By combining the motif of the ruined building with the image of the partially snow-covered graves, Carus sought to intensify in a deeply emotional way his purely visual impression of the scene. The ruin and the graves here become symbols of transience, while the evergreen firs and the shoots of grass already breaking through the snow symbolize hope for renewal. However, the ruins denoting a remote era are of less significance to the viewer than the image of a calm and unchanging nature. According to Prause, the inclusion of the firs gives this landscape a certain magnificence, a silent dignity, and a calm, serious air—all of which establish a close connection with a contemporary work by Friedrich, *Early Snow*,[7] exhibited in 1828 alongside Carus's painting at the Dresden Academy of Art. DS

1 Hans Joachim Neidhadt, *Die Malerei der Romantik in Dresden* (Leipzig 1976), p. 111.
2 Gerda Grashoff, *Carus als Maler* (Ph.D. diss., Münster 1926), p. 28.
3 Marianne Prause, *Carl Gustav Carus. Leben und Werk* (West Berlin 1968), no. 297, p. 151, fig. on p. 150; Dresden, Staatliche Kunstsammlungen, Kupferstich-Kabinett, inv. no. C 1963–623.
4 Marianne Prause, "Carl Gustav Carus als Maler" (Ph.D. diss., Cologne 1963), p. 45.
5 Elmar Jansen, ed., *Carl Gustav Carus. Lebenserinnerungen und Denkwürdigkeiten* (Weimar 1966), vol. 1, pp. 248 ff.
6 See Prause, *Carus. Leben und Werk*, nos. 297–99, pp. 150 ff.
7 Hamburg, Hamburger Kunsthalle, inv. no. 1057.

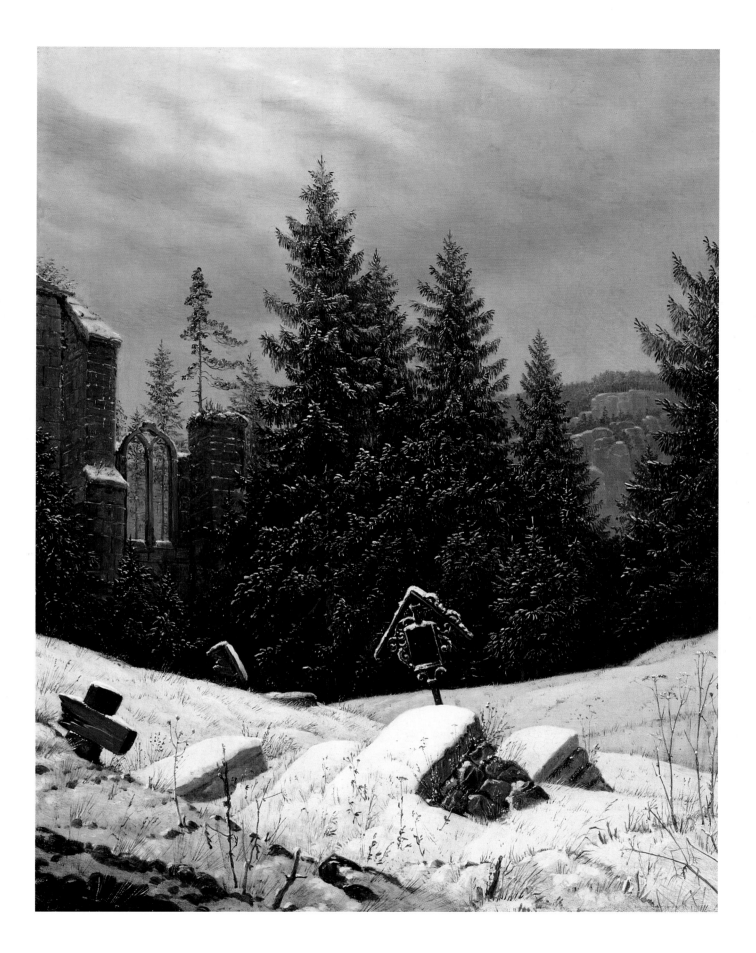

33 Carl Gustav Carus

1789–1869

Forest and Mountain Range

1834

Oil on board, 20.6 x 34 cm (mounted)
Dated on lower left: d 27 Sptb. 1834; on lower right: d 6t October 1834
Inv. no. I.3618

Provenance: formerly in the collection of Professor Felix Becker, Leipzig, who donated it
to the Graphische Sammlung of the Museum der bildenden Künste Leipzig in 1917

Carl Gustav Carus, in his *Letters on Landscape Painting* of 1831, defined "the main purpose of landscape art" as the "representation of a certain human mood (soul) through the reproduction of a corresponding mood in nature (reality)."[1] Influenced by Johann Wolfgang von Goethe's ideal of objective landscape art, Carus coined the term *"Erdlebenbilder"* (earth-life images) and in his seventh letter wrote: "The quietest spot in a forest, with its profuse vegetation, or the plainest grassy incline covered in delicate flowers, with a bluish horizon and a hazy blue sky arching overhead, offers the loveliest earth-life image that, be it small-scale or large-scale, leaves nothing to be desired–if only it is perceived by the soul."[2]

The small-format study titled *Forest and Mountain Range* is "perceived by the soul."[3] The level ground, the dense forest, the mountains, and the sky divide the landscape into four parallel sections. The mountain range appears to form a dividing line between heaven and earth – very much in the spirit of Caspar David Friedrich. Like him, Carus frequently dated his oil studies, as he did his drawings, with the date of

their composition. This might suggest that they were painted on the spot from nature as sketches to be used for later paintings.

Such compositions, often called "earth-life images," the term coined by Carus and used by him since 1826 in his "Letters on Earth Life," owed less to Romantic sensibilities than to a scientific understanding of landscape that, besides meteorological phenomena, concerned itself especially with geological observation. We can thus understand how the influence of the Norwegian Naturalist painter Johan Christian Clausen Dahl caused Carus, particularly in his oil studies, to move away from the allegorical Romantic landscape toward a holistic view of nature.

For Carus, too, the painted studies are a source of inspiration and, at the same time, are a medium that allow him, under the impression of light and air, to learn about nature. They sharpened his eye for reality, as is also shown by his studies of *Clouds* (see cat. no. 34) and *Tree with Clouds* as well as *Tree and Undergrowth*, all circa 1835, and in the inventory of the Graphische Sammlung of Leipzig's Museum der bildenden Künste.[4]

KM

1 Carl Gustav Carus, *Letters on Landscape Painting*. Before that, a letter from Goethe by way of introduction. Printed facsimile after 2ⁿᵈ reproduced edition of 1835, with a postscript by Dorothea Kuhn, Heidelberg 1972, p. 41.
2 Ibid., p. 119

3 Marianne Prause, *Carl Gustav Carus, Leben und Werk*, Berlin 1968, p.140, no. 235
4 Leipzig, Museum der bildenden Künste, Graphische Sammlung. Inventory number I. 3680, I. 3679, cf. Marianne Prause, as note 3, p. 171, no. 389; p. 170, no. 388

34 Carl Gustav Carus

1789–1869

Study of Clouds

c. 1835

Oil on cardboard, 16.1 x 21.7 cm (dimensions of support)
Unsigned
Inv. no. I. 3617

Provenance: in the collection of Professor Felix Becker, of Leipzig, who donated it to the Leipzig Museum in 1917

For the German Romantics, the image of the cloud was a symbol not only of the indeterminate and the chaotic, but also of desire for the infinite. Sketching or painting the sky also afforded an aesthetic pleasure in the phenomena of light and air. The sky offered an image of something that was indisputably alive and continually transforming.

This small oil study by Carl Gustav Carus, made around 1835,[1] shows a cumulus–nimbus formation. Despite the blue that shows through the white cloud mass, one has the overriding impression of these cloud forms hanging somewhat oppressively over the earth below. The brooding cumulus clouds both symbolize the unrestrained power of nature and serve as an objective and unprejudiced record of a meteorological occurrence. Such cloud studies by Carus encouraged his friend Johan Christian Clausen Dahl to produce his own. The often Realist character of Dahl's images is similar to the work of Carl Blechen and the early work of Adolf Menzel, and it anticipates the principles of plein-air painting.

German artists were introduced to a new, scientific theory of clouds in 1820 by Johann Wolfgang von Goethe in his epoch-making essay "The Cloud Forms According to Howard." Luke Howard, an English scientist and meteorologist, had attempted a systematic analysis and classification of the various forms assumed by clouds in his "Essay on the Modification of Clouds," published in 1803. Goethe learned of this text in 1815, although it did not become more widely known until 1818, when it was included in Howard's volume *The Climate of London*.

Howard distinguished between various basic types of cloud formations—cirrus, cumulus, stratus, and nimbus—each associated with a certain altitude and the related atmosphere. Goethe and Howard began to correspond with one another and an animated exchange of ideas was under way. In 1822, Howard sent Goethe (then in Weimar) an autobiographical sketch, which Goethe published. Goethe also dedicated to Howard a cycle of poems, published in 1820, which comprised verses titled "Stratus," "Cumulus," "Cirrus," and "Nimbus," framed by introductory and concluding poems called "The Atmosphere" and "Worthy of Note," respectively.

Goethe sought to persuade artists to record the cloud formations identified by Howard. He was unable to convince Caspar David Friedrich of the validity of this scientific categorization, this despite the profound symbolic importance, in Friedrich's work, of the sky, clouds, and mist. In 1821, however, Friedrich Preller the Elder did agree to provide Goethe with carefully finished "meteorological drawings" as formally commissioned.[2] Yet it appears that Goethe did not know of the depictions of clouds made by the two Dresden Romantic painters Carl Gustav Carus and Johan Christian Clausen Dahl, even though Goethe and Carus had maintained a regular correspondence since 1818 and the painter had visited Goethe in Weimar in 1821.

In 1831, Carus published his *Letters on Landscape Painting*, written between 1815 and 1824, and included a letter from Goethe of April 20, 1822, as its introduction. In the sixth of these letters Carus writes that "[since he] had carefully read Goethe's thoughts on cloud forms and then the beautiful poem [to Howard] in Goethe's third section on Science," he had found that "[new] thoughts [of his own] had been unlocked, which had given [him] new ideas and pointers for the representation of landscape and had newly revealed to [him] the 'secrets of the life of nature' and of 'the movement of the clouds and the shape of the mountains, the form of the trees and the waves of the sea' … Understood in this sense, art appears as the pinnacle of the sciences; in as far as it observes clearly and charmingly embraces the mysteries of science, it becomes, in the true sense of the word, mystical or, as Goethe has called it: orphic."[3]

KM

1 Marianne Prause, *Carl Gustav Carus. Leben und Werk* (West Berlin 1968), p. 175, no. 420.
2 Ina Weinrautner, *Friedrich Preller d.Ä. (1804–1878). Leben und Werk* (Münster 1997), p. 14.
3 Dorothea Kuhn, ed., *Carl Gustav Carus: Briefe über Landschaftsmalerei. Zuvor ein Brief von Goethe als Einleitung* (facsimile reprint of 2nd ed., of 1835, Heidelberg 1972), pp. 105–8.

36 Leo von Klenze

1784–1864

Italian Landscape

1829

Oil on canvas, 30.5 x 43 cm
Signed on the right: LvK [in the form of a monogram]
Inv. no. 1739

Provenance: in the collection of Maximilian Speck von Sternburg, in Lützschena; transferred to the Museum der bildenden Künste Leipzig in 1945 during the postwar process of nationalization; from 1996 in the Leipzig Museum collection as part of the Maximilian Speck von Sternburg Stiftung

Leo von Klenze, though trained as an architect, at an early age took a keen interest in painting. He acquired his first painting in 1817 and subsequently built up an extensive collection. Many of Klenze's paintings, widely praised for their quality, were acquired by King Ludwig I of Bavaria in 1841/42 for presentation to the Neue Pinakothek in Munich. Fifty-nine of the three hundred and twenty-one paintings in the first catalogue of this gallery collection came from Klenze's collection; these were exclusively the work of contemporary, and predominantly German, painters. Most were landscapes and genre scenes. Klenze was especially drawn to the work of Carl Wilhelm von Heideck and Carl Rottmann, both of whom he knew well.[1]

In 1815, Klenze took up painting in oils, having received some instruction from his friend Heideck. Between 1825 and 1863, Klenze produced seventy-eight paintings depicting landscapes, or views of cities and architectural motifs. His *Italian Landscape* of 1829 is one of his first works as a painter. In the catalogue of Klenze's paintings and drawings,[2] it is described as an "Imaginary Composition with Motifs from the Naples and Gaeta Region." In Klenze's own list of names and paintings, drawn up on the back of a pencil drawing,[3] the painting is designated as Speck Composition 5."[4]

A drawing in pencil and pen and ink, similar in size to the painting *Italian Landscape*, probably has a direct connection with it. Its format alone shows the drawing was made in Munich in 1829 as a model for a painting, on the basis of the smaller pencil sketches and studies that Klenze had made during his trip to Italy (including Naples) with Prince Ludwig in the winter of 1823. With the exception of minor alterations in the treatment of the figures—a fisherman replaces a goatherd and his flock—Klenze effectively transformed the drawing into a painting.

In its painterly execution, the *Italian Landscape* appears more sculptural and more compelling in spatial depth than the drawing. A telling contemporary commentary on Klenze's talents as a painter, and one which might have been written with the Leipzig painting in mind, is to be found in *Naglers Künstler-Lexikon* (1839): "Although he is only a dilettante in this sort of painting, he has achieved a truly astonishing degree of perfection in a very short time. Klenze is a sharp-eyed observer and he aims, above all, at achieving a truthful rendering of nature. His coloring is cheerful in mood and, in their overall effect, his pictures always achieve the loveliest sense of harmony. He also pays exemplary attention to detail."[5]

It is unclear whether Klenze's *Italian Landscape* was in fact commissioned by Maximilian Speck von Sternburg[6] or was intended as a gift to him. The two men, who became friends, met in 1828, when Ludwig I of Bavaria appointed Speck von Sternburg to collaborate on a scheme to help develop agriculture in Bavaria. Klenze, at the same time, became a member of the related association, the *Landwirtschaftliche Verein für Bayern*. SP

1 Norbert Lieb, "Der Architekt Klenze als Bildkünstler," in Norbert Lieb and Florian Hufnagel, *Leo von Klenze. Gemälde und Zeichnungen* (Munich 1979), pp. 35–59, especially pp. 35 ff.
2 *Leo von Klenze als Maler und Zeichner. 1784–1864* (exh. cat., Munich 1978), p. 53, no. G 2 with illustration; also p. 86, no. G 18 with illustration.

3 Munich, Bayerische Staatsbibliothek, Klenzeana 9, 13/47.
4 Oswald Hederer, *Leo von Klenze. Persönlichkeit und Werk* (Munich 1981), p. 416, no. 6, also p. 181, no. Z 170 a (verso).
5 G. K. Nagler, *Neues allgemeines Künstler-Lexikon oder Nachrichten von dem Leben und den Werken der Maler, Bildhauer, Baumeister, Kupferstecher, Form-

schneider, Lithographen, Zeichner, Medailleure, Elfenbeinarbeiter, etc.* (Munich 1839), vol. 7, p. 60.
6 On the art collection of Maximilian Speck von Sternburg, cf. *Maximilian Speck von Sternburg. Ein Europäer der Goethezeit als Kunstsammler* (exh. cat., Leipzig 1998); regarding the painting, pp. 387 ff., no. 1/174.

37 Ernst Ferdinand Oehme

1797–1855

Stolpen Castle

1830

Oil on canvas, 51.2 x 77.5 cm
Signed at the lower left: 18 EO [in the form of a monogram] 30
Inv. no. 2259

Provenance: in the possession of the Dresden art dealer Rusch in 1926; subsequently in the collection of Frau Lieberknecht, of Dresden; acquired in 1972 at a Leipzig auction

Prince Friedrich August of Saxony, Ernst Ferdinand Oehme's royal patron, in early 1825 wrote to the artist, who was at that time in Rome, to inform him that he had purchased a "small property" near Dresden and that he planned to decorate this with a "gallery of views of the homeland." The prince went on, "I should be delighted, my dear Oehme, to see some more of your work, and indeed to have you yourself back soon in our homeland, where you would certainly be greatly honored."[1]

Oehme obliged and, between 1827 and 1830, he painted several views of fortresses and castles in the region around Dresden, including *Scharfenberg Castle at Night* (1827),[2] *The Fortess of Hohnstein* (1827),[3] and *Colditz Castle* (1828).[4] Apparently, no record survives as to which pictures were intended exclusively for the royal gallery. In all probability, however, the view of *Stolpen Castle* in the Leipzig Museum[5] represents the last image in the commissioned series.[6]

The name "Stolpen," which is that of both the castle and of the nearby town lying between the Elbe-side "Saxon Switzerland" and the slopes of the Lausitz Mountains, is derived from the old Sorbish term *stolpy* (pillars). Around thirty million years ago, basalt lava, as it cooled, formed into four- to eight-sided pillars. In the twelfth century, to protect the salt route that linked the city of Halle with Bohemia, a fortress was erected on the basalt cupola formation.

The castle, indeed, has a colorful history, surviving to this day as a picturesque ruin. Before its destruction, both the bishops of Meissen and the princes of the House of Wettin had used it as a state prison. The prison achieved a dubious celebrity in the eighteenth century for its most famous inmate, Countess Cosel. Anna Konstanze Countess von Brockdorff (who from 1706 was allowed to assume the title Cosel, that

of the ruling family in the former Duchy of Oppeln in Silesia) was divorced from the Saxon Councillor and Cabinet Minister, the Freiherr von Hoym and, in 1705, became the mistress of the Saxon king August the Strong. In 1712, August the Strong lost power, but from 1716 he held his former lover captive in the fortress. She was forced to endure a twenty-eight-year imprisonment in the stately quarters of the Arsenal and an additional twenty-one-year sentence (until her death) in the Johannis Tower (or "Cosel Tower").

Oehme shows the view from the west looking up to the fortress at some distance, and fills the extensive foreground with *staffage*; a painstakingly rendered half-timbered house leads the eye into the middle distance and a cloud-filled sky hovers over the whole. Although not correctly rendered in terms of perspective, and with distant passages characterized by outlines that appear too blurred, Oehme's picture clearly indicates the ruins of the seven-pointed tower to the left, and next to it the Seiger Tower, then on the right the "Cosel Tower."

It may well have been patriotic pride and, in particular, the early-nineteenth-century Romantic enthusiasm for the architectural monuments of the Middle Ages, that inspired Friedrich August to commission Oehme and several other Dresden artists to provide suitable architectural views to decorate his gallery.

Oehme's painting in the Leipzig Museum is distinct from the aforementioned pictures in the series commissioned by Friedrich August. It is evident here that Oehme was concerned less with providing a view of Stolpen Castle that was accurate in every detail and more with capturing the characteristic features of the landscape of Saxony and in rendering these in a manner true to the spirit of Romanticism. SP

1 "Brief des Prinzen Friedrich August von Sachsen an Ernst Ferdinand Oehme in Rom, Dresden 9. März 1825," in *Dresdner Geschichtsblätter 8, no. 4 (1899)*, pp. 212 ff.
2 Ulrich Bischoff, ed., *Ernst Ferdinand Oehme. 1797–1855. Ein Landschaftsmaler der Romantik. Ausstellung zum 200. Geburtstag des Künstlers* (exh.

cat., Dresden 1997), cat. no. 9, p. 75 with colorplate; cat. raisonné no. 59, p. 187 with illustration.
3 See Bischoff, ed., cat. 8, p. 74 with colorplate; cat. raisonné no. 63, p. 188 with illustration.
4 See Bischoff, ed., cat. 10, p. 76 with colorplate, cat. raisonné no. 69, p. 188 with illustration.

5 See Bischoff, ed., cat. raisonné no. 87, p. 192 with illustration.
6 On the "gallery of views of the homeland," cf. Hans Joachim Neidhardt, "Ernst Ferdinand Oehme—Leben und Werk," in Bischoff, pp. 9–25, in particular p. 17.

1797–1855

Mountainous Landscape with a Group of Trees and a Chapel, with the Borschen in the Background (An Autumn Afternoon near Bilin in Bohemia)

1842

Oil on canvas, 77 x 109 cm
Signed at the lower left: E.Oehme./1842
Inv. no. 1932

Provenance: entered the collection of the House of Wettin in 1842; subsequently in the collection of S. Pfeifer, in Grosspösna, from whom it was acquired in 1964

Ernst Ferdinand Oehme formed a lifelong friendship with Adrian Ludwig Richter. They had met in Dresden when they were both training as artists there. Later, in Rome, their relationship grew in strength and intimacy as they discovered their mutual interest in issues related to religion and art. When Richter returned to Dresden in 1836 after seven years in Meissen, the two artists and their respective families became neighbors. From 1838 to 1842, they all lived in the same house, Vor dem Löbtauer Schlag 1. Richter wrote of the friendship in his memoirs: "Given such spatial proximity between Oehme and me, our shared concerns and the artistic exchange that took place as we worked only increased. If either one of us came upon any aspect of his picture that presented difficulties, he immediately called his neighbor over and the matter would be discussed and, whenever possible, resolved."[1]

The two friends set off with Carl Peschel on extended walking tours in the mountainous country around Dresden. They visited the Erzgebirge, the Harz Mountains, and the central ranges of northern Bohemia—with much enthusiasm. These destinations provided the artists with an endless supply of landscape motifs. In all probability, Richter led the way in the artistic "discovery" of Bohemia's landscape for this trio. Richter's Bohemian trip in 1834 had already influenced his treatment of the landscape there (cf. plate 25).

Oehme and Peschel keenly followed Richter's lead and the group continued to explore the region. In the spring and autumn of 1841, they made two trips together. One of these took them via Milleschauer (now Milesovka, Czech Republic), Bilin (now Bílina), Dux (Duchcov), Mariaschnee (Bohosudov), Graupen (Krupka), Peterswald (Petrovice u

Chabarovic), and Aussig (Ústí nad Labem). Numerous surviving studies by all three artists document this route.

As a result of this trip, Oehme painted Mountainous Landscape with a Group of Trees and a Chapel, with the Borschen in the Background.[2] The work reflects the strong influence on Oehme of Richter's late Romantic approach to the rendering of landscape. Here, Oehme has evidently drawn on both the thematic and the stylistic character of Richter's mature work. In terms of composition, Richter's influence is especially clear if one compares Oehme's painting with Richter's Church of Saint Anna at Graupen (1836)[3] and Evening Prayers (1841, cf. plate 26).[4] Rising ground with a magnificent group of trees and a chapel dominate the middle distance. This combination provides a reassuringly natural "stage set" for the activities of several groups of Bohemian country people, who are shown peacefully reclining by the spring in the foreground or are gathered for prayer at the chapel.

According to Karl-Ludwig Hoch, the model for the chapel painted by Oehme was Saint Blasius (Sv. Blazej) near Luschitz (Luzice). It is possible that a signed and rather painterly watercolor, now in a private collection in Dresden, was made in preparation for Oehme's composition in oils, although this may have been intended as an autonomous work made after the painting.[5] The Borschen (or Boren) visible in the right background lies near the town of Bilin (Bílina); it was renowned as a spa because of its alkaline mineral springs. It had been drawn by Johann Wolfgang von Goethe, but was also a motif much favored by Caspar David Friedrich and Adrian Ludwig Richter. It became known as the "Lion of Bilin" for its unusual form that resembled a reclining lion. SP

1 Heinrich Richter, ed., Lebenserinnerungen eines deutschen Malers. Selbstbiographie nebst Tagebuchaufzeichnungen und Briefen von Ludwig Richter (10th ed., Frankfurt am Main 1901), p. 33.
2 Ulrich Bischoff, ed., Ernst Ferdinand Oehme. 1797–1855. Ein Landschaftsmaler der Romatik. Ausstellung zum 200. Geburtstag des Künstlers

(exh. cat., Dresden 1977), cat. no. 32, p. 98, with colorplate; cat. raisonné no. 191, p. 207 with illustration.
3 Karl Josef Friedrich, Die Gemälde Ludwig Richters (Berlin 1937), text vol. no. 52, p. 56; illustration vol. fig. 81, p. 51; Hanover, Niedersächsisches Landesmuseum.

4 See Friedrich, text vol. no. 66, p. 63; illustration vol. fig. 102, p. 62; Leipzig, Museum der bildenden Künste.
5 Cf. Bischoff, ed., cat. no. 80, p. 148 with colorplate; cat. raisonné no. 176, p. 205 with illustration.

39 Carl Blechen
1798–1840

Valley with a Mill near Amalfi

c. 1831

Oil on canvas, 109 x 77.5 cm
Unsigned
Inv. no. 1257

Provenance: 1911 Count Georg Rothkirch of Schildau a. Bober; 1929 Paul Graupe,
Berlin; 1935 art dealer Carl Nicolai, Berlin; acquired from the art dealer Carl Nicolai,
Berlin, with funds from the *Kunstverein* (Art Association) of Leipzig among others

The conception of his painting *Valley with a Mill near Amalfi* dates from Blechen's stay in Naples during his yearlong sojourn in Italy, but it was painted following his return to Berlin.[1]

Italy intrigued Blechen not for its treasures of classical antiquity but rather for its brilliant light. His trip there led him to experiment with sketching outdoors, not only in pencil, but also in oil. The sketchbook from Amalfi, in particular, which comprises studies for the *Valley with a Mill near Amalfi*, earned Blechen a place among the precursors and founders of plein-air painting in German art.[2] Blechen placed the paper mill, a rather plain functional building, at the very center of his composition, surrounding it by a much more imposing building on the left, perhaps a palace, and a steep hill on the right. In the distant background, stark mountains tower over the valley. Slowly the eye is led up the trickling stream toward the ruin of a bridge just below the mill itself. This stepwise progression counteracts a visual rush to the main focus of the brightly lit mill. Two small figures in the foreground constitute a picturesque addition appropriate to the rural setting, whereas the tiny figures near the buttresses of the palace, dwarfed by the huge building and bent over by their labor, symbolize the forces of industry. While the former treatment has a long tradition in landscape painting, the introduction of industrial activities is a new theme in the early nineteenth century, and Blechen is one of the first to focus on it.

The emphatic symmetry of the composition with its central axis projecting deeply into the background elevates what would otherwise be a merely picturesque rendition of an early industrial landscape into something sublime.[3] Blechen expresses the contrast of opposing forces in shaded and sunlit passages, as well as in the choice of warm colors for the architectural structures and cool blues and greens for the natural elements. His flair for the dramatic raises this rigidly composed scene above the ordinary while his unflinching realistic rendition anchors it in time and space. HKA

1 There are slight discrepancies in the dating of this painting. In Herwig Guratzsch, ed., *Museum der Bildenden Künste Leipzig, Katalog der Gemälde* (Stuttgart: Verlag Gerd Hatje, 1995), p. 20, it is dated c. 1830, while Peter-Klaus Schuster dates it c. 1831 in Peter-Klaus Schuster, *Carl Blechen, Zwischen Romantik und Realismus*, exh. cat. (München: Prestel, 1990), p. 18. Hans Joachim Neidhardt is less specific in suggesting 1830/35 in Hans Joachim Neidhardt, *Deutsche Malerei des 19. Jahrhunderts* (Leipzig: Seemann, 1997), p. 115.
2 Schuster, *Carl Blechen, Zwischen Romantik und Realismus*, p. 17, and Neidhardt, *Deutsche Malerei im 19. Jahrhundert*, p. 115.
3 Schuster, *Carl Blechen, Zwischen Romantik und Realismus*, pp. 18–19.

40 Domenico Quaglio II

1786–1837

Reims Cathedral

1833

Oil on canvas, 74.5 x 94.5 cm
Signed at the lower left: Domenico Quaglio fec./Monachii 1833.
Inv. no. 732

Provenance: acquired from the artist by Friedrich Karl Hermann von Lucanus
(there are many references to the painting being in his possession) on behalf of Baron
Minigerode, in Halberstadt;[1] in 1896 acquired by the Leipzig Museum through the
bequest of Dr. Theodor Mahlmann, of Halberstadt

Trained as a painter of theatrical sets, Domenico Quaglio was also drawn to Medieval architecture. Considered the most important Munich painter of city views in the first half of the nineteenth century, he brought this art to its height in the Biedermeier Era (1815–48). His achievement was matched only by that of the Berlin painter Eduard Gärtner. Quaglio was also one of the first German painters for whom the architecture of the Middle Ages became the most important subject in its own right.

In the 1820s, Domenico Quaglio made numerous study trips to various parts of Germany and German-Austria (Bavaria, Swabia, Franconia, the Tyrol, the Salzkammergut, and the valleys of the Rhine, the Lahn, and the Mosel), and to France and Italy. During these travels, he would sketch the most famous architectural monuments, and consequently, he amassed an enormous store of motifs. On his return to his studio, he would translate these studies into paintings of architectural subjects. Like the views painted by the Venetian Bernardo Bellotto, these works were above all striking for their extremely varied interplay of light and shade, and their vast wealth of detail. Domenico Quaglio's paintings, serving as documents of architectural history, are of outstanding interest to students of art history.

In his predilection for choosing Gothic-style architecture and Medieval buildings as the subject matter of his paintings, Domenico Quaglio is recognizably a Romantic. By exaggerating the height of structures that were already vertical and by adopting a slightly raised viewing position, Quaglio achieves unusual perspective effects that heighten the overall impact of the depicted motifs. Quaglio's paintings are also characterized by his extremely refined oil technique, his carefully calculated lighting effects, and the harmonic interplay of architecture and *staffage*.

Quaglio frequently painted the cathedral in the northwestern French town of Reims, to which his attention had first been drawn in 1825 during a trip to France. Many Munich painters traveled there at that time to see the ceremonies marking the coronation of King Charles X. Quaglio recorded the Reims Cathedral from the southwest in a pencil-and-wash drawing and in two paintings in 1826–27.[2] This painting (1833), his last rendering of the cathedral, differs from earlier compositions in the treatment of the staffage and of the surrounding buildings. The composition is dominated by the cathedral's west facade. The Cathedral of Nôtre-Dame at Reims had come to be recognized as the epitome of "classical" perfection among examples of Gothic architecture. Its west facade is especially striking for the harmony of its parts and their stylistic unity, even though these were added over a very long period, from approximately 1250–55 until the third quarter of the fifteenth century. Quaglio's painting makes very clear the vertical tripartite division of the facade into a lower zone (with the large doors and their rich sculptural decoration), a central zone (with the great Rose Window), and an upper zone (with its clearly delineated gallery of statues, the *galerie des rois*).

Quaglio's particular interest in the Reims Cathedral may have been due to productions of Friedrich Schiller's play about Joan of Arc, the *Jungfrau von Orléans*,[3] where the fourth act closes with King Charles VII leading Joan to her coronation in front of the cathedral. The set requirements for staging this scene would certainly have been familiar to an experienced theatrical painter such as Quaglio. DS

1 Brigitte Trost, *Domenico Quaglio. 1787–1837. Monographie und Werkverzeichnis* (Munich 1973), no. 204, p. 139.
2 See Trost, no. 144, p. 130, fig. 227 (c. 1825; Munich, Staatliche Graphische Sammlung, inv. no. 886), no. 145a, p. 130 (1826; private collection in Bavaria; lithograph version made by Simon Quaglio in 1827); no. 145b, pp. 130ff. (1827;

former collection of Dr. Spieker, in Berlin, now in a private collection in Bavaria).
3 Schiller's Romantic tragedy was, incidentally, performed in Leipzig, on September 11, 1801. According to Trost, Simon Quaglio designed and painted the set for a production of the play that took place in 1825; he may well have referred, in making his designs, to the drawing completed shortly before by his brother; cf. Trost, p. 60.

41 Heinrich Bürkel

1802–1869

Mountain Village (Morning in a Tyrolean Village)

1834

Oil on canvas, 60 x 57.5 cm
Signed: HB [intertwined] ÜRKEL/1834
Inv. no. 22

Provenance: included in 1835 in the exhibition of the Dresden *Kunstverein*,[1] where it was raffled and acquired by Herr Conrektor Lochman, of Zittau; given to the Leipzig Museum in 1859 by Carl Lampe, of Leipzig

For Christian Schuchard, the first director of the Leipzig Museum, "the interest of his [Bürkel's] pictures [lies in their] animated, spirited character and treatment, the freshness of their coloring and their pleasant sense of airiness …" And in this particular painting he found a "very good" rendering of the "freshness of the morning," observing that "the cattle, drawn and painted in a beautiful and animated fashion, create the perfect mood of village life in the mountains."[2]

Bürkel's extensive oeuvre is dominated by such scenes of landscape and rural life in Bavaria and the Tyrol. This world became Bürkel's favorite subject and the various motifs that he employed in his work were discussed during the course of extended walking tours he took through the Alps with like-minded painters. In conscious opposition to the academic art of the time, Peter von Hess, Lorenzo Quaglio II, Johann Adam Klein, and Heinrich Bürkel paved the way in the Munich art world for genre painting.

Bürkel made an intense study of seventeenth-century Dutch painting, making copies in the Schleissheim gallery of works by, for example, Philips Wouwerman, landscapes by Jan Wynants, Jacob Issacksz. van Ruisdael, Lodewyck de Vadder, and Herman Saftleven, and of figure paintings by Adriaen Brouwer and Adriaen van de Velde.[3] Also important to Bürkel were works by his contemporary Peter von Hess, in as far as these superbly achieved the unity of atmosphere and mood in both

landscape and figures to which Bürkel aspired and that he eventually brought to perfection. As a landscape painter, Bürkel was above all interested in representations of the seasons, in particular, winter.

The rapid spread of rural genre painting is explained by the popularity of the village novel, which reached its peak between 1830 and 1850. Bürkel had read the novels of Jeremias Gotthelf and Karl Leberecht Immermann, who wrote of the connection between man and nature in a manner recalling the writings of Adalbert Stifter. Even if Bürkel's paintings largely showed an idyllic world, often filled with humorously cheerful or robustly comic incidents—a world that had in fact already virtually ceased to exist by the 1830s—he, like his fellow rural genre painters, was nonetheless dedicated to recording and developing typical features of rural life.

After its first public presentation, in 1834 at the exhibition of the Munich *Kunstverein*, the Leipzig picture[4] was shown the following year at the Dresden *Kunstverein* as "Morning in the Mountains, View from a Side Valley near Kufstein" and an engraved copy was made by Adolf Honeck.[5] A small version of the painting, made in 1839, is now in a private collection.[6] Here, the already slightly altered group of the old cowherd with his dog and cattle was again used by Bürkel in his painting of 1840, *Mountain Village with a Fountain*,[7] and the motif of cowherd and dog alone is seen in his *Farmhouse in the Mountains with a Fountain*.[8]

DS

1 A list of the works of art on display at the Dresden Academy of Art from August 2, 1835, is found in the catalogue published in Dresden in 1835; Bürkel's picture is cat. no. 412.
2 Christian Schuchard, *Catalog der Kunstwerke im Museum zu Leipzig. Nebst biographischen Mittheilungen über die Künstler* (Leipzig 1857), pp. 17ff.
3 Hans-Peter Bühler and Albrecht Krückl, *Heinrich Bürkel mit Werkverzeichnis der Gemälde* (Munich 1989), p. 28.

4 See Bühler and Krückl, no, 194, p. 246 with illustration on p. 327.
5 *Bilderchronik des Sächsischen Kunstvereins* (no loc., n.d.), illustration (engraving by Honeck entitled *Der Gebirgsmorgen [Morning in the Mountains]*). The reference here, in all probability, is to the Dresden painter and printmaker Adolf Hohneck (Hoheneck). According to Friedrich von Boetticher, *Malerwerke des neunzehnten Jahrhunderts. Beitrag zur Kunstgeschichte* vol. 1 (reprint of the first edition, of

1891–1901, Frankfurt am Main 1948), no. 8, p. 156 (erroneously dated 1831), a lithograph of one of the versions was made by the Munich lithographer, etcher, and painter Friedrich Hohe. According to Luigi von Buerkel, *Heinrich Bürkel. 1802–1869. Ein Malerleben der Biedermeierzeit [...]* (Munich 1940), no. 129, p. 132, Hohe made a lithograph of the painting now in the Leipzig Museum.
6 Cf. Bühler and Krückl, no. 195, p. 246 with illustration. It is possible that this picture is identical

to the raffled painting acquired by the painter Hohlweg (whom we may presume to be the Munich landscape painter Georg Hohlweg). On this point, see von Boetticher, no. 128, p. 132.
7 This picture is now in a private collection; cf. Bühler and Krückl, no. 196, p. 246 with illustration.
8 This picture, datable to approximately 1840, is now in a private collection. See Bühler and Krückl, no. 197, p. 246.

42 Carl Christian Vogel von Vogelstein

1788–1868

Ludwig Tieck sitting to the Portrait Sculptor David d'Angers

1834

Oil on canvas, 88.3 x 94.5 cm
Signed within the composition at the lower right on the side of the platform:
C. Vogel pinx. Dresden 1834
Inv. no. 475

Provenance: given to the Leipzig Museum in 1873 by the Leipzig publisher
Heinrich Brockhaus

It must have been an occasion of some social significance when the French sculptor David d'Angers paid a visit to Dresden in 1834. The sculptor's visit was still recalled quite clearly in the memoirs of the physician, scientist, and painter Carl Gustav Carus, who between 1824 and 1842 had regularly attended the celebrated readings given by the renowned Ludwig Tieck at his house on the Old Market in Dresden. D'Angers arrived to make a bust of the writer, theorist, and translator Tieck, who (with the exception of Friedrich Leopold Freiherr von Hardenberg, called Novalis) is considered the most outstandng and influential poet and personality of the German Romantic movement. The sitting began on October 28, 1834, in the studio of the painter Carl Christian Vogel von Vogelstein in the inn called the "Italian Village" (now Theaterplatz).

The protagonists in the depicted scene are Tieck himself and his daughter Dorothea, who is shown endeavoring to entertain the patient poet by reading to him. On the death of Dorothea Tieck, the painter wrote: "I am now very glad that I have been able to preserve her image for posterity, by including her portrait in the three repeated versions of my painting that show my studio, each time painting her from life and striving for an ever truer likeness."[1]

In addition to the two artists, shown working alongside each other (they had met during Vogel's visit to Paris), several leading figures in the intellectual and cultural life of Dresden are included in the painting. Wolf Heinrich Count Baudissin, resident in Dresden from 1827, was a friend of Ludwig Tieck and his daughter, and collaborated with her on the German translation of thirteen Shakespeare plays. The archaeologist Otto Magnus Freiherr von Stackelberg had attended the Dresden Academy of Art for a while and often kept company with both Count Baudissin and Vogel von Vogelstein. The physician and painter Carl Gustav Carus had been based in Dresden since 1814 and had met Vogel von Vogelstein when the latter was executing painted decorations at Pillnitz Castle (see cat. nos. 32, 33, 34). Vogel also added his son (Johannes Vogel, born in 1827) to the assembled group.

The picture in the Leipzig Museum successfully combines a number of established genres: the artist's self-portrait (with the painter or sculptor shown at work in his studio), the portrait of the artist, and the group portrait. More specifically, the work offers an attractive late Romantic record of a particular circle of friends in Dresden. In his copies of 1835 and 1836, moreover, the artist both enlarged and altered the depicted group. The version painted for a Mr. Sudienko in Kiev, for example, includes the figures of Carl August Böttinger, the archaeologist and writer on art; Carl Förster, the translator of Tasso, Dante, and Petrarch; and the novelist Baron von Ungern-Sternburg. In a version later entering the collection of Prince Johann Georg of Saxony, the figure of Carus is replaced by that of the engraver Moritz Steinla.[2] A large-scale sepia drawing of 1836 for the second of these copies is now in the Angers Museum.

Also of note is the decoration of the studio shown in the painting, which is both characteristic of the early- to mid-Biedermeier era and full of allusions to Vogel's artistic connection with the German painters of the Nazarene Circle in Rome. The copy of the Raphael self-portrait that hangs above the door signals Vogel's reverence for this Italian master. Leaning against the wall beside the door is the cartoon for Vogel's ceiling painting of the Ascension for the chapel of Pillnitz Castle near Dresden. In the window casement is a small bronze statuette after Peter Vischer's self-portrait on the grave of Saint Sebald in the church of that name in Nuremberg; and the medallion hanging below this might well be the portrait of Vogel von Vogelstein modeled by David d'Angers; a bronze medallion of this sort, dated 1830, in addition to a portrait bust of the painter, dated 1834, are also now in the Angers Museum. The marble bust of Ludwig Tieck made after the plaster version seen in the painting was completed in 1836 and soon thereafter dispatched to its admired model in Dresden.[3] DS

1 Cited in Rainer Richter, ed., Carl Christian Vogel von Vogelstein. 1788–1868. Eine Ausstellung zum 200. Geburtstag (exh. cat., Dresden 1988), p. 41.
2 Frankfurt am Main, Freies Deutsches Hoch-stift, Frankfurter Goethe-Museum, on loan since 1967 from the Federal Republic of Germany.
3 Dresden, Sächsische Landesbibliothek, inv. no. A.Tr.-A. 2.2.

43 Johann Christian Michael Ezdorf

1801–1851

The Cliffs of Magerøy Island in Norway

1836

Oil on canvas, 71 x 90 cm
Signed within the composition at the lower left on a rock: C. Ezdorf 1836
Inv. no. 80

Provenance: presumably acquired by the Saxon artists' association, the *Kunstverein*, in 1836; subsequently in the collection of E. A. Weinspach, in Pirna;[1] in 1849 donated to the Leipzig Museum by Hermann Härtel, of Leipzig

"A great rock with seagulls swarming all around it and with several smaller rocks at its base; to the right a piece of shore with a few seals reclining upon it; the sky is covered with tattered fragments of cloud. The solemn air of this subject and of the artist's approach to it, the calm, clear tonality and the superb painterly treatment come together here to achieve the precise mood intended by the artist."[2] This early description and evaluation of the painting was written by the former director of the Leipzig Museum, Christian Schuchard. The precision in Ezdorf's rendering of detail led "even mineralogists to take a scientific interest [in his work]"[3]—and the painting in the Leipzig Museum is no exception. At the center of the composition stands the North Cape, a rocky outcrop on the north of the Norwegian island of Magerøy, rising to three hundred and seven meters with a steep drop to the North Sea. This is generally regarded as the northernmost point of Europe. Ezdorf's picture was engraved by Wilhelm Witthöft for the Saxon artists' association, the *Kunstverein*, on the occasion of its exhibition in Dresden.[4]

Ezdorf was an artist who, in his lifetime, acquired a certain celebrity because of his somber, sometimes melancholic landscapes but who was thereafter swiftly forgotten. He made detailed landscape studies during walking tours in the Tyrol and the Bavarian Alps, and these studies enabled him to render splendid natural settings imbued with the effects of dramatic weather conditions. Soon established as a "specialist" in such scenes, he thus belonged to the particular group among Munich landscape painters who concentrated on a specific type of subject. His commitment to his own "speciality" was further strengthened by studying the work of seventeenth-century Dutch masters, primarily of Jacob Isaacksz. van Ruisdael and of Albert van Everdingen. Ezdorf was praised as the latter's "true and inspired pupil" by a contemporary commentator on the public exhibition of his painting *A Hammersmith in Sweden* (1835).[5]

In addition to painting Norwegian and other Scandinavian subjects, Ezdorf also specialized in rendering waterfalls; he was recognized as the most important "waterfall painter" active in Munich.[6] Ezdorf traveled to Scandinavia to experience nature in all its raw, unspoiled reality, and to be able to record this on the spot. Contemporaries revered his "deep and penetrating study of nature and his outstanding skill"[7] and responded enthusiastically to his landscapes rendered "with a fine feeling for nature."[8] "The paintings appear to depict entirely those [mythical] regions that were home to Ossian's heroes: the strangely jagged, mist-shrouded rocks, the sense of an atmosphere that is damp and heavy, and the solemnity that pervades the whole could well be the setting for [the tales of] those island kings."[9]

DS

1 Cf. Friedrich von Boetticher, *Malerwerke des neunzehnten Jahrhunderts. Beitrag zur Kunstgeschichte*, vol 1/1 (reprint of the first ed., of 1891–1901, Leipzig 1948), no. 5, p. 300.
2 Christian Schuchard, *Catalog der Kunstwerken im Museum zu Leipzig. Nebst biographischen Mittheilungen über die Künstler* (Leipzig 1857), p. 51.
3 See Schuchard, p. 51.
4 *Bilderchronik des Sächsischen Kunstvereins* (n. loc.

n.d.), unpaginated, unnumbered fig. entitled *Meeresufer auf der Insel Magaron* [Sea Coast of Magaron Island]; engraving by Witthöft.
5 Munich, Bayerische Staatsgemäldesammlungen, Neue Pinakothek, inv. no. WAF 252; see Barbara Eschenburg, ed., *Spätromantik und Realismus: Gemäldekataloge der Bayerischen Staatsgemäldesammlungen, Neue Pinakothek, München*, vol. 5 (Munich 1984), pp. 134ff., fig. on p. 134.

6 Siegfried Wichmann, *Münchner Landschaftsmaler im 19. Jahrhundert. Meister, Schüler, Themen* (Weyarn n.d.), p. 147.
7 Cf. "Kunstverein in München (Beschluss)," in Ludwig Schorn, ed., *Kunst-Blatt* 16/89 (November 5, 1835), p. 367.
8 Co., Hamburg, June 4, 1837, in Schorn, p. 286.
9 Söltl, *Die bildende Kunst in München* (Munich 1844), pp. 295ff.

44 Wilhelm Joseph Heine

1813–1839

*A Service at the Penitentiary Church
(Criminals at Church)*

1837
Oil on canvas, 76.5 x 105.5 cm
Signed within the composition on the pew at the lower right: W. Heine 1837
Inv. no. 105

Provenance: acquired in 1837 through the Leipzig *Kunstverein*

In the early nineteenth century, Düsseldorf evolved into a prominent art center in Europe. In close connection with the Düsseldorf Academy (founded in 1773 and reformed in the 1820s), the *Kunstverein* (established in 1829), and the other artists' association, the *Malkasten* (founded in 1848), a major artistic circle emerged; its practitioners subscribed to the "Düsseldorf School of Painting." Under the leadership of Peter von Cornelius, the Düsseldorf Academy became a bastion of Nazarene ideals and Romantic tendencies and championed large-scale murals as the most significant works that an artist could produce. After Wilhelm von Schadow was appointed director in 1826, the institution's emphasis shifted to easel painting and to Realistic painting. Düsseldorf artists now embraced not only genre and landscape painting but also subjects drawn from recent history, all of these taking into account a new level of self-awareness among the bourgeoisie. Increasingly, an emphasis on emotion, closeness to nature, and a commitment to the importance of color were the key principles. A socially critical strain also emerged among Düsseldorf painters. This aspect of their work aroused considerable comment and criticism well into the early twentieth century.

Wilhelm Joseph Heine is considered one of the most important representatives of the Düsseldorf painters. His much discussed and diversely interpreted key work, *A Service at the Penitentiary Church (Criminals at Church)*, was painted in 1837. The dispute provoked by this painting[1] first developed in 1839, when Hermann Püttmann, in an essay on the Düsseldorf School of Painting, gave Heine's picture the title *Criminals at the Penitentiary Church* and, in his catalogue, called it *Service at the Penitentiary Church*.[2] It is not known for certain whether Püttmann consulted the artist when drawing up his list of works. In 1837, the year in which it was painted, *A Service at the Penitentiary Church* was presented at the first annual exhibition of the Leipzig Kunstverein as *Criminals at Church*, and it was acquired as such for the collection of the future city museum. In 1838, the Leipzig Kunstverein commissioned Franz Seraph Hamfstaengl to make a lithographic copy of the painting, with the same title; this work was intended as a gift for the Kunstverein's members. Over the following years, writers referred to the painting using an increasing variety of titles.[3] The debate was again sparked in the 1980s when Wolfgang Hütt, alluding to the assumed original title, *A Service at the Penitentiary Church*, published an interpretation of Heine's image as a direct political witness to the German art of the *Vormärz* period (prior to the abortive German "Revolution" of March 1848).[4] Hütt related the painting specifically to the death of the priest from Hesse, Friedrich Ludwig Weidig, who had lost his life under mysterious circumstances while held for investigation at the Darmstadt penitentiary in 1837.[5]

Both the dazzling characterization of individual figures and the extraordinarily refined coloring qualify this painting as a true masterpiece of this young and highly gifted artist. What remains to be established is whether the painting was intended to refer directly to a specific political event.

A group of very individualized male figures beneath the gallery may be understood as representing the politically oppressed—liberal citizens, members of students' associations, and artisans. One cannot dispute that, in this work, Heine addressed a very explosive subject, for its resonance struck a resounding chord among Heine's contemporaries. Further evidence of this controversy can be found in the painted replica of 1838, now in the Nationalgalerie, Berlin,[6] and in the smaller painted version in the Kunstmuseum, Düsseldorf.[7] SP

1 Cf. Karsten Hommel, *Die Gaben des Leipziger Kunstvereins an seine Mitglieder 1838–1868* (M.A. diss., Berlin 1994), pp. 81–85.
2 Hermann Püttmann, *Die Düsseldorfer Malerschule und ihre Leistung seit der Errichtung des Kunstvereines im Jahre 1829. Ein Beitrag zur modernen Kunstgeschichte* (Leipzig 1839), pp. 154, 176.
3 Cf. Dieter Gleisberg, "Zwischen Progress und Konvention," in *150 Jahre Sammeln Zeitgenössischer Kunst. 150 Jahre Museum der bildenden Künste Leipzig. 1837–1987* (exh. cat., Leipzig 1987), pp. 5–16, particularly p. 16, note 4.
4 Wolfgang Hütt, *Die Düsseldorfer Malerschule* (Leipzig 1984), pp. 192 ff., fig. 152 on p. 221; also Hütt, *Die Düsseldorfer Malerschule 1819–1869* (Leipzig 1995), pp. 167 ff. and fig. 92 on p. 134.
5 Cf. Gleisberg, p. 8. On the life of Weidig and his trial, cf. Wilhelm Schulz, ed., *Der Tod des Pfarrers Dr Friedrich Ludwig Weidig. Ein actenmässiger und urkundlich Beitrag zur Beurtheilung des geheimeen Strafprozesses und der politischen Zustände Deutschlands* (Leipzig 1843; facsimile reprint Leipzig 1975).
6 Berlin, Staatliche Museen zu Berlin, Preussischer Kulturbesitz, Nationalgalerie, inv. no. W. S.77.
7 Düsseldorf, Kunstmuseum, inv. no. M 1977–3, in *Die Düsseldorfer Malerschule*, no. 98, p. 331, fig. 332.

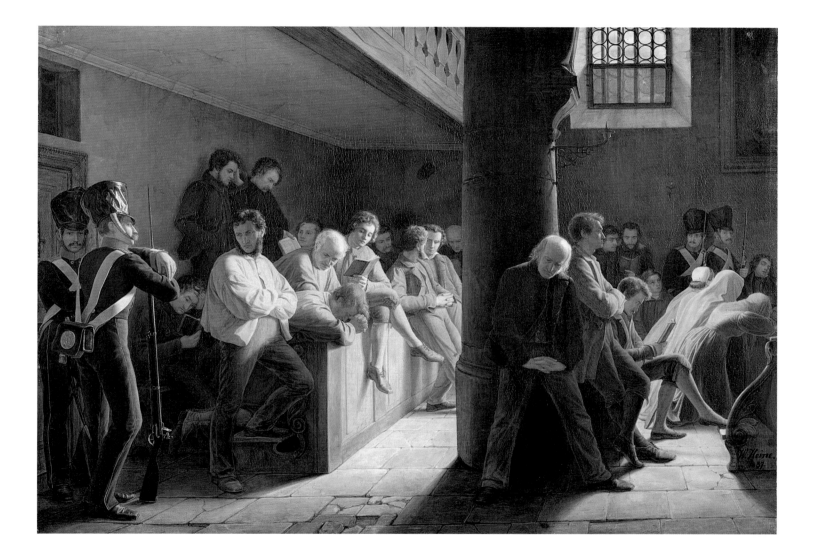

45 Heinrich Louis Theodor Gurlitt

1812–1897

The Northern Part of Lago di Garda

1839

Oil on canvas, 110.5 x 148 cm
Signed lower right: Gurlitt Muenchen 1839
Inv. no. 100

Provenance: 1839 gift of Johann Gottlob von Quandt, Dresden/Dittersbach

The painting of the northern part of Lago di Garda was a direct result of Gurlitt's visit to northern Italy in the summer of 1838. There, he made numerous drawings and oil studies—especially of Torbole and Pesciera.[1] He worked from these during the winter of 1838–39 on his return to Munich and created several paintings with similar motifs.[2] The painting shows the northern tip of the Lago di Garda as seen from an elevated point. The surrounding hills and mountains are reflected in the placid blue of the lake, as are the already slightly autumn-colored trees and bushes. The foreground consists of a sequence of descending rocky ledges on the left and a lower plain on the right. In the center of the foreground, a group of peasants are picturesquely resting or pausing on their way from the lake. In traditional *repoussoir* style, the foreground is shaded, the light falling most brightly on the sandy shore in the middle ground, while in the background the darker masses of the higher mountains, partly shrouded in clouds, are silhouetted against a light sky.

This work lies stylistically between Gurlitt's more naturalistic northern landscapes and the more idealized southern landscapes in which he sought to emulate the panoramic and summary style of Carl Rottmann. Gurlitt was part of Rottmann's circle in Munich in the mid-1830s, joining him on numerous walking and sketching tours around Munich and Salzburg. Rottmann's cycle of Italian landscapes inspired Gurlitt to go to Italy himself. His landscapes with Italian motifs were immediately popular, but there were also a number of critical voices who chided him for his tendency of "typifying and idealizing his landscapes."[3] Despite their freshness and charm, it is undeniable that a certain schematization can be detected in his works. Gurlitt himself admitted to a degree of abstraction. "It is true," he wrote in 1839, "that in landscapes as well as in historical painting, ... in order to achieve a higher degree of truthfulness, something of the simple naturalness has to be sacrificed."[4]

HKA

1 Ulrich Schulte-Wülwer and Bärbel Hedinger, *Louis Gurlitt, 1812–1897 Porträts europäischer Landschaften in Gemälden und Zeichnungen*, exh. cat. (Munich: Hirmer Verlag, 1997), p. 53.
2 Ibid., p. 56.
3 Ibid., pp. 56, 163.
4 Ibid., p. 56.

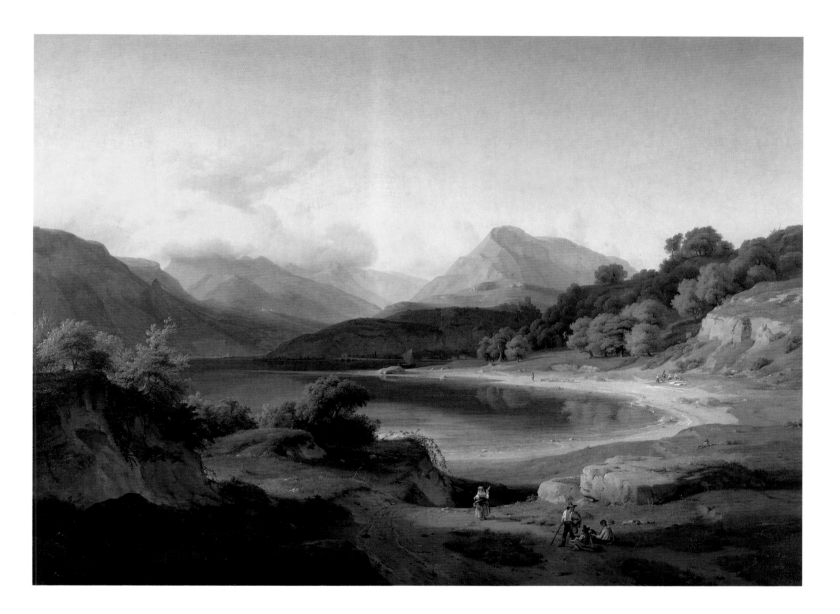

46 Johann Wilhelm Schirmer

1807–1863

The Grotto of Egeria

1841

Oil on canvas, 181 x 275 cm
Signed at the lower right: 1841/J.W. Schirmer
Inv. no. 219

Provenance: acquired for the Leipzig Museum in 1843 at the fourth exhibition of the
Leipzig *Kunstverein*

A spring outside the Porta Capua, one of the old city gates of Rome, was sacred to Egeria, an ancient goddess of springs and of birth who was believed to possess the gift of prophecy.[1] It was at this spring that the young women serving in the Temple of Vesta came to draw water. According to both Livy and Ovid, Egeria was the wife or lover and the advisor of Numa Pompilius, second king of Rome, who in secret nocturnal meetings regularly received her counsel on matters pertaining to government and religion. After the king's death, Egeria was said to have fled to the Grove of Diana near Ariccia, where in mourning the deceased she wept so copiously that Diana transformed her into a spring.

In this painting by Johann Wilhelm Schirmer, we find a calm water surface rendered in painstaking detail. The overall mood is harmonious. In the distance can be seen the Alban Hills. For Christian Schuchard, the first director of the Leipzig Museum, "the element of delicacy, in particular in the treatment of the plants, the water and the background … establishes the picture's particular mood. The arrangement of the illumination, the clarity in the shadows and in the rendering of the water, the truth both of the whole and of its individual parts, the evident self-confidence in both drawing and painting … make this picture one of the best manifestations of the new landscape painting."[2]

In his penetrating, realistic studies of landscape from the region around Düsseldorf, Schirmer had in fact already produced work in which he had freed himself from the influence of the Romantics. In this, the so-called German period of his career, the young painter was well on his way to becoming "the Ruisdael of his age," as his teacher Wilhelm von Schadow observed.[3]

A few years later the oil studies Schirmer made in Switzerland or in Normandy are distinguished by an immediacy and freshness that seem consciously to negate academic rules. Swiftly executed and brightly colored, the sketches capture fleetingly observed phenomena in rapid, vigorous brushstrokes; they show that Schirmer was edging toward a realistic form of plein-air painting. At the same time, Schirmer saw himself as upholding the Classical and Idealist landscape tradition, and his work did indeed undergo a significant stylistic transformation in Italy due to the influence of the work of Claude Lorrain, Nicolas Poussin, Joseph Anton Koch, and Johann Christian Reinhart. The painting in the Leipzig Museum is one of the most representative and well-loved works among the landscapes produced in the following years.

Rudi Theilmann[4] has demonstrated that, in *The Grove of Egeria*, Schirmer creates a lyrical mood, which he conveys through *staffage* and the symbols evoking Antiquity. The effect is that of an artificial Arcadia. Comparing the painting with two watercolors, Theilmann showed that Schirmer gradually introduced an affirmation of Christianity. The indeterminate architectural features appearing in the drawings[5] are more precisely defined in the painting through the addition of a belfry. This thematic reinterpretation places the architecture in a consciously antithetic relationship to the heathen grotto of Antiquity.[6] DS

1 The real Grotto of Egeria most probably could be found on the slopes of Mount Caelius. The ruins that are still revered, and frequently drawn and painted as the "Grotto of Egeria" lie below the church of Sant'Urbano on the slopes of Mount Almone. These ruins once formed part of the Nympheum of the villa of Herodes Attticus.

2 Christian Schuchard, *Catalog der Kunstwerke im Museum der bildenden Künste zu Leipzig. Nebst biographischen Mittheilungen über die Künstler* (Leipzig 1857), p. 154.
3 Cited in Rudi Theilmann, "Johann Wilhelm Schirmers Karlsruher Schule" (Ph.D. diss., Heidelberg 1971), p. 36 with note 169 on p. 243.
4 See Theilmann, p. 24.

5 In connection with the drawing in Nuremberg, the motif of a tomb on the Via Appia, visible in the right background alongside a few trees, has been mentioned; cf. "Neuerwerbung des Monats November des Germanischen Nationalmuseums Nürnberg," in *Weltkunst* 37/21 (November 1, 1967), p. 1095.
6 See Theilmann, pp. 239 ff., note 132.

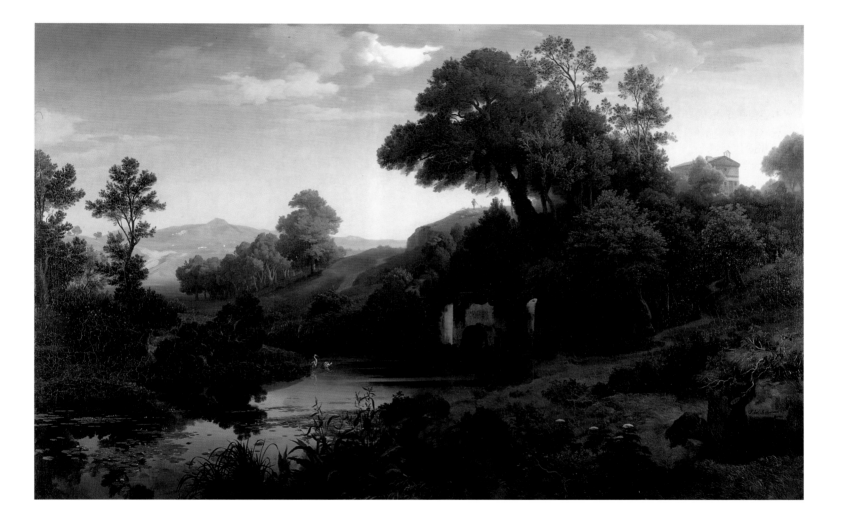

47 Moritz von Schwind

1804–1871

The Ride of Kuno of Falkenstein

1843/44

Oil on canvas, 152 x 94 cm
Unsigned
Inv. no. 528

Provenance: acquired in 1882 from the Leipzig artist's association, the *Kunstverein*, with funds bequeathed by Wilhelm Theodor Seyffarth

The Ride of Kuno of Falkenstein, one of the best known and best loved of Moritz von Schwind's fairy tale pictures, brings together many aspects of his engaging art: the combination of the world of fairy tales and sagas with a sense of reality, a striving for poetry and beauty (for Schwind synonymous with cheerfulness and joy in life), and an approach to painting in which color is strictly subordinate to line.

The painting has repeatedly been seen as a testament to Schwind's personal happiness as a recently married man. In the winter of 1841, after settling in Karlsruhe, Schwind met Luise Sachs, the daughter of a deceased army major from Baden. They married less than a year later. During their honeymoon, they traveled through Germany and Austria and visited Lake Constance, Innsbruck, Salzburg, and Linz. They continued by Danube steamer to Vienna and returned to Karlruhe at the end of October via Regensburg and Stuttgart. Schwind may have been influenced in this painting by landscapes observed in the vicinity of Hallstadt (where a stop of twelve days had been made after Salzburg, and where Schwind's younger brother was in charge of some of the mines).

Schwind likely took elements from a number of sagas and merged them to create the depicted scene. Common to virtually all versions, however, is the following narrative "core": The Lord of the castle at the top of the reputedly inaccessible Falkenstein rock challenged the young knight Kuno to fulfil a particular task if he wished to claim his daughter Irmengard as his bride. Within a single night Kuno had to forge a path up to the castle. Kuno secured the assistance of the dwarves by promising to close up one of the deep mines that threatened their mountain kingdom (in Schwind's painting Kuno is seen surreptitiously bidding farewell to the king of the dwarves). The upper part of the picture is reserved for the happy moment of Kuno's arrival before the castle gate—a scene testifying to Schwind's truly chivalric and Romantic pictorial imagination. The lower part is characterized by vivacity and a sparkling

humor, with its amusing treatment of the flight of the comical dwarves, who are probably among the artist's finest figural inventions. Schwind himself described the picture to his friend Bonaventura Genelli: "The picture I'm presently working on, although its subject is quite wild, fills me with the greatest joy. I adore painting trees and rocks and old walls—and there is certainly enough of all those, there's even a fully kitted-out chap on horseback—what more could one want?"[1]

In Ludwig Schorn's journal, the *Kunst-Blatt*, Schwind's painting was widely praised for its composition and draftsmanship; but, according to one commentator, "the use of oils as if they were watercolors" was not in general approved.[2] The graceful spiral arrangement of groups of figures, the treatment of space, the role of coloring and drawing here merge into a unity of pictorial effect at which Schwind had clearly been aiming in his earlier painting *The Knight Kurt Rides Out to Claim his Bride* (1835–39),[3] a composition in essence repeated in his painting *The Rose, or the Artist's Journey* (1846/47).[4]

In December 1843, Schwind started work on *The Ride of Kuno of Falkenstein*, which was commissioned by Countess Elise Ugarte. By the end of the following February, he was "ready to apply the final coat of varnish." Yet Schwind apparently made certain changes to the picture in 1853. The cartoon (the final, full-scale composition drawing for the painting), dated "around 1840," was acquired by the Leipzig Museum at the time of the Moritz von Schwind exhibition held in Karlsruhe and Leipzig. Probably somewhat cropped on three sides, this sheet may represent the last version of the composition to be elaborated before Schwind started painting. Only some of the landscape elements remain to be resolved. There are however preparatory sketches for the composition in various museum collections: these include a double-sided sheet with an appealing study in the Leipzig Museum collection of prints and drawings.[5] DS

1 Eugen Kalkschmidt, *Moritz von Schwind. Der Mann und das Werk* (Munich 1943), p. 65.
2 "Malerei," in Ernst Förster and Franz Kugler, eds., *Kunst-Blatt*, no. 95 (October 15, 1844), p. 348.
3 Painted after the ballad by Johann Wolfgang von Goethe, published in 1804; destroyed in a fire in 1931; formerly in Karlsruhe, Kunstahalle, inv. no. 521.

4 Berlin, Staatliche Museen zu Berlin, Preussischer Kulturbesitz, Nationalgalerie, inv. no. A I 110.
5 Sketches and studies are to be found in Darmstadt, Hessisches Landesmuseum, Kupferstichkabinett, inv. no. HZ 198–199; Munich, Städtische Galerie im Lenbachhaus, inv. no. G 12470 and G 2159; and Leipzig, Museum der bildenden Künste, Graphische Sammlung, inv. no. I 6981.

48 Karl Friedrich Lessing

1808–1880

German Mountain Landscape

1847

Oil on canvas, 82 x 126 cm
Signed lower left: CFL 1847
Inv. no. 134

Provenance: acquired in 1868 through the *Kunstverein* (Art Association) of Leipzig
from the Arthaber Collection of Vienna, Austria

Lessing's *German Mountain Landscape* is a panoramic view of a mountainous landscape as seen from an elevated point. In the foreground, a rough path with two approaching riders serves as *repoussoir*, while a castle-topped mountain in the middle ground constitutes the focal point. In the distance, a river meanders through a wide valley, while the mountains in the far background are rendered as mere silhouettes. Starting in 1832, Lessing went on repeated sketching tours in different mountain regions in Germany that had so far been ignored by fellow painters: one was the Eifel Mountains, the other the Harz Mountains, whose craggy formations and picturesque vistas intrigued Lessing and probably served as inspiration for this painting. Lessing, whose early landscapes were still in the Romantic tradition of Johan Christian Clausen Dahl, Karl Friedrich Schinkel, and Carl Blechen,[1] developed a style termed "modern realism" by his contemporaries during the 1830s.[2] There is no doubt that the *German Mountain Landscape* was painted in the studio, but the studies that preceded it were so thorough that the final result is highly realistic.

In the 1830s, Lessing started his series of paintings with historical subjects. His huge canvases, dealing with figures at the time of the Reformation, had an enormous impact.[3] In the *German Mountain Landscape*, he attempts a symbiosis of the two genres. However, the historical elements are as yet much less pronounced than in *The Siege*, painted only one year later. The medieval castle that sits proudly on top of the mountain, for instance, seems quite intact and the riders in the foreground may be interpreted as figures from an earlier period, although the allusion to historical costumes is not pronounced. While some scholars see Lessing's realistic landscapes only as a transition between his more romantic earlier and historical later works, many are of the opinion that they rank among his finest works. There is no doubt that through them his influence on the younger generation of painters, among them Andreas Achenbach and Adolf Lasinsky, was most profound.[4] HKA

1 Wolfgang Hütt, *Die Düsseldorfer Malerschule*
(Leipzig: Seemann, 1995), p. 70.
2 Ibid., pp. 116–17.
3 Wend von Kalnein, ed., *Die Düsseldorfer Maler-schule*, exh. cat. (Mainz/Rhein: von Zabern, 1979),
p. 89 ff.
4 Ibid., p. 96.

49 Adolph von Menzel

1815–1905

Gustav Adolph Greets his Wife outside Hanau Castle in January 1632

1847

Oil on canvas, 55 x 68 cm
Signed lower left: Menzel/1847
Inv. no. 849

Provenance: acquired in 1906 from the art dealer Mathilde Rahl, Berlin, with funds from the Theobald Petschke-Bequest

In 1847, the Art Society (*Kunstverein*) of Kassel commissioned Adolph von Menzel, thanks to the intervention of his longtime friend Carl Heinrich Arnold, to paint a work with a historical subject matter of his own choice.[1] Menzel decided on a scene from the life of the Swedish king, Gustav II Adolph, who led the Protestant armies during the Thirty Years' War. Menzel explained his choice of motif in a letter to the Art Society, writing, "Art has hitherto sought to simply show the heroic dimension of this king, who achieved lasting glory in the service of Germany. On this occasion, I thought it proper to highlight his human side, which is no less impressive."[2]

In this work, Menzel shows the king, who had won the first decisive battle for the Protestants at Breitenfeld in September 1631 and set up winter quarters at Hanau, as he greets his wife Maria Eleonora, a princess of Brandenburg, while she descends from her sleigh.[3] A large entourage, consisting of Gustav II Adolph's officers and coachmen as well as the traveling companions of Maria Eleonora, surrounds the embracing royal couple, who are placed at the center of the composition. The flag-draped castle wall on the left and a row of barren trees on the right serve as a backdrop to this historical event. The snow-covered ground, the leafless branches of the trees, and the overall somber lighting evoke a wintry atmosphere.

This oil sketch, painted in just a few weeks during the spring of 1847, remained incomplete. Menzel, however, believed it to be sufficiently developed so that a finished version would have been nothing more than a copy.[4] The work, full of movement and color, depicts a large group of people yet unequivocally focused on the central couple whose faces in profile are highlighted by white collars of lace and ermine. The reds of the carpet and the sleigh add warmth and drama to a joyous moment, defying both the inclemency of the season and the horrors of war. The members of the vast entourage remain largely anonymous, many faces turned away or hidden. The fact that not all of the bystanders are focused on the main event but are partially preoccupied with other matters has been criticized as distracting. It does, however, add an air of spontaneity to an otherwise formal scene. No preparatory drawings or sketches exist for the work, yet Menzel's striving for historical verisimilitude is apparent. Not only the portraits of the protagonists, but also the costumes, the baldachin of the sleigh, and the architectural features of the castle are all meticulously rendered and speak of his great love of historical detail. Like many other artists of the time, Menzel was undoubtedly influenced by the historical paintings of Louis Gallait and Edouard de Biefve.[5] He did however develop his own unrivaled historical style of painting that was to culminate in a series of paintings from the life of the Prussian king Frederick the Great. The realism, sensitivity, and masterly technique with which he painted those historical scenes are unparalleled in German art and make him one of Germany's most respected and beloved artists of the nineteenth century. This work lies between his remarkable pre-Impressionistic paintings of the 1840s such as *The Balcony Room* (1845)*, The Berlin-Potsdam Railway* (1847), and his later historical works. Since it contains stylistic elements of both phases, this painting can be seen as an important stepping-stone between two important phases of Menzel's artistic development. HKA

1 Claude Keisch and Marie Ursula Riemann-Reyher, eds., *Adolph von Menzel 1815–1905: Between Romanticism and Impressionism*, exh. cat. (New Haven and London: Yale University Press, 1996), p. 116.

2 Ibid.
3 Ibid. Cornelia Doerr has pointed out that the actual meeting took place outside of Hanau, and that the royal couple then proceeded together to the castle.

4 Gisold Lammel, *Adolph Menzel, Schriften und Aufzeichnungen* (Muenster: Lit, 1995), p. 26.
5 Claude Keisch and Marie Ursula Riemann-Reyher, eds., *Adolph Menzel 1815–1905: Between Romanticism and Impressionism*, p. 216.

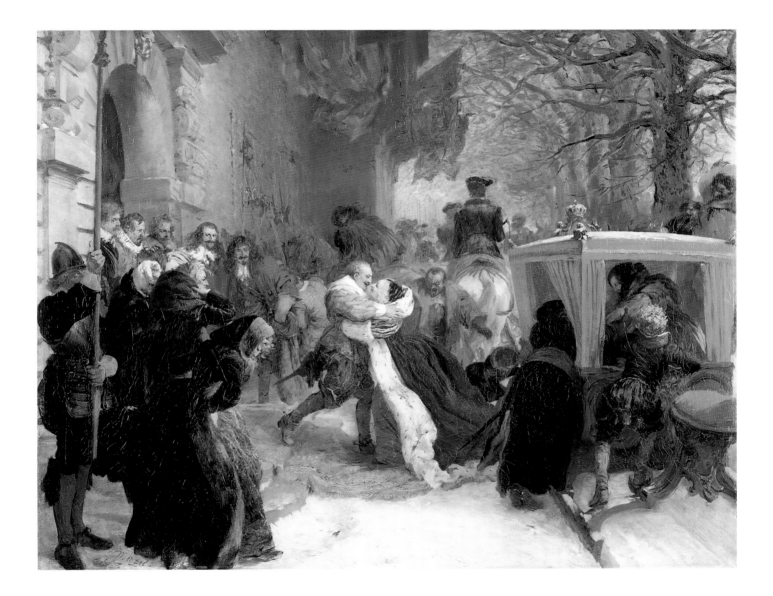

50 Adolph von Menzel

1815–1905

Head of a Girl

1851

Gouache, 22.5 x 19.1 cm
Inv. no. 1.4463

Provenance: acquired in 1895 with funds from the City of Leipzig

The head of a girl, painted in a palette confined to browns and beiges, is a fine example of Menzel's great skill as a graphic artist and portraitist. The strong features of this dark-haired, dark-eyed girl are rendered almost in full profile. The light, falling from the left, highlights her right temple and cheek, leaving the forehead, eye, and mouth in shadow. The dark, almost black, hair is fashionably gathered at the back into a braided chignon, while the shorter hair around her brow and temple spring up in charming and unruly curls. The high-necked brown dress with its narrow pleated white collar is also fashionable but quite simple in cut and style, characterizing the wearer as a member of the middle class.

Menzel, who did not view himself as a lowly portrait painter, created a vast number of portraits of historical and contemporary personalities.[1] The gouache of the head of a girl, however, must be seen as part of Menzel's more intimate portrait studies of members of his family and close circle of friends that date mostly between 1845 and the early 1850s.

His sister Emilie was his particular favorite—he drew and painted her asleep on a sofa, waiting at the door with a candle, or pursuing other feminine tasks.[2] It is tempting to identify the head of this young woman as Emilie since their coloring and their hairstyle correspond closely. Yet if one compares the features of the girl in the gouache with a pencil drawing also dated 1851, showing Emilie and her brother Richard seated at an upright piano with the painter himself standing at the back and a female relative knitting in the foreground, it becomes apparent that the girl and Emilie cannot be identical. Emilie's face is rounder and has features that are more delicate.

Menzel's portraits lack all sentimentality or idealization. He aimed to depict the character of the person portrayed straightforwardly and without pretensions,[3] and it was immaterial for Menzel whether the object of his sharp and sometimes unforgiving pencil was a king, a courtier, or an anonymous member of the working class. HKA

1 Gisold Lammel, *Adolph Menzel Bildwelt und Bildregie* (Dresden and Basle: Verlag der Kunst, 1993), pp. 145–47.
2 Claude Keisch and Marie Ursula Riemann-Reyher, eds., *Adolph Menzel 1815–1905: Between* *Romanticism and Impressionism*, exh. cat. (New Haven and London: Yale University Press, 1996), pp. 228–29.
3 Gisold Lammel, *Adolph Menzel Bildwelt und Bildregie*, p. 145.

51 Adolph von Menzel

1815–1905

Self-portrait with Worker near the Steam-hammer

1872

Gouache, 16 x 12.5 cm
Inv. no. 1972–5

Provenance: from the collection of Dr. Helene and Luzius Spengler, Davos, Switzerland; collection Curt Dinckler, Leipzig; 1972 gift of Heinz Senger, Neubrandenburg, from the estate of Annemarie Maurer, nee Dinckler, Leipzig

In 1869, the Heckmann Company, a Berlin-based iron and steel producer, commissioned Adolph Menzel to design a commemorative page honoring the company's fiftieth anniversary.[1] In the course of this project, Menzel became so fascinated with the development of modern industry that he traveled to Upper Silesia in 1872 to study firsthand the largest iron mill operating in Germany. His observations yielded more than 150 pencil studies and this gouache,[2] which served as a basis for a large oil painting titled *The Iron Rolling Mill*, completed in 1875. While the oil painting contains a large number of figures executing various tasks, the gouache centers on a single worker, whom Menzel placed in the middle of the foreground. The man, dressed in rough work clothes and a protective apron, turns toward the brightly glowing furnace as he works in the red-hot embers with long tongs. His work-toughened, muscular forearms, bare to the elbow, are lit by the fire, as is his face. The rest of his body is rendered in the shadows of the smoke-filled iron mill. Two other workers are sketchily drawn in the background and on the right Menzel has shown himself in a bowler hat. With his sketchbook in hand, half-hidden behind the wheel of a type of wheelbarrow-like transport truck used in the iron mill, he has depicted himself as a fascinated observer.

Although *The Iron Rolling Mill* is essentially a realistic painting, it contains certain elements that are almost Baroque in style: its chiaroscuro light effects, for example, that allow the figures to emerge from semi-darkness, and the crisscrossing diagonals of its composition. Similar elements can be found in the gouache. The dramatic lighting from the furnace, illuminating only the main figure and leaving most of the composition steeped in darkness, has a certain Baroque quality. The machinery and the substantial wall with its arch appear Piranesi-like, cavernous and threatening. On the preparatory pencil study for this work, Menzel wrote the words "gloomy" and "dark dirty wall"[3]—he has captured that quality through the predominant use of browns and blacks. The twisted stance of the main figure, which is determined by his task, can also be considered Baroque. Yet Menzel has neither dramatized nor exaggerated his subject. In an entirely realistic manner, he has rendered the worker as a symbol of the Industrial Age. Although Carl Blechen must be credited with having been the first German artist to elevate modern industry to a subject of artistic expression, Menzel achieved lasting fame for creating one of the "greatest paintings of modern history"[4] with *The Iron Rolling Mill*, in whose context this gouache must be seen.

HKA

1 Susanne von Falkenhausen, "Historie und Politik – Beliebigkeit und Sinngebung: Menzel und der Historismus," in Lucius Grisebach, ed., *Adolph Menzel, Zeichnungen, Druckgraphik und illustrierte Buecher,* exh. cat. (Berlin: Staatliche Museen Preussischer Kulturbesitz, 1984), p. 30.
2 Marie Ursula Riemann-Reyher, "Arbeiter im Walzwerk," in Jens Christian Jensen, ed., *Adolph Menzel, Gemaelde, Gouachen, Aquarelle, Zeichnungen aus der Sammlung-Dr.-Georg Schaefer-Stiftung, Schweinfurt* (Muenchen: Hirmer Verlag, 1998), p. 42.
3 Jens Christian Jensen, ed., *Adolph Menzel, Gemaelde, Gouachen, Aquarelle, Zeichungen aus der Sammlung Dr.-Georg-Schaefer-Stiftung, Schweinfurt,* cat. no. 64, p. 93.
4 Marie Ursula Rieman-Reyher, "Arbeiter im Walzwerk," in Jens Christian Jensen, ed., *Adolph Menzel Gemaelde, Gouachen, Aquarelle, Zeichungen aus der Sammlung Dr.-Georg-Schaefer-Stiftung, Schweinfurt,* p. 44.

52 Carl Spitzweg

1808–1885

The Confirmed Bachelor

1847–49

Oil on canvas, 38 x 46 cm
Unsigned
Inv. no. 1311

Provenance: in 1913 in the possession of Karl Loreck, nephew of the artist; until 1917 in the collection of R. Zahn, Plauen; auction in 1917 of the estate of Zahn through Helbing in Munich (Nov. 21, 1917); collection Dr. Buiswanger; 1935 art dealer Carl Nicolai, Berlin; acquired from Carl Nicolai by Henri Hinrichsen, Leipzig; acquired from Henri Hinrichsen by the Museum der bildenden Künste Leipzig in 1939; returned to Walter Hinrichsen, Chicago, in 1945, who left it to the Museum der bildenden Künste Leipzig as part of the Henri and Martha Hinrichsen-Bequest, together with works by Wilhelm Leibl and Fritz von Uhde

Since Carl Spitzweg remained a bachelor all his life, many scholars have attributed autobiographical meaning to the numerous solitary figures he painted—such as the tall dark gentleman who dominates this work. The closed silhouette of his figure reaches far into the sky, constituting the only strong vertical in an otherwise horizontal landscape. He is isolated in form and set apart in color from the rest of the scene, and turned away from the viewer. The book tucked under his arm and the brochure held behind his back suggest not only an intellectual lifestyle, but also a means of escaping loneliness. In haughty aloofness, he observes several couples in various degrees of devotion to one another.

Moving away from his early period of depicting single figures, Spitzweg here produces a painting typical of his works of the 1840s, which show a tendency to emphasize landscape rather than figures.[1] This development is undoubtedly due to his friendship with Eduard Schleich, the eminent Munich landscapist. The foundation of Spitzweg's works consisted of copious sketches drawn from nature that he kept throughout his life and often reused for different paintings. A very similar family group, for instance, was the subject of a work titled *A Summer Walk* (1841) for which a detailed preparatory drawing exists.[2] Spitzweg often painted the same theme in numerous variations. Very close to *The Confirmed Bachelor* are *The Forbidden Way* (1845) and *No Rose without Thorns* (1840–50), both showing a darkly clad gentleman contemplating a couple of lovers. Although Spitzweg himself was not the social eccentric he portrays here, he remained an artistic outsider. In his unacademic, highly personal style, color always played a secondary role in his work. Nonetheless, a decisive development toward more nuanced colors set in under the influence of the French masters, especially Delacroix and Diaz, whose works he studied during a pivotal trip to Paris in 1851.[3] From the beginning, Spitzweg was a master at balancing caricature and realism in his figures, thereby creating humorous but believable types.[4] Thanks to his keen observation of the human condition and his sympathy for humankind's plight, Spitzweg's humor has a timeless quality. The charm of his works is enhanced for us by the idyll of the "good old times" that he captures in his paintings. HKA

1 Manuel Albrecht, *Carl Spitzweg, Malerparadies* (Stuttgart: Schuler Verlagsgesellschaft, 1968), p. 26.
2 Ibid., pl. 2, and Jens Christian Jensen, *Carl Spitzweg* (Köln: DuMont, 1980), p. 31, fig. 30.
3 Jensen, *Carl Spitzweg*, p. 30.
4 Ibid., p. 21.

53 Carl Robert Kummer

1810–1889

Sunset in the Hebrides

c. 1853/54

Oil on canvas, 113.7 x 187 cm
Signed at the lower right: R. Kummer
Inv. no. 131

Provenance: acquired by the Leipzig Museum in 1855 from the artist, in exchange for an earlier work that it had been given by an anonymous art lover

In Carl Robert Kummer, the art historian Hans Joachim Neidhardt recognized a clear example of the late Romantic "Travel Painter."[1] As such, the artist introduced into German art landscapes previously unknown, including those of Dalmatia, Albania, and Montenegro. Kummer's essential aim in his landscape painting was to provide an objective rendering of the terrain in geological terms. Influenced by Johan Christian Clausen Dahl, Kummer made studies of the landscape around Dresden that evince a Romantic and Realist attitude. The studies Kummer made on the island of Capri, in particular, prove that he also approached the landscape of Italy with no preconceptions, studying the particular characteristics of each region and its vegetation almost with the exactitude of a geologist. The impact of sunlight lends an optical charm to these otherwise pedestrian landscape views, which nonetheless are distinguished by the artist's free brushwork.

Kummer's painting, fully titled *Sunset during a Storm in the Hebrides in Scotland*, and probably painted in 1853/54, was described in 1857 by Christian Schuchard, director of the Leipzig Museum, as a "fine picture by this productive artist, [an image] of great truth and effect and fresh in its treatment." In his biographical note on Kummer, Schuchard had already expressed his appreciation: "Kummer's achievements are based on truth to nature; the curious lighting effects in his treatment of landscape are rendered with fresh feeling and are freely painted, and they bear the mark of a particular and independent artistic vision."[2]

In 1851, Kummer set out from Dresden to Scotland, and in the course of his travels he produced a number of dark landscape scenes. Friedrich von Boetticher lists numerous Scottish landscape motifs that, possibly with the exception of the picture in the Leipzig Museum, were included in exhibitions at the Dresden Academy of Art between 1852 and 1855.[3] While the titles of some of these pictures already serve as a reminder that Kummer was a master of atmosphere and of mood in his routinely painted late works, in connection with the painting in the Leipzig Museum, we are particularly struck by the presence, among the works named, of a picture with an unusually extended subject: *Sunset with Approaching Storm on the Coast of Scotland with Characters from "Macbeth"*.[4]

The Hebrides, a group of around five hundred islands lying off the west coast of Scotland, settled by the Celts in the first millennium B.C. and conquered by the Vikings in the ninth century A.D., belonged from 1266 to Scotland. The harsh climate, the overpowering beauty of these islands, and the history and myths associated with them, inspired many poets, artists, and musicians in the Age of Romanticism— among them the composer Felix Mendelsohn-Bartholdy, who in 1828–29 traveled in Scotland. In 1832, he wrote his overture "The Hebrides (Fingal's Cave)," Op. 26, and on March 3, 1842, his "Scottish Symphony" (Symphony in A Minor, Op. 56) had its first performance at the Leipzig Gewandhaus, conducted by the composer himself. DS

1 Hans Joachim Neidhardt, *Die Malerei der Romantik in Dresden* (Leipzig 1976), p. 198.
2 Christian Schuchard, *Catalog der Kunstwerke im Museum zu Leipzig. Nebst biographischen Mittheilungen über die Künstler* (Leipzig 1857), p. 87.
3 Friedrich von Boetticher, *Malerwerke des neunzehnten Jahrhunderts. Beitrag zur Kunstgeschichte*, vol. 1 (reprint of 1st ed., of 1891–1901, Leipzig 1948), nos. 37–48, 50–55, p. 822.
4 See von Boetticher, nos. 45–48, p. 822.

55 Friedrich Preller the Elder

1804–1878

Landscape in the Sabine Hills with the Good Samaritan

1870

Oil on canvas, 115 x 167 cm
Signed at the lower right: 18 FP [in the form of a monogram] 70/Weimar
Inv. no. 415

Provenance: given to the Leipzig Museum in 1870 by Karl Voigt, of Leipzig, in memory
of his son, who had died that year

Friedrich Preller the Elder received his first real instruction in landscape painting from Joseph Anton Koch. Koch, the recognized master of the "heroic landscape," decisively influenced Preller's further artistic development, as the artist himself never tired of observing: "My good acquaintance with Joseph Koch in Rome brought me enlightenment in many things, and this period has so far proved the most instructive in my career."[1] And again, sixteen years later: "... for it was his [Koch's] influence that brought out the best in me as an artist."[2]

We may assume that it was also a work by Koch, as Preller's "teacher," that inspired him to produce the painting in the Leipzig Museum, *Landscape in the Sabine Hills with the Good Samaritan*.[3] Preller likely copied Koch's painting *The Serpentara near Olevano with Fighting Bulls*[4] when owned by Hermann Härtel, who commissioned Preller to decorate his house, called the "Roman House," in Leipzig.[5] Although Preller had visited the region around Olevano and had made many landscape sketches there,[6] his attention was directed at the landscape background seen in Koch's painting, which he incorporated into his own picture almost detail for detail. He was in fact to use this "set piece" for three further mythological landscapes.[7]

The Leipzig painting marks a change within Preller's late work in terms of subject. Earlier, he made this point: "Personally, I could never bring myself to treat a Christian subject in a work of art, and yet I regard myself as [an artist as] good as any and better than many, and one who works in humility and with respect for the Church."[8] From 1870 on, Preller looked far more favorably on biblical themes.

Preller's rendering of the Parable of the Good Samaritan[9] takes up a relatively small space in the foreground with the figures somewhat artificially set into the sunny scene. On the moss-, grass-, and bush-covered lower slopes of a mountainous landscape, the Samaritan kneels in front of the man who has been attacked, robbed, and left for dead. The latter reclines, his upper torso supported against a rock, while the Samaritan tends his wounds. The Samaritan's donkey grazes peacefully behind the nearby bushes. In the middle distance is the figure of the Levite, viewed from the back and little more than a silhouette, the man who "passed by on the other side," unmoved by the plight of the victim of the assault. At the right of the composition, an inward-arching olive tree leads the eye into the landscape in the background with its powerful mountain range: here one can identify the Volsci Mountains (on the left), the Praeneste Mountains (on the right), and, in the far distance, Monte Caco.[10] Vast clouds brood over the entire scene; and in the distance a storm clearly threatens—doubtless a reflection of the artist's earlier production of somber, wild northern European landscapes.

Preller's correspondence reveals that the Leipzig painting was commissioned by the book dealer Karl Voigt and had from the start been intended by him as a gift for the Leipzig Museum in memory of his deceased son: "... For many years I've been completing promised works, among them a picture with the Good Samaritan for the Museum in Leipzig."[11] "Today I'm sending the picture to Herr C. Voigt at Gartenstrasse 14 in Leipzig."[12]

SP

1 Letter of September 30, 1840, to Ferdinand von Biedenfeld, in Weimar, cited in Ina Weinrautner, "Edmund Kanoldt—ein Epigone Friedrich Prellers?", *Edmund Kanoldt. Landschaft als Abbild der Sehnsucht* (exh. cat., Karlsruhe 1994), p. 68.
2 Letter of July 27, 1856, to Marie Soest, in Hamburg, cited in Walther Witting, ed., *Künstlerisches aus Briefen Friedrich Prellers des Älteren. Zu seinem 100. Geburtstage, dem 25. April 1904* (Weimar 1903), p. 18.

3 Ina Weinrautner, *Friedrich Preller d. Ä. (1804–1878). Leben und Werk* (Münster 1997).
4 Otto von Lutterotti, *Joseph Anton Koch (1768–1839). Leben und Werk* (Vienna and Munich 1985), no. G 82, p. 303, fig. 60. The painting has been untraced since the end of the Second World War.
5 The copy (*Italian Landscape*, pen and ink with brush and wash over pencil) is now in Weimar,

Staatliche Kunstsammlungen, Kupferstich-Kabinett, inv. no. KK 8367).
6 Ina Weinrautner refers in this connection to a pencil drawing made in 1863 of the Serpentara near Olevano (auctioned by Kunsthaus Lempertz, sale no. 700, 1994, no. 162), which has a comparable landscape background; see Weinrautner, p. 375.
7 See Weinrautner, nos. 333, 335, 337.

8 Fragment of undated (and otherwise unidentified) letter to Marie Soest, see Weinrautner, p. 376.
9 The Gospel According to Saint Luke, 10: 30–37.
10 Information kindly supplied in 1985 by Dr. Domenico Riccardi, in Spoleto.
11 Letter of April 13, 1870, to the Princess Sayn-Wittgenstein, in Weimar, see Weinrautner, p. 376.
12 Letter of July 10, 1870, to Paul Erwin Boerner, in Weimar, see Weinrautner, p. 376.

56 Heinrich von Zügel
1850–1941

Sick Sheep

1872

Oil on canvas, 59 x 98.5 cm
Signed below toward the right: H. Zügel. München 1872.
Inv. no. 614

Provenance: acquired in 1888 through the Leipzig City Council at the auction of the collection of the Altgraf Franz zu Salm-Reiferscheid, of Prague, with interest accrued by the Theobald-Puetschke-Stiftung

The protagonists of Zügel's animal paintings are sheep and cattle, whose daily life he depicted in the most varied situations. He made careful studies of these animals' anatomies. He would then incorporate his findings in closely cropped paintings that would render every particular detail. In the early painting *Sick Sheep*,[1] we find Zügel still working in the style of the seventeenth-century Dutch animal painters or in a manner similar to that of his contemporaries Anton Braith or Friedrich Voltz. The 1870s, however, were to prove significant for Zügel's development as an animal painter. He gradually began to eschew the representation of individual animals in small-scale pictures in favor of showing large groups or herds in much larger compositions. "With pictures which had been carefully thought out down to the subtlest nuances, and his mixture of gray and brown tones with subdued local color on a dark ground, the young artist provoked enormous enthusiasm."[2] As early as 1873, at that year's World Exhibition in Vienna, Zügel received a gold medal for his painting *Washing the Sheep*.[3]

According to Eugen Diem, Zügel painted *Sick Sheep* in his native Murrhardt. Georg Biermann argues that it was a chance encounter on a walking tour that prompted the decision to show the animals in a wood.[4] The setting is rendered in subdued color with evening light that gleams in the background. This illumination binds the individual details, so that man and animals merge into a thematic and atmospheric unity that goes far beyond the artifice of a conventional landscape with *staffage*. Nowhere in Zügel's work does one come across a theatrical exaggera-tion or humanization of the depicted animals, though one can always detect a sensitive understanding for them.

Zügel's art was not centered on the individual animal. What gives his pictures their essential appeal is, rather, his concern with the interconnection between the animals within the flock (or herd), and their relationship to the landscape and to man. In the view of Biermann, it is precisely "in such subsidiary details that there is [revealed] … once again an instance of real artistic and human sensitivity. For an animal, too, experiences the inconstancy of life; and, just as today the painter may perhaps see in the image of a young bull standing in the sunlight a symbol of abounding, primeval power and health, by the same token he will recognize in the sick bull an allegory of human inadequacy."[5]

In the 1880s, Zügel completed his move toward large compositions, painted *en plein air*. Another picture by Zügel in the Leipzig Museum showing a shepherd, to which the artist gave the title *Stop if the Bar is Down* (1897),[6] is one of the most important works of his middle period. In the artist's best works, the painterly rendering of the animals and the landscape dissolves into an Impressionistically shimmering play of color. Zügel preferred the particular light and color moods of the late afternoon with its golden tone or the bluish coolness of the morning light. When, for example, he painted cows and sheep grazing beneath trees, he achieved a level of skill in his rendering of the bright sunlight that is in no way inferior to what is to be found in the finest zoo or garden scenes painted by other Impressionists. DS

1 Eugen Diem, *Heinrich von Zügel. Leben und Schaffen, Werk* (Recklinghausen 1975), no. 144 with unpaginated illustration (titled as *Sick Sheep Reclining in a Wood* and erroneously dated 1875).
2 See Diem, p. 17.
3 See Diem, no. 108, fig. on p. 57.
4 Georg Biermann, *Heinrich von Zügel* (Bielefeld and Leipzig 1910), p. 59.
5 See Biermann, p. 59.
6 Inv. no. 845; see Diem, no. 425 and unpaginated illustration.

57 Franz von Defregger

1835–1921

Grace before Meal

1875

Oil on canvas, 59 x 73.5 cm
Signed lower left: Defregger 1875
Inv. no. 488

Provenance: acquired in 1876 with funds from the bequest by Munkelt und Thilo

Franz von Defregger is principally known as a painter of historical scenes of his native Tyrol, but these works actually represent only a small part of his oeuvre. Genre scenes, such as his *Grace before Meal*, were one of Defregger's other "fortes." Painted when he was at the height of his creative powers, this painting combines his love for the rural life of his Tyrolean compatriots and his particular love of children.[1]

In this work, Defregger depicts real people in their natural setting. Awaiting their midday meal, a group of children is gathered around a table, their hands folded in prayer, attentively following their grandmother's words. The sweetly smiling and pensive faces of the children give this work its particular charm. The costumes, dirndl and lederhosen worn by the children, as well as the beautifully embroidered spencer, or short, waist-length jacket, and cap of the grandmother are rendered so realistically and with such refinement that they document a bygone era. Here, a farm kitchen is characterized by the pots and pans hanging on the wall near the hearth, by the rustic furniture, and by the bare flag-

stone floor. The animals that have strayed from the farmyard add to the atmosphere of rural domesticity. Defregger also has used the animal figures to balance the composition which, despite the depth of the room, is developed along a horizontal line—a construction typical for his works of the 1870s.

In concentrating on one event on which all participants are focused, Defregger closely followed Carl von Piloty's teachings. However, his palette of warm browns, with bright colors used only as accents, is more subtle than that of his teacher. Defregger used light effectively to highlight the main event without succumbing to the pathos often found in Piloty's work.[2] Although light falls through the half-opened window in the background, the group in the foreground emerges from a predominantly dark canvas. In a harmonious interaction of form and content, it seems to be their natural devoutness and warmth that brightens the room. Defregger's integrity of vision, painterly finesse, and sureness of composition elevate this work above shallow sentimentality. HKA

1 Hans Peter Defregger, *Defregger*, exh. cat.
(Rosenheim: Rosenheimer Verlagshaus, 1982),
p. 20.
2 See Defregger, p. 16.

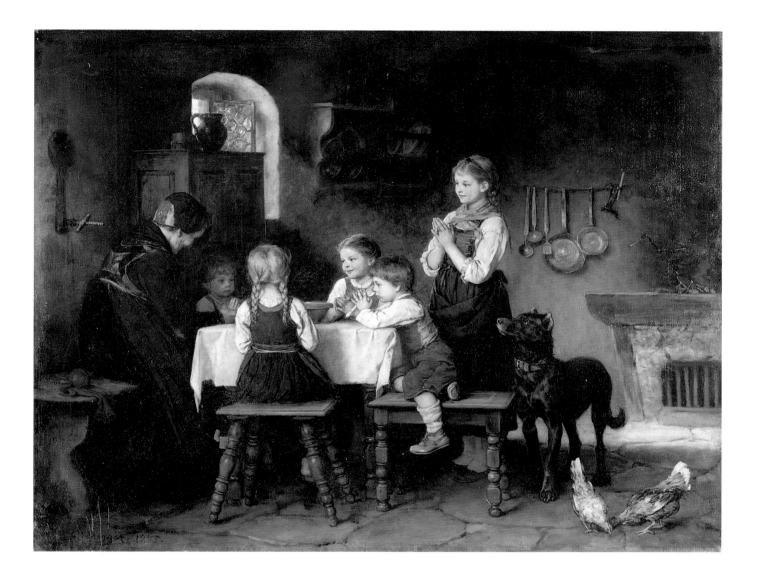

58 Karl Buchholz

1849–1889

From the "Webicht" near Weimar

1873

Oil on canvas, 77 x 111.5 cm
Signed at the lower right: K Buchholz; 1873/Weimar
Inv. no. 917

Provenance: in the collection of Fritz von Harck, in
Leipzig; given by Fritz von Harck in 1910 to the Leipzig
Kunstverein, from which it was transferred to the Leipzig
Museum

German landscape painting in the last quarter of the nineteenth century
had its center in Weimar. The so-called Weimar School was founded by
the Grand Duke Carl Alexander of Saxony. With his close friend, the
painter Stanislas Count Kalckreuth, and in spite of the resistance of
local conservative art circles, the Grand Duke of Saxony (Weimar Eise-
nach) established a training institution that departed from the prevailing
ideology and methods of German art academies. The staff of the new
school was committed to "the principle of the free and autonomous
training of students by individual masters. Crucial to the training offered
at Weimar were the uninterrupted study of nature and the autonomy
and free intellectual development of the individual student."[1]

Many gifted young artists, among them Franz von Lenbach, Arnold
Böcklin, Alexander Michelis, and Theodor Hagen, accepted an invita-
tion to teach at Weimar because they had become disenchanted with
what they perceived to be the antiquated concepts and procedures that
dominated art training in Munich and Düsseldorf. In Weimar much in-
spiration was drawn from French plein-air painting.[2] This approach to
painting particularly appealed to Karl Buchholz, who in the 1850s had
already started to take an interest in the work of seventeenth-century
Dutch painters and in that of the Barbizon School painters. In his early
career, Buchholz usually prepared multiple studies before producing a
painting; most of these studies have not survived.[3] Later, he tended to
produce direct records of his observations.[4] He favored landscape motifs
drawn from his immediate surroundings.

Among Buchholz's most outstanding works are the numerous
atmospheric spring and autumn landscapes he painted in the so-called
Webicht,[5] the former Grand Ducal hunting grounds. This remarkably
wild stretch of forest, with its dense growth of both deciduous and
coniferous trees, repeatedly attracted the artist's attention. Buchholz
was the first artist to attempt to capture the atmosphere of Webicht at
different times of the day and the year; in doing so, he encouraged the
next generation of Weimar painters to draw inspiration for landscapes
from this rich "natural store" of motifs.[6] The painting in the Leipzig
Museum, *From the "Webicht" near Weimar*,[7] dated 1873,[8] is one of Buch-
holz's earliest known *Webicht* pictures, and it is assumed to have been
one of a series of studies of *Autumn Evening in the Webicht*.

Buchholz liked to capture the unobtrusive charms of a landscape. As
in most of his works, the painting in Leipzig reveals the artist's propen-
sity for silence and solitude (he considered landscape the mirror of the
soul),[9] a characteristic that was later to dominate in a series of deeply
melancholy compositions. Even though some of Buchholz's landscapes
recall the work of the German Romantics, his work is nonetheless to-
tally free of idealizing and religious traits. Although Buchholz produced
a great many masterful "portraits" of landscape, he did not advance an
entirely new concept of landscape painting, as many of his Weimar col-
leagues had been able to do. While Buchholz was appreciated as an artist
in his own region, he never was honored officially. Painfully aware of
this slight, and despondent over his own work, this shy eccentric was
eventually driven to suicide. SP

1 [Von Bojanowsky], *Die Weimarische Kunstschule
vom 1. Oktober 1860 bis 1. Oktober 1885* (Weimar
1885). p. 5.
2 On the history of the Weimar Painting School,
cf. Walther Scheidig, *Die Weimarer Malerschule*
(Leipzig 1991).
3 Franz Hoffmann-Fallersleben describes how
Buchholz, though invariably regarding his prepara-
tory studies as essential to his work, did not treat
them very carefully. Sometimes he even destroyed
them over the course of time; cf. Franz Hoffmann-

Fallersleben, "Karl Buchholz. Persönliche Erinne-
rungen von Franz Hoffmann-Fallersleben," in
Der Türmer. Monatsschrift für Geist und Gemüt II
vol. 1 (October 1908–March 1909), pp. 573–87.
4 According to Hoffmann-Fallersleben, "he
[Buchholz] worked very keenly. Now in the studio,
now in the open air, he was relentlessly busy.
Yes, when he was outside, this man — usually so
silent — could become enormously inspired by a
motif or eloquent in response to a particular atmos-
phere."

5 In the fouteeenth century there emerged a
term, *Webit*, or *Wepet*, signifying a sort of swamp,
to describe the water-logged forest floor (caused by
the presence of numerous springs deriving from the
nearby River Ilm).
6 See Hoffmann-Fallersleben.
7 Karl Lindermann, "Karl Buchholz. Leben und
Werk" (re-copied version of 1946 of Ph.D. diss.,
originally Breslau 1941), pp. 26 ff., fig. 29.

8 The date inscribed on the painting in Leipzig is
difficult to read and has often been cited as 1877.
Recent research allows us, however, to date the
picture to 1873.
9 Hans Rosenhagen, "Karl Buchholz," in *Velhagen
& Klasings Monatshefte* 27/3 (1912–13). p. 45: "He
was a quiet, introverted man, who preferred to keep
to himself, avoiding the company of others and
having only one true friend: music, to which he
was passionately devoted."

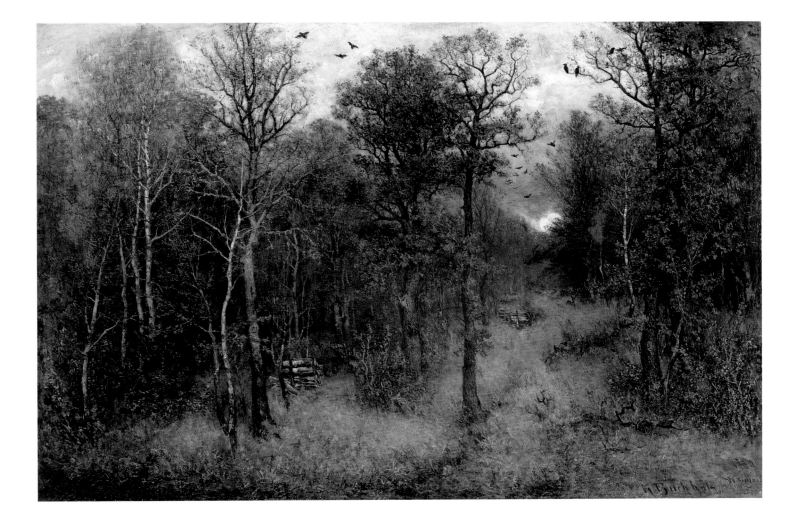

59 Franz von Lenbach
1836–1904

Portrait of Fritz von Harck

1879

Oil on canvas, 53 x 41 cm
Signed at the upper right: F. Lenbach 79.
Inv. no. 1386

Provenance: painted in Munich for Fritz von Harck, and remaining in the family collection after his death in 1917; in 1944 acquired by the Leipzig Museum, along with twenty-eight paintings as a bequest from Fritz von Harck

As the prototype of the painter of the *Gründerzeit* (the early years of the Second German Empire, founded in 1871), Franz von Lenbach brilliantly catered to the need among the nobility and the upper middle classes to have imposing portraits made of themselves. He developed a style of portraiture that satisfied public taste and also demonstrated great technical refinement, all the while conveying psychological empathy for his subjects. Among the eleven paintings by Lenbach in the Leipzig Museum, all except for a female half-figure nude depict high-ranking personages such as the Emperor Wilhelm I, King Ottto of Saxony, Helmut Count Moltke, and the Imperial Chancellor Otto von Bismarck. This group also includes four figures who had close connections to Leipzig: the composer Richard Wagner (1880); the collector Julius Otto Gottschald (1896), who presented an outstanding collection of fifty, mostly seventeenth-century Dutch paintings, to the Leipzig Museum; Franz von Holstein, the poet and composer; and Fritz von Harck.

Franz von Lenbach painted Harck, a young banker turned art scholar, in Munich in 1879, a year or so before Harck made what was probably his most significant purchase of a work of art. At this time, Harck kept company with Lenbach in addition to other artists such as Bruno Piglhein, Louis Neubert, Lorenz Gedon, Wilhelm Hecht, Wilhelm Busch, and Gotthard Kuehl. A true cosmopolite, whom the Leipzig archaeologist Franz Studniczka described as "one of van Dyck's cavaliers come to life,"[1] Harck was truly esteemed and appreciated in such a circle. Harck committed himself wholeheartedly to recruiting members for the association of the Friends of the Leipzig Kunstgewerbemuseum (Museum of Applied Arts). He was a member of the Leipzig *Kunstverein*. After a long struggle with cancer, Harck died in Leipzig in 1917.

In his will, Harck stipulated that almost all of his possessions should go initially to his wife Helene, but after her death they should become the property of the city of Leipzig. In Leipzig both the Kunstgewerbe-museum and the Museum der bildenden Künste received works of art and substantial sums of money as part of the Fritz von Harck bequest, while the collector's extensive library went to the Kunsthistorisches Institut (Art Historical Institute) in Florence, of which he had been a member. The most significant part of Fritz von Harck's art collection consisted of primarily Italian Renaissance works of applied art, including ninety-three especially valuable pieces of majolica. His collection of paintings, which he had assembled based on advice from the art historian and Berlin museum director Wilhelm von Bode (a friend and former fellow student), revealed above all his passion for Italian art.

A relevant commentary on Lenbach's remarkably unadorned portrait of Harck, which is nonetheless imposing in its self-confident turn of the head, can be found in a striking passage from Harck's obituary: "[the painting] is certainly a precious work of art, but it imbues his quintessentially Germanic appearance with a quality that is oriental. Moreover, we possess no adequate artistic or photographic record of Harck, who in his modesty shunned these. Yet, would that we did! His appearance, both as a young man and in his maturity, was so enchanting that one hardly ever encounters its equal in Germany. His energetic profile with the noble curve of his nose imbued his small head with real virility; the brown coloring of his face provided a pleasant contrast with blue eyes that sparkled with a world of charm, joy in life and humor. In build he was of medium height, slim and well-proportioned. The harmony of his body corresponded to that of his movements. A natural grace gave his appearance a sense of lightness and elegance. And, as a keen sportsman, he had acquired a pleasing physical elasticity and mobility. Above all, Harck was a first-rate horseman and a superb shot. He was also extremely well-dressed, without drawing attention to himself; and, although he never spent a great deal on his wardrobe, his clothes appeared to fit him as perfectly."[2] DS

1 Cited in "Karl-Heinz Mehnert, Fritz von Harck. 1855–1917," in Thomas W. Gaethgens, ed., *Museum der bildenden Künste Leipzig* (2nd ed., Paris 1997), p. 30.
2 *Die Stiftung Fritz von Harck an die Leipziger Museen* (Leipzig 1922), p. 13.

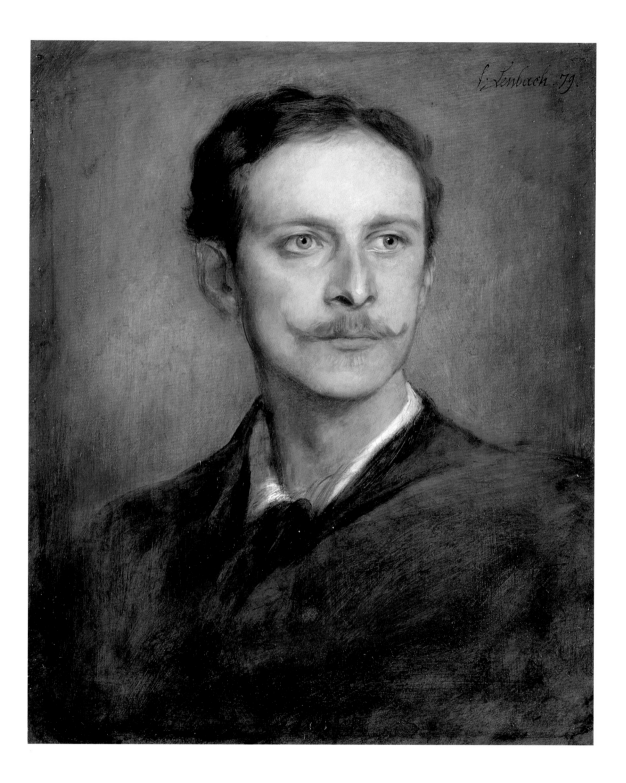

60 Max Liebermann

1847–1935

The Preserve Makers

1879

Oil on wood, 41 x 65.3 cm
Signed at the lower right: M. Liebermann
Inv. no. 738

Provenance: acquired in 1880 by the art dealer Thomas, of Paris; later, until 1897, in the possession of Léon Maitre, of Paris; in 1897 acquired at the principal Berlin exhibition of that year with funds derived from the Theobald Petschke-Stiftung

At the start of his career, Liebermann painted primarily portraits of his friends and relatives, but he also made studies of heads in the tradition of Franz von Lenbach and the artists of the Leibl Circle. In the early 1870s, however, Liebermann painted his first records of people at work and subjects he discovered on trips to Holland. By now, he focused on rendering the most varied types of handicraft and rural labor—the sort of tasks usually performed by women—and on evoking the character of the rural and village settings of such work.[1]

In the summer of 1872, in a shack at the harbor in Amsterdam, Liebermann happened upon a group of women preparing vegetables for preservation. He made a drawing[2] and an oil study[3] of them, and this scene became a new motif for him. A week after returning from Holland, Liebermann completed a painting that has since been thought to be the first version of the composition now in the Leipzig Museum.[4] On the advice of his Belgian teacher Charles Verlat, Liebermann sent this picture in August 1873 to the International Exhibition in Antwerp. Here, it was so rapturously received that the organizers made the mistake of selling it twice. A dispute concerning the rightful ownership of the exhibited picture resulted in a legal requirement that Liebermann paint a second version to be sold to the second of the two original buyers at a lower price. Liebermann painted this second version of the first composition[5] in the fall of 1873.[6] Six years later, he returned to the motif

and in the winter of 1879 he embarked on a second composition;[7] this picture is now in the Leipzig Museum.

In 1879, Liebermann departed from his initial composition in such a noticeable way that the painting comes closer to the aforementioned drawing of 1872. Both young and old women, seated on wooden benches and barrels, are shown cleaning vegetables. The interior they occupy is smaller than that depicted in the earlier painting and the figures partially overlap. As a result, the group appears more compact. The individual features of each woman are precisely rendered, yet the artist's focus on the activity portrayed and on the women absorbed in their work preserves the anonymity of each figure. Thus, Liebermann creates a respectful distance between him and the workers and, in turn, between the workers and the viewer.

When the picture of 1879 was first exhibited in Berlin, it aroused great anger among the art critics. Liebermann had to contend with accusations of having presented "a collection of hideously ugly women."[8] Several years passed before the aesthetic quality of the work was recognized and acknowledged publically. A pencil study, now in the Kupferstich-Kabinett in Dresden,[9] shows the figure of a woman in three-quarter profile bending to the right as she cleans vegetables; in the painting the figure is reversed. SP

1 On these subjects in Liebermann's oeuvre, see Katrin Boskamp, *Studien zum Frühwerk von Max Liebermann mit einem Verzeichnis der Gemälde und Ölstudien von 1866–1889* (Hildesheim, Zürich and New York 1994), pp. 32–47.
2 Composition sketch for *The Preserve Makers*, pencil, untraced; cf. Erich Hancke, *Max Liebermann. Sein Leben und seine Werke* (Berlin 1914), illustration on p. 149.

3 Untraced; see Matthias Eberle, *Max Liebermann. 1847–1935. Werkverzeichnis der Gemälde und Ölstudien*, vol. 1 1865–1899 (Munich 1995), no. 1872/9, p. 51, illustration on p. 52.
4 Winterthur, private collection; see Eberle, no. 1872/10, pp. 51–54, illustration on p. 53.
5 Switzerland, private collection; see Eberle, no. 1873/15, pp. 64ff., illustration on p. 66.
6 On the various compositions cf. also Eberle, pp. 51–54, 64ff. On the basis of style and prove-

nance, Katrin Boskamp succeeded in reconstructing an alternative sequence: in her view it was the study (cited in note 3, above) that was shown at the exhibition in Antwerp and that may thus be presumed to be the starting point for the subsequent repetition of the motif. According to this argument, the picture formerly regarded as the first version (cited in note 4, above) was in fact the second. See Boskamp, pp. 125–27.

7 See Eberle, no. 1880/2, pp. 178–81, illustration on p. 179.
8 Rosenberg in *Kunstchronik* 23/45 (October 4, 1888), p. 718, cited in Eberle, p. 180.
9 *Old Woman Cleaning Vegetables*, 1879 (?), pencil, Dresden, Staatliche Kunstsammlungen, Kupferstich-Kabinett, inv. no. C 1888–70–78; see Ruth Göres, "Die Handzeichnungen Max Liebermanns. Ihr Verhältnis zu seiner Malerei, ihr Beitrag zum Realismus" (Ph.D. diss., East Berlin 1971), no. 106.

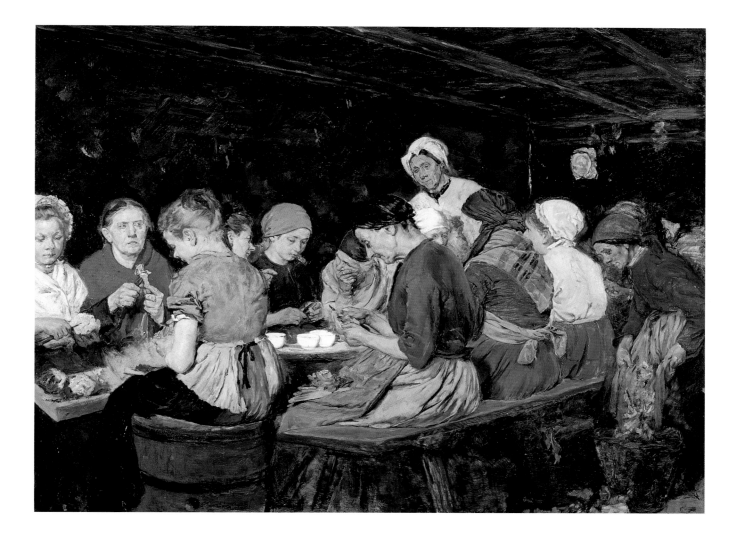

61 Max Liebermann

1847–1935

*Peasant Sitting in the Dunes
(Rest in the Dunes; In the Dunes)*

1896

Oil on canvas, 108.3 x 151.5 cm
Signed at the lower right: M. Liebermann
Inv. no. 723

Provenance: acquired in 1896 directly from the artist with funds derived from the
Theobald Petschke-Stiftung

Peasant Sitting in the Dunes[1] is one of the later, monumental images of workers painted by Max Liebermann. The artist intended this subject to form part of a series he had conceived, which would include such successful earlier pictures as the *Woman with Goats* (1887).[2] In connection with the preparatory drawings for another earlier picture, the *Walking Man* (1894),[3] which can be regarded as a pendant to the painting in the Leipzig Museum, Liebermann had already made a small oil study[4] that shows the seated man, though still without walking stick or basket, and in a more upright position.

Liebermann's model, who also posed for the *Walking Man*, was in real life a *kaaskoper*, a cheese peddler, who roamed alone across the barren dune landscape from village to village. He appears to be one of the most isolated figures that Liebermann ever painted.

The painting is based on a previously unknown oil sketch, which appears to have been made from nature[5] and is a third smaller in size than the finished picture. For the oil sketch, the man sits upright in the long grass so that both he and his basket are half-hidden. This arrangement was significantly altered in the final version: the figure now stands out clearly against the dune landscape. Bent with age and burdened with the basket that he has placed on the ground, he sits by the side of the path, leaning on his walking stick. His facial features are more strongly worked and reveal his exhaustion as he contemplates his solitude. In the landscape setting, the fresh green cedes to the now increased brown and yellow tones, producing a much bleaker effect.

Liebermann made many studies in preparation for the final painted composition; most of these must have predated the oil sketch. They include a rough drawing in charcoal,[6] four painterly drawings in chalk and charcoal for the seated figure,[7] and a study of the head.[8]

Response to Liebermann's picture, both from the public and among critics, was divided. While some complained about the "harshness of the painting technique" and a "certain overly insistent quality,"[9] others praised the strong emotional content of the composition. Early reviews referred to the painting as *The End of the Day* and in 1909 Liebermann used the figure of the man to illustrate the letter "Z" in a pictorial alphabet. The sentimentality of the painting prompted some to assume that Liebermann may have been thinking of his father, who was then dying, when he created the work. When the picture was included in the fifth exhibition of the artists' association *Die Elf* [The Eleven] at Eduard Schulte's gallery in Berlin, one reviewer commented: "The picture of the dunes, an old man with a basket on his back sitting in the dunes, is one of the best works from both the graphic and the chromatic points of view."[10] SP

1 Matthias Eberle, *Max Liebermann. 1847–1935. Werkverzeichnis der Gemälde und Ölstudien* vol. 1: *1865–1899* (Munich 1995), no. 1896/I, pp. 440–43, illustration on p. 441.
2 Munich, Bayerische Staatsgemäldesammlungen, Neue Pinakothek; see Eberle, no. 1890/I, pp. 352–54, illustration on p. 351.
3 Destroyed in the Second World War; see Eberle, no. 1894/10, pp. 417ff., illustration on p. 419.
4 Saint Petersburg, State Hermitage; see Eberle, no. 1894/6, p. 414 with illustration.
5 Prague, Národní Galerie, inv. no. O-10989; see Eberle, no. 1895/11, p. 436, illustration on p. 437.
6 *A Peasant Seated by the Side of a Path, with a Basket on his Back and a Walking Stick*, charcoal, private collection, published in *Max Liebermann in seiner Zeit* (exh. cat., West Berlin 1979), no. 279 recto, p. 550, illustration on p. 55.
7 *Seated Peasant with Basket and Walking Stick*, chalk, Berlin, Staatliche Museen zu Berlin, Preussischer Kulturbesitz, Kupferstichkabinett und Sammlung der Zeichnungen, inv. no. SZ 4; published in Ruth Göres, "Die Handzeichnungen Max Liebermanns. Ihr Verhältnis zu seiner Malerei, ihr Beitrag zum Realismus" (Ph.D. diss. East Berlin 1971), no. 6; *Seated Peasant (without Basket) and Walking Stick*, chalk, Dresden, Staatliche Kunstsammlungen, Kupferstich-Kabinett, inv. no. C 1897–8); see Göres, no. 137; *Seated Peasant with Basket in the Dunes*, chalk, Moscow, Pushkin Museum, inv. no. 6108; see Göres, no. 515; *Seated Peasant*, charcoal, Sotheby's Munich, sale of November 9, 1988, no. 40 with illustration; cf. Eberle, p. 442.
8 *Study of a Peasant's Head turned toward the Right with Folded Hands*, chalk, Moscow, Pushkin Museum, inv. no. 6107, see Göres, no. 514.
9 Erich Hancke, *Max Liebermann. Sein Leben und seine Werke* (Berlin 1914), p. 351.
10 Jaro Springer, "Die Ausstellung der XI," in *Kunst für Alle* 11 (1895–96), p. 212; cited in Eberle, p. 443.

62 Max Liebermann

1847–1935

Self-portrait in a Suit, Seated

c. 1917

Oil on canvas, 93.5 x 71.5 cm
Signed at the upper right: [dedication and year later removed]/M Liebermann
Inv. no. 2172

Provenance: in the Schulz Collection; acquired by the Leipzig Museum in 1968

Max Liebermann produced many self-portraits—in the form of drawings, lithographs, etchings, and paintings. While these constitute a substantial part of the artist's oeuvre, their exact number is difficult to calculate. Hermann Kunisch, who conducted thorough research into Liebermann's self-portraits,[1] concluded that there must be more than one hundred of them, although most of these are drawings or prints. Nonetheless, a substantial number of imposing medium- and large-scale painted self-portraits do exist. The earliest of these dates from 1866,[2] and Liebermann painted it when he was only nineteen and was a pupil of Carl Steffeck. Shortly thereafter, in 1873, he painted a bizarre and atypical portrait of himself as a cook in front of a luxuriant still life of vegetables.[3]

Liebermann's series of self-portraits gets fully under way some thirty years later. Surprisingly, not until he reaches age fifty-five does the artist embark on an intensive period of self-observation and self-questioning. From 1908, Liebermann depicted himself as an artist. Also notable is that a great many of Liebermann's self-portraits were produced in connection with specific events, personal experiences, or twists of fate.

Self-portrait in a Suit, Seated[4] presents the aging Liebermann as a dignified figure who is conventionally dressed in a pale gray, high-buttoned waistcoat and a dark gray suit. Against a neutral background, he strikes a calmly dignified pose as he is shown seated on a stool sitting with his legs crossed. He directs his thoughtful, but also somewhat absent, gaze at the viewer. The artist gives no visual clue to his profession.

As the date and dedication originally inscribed on this picture were removed, it is extremely difficult to establish exactly when it was painted. While the older literature[5] compares it with a self-portrait of 1918, now in the Kunsthalle in Mannheim,[6] and dates it to approximately 1917, Matthias Eberle assumes it to be later. On the basis of the similarity in both facial expression and pose with the *Self-portrait in a Suit* of 1928,[7] he proposes a dating of 1929. In early 1922, when he was suffering, and then recovering, from a serious illness, Liebermann painted a series of self-portraits recording his appearance in both conditions. It is possible that the painting in the Leipzig Museum was also made in the context of the artist's preoccupation with age and illness. The Leipzig Museum also possesses one of the earliest of Liebermann's drawn self-portraits.[8]

SP

1 Hermann Kunisch, "Max Liebermanns Selbstbildnisse," in *Jahrbuch Preussischer Kulturbesitz* 24 (1988), pp. 333–72.
2 Untraced; Matthias Eberle, *Max Liebermann. 1847–1935. Werkverzeichnis der Gemälde und Ölstudien*, vol. 1: *1865–1899* (Munich 1995), no. 1866/1, p. 30 with illustration.

3 Gelsenkirchen, Städtisches Museum, inv. no. Ib 62/3; see Eberle, no. 1873/13, p. 63, illustration on p. 65.
4 See Eberle, vol. 2, *1900–1935* (Munich 1996), no. 1929/5, p. 1204, illustration on p. 1205.
5 Cf. among other commentators, *Max Liebermann. Zeichnungen, Graphik, Gemälde: Kataloge der*

Graphischen Sammlung, vol. 3 (Leipzig 1974), unpaginated [p. 36], unnumbered fig. [fig. 37].
6 Mannheim, Kunsthalle, inv. no. M 466; see Eberle, vol. 2, no. 1918/3, pp. 949 ff., illustration on p. 950.
7 Private collection; see Eberle, vol. 2, no. 1928/4, pp. 1188, 1190, illustration on p. 1188.

8 *Self-portrait*, 1902, chalk over charcoal, Leipzig, Museum der bildenden Künste, Graphische Sammlung, inv. no. I.2334; see Ruth Göres, "Die Handzeichnungen Max Liebermanns. Ihr Verhältnis zu seiner Malerei, ihr Beziehung zum Realismus" (Ph.D. diss., East Berlin 1971), no. 181.

63 Edmund Kanoldt

1845–1904

Hero and Leander

1883

Oil on canvas, 195 x 122 cm
Signed at the lower right: EDMUND KANOLDT Karlsruhe 1883
Inv. no. 2162

Provenance: assigned to the Leipzig Museum in 1968 by the Ministry of Foreign Affairs
of the former German Democratic Republic

According to the ancient tale, every night Leander swam across the Hellespont from Abydos to the city of Sestos, where Hero served as a priestess at the Temple of Aphrodite. She would place a lamp in a window of the tower where she spent the night so that Leander should not lose his way. When, during the course of a particularly stormy night, the wind extinguished Hero's lamp, Leander drowned, and Hero, inconsolable over discovering his fate, plunged to her death from the tower.

Interestingly, Edmund Kanoldt did not follow the iconographic tradition of representing this story, which Franz Grillparzer had popularized in Germany in his play of 1831, *The Waves of the Sea and of Love*. The prevailing convention was to show either Leander swimming in the foreground with the lit window in the tower in the distance, or the scene in which Hero recognizes the corpse of her lover in the churning waves and kills herself. Kanoldt, however, depicts Hero, alone on the rocky shore at dawn, her extinguished lamp in her hand, looking out to sea, still full of desire but already with a sense of foreboding. On the cliffs above her, with the storm still raging, there looms the tower that once held out the promise of happy arrival but is now only a somber, brooding presence.

Kanoldt had treated the story of Hero and Leander previously. Fueled by the success of his painting *Odysseus Hunting after Goats* (1877),[1] which he had entered in a competition for the prize awarded by the Goethe-Stiftung in Weimar, Kanoldt became attracted to ancient Greek mythological themes. Between 1877 and 1886, he painted eight landscapes incorporating mythological figures, among them *Landscape with Hero awaiting Leander* (c. 1883).[2] In two subsequent versions of this theme—one of these the painting now in the Leipzig Museum,[3] the artist introduced only minor alterations into the composition, but he made the overall dimensions of the picture smaller. Preceding these in date was a small painted study,[4] focusing on the figure of Hero and the rocks immediately surrounding her. Only one charcoal drawing has been published as related to this painting: it shows Hero at the moment when she spies the drowned Leander at sea.

In 1886, the aforementioned series of eight paintings, illustrating the stories associated with Iphigenia, Sappho, Thetis and Achilles, Echo and Narcissus,[6] Hero, Dido and Aeneas, Cassandra, and Antigone, were reproduced in a portfolio published by Velte in Karlsruhe; the following year, with the addition of two subjects, and with poems by Alma Leschivos, this collection was republished by Amelang in Leipzig.[7] All the paintings share an emphatically vertical format and an almost unchanging compositional structure. As if viewing the scene from an elevated position, one looks across a dark foreground beyond the main character, who is positioned close to the edge of the composition. In the background loom the powerful landscape forms, each contrasted to a distant view across flat terrain or to a view of the sea. Intersecting diagonals link different parts of the composition and add depth to the picture space. The sky is invariably threatening, as are the contrasts of light and shade, all of which contribute substantially to the pictorial drama.

DS

1 Weimar, Staatliche Kunstsammlungen, Schloss-museum, inv. no. G 405b; see Angelika Müller-Scherf, *Edmund Kanoldt. Leben und Werk* (Pfaffen-weiler 1992), no. 62, p. 200.
2 Karlsruhe, Staatliche Kunsthalle, inv. no. 775; see Müller-Scherf, no. 134, pp. 233 ff.
3 Second version; see Müller-Scherf, no. 135, p. 234, and no. 136, p. 235; and *Hero*, c. 1883,

Euerbach, Georg Schäfer Collection, inv. no. 74382291 (erroneously titled *Iphigenia*).
4 Cf. *Edmund Kanoldt. Landschaft als Abbild der Sehnsucht* (Karlsruhe 1994), no. 43, p. 237, fig. on p. 163 (illustrated belonging to a private collection); see Müller-Scherf, no. 133, p. 233 (erroneously identified as in the possession of the Städtisches Gustav-Lübke-Museum, Hamm).

5 C. 1883, private collection; see Müller-Scherf, no. 589, p. 388.
6 The Leipzig Museum also has painted views of the compositions *Thetis and Achilles* and *Echo and Narcissus* (inv. nos. 2161 and 2163, respectively) that correspond in their dimensions with the *Hero and Leander* and, without doubt, once formed part of the same pictorial ensemble; cf. see Müller-Scherf,

no. 132, p. 232, and no. 145, p. 239, respectively. An oil composition sketch, previously ignored by critics, for *Echo and Narcissus* was presented to the Leipzig Museum as a long-term loan from a private collection in 1998, inv. no. D 112.
7 See Müller-Scherf, pp. 61–69.

64 Fritz von Uhde

1848–1911

"Suffer Little Children to Come Unto Me"

1884

Oil on canvas, 188 x 290.5 cm
Signed lower left: F. v. Uhde/1884
Inv. no. 550

Provenance: acquired in 1886 from the artist, Munich, through the Council of the City
of Leipzig, with funds from August Adolf Focke

With the work "*Suffer Little Children to Come Unto Me*," Fritz von Uhde made his first major impact on the art world. It not only is his first religious work—it also is one of his most important works depicting children. This painting was considered revolutionary because Uhde transposed a biblical scene to contemporary life. The realistic depiction of lower-class Germans in this context was met with incomprehension, even consternation. Neither the public, the art critics, nor conservative church circles were ready to accept this painting, though Uhde himself considered it one of his masterworks.[1] After much heated discussion, the Museum der bildenden Künste Leipzig bought the work in 1886, just two years after he completed it.[2]

Uhde renders Christ barefoot, clothed in a simple blue robe, and seated on a high-backed wooden chair at the right of a well-lighted, unornamented hall or school room. Following the biblical text, Jesus is surrounded by a group of children of various ages, who react to His presence in different ways. Most of them express a sense of awe. Yet one of the smaller children innocently has placed his head on Christ's lap;

the other, the little blond girl directly in front of Him, has reached out her hand to touch His. In their interaction, in the warmth radiating from this central focal point, Uhde has tried to go beyond the achievements of the French Impressionists. Along with Max Liebermann, Uhde had most completely absorbed the new technique. He expressed, however, his intention of adding another dimension to his work. "Rather than just a depiction of nature, I searched for something like soul," Uhde said. "I was occupied with painting children, studying them was more rewarding to me than studying adults at that time. I also wanted to give more to the children."[3]

Uhde's outstanding achievement was portraying children with great sensitivity and understanding, without veering into saccharine or genrelike cuteness as some of his contemporaries did. Uhde produced a large number of paintings of children, often using his three daughters whom he was raising by himself. This work is also the starting point of a series of biblical paintings, all in contemporary settings, in which Uhde expresses his deep religious feelings. HKA

1 Hans Joachim Neidhardt, *Deutsche Malerei des 19. Jahrhunderts* (Leipzig: Seemann, 1997), pp. 215–16.
2 Dorothee Hansen, ed., *Fritz von Uhde, Vom Realismus zum Impressionismus*, exh. cat. (Ostfildern-Ruit: Hatje, 1998), p. 90.
3 Ibid.

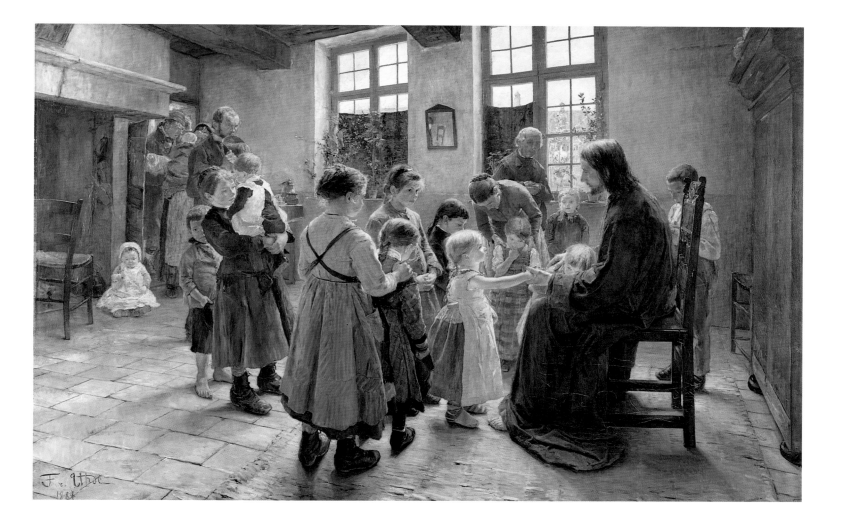

65 Fritz von Uhde

1848–1911

In Autumn (Shepherdess on the Moors near Dachau)

1890

Oil on canvas, 68.5 x 89 cm
Signed lower left: F. Uhde
Inv. no. 1308

Provenance: Wilhelm Weigand, Munich (1893 at the latest); in the collection of Henri
and Martha Hinrichsen, Leipzig (after 1924); acquired from the collection of Henri and
Martha Hinrichsen by the Museum der bildenden Künste Leipzig in 1939; returned to
Walter Hinrichsen, Chicago, in 1945, who left it to the Museum der bildenden Künste
Leipzig as part of the Henri and Martha Hinrichsen-Bequest

In the years following his masterwork *"Suffer Little Children to Come
Unto Me,"* 1884 (see cat. no. 64), Uhde concentrated on works of reli-
gious themes as well as on portraits of children. A landscape such as *In
Autumn*, therefore, represents an exceptional type of painting. Uhde re-
garded the painting not as a therapeutic antidote to his more intense re-
ligious works, but as a continuing process in the study of nature.[1] Here,
the lightness of the palette, consisting mainly of various shades of greens,
the open brushwork, and the incidental theme exemplify Uhde's mas-
tery of pleinairism, as developed by his French contemporaries.

In Autumn shows a serene yet somewhat melancholic landscape of
an empty field stretching deeply into the background on the left. A
small, tree-lined brook cuts the scene diagonally into two unequal parts,
separating the shepherdess from the cow. The feeling of a casually ob-
served, everyday situation prevails in this work. Compared to Uhde's
religious works, there is neither explicit action nor a theme of a story
related. The shepherdess with her back turned to the viewer defies all
interaction, her self-contained silhouette and introverted attitude em-
bodying the melancholy mood that permeates this painting. With his
Impressionistic technique and choice of an everyday subject matter,
Uhde clearly expresses his Secessionistic or *Jungendstil* tendencies and
confirms his reputation as one of the founders of modern painting in
Germany. HKA

1 Dorothee Hansen, ed., *Fritz von Uhde, Vom
Realismus zum Impressionismus*, exh. cat. (Ost-
fildern-Ruit: Hatje, 1998), p. 128.

66 Arnold Böcklin

1827–1901

The Island of the Dead V

1886

Enamel paint on wood, 80.7 x 150 cm
Signed above the lintel of the tomb on the extreme right: AB
Inv. no. 563

Provenance: acquired in 1886 through the *Kunstverein* (Art Association) of Leipzig from the art dealer Fritz Gurlitt, with funds from the Franz Dominic Grassi-Bequest

The Island of the Dead V is the final version of this subject painted by Böcklin between 1880 and 1886. Maria Berna, later Countess Oriola, who had just been widowed, commissioned him to paint a "painting for dreaming."[1] In this monumental and inspiring work, Böcklin achieved a maximum of effect with a minimum of elements, as Heinrich Wölfflin phrased it.[2] All five versions represent a view of a small, rocky island characterized as a necropolis by the tomb openings and a central group of cypresses. A small rowboat approaches over the quiet water, carrying a tall, veiled figure and a coffin. In the Leipzig painting, the viewer is closest to the island, whose rock formations are higher and whose semicircular shape is even more compact than in the earlier versions. The very low horizon gives the impression of a vast expanse of sea that surrounds this island. The lowering clouds and the cypresses, whose tops seem to be bending in the wind, are in odd contrast to the completely motionless water. The stillness conjured up by this scene is very much intentional. Böcklin said, "It shall become so quiet that you are frightened by a knock at the door."[3]

There can be no doubt that the viewer is about to witness a ritual performed in a sacred place. The Etruscan-type tomb openings and the veiled figure allude to Antiquity, the time of myths and ancient heroes that preoccupied Böcklin's imagination throughout his life. Although the island has the hushed, sanctified quality of an ancient holy site,[4] it corresponds neither to the description of the Elysian Fields where the Greek heroes enjoy the pleasures of eternal life, nor to the image of Charon ferrying the dead across the river Styx to the underworld. There has been much speculation about the actual site, but no particular island has been identified.[5] As Böcklin's approach to landscape painting was never a literal translation of a particular place, it is perhaps futile to search for the actual location that inspired him.[6]

Böcklin achieved monumentality in this work by reducing his composition essentially to horizontals and verticals and by rigorously adhering to the concept of centralized symmetry. The island consists of a compact group of verticals, sharply rising from the horizontal plain of the still water. Only the retaining wall, made up of large boulders, serves as a transition between the two contrasting bodies. The small boat constitutes the only diagonal. It, in turn, contains within its very limited space the same contrast of vertical and horizontal in the veiled figure and the draped coffin. Böcklin uses the contrast of size to reflect the insignificance of man and eternity of death. The palette is extremely limited, consisting mainly of ochers, grays, and greens, from which the white of the veiled figure and coffin, and red of the flower garlands stand out.

With this work Böcklin touches on a fundamental predicament in man's existence: his dilemma that on the one hand no man is an island, but that on the other hand he often perceives himself as being isolated from his fellow man. The perception was recognized not only by Böcklin's contemporaries, it inspired numerous artists and has lost none of its significance for viewers today. HKA

1 Andrea Linnebach, *Arnold Böcklin und die Antike, Mythos, Geschichte, Gegenwart* (Munich: Hirmer, 1991), pp. 102–3. The first version, today in the Kunstmuseum Basle, Böcklin set aside unfinished and painted a second version for Maria Berna, which is in the Metropolitan Museum of Art, New York, today. The third version, which was acquired by Adolf Hitler in 1933, is now in the National-galerie (SMPK) in Berlin. The fourth version is lost. The final version, painted in 1886, was acquired by

the Museum der bildenden Künste Leipzig, in the same year.
2 See Linnebach, *Arnold Böcklin und die Antike, Mythos, Geschichte, Gegenwart*, p. 101.
3 Gert Schiff, *German Masters of the Nineteenth Century, Paintings and Drawings from the Federal Republic of Germany*, exh. cat. (New York: The Metropolitan Museum of Art, 1981), p. 29.
4 See Linnebach, p. 116.
5 The island has alternately been identified as

St. Jurai, south of Dubrovnik in Croatia, the island of Pontikonissi near Corfu, Greece, the Ponza Islands in the Gulf of Gaeta, Italy, and with the castle of Alfonso of Aragon on the island of Ischia, Italy. The latter two sites were the only ones familiar to Böcklin who stayed in Ischia in 1879 and 1880, as mentioned by Franz Zegler, *Arnold Böcklin. Die Toteninsel. Selbstheroisierung und Abgesang der abend-ländischen Kultur* (Frankfurt am Main: Fischer Verlag, 1991), pp. 13–14. The same source notes that in an

interview with his pupil Friedrich Albert Schmidt, Böcklin had named Castle Alfonso as his inspiration. This statement, however, is undocumented.
6 Böcklin himself never referred to it as the *The Island of the Dead*, a title invented by the very astute art dealer Fritz Gurlitt, but rather as the "painting for dreaming" or the "Island of Tombs" ("Gräber-insel"), according to Linnebach, *Arnold Böcklin und die Antike, Mythos, Geschichte, Gegenwart*, p. 102.

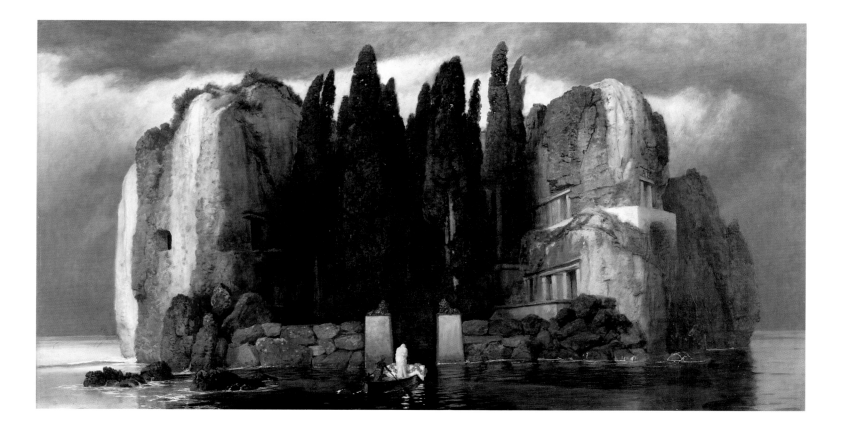

68 Josef Wenglein

1845–1919

Late Autumn on the Isar River

1892

Oil on canvas, 186.5 x 263 cm
Signed lower right: J. Wenglein 92/*Muenchen*
Inv. no. 699

Provenance: acquired in 1892 from the artist in Munich, with funds from the Theobald
Petschke-Bequest

The Isar River, which flows from the Alps through Munich and into the Danube, served as inspiration for many of Wenglein's landscapes. Here, Wenglein renders it not as the rushing stream carrying the melted snow from the mountains, but during the fall, as a nearly dry riverbed. The exposed rocks, the eddies and pools formed by the slowly flowing river, and the uprooted dead trees that spring torrents have left behind are rendered with precision and in great detail. A ridge along the riverbank with a higher elevation at the right divides the canvas nearly in equal halves. In the hazy distance at the left, the snow-covered peaks of the Benediktinerwand, part of the Bavarian Alps, are visible. The melancholy mood is heightened by the cloudy, gray sky.

Unlike Heinrich Bürkel, who had found inspiration in the spectacular mountain views and picturesque villages of Upper Bavaria, Wenglein was inspired by the flat expanse of the moors and the valley of the Isar, rendered here on a typically gray, autumn day. The impact of the large dimensions of this panoramic view is enhanced by Wenglein's choice of color, limited to subtle gradations of grays, blues, and beiges. This almost monochromatic palette underscores the emptiness of the scene, which is devoid of all animate life; the damp cold of a late autumn day is almost palpable.

From Adolf Lier, his professor at the Munich Academy of Art, Wenglein had absorbed the teachings of Courbet, whose unflinching realism had made a decisive impact on him.[1] But Wenglein had undoubtedly also studied the works of Carl Rottmann (see cat. nos. 18 and 19), whose Greek cycle, 1838–50, in particular, shows a tendency toward unpeopled and monumental landscapes. His emphasis on the tectonic qualities of the geological structures also must have impressed Wenglein. His work documents the continuation of stylistic traditions in Munich landscape painting. HKA

1 Heidi Ebertshäuser, *Malerei im 19. Jahrhundert,*
Münchner Schule (München: Keyser, 1979), p. 133.

69 Hugo von Habermann

1849–1929

Portrait of a Young Woman

1889

Oil on canvas, 131 x 100.5 cm
Signed within the composition: H v HABERMANN. 1889;
inscribed at the lower right: München.
Inv. no. 957

Provenance: in the collection of Philipp Johann Sparkuhle, in Bremen; acquired in
1913 from the art dealer Fritz Gurlitt, in Berlin, with funds derived from the Theobald
Petschke-Stiftung

Surprisingly, after more than one hundred and fifty years, there is still little definite information on the life and work of Hugo von Habermann. Only one monograph[1] exists, in addition to a few essays published during the artist's lifetime. Recently, on the occasion of an exhibition in the Städtische Galerie, Würzburg,[2] an extended essay was published about one of Habermann's major works, *A Problem Child*, which is in the collection of the Nationalgalerie in Berlin.[3]

Hugo von Habermann briefly outlined his own artistic agenda when he was invited, in 1913, to contribute to a collection of autobiographies of Munich artists and intellectuals: "After abandoning history painting and genre scenes, I painted some landscapes but devoted myself principally to female portraits. I made a thorough and ongoing study of the work of the Old Masters, not to imitate the appearance of their pictures but, rather, to probe their approach to pictorial construction and to use this for contemporary works. In a portrait I seek to achieve rhythm and a sense of movement and, as much as is possible, a constructive use of color; I aim also at incisive characterization, even of the merely charming, and to avoid excessive sweetness, or idiosyncrasy, in the overall approach and the representation, without overlooking the decorative effect of the image."[4]

The *Portrait of a Young Woman* in the Leipzig Museum[5] dates from the first years of the period in which Habermann devoted himself almost entirely to depicting such subjects. The painting shows a young woman leaning over the back of a chair. She appears keenly interested in an event that is occurring outside the depicted area. It is possible that she is observing someone or something through a window, effectively "spying" on an event taking place in the street in hopes of not being discovered. Her pose suggests charm but is also provocative; she seems to feel that she herself is not being observed. Habermann captures the excitement in her face, but he is primarily concerned with the rendering of her hands. This focus was, indeed, typical of his work as a portrait painter.

In preparing to paint *A Problem Child*, Habermann in fact made a separate small painting of the hands of the mother,[6] which he then both signed and dated, thus bestowing on it the rank of an autonomous work.[7] The Leipzig picture is also notable for the earthy tones that were to dominate Habermann's work until the turn of the century. It is impossible to identify conclusively the woman shown in the picture in the Leipzig Museum. Comparison with a portrait painted eight years later, however,[8] suggests that it might be Eugenie Knorr, wife of Thomas Knorr. Knorr was a partner in the well-known Munich publishing firm Knorr & Hirth, which in 1896 began publishing the journal *Jugend*. This publication served as a platform for some of the more culturally and socially progressive forces in Munich. Along with Georg Hirth and Fritz von Ostini, Thomas Knorr was dedicated to supporting the cultural life in the city. He himself was also a passionate collector of contemporary art, not only buying paintings but also commissioning works.

Two preparatory drawings for Habermann's *Portrait of a Young Woman* have been identified:[9] a rather rough drawing in pen and ink omits the details and notes the overall structure of the envisioned picture,[10] the other is a pen-and-ink study of only the head.[11] SP

1 Fritz von Ostini, *Hugo von Habermann* (Munich 1912).
2 Andreas Meyer, Annäherung. *"Ein Sorgenkind" von Hugo von Habermann, zur Ausstellung in der Städtischen Galerie Würzburg* (Würzburg 1994).
3 *A Problem Child*, 1886, oil on canvas, Berlin, Staatliche Musseen zu Berlin, Preussischer Kulturbesitz, Nationalgalerie, inv. no. A I 634.

4 W. Zils, ed., *Geistiges und künstlerisches München in Selbstbiographien* (Munich 1913), p. 136.
5 In his "List of paintings in oil and distemper, and pictures in pastel by Hugo von Habermann," Fritz von Ostini does not mention the picture in the Leipzig Museum.

6 A study of hands for the picture *A Problem Child*, 1886, oil on wood, Würzburg, Städtische Galerie, inv. no. E 6019.
7 Cf. Andreas Meyer, p. 12.
8 *Portrait of Eugenie Knorr*, 1897, oil on canvas, in 1912 in the Knorr Collection, Munich; now untraced; see von Ostini, plate V.

9 Cf. also the thorough entry on the Leipzig painting in *Museum der bildenden Künste. Jahresheft 1999* (Leipzig 2000), pp. 16–23.
10 Sketch for *Portrait of a Young Woman*, pen and ink, Würzburg, Städtische Galerie, inv. no. 04791a.
11 *Study for the Head of a Young Woman*, pen and ink, Würzburg, Städtische Galerie, inv. no. 04803.

70 Max Klinger

1857–1920

The Blue Hour (L'heure bleue)

1890

Oil on canvas, 191.5 x 176 cm
Signed at the lower left: 9 MK [in the form of a monogram] o
Inv. no. 833

Provenance: in the Wertheim Collection, Hamburg, from 1894; acquired in 1904 from
the art dealer Paul Cassirer, in Berlin, with funds derived from the Theobald Petschke-
Stiftung, Leipzig, and additional assistance from art patrons in Leipzig

In a letter of 1891 to his parents,[1] Max Klinger called this painting *The Women around a Fire*.[2] We may assume that Klinger had come to know the Parisian mural *Jeune filles au bord de la mer (Girls by the Sea)*, completed in 1879 by Pierre Puvis de Chavannes,[3] and would have noted how its soft coloring and the peaceful harmonies of its lines succeeded in evoking an atmosphere of calm and melancholy.

In a letter to the Dresden art historian Paul Schumann, Klinger spoke of the origin and the subject of this painting that he had conceived in Paris and had completed in Rome in 1890: "The first inspiration came from the studies of light and color on which I embarked years ago in Paris. I had already composed the picture then. It's only natural that, in the course of such a process, one involuntarily weaves in an idea, and so I've tried here to characterize in as far as possible three different types of contemplation: a passive dreaminess in the darkening evening, a sense of foreboding as one stares into the flames, and lastly, soaring reverie."[4]

In his own composition, Klinger goes far beyond the symbolism of the mural by Puvis de Chavannes. While the latter's figures turn away from the viewer and stare dreamily into the far distance, Klinger sought "… to reach, beyond the traditional pattern for art, a new immediacy and truth to life in the rendering of the nude."[5]

Originally Klinger used the French version of his title, "L'heure bleue," but it appears that the contemporary painting of this name by Albert Besnard has no connection with the German artist's work.[6] A drawn study of the head of the reclining figure has survived; this work is dated December 2, 1890.[7] In 1905, Klinger made a frame for the painting. The shimmering gray-silver tone of the frame does not merely surround the image; it virtually bestows on the work a grave character, the air of a sacred rite. KM

1 Letters from Max Klinger to his parents from Munich (of March 25, 1891) and from Rome (May 4, 1891), cited in *Max Klinger. 1857–1920* (exh. cat., Leipzig 1970), p. 76.
2 *Max Klinger. Bestandskatalog der Bildwerke, Gemälde und Zeichnungen im Museum der bildenden Künste Leipzig* (Leipzig 1995), p. 100, no. B 17.
3 Paris, Musée d'Orsay.
4 Cited in Paul Kühn, *Max Klinger* (Leipzig 1907), pp. 302–3.
5 Friedrich Gross in *Eva und die Zukunft. Das Bild der Frau seit der Französischen Revolution* (exh. cat., Munich 1986), p. 290.
6 According to *Max Klinger. 1857–1920*, p. 76.
7 Leipzig, Museum der bildenden Künste, Graphische Sammlung, inv. no. I 8110; cf. *Max Klinger. Bestandskatalog*, p. 219, no. C 453.

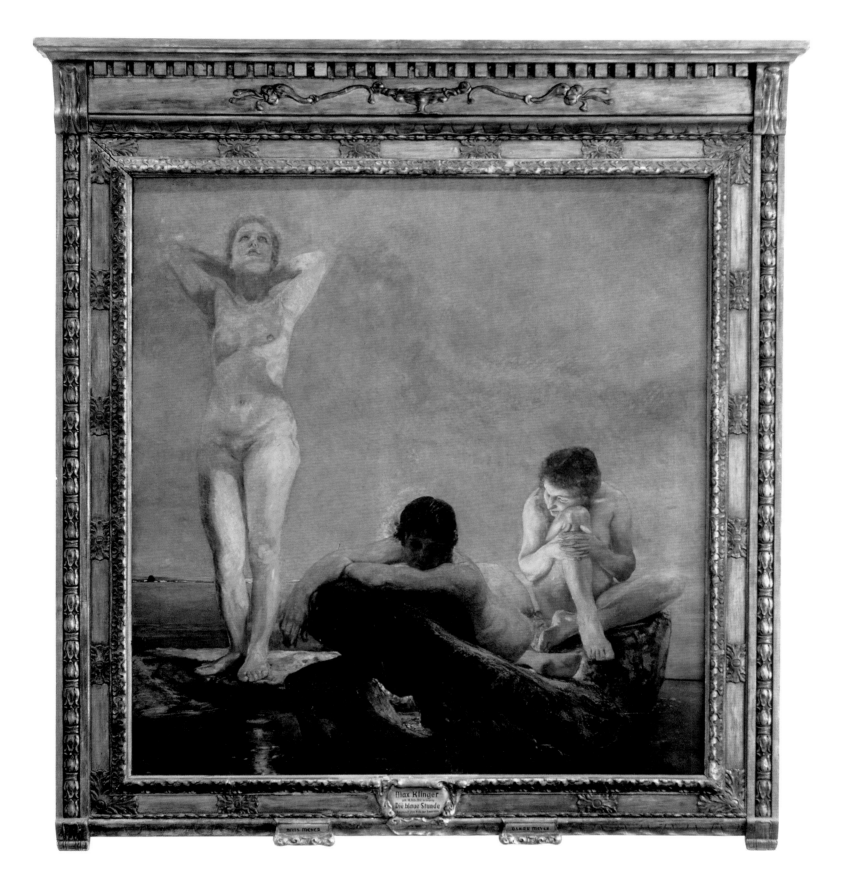

71 Max Klinger

1857–1920

The New Salome

1893

Head, décolletage and hands in Pentelic marble; hair (in present state) slightly stained in brown (originally, the face, throat, and hands in pale yellow); the hair and eyebrows dark brown, the eyes surrounded by dark shadow. Drapery in Hymettian cipolla marble; the head of the youth in Carrara marble; his hair now brownish, the face greenish (originallly deep blue). The head of the old man in Tuscan Porta Santa marble; the eyes of Salome transparent brown amber. The eyes of the youth opaque yellow sandstone. On Salome's left shoulder formerly a shell cameo as a fastening. The base in black Belgian limestone; the circular plinth in dark polished wood; the square support in veined limestone *(campan mélange)* from Bagnères di Bigorre, in the Pyrénées

Total height 192 cm. (figure 88 cm; base 16 cm, plinth 8 cm, support 80 cm)
Signed (formerly) on Salome's right hip in inlaid gold wire: MK [in the form of a monogram] 93
Inv. no. P 25

Provenance: acquired from the artist in 1894 with funds derived from the Theobald Petschke-Stiftung, Leipzig; the base, plinth, and square support presented by the artist in 1895

The New Salome of 1893[1] was Klinger's first important work as a sculptor. His engagement with sculptural polychromy was representative of a movement that had been under way in Germany since the early nineteenth century.

In 1884, Georg Treu, director of the Dresden Collection of Antiquities (the *Antikensammlung*), had published his programmatic text: "Should we color our statues?,"[2] in which he not only posed this crucial question but also showed, by reference to both theory and practice, that the sculptures of Antiquity were, without exception, colored. Treu not only commissioned contemporary artists to paint the surfaces of plaster casts of celebrated pieces from Antiquity; he also encouraged these artists to create their own polychrome sculptures. Arnold Böcklin, Robert Diez, Arthur Volkmann, and, not least, Max Klinger were among those convinced that "[if] one worked with materials appropriate to achieving the desired colored appearance, then … it would be possible to achieve a return to simplicity, to a strict adherence to the sculptural essence and one would be on the way towards the creation of [true] style, that is to say the omission of the inessential, of the mere aping of nature …"[3]

In addition to the *New Salome*, Klinger's *Cassandra* (1895),[4] his bust of Elsa Asenijeff (c. 1899–1900; see cat. no. 73),[5] and his monument to Beethoven (see cat. no. 74) assured colored sculpture in Germany around 1900 and demonstrated Klinger's achievement as a sculptor.

Klinger had been attracted to the story of Salome, and its psychological and philosophical significance, since his days as a student, as evinced by his early drawings.[6] His ideas for the sculpted *Salome* appear to date from at least 1885. A drawing he made in Paris of a coquettish girl in a hat is now generally seen as the origin of the later sculptured figure.[7] Further drawings now in Leipzig and Dresden are preparatory studies for the figure, most of which were executed in Rome.[8] The colored original model, in plaster, were made in Paris in 1887–88.[9] For the head, as also for the figure as a whole, there exist numerous bronze casts and/or reduced versions, in addition to a version in alabaster that was made, with the artist's permission, by the Berlin firm of Gladenbeck and marketed by the Leipzig firm of Carl. B. Lorck. The alabaster version was shown in Paris, London, Rome, New York, and Saint Louis, among other cities, and though not in the original medium, the work secured Klinger's international reputation as a sculptor. KM

1 *Max Klinger. Bestandskatalog der Bildwerke, Gemälde und Zeichnungen im Museum der bildenden Künste Leipzig* (Leipzig 1995), p. 51, no. A.I.
2 Georg Treu, *Sollen wir unsere Statuen bemalen?* (Berlin 1884).
3 Max Klinger, *Malerei und Zeichnung* (Munich 1891), cited in Max Klinger. *Die neue Salome. Meisterwerke aus dem Museum der bildenden Künste*

Leipzig: Dokumentation & Interpretation I (Leipzig 1983), p. 13.
4 Leipzig, Museum der bildenden Künste, inv. no. P 26; cf. *Max Klinger. Bestandskatalog*, p. 52, no. A 2.
5 Munich, Bayerische Staatsgemäldesammlungen; inv. no. B 739; cf. cat. no. 73.
6 *Salome*, pen and black ink, for the (so-called) sketchbook of 1874/77; Leipzig, Museum der

bildenden Künste, Graphische Sammlung, inv. no. NI. 2552; cf. *Max Klinger. Bestandskatalog*, p. 165, no. C 248.
7 Leipzig, Museum der bildenden Künste, Graphische Sammlung, inv. no. I. 3343; cf. *Max Klinger. Bestandskatalog*, p. 205, no. C 405.
8 *Studies of a Head*, Leipzig, Museum der bildenden Künste, Graphische Sammlung, inv. no. NI.10246; N.I.10248; *Studies of Drapery and Heads*,

Dresden, Staatliche Kunstsammlungen, Kupferstich-Kabinett, inv. no. C 1896–39, C 1896–40, C 1896–41.
9 Dresden, Staatliche Kunstsammlungen, Skulpturensammlung, inv. no. ZV 1269; cf. *Das Albertinum vor 100 Jahren — die Skulpturensammlung Georg Treus* (exh. cat., Dresden 1994), p. 239, no. 251.

72 Max Klinger

1857–1920

Athlete (study)

1898/1901

Bronze, h. 69 cm
Unsigned
Inv. no. P 29

Provenance: gift of Eduard Stöhr, in Leipzig, in 1903

Klinger had already addressed the subject of the athlete during his time in Rome when a wrestler from Munich, who was in the Italian capital at this time, served as a model for his painting *La forza e la debollezza* (Strength and Weakness).[1] This athlete was possibly the wrestler Rasso, with whom Klinger later worked frequently when in Leipzig. Rasso, however, served not only as a model for Klinger's treatment of the athlete,[2] but also posed for the male figure in the monumental marble group *Drama*.[3]

The small bronze figure of the *Athlete*, posed as if he were walking and with his arms raised and hands behind his head, was termed by Klinger a "sketch of an athlete." In a letter of October 7, 1901, to the writer Richard Dehmel, the artist claimed that he had "by no means made a 'dying' athlete" but, rather, a "study in bronze of a standing ath-

lete, about sixty centimeters in height."[4] A plaster model of this figure, made in 1898, was cast in bronze in 1901.[5]

In 1901, Klinger signed a contract with the German-American athlete Max Unger, called Strongford, who was at that time appearing at the Krystall-Palast in Leipzig. Unger was the model for the oversized athlete shown in what Klinger described as an "interestingly animated pose"[6] that was later combined with a female figure in the sculptural group *Genius and Passion*. Klinger made only a plaster version of this sculpture, and it has not survived. There nonetheless exist bronze casts of the oversized individual figure of an athlete, made in 1908, and one of these was placed, at the artist's request, on his tomb in Grossjena.[7] A 1901 drawing for a standing male nude is Klinger's study for the figure of the athlete. Here, too, Max Unger doubtless served as the model.[8]

KM

1 Formerly in the possession of Klinger's painter friend Otto Greiner; now untraced.
2 *Max Klinger. Bestandskatalog der Bildwerke, Gemälde und Zeichnungen im Museum der bildenden Künste Leipzig* (Leipzig 1995), p. 58, no. A 9.
3 Dresden, Staatliche Kunstsammlungen, Skulpturensammlung, inv. no. ZV 2203; cf. *Das Albertinum vor 100 Jahren—die Skulpturensammlung Georg Treus* (exh. cat., Dresden 1994), p. 240, no. 252.
4 Hans Wolfgang Singer, ed., *Briefe von Max Klinger aus den Jahren 1874 bis 1949* (Leipzig 1924), p. 148.
5 Plaster model in the Museum der bildenden Künste Leipzig, inv. no. P 711; cf. *Max Klinger. Bestandskatalog*, p. 58, no. 9a.
6 Letter of May 18, 1901, from Klinger to the

Berlin lawyer Julius Albers, cited in *Max Klinger. 1857–1920* (exh. cat., Leipzig 1970), p. 520.
7 *Max Klinger. 1857–1920* (exh. cat., Frankfurt am Main and Leipzig 1992), p. 325, no. 176.
8 Munich, Staatliche Graphische Sammlung, inv. no. 1910: 44; cf. *Max Klinger. Zeichnungen-Zustandsdrucke-Zyklen* (exh. cat., Munich 1996), p. 181, no. 41.

73 Max Klinger

1857–1920

Bust of Elsa Asenijeff

1899–1900

Bronze, h. 84.5 cm
Signed in the back: BRONZE NOACK LEIPZIG; on a bronze plaquette on the interior: Max Klinger "Elsa Asenijeff" Abguss vom Gipsmodell im Museum der bildenden Künste I.713 [Cast from the plaster model in the Leipzig Museum collection, inv. no. I.713]
Inv. no. P 797

Provenance: cast commissioned by the Museum der bildenden Künste Leipzig from the bronze-caster Noack, in Leipzig

The portrait bust of Max Klinger's lover Elsa Asenijeff was commissioned in 1990 by the Leipzig Museum as a bronze cast from the plaster model of 1899/1900[1] made for the polychrome bronze sculpture completed around 1900 and now in the Bayerische Staatsgemäldesammlungen in Munich.[2] It appears that Klinger himself did not in this case think about having a cast made, yet in the case of the other plaster models for sculptures in marble there exist casts made at the time at Klinger's request.[3] Both in the plaster model and in the bronze cast taken from it, Klinger's personal sculptural "handwriting" is very clear. The lively surface appears almost Impressionistic in character, and the similarities to the work of Rodin are evident.

The writer Elsa Asenijeff (actually Elsa Nesteroff, née Packney) was born in Vienna in 1867 and was divorced from a Bulgarian diplomat who had died mysteriously in a sanatorium in Bräunsdorf, near Freiburg in Saxony. She met Max Klinger in 1898 at a reading given by Detlef von Liliencron at the Leipzig Literary Society. They embarked on a passionate affair that was to last for more than fifteen years. Elsa Asenijeff was Klinger's lover, model, and, from 1900, the mother of their daughter Desirée, who was born in Paris while Klinger was at work on his monument to Beethoven (see cat. no. 74).

The dazzling beauty of Elsa Asenijeff was recorded by Klinger in several paintings—both studies of her head and full-length figures.[4] Asenijeff, in turn, produced a detailed and enthusiastic description of the evolution of his *Beethoven* monument in her 1902 essay, *Max Klinger's Beethoven. A Study in Art and Technique.*[5] Among Asenijeff's other publications were the *Diary of an Emancipated Woman* (1901), *The Kiss of Maia* (1903), and *Epithalamia* (1907); for all of these Klinger produced drawings. For many years Elsa Asenijeff was effectively the center of social and cultural life in Leipzig. After her separation from Klinger in 1916, she entered into a period of great instability, experiencing extreme and debilitating shifts of mood. In 1924, both psychologically and physically shattered, she was placed in an asylum. KM

1 Leipzig, Museum der bildenden Künste, inv. no. P 797; cf. *Max Klinger. Bestandskatalog der Bildwerke, Gemälde und Zeichnungen im Museum der bildenden Künste Leipzig* (Leipzig 1995), p. 63, no., A 16 (plaster), p. 63, no. A 16a (bronze).
2 Inv. no. B 739.
3 *Wilhelm Wundt*, 1908, Leipzig, Museum der bildenden Künste, inv. nos. P 30 (bronze) and P 719 (plaster); cf. *Max Klinger. Bestandskatakog*, p. 77, no. A 36 and p. 78, no. 36a, respectively.
4 *Study of the Head of Elsa Asenijeff*, c. 1900; *Portrait of Elsa Asenijeff in a Garden*, c. 1903; *Portrait of Elsa Asenijeff in an Interior*, c. 1904, all in Museum der bildenden Künste Leipzig, inv. nos. 2620, 2189, and 2180, respectively; see *Max Klinger. Bestandskatakog*, p. 111, no. B 32; p. 112, no. B 34; p. 112, no. B 35, respectively.
5 Elsa Asenijeff, *Max Klingers Beethoven. Eine kunst-technische Schrift* (Leipzig 1902).

1857–1920

Beethoven

1902

Upper body and feet in Greek marble from Syra; drapery in alabaster from Laas. "Rock" base and eagle in marble from the Pyrénées; eyes of the eagle in amber, its claws in bronze. Throne in bronze; angels' heads around the top of its back in ivory, mosaic strips on the edge of the throne made up out of antique glass panels, agate, jasper, and mother-of-pearl, underlaid with gold foil; arms of the throne formerly gilt. Pedestal in violet marble from the Pyrénées
Total height 310 cm ("rock" base 150 cm; throne 155 cm; pedestal 107.5 cm)

Signed on the left edge of the back of the throne: MK [in the form of a monogram] MCM [date of completion of the mold for the cast] und P. Bingen f. [name of the bronze-caster in Paris]
Inv. no. P 28

Provenance: acquired from the artist in 1902 with the assistance of an acquisitions committee

After selling his *New Salome* (see cat. no. 71), Klinger had sufficient financial means to acquire unusual types of marble for sculpting his long-planned monument to Beethoven. Klinger's travels took him as far as Greece. The blocks of marble he had ordered arrived in Leipzig in July 1894, and that same year Klinger took the measurements for the figure of the composer. The marble for the drapery was found in 1897 in Laas in the Tyrol, that for the "rock" base and the eagle only in 1899 in the Pyrénées. Klinger's first drawings for the drapery, and a sheet with childrens' heads (for the angels' heads on the throne), were made in 1886.[1] Further drapery studies both with and without the figure's feet are dated to early 1897.[2]

Klinger embarked on his work for the throne component of the sculpture in 1897. Klinger worked in Paris on a wax cast until January 1901. Simultaneously he worked further on the figure, and he completed the mosaic for the upper part of the throne. The angels' heads (the central one based on a portrait of Klinger's lover Elsa Asenijeff as a child) were then modeled in wax, and bronze casts were made from this. Their execution in African ivory was carried out by the specialist ivory carver Roussel in Paris. The throne, the alloy for which required a thousand kilograms of copper, tin, and brass, was cast in December 1891.

In February 1902, Klinger, now in Leipzig, began to assemble the finished work; this process was completed on March 15, 1902. Initially,

the pedestal below the throne bore a quotation from Goethe's *Faust*: "Staring deeply into the loneliness that lies beneath my feet." When assembling the monument, however, Klinger removed these words and thereby freed his Beethoven from the "Faustian significance of the enthroned hero."[3]

The back and the sides of the throne depict scenes from the Bible and from Classical mythology: at the center we find a Crucifixion placed above the Birth of Aphrodite, the two motifs linked by the figure of John the Baptist, who is shown as a desert preacher pointing angrily at the Classical Goddess of Beauty. On the sides of the throne a scene with Adam and Eve and one with Tantalus are juxtaposed with a rendering of the Agonies of Prometheus and the story of Ixion.

For the head of his figure of Beethoven, Klinger used the mask taken in 1812 as a model.[4] In 1880, Klinger had based his figure of Adam on Beethoven's features when creating the eponymous etching from the cycle *Eve and the Future*.[5] In 1890, a likeness of the composer's face reappears in that of the Evangelist John in Klinger's paintings of the *Crucifixion*[6] and the *Pietà*.[7] In 1896, a portrait of Beethoven was incorporated into the etched *ex libris* made for the library of the Leipzig music publisher Peters.[8] KM

1 Leipzig, Museum der bildenden Künste, Graphische Sammlung, inv. no. 1959–63, I.989; cf. *Max Klinger. Bestandskatakog der Bildwerke, Gemälde und Zeichnungen im Museum der bildenden Künste Leipzig* (Leipzig 1995), p. 209, no. C 422, no. C 423.
2 Leipzig, Museum der bildenden Künste, Graphische Sammlung, inv. no. I.988, I.985, I.986, I.984, I.983, cf. *Max Klinger. Bestandskatalog*, p. 229, no. C 504, no. C 505, p. 230, nos. C 506–C 509.

3 Dieter Gleisberg. "'Ja, Er trat durch meine Träume'. Max Klinger in seinem Verhältnis zu Goethe," in *Marginalien. Zeitschrift für Buchkunst und Bibliophile* 151/3 (1998), p. 4.
4 Bonn, Beethoven-Haus, Sammlung Bodmer.
5 Hans Wolfgang Singer, *Max Klingers Radierungen, Stiche und Steindrucke. Wissenschaftliches Verzeichnis von Hans Wolfgang Singer* (Berlin 1909), p. 23, no. 47.

6 Leipzig, Museum der bildenden Künste, inv. no. 1117; cf. *Max Klinger. Bestandskatalog*, p. 100, no. B 16.
7 Formerly Dresden, Gemäldegalerie, destroyed in the Second World War.
8 See Singer, p. 123, no. 314; Henry Tauber, *Max Klingers Exlibrisiwerk* (Wiesbaden 1989), pp. 61 ff., no. 8.

75 Wilhelm Leibl

1844–1900

The Spinner

1892

Oil on canvas, 65 x 74 cm
Signed lower right: W. Leibl./92.
Inv. no. 928

Provenance: acquired in 1910 from the art dealer Eduard Schulte, Berlin, with funds
from the Theobald Petschke-Bequest among others

Leibl painted *The Spinner* during the years he lived in Aibling, a small village near Munich. The names of the two women are known,[1] but the strong genrelike elements distinguish the painting from portraiture. The older woman, seated in the foreground and seen in profile, focuses intently on her work at the spinning wheel. Her figure dominates the canvas, while the younger woman, crocheting quietly on the window bench, is relegated to a minor role. The interior in which the women are working is a well-furnished Bavarian farmhouse, where sunlight streams through two windows, dappling the room with its warm radiance. As in his most famous painting, *Three Women in Church* (1882), Leibl depicts these peasant women absorbed in their thoughts, seemingly oblivious of each other. Here, however, the composition is much freer, the placement of the figures much less hierarchical.

In this painting, Leibl departs from his earlier anecdotal genre scenes, seeking to depict the figures as simply existing in their natural environment. None of his paintings shows the people straining under heavy or monotonous labor.[2] Here, the traditionally feminine tasks of spinning and crocheting evoke a sense of domestic serenity and a feeling of time standing still. The costumes, the traditional dirndl as worn by women in rural Bavaria even today, add to the feeling of timelessness. Lacking Courbet's social criticism and Millet's heroization of the peasant,[3] Leibl was content to capture these simple people pursuing simple, ordinary tasks. It is his recognized achievement to have done so with great sensitivity and a masterly technique. HKA

1 According to Mayr (1935), the two women portrayed in this work are the so-called Tumin, in the foreground, and the Kögel-Marie in the background, in Götz Cymmek, ed., *Wilhelm Leibl zum 150. Geburtstag*, exh. cat. (Munich: Bayrische Staatsgemäldesammlung Neue Pinakothek, 1994), p. 420.

2 Ibid., p. 70.
3 Eberhard Ruhmer, *Der Leibl-Kreis und die reine Malerei* (Rosenheim: Rosenheimer Verlagshaus, 1984), p. 399.

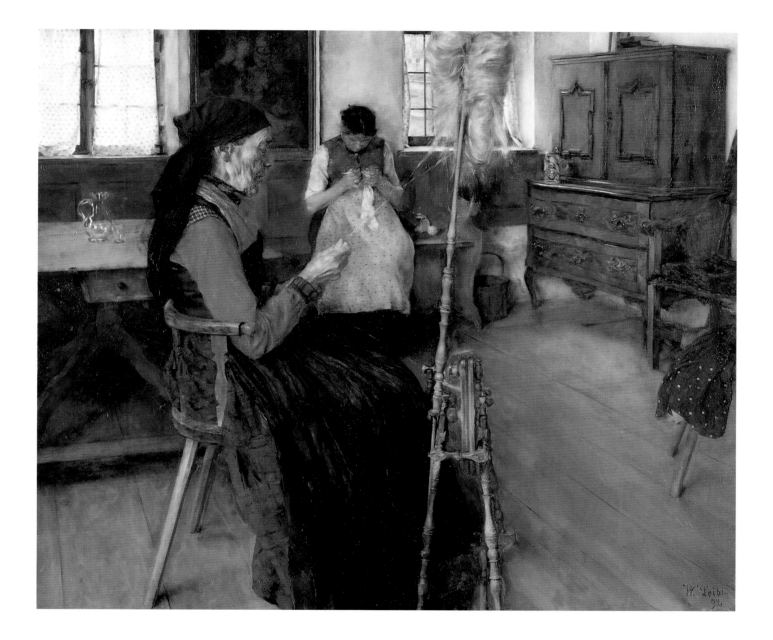

76 Wilhelm Leibl

1844–1900

Portrait of Frau Rieder, the Apothecary's Wife

1893

Oil on wood, 35.3 x 24 cm
Signed upper right: W. Leibl/93
Inv. no. 1200

Provenance: acquired in 1929 on the Munich art market, with funds from the
Dr. Engel Foundation et al.

Although Leibl's first success in 1869 was the portrait of a woman, Minna Gedon, he wrote in a letter as late as 1900 that, "as far as I am concerned, it is generally said that I cannot paint female portraits."[1] Indeed, Leibl did not produce many portraits of aristocratic or bourgeois women, but concentrated on depicting Bavarian peasants. However, both the early portrait for which he received a gold medal at the Paris Salon in 1870, as well as the *Portrait of Frau Rieder, the Apothecary's Wife*, certainly contradict the general assumption. The eminent art historian Julius Meier-Graefe even praised Leibl as the greatest portrait painter since Rembrandt.[2] In his early portraits, Leibl employed a Rembrandt-esque chiaroscuro, letting the partially lighted figures emerge from a dark background. He makes use of this technique somewhat in the portrait of *Frau Rieder*, but new elements come into play as well. The most remarkable feature of this work is the sense of intimacy projected by the sitter, who is placed very close to the foreground and whose gaze is penetrating.

It is not known whether or not this portrait was painted on commission. It is obvious, however, that Leibl was fascinated by the sensitive beauty of this elegant young woman. Her narrow face, with its searching eyes and its sensuous lips, is seen from slightly above and at an angle. Mrs. Rieder is very fashionably dressed in a light coat, with a gold pin attached to the black collar. Her little black hat, topped with a blue and black aigrette, or plume, is perched at a rakish angle. The sitter's elegance would have set her apart from the small-town bourgeoisie, but as the wife of a well-established apothecary she would certainly have been a leading figure in society. Leibl seems to have been quite intrigued by the pensive and apparently not entirely happy young woman. The loose brushwork with which he rendered the coat and hair, in particular, is some of the most sensuous technique found in his work. The color scheme too is extraordinarily vibrant; the fine gradations of pink, ocher, and grays are not far removed from works by Degas or Manet.[3] HKA

1 Götz Cymmek, ed., *Wilhelm Leibl zum 150. Geburtstag.* exh. cat. (München: Bayrische Staats-gemäldesammlung Neue Pinakothek, 1994), p. 430.
2 Ibid., p. 75.
3 Eberhard Ruhmer, *Der Leibl-Kreis und die reine Malerei* (Rosenheim: Rosenheimer Verlagshaus, 1984), p. 414.

77 Wilhelm Leibl

1844–1900

Waiting

1898

Oil on wood, 34.8 x 26.5 cm
Signed upper right: W. Leibl/98.
Inv. no. 769

Provenance: acquired in 1901 from the commemorative exhibition during the VIII Art
Exhibition in Munich

Therese Haltmaier, the young woman portrayed in this picture, was Leibl's cook while he was living in the village of Aibling, near Munich.[1] The title *Waiting* was not chosen by Leibl himself, but was added at a later date. As in *The Spinner* (see cat. no. 75), the sitter is seen in profile, but whereas the former is absorbed in her work, the woman here is shown resting with her hands folded in her lap. Like *Frau Rieder, the Apothecary's Wife* (see cat. no. 76), she is seen very close to the foreground, but without seeking direct contact with the viewer. It is a genre-type portrait, devoid of all anecdote. The festive costume, in particular the addition of the black felt hat, trimmed with two gold tassels, indicates that the young woman is dressed to go out. Yet her quiet pose, as well as the pensive expression of her face, denotes no urgency or hurry.

The extremely self-contained attitude of the figure is in direct contrast to the rather nervous brushwork. While the face of the sitter is painted in a very closed manner, the brushwork Leibl uses for the skirt and apron is quite summary. This manner is even more pronounced in the handling of the many-faceted background. The curtains, the window ledge, the recess in the wall, the shelf, or paneling as well as the chair are all rendered in a blurred, indistinct technique. The overall color scheme is dominated by the grays and blues of the sitter's costume. Leibl has dissolved even the very solidly built wall into a myriad of colored patches, ranging from whites and gray-greens to light blues. This light-flooded room, which may have been the kitchen in which Therese worked, is probably Leibl's most Impressionistic interior. Indeed, during the last two years of his life, Leibl turned away from the Impressionistic technique he employed with such remarkable effect here. HKA

1 Götz Cymmek, ed., *Wilhelm Leibl zum 150.
Geburtstag*, exh. cat. (München: Bayrische Staats-
gemäldesammlung Neue Pinakothek, 1994), p. 510.

78　Hans Thoma

1839–1924

Landscape along the Main River

1893

Oil on canvas, 99.5 x 133 cm
Signed lower right: HTh (Monogr.) 93.
Inv. no. 709

Provenance: acquired in 1894 from the art dealer Ernst Arnold, Dresden, through the
Council of the City of Leipzig

"A born realist, I wanted to paint nothing I had not seen myself, experienced myself—wherever I looked there was beauty enough—people, animals, landscapes intertwined in harmonious lines, that is what I had in mind," thus Thoma described his approach to painting.[1] Although his prodigious oeuvre includes numerous portraits, still lifes, and mythological as well as allegorical scenes, it is the landscape that defines his work. Perhaps best known for his views of the Black Forest where he was born, Thoma also painted the Main River repeatedly during the years he lived in Frankfurt am Main. In this version, a bucolic scene of children and sheep in the foreground and a rustic couple in the middle ground opens up to a wide view of the peacefully meandering Main on whose further bank a village is nestled. The dominant element of the painting is not the river itself but the rhythmically spaced trees, poplars, and willows that extend over the entire height and breadth of the canvas. The bright sunlight that suffuses the scene, though possible on a summer's day, is not typical of this area of Germany, whose "sad gray or milky blue sky" Thoma found uninspiring after his travels in Italy.[2] The deep blue and the vibrant greens of Italy had made a lasting impact on him and he subsequently transposed them onto his German landscapes, thereby adding an element of idealization to an otherwise realistic view.

After his first successful exhibition in 1890, Thoma started to move away from the realism of Courbet and toward a style that was strongly influenced by Böcklin's works. Not only did he paraphrase a number of Böcklin's mythological paintings, even his landscapes show a tendency toward the idyllic and mythological.[3] Here, the harmonious coexistence of man and nature is indicative of Thoma's deep yet uncomplicated religious conviction—his belief in the beauty of all creation. Because of his remarkably fresh and straightforward approach to landscape painting, he was one of the most admired German artists at the turn of the century.

HKA

1　Peter Wegmann, "Thoma – Landschaften," in
*Hans Thoma, 1839–1924, Gemälde und Zeichnungen
aus der Sammlung Georg Schäfer, Schweinfurt*, exh. cat.
(Schweinfurt: Sammlung Georg Schäfer, 1989),
p. 25.
2　Ibid., p. 28.
3　Ibid., p. 31.

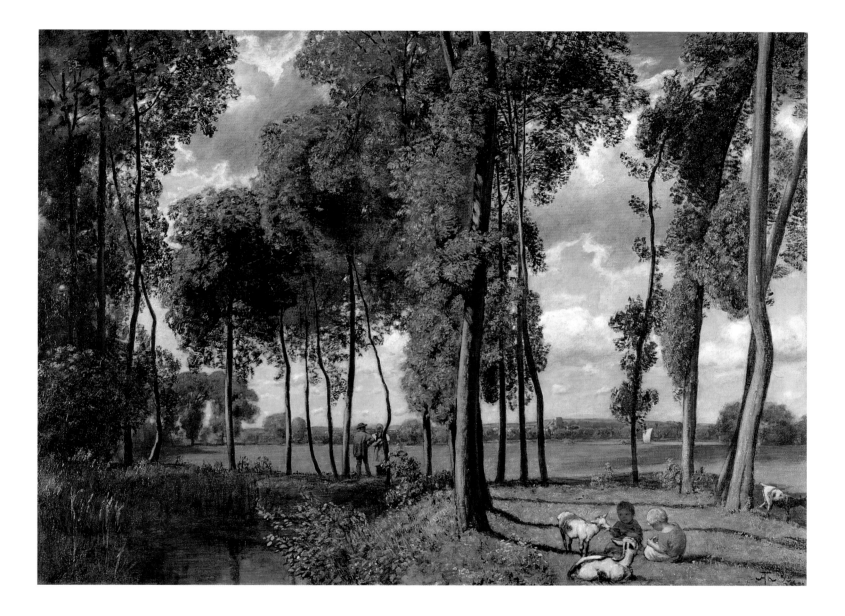

79 Wilhelm Trübner

1851–1917

View of Kronberg in the Taunus Mountains (with Mowers I)

1896

Oil on canvas, 62.5 x 76.5 cm
Signed at the lower right: W. Trübner. 1896.
Inv. no. 875

Provenance: acquired in 1908 from the artist at the Trübner exhibition organized by the Leipzig *Kunstverein*, with funds provided by the bequest of Carl Lampe-Vischer, in Leipzig[1]

The Leipzig Museum posseses a small but high-quality collection of works by Wilhelm Trübner. This collection documents both his evolution as a member of the circle around Wilhelm Leibl and the thematic variety of his work, as seen in such examples as the attractive *Still Life with Apples and Pears* of 1876,[2] the striking *Portrait of the Composer Joseph Gungl*, and a version of the *Battle of the Giants* (both 1877).[3] Trübner's *View of Kronberg in the Taunus Mountains (with Mowers I)*[4] extends the collection to a work from the late 1890s and thereby to a painting that illustrates the artist's very personal and individual contribution to German Impressionism.

The sources of Trübner's remarkable landscape paintings can be traced to the walking tours he took with Carl Schuch and Albert Lang in 1871 around Bernried, near Munich; and to an extended study tour he made with Schuch that led the two artists from the Baltic island of Rügen, through the Harz Mountains, and then the Bavarian Forest. These travels introduced Trübner to numerous landscape motifs that inspired him. Trübner subsequently devoted individual paintings and sometimes entire series to illustrating these motifs: Lake Herrenchiem (1874), Weissling (1876), Heidelberg (1889), Lake Frauenchiem (1891), the monastery at Seeon (1892), Lake Constance, the Black Forest, and the monastery at Amorbach (1899), Hermsbach Castle (1904–07), Lake Starnberg (1907–12), and the convent of Neuburg near Heidelberg (1913/14). Trübner had a high regard for landscape as an integral part of civilization. Central to his work as a landscape painter are images of buildings of architectural significance.

In 1896–97, Trübner painted a series of landscapes in the Taunus Mountains, all of which focused on a view of the city of Kronberg. Located in the Upper Taunus, Kronberg had intermittently served as a spa since 1568 because of its mineral springs; it later became a well-known health resort. Apparently, Trübner came to know Kronberg in 1896 when he moved to Frankfurt am Main. The Taunus Mountains, a range of medium height that runs through the present day *Länder* of Hesse and the Rhineland-Palatinate, forms the southeastern section of the Rhine slate mountains and offers an attractive and fascinating topography. Trübner spent two years working there, producing five paintings with varying views of the castle (constructed about 1220) and the city. Alongside another work of 1896, the *View of Cronberg in the Taunus Mountains: View from the Southwest*, where the city and the castle are seen across the meadows,[5] the Leipzig Museum's painting is a key work in this series. Both paintings, moreover, also exist in almost identical second versions.[6]

In this summer landscape, we look across a valley with meadows extending some way into the distance toward Friedrichshof Castle, a splendid historicist structure built in 1889–93 in Tudor style for the Empress Viktoria, widow of Emperor Friedrich III. Beyond, rises the peak known as the Altkönig (The Old King), expansively arching over the hilly terrain. In this painting, as in others by Trübner, he places ostensibly "uninteresting" landscape details to capture our attention and to anchor the scene in compositional terms. We view the city lying at the foot of the castle, as if we were approaching from the south, so that the forested slope largely masks the sea of houses. The flat landscape of the foreground and middle distance is charmingly brought to life through the presence of two farmworkers shown mowing the grass. Especially impressive is Trübner's ability to "fill out" precisely this "empty" central area of the picture through painterly, yet radically simple, means. DS

1 This information is provided in Klaus Rohrandt, "Wilhelm Trübner (1851–1917). Kritischer und beschreibender Katalog sämmtlicher Gemälde, Zeichnungen und Druckgraphik. Biographie und Studien zum Werk" (Ph.D. diss., Kiel 1972), no. G 622, p. 513; previously attributed erroneously to the collection of Dr. Karl Lampe-Vischer (in

Leipzig?); acquired from the Leipzig *Kunstverein* as part of the Lampe-Vischer bequest.
2 Inv. no. 3063.
3 Inv. nos. 1104 and 929, respectively.
4 See Rohrandt, no. G 622, p. 513.
5 Frankfurt am Main, Städelsches Kunstinstitut, inv. no. SG 29; see Rohrandt, no. G 624, pp. 514 ff.

(where it has the title *View of Cronberg im Taunus [with Row of Willows I]*).
6 Regarding the picture in Frankfurt am Main, see Rohrandt, no. G 625, p. 515. The second version of the picture in Leipzig has not been traced; see Rohrandt, no. G 623, pp. 513 ff.

80 Ludwig Dill

1848–1940

Evening in the Moorland Wood

1898

Distemper on cardboard, 52.5 x 65.5 cm
Signed at the lower left: L. Dill. 98
Inv. no. 888

Provenance: in the possession of the Leipzig-born painter Alexander Schmidt-Michelsen, of Berlin, who donated it to the Leipzig Museum in 1908, along with thirty-five paintings

The artistic "discovery" of the landscape around Munich took place in the first half of the nineteenth century. Ferdinand and Wilhelm Kobell, Johan Georg von Dillis, and Heinrich Bürkel led the way, rebelling against the dominance of German academic art. The second generation of Munich-based landscape painters, which included Eduard Schleich the Elder, Carl Spitzweg, and Christian Ernst Bernhard Morgenstern, progressed toward plein-air painting and, taking their cue from the French artists at Barbizon, painted animated landscapes in the manner of the *paysage intime*.

From around 1860, the village of Dachau, in particular, became a center for this new movement. These environs inspired even the Realist genre and religious painter Fritz von Uhde to produce one of his finest landscapes (see cat. no. 65). True to Émile Zola's definition— "a work of art is a detail from nature seen through the temperament of a particular individual"[1]—the artist's point of view alone now determined which motif was appropriated to a certain work. The majority of pictures painted at Dachau were of unassuming landscape details; many paintings omitted characteristics of the local environment. It was above all the *Moos*, the wet moorland around Dachau, with its often rapidly altering effects of light and color, that enchanted the painters.

Ludwig Dill described his first encounter with the landscape of Dachau: "My first visit to him [the painter Adolf Hölzel], in Dachau in 1892, was significant for me in every respect, and it encouraged me to work there myself for a longer time … From Dachau we made trips further and further into the moorland, where our enthusiasm knew no bounds. The pale terrain was our utter undoing. And that's where I made my decision!! It had to be Dachau and only Dachau!!".[2]

In contrast to the pursuits of his artist friends Hölzel and Arthur Langhammer, Dill devoted himself exclusively to landscape painting at Dachau, overcoming an initial tendency toward Impressionism. In the works that Dill painted at Dachau, groups of poplars and birches recur consistently, "emblematic of a landscape left to its own devices and untouched by human intervention."[3]

The picture in the Leipzig Museum is characteristic of Dill's work for its summary treatment of the foliage, its stylized rendering of the bark, its blurred outlines, and the grouping of the individual trees, which on occasion are sharply cropped by the picture frame. Classified by Bärbel Schäfer as belonging to the "Edge of the Wood" series,[4] *Evening in the Moorland Wood* forms one of a group of seven images showing trees around a watercourse, with the view between them opening to reveal the landscape.

Alongside the *Peace of Evening*, now in the Galerie Neue Meister in Dresden,[5] the Leipzig painting is the most closely and emphatically cropped image of this series. According to the critic Arthur Roessler, "Many of Dill's pictures are painted in such wonderful colors that one can almost imagine that these tones are the scent of a fine pollen made visible."[6] Roessler also referred to the "esoteric content" of these paintings, claiming that "[Dill] paints in much the same spirit as Ibsen or Maeterlick writes plays."[7] The paintings that best demonstrate Dill's "discovery" of the intimate moorland around Dachau also are related thematically and stylistically to works produced at almost exactly the same time by both the Scottish artists' group The Glasgow Boys and by the painters working at the north German colony at Worpswede. Another Dachau scene by Dill, *Willows in Moorland* (1905), once in the Leipzig Museum, is among those works destroyed during the Second World War.[8]

DS

1 Cited in Elisabeth Boser, "Von München nach 'Neu-Dachau'. Eine Künstlerkolonie unde ihre Voraussetzungen," in *Deutsche Künstlerkolonien 1890–1910. Worpswede, Dachau, Willingshausen, Grötzingen, Die "Brücke," Murnau* (exh. cat., Karlsruhe 1998), p. 204 with note 13 on p. 212.
2 See Boser, p. 207 and note 24, and p. 209 and note 30.

3 Erika Rödiger-Diruf, "Sehnsucht nach Natur. Zur Entwicklungsgeschichte der Künstlerkolonien im 19. Jahrhundert," in *Deutsche Künstlerkolonien*, p. 59.
4 Bärbel Schäfer, *Ludwig Dill. Leben und Werk* (n. loc. 1998), nos. 1096–1169, pp. 360–69; for the picture in the Leipzig Museum, see no. 1110, p. 362 with illustration.

5 Dresden, Staatliche Kunstsammlungen, Gemäldegalerie Neue Meister, gallery no. 2416; see Schäfer, no. 1107, p. 302 with illustration.
6 Arthur Roessler, Neu-Dachau. Ludwig Dill, Adolf Hölzel, Arthur Langhammer (Bielefeld-Leipzig 1905), p. 51.
7 See Roessler, p. 55.

8 Inv. no. 867; acquired in 1908 through the Leipzig *Kunstverein*; see ACTA, Dokumente und Correspondenz, das Verzeichnis der Kunstwerke betr., vol. 2 Städtisches Museum der bildenden Künste 1897-, fols. 159, 163, 182, Museum der bildenden Künste Leipzig, Archiv.

81 Lovis Corinth
1858–1925

Salome II

1899/1900

Oil on canvas, 127 x 147 cm
Signed at the lower left: LOVIS CORINTH/1900.
Inv. no. 1531

Provenance: acquired in 1900 by Carl Toelle at the second exhibition of the Berlin
Secession; in the collection of Paul Geipel, in Dresden; acquired in 1956 through the
Geipel-Stiftung, Dresden

The New Testament story of Salome, closely connected with that of John the Baptist,[1] has repeatedly been reworked by both writers and artists.[2] After John had openly condemned as illegal the union of Herod Antipas and Herodias, the former wife of his half-brother, Herodias seethed with a desire for revenge. To achieve her ends she enlisted her daughter Salome to perform a dance for Herod, her stepfather (who was much taken with her and ready to fulfil any wish that she might announce), and to then request to be presented with the head of John the Baptist. Gustave Moreau's painting of Salome (1874–76), described so vividly and influentially in Joris-Karl Huysmans's novel À Rebours [Against the Grain] (1884); Gustave Flaubert's short story Herodias (1878); and Oscar Wilde's play Salomé (1893), on which Richard Strauss based his opera of 1903—all paved the way for Salome to become one of the most favored themes in late-nineteenth-century art.[3]

Lovis Corinth's own interpretation of the explosive and provocative story focuses on its closing episode. Corinth locates the scene in full daylight and skillfully crops the figures of virtually all the participants. Thus, the viewer's attention is immediately focused on the centrally placed Salome, to whom a slave is seen presenting the head of John the Baptist in a blue bowl. As she bends forward, Salome bares her breasts, which almost touch the head of John. With her right hand she eases open one of the dead man's eyes and gazes at it lasciviously. This dis-

turbing, but simultaneously, very sensual, scene—which can, moreover, be justified as an illustration of the closing monologue of Wilde's play: "Now I shall kiss thee! … But why doest thou not look at me, Joakanaan? Thine eyes, that were so full of terror … are closed now … Lift up thine eyelids, Jokanaan! … Art thou afraid of me Jokanaan, afraid that thou might see me?"[4]—is underscored by the presence of the servants from the king's retinue who look on with seeming indifference.

Corinth wanted to show his painting Salome[5] at the exhibition of the Munich Secession, but it was rejected by the Selection Committee. According to Corinth's own account: "I then showed my picture to my friend Walter Leistikow, who was at that moment in Munich trying to drum up support for the [recently founded] Secession in Berlin. He reacted enthusiastically and asked me to give the picture to the Berlin Secession, where they would be only too glad to exhibit it, and he expected this work to be a great success. And that's how it turned out. For Berlin I was a 'name'."[6] The success of Corinth's Salome was in fact so considerable that a day before the exhibition opened[7] the painting had already found a buyer.[8] Corinth was later asked by Max Reinhardt to supply costumes for his new production of Wilde's play, starring Gertrud Eysold in the title role, which was to open in 1902 at the Kleines Theater on Unter den Linden.[9] Not long after this production, Corinth painted a portrait of the actress in the role of Salome.[10] SP

1 The Gospel According to Saint Matthew, 14: 3–11; The Gospel According to Saint Mark, 6: 17–28.
2 Cf. Hugo Daffner, Salome. Ihre Gestalt in Geschichte und Kunst. Dichtung, Bildende Kunst, Musik (Munich 1912); Kerstin Merkel, Salome: Ikonographie im Wandel (Frankfurt am Main, Berne and New York 1990).
3 Cf. Mechtilde Hatz, "Frauengestalten des Alten

Testaments in der bildenden Kunst von 1850 bis 1918: Eva, Dalila, Judith, Salome" (Ph.D. diss., Heidelberg 1972); Erika Wächter, "Die Darstellung der tanzenden Salome in der bildenden Kunst zwischen 1870 und 1920" (Ph.D. diss., Berlin 1993).
4 Oscar Wilde, Salome. Tragedy in One Act with Six Drawings by Aubrey Beardsley (London 1894).
5 Béatrice Hernad, ed., Charlotte Berend-Corinth: Lovis Corinth. Die Gemälde. Werkverzeichnis (2nd

ed., Munich 1992), p. 79, no. 171, illustration on p. 391.
6 Lovis Corinth, Selbstbiographie (Leipzig 1926), p. 118.
7 Katalog der Zweiten Kunstausstellung der Berliner Secession (Berlin 1900), p. 19, no. 38, unnumbered plate [5].
8 Rudolf Klein, Lovis Corinth (Berlin, n.d.), p. 18.

9 Cf. Franzjoseph Janssen, "Bühnenbild und bildende Künstler. Ein Beitrag zur Geschichte des modernen Bühnenbildes in Deutschland" (Ph.D. diss., Munich 1956, and Frankfurt am Main 1957), pp. 30, 33ff.; Carl Niessen, Max Reinhardt und seine Bühnenbildner (Cologne 1958), pp. 10–12.
10 See Hernad, p. 91, no. 252, illustration on p. 440.

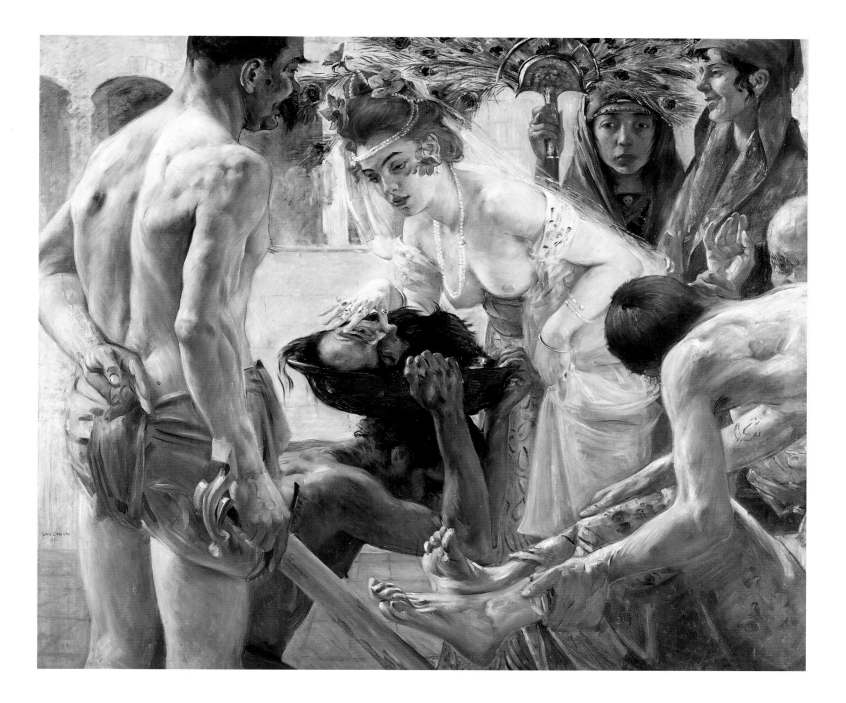

83 Max Slevogt

1868–1932

Self-portrait with Brush and Palette

1906

Oil on canvas, 103 x 93 cm
Unsigned
Inv. no. 1096

Provenance: purchased in 1916 from the art dealer Heinrich Thannhauser, in Munich, with funds derived from the Theobald Petschke-Stiftung in Leipzig

The painter Max Slevogt almost seems surprised to see himself reflected as the individual whose bulky body fills out the picture plane and narrow space. His casually clothed figure exudes robust power and a forceful directness. Only his brush and palette indicate that he is the painter whose dazzling landscapes, scenes of seductively charming and hot-blooded dancers, and images of Mozart's operas brought him international fame.

The figure is firmly positioned within the rectangle of the painting. The verticality of the body is opposed to the horizontality of the palette and, above all, to the rising diagonal above the figure's left arm, which finds its continuation in the swelling, blue-black curtain (an astonishing intrusion into this modern image and one perhaps drawn from the repertoire of the Baroque portrait). While the artist's face, with its thick application of paint, is rendered in a more detailed and "sculptural" fashion, the remaining details of the figure are loosely painted, and the firm contours are repeatedly interrupted. The coloring, with its predominantly yellowish-gray tone, appears almost emphatically restrained.

"… all my self-portraits displease me, by the way, although every time I try to approach them conscientiously," Max Slevogt confessed to Bruno Cassirer in 1924.[1] While this remark may seem somewhat curious, bearing in mind the numerous self-portraits Slevogt produced (of which the Leipzig Museum also possesses eight prints), it does nonetheless seem to relate to the artist's peculiarly indecisive appearance in this painting. While it is true that Slevogt depicts himself at work, he does not appear to be engaged in the act of painting; rather, we may assume that he is looking fixedly at the model, yet without registering any sense of anxiety about the next step. "A sense of self-absorption, indeed of distraction about the eyes establishes an irritating contrast with the sense of vitality about the body … Slight doubts arise as to whether the artist, here at the peak of his talent and at the acme of his fame, really regards it as fitting that he should record his own image in this fashion. Behind the assuredly composed picture this palpable sense of dichotomy reveals the sensitive Slevogt who always shied away from the clamor of public life."[2]

According to Hans-Jürgen Imiela, the painting in the Leipzig Museum was produced in 1906. It may, therefore, be classified among Slevogt's portraits of the period 1903–6 in which the artist depicts himself at work. In these portraits, Slevogt gives expression to a "stillness bordering on apathy," for, according to Imiela, in "a period in which long preparation, assured skill and proven mastery threaten to transform the painting of portraits into demonstrations of mere pictorial efficiency, then the self-portrait too tends to the representation of qualities that relate to the artist's public function and that lie beyond the atmosphere of the studio and the private sphere."[3] This role, which Slevogt was able to play to perfection and that he indeed recognized as necessary, finds its least ambiguous reflection in the self-portrait with his wife, painted in 1905, called *Bal paré*.[4] Other self-portraits of this period are limited to the head and the upper body and largely convey Slevogt's moments of calm observation.[5] DS

1 Letter of late December 1924, cited in Hans-Jürgen Imiela, *Max Slevogt. Ein Monographie* (Karlsruhe 1968), p. 100 with note 45 on p. 380.
2 Michael Freitag, *Max Slevogt* (West Berlin 1988), no. 90.
3 See Imiela, p. 102.
4 See Imiela, illustration on p. 101.
5 Cf. the list of self-portraits in Imiela, note 46 on p. 380.

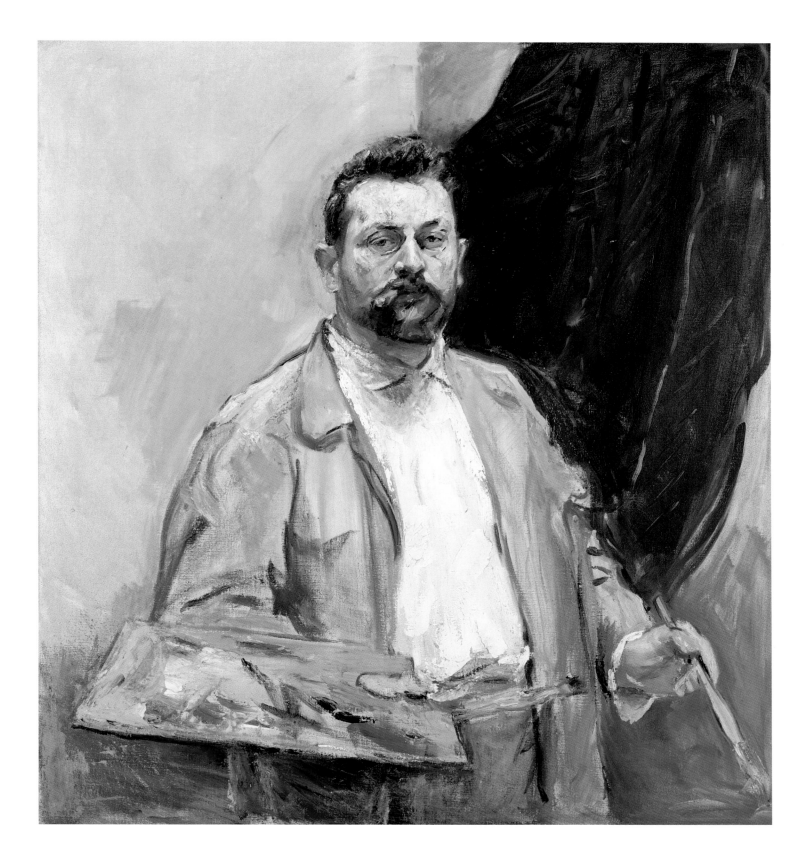

84 Franz von Stuck

1863–1928

The Crucifixion

1913

Distemper on canvas, 190 x 165 cm
Signed at the lower right: FRANZ/VON STUCK/1913
Inv. no. 960

Provenance: acquired in 1913 from the artist at the eleventh international art exhibition in Munich, with the assistance of the City of Leipzig and with funds derived from the Theobald Petschke-Stiftung in Leipzig

"There is much talk of this picture in Munich and, without doubt, it represents a concentration of energies and on the whole a not insignificant expression of feeling. But the decorative essence in Stuck's work clings to this composition too; here he seems above all concerned with effect, and one cannot help thinking that it's more or less like this that one might treat the principal scene of a mystery play at the Munich Artists' Theater. What Stuck has painted here is the importance of a moment in world history, but not the eternal mystery of the greatest sacrifice and the resulting universal salvation."[1]

The most striking qualities of Stuck's Crucifixion images are their turbulent emotionalism, their strong element of pathos, and their use of declamatory gesture.[2] Nonetheless, in the Munich exhibition of 1913, this work impressed spectators "through the grandiose simplicity of its painterly idea: the figure of Christ on the Cross transfigured by an unearthly white light—juxtaposed with depths of a velvety blackness and the dark azure blue of the cloak of his mother"[3]—qualities that made many think of glass painting. The group of Christ's mother and Saint John, the two crosses with the thieves, the small visible strip of earth, and the black circle of the masked sun—everything objective in the composition is reduced to the clearest and simplest form, to summary planes of color, and to contrasts of color and brightness, so that there is a persistent effect of silhouette. The composition is determined by the figure of the cross-bearing Christ being shifted slightly out of the center of the picture. The three crosses as a group, and also the figural groups, are placed diagonally in relation to the picture plane and thus appear to be "falling away" from the composition. In contrast, the figure of Saint John, which is inclined toward Christ, underlines the significance of his own gesture of catching and supporting the fainting figure of Mary. Like Max Klinger in his monumental Crucifixion of 1890,[4] Franz von Stuck and many other artists of this period[5] depicted the historically correct, Roman form of execution with the crosses placed directly on the earth, although they did not usually show the attached bench.

Although Stuck was not keenly interested in the subject of the Crucifixion, he nonetheless produced a relatively large number of pictures of this theme. Stuck's first Crucifixion was painted in 1892;[6] it included a large group of mourners surrounding the figure of Mary. A second, painted in 1906,[7] is already closer to the compositional solution that Stuck adopted for the work now in Leipzig, in terms of both its formal arrangement and the rendering of individual components, although the 1913 painting is a more intense version of the scene. A late picture, painted before 1915,[8] positions the crucified Christ frontally in relation to the viewer with two groups of figures at his feet—one mourning, the other gesticulating wildly.

An undated, smaller version in wax crayon, which appears to be closest in every respect to the painting in Leipzig,[9] is found in a private collection in Mannheim;[10] a signed but undated study in oil on paper, now in private hands in Munich, is cited by Heinrich Voss in connection with the Leipzig Crucifixion.[11] DS

1 Gottfried Hinkel, "Internationale Kunstausstellung München 1913. I. Deutschland, Österreich-Ungarn und Schweiz," in Deutsche Kunst und Dekoration 33/2 (October 1913–March 1914), p. 116, fig. on p. 123.
2 Heinrich Voss, Franz von Stuck. 1863–1928. Werkkatalog der Gemälde mit einer Einführung in seinen Symbolismus (Munich 1973), p. 31.

3 Fritz von Ostini, "Neue Arbeiten von Franz von Stuck," in Deutsche Kunst und Dekoration 31/1/2 (October 1, 1915), p. 9.
4 Leipzig, Museum der bildenden Künste, inv. no. 1117; see Voss, no. 426/293, p. 301, illustration on p. 194.
5 Cf. "Exkurs zur Deutung der neuidealistischen Formgestaltung am Themenbeispiel des Todes

Christi," in Friedrich Gross, Jesus, Luther und der Papst in Bilderkampf 1871 bis 1918. Zur Malereigeschichte der Kaiserzeit (Marburg 1989), pp. 253–70.
6 Stuttgart, Staatsgalerie, inv. no. 1116; see Voss, no. 77/290, pp. 267 ff., illustration on unpaginated p. [114].
7 See Voss, no. 304/291, p. 291, illustration on p. 166.

8 See Voss, no. 459/294, p. 304, illustration on p. 202.
9 See Voss, no. 426/293, p. 301, illustration on p. 194.
10 95 x 90 cm; color photograph in Leipzig, Museum der bildenden Künste, Archiv.
11 c. 1913; see Voss, no. 425/292, p. 301, illustration on p. 194.

Artists' Biographies

ANDREAS ACHENBACH
Born 1815 in Kassel – died 1910 in Düsseldorf

Thanks to his precocious talent, Andreas Achenbach was enrolled at the renowned Düsseldorf Academy of Art at the early age of 12. Among his teachers were Heinrich Christoph Kolbe, Carl Friedrich Schaeffer, and Johann Wilhelm Schirmer, the most famous landscapist in Düsseldorf. In the early 1830s, Achenbach traveled to the North Sea and the Baltic Sea with his father and as far north as Goteborg, Sweden, in 1835. That year he left the Düsseldorf Academy with a number of other students and went to Munich. After a sojourn in Frankfurt am Main in 1837 with Alfred Rethel, he returned to Düsseldorf. He would leave again only on occasional trips to Holland, Norway, Paris, and Italy.

The motifs he favored, such as the mills from the vicinity of Düsseldorf, the northern seascapes, especially the rocky coast of Norway, were immensely popular and represent a counterpoint to the works with Italian themes painted by an ever-increasing number of German painters drawn to Italy, among them Achenbach's brother Oswald. Achenbach's influence was not so great as Schirmer's but did extend to some of Schirmer's students such as Hans Gude, Albert Flamm, and Alexander Michelis, who in turn transferred the Düsseldorf traditions to the art academy at Weimar, where realistic landscape painting was continued under the direction of Stanislaus von Kalckreuth. HKA

CARL BLECHEN
Born 1798 in Cottbus – died 1840 in Berlin

Blechen was primarily self-taught when he went to Berlin to train at a bank in 1822 and simultaneously entered the Berlin Academy of Art. He was accepted into the class of landscapist P. L. Luetke the following year. The same year he traveled to Dresden where he met Johan Christian Clausen Dahl and likely Caspar David Friedrich. From that moment on, Blechen's work was influenced by these two diametrically opposed landscapists. To his good fortune, the most influential artist in Berlin, the architect Karl Friedrich Schinkel, took note of his talent and procured a position for him as painter at the Königsstädter Theater—a position he held from 1824 to 1827. A year's travel in Italy, from October 1828 to November 1829, was the determining factor in his artistic development. After his return to Berlin, he was appointed professor of landscape painting at the academy in 1831, and made a full member in 1835. However, he succumbed to severe depression, was confined to a sanatorium in 1836, and died in 1840 without having recovered.

His Italian drawings, oil sketches, and paintings not only gained him recognition as a realist, but also placed him among the forerunners of Impressionism such as Dahl, Thomas Fearnley, Adolph Menzel, J. M. W. Turner, and John Constable. HKA

ARNOLD BÖCKLIN
Born 1827 in Basel, Switzerland – died 1901 in San Domenico near Fiesole, Italy

Born the third of eight children of Christian Friedrich Böcklin and Ursula Böcklin-Lippe, Arnold Böcklin in 1845 entered the class of the landscapist Johann Wilhelm Schirmer at the prestigious Düsseldorf Academy of Art. He left the academy in 1847, returned to Basel, then joined his friend and fellow painter Rudolf Koller in Paris the following year. The events of the revolution of 1848 left Böcklin horrified so he returned posthaste to Basel. In 1850, he went to Rome, the first of many and extended stays in Italy. He married Angela Pascucci in 1853 and moved to Munich with his family in 1858. There, his painting *Pan among the Reeds* was exhibited by the *Kunstverein* and bought by the king of Bavaria for the Neue Pinakothek. He taught at the Academy of Art in Weimar from 1860 to 1862, but was drawn back to Rome where he lived until 1866. From the fall of 1866 to 1871, Böcklin returned to his native city of Basel where he was commissioned to paint frescoes in the stairwell of the museum. Having completed his commission, Böcklin moved to Munich in 1871, and then moved on to Florence in 1874. He stayed there for the next ten years, during which time the first versions of the *The Island of the Dead* were painted. In 1885, he moved to Zurich but returned to Florence in 1892 to spend the final decade of his life there.

Although Swiss by birth—and perhaps one should consider him Italian by inclination—Böcklin is associated with German painting because of his training, his teaching, and his influence. His work goes beyond the teachings of Schirmer or Lessing in developing a highly personal style, interweaving realistic landscapes with mythological figures, often rendered in stridently bright colors. He became an inspiration for the generation of German Symbolist painters, among them Hans Thoma, Franz von Stuck, and Max Klinger. HKA

KARL BUCHHOLZ
Born 1849 in Schlossvippach, near Weimar – died (by suicide) 1889 in Oberweimar

Karl Buchholz's intimate landscape renderings are related stylistically to the work of the Barbizon School. While Buchholz had little influence on landscape painting in the context of Weimar and its own ar-

tistic tradition, he represented a development that contributed to a more widely practiced form of German Impressionism.

Early on, Buchholz trained with a painter in Kölleda from 1863–66. A year later, he attended the Art School in Weimar, studying under Alexander Michelis, from 1868 under Max Schmidt, and from 1871 under Theodor Hagen. He had his own studio in Weimar from 1867. After the death of his father in 1868, he moved with his mother to Oberweimar and was based there, in relative isolation, for the rest of his life. In 1875, he befriended the painter Franz Hoffmann-Fallersleben. With the exception of a few sojourns in the Harz Mountains and on the Baltic Coast, and several visits to Berlin and to Munich, Buchholz continued to be based in Weimar. The first public recognition for Buchholz came posthumously, in 1905, when his work was included in a Berlin show devoted to German landscape painting, and then in the 1906 German Centennial Exhibition held in Berlin. SP

HEINRICH BÜRKEL
Born 1802 in Pirmasens – died 1869 in Munich

Heinrich Bürkel was among the most important and popular practitioners of genre and landscape painting in early Biedermeier Munich (1815–48). His mildly moralizing scenes of country life influenced painting in Munich well into the second half of the nineteenth century. Around 1815, Bürkel was apprenticed to a legal clerk in Pirmasens. In 1821, he traveled to Strasbourg and in 1822 made a walking tour to Munich. The Classicist instructor Johann Peter von Langer did not admit Bürkel into the Munich Academy of Art because Langer claimed that Bürkel's work offered no evidence of talent.

In 1824–25, Bürkel shared a studio with Ernst Kaiser. In 1825, he became a member of the Munich artists' association, the *Kunstverein*. The next year, he made walking tours in the lower slopes of the Alps and in 1827 he traveled with Friedrich Nerly to the Dolomites. In 1829, he traveled to northern Italy and he made further trips to Italy in 1830–32, staying in Naples, Pompei, Amalfi, and Paestum. In 1833, he became a member of the Braunschweig *Kunstverein*, and in 1836 a member of the equivalent association in Nuremberg. Both in that year and in 1838, he traveled again to Italy. In 1840, he visited Vienna, where he became a friend of the poet Adalbert Stifter. In 1843, Bürkel became an honorary member of the Dresden Academy of Art and of that in Vienna, and in 1858 of the Munich Academy of Art. He once again traveled to Italy in the winter of 1853–54. DS

CARL GUSTAV CARUS
Born 1789 in Leipzig – died 1869 in Dresden

Alongside Philipp Otto Runge, Carl Gustav Carus is regarded as the most important painter-theorist of the Romantic movement in Germany. Furthermore, he was the most outstanding representative of Dresden Romanticism along with Caspar David Friedrich and Johan Christian Clausen Dahl. In addition, Carus has retained his reputation as one of the most revered contributors to scientific, and in particular medical, research during the nineteenth century in Germany.

Carus was the son of the owner of a dye works. He took his first drawing lessons with Julius A. Dietz in Leipzig. In 1804–10, he attended Leipzig University, studying a range of sciences and philosophy, and beginning in 1806, medicine. During this period, he also spent a year studying drawing. In 1809, he started work as a clinical trainee in the St. Jakob-Hospital, Leipzig; in 1811–14, he was an assistant physician at the Trierischen Institut, Leipzig. In 1811, he received his formal qualification as a physician and embarked on medical research. Simultaneously, he taught himself to paint in oils. In 1814, he was appointed to the position of professor of obstetrics at the Surgical and Medical Academy in Dresden (retaining this position until 1864). In 1819, he traveled to the Baltic island of Rügen, in 1820 through the Riesengebirge, in 1821, 1828, and 1841 through Switzerland to Italy, and in 1844 to England and Scotland. In 1827, he served as physician to the Saxon Court in Dresden and gave up his academic work. DS

LOVIS CORINTH
Born 1858 in Tapiau, East Prussia (now Gvardeisk, Russian Federation) – died 1925 in Zandvoort, Holland

Lovis Corinth is regarded, alongside Max Liebermann and Max Slevogt, as a leading representative of German Impressionism. A prolific painter, etcher, and lithographer, Corinth produced portraits and religious and mythological paintings, genre scenes, landscapes, and still lifes.

Corinth trained under Otto Günther in 1876–80 at the Königsberg Academy of Art. In 1880–84, he studied under Franz von Defregger and Albert Löfftz at the Munich Academy of Art. After military service (1882) and a stay in Antwerp (1884), Corinth trained under William Bouguereau and Nicolas Robert-Fleury in 1884–87 at the Académie Julian in Paris. During this time, he also traveled in the Black Forest, in Lorraine, and in Holstein. He spent the winter of 1887–88 in Berlin and then returned to Königsberg, where he remained until 1891.

At this time, Corinth became friends with the Berlin painter Walter Leistikow. Corinth was based in Munich from October 1891 to March 1900, making frequent visits to villages in the surrounding country, and also traveling to Switzerland, Appenzell, Zoppot on the Baltic (now Sopot, Poland), and Berlin. In 1900, he moved to Berlin, where he opened a private school of painting, which he ran until 1914. He married Charlotte Berend, one of his first pupils, in 1903. From 1902, he was a member of the executive board of the Berlin Secession (which had been established in 1898), and was elected its president in 1911, the year in which he also suffered a stroke. In 1921, he received an honorary doctorate from the University of Königsberg; in 1925, he was made an honorary member of the Munich Academy of Art. SP

JOHAN CHRISTIAN CLAUSEN DAHL
Born 1788 in Bergen, Norway – died 1857 in Dresden

Alongside Caspar David Friedrich, Johan Christian Clausen Dahl is regarded as the chief representative of Romantic landscape painting associated with Dresden. Yet his work almost always depicted scenes of his native Norway. He effectively laid the foundations for an independent Norwegian tradition of painting.

His career began in Bergen where he trained as a decorative painter under Johan Georg Müller from 1803 to 1809. Dahl worked simultaneously on landscape and portrait painting (having had no formal training in either discipline). In 1814–17, he studied at the Copenhagen Academy of Art under Christian August Lorentzen and Nicolaj Dajon. After a short stay in Berlin, he moved to Dresden in 1818. He became a friend of Caspar David Friedrich and in 1823 moved into his Dresden house.

In 1819, he made his first sketching trip to the "Saxon Switzerland," not far from Dresden, and to Bohemia. A year later, he became a member of the Dresden Academy of Art. His son Siegwald became a painter specializing in the depiction of animals.

Dahl traveled to Italy, initially staying in Naples (where he met Franz Ludwig Catel), and later spending time in Rome. In Italy, he experimented with plein-air painting. In 1824, he was appointed to the rank of Extraordinary Professor at the Dresden Academy (and in 1828 was named an honorary member of this institution). Among his pupils were Carl Blechen and Ernst Ferdinand Oehme. Over the years, he traveled in his native Norway. In 1847, he also traveled to Paris and Brussels. DS

FRANZ VON DEFREGGER
Born 1835 in Stornach, Tyrol – died 1921 in Munich

Like his ancestors, Franz von Defregger was born and raised on a farm in Stronach, Tyrol. Upon his father's death, the twenty-three-year-old Franz took over the farm, but was so disenchanted with his life there that he planned to emigrate to America in 1858–59. When those plans fell through, he decided to go to Innsbruck to study the art of wood carving. In 1860, he met Carl von Piloty, professor of history painting at the Munich Academy of Art. Piloty recognized the young man's talents but advised him to first get some training with Hermann van Dyck at the School of Applied Arts. Defregger followed his advice, going on to Paris to continue his studies there in 1863. Although he was rejected by the art academy, he used his two-year stay in Paris to advantage, studying the great art collections and the works in the studios of the contemporary French artists such as Édouard Manet and Claude Monet. After a brief sojourn in the Tyrol, he returned to Munich in 1865, and was finally admitted into Piloty's class in the fall of 1866. By 1868, he achieved his first success with *Speckbacher and his son Anderl*, a theme from the resistance against Napoleon by Tyrolean farmers. In the next decade, Defregger went on to specialize in this type of history painting with nationalist overtones as well as in peasant genre. After a long and serious illness that made it almost impossible for him to paint, Defregger reached the height of his popularity in the mid-1870s and was appointed a professor at the academy in Munich in 1878. His works became more repetitive and anecdotal during the 1880s and 1890s. During this period, he turned more and more toward portraiture, with a particular strength in children's portraits.

Despite the years spent in Paris, Defregger was virtually untouched by the latest artistic developments there. He always remained a realist, his choice of themes mainly determined by the love for his native Tyrol. Only his sketches and some of his portraits reveal some Impressionistic passages. Defregger received numerous honors and medals throughout his career, and was knighted by the king of Bavaria in 1883. After the turn of the century, his fame began to wane due to a change in popular taste. He died in Munich at the age of 86 after a long and prolific career.
HKA

LUDWIG DILL
Born 1848 in Gernsbach, near Baden-Baden – died 1940 in Karlsruhe

Ludwig Dill, along with Adolf Hölzel and Arthur Langhammer, is the most important representative of the New Dachau School, one of many artists' colonies to be founded in Germany in the late nineteenth century. Dill is known as a painter and draftsman. He studied architecture at the Technical College (*Technische Hochschule*) in Stuttgart, under Christian Friedrich Leins and Adolf Gnauth, but he left after three years without taking his final examination. Dill then studied painting under Carl Raab, Otto Seitz, and Carl von Piloty at the Munich Academy of Art.

In 1874–75, he made a study trip to the south of France, Italy, and Switzerland. In 1877, he worked with Gustav Schönleber in Chioggia,

near Venice, and regularly spent his summers there for many years. In 1880, he traveled with Gustav Schönleber to Holland, and in 1888 to Belgium. In 1892, Dill was a founding member of the Munich Secession and served as president from 1894–99. He moved to Dachau, near Munich, and became the cofounder of the colony and artists' association *Neu-Dachau* (New Dachau), so called to distinguish it from the preexisting artists' colony based there. In 1899, Dill was appointed to a superior teaching post at the Karlsruhe Academy of Art. In 1912–14, he made study trips to Holland and Belgium. In 1918, he received an honorary doctorate in engineering from the Technical University, Karlsruhe.
DS

JOHANN CHRISTIAN MICHAEL EZDORF
Born 1801 in Pössneck, on the River Orla in Thuringia – died 1851 in Munich

Johann Christian Michael Ezdorf was the brother of the landscape painter and etcher Christian Friedrich Ezdorf.[1] Johann may have studied at the Munich Academy of Art, although this has yet to be proven on the basis of documentary evidence. Ezdorf was probably self-taught, learning a great deal from observing and sketching landscapes while on walking tours in the mountainous country around Munich. Settling in Munich, he made numerous trips to northern Europe: in 1821 to Norway, the North Cape, and Sweden. He remained in Stockholm for a long time and was elected a member of the Academy of Art there. In 1827, he traveled to Iceland and to Sweden; in 1835, to England; and in 1849, once again to Norway. He was appointed painter to the court of Saxony-Meiningen. Ezdorf is a member of the so-called Nordic Artists' Circle gathered around the Norwegian painter Thomas Fearnley and the Munich artist Christian Ernst Bernhard Morgenstern. DS

1 In the older literature the biographies of the two brothers are frequently confused. Except where reliable new information has come to light, the biography given here is based on the following source: Thieme, Ulrich, ed. *Allgemeinen Lexikon der bildneden Künstler von der Antike bis zur Gegenwart* [...] (Leipzig 1915), vol. 11, pp. 144–45.

CASPAR DAVID FRIEDRICH
Born 1774 in Greifswald – died 1840 in Dresden

Caspar David Friedrich is recognized as one of the foremost painters of German Romanticism. His achievement lies mainly in elevating pure landscape to works of religious significance. His paintings are informed by his contemplations of man's state on earth and of his path to salvation. Filled with symbols and hidden meanings, Friedrich's northern landscapes go beyond the naturalistic rendition of reality. In their lyrical and often somber expression, they are among the most poetic and moving paintings of this era.

Friedrich received his early training from Johann Gottfried Quistrop, a local artist in Greifswald. Subsequently, he attended the Copenhagen Academy of Art from 1794 to 1798. In 1798, he moved to Dresden, a city he chose because of its lovely surrounding countryside and because of the landscape painters Johann Christian Klengel, Jacob Wilhelm Mechau, and Adrian Zingg, who were working there. Friedrich remained in Dresden all his life with the exception of taking a number of trips to his native Greifswald and the nearby Island of Rügen in the Baltic Sea. He also undertook a number of walking and sketching tours in the Riesengebirge, a mountain range near Dresden. He never traveled south, disdaining the general trend of German painters to go to Italy. The most successful year of his career was 1810 when he was awarded a prize by the Weimar Art Association, the *Kunstverein*, under the auspices of

Johann Wolfgang von Goethe. During the same year, he was proposed as a member of the Berlin academy and both his *Monk by the Sea* and *Abbey in an Oakwood* were purchased by the king of Prussia, Frederick William III. A definite change in mood is noticeable in Friedrich's paintings around 1818, the year he married nineteen-year-old Caroline Bommer. In 1824, he was appointed assistant professor for landscape painting at the Dresden Academy of Art, but was never made full professor, a privilege that went to his close friend Johan Christian Clausen Dahl. Friedrich fell ill sometime around 1825 and a new sense of gloom starts to pervade his paintings. He managed to regain a more positive outlook after 1830, finding the strength and vision to paint some of his most remarkable works such as *Large Enclosure near Dresden* and *Stages of Life*. In 1835, Friedrich suffered a stroke and for the last few years of his life, spent in financial misery, he was capable only of limited artistic production. HKA

ANTON GRAFF
Born 1736 in Winterthur, Switzerland – died 1813 in Dresden

Except for Johann Friedrich August Tischbein, Anton Graff was the most important German portrait painter in the late eighteenth and early nineteenth centuries, the period known as the "Age of Goethe." Graff began his training in 1753 at Johann Ulrich Schellenberg's Drawing and Painting School in Winterthur, where he studied for three years. In 1756–57, he continued his training in Augsburg under the engraver Johann Jakob Haid and also trained as a portrait painter. In 1757–59, he was apprenticed in Ansbach to the painter Leonhard Schneider, and then returned to Augsburg. In the following years, Graff worked as a portrait painter in various German and Swiss cities, including Regensburg, Winterthur, and Zürich.

In 1766, Graff became a member of the Dresden Academy of Art and was appointed court painter in Dresden. Between 1769 and 1800, he was commissioned to paint portraits and traveled frequently to Leipzig, Karlsbad (now Karlovy Vary, Czech Republic), Berlin, Teplitz (now Teplice, Czech Republic), and Switzerland. In 1783, he became an honorary member of the Berlin Academy of Art. Six years later, he was appointed professor of portraiture at the Dresden Academy. In 1807, he was presented to the Emperor Napoleon. In 1810–11, he traveled in Switzerland. In 1812, he became an honorary member of the Vienna Academy of Art and of the Munich Academy of Art. DS

HEINRICH LOUIS THEODOR GURLITT
Born 1812 in Altona near Hamburg – died 1897 in Naundorf

Louis Gurlitt was highly regarded by the outstanding landscapists of his day, such as Johan Christian Clausen Dahl, Andreas Achenbach, and both Carl and Leopold Rottmann, and was a successful painter during his lifetime, but his fame soon diminished after his death. His work, which combines the more realistic teachings of the Copenhagen Academy with the more idealistic tendencies as explored by Carl Rottmann in Munich, however has earned greater appreciation in recent years.

The small town of Altona where Gurlitt was born and raised, although incorporated into the city of Hamburg today, belonged to Denmark at the time. Gurlitt received his first serious art instruction from Siegfried Bendixen in Hamburg between 1828 and 1832. Since Hamburg had no art academy and since Gurlitt was a Danish citizen, he went to Copenhagen to join the class of Christoff Wilhelm Eckersberg at the Academy of Art. Like his idol, Christian Morgenstern, he trave-

led to Norway for the first time shortly before beginning his studies in Copenhagen. He returned to Norway and Sweden again in 1835. In 1836, he established himself in Munich, gaining a reputation as an outstanding painter of northern landscapes.

In the summer of 1838, Gurlitt finally realized his dream of a trip to Italy, but could travel only as far south as the Lago di Garda. From 1843 to 1846, he was able to afford a longer stay in Rome, Naples, and Palermo. He returned to Germany, repeatedly changing his place of residence, living in Berlin, Leipzig, Dresden, and Vienna, among others. In the 1860s, he traveled to Spain and Portugal. He returned to Italy, whose natural beauty remained his foremost inspiration, for the last time in 1877. On his frequent and extensive trips he constantly sought motifs for his landscapes. Inspired by the ideas of Alexander von Humboldt, Gurlitt sought to enlarge on Rottmann's Greek and Italian cycles, and paint an all-encompassing European cycle. This dream remained unfulfilled. HKA

HUGO VON HABERMANN
Born 1849 in Dilligen on the Danube – died 1929 in Munich

Although Hugo von Habermann produced landscapes, history paintings, and genre scenes, he primarily focused on creating female portraits and figure paintings. His early work was influenced by the Realist and early Impressionist art of the members of the circle around Wilhelm Leibl and the Realism and Naturalism of Gustave Courbet. Habermann gradually evolved from Naturalism to a more stylized approach that was sometimes similar to turn-of-the-century *Jugendstil*, the Art Nouveau movement in Germany.

Habermann moved with his family to Munich at age ten. As a youngster, he had intensive instruction in drawing. He studied under Alexander Strähuber, Hermann Anschütz, Ferdinand Barth, and Otto Seitz at the Munich Academy of Art in 1871–79. He also studied there under Carl von Piloty from 1873–79. Then, Habermann founded a private school of painting with Fritz von Uhde and Bruno Piglheim, but the school soon closed. From around 1889, he worked for the selection and organization committee for state-sponsored art exhibitions both in Germany and abroad. In 1892, he was one of the founding members of the Munich Secession, serving as its second vice president in 1893 and its president in 1904. At the request of Max Klinger and Count Stanislas Kalckreuth, Habermann was appointed a member of the executive board of the Villa Romana-Stiftung to administer the German artists' villa in Florence and the distribution of the related stipends. He served as professor at the Munich Academy of Art from 1905 to 1924. SP

WILHELM JOSEPH HEINE
Born 1813 in Düsseldorf – died 1839 in Düsseldorf

In his work, Wilhelm Joseph Heine often assumed a socially critical attitude, and he may be seen as one of the first representatives of this trend in German art. On account of his early death, his overall output was relatively small. Nonetheless, his individual style assures him a significant place among the painters of the Düsseldorf School.

In 1829–38, Heine studied under Theodor Hildebrandt and others at the Düsseldorf Academy of Art. In 1838, he traveled to Munich and in the Tyrol. He remained based in Düsseldorf throughout his career. He was a member of the "anti-academic circle" of genre painters gathered around Johann Peter Hasenclever and Carl Wilhelm Hübner. SP

GUSTAV ADOLPH HENNIG
Born 1797 in Dresden – died 1869 in Leipzig

Born and raised in Dresden, Gustav Hennig studied with Johann David Schubert and Friedrich Matthäi between 1810 and 1814 at the art academy there. After working a few years as a portraitist mainly in Leipzig and Halle, he returned to Dresden in 1820. Between 1823 and 1826, he lived in Italy. Hennig spent most of his time in Rome, rooming there with the prominent landscapist Joseph Anton Koch, but he visited several other cities as well. On returning to Germany, Hennig established himself in Leipzig, where he received a teaching position at the academy in 1840. He later was made a full professor. In 1832–33, he spent another year in Italy—this time, mainly in Florence.

During his stay in Italy, Hennig belonged to the circle of the Nazarene painters, whose historically oriented style and preoccupation with religious themes can be felt in his work. A development from the romanticism of the Nazarenes toward a more realistic style can be detected in Hennig's works. Although he worked foremost as a portraitist, he painted genre and historical scenes and religious works as well.

HKA

HEINRICH MARIA VON HESS
Born 1798 in Düsseldorf – died 1863 in Munich

Alongside Peter von Cornelius, Heinrich Maria von Hess was the most important history painter active in Munich. He is best remembered for his schemes of decorative painting for Munich churches that were commissioned by King Ludwig I.

Hess was the brother of the battle and genre painter Peter von Hess and the animal painter Carl Hess. Beginning in 1806, Heinrich trained with his father, the engraver Carl Ernst Christoph Hess, in Munich. In 1813–17, he studied under Johann Peter von Langer at the Munich Academy of Art. He briefly collaborated with Peter von Cornelius in the fresco decoration for the Glyptothek in Munich. In 1821–26, he lived and worked in Rome, where he met and befriended, among others, Bertel Thorwaldsen, Antonio Canova, Martin von Wagner, Julius Schnorr von Carolsfeld, and members of the Nazarene Circle. He was also introduced to Prince Ludwig, heir to the Bavarian throne.

In 1826, at the suggestion of Peter von Cornelius, Hess became a member of the Munich Academy of Art, where a year later he began to teach painting. He also served as head of a set of workshops specializing in painting on glass, the *Königliche Anstalt für Glasmalerei*. In 1830–37, he provided the painted decoration of the Munich court church, the Allerheiligen-Hofkirche; in 1834, he was commissioned to provide painted decoration for the Basilica of Saint Boniface in Munich, where he worked between 1837 and 1844. In 1839, he became an honorary member of the Copenhagen Academy of Art. In 1847–49, he served as provisional head of the Munich Academy, but then abandoned all his offices at that institution. In 1849, he served as director of the united Bavarian state collections in Munich.

DS

EDMUND KANOLDT
Born 1845 in Grossrudestedt, Thuringia – died 1904 in Bad Nauheim

Edmund Kanoldt relied on themes from Antiquity and from the era of Romanticism in his landscape paintings. As an illustrator, he contributed to a wide range of publications, from editions of the works of Goethe, Schiller, and Shakespeare to stories by Joseph Freiherr von Eichendorff and Theodor Storm.

Kanoldt moved with his family to Jena in 1851. Around 1862, he was apprenticed to a book dealer in Weimar while attending classes at the Drawing School in Weimar. He studied there under Friedrich Preller the Elder for five years until 1869. In 1865, Kanoldt made a study trip to the Baltic island of Rügen, and in 1867–69, he traveled to Thuringia, to the forests of southern Bohemia, and along the Rhône. His style was particularly influenced in Rome by the work of Karl Heinrich Dreber, called Franz-Dreber, during a three-year stay until 1872. The next year, he was commissioned to provide illustrations for the luxury publication "Italy. A Tour on Foot from the Alps to Mount Etna." He spent 1875 in Moscow. From 1876, he was based in Karlsruhe and he took painting lessons with Ferdinand Keller that winter. In 1878, Kanoldt won a gold medal for his work in the student exhibition of the Art School in Karlsruhe. At this time he also established himself as a private art teacher in Karlsruhe. In the following years he continued to visit Italy. In 1881, his son Alexander was born. In the 1920s and 1930s, he would become a leading representative of the movement known as "New Objectivity," (*Neue Sachlichkeit*). In 1885, Kanoldt was appointed professor at Karlsruhe; he also cofounded a school for women painters there.

DS

JOHANN CHRISTIAN KLENGEL
Born 1751 in Kesseldorf, near Dresden – died 1824 in Dresden

Among the landscapists associated with Dresden, Johann Christian Klengel, both as painter and etcher, is regarded as a forerunner of Romanticism. Klengel trained in Dresden as a bookbinder while taking drawing lessons with Charles Hutin. In 1764, he studied at the Dresden Academy of Art and benefited from a course on perspective taught by Bernardo Bellotto. A year later, he studied with Christian Wilhelm Ernst Dietrich, called Dietricy, at whose home he lived from 1768 to 1774. During this time, Klengel made his first etchings. He became a member of the Dresden Academy of Art in 1777 and an honorary member of the Berlin Academy of Art in 1786. He traveled in Italy from 1790–92. In 1800, he started teaching at the Dresden Academy, and in 1816 became professor of landscape painting there.

DS

LEO VON KLENZE
Born 1784 in Schladen in the Harz Mountains – died 1864 in Munich

Leo von Klenze is regarded as the most important representative of southern German Classicism. Over the course of fifty years, he was responsible for most of the buildings that still determine the architectural character of the center of Munich. He was also active as a painter and a draftsman. Most of his pictures are of Italian and Greek landscapes.

Klenze began studying law at age sixteen but soon switched to architecture. Until 1803, he studied under Friedrich Gilly and Adolf Hirt at the Berlin Architectural Academy. He received additional training as an assistant in the architectural practice and factory run by Percier and Fontaine in Paris. Between 1803 and 1857, he made more than twenty-six trips to Italy. In 1804–13, he served as architect to the Kassel Court of King Jérome.

In 1813, he married Felicitas Blangni, an Italian, and lived in Paris for two years until 1815. During a trip to Vienna in 1814, Klenze met Prince Ludwig, heir to the Bavarian throne, who then appointed him to serve as his private architect in Munich, a post he held from 1816 to 1864. In 1834–35 and 1838, he traveled in Greece in a diplomatic capacity. Between 1839 and 1852, he made several trips to Russia, where he oversaw the building of the new museum in Saint Petersburg.

SP

MAX KLINGER

Born 1857 in Leipzig – died 1920 in Grossjena, near Naumburg

Max Klinger is celebrated particularly for the dazzling technical range of his work and for his extensive output as a printmaker. His oeuvre as a whole (as painter, printmaker, and sculptor) embraced both Naturalism and Symbolism. His painting reflects the Neo-Classical style associated with German artists working in Italy but also provides evidence of an early interest in plein-air painting and Impressionism. Klinger attracted considerable attention through his contribution to the revival of polychromatic sculpture that juxtaposed a range of different materials. The combination of painting and sculpture in many of his works did much to support the notion of the "total work of art" (the *Gesamtkunstwerk*), about which Klinger wrote in his 1891 text on "Painting and Drawing" (*Malerei und Zeichnung*).

Klinger had his first art lessons in 1863–67 with the Leipzig draftsman Brauer. In 1874, he studied under Ludwig Des Courdes and Carl Gussow at the Art School in Karlsruhe, and in 1875 continued under Gussow and Paul Thumann at the Berlin Academy of Art. He completed military service in Leipzig in 1876–77; he then moved to Berlin. Klinger made short stays in Brussels (1879) and Munich (1880). He worked in Paris from 1883–86, but returned to Berlin and Leipzig during this period. In 1886, he moved to Berlin. In 1888–93, he worked primarily in Rome; he settled in Leipzig in 1893 and built a studio there three years later. In 1906, he established a foundation to award an annual Villa Romana prize that enabled German artists to study in Italy. Klinger in 1910 met Gertrude Bock, who became his principal model, and he married her in 1919. KM

JOSEPH ANTON KOCH

Born 1768 in Obergiblen, near Elbingenalp in Upper Lechtal in the Tyrol – died 1839 in Rome

Among the German artists living in Rome, Joseph Anton Koch is regarded as the most important landscape painter. Combining heroic, classicizing, and Romantic features, his landscapes influenced the evolution of this genre around 1800.

Before he began to study painting, Koch in 1781 worked as a shepherd in Kubach, near Obergiblen. A year later, he began training as a priest in Dillingen. In 1784, he briefly studied with the sculptor Ignaz Ingerl in Augsburg. In 1785–91, as a pupil at the Hohe Karlsschule in Stuttgart, he studied under the landscape painter Adolf Friedrich Harper and the history painter Philipp Friedrich Hetsch. In 1791, he fled to Strasbourg, where he was in contact with an association of Jacobins. In 1792–94, he traveled in Switzerland, taking walking tours in the Jura Mountains and the Bernese Alps.

At the end of 1794 he left for Italy, visiting Milan, Bologna, Florence, Rome, Naples, and Paestum. From 1795 he lived in Rome, where he became a friend there of Asmus Jakob Carstens, Eberhard Wächter, and Johann Christian Reinhart. He spent three years in Vienna, from 1812 to 1815, where he came to know Friedrich Schlegel, Wilhelm and Caroline von Humboldt, the brothers Ferdinand and Friedrich Olivier, Julius Schnorr von Carolsfeld, and Heinrich Reinhold. In 1815, he returned to Rome. In 1825–28, he worked on frescoes illustrating scenes from Dante in the Casino Massimo in Rome. In 1834, he published a volume on art, the *Modern Chronicle of Art [...] or the Rumford Soup*, on which he had collaborated with Bonaventura Genelli and Johann Christian Reinhart. DS

GOTTHARDT KUEHL

Born 1850 in Lübeck – died 1915 in Dresden

Initially working in a Naturalist style, Gotthardt Kuehl gradually evolved into one of the most important representatives of plein-air painting in Germany. He made a crucial contribution to the emergence and success of Impressionism in Germany, especially in Dresden, where he had a great influence on many pupils. Kuehl first attended the Commercial College in Lübeck, but in 1867–70 he studied at the Dresden Academy of Art under Adrian Ludwig Richter, Adolf Ehrhardt, and others. From 1870–73, he trained under Wilhelm von Diez at the Munich Academy of Art.

From 1874, he was based in Munich as an independent artist and was a founding member there of the artist's society "Allotria." Between 1879 and 1889 he was based in Paris, but he traveled extensively in these years, above all to Germany and Holland. He exhibited his work at the Paris Salons and he took up plein-air painting. In 1886–93, he was again based in Munich. During this period, he was appointed to a professorship at the Academy and in 1892 he became a founding member of the Munich Secession. He also made prolonged visits to the village of Dachau (site of a German artists' colony and where a new colony, *Neu-Dachau*, was established in 1894). In 1895, he was appointed professor at the Academy in Dresden and he moved there. He continued to travel frequently, making a long stay in Italy in 1907. DS

CARL ROBERT KUMMER

Born 1810 in Dresden – died 1889 in Dresden

As a landscape painter, Carl Robert Kummer is one of the most important representatives of the second generation of Romantic artists in Dresden. He was the brother of the painter Julius Kummer (who emigrated to America in 1849) and the godson of Caspar David Friedrich. In 1826–29, Kummer studied under Carl August Richter at the Dresden Academy of Art, but was more strongly influenced by Johan Christian Clausen Dahl. He was effectively a self-taught artist.

Over the years, Kummer traveled quite a bit. In 1829, he went to Austria; in 1830–31 and 1832–36 he traveled in Italy; in the interim, from fall 1833 until spring 1835, Kummer traveled in Hungary. In 1836, he settled in Dresden. From 1839, he spent almost every summer in the Salzkammergut in the Austrian Alps. He also traveled in Dalmatia and Montenegro (1846), to Scotland (1851), to Portugal (1859), as a companion to Prince Georg of Saxony, and to Egypt (1867). In 1848, he became an honorary member of the Dresden Academy and in 1859, he was appointed to the rank of professor at the academy. DS

WILHELM LEIBL

Born 1844 in Cologne – died 1900 in Würzburg

Wilhelm Leibl left Cologne in 1864 to study at the Academy of Art in Munich with Anschütz, von Ramberg, and von Piloty. He finished his studies in 1869 and met Courbet the same year at the first International Exhibition in Munich. Leibl's entry, the portrait of Minna Gedon, was well received and he was awarded the Gold Medal for the same painting at the Paris Salon of 1870. On returning to Munich he became increasingly disenchanted with the official art scene and isolated himself for the rest of his life in various Bavarian villages. Here, he found subjects conducive to his realistic genre style, drawing his models primarily from the villagers. His most important work, *Three Women in Church* (1882), was greatly admired for its Holbeinesque precision, but

failed to fetch the hoped-for price. It was not until the 1890s that Leibl was considered the foremost German Realist.

Leibl was greatly influenced by Courbet's realism, by the French master's unsentimental portrayal of everyday life. In the isolation of village life, he turned away from history painting as taught at the Munich academy by Piloty, and toward increasingly simple and powerful genre paintings. The influence of the German Renaissance painters is particularly strong during the 1870s, while a new lightness of brushwork and palette, no doubt a reaction to French Impressionism, determine his later works. Leibl was the center of a group of painters, whose friendship, criticism, and support he valued. This informal association of artists, the so-called Leibl-Kreis, consisted of Johann Sperl, Rudolph Hirth du Frênes, Karl Haider, and Fritz Schider, among others. HKA

FRANZ VON LENBACH
Born 1836 in Schrobenhausen, Upper Bavaria – died 1904 in Munich

As a leading portrait painter to royal courts across Europe and to the upper bourgeoisie of the German Empire, Lenbach achieved the status of a true German "painter prince." He initially attended the Agricultural and Commercial College in Landshut (1848–51) and then worked as an apprentice stonemason in his father's building firm. In 1851–52, he was a guest pupil of the sculptor Anselm Sickinger in Munich. In 1853, he studied at the private Munich school for painting run by the portraitist Albert Gräfle, and in February 1854, he obtained a place at the Munich Academy of Art. Here he studied under Georg Hiltensberger, then Hermann Anschütz (from 1855), and Carl von Piloty (from 1857).

In 1858, Lenbach was in Italy, where he visited Rome, Florence, and Venice. In 1859, he traveled to Paris and Brussels. In 1860–62, he taught history painting at the Art School in Weimar. From 1862, he was primarily based in Munich, though he stayed in Rome for two years beginning in 1864. In 1867–68, he was commissioned by Adolf Friedrich Count von Schack to paint copies of works in museum collections in Madrid. In 1870, he made a long stay in Vienna, and often spent time there during the next five or six years.

From 1871, he received commissions for portraits from various monarchs of the period, among them the Emperor Wilhelm I of Germany and the Emperor Franz Joseph of Austria-Hungary. In 1876, he became an honorary member of the Munich artists' society "Allotria," becoming its president in 1879. In 1883–87, he had a studio in Rome. In 1883–89, he had a villa built in Munich by Gabriel von Seidl. In 1896, he was elected the first Vorsitzender of the Munich Artists' Association, the *Künstlergenossenschaft*. DS

KARL FRIEDRICH LESSING
Born 1808 in Bresslau – died 1880 in Karlsruhe

In 1822, Lessing went to Berlin to study architecture with Karl Friedrich Schinkel, the renowned Classicist architect of the Prussian court, but soon changed course to study painting. He followed Wilhelm von Schadow from Berlin to Düsseldorf when the latter was appointed director of the academy there in 1826. Lessing, although never a professor at the Düsseldorf Academy of Art, did exercise considerable influence on the students of that institution. In 1858, he accepted the position as director of the museum (Gemäldegalerie) in Karlsruhe, but declined the directorship of the Düsseldorf Academy of Art in 1867.

His fellow painters credited him with developing a realistic approach to landscapes. Originally interested in landscape painting, he turned to historical subjects under the influence of von Schadow, eventually combining the two genres. He also drew parallels between historical scenes and contemporary political events, thus representing the artist's voice of the liberal bourgeoisie. He had a profound influence on the younger generation of landscapists. HKA

MAX LIEBERMANN
Born 1847 in Berlin – died 1935 in Berlin

One of the leading German Impressionists, Max Liebermann produced landscapes and genre scenes, and was also from the 1890s a prolific portraitist. As a student in Berlin, Liebermann took art lessons with Carl Steffeck. In 1868–73, he trained under Paul Thumann, Ferdinand Pauwels, and Charles Verlat at the Art School in Weimar. In 1871, accompanied by Theodor Hagen, he visited the Hungarian painter Mihaly von Munkácsy in Düsseldorf, then made a first short stay in Holland. In 1872, Liebermann traveled to Paris and again to Holland and made his first attempts at plein-air painting. In 1873, he moved from Weimar to Paris. The next year, he spent the summer painting at Barbizon. In 1875, the artist made his third study trip to Holland, the following year returning to make a five-month stay in Amsterdam and Haarlem, where he became deeply interested in the work of the seventeenth-century painter Frans Hals. He would continue to return to Holland at least once a year. In 1878, he visited Venice and moved to Munich.

In 1884, Liebermann moved to Berlin, where he married Martha Marckwald. From around 1890 he made numerous visits to Paris, Hamburg, and Italy. In 1897, he was appointed to a professorship at the Academy of Art in Berlin, but did not actively teach there. In 1898, he was a founding member of the Berlin Secession, serving as its president from 1899–1911. In 1920–32, Liebermann was president of the Prussian Academy of Art, eventually in an honorary capacity, but he was forced to resign from the institution when the National Socialists seized power in Germany in 1933. Many paintings by Liebermann were then removed from public collections. SP

ADOLPH VON MENZEL
Born 1815 in Breslau (today Proclaw, Poland) – died 1905 in Berlin

As a child, Adolph Menzel helped his father in his lithography workshop in Breslau. In 1830, the family moved to Berlin, hoping to find more employment in the field of commercial lithographic illustrations. When his father died just two years later, the sixteen-year-old Adolph supported his mother, sister, and brother with income from his illustrations. He was largely self-taught, although he attended a class at the Berlin Academy of Art for a short time in 1833. Menzel, whose talent as a draftsman and illustrator began to be recognized, was chosen to illustrate Georg Kugler's *History of Fredrick the Great*, published in 1842. This much-admired work became the basis of Menzel's fame. He subsequently was commissioned repeatedly to illustrate works on the life and the army of the Prussian king. Menzel's passionate interest in this multifaceted monarch culminated in a series of oil paintings, including his *Flute Concert at Sanssouci*, (1850–52). The cycle was to occupy him from 1849 to 1860.

Menzel, who taught himself the technique for oil painting in the late 1830s, had painted a number of remarkably pre-Impressionistic paintings during the 1840s, including *The Balcony Room*, (1845). However, in the following decades he turned decisively toward Realism, a style in which he excelled, thanks to his sharp observation of nature and his enormous

skill as a draftsman. In his historical paintings, he was able to create a sense of authenticity by combining a great number of meticulously studied details with sensitively captured characteristics of various historical figures into convincing illustrations of scenes from the past. During his later years, which coincided with the German Empire (founded in 1871), he was a favorite of its ruling family, the Hohenzollern, and he documented many of the political and social events of the Imperial Court. In 1856, he became a professor at the Berlin Academy of Art, and received the order of *Pour le merit* in 1858 and the most distinguished Order of the Black Eagle in 1898.

Although Menzel enjoyed great respect and success during his lifetime, the true scope of the diversity and modernity of his oeuvre has been recognized only recently. Especially his Impressionistic works of the 1840s, his liberal political statements made by paintings like his *Lying in State of the March Dead,* (1848), and the social statement made by *The Iron Rolling Mill,* (1875), add further dimensions to a painter of brilliant technical skill who had been appreciated earlier as the beloved raconteur of history and as the sharp observer of contemporary life.　　HKA

ERNST FERDINAND OEHME
Born 1797 in Dresden – died 1855 in Dresden

Ernst Ferdinand Oehme, one of the younger members of the circle of artists gathered around Caspar David Friedrich and Johan Christian Clausen Dahl in Dresden, was extremely influenced by the work of these two masters. Oehme is now regarded as an important representative of the second generation of Romantic landscape painters in Dresden.

In 1814, he began training as a teacher in the Friedrichstadt district of Dresden. In 1815–17, he worked in Dresden as an assistant to the sign writer at the former Pirna Gate in Dresden. He also began teaching himself to paint and draw. In 1819–21, he studied under Johan Christian Clausen Dahl and Caspar David Friedrich at the Dresden Academy of Art. He then received a stipend from Prince Friedrich August of Saxony enabling him to travel, study, and work in Italy from 1822–25. There he met Carl Wagner, Ludwig Richter, Carl Peschel, and Julius Schnorr von Carolsfeld. He returned to Germany via the Tyrol and Switzerland. In 1827, he married Emma Auguste Wiedemann.

In 1826–39, he took numerous trips to the Erzgebirge, Upper Bavaria, and the Mulden Valley. From 1841, he made many walking tours with Carl Peschel and Ludwig Richter in northern Bohemia, in the Harz Mountains, in the Upper Lausitz Mountains, and in Franconia. In 1842, he was appointed drawing master at the Blochmannsche Erziehungs-Institut (later known as the "Vitzhumsches Gymnasium") in Dresden. In 1846, he was appointed painter to the Saxon court in Dresden and became an honorary member of the Dresden Academy.　　SP

JOHANN HEINRICH FERDINAND OLIVIER
Born 1785 in Dessau – died 1841 in Munich

Johann Heinrich Ferdinand Olivier, the third son of Ferdinand Olivier and his wife Louise Niedhardt, was taught drawing by the landscapist Karl Wilhelm Kolbe. In 1804, he and his brother Heinrich, also a painter, went on to Dresden, where they were more influenced by Caspar David Friedrich than by their teachers at the Academy of Art, Jakob Wilhelm Mechau and Carl Ludwig Kaaz. Due to his excellent knowledge of French, Ferdinand was sent to Paris on a diplomatic mission in 1807, staying there until 1809. In 1811, he settled in Vienna where he and his brothers, Heinrich and Woldemar Friedrich, belonged to the

circle of the philosopher Friedrich Schlegel, Philipp Veit, Schnorr von Carolsfeld, and Joseph Anton Koch. In 1815, and again in 1817, he traveled and sketched extensively in and around Salzburg. The sketches from these trips were to become the basis of his most significant paintings. Both he and Friedrich became members of the Guild of St. Luke in 1817, but unlike his brother he did not convert to Catholicism, nor did he go to Rome to join the Nazarenes. In 1830, he moved to Munich, and was appointed professor of art history at the Academy of Art, where he remained until his death.

Two paintings executed on commission for the church in Wörlitz in 1810 for the first time combine medieval elements with landscape painting according to the philosophical theories of Friedrich Schlegel, and can be considered the earliest paintings done in the Nazarene style, although they predate the formation of the Nazarenes in Rome. Ferdinand Olivier, whose works emphasize the harmony of man and nature, found a new expression of spirituality in landscape painting.　　HKA

WOLDEMAR FRIEDRICH OLIVIER
Born 1797 in Dessau – died 1859 in Dessau

Woldemar Friedrich was the younger brother of Johann Heinrich Ferdinand Olivier and similarly received drawing instructions from Karl Wilhelm Kolbe. He subsequently trained as a sculptor with Friedemann Hunold, but eventually turned to painting, which he learned autodidactically. He joined his brothers, Ferdinand and Heinrich, in Vienna in 1811, and attended the art academy there. He fought as a volunteer against Napoleon, rejoining his brother in Vienna after Napoleon's defeat. Olivier traveled with his brother Ferdinand and a number of other artists from Vienna to Salzburg in the summer of 1817, discovering the beauties of that city and its environs. In 1818, he went to live in Rome, where his close friend Julius Schnorr von Carolsfeld had preceded him. Like von Carolsfeld, Olivier joined the Nazarenes, the group of Revivalist German painters, whose leading figures were Johann Friedrich Overbeck, Peter von Cornelius, Wilhelm von Schadow, and Philipp Veit. He returned to Vienna in 1823 and married his brother's stepdaughter, Fanny Heller, two years later. After several failed attempts, he finally moved to Munich in 1830, working as Schnorr's assistant on the wall paintings in the royal residence, the Königsbau. Following the death of his brother Heinrich, Olivier returned to his native Dessau in 1850 and spent his last years there.

Olivier's works are characterized by his outstanding skills as a draftsman. The precise lines of his pen-and-pencil drawings determine the style of his oil paintings. Like many of his fellow Nazarenes, Olivier was inspired by the works of the Italian Renaissance, and sought to recapture their quality of *disegno*, or drawing, as well as their spiritual content.　　HKA

JOHANN FRIEDRICH OVERBECK
Born 1789 in Lübeck – died 1869 in Rome

Johann Friedrich Overbeck's formally rigorous early works rank among the most striking achievements of Nazarene art. They were created under the influence of Medieval and Early Renaissance German painting and the art of the Early Italian Renaissance that evinced Overbeck's true depth of feeling and his fresh response to nature. Overbeck's oeuvre as a draftsman was equally impressive.

Overbeck's training began in 1804 when he studied drawing under Joseph Nicolaus Peroux. From 1806 to 1810, he studied under Friedrich Heinrich Füger at the Academy of Art in Vienna, where he be-

came a friend of Franz Pforr. In 1809, he cofounded the German artists' association, the Brotherhood of Saint Luke, with Pforr, Joseph Wintergerst, Konrad Hottinger, Ludwig Vogel, and Joseph Sutter. In 1810, Overbeck, Pforr, Hottinger, and Vogel left the Viennese Academy and moved to Rome.

The center of the young artists' activities, and of what later came to be known as the Nazarene Movement, was the monastery of San Isidoro. There, they became friends with Peter von Cornelius. In 1813, Overbeck converted to Catholicism. Three years later, he received a commission to provide decorations for the Casa Bartholdy, and he executed two frescoes for that location. In 1817, he received a commission to provide frescoes for the Tasso Hall in the Villa Massimo in Rome, but he abandoned work on this project in 1827. He become an honorary member of the Academies in Munich (1829), Vienna (1836), Florence (1844), Berlin (1845), and Antwerp (1863). In 1831, he also became a member of the Accademia di San Luca in Rome. DS

FRIEDRICH PRELLER THE ELDER
Born 1804 in Eisenach – died 1878 in Weimar

Friedrich Preller the Elder tried his hand at woodcarving and drawing, initially without any instruction. In 1814, he became a pupil at the Free Drawing School in Weimar. In 1821, he met Johann Wolfgang von Goethe, who subsequently provided support for the young artist. In 1821–23, he made repeated visits to the public galleries in Dresden to make copies of paintings by the Old Masters. In 1824–26, he received a stipend from the Grand Duke of Saxony, Carl August, enabling him to study in Antwerp under Mathieu Van Bree and then in Milan under the director of the local Academy of Art, Cattaneo.

In 1828–31, he lived in Rome and traveled to Olevano and Subiaco, where he met Bonaventura Genelli, Joseph Anton Koch, and Johann Christian Reinhart, among others. In 1831, he returned to Weimar and took a teaching post at the local drawing school. In the same year, he married Marie Erichsen; their son Friedrich was born in 1838. He made many journeys to the Baltic island of Rügen, to Holland, to Norway, and in the Riesengebirge. In the 1840s, he became friends with Franz Liszt, and designed costumes and stage sets. In 1859–61, he traveled in Italy. In 1862, his wife died, and two years later he married Jenny Krieger. From 1868, he served as director of the drawing school in Weimar.

Working to some degree in the tradition of the seventeenth-century classicizing treatment of landscape, though initially influenced by the idealistic strain in German Romantic painting, Preller represented an approach to art that remained unconditionally tied to the ideals of Classicism. Among his most important works are the Odyssey Cycle, painted for the "Roman House" in Leipzig, and the so-called Preller Gallery in the museum in Weimar. SP

DOMENICO QUAGLIO II
Born 1786 in Munich – died 1837 in Hohenschwangau, near Füssen

The best-known representative of the Quaglio family of artists, Domenico is regarded as the most important Munich painter of city views (*vedute*) active in the first half of the nineteenth century. He succeeded in combining the eighteenth-century legacy of this branch of painting with the Realistic and Romantic tendencies of his own time. Domenico came from a family of artists of Italian origin: he was the son of Giuseppe, and the brother of Angelo I, Lorenzo II, and Simon Quaglio. He studied perspective, architecture, and theatrical set decoration under his father.

He went on to study etching and lithography under Johann Michael Mettenleiter and Carl Ernst Christoph Hess at the Munich Academy of Art. From 1803–4, he painted sets for the Munich court theater and from 1808–18, he specialized in painted architectural elements.

In 1819, he made his first paintings in oils, soon dedicating himself exclusively to architectural motifs. He took numerous study trips throughout Europe. In 1823, he became a founding member of the *Kunstverein*, the Munich artists' association. A year later, he became an honorary member of the Munich Academy of Art; and subsequently a member of the Academies of Berlin, Kassel, and Leipzig. DS

JOHANN CHRISTIAN REINHART
Born 1761 in Hof, Upper Franconia – died 1847 in Rome

Johann Christian Reinhart was the first in a long series of German artists to live and work in Rome. Alongside Joseph Anton Koch, he was the most important German representative of a Classical approach to landscape painting found among the German painters working in Italy around 1800. Moreover, he wrote a great many texts on art theory.

As a young man, Reinhart began to study theology but soon turned to art. He studied under Adam Friedrich Oeser at the Leipzig Academy of Art from 1779 to 1782. In 1782, he also produced etchings. A year later, Reinhart moved to Dresden, where he studied under Johann Christian Klengel at the Academy of Art. In 1784, he made walking tours through Saxony and Bohemia and then returned to Leipzig where in 1785 he became a friend of the poet and dramatist Friedrich Schiller. Reinhart lived in Meiningen from 1786 to 1789 but traveled to Italy in fall 1789. By the end of that year, he settled in Rome, eventually teaching an evening class in nude life drawing for German artists in Rome. In 1810, Reinhart was elected to membership of the Berlin Academy of Art. In 1810–11, he and Friedrich Sickler published a "Roman almanac for artists and art lovers." In 1813, he became a member of the Accademia di San Luca, the Roman artists' association, and in 1829 he was a founding member of the Association of German Artists in Rome. In 1830, he became a member of the Munich Academy of Art, and in 1839 he was appointed court painter. DS

FRIEDRICH PHILIPP REINHOLD
Born 1779 in Gera – died 1840 in Vienna

Friedrich Philipp Reinhold was born into a dynasty of painters. His father, his brothers Gustav and Heinrich, and his three sons Friedrich, Franz, and Karl all worked as painters and graphic artists. He studied with Johann Eleazar Zeissig, called Schenau, at the Dresden Academy of Art between 1797 and 1804. He is said to have been close to Caspar David Friedrich, who had no students as such, but who was certainly Dresden's most outstanding landscapist. In 1805, Reinhold moved to Vienna where he remained for the rest of his life. From 1805 to 1811, he finished his studies at the Vienna Academy of Art, joining the circle of Johann Friedrich Overbeck, Joseph Sutter, Joseph Wintergerst, Ferdinand Olivier, and Julius Schnorr von Carolsfeld. He interrupted his stay in Vienna for one year, working as a portraitist in Gera and Leipzig in 1811–12. On his return to Vienna, at first he produced mainly historic paintings and portraits, but after 1816, turned exclusively to landscapes.

Reinhold's style was firmly rooted in Romanticism, influenced both by Caspar David Friedrich and the young Viennese artists around Overbeck, who became known as the Nazarenes after they established themselves in Rome about 1810–11. HKA

ADRIAN LUDWIG RICHTER
Born 1803 in Dresden – died 1884 in Dresden

Adrian Ludwig Richter was one of the principal German representatives of late Romantic painting. He achieved wide popularity through his folkloric illustrations for fairy tales, stories, and collections of songs. Initially trained by his father, Carl August Richter, the younger Richter attended the Dresden Academy of Art from 1816–23. He also served as an assistant in his father's studio. In 1820–21, he traveled in the south of France. A stipend from the Dresden publisher and bookseller Johann Christoph Arnold enabled him to study and work in Italy from 1823–27. In Rome, he met Joseph Anton Koch and also became friends with Julius Schnorr von Carolsfeld, Carl Wagner, Ernst Ferdinand Oehme, and Carl Peschel. In 1827, he married Auguste Freudenberg.

In 1828–35, Richter served as instructor in drawing at the Porcelain Factory in Meissen. From the 1830s, he worked closely with various Leipzig-based publishers. In 1834, he made a journey through Bohemia. He returned in 1835 to Dresden, where he taught landscape painting at the Academy from 1836 to 1876, holding the rank of professor for thirty-five years. Beginning in 1837, he traveled frequently in France, Bohemia, the Riesengebirge, and the Harz Mountains. In 1851, he was appointed to the Academic Council of the Munich Academy of Art and became an honorary member of the institution. Eight years later, in 1859, he started suffering from an acute nervous condition and had difficulties with his eyesight. He began working on his memoirs in 1869. In 1878, he became an honorary citizen of Dresden.　　　　SP

CARL ROTTMANN
Born 1797 in Handschuhsheim near Heidelberg – died 1850 in Munich

In Heidelberg, where Carl Rottmann grew up during the first years of the nineteenth century, many of the founders of German Romanticism, among them Achim von Arnim, Clemens Brentano, and Friedrich Hegel, lived and worked. Although Rottmann's father was also an artist, the most important influence on Carl came from Carl Fohr and the Scottish painter George Augustus Wallis, who lived in Heidelberg from 1812 to 1816. Rottmann in 1821 moved to Munich, where he was influenced by Joseph Anton Koch's 'heroic landscapes' (see cat. no. 48). Having seen the work Rottmann had brought back from his first visit to Italy in 1826–27, King Ludwig I of Bavaria commissioned him to paint a series of frescoes of Italian landscapes. To gather material for this project, Rottmann spent 1829–30 again in Italy. He executed twenty-eight frescoes in the arcades of the garden of the royal residence (Hofgartenarkaden) in Munich between 1830 and 1834. Subsequently, the king commissioned him to paint a series of Greek landscapes. Rottmann spent 1834–35 in Greece and painted his "Greek Cycle" between 1838 and 1850. Plagued by disease and constantly urged to work faster by the impatient king, Rottmann died shortly after completing the cycle.

In these two cycles, Rottmann took landscape painting from the realm of picturesque views to new monumental heights. Rottmann's style developed from a realistic rendition of nature into an artistic analysis of a given topography. His later cycle, considered too stark and lacking in pleasing detail, met with much criticism. His mature style, however, represents a milestone in the development of landscape painting of the Munich school. His followers include many of the important landscapists in Munich, including Christian Morgenstern, Ernst Fries, and Eduard Schleich the Elder.　　　　HKA

PHILIPP OTTO RUNGE
Born 1777 in Wolgast – died 1810 in Hamburg

Along with Caspar David Friedrich, Philipp Otto Runge is recognized as one of the founding fathers and leading theorists of Romantic art in Germany. Runge was the son of a shipowner and merchant. From 1789, as a pupil at the state school in Wolgast, he was taught by the theologian and poet Gotthard Ludwig Kosegarten, who had a long-lasting impact on Runge's imagination. In 1795, Runge moved to Hamburg. In 1797–98, he studied drawing with Heinrich Joachim Herterich and in 1798–99 with Gerdt Hardorff the Elder. He also received his first instruction in painting from Jobst Eckhardt. From late October 1799 to the end of March 1801, Runge studied under Nicolai Abraham Abildgaard and Jens Juel at the Copenhagen Academy of Art. In 1801, he met Caspar David Friedrich and Johann Gottfried Quistorp in Greifswald.

To continue his artistic training, Runge moved to Dresden in 1801. Though he did not attend classes at the Academy of Art, he remained in contact with those teaching and studying there. In Dresden, he attended lectures on anatomy given by Gotthilf Heinrich von Schubert. He came to know Ludwig Tieck and Anton Graff. Runge moved to Hamburg in 1804. He began corresponding with Johann Wolgang von Goethe on the subject of their simultaneous research into color theory. In 1808, he became a member of the Hamburg Society for the Promotion of the Arts and the Useful Industries. In 1810, Friedrich Christoph Perthes published Runge's essay on the "Color Sphere."　　　　KM

WILHELM VON SCHADOW
Born 1788 in Berlin – died 1862 in Düsseldorf

Wilhelm von Schadow was the son of the famous sculptor Johann Gottfried Schadow, best known for the Quadriga on the Brandenburg Gate in Berlin. Trained early by his father, he continued his studies at the Berlin Academy of Art. In 1811, he went to Rome with his brother Rudolph and joined the Brotherhood of St. Luke, the group of German painters who were soon known as the "Nazarenes." Under their influence, von Schadow converted to Catholicism in 1814 because religious conviction and religious painting were of utmost importance to the Nazarenes. He worked on their first important commission, the decoration of the Casa Bartholdy, along with Johann Friedrich Overbeck, Peter von Cornelius, and Philipp Veit. In 1819, he returned to Berlin, where he was appointed a professor at the art academy. In 1826, he replaced his fellow Nazarene Peter von Cornelius as director of the Academy of Art in Düsseldorf. During his directorship this academy attained its international reputation, attracting students not only from all over Europe, but from America as well. Von Schadow returned to Rome twice more, in 1830–31 and in 1839–40. He was knighted in 1845 and retired from the academy in 1859, just three years before his death.

Von Schadow remained indebted to the Nazarene teachings all his life, retaining the linear style and the clear local colors throughout his oeuvre. Although he painted some remarkable portraits, he felt that religious subjects were of foremost importance and devoted himself to these. His true significance for the development of German art during the nineteenth century, however, was his reorganization of the Düsseldorf Academy of Art. Under his stewardship, Realism in genre scenes as well as in landscapes was developed and taught there, influencing a whole generation of painters from many countries, including Albert Bierstadt, Emanuel Leutze, and Worthington Whittredge, who were of great importance to artistic development in the United States.　　　　HKA

JOHANN WILHELM SCHIRMER
Born 1807 in Jülich – died 1863 in Karlsruhe

As one of the most outstanding and influential landscape painters of the first half of the nineteenth century, Johann Wilhelm Schirmer played a pivotal role in the evolution of German painting from Romanticism to Naturalism. Schirmer was also recognized as an etcher and lithographer.

The son of a bookbinder, Schirmer was initially trained to follow in the same line of work. In 1825, he began studies under Wilhelm von Schadow and Heinrich Christoph Kolbe at the Düsseldorf Academy of Art. In 1827, with Carl Friedrich Lessing, he founded the landscape painting club, the "Landschaftlicher Componierverein." At this time, he was also encouraged by Lessing to devote himself to landscape painting, and Schadow asked him to teach a landscape painting class at the academy in 1829. From 1820–40, Schirmer started traveling widely, visiting the Eifel region, Belgium, Switzerland, Normandy, and Italy. In 1839, he became a professor at the Düsseldorf Academy; among his students here were Andreas Achenbach, Arnold Böcklin, and Anselm Feuerbach. In 1851, he traveled to the south of France. In 1854, he was invited by Friedrich I Grand Duke of Baden to establish an academy in Karlsruhe; he headed this institution from 1855. Hans Thoma was among his students there. DS

JULIUS SCHNORR VON CAROLSFELD
Born 1794 in Leipzig – died 1872 in Dresden

Julius Schnorr von Carolsfeld came from a family of artists. He was trained by his father, the history and portrait painter Veit Hans Schnorr von Carolsfeld. In 1806, he showed his work for the first time at the exhibition of the Dresden Academy of Art. In 1811, he began his studies at the Academy of Art in Vienna, where he became a close friend of the brothers Friedrich and Ferdinand Olivier and of Joseph Anton Koch.

Schnorr von Carolsfeld spent ten years in Italy, from 1817–27. In Rome, he became a member of the German artists' association, the Brotherhood of Saint Luke. For six years he worked on the frescoes for the Ariosto Room in the Casino Massimo. In 1825, he was appointed to teach at the Academy of Art in Munich and moved there two years later. He subsequently was appointed professor of history painting. From 1831, he worked on the Nibelungen frescoes in the Royal Palace, the *Residenz*, in Munich (completed in 1867, by his assistants), and in 1835–43 on the frescoes for its Imperial Halls *(Kaisersäle)*. In 1846, he moved to Dresden and until 1871 taught at the Dresden Academy of Art. He also served as director of the Picture Gallery, the *Gemäldegalerie*.

A leading figure in the Roman Nazarene Circle, Julius Schnorr von Carolsfeld was one of the most important draftsmen of the nineteenth century, as shown by the properties in his landscapes, portraits, and nudes and by the preparatory drawings for his extensive work in fresco. Among his best-known works are the Nibelungen frescoes in Munich and the drawings for his *Bible in Pictures*. DS

MORITZ VON SCHWIND
Born 1804 in Vienna – died 1871 in Niederpöking on Lake Starnberg, near Munich

A painter-poet, draftsman, and printmaker, Moritz von Schwind is among the most important representatives of late Romanticism in Germany. He is known especially for creating works based on motifs from fairy tales and historical sagas.

Schwind was the son of a Viennese court official. In 1818–21, he studied philosophy at Vienna University. He went on to the Vienna Academy of Art until 1823 and trained there under Leopold von Kupelwieser, Peter Krafft, and Ludwig Ferdinand Schnorr von Carolsfeld. In 1828, he moved to Munich, where he studied composition under Peter von Cornelius at the Munich Academy of Art. In 1832, he was commissioned to decorate the Ludwig Tieck Room in the Royal Palace (the *Residenz*) in Munich. From March to October 1835, he traveled in Italy.

Schwind received numerous commissions for murals, including in 1838, the decoration of the garden room on the estate of Rüdigsdorf near Altenburg, with scenes from the tale of Amor and Psyche (largely executed by Leopold Schulz). In 1841–47, he worked in Karlsruhe, where he decorated the main staircase of the art gallery, the Kunsthalle. In 1844–46, he was based in Frankfurt am Main. In 1846, he took a teaching post at the Munich Academy, and a year later attained the rank of professor. In 1848, he worked as an illustrator for the serial publications *Münchner Bilderbogen* and *Fliegende Blätter*. Until 1864, he produced scenes of travel, which were not intended for public display. In 1853–55, he worked on frescoes for the Wartburg near Eisenach. In 1863–67, he produced painted decoration for the Opera in Vienna. DS

MAX SLEVOGT
Born 1868 in Landshut, Bavaria – died 1932 in Neukastel, in the Palatinate

A richly imaginative painter and an outstanding draftsman and printmaker, Max Slevogt rivaled Max Liebermann and Lovis Corinth as a representative of German Impressionism. His oeuvre also embraces Naturalist and Realist images close to the work of Munich painters or that of the circle around Wilhelm Leibl. In addition to mythological and biblical subjects, scenes of contemporary life, and portraits, Slevogt painted landscapes and an impressive series of celebrated actors and opera singers "in character."

In 1884–90, Slevogt studied at the Munich Academy of Art under Gabriel Ritter von Hackl, Caspar Herterich and, from 1888, Wilhelm von Diez. In 1889, he spent a semester at the Académie Julian in Paris. Throughout his career, he traveled widely, beginning with a stay in Italy (Rome, Florence, and Capri) in 1890. Then he was based in Munich, where he was a founding member of the Secession in 1892 and of the artists' Free Union (*Freie Vereinigung*) in 1894. He worked as an illustrator for the satirical journal *Simplizissimus* from 1896 and contributed to the art and social journal *Jugend* from 1900–1903. In 1901, he moved to Berlin, where he became a member of the Berlin Secession and later of the Free Secession. Also in 1901, he started a successful parallel career as a book illustrator. He became a member of the Berlin Academy of Art and taught there from 1917. After the outbreak of the First World War in 1914, he briefly served as a war artist in Belgium and France. In 1915, he became a member of the Dresden Academy of Art and an honorary member of the Academies of Munich and Vienna. DS

CARL SPITZWEG
Born 1808 in Munich – died 1885 in Munich

Carl Spitzweg was the second son of Simon Spitzweg, an ambitious shopkeeper, and his wife Franziska. His father wanted Carl to study medicine, but this dream was not realized. Carl trained as a pharmacist, finishing his studies at the University of Munich in 1832. The following year, he suffered a serious illness, probably typhoid fever. During his recovery, he started drawing seriously and came to the conclusion that he

wanted to devote his life to art. Since he considered himself too old to apply to the academy of art, he acquired the necessary skills himself. A number of painter friends, such as Heinrich Hansonn, Berhard Stange, Dietrich Langko, and above all Eduard Schleich, helped him in his endeavors. After an unhappy love affair with Clara Lechner, Spitzweg remained unmarried, but was not the social outsider he so often portrayed. Throughout his life, he was very close to his younger brother and his family, and also enjoyed a large circle of artist friends. In their company, he undertook numerous journeys. The trip to Paris and London in 1851 was the most decisive. He was particularly influenced by Eugène Delacroix, Narcisse Virgile Diaz, and other painters of the Barbizon School as well as by the illustrators Honoré Daumier, Gustave Doré, and Jean Grandville. He found London overwhelming with its myriad of exotic impressions during the great Crystal Palace Exposition and was content to return to the far less hectic lifestyle of his native Munich.

Considered an artistic outsider because he eschewed any contact with the academic art scene, he nonetheless had joined the *Kunstverein* as early as 1835. Financially independent, he had the rare luxury of painting according to his own inclinations. He concentrated on single figures or small groups, mostly set in picturesque small towns or in mountainous landscapes. In his humorous style, he always balanced caricature and realism, thereby creating unforgettable "types." He became the quintessential painter of the Biedermeier genre in Munich.　　HKA

FRANZ VON STUCK
Born 1863 in Tettenweis, near Passau – died 1928 in Munich

Like Franz von Lenbach, Franz von Stuck was a leading figure in the Munich art world around 1900. His work offered an influential example of the contemporary tendency toward universalism and the total work of art (the *Gesamtkunstwerk*). As teacher of Vasily Kandinsky, Paul Klee, Alfred Kubin, Hans Purrmann, and Josef Albers, he also had a significant indirect impact on the development of the progressive movement in the art of the twentieth century.

The son of a miller, Stuck initially attended the Regional Commercial College in Passau. In 1878–81, he studied under Ferdinand Barth at the School of Applied Art in Munich, and then in 1881 he transferred to the Munich Academy of Art. Here he studied under Wilhelm Lindenschmit the Younger and later under Ludwig von Löfftz. Stuck nonetheless made great progress as a self-taught artist, responding above all to the example of the work of Wilhelm von Diez, Arnold Böcklin, and Franz von Lenbach. In 1887–92 he contributed to the journal *Fliegende Blätter* and in 1896–1901 to *Jugend*. In 1892, Stuck became a founding member of the Munich Secession, and later its acting president. In 1893, he was appointed to a professorship at the Munich Academy, where he taught from 1895. In 1906, he was ennobled. During his career, he became an honorary member of the Academies of Berlin, Dresden, Vienna, Milan, and Stockholm.　　DS

HANS THOMA
Born 1839 in Bernau, Black Forest – died 1924 in Karlsruhe

Hans Thoma left his native village of Bernau in the Black Forest to start his artistic training in Basel, Switzerland. He went on to Karlsruhe when he was accepted at the academy of art there in 1859. His most renowned teacher there was Johann Wilhelm Schirmer, the outstanding representative of the Düsseldorf landscapists. Between 1867 and 1870, Thoma settled in Düsseldorf, where he met Otto Scholderer with whom

he traveled to Paris in 1868. There, Thoma was greatly impressed by Courbet and the painters of the Barbizon School. From 1870 to 1876, he lived in Munich where he came under the influence of Arnold Böcklin. Thoma also was loosely connected with Leibl and his circle. In 1876, he left Munich for Frankfurt, where he stayed until 1899. The years in Frankfurt constitute the most productive and successful period of his career. His first successful exhibition took place in Munich in 1890; he then was elected into the Munich Academy as an honorary member. In 1899, he was appointed director of the art gallery in Karlsruhe and professor at the academy—positions he held until 1919. He died in Karlsruhe in 1924.

Thoma was first and foremost a realist, heavily influenced by Courbet. During the years in Munich, Böcklin had significant influence on him as well. Although often criticized for the inconsistent quality of his figurative works, his landscapes retain a high level of structural control and freshness of view for which he is remembered throughout his œuvre.　　HKA

WILHELM TRÜBNER
Born 1851 in Heidelberg – died 1917 in Karlsruhe

Initially a representative of Munich Realism and a member (alongside Wilhelm Leibl himself and Carl Schuch) of the "Leibl Circle," Wilhelm Trübner developed a highly personal style in his work. As a portraitist, a landscapist, and a painter of genre scenes and, in particular, of still lifes, he favored pale tones and was mindful of the principles of pleinairism and, increasingly, of Impressionism.

Trübner began training as a goldsmith in Hanau, but soon moved to the Art School in Karlsruhe, where he studied under Karl Friedrich Schick in 1867–68. In 1869, he transferred to the Munich Academy of Art, where he was taught by Alexander (Sándor) Wagner and, from 1870, by Wilhelm von Diez. In 1869–70, he took lessons with Hans Canon in Stuttgart. In 1872–73, he traveled in Italy, Brussels and Holland. He then moved to Munich. In 1892, he became a member of the Munich Secession and in 1893 of the Free Union (*Freie Vereinigung*). In 1896–97, he taught at the Städel Art Institute in Frankfurt am Main, and he then opened his own school of painting. In 1902, he was a founding member of the Frankfurt-Cronberg artists' association. In 1903, he was appointed to a professorship at the Karlsruhe Academy of Art, serving as director in 1904 and 1910. He was also a founding member of the German Artists' Union (the *Deutscher Künstlerbund*) in Weimar.　　DS

FRITZ VON UHDE
Born 1848 in Wolkenburg, Saxony – died 1911 in Munich

Fritz von Uhde's encounter with Wilhelm von Kaulbach in 1864 and a meeting with Julius Schnorr von Carolsfeld made him decide on a career as a painter. He was accepted at the Dresden Academy of Art in 1866, but stayed only for a brief period. Frustrated with his studies, he decided to join the Saxon cavalry, taking part in the Franco-Prussian War of 1870–71. He did not give up painting during his career as an officer but rather used his experiences in the field for his earliest paintings. He left the army in 1877 and applied unsuccessfully to be admitted into Carl von Piloty's art class at the Munich Academy. In 1879, Uhde went to Paris and came under the influence of the Hungarian painter Mihaly Munkascy. He returned to Munich in 1880 and married Amalie Enders. During the same year, he also met Max Liebermann, who was to become his close friend and rival.

Following Liebermann's advice, he traveled to Holland in 1882. His experiences there resulted in a decisive change of style. Uhde started painting with a lighter palette, and turned to new subject matters: children and religious scenes. The first major work to result was *"Suffer Little Children to Come Unto Me"* (1884). The work was considered revolutionary because of its setting in contemporary Germany, and it constituted his first major success. For the most part, the paintings he exhibited were of religious themes, whereas the many portraits of his three daughters were of a private nature. Von Uhde was one of the founding members of the Munich Secession, and became its president in 1899. He is celebrated as one of the founders of modern painting in Germany.

HKA

CARL CHRISTIAN VOGEL VON VOGELSTEIN
Born 1788 in Wildenfels, in the Erzgebirge – died 1868 in Munich

Carl Christian Vogel von Vogelstein is best known as a portraitist whose work was clearly that of an artist significantly influenced by the Idealism of the Nazarene Movement. In 1804, he moved with his family to Dresden, where he initially trained with his father, the painter and art theorist Christian Leberecht Vogel. In 1805–7, he studied at the Dresden Academy of Art. In 1807, he accompanied the family of the Baron von Löwenstern, whose daughter was Vogel von Vogelstein's student, to Dorpat (now Tartu, Estonia). In 1808–12, he worked as a portrait painter in Saint Petersburg, living in the palace of Prince Gagarin; he then spent some time in Berlin and Dresden.

In 1813–20 (as also in 1842–44, 1851–52, and 1865), he lived and worked in Italy, where he came into contact with members of the Nazarene Circle. In 1819, he converted to Catholicism. A year later, he became a professor at the Dresden Academy, serving in this capacity until 1853. In 1823–29, he executed murals in the Neues Palais of the castle at Pillnitz. In 1824, he was appointed court painter in Dresden. In 1830, he made a long visit to Paris. In 1831, he was ennobled. In 1834, he traveled to England via Holland and Belgium. In 1836, in response to portrait commissions, he traveled to Kloster Ossegg (now Osék, Czech Republic), Prague, Vienna, and Schönbrunn. In 1853, he formally retired from the Dresden Academy and moved to Munich.

DS

CARL WAGNER
Born 1796 in Rossdorf on the Rhône – died 1867 in Meiningen

Influenced by Johan Christian Clausen Dahl and Caspar David Friedrich, Carl Wagner in time became a Romantic painter, printmaker, and gifted draftsman whose landscape studies demonstrate a proto-Impressionist vigor. Nonetheless, his talents went unrecognized for many decades.

Wagner spent his early boyhood in Meiningen, where his father, Ernst Wagner, was appointed court poet to the Duke. In 1816–20, the younger Wagner received a stipend from the Duke enabling him to study at the Dresden Academy of Art, where he was a pupil of Carl August Richter and Traugott Faber. He also became a friend of Ernst Ferdinand Oehme, Adrian Ludwig Richter, and Carl Wilhelm Götzloff. In 1820, he returned to Meiningen, where he was appointed inspector of the Ducal Art Gallery, court painter, and designer and decorator for the Meiningen Court Theater. He also served as a companion to the Duke's heir on a journey through Switzerland to the Tyrol and to Milan. In 1822–25, he received a second Ducal stipend, this time enabling him to live and work in Rome.

Wagner made extensive study trips in Italy and came into contact with Johann Christian Reinhart, one of his predecessors in the posts at Meiningen. In 1825, he returned to Meiningen, and served as head of the collection of prints and drawings. Over the years, he traveled in the Alps with the Alpine explorer Adolf Schaubach. Beginning in 1830, he made numerous extended walking tours in the Thuringian Forest, and subsequently in Switzerland, the Tyrol, Belgium, and northern France, among other locations.

DS

JOSEF WENGLEIN
Born 1845 in Munich – died 1919 in Bad Tölz

After briefly attending the university in his native Munich, Josef Wenglein switched to the Academy of Art in 1866. He was a student of J. G. Steffan until 1870 when he joined the class of one of Munich's foremost landscape painters, Adolf Lier. Through his teacher Lier, he took in the achievements of the Barbizon painters but the tradition of English landscape painting, especially John Constable, influenced him as well. All his life, Wenglein found his inspiration in the vicinity of his native city. Along with Ludwig Willroider, Wenglein is one of the last plein-air landscapists of the old Munich school, a tradition started by Eduard Schleich and Lier. By the late 1870s, he had found his personal style of expression. The paintings of the 1880s are considered his finest works.

Strictly a landscapist, Wenglein preferred the flat expanses of the Upper Bavarian moors and scenes along the Isar River to the more spectacular views of the Alps. His work shows a tendency toward coloristic vibrancy and often dramatic light effects. He was appointed a professor at the academy of art in 1883 and elected an honorary member of the academy in 1886. In 1919, he died in Bad Tölz, near Munich. HKA

HEINRICH VON ZÜGEL
Born 1850 in Murrhardt, in Württemberg – died 1941 in Munich

Heinrich von Zügel is one of the most important German painters of animals. His style evolved from the Realism of the 1870s (the *Gründerzeit* period in Germany) to one in keeping with the era of Impressionism. As a young boy, Zügel followed in his father's footsteps and became a shepherd. He then attended a school to learn handicrafts in Schwäbisch-Hall; in 1867–69, he studied under Bernhard Neher the Younger and Heinrich von Rustige at the Art School in Stuttgart. In 1869, when he moved to Munich, he continued his artistic development under the guidance of the animal painter Anton Braith, his colleagues who were students of Wilhelm Diez, and with Gotthardt Kuehl. In 1876, his son Willy was born (he later became a sculptor specializing in animal subjects).

In 1858, Zügel studied in Paris, in 1889 in Holland, and in 1890 in Belgium. In 1889, he was appointed to the rank of Royal Bavarian Professor. In 1892, he became a founding member of the Munich Secession. In 1894–95, he was a professor at the Karlsruhe Academy of Art and in 1895–1922 served as professor at the Munich Academy. From 1895, he regularly spent his summers at Wörth on the Rhine, where he founded the Zügel School. In 1896–97, he made study trips to Finkenwerder on the Elbe, in 1897–1900 to the Rauhe Highlands, and in 1901-4 to the Lüneberg Heath. He was made an honorary member of the Munich Academy in 1888 and of the Academies of Dresden (in 1902), Berlin (in 1904), and of Antwerp. In 1930, he received an honorary doctorate at the University of Giessen. DS

Bibliography

Compiled by Anka-Roberta Lazarus

BIBLIOGRAPHY
(by date)

Lietzmann, Hilda, comp. *Bibliographie zur Kunstgeschichte des 19. Jahrhunderts: Publikationen der Jahre 1940–1966.* Studien zur Kunst des 19. Jahrhunderts, no. 4. Munich: Prestel, 1968.

Prause, Marianne, comp. *Bibliographie zur Kunstgeschichte des 19. Jahrhunderts: Publikationen der Jahre 1967–1979, mit Nachträgen zu den Jahren 1940–1966.* Materialien zur Kunst des 19. Jahrhunderts, no. 31. Munich: Prestel, 1984.

MONOGRAPHS
(by author)

Andrews, Keith. *The Nazarenes: A Brotherhood of German Painters in Rome.* Oxford: Clarendon Press, 1964.

Beenken, Hermann. *Das neunzehnte Jahrhundert in der deutschen Kunst: Aufgaben und Gehalte. Versuch einer Rechenschaft.* Munich: Verlag F. Bruckmann, 1944.

Benz, Richard, and Arthur v. Schneider. *Die Kunst der deutschen Romantik.* Munich: R. Pieper & Co.Verlag, 1939.

Börsch-Supan, Helmut. *Die Deutsche Malerei von Anton Graff bis Hans von Marées 1760–1870.* Munich: C.H. Beck; Deutscher Kunstverlag, 1988.

Brieger, Lothar. *Das Genrebild. Die Entwicklung der bürgerlichen Malerei.* Munich: Delphin-Verlag, 1922.

Brieger, Peter. *Die Deutsche Geschichtsmalerei des 19. Jahrhunderts.* Kunstwissenschaftliche Studien, no. VII. Berlin: Deutscher Kunstverlag, 1930.

Busch, Werner: *Die notwendige Arabeske. Wirklichkeitsaneignung und Stilisierung in der deutschen Kunst des 19. Jahrhunderts.* Berlin: Gebr. Mann Verlag, 1985.

Busch, Werner, and Wolfgang Beyrodt, eds. *Kunsttheorie und Kunstgeschichte des 19. Jahrhunderts in Deutschland. Kunsttheorie und Malerei, Kunstwissenschaft, Texte und Dokumente.* Stuttgart: Philipp Reclam Junior, 1982.

Eberlein, Kurt Karl, and Karl Georg Heise. *Die Malerei der deutschen Romantiker und Nazarener im Besonderen Overbecks und seines Kreises.* Munich: Kurt Wolff Verlag, 1928.

Ebertshäuser, Heidi C., ed. *Kunsturteile des 19. Jahrhunderts: Zeugnisse – Manifeste – Kritiken zur Münchner Malerei.* Pantheon-Colleg. Munich: Bruckmann, 1983.

Edler, Doris. *Vergessene Bilder: Die deutsche Genremalerei in den letzten Jahrzehnten des 19. Jahrhunderts und ihre Rezeption durch Kunstkritik und Publikum.* Kunstgeschichte, no. 14. Münster; Hamburg: Lit, 1992.

Einem, Herbert von. *Deutsche Malerei des Klassizismus und der Romantik: 1760 bis 1840.* Munich: Verlag C.H. Beck, 1978.

Feist, Peter H., et al. *Geschichte der deutschen Kunst 1760–1848.* Leipzig: VEB E.A. Seemann, 1986.

Geese, Walter. *Die heroische Landschaft von Koch bis Böcklin.* Studien zur Deutschen Kunstgeschichte, no. 271. Strasbourg: J.H. Ed. Heitz, 1930.

Geismeier, Willi. *Biedermeier. Das Bild vom Biedermeier. Zeit und Kultur des Biedermeier. Kunst und Kunstleben des Biedermeier.* Leipzig: VEB E.A. Seemann Verlag, 1979.

Geismeier, Willi. *Die Malerei der deutschen Romantiker.* Dresden: VEB Verlag der Kunst, 1984.

Geller, Hans, and Herbert von Einem. *Die Bildnisse der deutschen Künstler in Rom 1800–1830. Mit einer Einführung in die Kunst der Deutschrömer.* Berlin: Deutscher Verein für Kunstwissenschaft, 1952.

Gerstenberg, Kurt, and Paul Ortwin Rave. *Die Wandgemälde der deutschen Romantiker im Casino Massimo zu Rom.* Jahresgabe des Deutschen Vereins für Kunstwissenschaft, 1934. Berlin: Deutscher Verein für Kunstwissenschaft, n.d.

Gramlich, Sybille. *Architekturmalerei im 19. Jahrhundert in Deutschland. Künstler, Themen, Käufer in Berlin und München. Studien zu einer fast vergessenen Kunstgattung.* Dissertation am Fachbereich Geschichtswissenschaften. Berlin: Freie Universität, 1990.

Gurlitt, Cornelius. *Die deutsche Kunst seit 1800: Ihre Ziele und Taten.* 4th rev. ed. Berlin: Georg Bondi, 1924.

Hamann, Richard. *Die deutsche Malerei im 19. Jahrhundert.* Leipzig; Berlin: B.G. Teubner, 1914.

Hamann, Richard, and Jost Hermand. *Gründerzeit.* Deutsche Kunst und Kultur von der Gründerzeit bis zum Expressionismus, no. I. Berlin: Akademie-Verlag, 1965.

Hamann, Richard, and Jost Hermand. *Naturalismus.* Deutsche Kunst und Kultur von der Gründerzeit bis zum Expressionismus, no. II. Berlin: Akademie-Verlag, 1959.

Hamann, Richard, and Jost Hermand. *Impressionismus.* Deutsche Kunst und Kultur von der Gründerzeit bis zum Expressionismus, no. III. Berlin: Akademie-Verlag, 1960.

Hamann, Richard, and Jost Hermand. *Stilkunst um 1900.* Deutsche Kunst und Kultur von der Gründerzeit bis zum Expressionismus, no. IV. Berlin: Akademie-Verlag, 1967.

Hildebrandt, Hans. *Die Kunst des 19. und 20. Jahrhunderts.* Handbuch der Kunstwissenschaft. Potsdam: Akademische Verlags-Gesellschaft m.b.H., 1924.

Hofmann, Werner. *Das irdische Paradies. Motive und Ideen des 19. Jahrhunderts.* 3nd ed. Munich: Prestel, 1991.

Hofmann, Werner. *Bruchlinien. Aufsätze zur Kunst des 19. Jahrhunderts.* Munich: Prestel, 1979.

Hütt, Wolfgang. *Die Düsseldorfer Malerschule 1819–1869.* Leipzig: E.A. Seemann, 1995.

Jensen, Jens Christian. *Malerei der Romantik in Deutschland.* Cologne: DuMont, 1985.

Keller, Horst. *Deutsche Malerei des 19. Jahrhunderts.* Munich: Hirmer, 1979.

Klessmann, Eckart. *Die Welt der Romantik. Große Kulturepochen in Texten, Bildern, Zeugnissen.* Munich: Verlag Kurt Desch, 1969.

Kocka, Jürgen, and Manuel Frey, eds. *Bürgerkultur und Mäzenatentum im 19. Jahrhundert.* Bürgerlichkeit, Wertewandel., Mäzenatentum, no. II. Berlin: Fannei & Walz Verlag, 1998.

Lammel, Gisold. *Deutsche Malerei des Klassizismus.* Leipzig: VEB E.A. Seemann Verlag, 1986.

Ludwig, Horst. *Münchner Malerei im 19. Jahrhundert.* Munich: Hirmer Verlag, 1978.

Muther, Richard. *Geschichte der Malerei im XIX. Jahrhundert.* 3 vols. Munich: G. Hirth's Kunstverlag, 1893–1894.

Neidhardt, Hans Joachim. *Die Malerei der Romantik in Dresden.* Leipzig: VEB E.A. Seemann Verlag, 1976.

Neidhardt, Hans Joachim. *Deutsche Malerei des 19. Jahrhunderts.* Rev. ed. Leipzig: Seemann Verlag, 1997.

Noack, Friedrich. *Das Deutschtum in Rom seit dem Ausgang des Mittelalters.* 2 vols. Stuttgart; Berlin; Leipzig: Deutsche Verlags-Anstalt, 1927.

Roters, Eberhard. *Malerei des 19. Jahrhunderts: Themen und Motive.* 2 vols. Cologne: DuMont, 1998.

Sala, Charles. *Caspar David Friedrich und der Geist der Romantik.* Paris: Editions Pierre Terrail, 1993.

Scheidig, Walther. *Die Weimarer Malerschule 1860–1900.* Leipzig: E.A. Seemann, 1991.

Schindler, Herbert. *Nazarener: Romantischer Geist und christliche Kunst im 19. Jahrhundert.* Regensburg: Verlag Friedrich Pustet, 1982.

Schmidt, Max. *Kunstgeschichte des XIX. Jahrhunderts.* 2 vols. Leipzig: Verlag von E.A. Seemann, 1906.

Schmidt, Paul Ferdinand. Deutsche Malerei um 1800. Vol. 1. *Deutsche Landschaftsmalerei von 1750 bis 1830.* Munich: R. Pieper & Co. Verlag, 1922.

Schmidt, Paul Ferdinand. Deutsche Malerei um 1800. Vol. 2. *Bildnis und Komposition vom Rokoko bis zu Cornelius.* Munich: R. Pieper & Co. Verlag, 1928.

Schmidt, Paul Ferdinand. *Biedermeier-Malerei. Zur Geschichte und Geistigkeit der deutschen Malerei in der ersten Hälfte des neunzehnten Jahrhunderts.* 2nd rev. ed. Munich: Delphin-Verlag, 1923.

Schoch, Rainer. *Das Herrscherbild in der Malerei des 19. Jahrhunderts.* Studien zur Kunst des 19. Jahrhunderts, no. 23. Munich: Prestel, 1975.

Schwarz, Heinrich. *Salzburg und das Salzkammergut. Eine künstlerische Entdeckung in hundert Bildern des neunzehnten Jahrhunderts.* Vienna: Verlag von Anton Schroll, 1926.

Stein, Wilhelm. *Die Erneuerung der heroischen Landschaft nach 1800.* Studien zur Deutschen Kunstgeschichte, no. 201. Strasbourg: J.H. Ed. Heitz (Heitz & Mündel), 1917.

Wichmann, Siegfried. *Münchner Landschaftsmaler im 19. Jahrhundert. Meister, Schüler, Themen.* Weyarn: Seehamer Verlag, n.d.

Wichmann, Siegfried. *Realismus und Impressionismus in Deutschland: Bemerkungen zur Freilichtmalerei des 19. und beginnenden 20. Jahrhunderts.* Stuttgart: Schuler Verlagsgesellschaft mbH, 1964.

Wirth, Irmgard. *Berliner Malerei im 19. Jahrhundert: Von der Zeit Friedrichs des Großen bis zum ersten Weltkrieg.* Berlin: Siedler Verlag, 1990.

Zeitler, Rudolf. *Die Kunst des 19. Jahrhunderts.* Propyläen Kunstgeschichte, no. 11. Reprint (22 vols. in 18), Frankfurt am Main; Berlin; Vienna: Verlag Ullstein GmbH, 1985.

EXHIBITION CATALOGUES
(by exhibition venue)

Berlin

Tschudi, Hugo von. *Ausstellung deutscher Kunst aus der Zeit von 1775–1875 in der Königlichen Nationalgalerie: Berlin 1906.* Munich: Verlagsanstalt F. Bruckmann A.-G., 1906.

Staatliche Museen zu Berlin. *Deutsche Romantik: Gemälde, Zeichnungen.* Exh. cat. Berlin: Staatliche Museen zu Berlin, Nationalgalerie, 1965.

Plessen, Marie-Louise, ed. *Marianne und Germania 1789–1889. Frankreich und Deutschland. Zwei Welten – eine Revue.* Exh. cat. Loc. cit.: Argon; Berliner Festspiele, 1996.

Bott, Katharina, ed.; Bott, Gerhard, ed. *Vice Versa: Deutsche Maler in Amerika, amerikanische Maler in Deutschland 1813–1913.* Exh. cat. Munich, Hirmer Verlag, 1996.

Bern

Glaesemer, Jürgen, ed. *Traum und Wahrheit: Deutsche Romantik aus Museen der Deutschen Demokratischen Republik.* Exh. cat. Bern: Kunstmuseum, 1985.

Dresden

Prause, Marianne, ed. *Die Kataloge der Dresdner Akademie-Ausstellungen: 1801–1850.* Quellen und Schriften zur bildenden Kunst, no. 5. Berlin: Hessling, 1975.

Frankfurt am Main
Städel – Städtische Galerie im Städelschen Kunstinstitut Frankfurt am Main. *Die Nazarener.* Exh. cat. Frankfurt am Main: Städel, 1977.

Karlsruhe
Städtische Galerie Karlsruhe. *Deutsche Künstlerkolonien 1890–1910: Worpswede, Dachau, Willingshausen, Grötzingen, Die "Brücke", Murnau.* Exh. cat. Karlsruhe: Städtische Galerie, 1998.

Leipzig
Museum der bildenden Künste Leipzig. *Das 19. Jahrhundert in München. Gemälde und Zeichnungen aus dem Besitz des Museums der bildenden Künste Leipzig.* Exh. cat. Leipzig: Edition Leipzig, 1992.

Mainz
Kalnein, Wend von, ed. *Die Düsseldorfer Malerschule.* Exh. cat. Mainz: Verlag Philipp von Zabern, 1979.

Munich
Bayerische Staatsgemäldesammlungen; Haus der Kunst München. *München 1869–1958: Aufbruch zur modernen Kunst. Rekonstruktion der ersten internationalen Kunstausstellung 1869. Leibl und sein Kreis. Vom Jugendstil zum Blauen Reiter. Gegenwart.* Exh. cat. Munich: Haus der Kunst, 1958.
Bayerische Staatsgemäldesammlungen und Ausstellungsleitung Haus der Kunst München e.V. *Die Münchner Schule 1850–1914.* Exh. cat. Munich: Bayerische Staatsgemäldesammlungen, 1979.
Städtische Galerie im Lenbachhaus. *Münchner Landschaftsmalerei 1800–1850.* Exh. cat. Munich: Städtische Galerie, 1979.
Heilmann, Christoph, ed. *"In uns selbst liegt Italien": Die Kunst der Deutsch-Römer.* Exh. cat. Munich: Hirmer Verlag, 1987.
Wichmann, Siegfried. *Münchner Maler des 19. Jahrhunderts und die Schule von Barbizon.* Exh. cat. Weyarn: Seehamer Verlag, 1996.

New York
The Metropolitan Museum of Art. *German Masters of the Nineteenth Century: Paintings and Drawings from the Federal Republic of Germany.* Exh. cat. New York: Harry N. Abrams, Inc., Publishers, 1981.

Nuremberg
Germanisches Nationalmuseum Nürnberg. *Klassizismus und Romantik in Deutschland: Gemälde und Zeichnungen aus der Sammlung Georg Schäfer, Schweinfurt.* Exh. cat. Schweinfurt: Sammlung Georg Schäfer, 1966.
Germanisches Nationalmuseum Nürnberg. *Der frühe Realismus in Deutschland 1800–1850: Gemälde und Zeichnungen aus der Sammlung Georg Schäfer, Schweinfurt.* Exh. cat. Schweinfurt: Sammlung Georg Schäfer, 1967.
Germanisches Nationalmuseum Nürnberg. *Sammlung Georg Schäfer, Schweinfurt: Deutsche Malerei im 19. Jahrhundert.* Exh. cat. Schweinfurt: Sammlung Georg Schäfer, 1977.

Paris
Orangerie des Tuileries. *La peinture allemande à l'époque du Romantisme.* Exh. cat. Paris: Editions des musées nationaux, 1976.
Musée du Petit Palais. *Symboles et Réalités: La peinture allemande 1848–1905.* Exh. cat. Paris: Association Française d'Action Artistique, 1984.

Rome
Galleria Nazionale d'Arte Moderna, Rom. *Die Nazarener in Rom: Ein deutscher Künstlerbund der Romantik.* Exh. cat. Munich: Prestel, 1981.

Vienna
Fillitz, Hermann, ed.; Telesko, Werner, comp. *Der Traum vom Glück. Die Kunst des Historismus in Europa.* 2 vols. Exh. cat. Vienna: Künstlerhaus-Ges.m.b.H., 1996.

CATALOGUES OF COLLECTIONS
(by city)

Berlin
Staatliche Museen zu Berlin. *Deutsche Kunst 19./20. Jahrhundert. Altes Museum – National-Galerie.* 2 vols. Berlin: Staatliche Museen zu Berlin, 1966.

Bremen
Gerkens, Gerhard; Heiderich, Ursula. *Katalog der Gemälde des 19. und 20. Jahrhunderts in der Kunsthalle Bremen.* 2 vols. Bremen: Kunsthalle, 1973.

Cologne
Andree, Rolf, comp.; Osten, Gert von der, ed.; Keller, Horst, ed. *Katalog der Gemälde des 19. Jahrhunderts im Wallraf-Richartz-Museum.* Kataloge des Wallraf-Richartz-Museums, Vol. I. Cologne: Wallraf-Richartz-Museum, 1964.

Darmstadt
Howaldt, Gabriele, ed. *1: Malerei 1800 bis um 1900.* Kataloge des Hessischen Landesmuseums, Darmstadt, no. 7. Ed. Gerhard Bott. Hanau: Dr. Hans Peters Verlag, 1979.

Düsseldorf
Andree, Rolf, comp. *Die Gemälde des 19. Jahrhunderts mit Ausnahme der Düsseldorfer Schule,* Kataloge des Kunstmuseums Düsseldorf, IV. Malerei. Vol. 1. Düsseldorf: Kunstmuseum der Stadt Düsseldorf, 1968.
Markowitz, Irene, comp. *Die Düsseldorfer Malerschule.* Kataloge des Kunstmuseums Düsseldorf IV. Vol. 2. Düsseldorf: Kunstmuseum der Stadt Düsseldorf, 1969.
Sitt, Martina, ed. *Angesichts der Ereignisse: Facetten der Historienmalerei zwischen 1800 und 1900. Aus dem Bestand des Kunstmuseums Düsseldorf im Ehrenhof mit Sammlung der Kunstakademie (NRW).* Exh. cat. Cologne: Böhlau, 1999.

Essen
Held, Jutta, ed. *Museum Folkwang Essen: Katalog der Gemälde des 19. Jahrhunderts.* 2nd ed. Essen: Museum Folkwang, 1971.

Frankfurt am Main
Holzinger, Ernst, ed. *Städelsches Kunstinstitut Frankfurt am Main: Die Gemälde des 19. Jahrhunderts.* 2 vols. Frankfurt am Main: Verlag G. Schulte-Blumke, 1972.

Halle

Volland, Karin, ed. *Malerei des 19. Jahrhunderts: Bestandskatalog.* Halle: Staatliche Galerie Moritzburg, Landeskunstmuseum Sachsen-Anhalt, 1996.

Hamburg

Krafft, Eva Maria, ed. *Katalog der Meister des 19. Jahrhunderts in der Hamburger Kunsthalle.* Loc.cit.: 1969

Kassel

Heinz, Marianne, comp. *Staatliche Kunstsammlungen Kassel: Bestandskatalog der Gemälde des 19. Jahrhunderts.* Kataloge der Staatlichen Kunstsammlungen Kassel, Neue Galerie, I. Kassel: Neue Galerie, Staatliche und Städtische Kunstsammlungen, 1991.

Karlsruhe

Lauts, Jan, ed.; Zimmermann, Werner, ed. Staatliche Kunsthalle Karlsruhe. *Katalog neuere Meister 19. und 20. Jahrhundert.* 2 vols. Karlsruhe: Staatliche Kunsthalle, 1971–1972.

Munich

Ruhmer, Eberhard. *Bayerische Staatsgemäldesammlungen: Schack-Galerie. Vollständiger Katalog.* 2 vols. Munich: Bayerische Staatsgemäldesammlungen, 1969.

Ludwig, Horst, comp. *Bayerische Staatsgemäldesammlungen, Neue Pinakothek, München: Malerei der Gründerzeit. Vollständiger Katalog.* Gemäldekataloge, Vol. VI. Munich: Hirmer Verlag, 1977.

Hardtwig, Barbara, comp. *Bayerische Staatsgemäldesammlungen, Neue Pinakothek, München. Nach-Barock und Klassizismus. Vollständiger Katalog.* Gemäldekataloge, Vol. III. Munich: Hirmer Verlag, 1978.

Eschenburg, Barbara. *Bayerische Staatsgemäldesammlungen, Neue Pinakothek, München: Spätromantik und Realismus. Vollständiger Katalog.* Gemäldekataloge, Vol. V. Munich: Hirmer Verlag, 1984.

Stuttgart

Holst, Christian v., comp. *Malerei und Plastik des 19. Jahrhunderts.* Stuttgart: Staatsgalerie, 1982

DICTIONARIES
(by publication date)

Pecht, Friedrich. *Deutsche Künstler des neunzehnten Jahrhunderts: Studien und Erinnerungen.* 4 vols. Nördlingen: Verlag der C. H. Beck'schen Buchhandlung, 1877–1885.

Boetticher, Friedrich von. *Malerwerke des neunzehnten Jahrhunderts: Beitrag zur Kunstgeschichte.* 2 vols. in 4. 1891–1901. Reprint, Leipzig: H. Schmidt & C. Günther Pantheon Verlag für Kunstwissenschaft, 1948.

Fuchs, Heinrich. *Die österreichischen Maler des 19. Jahrhunderts.* 4 vols. Vienna: Dr. Heinrich Fuchs Selbstverlag, 1972–1974.

Münchner Maler im 19. Jahrhundert. 4 vols. Munich: Bruckmann, 1981–1983.

Thieme, Ulrich; Becker, Felix. *Allgemeines Lexikon der Bildenden Künstler von der Antike bis zur Gegenwart.* 37 vols. Leipzig 1907–1950. Reprint, Munich; New York; London; Paris: K. G. Saur, 1992.

Schweers, Hans F. *Gemälde in deutschen Museen. Katalog der ausgestellten und depotgelagerten Werke.* 10 vols. Munich; New Providence; London; Paris: K. G. Saur, 1994.

Saur. Allgemeines Künstler-Lexikon. Die Bildenden Künstler aller Zeiten und Völker. Hitherto existing: 22 vols. Munich; Leipzig: K. G. Saur, 1992-hitherto 1999.

Lexikon der Düsseldorfer Malerschule 1819–1918. 3 vols. Munich: Bruckmann, 1997–1998.

THE ARTISTS

Achenbach

Sitt, Martina. *Andreas und Oswald Achenbach "Das A und O der Landschaft".* Exh. cat. Cologne: Wienand Verlag, 1997.

Blechen

(Rave, Paul Ortwin). *Karl Blechen. Leben, Würdigungen, Werk.* Denkmäler deutscher Kunst. Berlin: Deutscher Verein für Kunstwissenschaft, 1940.

Schuster, Peter-Klaus, ed., et al. *Carl Blechen. Zwischen Romantik und Realismus.* Exh. cat. Berlin; Munich: Nationalgalerie; Prestel-Verlag, 1990.

Böcklin

Andree, Rolf, et al. *Arnold Böcklin. Die Gemälde.* Schweizerisches Institut für Kunstwissenschaft, Oevrekatalog Schweizer Künstler, no. 6. Basel; Munich: Friedrich Reinhardt Verlag; Prestel, 1977.

Kunstmuseum Basel, and Basler Kunstverein. *Arnold Böcklin 1827–1901. Gemälde, Zeichnungen, Plastiken. Ausstellung zum 150. Geburtstag.* Exh. cat. Basel; Stuttgart: Schwabe & Co. Verlag, 1977.

Magistrat der Stadt Darmstadt. *A. Böcklin 1827–1901.* Exh. cat. 2 vols. Darmstadt: Mathildenhöhe, 1977.

Buchholz

Hoffmann-Fallersleben, Franz. "Karl Buchholz. Persönliche Erinnerungen von Franz Hoffmann-Fallersleben." *Der Türmer. Monatsschrift für Geist und Gemüt* 11, no. 1 (Oktober 1908-März 1909): 573–578.

Lindemann, Karl. *Karl Buchholz. Leben und Werk.* Typescript. Loc.cit.: 1946.

Scherf, Helmut. "Karl Buchholz (1849–1889)." *Weltkunst* 60, no. 22, 15. November 1990, 3854–3857.

Bürkel

Buerkel, Luigi von. *Heinrich Bürkel 1802–1869. Ein Malerleben der Biedermeierzeit.* Munich: F. Bruckmann, 1940.

Bühler, Hans-Peter, and Albrecht Krückl. *Heinrich Bürkel mit Werkverzeichnis der Gemälde.* Munich: Bruckmann, 1989.

Carus

Jansen, Elmar, ed. *Carl Gustav Carus. Lebenserinnerungen und Denkwürdigkeiten.* Rev. ed. 2 vols. Weimar: Gustav Kiepenheuer Verlag, 1966.

Prause, Marianne. *Carl Gustav Carus. Leben und Werk.* Berlin: Deutscher Verlag für Kunstwissenschaft, 1968.

Corinth

Corinth, Lovis. *Selbstbiographie*. Leipzig: Verlag von S. Hirzel, 1926.
Behrend-Corinth, Charlotte, *Lovis Corinth. Die Gemälde. Werkverzeichnis.* 2nd rev. ed. Comp. Béatrice Hernad, and Hans-Jürgen Imiela. Munich: Bruckmann, 1992.

Dahl

Bang, Marie Lødrup. *Johan Christian Dahl 1788–1857. Life and Works.* 3 vols. Oslo: Norwegian University Press, 1987.

Defregger

Defregger, Hans Peter, ed. and Wolfgang Hütt, comp. *Defregger 1835–1921.* Leipzig: VEB E. A. Seemann, 1986.

Dill

Roeßler, Arthur. *Neu-Dachau. Ludwig Dill, Adolf Hölzel, Arthur Langhammer.* Künstler-Monographien, no. LXXVIII. Ed. H. Knackfuß. Bielefeld; Leipzig: Verlag von Velhagen und Klasing, 1905.
Schäfer, Bärbel. *Ludwig Dill. Leben und Werk.* n.p.: 1997.

Friedrich

Börsch-Supan, Helmut and Karl Wilhelm Jähnig. *Caspar David Friedrich. Gemälde, Druckgraphik und bildmässige Zeichnungen.* Studien zur Kunst des 19. Jahrhunderts, Sonderband. Munich: Prestel, 1973.
Staatliche Kunstsammlungen Dresden. *Caspar David Friedrich und sein Kreis.* Exh. cat. Dresden: Staatliche Kunstsammlungen, 1974.
Hamburger Kunsthalle. *Caspar David Friedrich 1774–1840.* Exh. cat. Munich: Prestel, 1974.

Graff

Berckenhagen, Ekhart. *Anton Graff. Leben und Werk.* Berlin: Deutscher Verlag für Kunstwissenschaft, 1967.
Meisterwerke aus dem Museum der bildenden Künste Leipzig: Dokumentation & Interpretation. (Anton Graff: Selbstbildnis vor der Staffelei). Leipzig: Museum der bildenden Künste Leipzig, 1986.

Gurlitt

Schulte-Wülwer, Ulrich, and Bärbel Hedinger, eds. et al. *Louis Gurlitt 1812–1897. Porträts europäischer Landschaften in Gemälden und Zeichnungen.* Exh. cat. Munich: Hirmer Verlag, 1997.

Habermann

Ostini, Fritz von. *Hugo von Habermann.* Munich: R. Pieper & Co, 1912.
Meyer, Andreas. *Annäherung "Ein Sorgenkind" von Hugo von Habermann.* Exh. cat. Würzburg: Städtische Galerie, 1994.

Kanoldt

Müller-Scherf, Angelika. *Edmund Kanoldt – Leben und Werk.* Kunstgeschichte, no. 1. Pfaffenweiler: Centaurus-Verlagsgesellschaft, 1992.
Stadt Karlsruhe, Städtische Galerie. *Edmund Kanoldt – Landschaft als Abbild der Sehnsucht.* Exh. cat. Karlsruhe: Städtische Galerie, 1994.

Klengel

Maedebach, Heino. *Joh. Christian Klengel (1751–1824). Ein Wegbereiter der romantischen Landschaftsmalerei in Sachsen.* Werkverzeichnis. Typoskript. n.p.: n.d.

Klenze

Bayerische Akademie der Schönen Künste München. *Leo von Klenze als Maler und Zeichner 1784–1864.* Exh. cat. Munich: Bayerische Akademie der schönen Künste, 1977.
Lieb, Norbert, and Florian Hufnagl. *Leo von Klenze. Gemälde und Zeichnungen.* Comp. Oswald Hederer Munich: Callwey Verlag, 1979.
Hederer, Oswald. *Leo von Klenze. Persönlichkeit und Werk.* 2nd ed. Munich: Verlag Georg D. W. Callwey, 1981.

Klinger

Vogel, Julius. *Max Klingers Leipziger Skulpturen Salome, Kassandra, Beethoven, Das badende Mädchen, Franz Liszt.* Leipzig: Hermann Seemann Nachfolger, 1902.
Kühn, Paul. *Max Klinger.* Leipzig: Druck und Verlag von Breitkopf & Härtel, 1907.
Pastor, Willy. *Max Klinger.* 2nd rev. ed. Berlin: Verlag von Amsler & Ruthardt, 1919.
Singer, Hans Wolfgang, ed. *Briefe von Max Klinger aus den Jahren 1874 bis 1919.* Leipzig: Verlag von E.A. Seemann, 1924.
Museum der bildenden Künste Leipzig. *Max Klinger 1857–1920. Ausstellung zum 50. Todestag des Künstlers.* Exh. cat. Leipzig: Museum der bildenden Künste, 1970.
Museum der bildenden Künste Leipzig. *Max Klinger 1857–1920.* Exh. cat. Leipzig: Ed. Leipzig, 1992.
Museum der bildenden Künste Leipzig. *Max Klinger. Bestandskatalog der Bildwerke, Gemälde und Zeichnungen im Museum der bildenden Künste Leipzig.* Leipzig: Museum der bildenden Künste; E.A. Seemann Kunstverlagsgesellschaft mbH, 1995.

Koch

Lutterotti, Otto R. von. *Joseph Anton Koch 1768–1839. Mit Werkverzeichnis und Briefen des Künstlers.* Denkmäler deutscher Kunst. Berlin: Deutscher Verein für Kunstwissenschaft, 1940.
Frank, Hilmar, ed. *Moderne Kunstchronik. Briefe zweier Freunde in Rom und der Tartarei über das moderne Kunstleben und Treiben; oder die Rumfordische Suppe gekocht und geschrieben von Joseph Anton Koch in Rom.* Gustav Kiepenheuer Bücherei, no. 53. Leipzig; Weimar: Gustav Kiepenheuer Verlag, 1984.
Lutterotti, Otto R. von. *Joseph Anton Koch 1768–1839. Leben und Werk. Mit einem vollständigen Werkverzeichnis.* Vienna; Munich: Herold Verlag, 1985.
Holst, Christian von. *Joseph Anton Koch 1768–1839. Ansichten der Natur.* Exh. cat. Stuttgart: Staatsgalerie; Edition Cantz, 1989.

Kuehl

Gerkens, Gerhard, Horst Zimmermann, et al. *Gotthardt Kuehl 1850–1915.* Exh. cat. Leipzig: E. A. Seemann, 1993.
Neidhardt, Ute. *Gotthardt Kuehl und die Dresdener Malerei von 1895 bis 1915.* 2 Vols. Dissertation am Kunsthistorischen Institut. Leipzig: Karl-Marx-Universität, 1988.

Leibl

Waldmann, Emil. *Wilhelm Leibl. Eine Darstellung seiner Kunst. Gesamtverzeichnis seiner Gemälde.* Berlin: Bruno Cassirer, 1914.
Czymmek, Götz, and Christian Lenz, Christian, eds., et al. *Wilhelm Leibl zum 150. Geburtstag.* Exh. cat. Munich; Cologne: Neue Pinakothek; Wallraf-Richartz-Museum, 1994.

Lenbach

Städtische Galerie im Lenbachhaus München. *Franz von Lenbach 1836–1904.* Exh. cat. Munich: Lenbachhaus, 1987.

Liebermann

Busch, Günter, ed. *Max Liebermann. Vision der Wirklichkeit. Ausgewählte Schriften und Reden.* Frankfurt am Main: Fischer-Taschenbuch-Verlag, 1993.

Boskamp, Katrin. *Studien zum Frühwerk von Max Liebermann mit einem Katalog der Gemälde und Ölstudien von 1866–1889.* Studien zur Kunstgeschichte, no. 88. Hildesheim; Zurich; New York: Georg Olms Verlag, 1994.

Eberle, Matthias. *Max Liebermann 1847–1935. Werkverzeichnis der Gemälde und Ölstudien. No. I 1865–1899, no. II 1900–1935.* 2 vols. Munich: Hirmer Verlag, 1995–96.

Menzel

Tschudi, Hugo von, ed.; Schwedeler-Meyer, E. and J. Kern, comp. *Adolph von Menzel – Abbildungen seiner Gemälde und Studien.* Auf Grund der von der Kgl. Nationalgalerie im Frühjahr 1905 veranstalteten Ausstellung … Munich: Verlagsanstalt F. Bruckmann A.-G., 1906.

Staatliche Museen zu Berlin, Nationalgalerie. *Adolph Menzel. Gemälde, Zeichnungen.* Exh. cat. Berlin: 1980.

Keisch, Claude, and Marie Ursula Riemann-Reyher, eds., et al. *Adolph Menzel 1815–1905. Das Labyrinth der Wirklichkeit.* Exh. cat. Cologne: DuMont, 1996.

Oehme

Bischoff, Ulrich, ed.; Neidhardt, Hans Joachim, comp., et al. *Ernst Ferdinand Oehme 1797–1855. Ein Landschaftsmaler der Romantik. Mit Beiträgen von … und dem Werkverzeichnis der Gemälde und bildmäßigen Zeichnungen Oehmes.* Exh. cat. Dresden: Dresdener Kunstauktionshaus Neumeister, 1997.

Olivier

Grote, Ludwig. *Die Brüder Olivier und die deutsche Romantik.* Forschungen zur deutschen Kunstgeschichte, no. 31. Berlin: Rembrandt-Verlag, 1938.

Overbeck

Howitt, Margaret Binder. *Friedrich Overbeck. Sein Leben und Schaffen. Nach seinen Briefen und anderen Documenten geschildert … No.1 1789–1833, no.2 1833–1869.* 2 vols. Ed. Franz Binder. Freiburg im Breisgau: Herder'sche Verlagshandlung, 1886.

Blühm, Andreas, and Gerhard Gerkens, eds., et al. *Johann Friedrich Overbeck 1789–1869. Zur zweihundertsten Wiederkehr seines Geburtstages.* Exh. cat. Lübeck: Museum für Kunst und Kulturgeschichte der Hansestadt Lübeck, Behnhaus, 1989.

Preller

Witting, Walther, ed. *Künstlerisches aus den Briefen Friedrich Prellers des Älteren. Zu seinem 100. Geburtstage, dem 25. April 1904.* Weimar: Hermann Böhlaus Nachfolger, 1903.

Weinrautner, Ina. *Friedrich Preller d. Ä. (1804–1878). Leben und Werk.* Monographien, no. 14. Münster: LIT, 1997.

Quaglio

Trost, Brigitte. *Domenico Quaglio 1787–1837. Monographie und Werkverzeichnis.* Materialien zur Kunst des 19. Jahrhunderts, no. 6. Munich: Prestel, 1973.

Reinhart

Baisch, Otto. *Johann Christian Reinhart und seine Kreise. Ein Lebens- und Culturbild. Nach Originalquellen dargestellt.* Leipzig: Verlag von E. A. Seemann, 1882.

Feuchtmayr, Inge. *Johann Christian Reinhart 1761–1847. Monographie und Werkverzeichnis.* Materialien zur Kunst des 19. Jahrhunderts, no. 15. Munich: Prestel, 1975.

Schmid, F. Carlo. *Naturansichten und Ideallandschaften. Die Landschaftsgraphik von Johann Christian Reinhart und seinem Umkreis.* Berlin: Gebr. Mann Verlag, 1998.

Reinhold

Kunstgalerie Gera. *Heinrich Reinhold (1788–1825). Italienische Landschaften. Zeichnungen, Aquarelle, Ölskizzen, Gemälde.* Exh. cat. Gera: Kunstgalerie, 1988.

Richter

Richter, Heinrich, ed. *Lebenserinnerungen eines deutschen Malers. Selbstbiographie nebst Tagebuchniederschriften und Briefen von Ludwig Richter.* 10th ed. Frankfurt am Main: Verlag von Johannes Alt, 1901.

Friedrich, Karl Josef. *Die Gemälde Ludwig Richters.* Forschungen zur deutschen Kunstgeschichte, no. 24. Berlin: Deutscher Verein für Kunstwissenschaft, 1937.

Staatliche Kunstsammlungen Dresden. *Ludwig Richter und sein Kreis. Ausstellung zum 100. Todestag.* Exh. cat. Leipzig: Edition Leipzig, 1984.

Rottmann

Bierhaus-Rödiger, Erika. *Carl Rottmann 1797–1850. Monographie und kritischer Werkkatalog.* Comp. Hugo Decker, and Barbara Eschenburg. Studien zur Kunst des 19.Jahrhunderts, Sonderband. Munich: Prestel-Verlag, 1978.

Heilmann, Christoph, and Erika Rödiger-Diruf, eds. *Landschaft als Geschichte: Carl Rottmann 1797–1850. Hofmaler König Ludwigs I.* Exh. cat. Munich: Hirmer-Verlag, 1998.

Runge

Runge in seiner Zeit. Exh. cat. Munich: Prestel, 1977.

Traeger, Jörg. *Philipp Otto Runge oder die Geburt einer neuen Kunst.* Munich: Prestel, 1977.

Betthausen, Peter, ed. *Philipp Otto Runge – Briefe und Schriften.* Berlin: Henschelverlag Kunst und Gesellschaft, 1981.

Schirmer

Zimmermann, Kurt. *Johann Wilhelm Schirmer.* Dissertation an der Philosophischen Fakultät der Christian-Albrechts-Universität zu Kiel. Saalfeld: Adolf Nieses Nachf. Werner Klöppel, 1920.

Theilmann, Rudi. *Johann Wilhelm Schirmers Karlsruher Schule.* Dissertation an der Philosophischen Fakultät. Heidelberg: Ruprecht-Karl-Universität, 1971.

Schnorr

Schnorr von Carolsfeld, Franz, ed. *Briefe aus Italien von Julius Schnorr von Carolsfeld, geschrieben in den Jahren 1817 bis 1827. Ein Beitrag zur Geschichte seines Lebens und der Kunstbestrebungen seiner Zeit.* Gotha: Friedrich Andreas Perthes, 1886.

Schnorr von Carolsfeld, Franz, ed. *Künstlerische Wege und Ziele. Schriftstücke aus der Feder des Malers Julius Schnorr von Carolsfeld.* Leipzig: Verlag von Georg Wigand, 1909.

Museum der bildenden Künste Leipzig. *Julius Schnorr von Carolsfeld 1794–1872.* Exh. cat. Leipzig: Museum der bildenden Künste Leipzig, 1994.

Schwind

Stoeffl, Otto, ed. *Moritz von Schwind – Briefe.* Leipzig: Bibliographisches Institut, n.d.

Haack, Friedrich. *M. von Schwind.* Künstler-Monographien, no. XXXI. Ed. H. Knackfuß. Bielefeld; Leipzig: Verlag von Velhagen & Klasing, 1898.

Staatliche Kunsthalle Karlsruhe. *Moritz von Schwind: Meister der Spätromantik.* Exh. cat. Ostfildern-Ruit: Verlag Gerd Hatje, 1996.

Slevogt

Alten, W. von. *Max Slevogt.* Künstlermonographien, no. 116. Ed. H. Knackfuß. Bielefeld; Leipzig: Verlag von Velhagen & Klasing, 1926.

Imiela, Hans Jürgen. *Max Slevogt – Briefe 1912–1932. Sammlung Franz Josef Kohl-Weigand.* St. Ingbert/Saar: Kohl-Weigand, 1960.

Imiela, Hans-Jürgen. *Max Slevogt. Eine Monographie.* Karlsruhe: G. Braun, 1968.

Spitzweg

Roennefahrt, Günther. *Carl Spitzweg. Beschreibendes Verzeichnis seiner Gemälde, Ölstudien und Aquarelle.* Munich: Bruckmann, 1960.

Jensen, Jens Christian. *Carl Spitzweg.* Cologne: Verlag M. DuMont Schauberg, 1971.

Wichmann, Siegfried. *Carl Spitzweg und die französischen Zeichner Daumier, Grandville, Gavarni, Doré.* Exh. cat. Herrsching: Schuler Verlagsgesellschaft, 1985.

Stuck

Bierbaum, O. J. *Stuck.* Künstler-Monographien, no. 42. Ed. H. Knackfuß. Bielefeld; Leipzig: Verlag von Velhagen & Klasing, 1908.

Becker, Edwin. *Franz von Stuck 1863–1928: Eros & Pathos.* Exh. cat. Amsterdam; Zwolle: Van Gogh Museum; Waanders Uitgevers, 1995.

Thoma

Thode, Henry, ed. *Thoma. Des Meisters Gemälde in 874 Abbildungen.* Klassiker der Kunst in Gesamtausgaben, no. 15. Stuttgart; Leipzig: Deutsche Verlags-Anstalt, 1909.

Beringer, Jos. Aug., ed. *Hans Thoma. Aus achtzig Lebensjahren. Ein Lebensbild aus Briefen und Tagebüchern gestaltet … Hans Thoma. Gesammelte Schriften und Briefe.* Ed. Jos. Aug. Beringer. Leipzig: Koehler & Amelang, 1929.

Trübner

Rohrandt, Klaus. *Wilhelm Trübner (1851–1917). Kritischer und beschreibender Katalog sämtlicher Gemälde, Zeichnungen und Druckgraphik. Biographie und Studien zum Werk.* 1 Vol. Dissertation. Kiel: Christian-Albrechts-Universität, 1972.

Kurpfälzisches Museum der Stadt Heidelberg. *Wilhelm Trübner 1851–1917.* Exh. cat. Heidelberg: Kurpfälzisches Museum, 1994.

Uhde

Rosenhagen, Hans, ed. *Uhde. Des Meisters Gemälde in 285 Abbildungen.* Klassiker der Kunst in Gesamtausgaben, no. 12. Stuttgart; Leipzig: Deutsche Verlags-Anstalt, 1908.

Hansen, Dorothee, ed. *Fritz von Uhde. Vom Realismus zum Impressionismus.* Exh. cat. Ostfildern-Ruit: Hatje, 1998.

Vogel v. Vogelstein

Richter, Rainer. *Carl Christian Vogel von Vogelstein 1788–1868.* Exh. cat. Dresden: Staatliche Kunstsammlungen, 1988.

Wagner

Staatliche Museen Meiningen. *Carl Wagner (1796–1867): Malerei und Grafik.* Exh. cat. Meiningen: Staatliche Museen, n.d.

König, Oskar Alfred. *Der romantische Landschaftsmaler und Meininger Hofmaler Carl Wagner 1796–1867.* Crailsheim: Carl Wagner Verlag, 1990.

Zügel

Diem, Eugen. *Heinrich von Zügel: Leben, Schaffen, Werk.* Recklinghausen: Verlag Aurel Bongers, 1975.

Diem, Eugen, et al. *Heinrich von Zügel und seine Zeit.* Recklinghausen: Verlag Aurel Bongers, 1986.

Index of Artists

Photographic Credits:

the food of
FRANCE

the food of
FRANCE

Photography by Chris L. Jones
Recipes by Maria Villegas and
Sarah Randell

MURDOCH BOOKS®
Sydney • London • Vancouver • New York

CONTENTS

FOOD JOURNEYS IN FRANCE

the food of
FRANCE

THE FRENCH PRESIDE OVER ONE OF THE WORLD'S GREAT CULINARY HERITAGES, FROM RIPE CAMEMBERT TO BUTTERY CROISSANTS AND EXQUISITE PASTRIES TO VINTAGE CHAMPAGNE, AND NOWHERE IS IT BETTER, OR ENJOYED MORE, THAN IN FRANCE ITSELF.

France's reputation for wonderful food and cooking is often thought of as being based on technical skills and extravagant, expensive ingredients—on sauces that need to be reduced, and foie gras, truffles and other delicacies. This is *haute cuisine,* "classic cooking," which was developed by the chefs of the French aristocracy and reached its heyday in the nineteenth century under legendary French chefs like Auguste Escoffier. *Haute cuisine* is a time-consuming art form that adheres to strict rules, and this elegant form of cooking requires an understanding of its special methods and techniques, skills honed by long apprenticeships in the kitchens of great restaurants, particularly in creating the subtle sauces that are its foundation. Nowadays this style of cooking is found mostly in expensive restaurants, but it can represent the highest art of cooking, one celebrated in stars by the famous Michelin guide.

Nouvelle cuisine, "new cooking," was a reaction to the dominance of *haute cuisine* in the 1960s, when chefs, including Paul Bocuse and the Troisgros brothers, banded together to create lighter dishes with less reliance on heavy sauces and a willingness to experiment with nontraditional ingredients and cooking styles. *Nouvelle cuisine* encouraged innovation, and though some of its precepts were later abandoned, it had a lasting influence on French cooking.

Fundamentally, however, French food is a regionally based cuisine and many French dishes are called after their place of origin, from *entrecôte à la bordelaise* to *sole à la normande* to *boeuf à la bourguignonne.* Eating your way around France

France is a strong agricultural nation and grows wonderful local produce, from beans to cherries and apricots to red currants. They are sold in daily and weekly markets all over France, such as this one closing up after a busy morning in Périgueux. The land also supports a good dairy industry with much of the milk used in cheeses. Cafés, like this Marseilles one, are a French institution.

Every town in France has a market selling local and seasonal produce such as asparagus and eggs, and artisan-made bread, cheese and wines. Here, bread is sold at a Provence market and vegetables are temptingly displayed in a Paris market. George Mulot's pâtisserie in Paris is a feast for the eyes, while Honfleur (center photograph) is one of France's many fishing ports.

reveals regional differences that are still very distinct, and most restaurants cook not only dishes of the region, but those of the town or village. This is a result not only of tradition, but also of an enduring respect for local produce, *les produits du terroir*. Each area of France grows or produces food uniquely suited to its terrain and climate, such as chickens from Bresse, walnuts from Grenoble, butter from Normandy and mustard from Dijon. Nowadays, there is more crossover between the provinces, and the best, not just the local, vegetables can be found in the markets, but the notion of regional specialties still underlies French cooking.

This respect for ingredients extends also to eating fruit and vegetables only at the height of their season. Recipes change to reflect the best that each month has to offer, and every month seasonal fruits and vegetables are eagerly awaited, like the summer melons of Provence or the autumn walnuts and winter truffles of the Dordogne.

The French have also gone to great lengths to protect their ingredients and traditional methods of food preparation. The strict *appellation d'origine contrôlée* (AOC) system that they use to keep their cheese and wines as authentic as possible is also being extended to an increasing number of other important and regionally based food products, such as Puy lentils and carrots from Créances.

The French love food and though many traditions have changed—an office worker is just as likely to grab a quick sandwich on the run as enjoy a four-course lunch—as a foundation of French culture eating and drinking remain remarkably important. One of the great joys of France is starting the morning with a *petit déjeuner* of a fresh croissant and a *café au lait*. Lunch is still the main meal of the day for many, though dinner may be equally substantial, and with many shops and work places closed between 12:30 and 3:30, it can extend to three or four courses with wine.

Despite the emergence of the *hypermarché,* specialty food shops and weekly markets are integral to the French way of life. There is a *boulangerie* in every village; meat is purchased at a *boucherie*; while a *charcuterie* specializes in pork products and delicatessen items and a *pâtisserie* in baked goods. Markets are usually held weekly, and in some areas you can follow the same stallholders from town to town through the week. Even Paris has its neighborhood markets, and there are also specialty markets, such as the garlic market in Aix-en-Provence in July and the foie gras market in the winter in Sarlat in Périgord.

9

THE FOOD OF THE NORTH

Paris is a world culinary center, where neighborhood markets sell fantastic produce from all over France. Much of the city's reputation lies with its restaurants, a legacy of the revolution when private chefs had to find a new living. Parisians are legendarily discerning about their food and it is here you find the real home of the baguette, the country's most refined pâtisseries and its finest cheese shops.

Brittany is traditionally a fishing and farming region with outstanding seafood, including native oysters, and wonderful early fruits and vegetables. Sweet crêpes and savory buckwheat galettes are found throughout the region. Its sea salt, *sel de guerande*, is used all over France.

Normandy's rich pastures are home to some of France's greatest cheeses: Camembert, Pont l'Evêque and Livarot; along with crème fraîche, butter and apples—three classic ingredients in French cuisine. There are also pré-salé lamb (raised in salt marshes), mussels, oysters, cider and calvados.

Known as "the Garden of France," the Loire Valley produces fruit, vegetables and white wines. Wild mushrooms are grown in the caves of Saumur and regional dishes include rillettes, andouillettes and tarte Tatin. The region also produces fine goat cheeses, including Crottin de Chavignol. Poitou-Charentes on the Atlantic Coast has some of France's best oyster beds near Marennes and is the home of Charentais melons, unsalted butter and Cognac.

Nord-Pas-de-Calais along the coast includes Boulogne-sur-mer, France's biggest fishing port. Inland the washed-rind Maroilles cheese, andouillettes and Flemish beers, used for cooking in dishes such as *carbonnade à la flamande*, can be found. Picardie has vegetables, fruit and pré-salé lamb.

Champagne-Ardennes is a rural region, with Champagne famous not just for its wine, but also for cheeses such as Brie and Chaource. In the rugged north, the game forests of Ardennes have created a tradition of charcuterie. Jambon d'Ardennes and pâtés d'Ardennes are world famous.

Bordering Germany, Alsace-Lorraine's mixed heritage is reflected in its cuisine. Its charcuterie is used in quiche lorraine, *choucroute garnie*, *tarte flambée* and *baeckenoffe* (stew). Meat dishes *à la lorraine* are served with red cabbage cooked in wine, while Alsace's baking has Germanic influences with pretzels, rye bread and kugelhopf.

Paris has a wonderful choice of food with the finest produce brought to the capital from all over France. It is known for its baguettes, upscale *traiteurs* (take-out food shops) and sidewalk cafés. Cabbage is used in many local Alsace-Lorraine dishes, while oysters, apples and soft cheeses are eaten all over Normandy and Brittany, such as in these waterfront cafés in Honfleur.

Lyon's Quai Saint Antoine market in the center of this gastronomic city sells everything from eggs and scallions to potatoes and charcuterie. Limousin is a meat-rearing area and home to wild mushrooms. Mild red onions grow in Burgundy, pears are a Savoie specialty and chickens from Bresse have AOC status. Cheeses from the Alps are among France's best.

THE FOOD OF THE EAST AND CENTER

Central France is made up of the regions of Auvergne and Limousin. With very cold winters, the cuisine of these areas tends to be hearty and potatoes and cabbages are heavily used for dishes such as *aligot* and *potée auvergnate* (one-pot pork and cabbage stew). Limousin is famous for its beef, lamb, pork and veal and Auvergne for its game and tiny green Puy lentils. The area also produces Cantal and Saint Nectaire cheeses, as well as blue cheeses such as Bleu d'Auvergne and Fourme d'Ambert. Auvergne is known for its bottled mineral waters, including Vichy and Volvic.

Burgundy is world famous for its red and white wines with the wine industry centered around the town of Beaune. Burgundian dishes tend to be rich, full of flavor and a perfect match for the area's wines. Wine is also an important part of the region's cooking, and *à la bourguignon* usually means cooked in red wine. Beef bourguignon, coq au vin, Bresse chicken cooked with cream and wild morels, snails filled with garlic herb butter and slices of *jambon persillé* (ham and parsley set in aspic) are all Burgundian classics. Dijon is synonymous with mustard and is also the home of *pain d'épices* (spicy gingerbread) and kir—white wine mixed with *crème de cassis* from local black currants.

One of France's great gastronomic capitals, Lyon is home to great restaurants, including Paul Bocuse's, as well as many simple *bouchons* (traditionally working-class cafés) and brasseries all over the city. Considered to be the charcuterie center of France, Lyon is renowned for its andouillettes, cervelas and rosette sausages, served at *bouchons* along with *salade lyonnaise*, pike quenelles, *poulet au vinaigre* (chicken stewed in vinegar), potato gratins, the fresh herb cheese *cervelle de canut* (silk-weavers' brains) and *pots* (one pint bottles) of local Beaujolais or Côtes du Rhône. The surrounding countryside produces excellent fruit and vegetables, as well as AOC chickens from Bourg-en-Bresse.

The East of France rises up into the French Alps and is made up of three regions, Franche-Comté in the north and Savoie and Dauphiné in the south. These mountain regions have great cheese-making traditions, and in the summer *alpages* cheeses such as Reblochon are still made from the milk of animals taken up to the high meadows. Tomme de Savoie, Beaufort and Comté are other mountain cheeses, and dishes include fondues and raclettes. Potatoes are found all over the Center and East, but it is Dauphiné that gives its name to the famous *gratin dauphinois*.

THE FOOD OF THE SOUTH AND SOUTHWEST

Bordeaux is associated with great wines and the *grands crus* of Médoc and Saint Emilion are world famous, as are dessert wines from Sauternes. Red wine is used in cooking and these dishes are usually known as *à la bordelaise*, such as *entrecôte à la bordelaise*. Oysters from the Atlantic beds at Arcachon and pré-salé lamb from Pauillac are specialties.

Goose and duck confit and foie gras are the Dordogne and Lot's most famous exports along with the black truffles and walnuts of Périgord. Black truffles and foie gras are used as a garnish in many southwest dishes and these dishes are sometimes known as *à la périgourdine*. Walnuts are used in *salade aux noix* and in oils, and prunes are grown at Agen.

Gascony is a largely rural area that produces Armagnac and is famous, along with the Dordogne, for its foie gras, duck and goose confit, pâtés and terrines and for the use of goose fat in its cooking. Home made and local specialties can be tasted at *fermes auberges* (farmhouse restaurants).

The southwest Basque country close to Spain flavors its food with spicy *piment d'Espelette*, dried red chiles, which are also often used in the salting mixture for the local Bayonne ham. Tuna are caught off the Atlantic coast, and the tradition of baking, such as making *gâteau basque*, is strong.

The flavors of Provence are those of the Mediterranean: olives, olive oil, garlic, eggplant, zucchini, tomatoes and *herbes de provence,* along with melons from Cavaillon, strawberries and peaches. Provençal cuisine includes the strong flavors of aïoli, anchoïade and tapenade; pissaladière and pistou from the Italian-bordering Côte d' Azur; simple broiled fish and the classic bouillabaisse; red rice from the Camargue and honey and candied fruit.

Close to Spain, Languedoc-Roussillon is home to the famous Roquefort blue cheese, which is aged in caves. Along the coast, anchovies are conserved and the area uses salt cod in dishes such as *brandade de morue*. There is fresh seafood from the Mediterranean and *bourride* is Languedoc's bouillabaisse. Inland, there is hearty cassoulet from Carcassonne, Castelnaudary and Toulouse, sausages from Toulouse and pink garlic from Tarn.

Corsica, closer to Italy and Sardinia than France, has a tradition of Italian charcuterie, pasta and polenta. *Stufato* is a classic rich beef stew, where the sauce is served over pasta.

Many great wines have been aged in Bordeaux's cellars, such as this one at Château Lafite-Rothschild. Tapenade, olives and garlic are the tastes of the South, while figs, lemons and tomatoes grow well in the hot climate. In Marseilles, tiny snails are sold alongside fish on the harbor front. Black truffles are a winter specialty in the Dordogne and fougasse is a bread from Provence.

15

SOUPS

FRENCH ONION SOUP

THE ORIGINS OF THIS ONION SOUP ARE UNCLEAR, SOME CLAIMING IT TO BE A LYONNAIS INVENTION AND OTHERS CREDITING IT TO PARIS. THERE IS ALSO MUCH DISPUTE OVER HOW THE DISH SHOULD BE MADE: WHEN TO ADD THE BREAD AND WHETHER THE ONIONS ARE COARSELY SLICED OR PURÉED.

Lyon is certainly the area of France most associated with the onion: "à la lyonnaise" means a dish containing onions.

3 tablespoons butter
1 1/2 lb. onions, finely sliced
2 garlic cloves, finely chopped
1/3 cup all-purpose flour
8 cups beef or chicken stock
1 cup white wine
1 bay leaf
2 thyme sprigs
12 slices stale baguette
4 oz. Gruyère, finely grated

SERVES 6

MELT the butter in a heavy-bottomed saucepan and add the onions. Cook over low heat, stirring occasionally, for 25 minutes, or until the onions are a deep golden brown and begin to caramelize.

ADD the garlic and flour and stir continuously for 2 minutes. Gradually blend in the stock and the wine, stirring all the time, and bring to a boil. Add the bay leaf and thyme and season. Cover the saucepan and simmer for 25 minutes. Remove the bay leaf and thyme and check the seasoning. Preheat the broiler.

TOAST the baguette slices, then divide among six warmed soup bowls and ladle the soup over the top. Sprinkle with the grated cheese and broil until the cheese melts and turns a light golden brown. Serve immediately.

CAULIFLOWER SOUP

2 tablespoons butter
1 onion, finely chopped
1/2 celery stalk, finely chopped
1 1/4 lb. cauliflower, broken into florets
1 3/4 cups chicken stock
1 1/4 cups milk
1 bay leaf
1 thyme sprig
1/2 cup whipping cream
freshly grated nutmeg
2 tablespoons chopped chives

SERVES 4

MELT the butter in a large saucepan and add the onion and celery. Cook over low heat until the vegetables are softened but not browned. Add the cauliflower, stock, milk, bay leaf and thyme and bring to a boil. Cover the saucepan, reduce the heat and simmer for 20 minutes, or until the cauliflower is tender.

ALLOW the soup to cool, then remove the bay leaf and thyme. Purée the soup until smooth in a blender or food processor and return to the clean saucepan. Bring to a boil, stirring constantly, add the cream and reheat without boiling. Season with salt, white pepper and nutmeg. Serve garnished with chives.

CAULIFLOWER SOUP

CHICKEN CONSOMMÉ

STOCK

2 lb. chicken carcasses, halved
6 oz. chicken legs
1 carrot, chopped
1 onion, chopped
1 celery stalk, chopped
2 parsley sprigs
20 black peppercorns
1 bay leaf
1 thyme sprig

CLARIFICATION MIXTURE

2 chicken drumsticks
1 carrot, finely chopped
1 leek, finely chopped
1 celery stalk, finely chopped
10 black peppercorns
1 parsley sprig, chopped
2 tomatoes, chopped
2 egg whites, lightly beaten

sea salt
1 small carrot, julienned
1/2 small leek, white part only,
 julienned

SERVES 4

TO MAKE the stock, remove any skin and fat from the chicken carcasses and legs and place in a large heavy-bottomed saucepan with 12 cups cold water. Bring to a boil and skim any fat that floats to the surface. Add the remaining ingredients and simmer for 1 1/2 hours, skimming occasionally. Strain the stock (you should have about 6 cups) and return to the clean saucepan.

TO MAKE the clarification mixture, remove the skin and meat from the chicken drumsticks and discard the skin. Chop the meat finely (you will need about 5 oz.) and mix with the carrot, leek, celery, peppercorns, parsley, tomatoes and egg white. Add 3/4 cup of the warm stock to loosen the mixture.

ADD the clarification mixture to the strained stock and whisk in well. Bring to a gentle simmer. As the mixture simmers the clarification ingredients will bind with any impurities and form a "raft." As the raft rises, gently move it with a wooden spoon to one side of the saucepan away from the main movement of the simmering stock (this will make it easier to ladle out the stock later). Simmer for 1 hour, or until the stock is clear.

LADLE OUT the chicken stock, taking care not to disturb the raft, and strain through a fine sieve lined with damp cheesecloth. Place sheets of paper towel over the top of the consommé and then quickly lift away to remove any remaining fat. Season with coarse sea salt (or other iodine-free salt, as iodine will cloud the soup).

JUST BEFORE serving, reheat the consommé. Place the julienned vegetables in a saucepan of boiling water and cook for 2 minutes until just tender. Drain well, spoon into warmed soup bowls and pour the consommé over the top.

Clarity is the hallmark of a good consommé. This soup uses a clarification mixture that forms a "raft," to which all the impurities cling. The stock is then strained through fine cheesecloth, leaving a beautifully transparent liquid.

CRAB BISQUE

ORIGINALLY BISQUES WERE MADE WITH POULTRY AND GAME BIRDS (IN PARTICULAR PIGEONS) AND WERE MORE OF A STEW. TODAY THEY HAVE EVOLVED INTO RICH VELVETY SOUPS AND TEND TO USE CRUSTACEANS. YOU CAN RESERVE SOME OF THE CRAB MEAT OR CLAWS FOR A GARNISH.

2 lb. live crabs
3 tablespoons butter
1/2 carrot, finely chopped
1/2 onion, finely chopped
1 celery stalk, finely chopped
1 bay leaf
2 thyme sprigs
2 tablespoons tomato paste
2 tablespoons brandy
1/2 cup dry white wine
4 cups fish stock
1/3 cup rice
1/4 cup heavy cream
1/4 teaspoon cayenne pepper

SERVES 4

PUT the crabs in the freezer for 1 hour. Remove the top shell and bony tail flap from the underside of each crab, remove the gills from both sides of the crab, then remove the grit sac. Detach the claws and legs.

HEAT the butter in a large saucepan. Add the vegetables, bay leaf and thyme and cook over moderate heat for 3 minutes, without allowing the vegetables to color. Add the crab claws, legs and body and cook for 5 minutes, or until the crab shells turn red. Add the tomato paste, brandy and white wine and simmer for 2 minutes, or until reduced by half.

ADD the stock and 2 cups water and bring to a boil. Reduce the heat and simmer for 5 minutes. Remove the shells and reserve the claws. Finely crush the shells with a mortar and pestle (or in a food processor with a little of the soup).

RETURN the crushed shells to the soup with the rice. Bring to a boil, reduce the heat, cover the saucepan and simmer for 30 minutes, or until the rice is very soft.

STRAIN the bisque into a clean saucepan through a fine sieve lined with damp cheesecloth, pressing down firmly on the solids to extract all the cooking liquid. Add the cream and season with salt and cayenne, then gently reheat to serve. Ladle into warmed soup bowls and garnish, if you like, with the crab claws or some of the meat.

You will need a large saucepan or stockpot for making crab bisque—the crab shells take up a lot of room in the saucepan.

LEEK AND POTATO SOUP

LEEK AND POTATO SOUP CAN BE SERVED HOT OR CHILLED. IN ITS HOT FORM THE DISH IS TRADITIONALLY FRENCH. THE CHILLED VERSION, VICHYSSOISE, WAS THOUGHT TO HAVE BEEN FIRST SERVED AT THE RITZ-CARLTON HOTEL IN NEW YORK BY A FRENCH CHEF FROM VICHY.

3 tablespoons butter
1 onion, finely chopped
3 leeks, white part only, sliced
1 celery stalk, finely chopped
1 garlic clove, finely chopped
1/2 lb. potatoes, chopped
3 cups chicken stock
3/4 cup whipping cream
2 tablespoons chopped chives

SERVES 6

MELT the butter in a large saucepan and add the onion, leeks, celery and garlic. Cover the saucepan and cook, stirring occasionally, over low heat for 15 minutes, or until the vegetables are softened but not browned. Add the potatoes and stock and bring to a boil.

REDUCE the heat and simmer, covered, for 20 minutes. Allow to cool a little before puréeing in a blender or food processor. Return to the clean saucepan.

BRING the soup gently back to a boil and stir in the cream. Season with salt and white pepper and reheat without boiling. Serve hot or well chilled, garnished with chives.

Do not rush the initial cooking of the leeks. The long cooking time over low heat is what gives them their sweet flavor.

WATERCRESS SOUP

2 tablespoons butter
1 onion, finely chopped
1/2 lb. potatoes, diced
2 1/2 cups chicken stock
2 lb. watercress, trimmed and
 chopped
1/2 cup whipping cream
1/2 cup milk
freshly grated nutmeg
2 tablespoons chopped chives

SERVES 4

MELT the butter in a large saucepan and add the onion. Cover the saucepan and cook over low heat until the onion is softened but not browned. Add the potatoes and chicken stock and simmer for 12 minutes, or until the potatoes are tender. Add the watercress and cook for 1 minute.

REMOVE FROM the heat and allow the soup to cool a little before pouring into a blender or food processor. Blend until smooth and return to the clean saucepan.

BRING the soup gently back to a boil and stir in the cream and milk. Season with nutmeg, salt and pepper and reheat without boiling. Serve garnished with chives.

WATERCRESS SOUP

A pavement café in Marseille.

Basil is more usually associated with Italy than with France but, in fact, the herb originated not in Italy, but in India. It was introduced to Europe in the sixteenth century and is often used in southern French cooking as a perfect match for Provençal tomatoes and olive oil. It can be bought in pots or bunches.

SOUPE AU PISTOU

PISTOU IS A PROVENÇAL MIXTURE OF GARLIC, BASIL AND PARMESAN MIXED TOGETHER WITH OLIVE OIL FROM THE SOUTH OF FRANCE. SIMILAR TO ITALIAN PESTO, IT IS THE TRADITIONAL ACCOMPANIMENT TO THIS SPRING VEGETABLE SOUP AND IS ADDED AT THE TABLE.

1¼ cups dried white beans, such as cannellini, navy or flageolet
2 teaspoons olive oil
1 onion, finely chopped
2 garlic cloves, crushed
1 celery stalk, chopped
3 carrots, diced
bouquet garni
4 potatoes, diced
¼ lb. small green beans, chopped
2 cups chicken stock
3 tomatoes
4 zucchini, diced
1½ cups vermicelli, broken into pieces
1 cup peas, fresh or frozen

PISTOU
6 garlic cloves
1⅓ cups basil leaves
1 cup Parmesan, grated
¾ cup olive oil

SERVES 4

SOAK the dried beans in cold water overnight, then drain, put in a saucepan and cover with cold water. Bring to a boil, then lower the heat and simmer for 1 hour, or until the beans are tender. Drain well.

TO MAKE the pistou, put the garlic, basil and Parmesan in a food processor or a mortar and pestle and process or pound until finely mashed. Slowly add the olive oil, with the motor running if you are using the food processor or pounding constantly with the mortar and pestle, and mix thoroughly. Cover with plastic wrap and set aside.

HEAT the olive oil in a large saucepan, add the onion and garlic and cook over low heat for 5 minutes until softened but not browned. Add the celery, carrots and bouquet garni and cook for 10 minutes, stirring occasionally. Add the potatoes, green beans, chicken stock and 7 cups water and simmer for 10 minutes.

SCORE a cross in the top of each tomato. Plunge into boiling water for 20 seconds, then drain and peel the skin away from the cross. Chop the tomatoes finely, discarding the cores. Add to the soup with the zucchini, dried beans, vermicelli and peas and cook for 10 minutes or until tender (if you are using frozen peas, add them at the last minute just to heat through). Season and serve with pistou on top.

BOURRIDE

THIS RICH FISH SOUP CAN BE SERVED IN A VARIETY OF WAYS. THE BREAD CAN BE PUT IN A DISH WITH THE FISH PILED ON TOP AND THE SOUP LADLED OVER, OR THE BROTH MAY BE SERVED WITH CROUTONS AND THE FISH EATEN SEPARATELY WITH BOILED POTATOES AS A MAIN COURSE.

GARLIC CROUTONS
1/2 stale baguette, sliced
1/4 cup olive oil
1 garlic clove, halved

AÏOLI
2 egg yolks
4 garlic cloves, crushed
3–5 teaspoons lemon juice
1 cup olive oil

STOCK
1/4 teaspoon saffron threads
4 cups dry white wine
1 leek, white part only, chopped
2 carrots, chopped
2 onions, chopped
2 long pieces orange zest
2 teaspoons fennel seeds
3 thyme sprigs
5 lb. whole firm white fish such as monkfish, sea bass, cod, perch, or sole, filleted, skinned and cut into 1 1/2 inch pieces (reserve the trimmings)
3 egg yolks

SERVES 4

PREHEAT the oven to 315°F. Brush the bread with oil and bake for 10 minutes until crisp. Rub one side of each slice with garlic.

TO MAKE the aïoli, put the egg yolks, garlic and 3 teaspoons of the lemon juice in a mortar and pestle or food processor and pound or mix until light and creamy. Add the oil, drop by drop from the tip of a teaspoon, whisking constantly until it begins to thicken, then add the oil in a very thin stream. (If you're using a processor, pour in the oil in a thin stream with the motor running.) Season, add the remaining lemon juice and, if necessary, thin with a little warm water. Cover and refrigerate.

TO MAKE the stock, soak the saffron threads in a tablespoon of hot water for 15 minutes. Put the saffron, wine, leek, carrots, onions, orange zest, fennel seeds, thyme and fish trimmings in a large saucepan with 4 cups water. Cover and bring to a boil, then simmer for 20 minutes, skimming occasionally. Strain into a clean saucepan, pressing the solids with a wooden spoon to extract all the liquid. Bring the stock to a gentle simmer, add half the fish and poach for 5 minutes. Remove and keep warm while you cook the rest of the fish, then remove them from the saucepan and bring the stock back to a boil. Boil for 5 minutes, or until slightly reduced, and remove from the heat.

PUT HALF the aïoli and the egg yolks in a bowl and mix until smooth. Whisk in a ladleful of hot stock, then gradually add 5 ladlefuls, stirring constantly. Pour back into the saucepan holding the rest of the stock and whisk over low heat for 3–5 minutes, or until the soup is hot and slightly thicker (don't let it boil or it will curdle). Season with salt and pepper.

TO SERVE, put two garlic croutons in each bowl, top with a few pieces of fish and ladle over the hot soup. Serve the remaining aïoli separately.

Use slightly stale bread for the croutons. Rubbing with the cut side of the garlic will give them a mild flavor. Buy whole fish and cut them up yourself, keeping the trimmings. A flavorsome stock, made with fresh trimmings, is the basis of a good fish soup.

GARLIC SOUP

GARLIC SOUPS ARE SERVED THROUGHOUT FRANCE. IN PROVENCE, A SIMPLE SOUP OF GARLIC, HERBS AND OLIVE OIL IS KNOWN AS *AÏGO BOUÏDO*. THE SOUTHWEST VERSION, MADE WITH GOOSE FAT, IS CALLED *LE TOURAIN*. THIS SOUP IS GIVEN MORE SUBSTANCE WITH POTATO TO THICKEN IT.

2 bulbs of garlic, about 30 cloves,
 cloves separated
1/2 cup olive oil
4 oz. bacon, finely chopped
1 baking potato, diced
6 cups chicken stock or water
bouquet garni
3 egg yolks

CHEESE CROUTONS
1/2 baguette or 1 ficelle, sliced
1 3/4 oz. Gruyère, grated

SERVES 4

SMASH the garlic with the flat side of a knife and peel. Heat 1 tablespoon of the oil in a large heavy-bottomed saucepan and cook the bacon over moderate heat for 5 minutes without browning. Add the garlic and potato and cook for 5 minutes until softened. Add stock and bouquet garni, bring to a boil and simmer for 30 minutes, or until the potato starts to dissolve into the soup.

PUT the egg yolks in a large bowl and pour in the remaining oil in a thin stream, whisking until thickened. Gradually whisk in the hot soup. Strain back into the saucepan, pressing to extract all the liquid, and heat gently without boiling. Season.

TO MAKE the cheese croutons, preheat the broiler and lightly toast the bread on both sides. Sprinkle with the cheese and broil until melted. Place a few croutons in each warm bowl and ladle the soup over the top, or serve the croutons on the side.

Keeping the garlic cloves whole, rather than chopping them, gives a much sweeter flavor.

CABBAGE SOUP

3 1/2 oz. dried white beans
4 oz. bacon, cubed
3 tablespoons butter
1 carrot, sliced
1 onion, chopped
1 leek, white part only, roughly
 chopped
1 turnip, peeled and chopped
bouquet garni
5 cups chicken stock
3/4 lb. cabbage, finely shredded

SERVES 4

SOAK the beans overnight in cold water. Drain, put in a saucepan and cover with cold water. Bring to a boil and simmer for 5 minutes, then drain. Put the bacon in the same saucepan, cover with water and simmer for 5 minutes. Drain and pat dry with paper towels.

MELT the butter in a large heavy-bottomed saucepan, add the bacon and cook for 5 minutes, without browning. Add the beans, carrot, onion, leek and turnip and cook for 5 minutes. Add the bouquet garni and chicken stock and bring to a boil. Cover and simmer for 30 minutes. Add the cabbage, uncover and simmer for 30 minutes, or until the beans are tender. Remove the bouquet garni before serving and season to taste.

CABBAGE SOUP

HORS D'OEUVRES AND APPETIZERS

A mortar and pestle are ideal for making tapenade, which should be a fairly rough paste. The name comes from *tapenado*, the Provençal word for caper.

AÏOLI

OFTEN REFERRED TO AS "PROVENCE BUTTER," AÏOLI IS A SIMPLE BUT SUPERB GARLIC-FLAVORED MAYONNAISE. IT IS SERVED WITH A SELECTION OF CRUDITÉS OR HOT VEGETABLES, POACHED CHICKEN, SNAILS OR FISH, AND IT CAN ALSO BE ADDED TO FISH SOUPS.

4 egg yolks
8 garlic cloves, crushed
1/2 teaspoon salt
2 tablespoons lemon juice
2 cups olive oil

CRUDITÉS
6 baby carrots, trimmed, but with green tops left on
6 asparagus spears, trimmed and blanched
6 green beans, trimmed and blanched
6 button mushrooms, halved
1 yellow pepper, seeded and cut into strips
1 red pepper, seeded and cut into strips
6 cauliflower florets
1 fennel bulb, cut into strips

SERVES 6

PUT the egg yolks, garlic, salt and half the lemon juice in a mortar and pestle or food processor and pound or mix until light and creamy. Add the oil, drop by drop from the tip of a teaspoon, whisking constantly until it begins to thicken, then add the oil in a very thin stream. (If you're using a processor, pour in the oil in a thin stream with the motor running.) Season, add the remaining lemon juice and, if necessary, thin with a little warm water.

ARRANGE the crudités around a large platter and serve the aïoli in a bowl in the center. You can keep the aïoli sealed in a sterilized jar in the refrigerator. It will last for up to 3 weeks.

TAPENADE

2 cups black olives, pitted
3 tablespoons capers, rinsed
8 anchovies
1 garlic clove, crushed
3/4 cup olive oil
1 tablespoon lemon juice
2 teaspoons Dijon mustard
1 teaspoon chopped thyme
1 tablespoon chopped parsley

SERVES 6

POUND TOGETHER the olives, capers, anchovies and garlic, either using a mortar and pestle or a food processor. Add the olive oil, lemon juice, mustard and herbs and pound or process again until you have a fairly rough paste.

SERVE with bread or crudités for dipping. Can be kept, covered, in the refrigerator for several days.

TAPENADE

LEEKS A LA GRECQUE

A LA GRECQUE REFERS TO THE GREEK STYLE OF COOKING, USING OLIVE OIL, LEMON, HERBS AND SPICES. THESE INGREDIENTS THAT ARE SO READILY FOUND IN THE DUSTY GREEK HILLSIDES ARE EQUALLY AT HOME IN THE MORE VERDANT LANDSCAPE OF FRANCE.

¼ cup extra virgin olive oil
2 tablespoons white wine
1 tablespoon tomato paste
¼ teaspoon sugar
1 bay leaf
1 thyme sprig
1 garlic clove, crushed
4 coriander seeds, crushed
4 peppercorns
8 small leeks, trimmed
1 teaspoon lemon juice
1 tablespoon chopped parsley

SERVES 4

PUT the oil, wine, tomato paste, sugar, bay leaf, thyme, garlic, coriander seeds, peppercorns and 1 cup water in a large non aluminum frying pan. Bring to a boil, cover and simmer for 5 minutes.

ADD the leeks in a single layer and bring just to a simmer. Reduce the heat, cover the frying pan again and cook for 20–30 minutes, or until the leeks are tender (pierce with a fine skewer). Take out the leeks and put them in a serving dish.

ADD the lemon juice to the cooking liquid and boil rapidly until the liquid is slightly syrupy. Remove the bay leaf, thyme and peppercorns. Season with salt and pour over the leeks. Serve the leeks cold, sprinkled with chopped parsley.

MUSHROOMS A LA GRECQUE

2 tomatoes
⅓ cup extra virgin olive oil
¼ cup white wine
2 shallots, finely chopped
1 garlic clove, crushed
6 coriander seeds, lightly crushed
1 bay leaf
1 thyme sprig
1 lb. button mushrooms
2 teaspoons lemon juice
pinch of sugar
1 tablespoon chopped parsley

SERVES 4

SCORE a cross in the top of each tomato. Plunge into boiling water for 20 seconds, then drain and peel the skin away from the cross. Chop the tomatoes, discarding the cores.

PUT the oil, wine, tomatoes, shallots, garlic, coriander seeds, bay leaf, thyme and 1 cup water in a non aluminum saucepan. Bring to a boil, cover and simmer for 10 minutes. Uncover the saucepan, add the mushrooms and simmer for another 10 minutes, stirring occasionally. Take out the mushrooms with a slotted spoon and put them in a serving dish.

BOIL the cooking liquid rapidly until you have only about 1 cup left. Remove the bay leaf and thyme. Add the lemon juice and season with salt, pepper and the sugar. Pour the liquid over the mushrooms and allow to cool. Serve the mushrooms cold, sprinkled with chopped parsley.

MUSHROOMS A LA GRECQUE

ASPARAGUS WITH HOLLANDAISE SAUCE

24 asparagus spears

HOLLANDAISE SAUCE
2 egg yolks
2 teaspoons lemon juice
$^1/_3$ cup unsalted butter, cut into
 cubes

SERVES 4

WASH the asparagus and remove the woody ends (hold each spear at both ends and bend it gently—it will snap at its natural breaking point). Cook the asparagus in a frying pan of simmering salted water for 4 minutes, or until just tender. Drain, then cool under cold running water.

TO MAKE the hollandaise sauce, put the egg yolks and lemon juice in a saucepan over very low heat. Whisk continuously, adding the butter piece by piece until the sauce thickens. Do not overheat or the eggs will scramble. Season.

(ALTERNATIVELY, put the eggs yolks, salt and pepper in a blender and mix together. Heat the lemon juice and butter together until boiling and then, with the motor running, pour onto the yolks in a steady stream.)

ARRANGE a few asparagus spears on each plate and spoon the hollandaise over the top.

Pound the anchoïade mixture to a coarse paste and then add a little extra olive oil to give it a spreadable consistency.

ANCHOÏADE

COLLIOURE ON THE SOUTH COAST IS THE HOME OF ANCHOVY FISHING IN FRANCE AND IT IS FROM THE SOUTH THAT THIS PUNGENT ANCHOVY PASTE HAILS. IT CAN BE SERVED AS A DIP, STIRRED INTO DRESSINGS AND STEWS, OR SPREAD ON BREAD, FISH AND CHICKEN AND THEN BROILED.

$2^3/_4$ oz. anchovy fillets in oil
2 garlic cloves
14 black olives, pitted
1 small tomato
1 teaspoon thyme leaves
3 teaspoons chopped parsley
olive oil
8 slices baguette

SERVES 4

PUT the anchovies (with their oil), garlic, olives, tomato, thyme, 1 teaspoon chopped parsley and a generous grinding of black pepper in a mortar and pestle or food processor and pound or mix until you have a coarse paste. Add a little extra olive oil if the paste is too thick—it should have a spreadable consistency.

PREHEAT the broiler and toast the baguette slices on both sides until golden brown. Spread the anchoïade over the baguette and sprinkle with the remaining parsley.

ANCHOÏADE

COURONNE a ring loaf with a dense texture and hard crust. The name means crown or wreath and the hole means you can thread your arm through it when you are out shopping.

PAIN D'ÉPICES a specialty of Dijon, this spiced gingerbread is flavored with honey, aniseed, ginger and cinnamon. Though called a bread, it is more of a cake and can keep for weeks.

PAIN means "bread" in general, as well as this kind of sourdough loaf, twice as big as a baguette and weighing about 13 oz.–1 lb. This standard family loaf keeps for longer than a baguette.

PAIN POILÂNE a crusty wood-fired sourdough loaf produced by the Poilâne family at their bakery in Paris. Exported world-wide, it is so well known that it has become a type of its own.

PAIN DE CAMPAGNE a rustic country-style loaf usually made with white, whole wheat and rye flours. This one is a sourdough version from Provence, but they vary from baker to baker.

PAIN AUX NOIX walnut bread made with whole wheat and white flours and flavored with chopped walnuts. Very good toasted and eaten with cheese.

MÉTURE a round yeasted corn bread that is a favorite of the Basque country. It is baked in a round metal dish and has a crust that cracks as it rises.

PAIN AUX OLIVES made by rolling olive paste into bread dough to give a scrolled effect. Some olive breads have whole or chopped olives kneaded into the dough instead.

PAIN AUX HERBES bread flavored with herbs. The herbs used may be fresh or dried and can be an individual flavor or a mix, such as fines herbes or herbes de Provence.

PAIN AU CHOCOLAT a rich butter croissant dough wrapped around one or two sticks of chocolate and baked. Usually eaten warm at breakfast.

CROISSANTS made with fresh butter, croissants should have a light texture. The dough is yeast-risen, incorporating layers of butter that make the pastry flaky.

PAIN AUX RAISINS yeasted butter dough rolled up with raisins to form a snail shape. It is baked and then heavily glazed with icing or preserves.

FRANCE'S BOULANGERIES are named after *boules,* the round balls of dough found in bakeries. Every village in France must by law have a shop that sells bread and in most villages the boulangerie will bake bread twice daily. If there is no boulangerie, the general village shop will display a *"depôt de pain"* sign showing that it sells bread brought to the "depot" daily. A boulangerie may also double-up as a patisserie

BREAD

BREAD IS AN ESSENTIAL PART OF FRENCH LIFE. EATEN WITH EVERY MEAL, BREAD IS BOUGHT DAILY, OR EVEN TWICE DAILY, AND BY LAW, EVERY VILLAGE IN FRANCE MUST HAVE A SHOP MAKING OR SELLING BREAD.

Breads are sold not only by the loaf (*la pièce*) but also by weight, perpetuating the tradition of buying just enough bread for each meal or day. Boulangeries bake twice daily so that people can have the freshest bread possible, especially since a baguette made of just wheat flour, yeast and salt begins to go stale after only a few hours.

Bread has been the staple of the French diet since the Middle Ages. The first loaves were large and coarse, made from a mix of flours and unsalted because of the high cost of salt. Not until the seventeenth century was white bread invented when a method for removing bran was discovered.

THE BAGUETTE

The baguette is seen as a symbol of France, but many Frenchmen see it instead as a symbol of Paris. Invented in the nineteenth century and based on Viennese bread, it was made from white flour and a sourdough starter, then rolled up into a slim, light loaf with lots of crust. Paris, always a great consumer of bread due to its place in the center of the Beauce wheat plains, immediately took to the new loaf, though it was not until the twentieth century that it became truly popular in rural France. The best baguettes have a crisp, golden outside, with the score marks rising above the crust.

and all boulangeries bake croissants, brioche and *pain au chocolat* to be eaten with a *café au lait* for a simple French breakfast. Bread is also handmade by small artisan producers and sold in markets, along with specialties such as the pastries being eaten as a snack *(le goûter)* by these two girls in a market in Provence, and also traditional breads such as the *pain au levain* sold from this van in a Lyon market.

TYPES OF BREADS

Although the elegant baguette is still France's most popular bread, the more rustic and nutritious *pain de campagne* is growing in popularity, as are other loaves made from barley and rye. These country-style breads often use a *levain* (sourdough starter) rather than yeast. Sourdough breads have a long production time, but they do keep for a few days rather than going stale quickly like baguettes. These loaves may also be baked in a wood-fired oven, which adds a smoky taste.

A real baguette is actually a certain weight and size (about 28 inches in length and 8 oz. in weight) and not all long loaves are baguettes. A ficelle is thinner and lighter and a flûte is midway between the two, though all are made in the same way. A long, thin *pain au levain* (sourdough bread) may also be labelled as a baguette, and although strictly it is not, the shape is now so recognizable that the name covers many things.

THE SOURDOUGH BREADS shown here are made by the French *levain* system, using a living sourdough starter in which the yeasts that cause the bread to rise are organic. The starter ferments for at least a few days to give the bread its tangy taste.

FOUGASSE a flat bread very common in the South and made with olive oil. It can be sweet or flavored with savory items like bacon. The sweet version from Provence is served at Christmas.

BRIOCHE a sweet yeasted bread that is made with butter and eggs and has an almost cake-like texture. This classic top-knot shape is known as a *brioche à tête* or Parisian brioche.

PAIN AU LEVAIN a classic sourdough loaf made with a starter of naturally occurring yeasts and risen overnight to improve its flavor. Also known as a *pain à l'ancienne*.

BAGUETTE this classic French loaf makes up about 80% of bread sold in France. Baguettes get stale very quickly so they are baked two or three times a day to be fresh for each meal.

CROISSANT AUX AMANDES these croissants are filled with almond paste and sprinkled with chopped or sliced almonds. They are eaten at breakfast or as a snack.

FICELLE meaning "string," a ficelle is a long narrow loaf like a baguette but about half the weight and thinner.

TOURTON a baguette-type loaf where two long pieces of dough are joined together to get the maximum amount of crust. The shape makes it easy to carry looped over your arm.

PAIN DE SEIGLE a rye bread made of rye and wheat flours. Traditional to France's mountain areas, it is often eaten with oysters and *fruits de mer*. This is an organic version.

PETIT PAIN the name given to anything small enough to eat as a roll. They vary from being a mini baguette to a small brioche or soft white milk roll.

PAIN AUX CÉRÉALES a multigrain bread usually containing about five different grains. Sometimes the number of grains is included in the name.

BOULE meaning "ball," these are the loaves that gave the *boulangerie* its name. Generally made with wheat flour.

BÂTARD a traditional white loaf weighing about 1 lb. with an irregular appearance. Bâtard means "bastard" and it is sold by the loaf and by weight.

CELERY ROOT REMOULADE

juice of 1 lemon
2 celery roots, trimmed and peeled
2 tablespoons capers
5 cornichons, chopped
2 tablespoons finely chopped
 parsley

MUSTARD MAYONNAISE
2 egg yolks
1 tablespoon white wine vinegar or
 lemon juice
1 tablespoon Dijon mustard
1/2 cup light olive oil

SERVES 4

PLACE 4 cups cold water in a large bowl and add half the lemon juice. Roughly grate the celery roots and then place in the acidulated water. Bring a saucepan of water to a boil and add the remaining lemon juice. Drain the celery roots and add to the water. After 1 minute, drain and cool under running water. Pat dry with paper towels.

TO MAKE the mustard mayonnaise, put the egg yolks, vinegar or lemon juice and mustard in a bowl or food processor and whisk together. Add the oil, drop by drop from the tip of a teaspoon, whisking constantly until it begins to thicken, then add the oil in a very thin stream. (If you're using a processor, pour in the oil in a thin stream with the motor running.) Season and, if necessary, thin with a little warm water.

TOSS the celery roots with the mayonnaise, capers, cornichons and parsley. Serve with bread.

Once the mayonnaise has started to thicken, you can add the oil in a thin stream, whisking constantly.

POTATO SALAD

POTATO VARIETIES CONTAIN VARYING AMOUNTS OF STARCH, MAKING THEM EITHER "WAXY" OR "MEALY."
WAXY OR ALL-PURPOSE VARIETIES, SUCH AS DESIREE OR YUKON GOLD, ARE LOWER IN STARCH AND
HOLD THEIR SHAPE WHEN COOKED, MAKING THEM BETTER FOR SALADS.

4 large waxy potatoes, cubed
3 celery stalks
1 red pepper
1 tablespoon olive oil
1/3 cup mayonnaise (page 286)
juice of 1 lemon
1 1/2 tablespoons chopped parsley

SERVES 4

PUT the potatoes in a large saucepan, cover with cold water and cook for 15 minutes, or until just tender (don't allow them to over-cook). Refresh under cold water and drain.

STRING the celery stalks and cut them into very small cubes. Cut the pepper in half, remove the seeds and dice finely.

PUT the potatoes, celery and pepper in a bowl, add the olive oil, mayonnaise, lemon juice and parsley and toss well. Season well before serving.

POTATO SALAD

RAW OYSTERS

24 oysters in their shells
1 shallot, finely chopped
2 tablespoons red wine vinegar
1 lemon, cut into wedges

SERVES 4

SHUCK the oysters by holding each one, rounded side down, in a cloth in your left hand. Using an oyster knife, carefully wiggle the point of the knife between the two shells and, keeping the blade flat, run the knife across the top shell to sever the muscle. Pull off the top shell and loosen the oyster from the bottom shell, being careful not to lose any liquid. Nestle the opened oysters on a bed of crushed ice or rock salt on a large platter (this will keep them steady).

MIX the shallot with the red wine vinegar and some black pepper in a small bowl. Put this in the center of the platter and arrange the lemon wedges around the oysters. Serve with slices of rye bread and butter.

RAW OYSTERS

OYSTERS MORNAY

24 oysters in their shells
3 tablespoons butter
1 shallot, finely chopped
1/4 cup all-purpose flour
1 1/2 cups milk
pinch of nutmeg
1/2 bay leaf
2 tablespoons Gruyère, grated
1/4 cup Parmesan, grated, plus a
 little extra for broiling

SERVES 6

SHUCK the oysters, reserving all the liquid. Strain the liquid into a saucepan. Rinse the oysters to remove any bits of shell. Wash and dry the shells.

MELT 2 tablespoons of the butter in another saucepan, add the shallot and cook, stirring, for 3 minutes. Stir in the flour to make a roux and stir over very low heat for 3 minutes without allowing the roux to brown. Remove from the heat and add the milk gradually, stirring after each addition until smooth. Return to the heat, add the nutmeg and bay leaf and simmer for 5 minutes. Strain through a fine sieve into a clean saucepan.

HEAT the oyster liquid in the saucepan to a simmer (add a little water if you need more liquid). Add the oysters and poach for 30 seconds, then take them out with a slotted spoon and put them back into their shells. Stir the cooking liquid into the sauce. Add the cheeses and remaining butter and stir until they have melted into the sauce. Season with salt and pepper. Preheat the broiler.

SPOON a little sauce over each oyster, sprinkle with Parmesan and place under the hot broiler for a couple of minutes, or until golden brown.

To store oysters, wrap them in a damp cloth and refrigerate in the salad compartment for up to 3 days. Eat oysters that have been shucked immediately.

OYSTERS MORNAY

ARTICHOKES VINAIGRETTE

THIS IS THE CLASSIC WAY TO SERVE ARTICHOKES: BE SURE TO BUY THE BEST ONES AVAILABLE. SMALLER ARTICHOKES CAN ALSO BE PREPARED IN THIS FASHION, BUT CUT THEM INTO QUARTERS AND SERVE WITH THE DRESSING RATHER THAN LEAVING WHOLE AND REMOVING THE LEAVES ONE BY ONE.

juice of 1 lemon
4 globe artichokes

VINAIGRETTE
5 tablespoons olive oil
2 scallions, finely chopped
2 tablespoons white wine
2 tablespoons white wine vinegar
1/4 teaspoon Dijon mustard
pinch of sugar
1 tablespoon finely chopped
 parsley

SERVES 4

TO PREPARE the artichokes, bring a large saucepan of salted water to a boil and add the lemon juice. Break the stems from the artichokes, pulling out any strings at the same time, and then trim the bottoms flat. Add the artichokes to the water and put a small plate on top of them to keep them submerged. Cook at a simmer for 25–30 minutes, or until a leaf from the bottom comes away easily. (The bottom will be tender when pierced with a skewer.) Cool quickly under cold running water, then drain upside down on a baking sheet.

TO MAKE the vinaigrette, heat 1 tablespoon of the oil in a small saucepan, add the scallions and cook over low heat for 2 minutes. Allow to cool a little, then add the white wine, vinegar, mustard and sugar and gradually whisk in the remaining oil. Season well with salt and pepper and stir in half the parsley.

PLACE an artichoke on each plate and gently pry it open a little. Spoon the dressing over the top, allowing it to drizzle into the artichoke and around the plate. Pour the remaining dressing into a small bowl for people to dip the leaves. Sprinkle each artichoke with a little parsley.

EAT the leaves one by one, dipping them in the vinaigrette and scraping the flesh off the leaves between your teeth. When you reach the middle, pull off any really small leaves and then use a teaspoon to remove the furry choke. Once you've removed the choke, you can get to the tender bottom or "heart" of the artichoke.

Whisking the remaining oil into the vinaigrette.

PETITS FARCIS

THIS WONDERFUL DISH FROM PROVENCE MAKES GOOD USE OF THE REGION'S ABUNDANCE OF GARDEN PRODUCE AND THE STUFFING CAN INCLUDE ANY HERBS, MEAT OR CHEESES AT HAND. SERVE HOT OR COLD WITH BREAD FOR A SIMPLE SUMMER LUNCH.

Hollow out the vegetables with a spoon and brush the edges with a little oil before filling with the ground meat stuffing.

2 small eggplants, halved lengthwise
2 small zucchini, halved lengthwise
4 tomatoes
2 small red peppers, halved lengthwise and seeded
4 tablespoons olive oil
2 red onions, chopped
2 garlic cloves, crushed
1/2 lb. ground pork
1/2 lb. ground veal
1/4 cup tomato paste
1/3 cup white wine
2 tablespoons chopped parsley
1/2 cup Parmesan, grated
1 cup fresh bread crumbs

SERVES 4

PREHEAT the oven to 350°F. Grease a large roasting pan with oil. Use a spoon to hollow out the centers of the eggplants and zucchini, leaving a border around the edge. Chop the flesh finely.

CUT the tops from the tomatoes (don't throw away the tops). Use a spoon to hollow out the centers, catching the juice in a bowl, and chop the flesh roughly. Arrange the vegetables, including the red peppers, in the roasting pan. Brush the edges of the eggplants and zucchini with a little of the oil. Pour 1/2 cup water into the roasting pan.

HEAT HALF the oil in a large frying pan. Cook the onions and garlic for 3 minutes, or until they have softened. Add the ground meat and stir for 5 minutes until the meat browns, breaking up any lumps with the back of a fork. Add the chopped eggplants and zucchini and cook for another 3 minutes. Add the tomato pulp and juice, tomato paste and wine. Cook, stirring occasionally, for 10 minutes.

REMOVE the frying pan from the heat and stir in the parsley, Parmesan and bread crumbs. Season well with salt and pepper. Spoon the mixture into the vegetables. Place the tops back on the tomatoes. Sprinkle the vegetables with the remaining oil and bake for 45 minutes, or until the vegetables are tender.

MILLEFEUILLE OF LEEKS AND POACHED EGGS

MILLEFEUILLE MEANS "A THOUSAND LEAVES" AND REFERS TO THE MANY LAYERS OF THE PUFF PASTRY.
YOU CAN EITHER USE THE RECIPE IN THIS BOOK OR 11 OZ. STORE-BOUGHT PUFF PASTRY. MAKE SURE
YOU USE THE FRESHEST EGGS YOU CAN FIND.

1/2 batch puff pastry (page 281)
1 egg, lightly beaten
3 leeks, white part only
2 tablespoons butter
4 eggs

BEURRE BLANC
2 shallots, finely chopped
1 tablespoon butter
3 tablespoons white wine
3/4 cup chicken stock
3/4 cup unsalted butter, chilled and
 diced

SERVES 4

PREHEAT the oven to 375°F. Roll out the pastry on a lightly floured surface to make a 91/2 x 5 inch rectangle. Chill for 10 minutes and then cut into four equal triangles. Trim the edges so they are straight. Place the triangles on a damp baking sheet, lightly brush with the beaten egg and bake for 15 minutes, or until puffed and golden brown. Slice the triangles in half horizontally and use a spoon to remove any uncooked dough from the inside.

CUT the leeks in half and then into thin julienne strips. Melt the butter in a frying pan, add the leeks and cook, stirring, for 10 minutes or until they are tender. Season with salt.

TO POACH the eggs, bring a saucepan of water to a boil. Crack an egg into a ramekin, reduce the heat and slide the egg into the simmering water. Poach for 3 minutes, then remove carefully with a slotted spoon and drain on paper towels. Poach all the eggs in the same way.

TO MAKE the beurre blanc, fry the shallots gently in the butter until they are tender but not browned. Add the wine and bubble in the frying pan until reduced by half. Add the stock and continue cooking until reduced by a third. Add the butter, piece by piece, whisking continuously until the sauce thickens—take care not to overheat. You may need to move the frying pan on and off the heat to keep the temperature even. Season the beurre blanc with salt and white pepper.

ARRANGE the bottom triangles of pastry on a serving dish, top each one with a spoonful of warm leek, then a poached egg and a little beurre blanc. Cover with the pastry tops and serve with the beurre blanc drizzled around or on the side.

Cook the julienned leeks in the butter until they are tender. When making the beurre blanc, take care not to overheat the sauce or the butter will melt too quickly and not form an emulsion.

Spoon the choux pastry around the edge of the baking dish and bake until well risen. To remove the bone from the trout, simply lift off the top fillet and then pull the bone away cleanly.

SMOKED TROUT GOUGÈRE

FOR A GOUGÈRE, CHOUX PASTRY IS TRADITIONALLY PIPED INTO A CIRCULAR OR OVAL SHAPE AND FILLED WITH A SAVORY MIXTURE. IF YOU PREFER, THE PASTRY CAN ALSO BE MADE INTO SMALL CHOUX BUNS, SPLIT OPEN AND THE FILLING SPOONED INTO THE CENTERS.

1/4 cup butter
1 cup all-purpose flour, sifted twice
1/4 teaspoon paprika
3 large eggs, beaten
3/4 cup Gruyère, grated

FILLING
3/4 lb. smoked trout
3 cups watercress, trimmed
2 tablespoons butter
1/4 cup all-purpose flour
1 1/4 cups milk

SERVES 4

PREHEAT the oven to 400°F and put a baking sheet on the top shelf to heat up.

MELT the butter with 3/4 cup water in a saucepan, then bring it to a rolling boil. Remove from the heat and sift in all the flour and the paprika. Return to the heat and beat continuously with a wooden spoon to make a smooth shiny paste that comes away from the side of the pan. Cool for a few minutes. Beat in the eggs one at a time, until shiny and smooth—the mixture should drop off the spoon but not be too runny. Stir in two-thirds of the cheese.

SPOON the dough round the edge of a shallow, lightly greased baking dish. Put this in the oven on the hot baking sheet and cook for 45–50 minutes, or until the choux is well risen and browned.

MEANWHILE, to make the filling, peel the skin off the trout and lift off the top fillet. Pull out the bone. Break the trout into large flakes. Wash the watercress and put in a large saucepan with just the water clinging to the leaves. Cover the saucepan and steam for 2 minutes, or until it has just wilted. Drain, cool and squeeze with your hands to get rid of the excess liquid. Roughly chop the watercress.

MELT the butter in a saucepan, stir in the flour to make a roux and cook, stirring, for 3 minutes over a very low heat without allowing the roux to brown. Remove from the heat and add the milk gradually, stirring after each addition until smooth. Return to the heat and simmer for 3 minutes. Stir in the smoked trout and watercress and season well.

SPOON the trout filling into the center of the cooked choux pastry and return to the oven for 10 minutes, then serve immediately.

PROVENÇAL TART

PASTRY
2 cups all-purpose flour
2/3 cup butter, diced
1 egg yolk, beaten

2 tablespoons olive oil
1 large white onion, finely chopped
10 tomatoes (or 2 x 14^1/$_2$ oz. cans
 diced tomatoes)
1 teaspoon tomato paste
2 garlic cloves, finely chopped
1 tablespoon roughly chopped
 oregano, plus a few whole leaves
 to garnish
1 red pepper
1 yellow pepper
6 anchovies, halved
12 pitted olives
drizzle of olive oil

SERVES 6

TO MAKE the pastry, sift the flour into a bowl, add the butter and rub in with your fingertips until the mixture resembles bread crumbs. Add the egg yolk and a little cold water (about 2–3 teaspoons) and mix with a flexible bladed knife until the dough just starts to come together. Bring the dough together with your hands and shape into a ball. Wrap in plastic wrap and put in the refrigerator to rest for at least 30 minutes.

HEAT the oil in a frying pan, add the onion, cover and cook over very low heat for 20 minutes, stirring often, until softened but not browned.

SCORE a cross in the top of each tomato. Plunge into boiling water for 20 seconds, then drain and peel the skin away from the cross. Chop the tomatoes, discarding the cores. Add the tomatoes, tomato paste, garlic and oregano to the frying pan and simmer, uncovered, for 20 minutes, stirring occasionally. Once the tomato is soft and the mixture has become a paste, allow to cool.

ROLL OUT the pastry to fit a 13^1/$_2$ x 10^1/$_2$ inch shallow baking sheet. Prick the pastry gently all over, without piercing right through. Cover the pastry with plastic wrap and chill for 30 minutes. Preheat the broiler.

CUT the peppers in half, remove the seeds and membrane and place, skin side up, under the hot broiler until the skin blackens and blisters. Allow to cool before peeling away the skin. Cut the peppers into thin strips.

REDUCE the oven to 400°F. Line the pastry shell with a crumpled piece of waxed paper and fill with baking beads (use dried beans or rice if you don't have beads). Blind bake the pastry for 10 minutes, remove the paper and beads and bake for another 3–5 minutes, or until the pastry is just cooked but still very pale. Reduce the oven to 350°F.

SPREAD the tomato mixture over the pastry, then scatter with peppers. Arrange the anchovies and olives over the top. Brush with olive oil and bake for 25 minutes. Scatter with oregano leaves to serve.

Simmer the filling until the tomato is so soft that it forms a paste.

PISSALADIÈRE

PISSALADIÈRE TAKES ITS NAME FROM *PISSALAT*, PURÉED ANCHOVIES. IT CAN VARY IN ITS TOPPING FROM ONIONS AND ANCHOVIES TO ONIONS, TOMATOES AND ANCHOVIES OR SIMPLY ANCHOVIES PURÉED WITH GARLIC. TRADITIONAL TO NICE, IT CAN BE MADE WITH A BREAD OR PASTRY BASE.

3 tablespoons butter
1 tablespoon olive oil
3 lb. onions, thinly sliced
2 tablespoons thyme leaves
1 batch bread dough (page 277)
1 tablespoon olive oil
16 anchovies, halved lengthwise
24 pitted olives

SERVES 6

MELT the butter with the olive oil in a saucepan and add the onions and half the thyme. Cover the saucepan and cook over low heat for 45 minutes, stirring occasionally, until the onion is softened but not browned. Season and cool. Preheat the oven to 400°F.

ROLL OUT the bread dough to roughly fit a greased 13^1/$_2$ x 10^1/$_2$ inch shallow baking sheet. Brush with olive oil, then spread with the onions.

LAY the anchovies in a lattice pattern over the onions and arrange the olives in the lattice diamonds. Bake for 20 minutes, or until the dough is cooked and lightly browned. Sprinkle with the remaining thyme leaves and cut into squares. Serve hot or warm.

Spread the softened onions over the bread base and then arrange the anchovies over the top in the traditional lattice pattern.

TARTE FLAMBÉE

TARTE FLAMBÉE IS THE ALSATIAN VERSION OF THE PIZZA. IT IS COOKED QUICKLY AT A VERY HIGH TEMPERATURE IN A WOOD-FIRED OVEN AND TAKES ITS NAME FROM THE FACT THAT THE EDGE OF THE DOUGH OFTEN CAUGHT FIRE IN THE INTENSE HEAT OF THE OVEN.

2 tablespoons olive oil
2 white onions, sliced
1/$_2$ cup cream cheese or farmer's
 cheese
3/$_4$ cup crème fraîche
6^1/$_2$ oz. piece of bacon, cut into
 small strips
1 batch bread dough (page 277)

SERVES 6

PREHEAT the oven to 450°F. Heat the olive oil in a saucepan and fry the onions until softened but not browned. Beat the cream or farmer's cheese with the crème fraîche and then add the onions and bacon and season well.

ROLL OUT the bread dough into a rectangle about 1/$_8$ inch thick—the dough needs to be quite thin, like a pizza—and place on a greased baking sheet. Fold the edge of the dough over to make a slight rim. Spread the topping over the dough, right up to the rim, and bake for 10–15 minutes, or until the dough is crisp and cooked and the topping browned. Cut into squares to serve.

TARTE FLAMBÉE

EGGS & CHEESE

Maconnass
45% mg Saône-et-Loire

16.80

Pièce

e Mémé
5% mg Queccy

35.00

Pièce

Pouliguys¹ Pièce
456 mg Berry

51.50

Pièce

Once the crêpe starts to come away from the side of the pan, turn it over.

CERVELLE DE CANUT

HAM, MUSHROOM AND CHEESE CRÊPES

1 batch crêpe batter (page 282)
1 tablespoon butter
1³/₄ cups mushrooms, sliced
2 tablespoons whipping cream
1¹/₄ cups Gruyère, grated
²/₃ cup ham, chopped

SERVES 6

HEAT a large crêpe or frying pan and grease with a little butter or oil. Pour in enough batter to coat the bottom of the frying pan in a thin even layer and pour out any excess. Cook over moderate heat for about a minute, or until the crêpe starts to come away from the side of the frying pan. Turn the crêpe and cook on the other side for 1 minute or until lightly golden. Stack the crêpes on a plate, with pieces of waxed paper between them, and cover with plastic wrap while you cook the rest of the batter to make six large crêpes.

PREHEAT the oven to 350°F. Heat the butter in a frying pan, add the mushrooms, season well and cook, stirring, for 5 minutes, or until all the liquid from the mushrooms has evaporated. Stir in the cream, cheese and ham.

LAY one crêpe on a board or work surface. Top with a sixth of the filling and fold the crêpe into quarters. Place it on a baking sheet and then fill and fold the remaining crêpes. Bake for 5 minutes then serve immediately.

CERVELLE DE CANUT

CERVELLE DE CANUT IS A LYONNAIS DISH. THE NAME MEANS "SILK WEAVERS' BRAINS" (APPARENTLY SILK WEAVERS WERE CONSIDERED TO BE QUITE STUPID). DEPENDING ON THE TYPE OF CHEESE THAT YOU USE, THE DISH CAN BE EITHER SMOOTH AND CREAMY OR MORE COARSE.

1 lb. curd cheese or farmer's cheese
2 tablespoons olive oil
1 garlic clove, finely chopped
2 tablespoons chopped chervil
4 tablespoons chopped parsley
2 tablespoons chopped chives
1 tablespoon chopped tarragon
4 shallots, finely chopped

SERVES 8

BEAT the curd cheese or farmer's cheese with a wooden spoon, then add the olive oil and garlic and beat it into the cheese. Add the herbs and shallots and mix together well. Season and serve with pieces of toast or bread, perhaps after dessert as you would cheese and crackers.

OMELET AUX FINES HERBES

THE OMELET IS WONDERFULLY ACCOMMODATING TO PERSONAL TASTE—IT CAN BE FOLDED, ROLLED OR LEFT FLAT, COOKED ON ONE SIDE OR BOTH. THIS FOLDED OMELET IS TRADITIONALLY *BAVEUSE* (CREAMY) IN THE MIDDLE AND COOKED ONLY ON ONE SIDE BEFORE BEING FOLDED.

1 tablespoon butter
2 shallots, finely chopped
1 garlic clove, crushed
2 tablespoons chopped parsley
2 tablespoons chopped basil
1/2 tablespoon chopped tarragon
2 tablespoons heavy cream
8 eggs, lightly beaten
oil

SERVES 4

MELT the butter in a frying pan and cook the shallots and garlic over low heat until tender. Stir in the herbs and then pour into a bowl. Mix in the cream and eggs and season well.

HEAT A LITTLE oil in a nonstick frying pan. Pour a quarter of the batter into the frying pan and cook gently, constantly pulling the set egg around the edge of the frying pan into the center, until the omelet is set and browned underneath and the top is just cooked. Fold the omelet into three and slide it out of the frying pan onto a plate with the seam underneath. Serve hot, for someone else to eat, while you cook up the remaining three omelets.

When the omelet is set and browned underneath, fold it in three so the inside stays creamy.

CROQUE MONSIEUR

5 tablespoons unsalted butter
4 tablespoons all-purpose flour
3/4 cup milk
1/2 teaspoon Dijon mustard
1 egg yolk
grated nutmeg
12 slices white bread
6 slices ham
1 cup Gruyère, grated

SERVES 6

MELT 3 tablespoons of the butter in a saucepan, add the flour and stir over low heat for 3 minutes. Slowly add the milk and mustard, whisking constantly. Allow to simmer until the mixture has thickened and reduced by about a third. Remove from the heat and stir in the egg yolk. Season with salt, pepper and nutmeg and allow to cool completely.

PLACE HALF of the bread slices on a baking sheet. Top each piece of bread with a slice of ham, then with some of the sauce, then Gruyère and finally with another piece of bread. Melt half of the remaining butter in a large frying pan and fry the sandwiches on both sides until they are golden brown, adding the remaining butter when you need it. Cut each sandwich in half to serve.

CROQUE MONSIEUR

ZUCCHINI SOUFFLÉ

SOUFFLÉS HAVE DEVELOPED A REPUTATION AS UNPREDICTABLE CREATIONS, BUT THEY ARE NOT HARD TO MAKE. THE SECRET LIES IN BEATING THE EGG WHITES TO THE RIGHT STIFFNESS AND SERVING THE SOUFFLÉ STRAIGHT FROM OVEN TO TABLE. YOU COULD USE BROCCOLI INSTEAD OF ZUCCHINI.

1 tablespoon butter, melted
1 1/2 tablespoons dried
 bread crumbs
3/4 lb. zucchini, chopped
1/2 cup milk
2 tablespoons butter
1/4 cup all-purpose flour
2/3 cup Gruyère or Parmesan, finely
 grated
3 scallions, finely chopped
4 eggs, separated

SERVES 4

Grate the cheese for soufflés finely so that it melts quickly without forming bubbles of oil.

BRUSH a 6-cup soufflé dish with the melted butter and then put the bread crumbs in the dish. Rotate the dish to coat the side completely with bread crumbs. Pour out the excess bread crumbs.

COOK the zucchini in boiling water for 8 minutes until tender. Drain and then put the zucchini in a food processor with the milk and mix until smooth. Alternatively, mash the zucchini with the milk and then press it through a sieve with a wooden spoon. Preheat the oven to 350°F.

MELT the butter in a heavy-bottomed saucepan and stir in the flour to make a roux. Cook, stirring, for 2 minutes over low heat without allowing the roux to brown. Remove from the heat and add the zucchini purée, stirring until smooth. Return to the heat and bring to a boil. Simmer, stirring, for 3 minutes, then remove from the heat. Pour into a bowl, add the cheese and scallions and season well. Mix until smooth, then beat in the egg yolks until smooth again.

WHISK the egg whites in a clean dry bowl until they form soft peaks. Spoon a quarter of the egg white onto the soufflé mixture and quickly but lightly fold it in to loosen the mixture. Lightly fold in the remaining egg white. Pour into the soufflé dish and run your thumb around the inside rim of the dish, about 3/4 inch into the soufflé mixture (try not to wipe off the butter and bread crumbs). This ridge helps the soufflé to rise without sticking.

BAKE for 45 minutes, or until the soufflé has risen and wobbles slightly when tapped. Test with a skewer through a crack in the side of the soufflé—the skewer should come out clean or slightly moist. If the skewer is slightly moist, by the time the soufflé makes it to the table it will be cooked in the center. Serve immediately.

Round zucchini are used in the same way as the more common long variety.

CAMEMBERT DE NORMANDIE this AOC cheese is produced in Normandy from unpasteurized milk. The rind is covered in white mold and it has a yellow creamy pâte. A table or cooking cheese.

BRIE DE MEAUX France's most famous brie, this unpasteurized AOC cheese from the Île-de-France is usually sold half ripe. When very ripe, its white surface reddens. A good table cheese.

LIVAROT this washed-rind AOC cheese from Normandy is known as "the Colonel" due to stripes of grass that bind its shape. A table cheese eaten very ripe, it has a spicy taste and pungent smell.

MIMOLETTE/BOULE DE LILLE produced like Dutch Edam, the name comes from *mi-mou,* "half-soft," but it is usually eaten very hard, after up to 2 years of aging. Use in cooking or eat with beer.

NEUFCHÂTEL a classic soft, white-rinded AOC cheese from Normandy, that comes in shapes such as a heart, log or square. A table cheese whose rind can be eaten, it is good with bread.

MORBIER this mild cheese from Franche-Comté is cut by a dark line, originally ash separating two layers of milk from two milkings, but now just decorative. A table cheese or melted on bread.

BRILLAT-SAVARIN created in the 1930s and named after a French food writer, this mild, triple-cream cheese, with its very high butterfat content, is made mainly around Normandy.

CARRÉ DE L'EST made in Alsace, Champagne-Ardennes and Lorraine, this soft cheese comes with an extremely sticky orange washed-rind. Here it has been washed in plum *eau de vie*.

MUNSTER/MUNSTER-GÉROMÉ this washed-rind AOC cheese from Alsace, Lorraine and Franche-Comté has a pungent smell and is traditionally eaten with potatoes, cumin and wine.

CHAOURCE this AOC cheese is produced in Bourgogne and Champagne and is eaten when only 2 or 3 weeks old. It is a table cheese with a white mold rind and light creamy pâte.

BEAUFORT a large, round AOC mountain cheese from the Rhône-Alpes. A Gruyère-type table cheese with a concave surface, it is also used in fondue. *Beaufort d'alpage* is particularly flavorsome.

FLEUR DU MAQUIS this aromatic goat cheese from Corsica is covered with chile, juniper and wild herbs and is named after the "maquis," the scrubby landscape of the island.

MOUNTAIN CHEESES Each spring in the French Alps, herds of cows begin their annual transhumance from the winter lowlands to the *alpages,* the highland pastures. The farmers live in chalets while their herds eat the grass, herbs and flowers that will result in the rich, high-fat milk needed to produce cheeses such as *reblochon* and *beaufort d'alpage*, aged in cellars below their chalets.

CHEESE

FRANCE PROUDLY PRODUCES OVER 500 VARIETIES OF CHEESES, MANY OF THEM AMONG THE WORLD'S BEST, AND A REFLECTION OF THE STRENGTH OF REGIONAL TRADITIONS THAT HAD GENERAL DE GAULLE FAMOUSLY ASKING HOW ANYONE COULD GOVERN A COUNTRY WITH SO MANY CHEESES.

THE APPELLATION D'ORIGINE CONTRÔLÉE (AOC)

The AOC is granted to quality cheeses produced in a specified region following established production methods. AOC cheeses can be distinguished by a stamp and often by wording on the package such as *Fabrication traditionnelle au lait cru avec moulé à la louche* on AOC camembert.

CHEESEMAKERS

Fermier cheeses are farmhouse cheeses, using milk from the farmer's herd and traditional methods. *Artisanal* cheeses come from independent farmers using their own or others' milk. *Coopérative* cheeses are made at a dairy with milk coming from cooperative members. *Industriel* cheeses are produced in factories. Many *artisanal* and *fermier* cheesemakers have made traditional cheeses for generations, often in small quantities and sold just within their region. Only a few AOC or well-known cheeses reach a wider audience. Some cheese, such as camembert, is produced by *fermier, coopérative* and *industriel* methods with very different qualities.

MILK FOR CHEESE

French cheeses are made from cow's, goat's and sheep's milk, with ewe's milk being the strongest in flavor. Milk is pasteurized or *lait cru* (raw), which produces more complex flavors as the cheese develops. All *fermier* cheeses are made of *lait cru* and it is compulsory for some AOC cheeses.

CAMEMBERT is made at Isigny Ste Mère in Normandy using *industriel* methods but following AOC guidelines to the letter. First, a starter is added to the milk and left overnight. The milk is heated to no more than 98°F, rennet added and the milk left to coagulate. Five portions of curds are ladled into perforated plastic molds (*moulé à la louche*), with time between each "pass" to evenly distribute the fat. The whey is

GOAT'S MILK CHEESES are produced all over France, with some of the most famous found in the Loire Valley, including the *crottin de Chavignon*, Provence and Corsica. Goat cheeses were traditionally made seasonally, with the best cheeses produced in the spring from rich milk. Some are dusted with ash to encourage a mold to appear, while others are decorated with herbs or soaked in oil.

TYPES OF CHEESES

Cheeses can be categorized into families, and looking at the rind and the texture of the *pâte* (inside) of a cheese can help you determine its category and therefore roughly its taste.

FRESH CHEESE (fromage frais, chèvre frais) cheeses with no rind (because they haven't been ripened). A mild or slightly acidic taste and a high moisture content.

PÂTE FLEURIE (Camembert, Brie) soft cheeses with an edible white rind. These uncooked, unpressed (drained naturally) cheeses are high in moisture, causing white molds to form a rind. A creamy, melting pâte and sometimes a mushroom taste.

PÂTE LAVÉE (Munster and Livarot) soft cheeses with washed rinds. These uncooked, unpressed high-moisture cheeses develop a cat's-fur mold when ripening, which is washed away in a process that encourages sticky orange bacteria to ripen the cheese from the outside in. They often have a smooth, elastic pâte, piquant taste and pungent aroma.

FROMAGES DE CHÈVRE goat cheeses. These uncooked, unpressed cheeses have a slightly wrinkled rind and fresh taste when young, while older cheeses are more wrinkly, often with a blue mold (sometimes encouraged by dusting with ash) and a more intense, nutty, "goat" flavor.

PÂTE PERSILLÉE (Roquefort, Bleu d'Auvergne) blue cheeses. A penicillium is introduced into the cheeses, which in some cases, via airholes, spreads into blue veins. These uncooked, unpressed cheeses tend to have a sharp flavor and aroma.

PÂTE PRESSÉE (Cantal, Port-du-Salut) semi-hard cheeses with a supple rind that hardens with age. These uncooked cheeses are pressed so the dry cheese matures slowly to produce a well-developed mellow taste. They are washed to seal the rind and molds are brushed off as the cheese ripens, or sealed in plastic or wax to stop the rind forming. The pâte varies from supple to hard if aged.

PÂTE CUITE (Beaufort, Emmental) hard mountain cheeses with a thick rind, depending on their age. These are cheeses whose curds have been finely cut, cooked and pressed and can be matured for a long time. They often have a fruity or nutty flavor and, with little moisture, a high fat content.

drained, then the cheeses removed from the molds, salted and sprayed with mold and moved to drying rooms for two weeks while the white mold grows. Finally, the cheeses are wrapped in waxed paper and put in a wooden box to continue to age. There is up to four weeks of maturing (*affinage*) in the box, with many locals preferring the cheese when it is *moitié affiné* (half mature), with the heart not yet creamy.

CHÈVRE FERMIER an artisan-made goat's-milk cheese. There are many different types, but this version is very fresh and has a mild flavor and aroma. Eat on its own or with bread.

MAROILLES this square AOC cheese from the North has a washed rind that darkens with age to a distinctive red. The pâte is soft and sweet and it is eaten with beer or used in cooking.

GRUYÈRE DE SAVOIE a hard cheese from the Frache-Comté and Savoie. Gruyère refers to the variety of cheese, of which there are many types. Good for grating and cooking.

ABONDANCE a firm, aged mountain cheese from the Alps, made from the milk of Abondance cows. The curds are pressed twice and salted, which gives a dense texture and a fruity taste.

TOMME DE SAVOIE the generic name for a type of cow's milk cheese made in the Savoie. They have a hard rind but an elastic, mellow tasting pâte inside. A table and cooking cheese.

POULIGNY-SAINT-PIERRE an AOC goat's-milk cheese, covered with a blue mold that develops as the cheese ages (this one is young). It has a strong taste and aroma.

OSSAU-IRATY-BREBIS PYRÉNÉES this AOC cheese is made with ewe's milk during the summer when sheep are in the mountain pastures. A table and grating cheese.

EMMENTAL a cooked, nutty cheese based on the Swiss version, with a pale, holey pâte. The Emmental Grand Cru has a red label guaranteeing its quality. A table and cooking cheese.

ROQUEFORT a strong, creamy AOC blue cheese, which must ripen in the caves of Cambalou. Cut the cheese with a warm knife to prevent it from crumbling. A table and cooking cheese.

CHAUMES an orange washed-rind cheese produced with milk from several areas. The pâte is semi-soft and the flavor very mild. A table cheese that broils well, it is similar to Port Salut.

REBLOCHON a Savoie AOC mountain cheese made from milk from the cow's rich second milking. A good table cheese, it has an orange rind, white mold, walnut flavor and creamy pâte.

CANTAL an AOC cheese from the mountains of Auvergne, sold as a young, sweet, white cheese or matured with a dark yellow rind and strong taste. A table and cooking cheese.

EGGS EN CROUSTADE

A CROUSTADE IS A HOLLOWED-OUT PIECE OF BREAD THAT HAS BEEN FRIED OR BAKED TO MAKE A FIRM LITTLE SHELL FOR FILLINGS. CROUSTADES PROVIDE THE PERFECT BASE FOR POACHED EGGS. FOR A NEATER FINISH, TRIM EACH EGG INTO A CIRCLE TO FIT THE WELL.

CROUSTADES
1 stale unsliced loaf white bread
3 tablespoons butter, melted
1 garlic clove, crushed

HOLLANDAISE SAUCE
2 egg yolks
2 teaspoons lemon juice
6 tablespoons unsalted butter, cut
 into cubes

4 eggs
1 teaspoon finely chopped parsley

SERVES 4

TO MAKE the croustades, preheat the oven to 350°F. Cut four 1¹/₄-inch thick slices from the bread and remove the crusts. Cut each piece of bread into a 3¹/₂-inch square, then use a 2¹/₂-inch round cutter to cut a circle in the center of the bread, without cutting all the way through. Use a knife to scoop out the bread from the center to form a neat hollow.

MIX TOGETHER the melted butter and garlic and brush all over the bread. Place on a baking sheet and bake for 8 minutes, or until crisp and lightly golden. Keep warm.

TO MAKE the hollandaise sauce, put the egg yolks and lemon juice in a saucepan over very low heat. Whisk continuously, adding the butter piece by piece until the sauce thickens. Do not overheat or the eggs will scramble. Season with salt and pepper. The sauce should be of pouring consistency—if it is too thick, add 1–2 tablespoons of hot water to thin it.

(ALTERNATIVELY, put the eggs yolks, salt and pepper in a blender and mix together. Heat the lemon juice and butter together until boiling and then, with the motor running, pour onto the yolks in a steady stream.)

TO POACH the eggs, bring a saucepan of water to a boil. Crack an egg into a small bowl, reduce the heat and slide the egg into the simmering water. Poach for 3 minutes, then remove carefully with a slotted spoon and drain on paper towels. Poach the other three eggs. Trim off the uneven ends of the egg white to make a circle.

GENTLY PLACE an egg into each croustade. Pour over a little hollandaise sauce and sprinkle with parsley. Serve at once with extra hollandaise.

Use the freshest eggs you can find for poaching, so that the whites don't spread too much in the water. If you can't guarantee their freshness, add a little vinegar to the water to keep the whites together.

Cook the onions for the tart slowly to bring out the sweetness.

ONION TART

1 batch tart pastry (page 278)
3 tablespoons butter
1¹/₄ lb. onions, finely sliced
2 teaspoons thyme leaves
3 eggs
1¹/₄ cups heavy cream
¹/₂ cup Gruyère, grated
grated nutmeg

SERVES 6

PREHEAT the oven to 350°F. Line a 9-inch fluted loose-bottomed tart pan with the pastry. Line the pastry shell with a crumpled piece of waxed paper and baking beads (use dried beans or rice if you don't have beads). Blind bake the pastry for 10 minutes, remove the paper and beads and bake for another 3–5 minutes, or until the pastry is just cooked but still very pale.

MEANWHILE, melt the butter in a small frying pan and cook the onions, stirring, for 10–15 minutes or until tender and lightly browned. Add the thyme leaves and stir well. Allow to cool. Whisk together the eggs and cream and add the cheese. Season with salt, pepper and nutmeg.

SPREAD the onions into the pastry shell and pour the egg mixture over the top. Bake for 35–40 minutes, or until golden brown. Allow to rest in the pan for 5 minutes before serving.

FLAMICHE

A SPECIALTY OF THE PICARDIE REGION, FLAMICHE IS MADE BOTH AS AN OPEN TART AND A CLOSED PIE. YOU WILL USUALLY COME ACROSS IT WITH A LEEK FILLING, AS HERE, BUT IT CAN ALSO BE MADE WITH ONIONS, PUMPKIN OR SQUASH.

1 batch tart pastry (page 278)
1 lb. leeks, white part only, finely sliced
3 tablespoons butter
6 oz. Maroilles (soft cheese), Livarot or Port-Salut, chopped
1 egg
1 egg yolk
¹/₄ cup heavy cream
1 egg, lightly beaten

SERVES 6

PREHEAT oven to 350°F and put a baking sheet on the top shelf. Use three-quarters of the pastry to line a 9-inch fluted loose-bottomed tart pan.

COOK the leeks for 10 minutes in boiling salted water, then drain. Heat the butter in a frying pan, add the leeks and cook, stirring, for 5 minutes. Stir in the cheese. Pour into a bowl and add the egg, egg yolk and cream. Season and mix well.

POUR the filling into the pastry shell and smooth. Roll out the remaining pastry to cover the pie. Pinch the edges together and trim. Cut a hole in the center and brush egg over the top. Bake for 35–40 minutes on the baking sheet until browned. Leave in the pan for 5 minutes before serving.

FLAMICHE

QUICHE LORRAINE

TRADITIONALLY SERVED ON MAY DAY TO CELEBRATE THE START OF SPRING, QUICHE LORRAINE IS A REGIONAL DISH FROM NANCY IN LORRAINE AND IS MADE USING BACON, ANOTHER SPECIALTY OF THE AREA. THIS FOLLOWS THE ORIGINAL RECIPE, WHICH WAS MADE WITHOUT CHEESE.

1 batch tart pastry (page 278)
2 tablespoons butter
10 oz. bacon, diced
1 cup heavy cream
3 eggs
grated nutmeg

SERVES 8

PREHEAT the oven to 400°F. Line a 10-inch fluted loose-bottomed tart pan with the pastry. Line the pastry shell with a crumpled piece of waxed paper and baking beads (use dried beans or rice if you don't have beads). Blind bake the pastry for 10 minutes, remove the paper and beads and bake for another 3–5 minutes, or until the pastry is just cooked but still very pale. Reduce the heat to 350°F.

MELT the butter in a small frying pan and cook the bacon until golden. Drain on paper towels.

MIX TOGETHER the cream and eggs and season with salt, pepper and nutmeg. Scatter the bacon into the pastry shell, then pour in the egg mixture. Bake for 30 minutes, or until the filling is set. Allow to rest in the pan for 5 minutes before serving.

Blind bake, then fill the pastry shell on the oven shelf, so you don't have to worry about spillages.

BLUE CHEESE QUICHE

1 cup walnuts
1 batch tart pastry (page 278)
3/4 cup blue cheese, mashed
1/3 cup milk
3 eggs
2 egg yolks
3/4 cup heavy cream

SERVES 8

PREHEAT the oven to 400°F. Toast the walnuts on a baking sheet for 5 minutes, then chop. Line a 10-inch fluted loose-bottomed tart pan with the pastry. Line the pastry shell with a crumpled piece of waxed paper and baking beads (use dried beans or rice if you don't have beads). Blind bake the pastry for 10 minutes, remove the paper and beads and bake for another 3–5 minutes, or until the pastry is just cooked but still very pale. Reduce the heat to 350°F.

MIX TOGETHER the blue cheese, milk, eggs, egg yolks and cream and season. Pour into the pastry shell and sprinkle with the walnuts. Bake for 25–30 minutes, or until the filling is just set. Allow to rest in the pan for 5 minutes before serving.

BLUE CHEESE QUICHE

PÂTÉS & TERRINES

Gently fry the onion and garlic before adding the chicken livers and thyme. Once the livers have changed color, add the brandy.

CHICKEN LIVER PÂTÉ

1 lb. chicken livers
1/3 cup brandy
6 tablespoons unsalted butter
1 onion, finely chopped
1 garlic clove, crushed
1 teaspoon chopped thyme
1/4 cup heavy cream
4 slices white bread

SERVES 6

TRIM the chicken livers, cutting away any discolored spots and veins. Rinse them, pat dry with paper towels and cut in half. Place in a small bowl with the brandy, cover and let sit for a couple of hours. Drain the livers, reserving the brandy.

MELT half of the butter in a frying pan, add the onion and garlic and cook over low heat until the onion is soft and transparent. Add the livers and thyme and stir over moderate heat until the livers change color. Add the reserved brandy and simmer for 2 minutes. Cool for 5 minutes.

PLACE the livers and liquid in a food processor and whiz until smooth. Add the remaining butter, cut into pieces, and process again until smooth. (Alternatively, roughly mash the livers with a fork, then push them through a sieve and mix with the melted butter.) Pour in the cream and process until incorporated.

SEASON the pâté and spoon into an earthenware dish or terrine, smoothing the surface. Cover and refrigerate until firm. If the pâté is to be kept for more than a day, chill it and then pour clarified butter over the surface to seal.

TO MAKE Melba toasts, preheat the broiler and cut the crusts off the bread. Toast the bread on both sides, then slice horizontally with a sharp serrated knife to give you eight pieces. Carefully toast the uncooked side of each slice and then cut it into two triangles. Serve with the pâté.

TERRINE DE CAMPAGNE

THIS IS THE DISH THAT YOU WILL FIND IN RESTAURANTS IF YOU ORDER *PÂTÉ MAISON*. IT IS OFTEN
SERVED WITH PICKLED VEGETABLES AND COARSE COUNTRY BREAD. TERRINE DE CAMPAGNE FREEZES
VERY WELL IF YOU HAVE SOME LEFT OVER OR WANT TO MAKE IT IN ADVANCE.

1 lb. 6 oz. lean pork, cut into cubes
6½ oz. pork belly, cut into strips
6½ oz. chicken livers, trimmed
3½ oz. bacon, chopped
1½ teaspoons sea salt
½ teaspoon black pepper
pinch of grated nutmeg
8 juniper berries, lightly crushed
3 tablespoons brandy
2 shallots, finely chopped
1 large egg, lightly beaten
sprig of bay leaves
8 thin bacon slices

SERVES 8

PUT the lean pork, pork belly, chicken livers and
chopped bacon in a food processor and roughly
chop into small dice (you will need to do this in
two or three batches). Alternatively, finely dice the
meat with a sharp knife.

PUT the diced meat in a large bowl and add the
sea salt, pepper, nutmeg, juniper berries and
brandy. Mix carefully and allow to marinate in the
refrigerator for at least 6 hours or overnight.

PREHEAT the oven to 350°F. Lightly butter an
8 x 2¾ x 3½ inch terrine or loaf pan. Add the
shallots and egg to the marinated meat and
carefully mix together.

The free-range chicken and egg
stall at a Lyon market.

PUT a sprig of bay leaves in the bottom of the
terrine and then line with the bacon slices, leaving
enough hanging over the sides to cover the top.
Spoon the filling into the terrine and fold the ends
of the bacon over the top. Cover the top with a
layer of well-buttered waxed paper and then wrap
the whole terrine in a layer of aluminum foil.

PLACE the terrine in a large baking dish and pour
water into the baking dish to come halfway up
the sides of the terrine. Bake in this bain-marie for
1½ hours, or until the pâté is shrinking away from
the sides of the terrine.

TAKE the terrine out of the bain-marie and allow
the pâté to cool, still wrapped in the paper and
foil. Once cold, drain off the excess juices and
refrigerate for up to a week. You may find that a
little moisture has escaped from the pâté—this is
quite normal and prevents it from drying out.
Run a knife around the inside of the terrine to
loosen the pâté and then turn out onto a board
and serve in slices.

PORK RILLETTES

Use two forks to shred the meat.

PORK RILLETTES

OFTEN KNOWN AS *RILLETTES DE TOURS*, THIS SPECIALTY OF THE LOIRE VALLEY IS THE FRENCH VERSION OF POTTED MEAT. SPREAD ON TOAST OR BREAD AND SERVE WITH A GLASS OF WINE, OR STIR A SPOONFUL INTO SOUPS AND STEWS TO ADD FLAVOR.

1 1/2 lb. pork neck or belly, rind and bones removed
5 oz. pork back fat
1/3 cup dry white wine
3 juniper berries, lightly crushed
1 teaspoon sea salt
2 teaspoons dried thyme
1/2 teaspoon ground nutmeg
1/4 teaspoon ground allspice
pinch of ground cloves
1 large garlic clove, crushed

SERVES 8

PREHEAT the oven to 275°F. Cut the meat and fat into short strips and put in a casserole with the rest of the ingredients. Mix together thoroughly and cover. Bake for 4 hours, by which time the pork should be soft and surrounded by liquid fat.

PUT the meat and fat into a sieve placed over a bowl to collect the fat. Shred the warm meat with two forks. Season if necessary. Pack the meat into a 3-cup dish or terrine and allow to cool. Strain the hot fat through a sieve lined with damp cheesecloth.

ONCE the pork is cold, pour the fat over it (you may need to melt the fat first if it has solidified as it cooled). Cover and refrigerate for up to a week. Serve at room temperature.

DUCK RILLETTES

1 1/4 lb. pork belly, rind and bones removed
6–8 duck legs
1/2 cup dry white wine
1 teaspoon sea salt
1/4 teaspoon black pepper
1/2 teaspoon ground nutmeg
1/4 teaspoon ground allspice
1 large garlic clove, crushed

SERVES 8

PREHEAT the oven to 275°F. Cut the pork belly into small pieces and put in a casserole with the rest of the ingredients and 1 cup water. Mix together thoroughly and cover with a lid. Bake for 4 hours, by which time the meat should be soft and surrounded by liquid fat.

PUT the meat and fat into a sieve placed over a bowl to collect the fat. Remove the meat from the duck legs and shred all the warm meat with two forks. Season if necessary. Pack the meat into a 3-cup dish or terrine and allow to cool. Strain the fat through a sieve lined with damp cheesecloth.

ONCE the meat is cold, pour the fat over it (you may need to melt the fat first if it has solidified as it cooled). Cover and refrigerate for up to a week. Serve at room temperature.

SALMON TERRINE

IF YOU CAN FIND WILD SALMON IT WILL GIVE A MUCH BETTER FLAVOR THAN FARMED. A MILD SMOKED SALMON IS BETTER THAN A REALLY SMOKY ONE—SOME SMOKED SALMON VARIETIES CAN BE SO STRONG THEY MAKE THEIR PRESENCE FELT THROUGHOUT THE WHOLE TERRINE.

1 lb. 6 oz. salmon fillet, skinned and
 all small bones removed
4 eggs
2^1/$_4$ cups heavy cream
1/$_3$ cup finely chopped chervil
1 lb. button mushrooms
1 teaspoon lemon juice
2 tablespoons butter
1 tablespoon grated onion
2 tablespoons white wine
10 large spinach leaves
10 oz. smoked salmon, thinly sliced

LEMON MAYONNAISE
1 tablespoon lemon juice
grated zest of 1 lemon
1 cup mayonnaise (page 286)

SERVES 8

Line the terrine with the salmon, leaving the slices hanging over the sides. Once the terrine is filled, fold the salmon over to cover the top.

PREHEAT the oven to 325°F. Purée the salmon fillet and eggs in a food processor until smooth. Push through a fine sieve into a glass bowl. (Alternatively, mash with a fork and push through a fine sieve.) Place the bowl over iced water, then gradually mix in the cream. Stir in the chervil and season. Cover and put in the refrigerator.

DICE the mushrooms and toss with the lemon juice to prevent discoloring. Melt the butter in a frying pan and cook the onion, stirring, for 2 minutes. Add the mushrooms and cook for 4 minutes. Add the wine and cook until it has evaporated. Season and remove from the heat.

DIP the spinach leaves in boiling water, then remove them carefully with a slotted spoon and lay them flat on paper towels.

BRUSH an 8 x 2^3/$_4$ x 3^1/$_2$ inch terrine or loaf pan with oil and line the bottom with waxed paper. Line the bottom and sides with the smoked salmon, leaving enough hanging over the sides to cover the top. Spoon in enough salmon mixture to half-fill the terrine. Lay half the spinach over the salmon mixture, then spread with the mushrooms and another layer of spinach. Cover with the remaining salmon mixture, fold over the smoked salmon and cover with a piece of buttered waxed paper.

PLACE the terrine in a large baking dish and pour water into the baking dish to come halfway up the side of the terrine. Bake in this bain-marie for 45–50 minutes, or until a skewer inserted into the terrine comes out clean. Leave for 5 minutes before unmolding onto a serving plate. Peel off the waxed paper, cover and chill the terrine.

TO MAKE the lemon mayonnaise, stir the lemon juice and zest through the mayonnaise and serve with slices of salmon terrine.

PÂTÉ EN CROÛTE

THE WORD "PÂTÉ" MEANING CRUST, WAS TRADITIONALLY ONLY USED WHEN REFERRING TO THIS DISH. THESE DAYS, THE WORDS PÂTÉ AND TERRINE ARE USED INTERCHANGEABLY AND PÂTÉ IS SYNONYMOUS WITH ALL KINDS OF MEAT AND SEAFOOD PASTES, NOT JUST THOSE WITH A PASTRY CRUST.

1 1/4 lb. veal scallopine slices, finely diced
1/2 lb. lean pork, finely diced
6 1/2 oz. bacon, finely diced
large pinch of ground cloves
large pinch of allspice
finely grated zest of 1 lemon
2 tablespoons brandy
2 bay leaves
1 tablespoon butter
1 large garlic clove, crushed
1 onion, finely chopped
6 1/2 oz. wild or chestnut mushrooms, finely chopped
3 tablespoons finely chopped parsley
1 batch puff pastry (page 281)
1 egg, lightly beaten

SERVES 8

MIX TOGETHER the veal, pork, bacon, cloves, allspice, lemon zest and brandy. Stir well, tuck the bay leaves into the mixture, then cover and allow to marinate in the refrigerator for at least 6 hours or preferably overnight.

MELT the butter in a frying pan and add the garlic and onion. Cook over low heat for 10 minutes, then add the mushrooms and cook for another 10 minutes, until they are softened and the liquid from the mushrooms has evaporated. Stir in the parsley and allow to cool.

REMOVE the bay leaves from the marinated meat. Add the cold mushroom mixture to the raw meat, season well and mix together thoroughly.

PREHEAT the oven to 400°F. Roll out the pastry on a lightly floured surface into a 15-inch square, trim the edges and keep for decoration. Pile the meat mixture onto the middle of the pastry, shaping it into a rectangle about 12 inches long. Brush the edges of the pastry with a little beaten egg. Fold the pastry over the meat as if you were wrapping a package. Place on a baking sheet, seam side down.

DECORATE the package with shapes cut from the pastry scraps and brush all over with beaten egg. Cook on the middle shelf of the oven for 15 minutes, then reduce the temperature to 350°F and cook for 1–1 1/4 hours, or until the filling is cooked and the pastry golden brown. Cool completely before serving in slices with pickles.

Pâté for sale at a Provence market.

SEAFOOD

Cut down each side of the underside of the lobster tail and peel back the shell.

A busy Provence port.

POACHED SEAFOOD WITH HERB AÏOLI

THE BEST WAY TO APPROACH THIS RECIPE IS AS A GUIDE—AS WITH ALL SEAFOOD COOKING, YOU SHOULD ALWAYS ASK YOUR FISHMONGER'S ADVICE AS TO WHAT'S THE BEST CATCH THAT DAY. DON'T FORGET TO PROVIDE FINGERBOWLS.

2 raw lobster tails
12 mussels
1/2 lb. scallops on their shells
1 lb. shrimp
1 cup dry white wine
1 cup fish stock
pinch of saffron threads
1 bay leaf
4 black peppercorns
4 x 2 oz. salmon fillets

HERB AÏOLI
4 egg yolks
4 garlic cloves, crushed
1 tablespoon chopped basil
4 tablespoons chopped flat-leaf
 parsley
1 tablespoon lemon juice
3/4 cup olive oil

lemon wedges

SERVES 4

REMOVE the lobster meat from the tail by cutting down each side of the underside with scissors and peeling back the middle piece of shell. Scrub the mussels and remove their beards, discarding any that are open and don't close when tapped on the work surface. Remove the scallops from their shells and pull away the white muscle and digestive tract around each one, leaving the roes intact. Clean the scallop shells and keep them for serving. Peel and devein the shrimp, leaving the tails intact, and butterfly them by cutting them open down the backs.

TO MAKE the herb aïoli, put the egg yolks, garlic, basil, parsley and lemon juice in a mortar and pestle or food processor and pound or mix until light and creamy. Add the oil, drop by drop from the tip of a teaspoon, pounding constantly until the mixture begins to thicken, then add the oil in a very thin stream. (If you're using a processor, pour in the oil in a thin stream with the motor running.)

PUT the wine, stock, saffron, bay leaf and peppercorns in a frying pan and bring to a very slow simmer. Add the lobster and poach for 5 minutes then remove, cover and keep warm.

POACH the remaining seafood in batches: the mussels and scallops will take about 2 minutes to cook and open (discard any mussels that have not opened after this time). The shrimp will take 3 minutes and the salmon a little longer, depending on the thickness. (Keep the poaching liquid to use as soup stock.) Cut the lobster into thick medallions, put the scallops back on their shells and arrange the seafood on a large platter with the aïoli in a bowl in the center. Serve with lemon wedges.

CRAB SOUFFLÉS

1 tablespoon butter, melted
2 cloves
1/4 small onion
1 bay leaf
6 black peppercorns
1 cup milk
1 tablespoon butter
1 shallot, finely chopped
2 tablespoons all-purpose flour
3 egg yolks
1 lb. cooked crab meat
pinch of cayenne pepper
5 egg whites

SERVES 6

PREHEAT the oven to 400°F. Brush six 1/2-cup ramekins with the melted butter.

PRESS the cloves into the onion, then put in a small saucepan with the bay leaf, peppercorns and milk. Gently bring to a boil, then remove from the heat and allow to infuse for 10 minutes. Strain the milk.

MELT the butter in a heavy-bottomed saucepan, add the shallot and cook, stirring, for 3 minutes until softened but not browned. Stir in the flour to make a roux and cook, stirring, for 3 minutes over low heat without allowing the roux to brown.

REMOVE from the heat and add the infused milk gradually, stirring after each addition until smooth. Return to the heat and simmer for 3 minutes, stirring continuously. Beat in the egg yolks, one at a time, beating well after each addition. Add the crab meat and stir over the heat until the mixture is hot and thickens again (do not let it boil). Pour into a large heatproof bowl, then add the cayenne and season well.

WHISK the egg whites in a clean dry bowl until they form soft peaks. Spoon a quarter of the egg white onto the soufflé mixture and quickly but lightly fold it in to loosen the mixture. Lightly fold in the remaining egg white. Pour into the ramekins and then run your thumb around the inside rim of each ramekin. This ridge helps the soufflés to rise evenly without sticking.

PUT the ramekins on a baking sheet and bake for 12–15 minutes, or until the soufflés are well risen and wobble slightly when tapped. Test with a skewer through a crack in the side of a soufflé—the skewer should come out clean or slightly moist. If the skewer is slightly moist, by the time the soufflés make it to the table they will be cooked in the center. Serve immediately.

Fold a quarter of the egg white into the soufflé mixture to loosen it up before you add the rest.

Unloading the catch in Marseille.

The Quai des Belges, Marseille.

COQUILLES SAINT JACQUES MORNAY

SCALLOPS IN FRANCE ARE NAMED AFTER SAINT JAMES. THEIR SHELLS WERE ONCE WORN BY PILGRIMS WHO FOUND THEM AS THEY WALKED ALONG THE SPANISH COAST ON THEIR PILGRIMAGE TO A CATHEDRAL IN SPAIN DEDICATED TO THE SAINT.

COURT BOUILLON
1 cup white wine
1 onion, sliced
1 carrot, sliced
1 bay leaf
4 black peppercorns

24 scallops on their shells
3 tablespoons butter
3 shallots, finely chopped
3 tablespoons all-purpose flour
1²/₃ cups milk
1 cup Gruyère, grated

SERVES 6

TO MAKE the court bouillon, put the wine, onion, carrot, bay leaf, peppercorns and 2 cups water into a deep frying pan, bring to a boil and simmer for 20 minutes. Strain the court bouillon and return to the clean frying pan.

REMOVE the scallops from their shells and pull away the white muscle and digestive tract from each one, leaving the roes intact. Clean the shells and keep for serving.

BRING the court bouillon to a gentle simmer, add the scallops and poach over low heat for 2 minutes. Remove the scallops from the court bouillon, drain and return to their shells. Pour away the court bouillon.

MELT the butter in a heavy-bottomed saucepan, add the shallots and cook, stirring, for 3 minutes. Stir in the flour to make a roux and cook, stirring, for 3 minutes over low heat without allowing the roux to brown.

REMOVE from the heat and add the milk gradually, stirring after each addition until smooth. Return to the heat and simmer, stirring, for about 3 minutes, until the sauce has thickened. Remove from the heat and stir in the cheese until melted. Season with salt and pepper. Preheat the broiler. Spoon the sauce over the scallops and place under the broiler until golden brown. Serve immediately.

Poach the scallops in court bouillon first, so that they are thoroughly cooked before they are broiled. The heat of the broiler alone isn't enough to cook them.

GARLIC SHRIMP

24 large shrimp
6 garlic cloves, crushed
1–2 small red chiles, very finely
 chopped
1 cup olive oil
4 tablespoons butter
2 tablespoons chopped parsley

SERVES 4

PEEL and devein the shrimp, leaving the tails intact. Preheat the oven to 425°F. Sprinkle the garlic and chiles into four cast iron or gratin dishes. Divide the oil and butter among the dishes.

PUT the dishes on a baking sheet in the oven and heat for about 6 minutes, or until the butter has melted.

DIVIDE the shrimp among the dishes (put them in carefully, without splashing yourself with hot oil) and bake for 7 minutes, or until the shrimp are pink and tender. Sprinkle with parsley and serve immediately with crusty bread.

SNAILS WITH GARLIC BUTTER

THERE ARE MANY VARIETIES OF EDIBLE SNAIL, WITH THE MOST COMMON BEING *PETITS GRIS* OR THE SLIGHTLY LARGER *ESCARGOTS DE BOURGOGNE*, ALSO KNOWN AS THE ROMAN SNAIL. CANNED SNAILS ARE SOLD ALONG WITH THEIR SHELLS AND ARE EASIER TO USE THAN FRESH ONES.

Simmer the snails and then allow to cool in the poaching liquid.

1 cup white wine
1 cup chicken stock
3 tarragon sprigs
24 canned snails, well drained
24 snail shells
2 garlic cloves, crushed
2 tablespoons finely chopped basil
 leaves
2 tablespoons finely chopped
 parsley
2 tablespoons finely chopped
 tarragon leaves
²/₃ cup butter, at room temperature

SERVES 4

PUT the wine, stock, tarragon and ¹/₂ cup water in a small saucepan and boil for 2 minutes. Add the snails and simmer for 7 minutes. Remove from the heat and allow to cool in the poaching liquid. Drain and place a snail in each shell. Preheat the oven to 400°F.

MIX TOGETHER the garlic, basil, parsley and tarragon. Mix in the butter and season well.

PUT a little garlic butter into each shell and arrange them on a snail plate or baking sheet covered with a layer of rock salt. Bake for 7–8 minutes, or until the butter melts and the snails are heated through. Serve immediately with crusty bread to mop up the garlic butter.

SNAILS WITH GARLIC BUTTER

Leaving the skin on the fish is traditional as originally whole fish would have been used for this dish. The skin also helps the pieces hold together while the soup is cooking.

Fishermen selling their morning's catch on the Quai des Belges, in the old port of Marseille.

BOUILLABAISSE

BOUILLABAISSE IS THE MOST FAMOUS FRENCH FISH SOUP AND IS ASSOCIATED WITH THE SOUTH OF THE COUNTRY, PARTICULARLY MARSEILLE. AS A FISHERMAN'S MEAL IT IS OFTEN MADE WITH WHOLE FISH, ESPECIALLY *RASCASSE* (SCORPION FISH). USING FILLETS IS MUCH SIMPLER.

ROUILLE
1 small red pepper
1 slice white bread, crusts removed
1 red chile
2 garlic cloves
1 egg yolk
1/3 cup olive oil

SOUP
18 mussels
3 lb. firm white fish fillets such
 as red mullet, bass, snapper,
 monkfish, rascasse (scorpion
 fish), John Dory or eel, skin on
2 tablespoons oil
1 fennel bulb, thinly sliced
1 onion, chopped
1 1/2 lb. ripe tomatoes
5 cups fish stock or water
pinch of saffron threads
bouquet garni
2-inch piece of orange zest

SERVES 6

TO MAKE the rouille, preheat the broiler. Cut the pepper in half, remove the seeds and membrane and place, skin side up, under the hot broiler until the skin blackens and blisters. Allow to cool before peeling away the skin. Roughly chop the pepper.

SOAK the bread in 3 tablespoons water, then squeeze dry with your hands. Put the pepper, chile, bread, garlic and egg yolk in a mortar and pestle or food processor and pound or mix together. Gradually add the oil in a thin stream, pounding or mixing until the rouille is smooth and has the texture of thick mayonnaise. Cover and refrigerate the rouille until needed.

TO MAKE the soup, scrub the mussels and remove their beards. Discard any mussels that are already open and don't close when tapped on the work surface. Cut the fish into bite-size pieces.

HEAT the oil in a large saucepan and cook the fennel and onion over medium heat for 5 minutes, or until golden.

SCORE a cross in the top of each tomato. Plunge into boiling water for 20 seconds, then drain and peel the skin away from the cross. Chop the tomatoes, discarding the cores. Add to the pan and cook for 3 minutes. Stir in the stock, saffron, bouquet garni and orange zest, bring to a boil and boil for 10 minutes. Remove the bouquet garni and either push the soup through a sieve or purée in a blender. Return to the cleaned pan, season well and bring back to a boil.

REDUCE the heat to a simmer and add the fish and mussels. Cook for 5 minutes or until the fish is tender and the mussels have opened. Throw out any mussels that haven't opened in this time. Serve the soup with rouille and bread. Or take out the fish and mussels and serve separately.

LOBSTER THERMIDOR

LOBSTER THERMIDOR WAS CREATED FOR THE FIRST NIGHT CELEBRATIONS OF A PLAY CALLED "THERMIDOR" IN PARIS IN 1894. TRADITIONALLY THE LOBSTER IS CUT IN HALF WHILE ALIVE, BUT FREEZING IT FIRST IS MORE HUMANE.

2 live lobsters
1 cup fish stock
2 tablespoons white wine
2 shallots, finely chopped
2 teaspoons chopped chervil
2 teaspoons chopped tarragon
1/2 cup butter
2 tablespoons all-purpose flour
1 teaspoon dry mustard
1 cup milk
2/3 cup Parmesan, grated

SERVES 4

PUT the lobsters in the freezer an hour before you want to cook them. Bring a large pan of water to a boil, drop in the lobsters and cook for 10 minutes. Drain and cool slightly before cutting off the heads. Cut the lobster tails in half lengthwise. Use a spoon to ease the lobster meat out of the shells and cut it into bite-size pieces. Rinse the shells, pat dry and keep for serving.

PUT the stock, wine, shallot, chervil and tarragon into a small saucepan. Boil until reduced by half and then strain.

MELT 4 tablespoons of the butter in a heavy-bottomed saucepan and stir in the flour and mustard to make a roux. Cook, stirring, for 2 minutes over low heat without allowing the roux to brown.

REMOVE from the heat and add the milk and the reserved stock mixture gradually, stirring after each addition until smooth. Return to the heat and stir constantly until the sauce boils and thickens. Simmer, stirring occasionally, for 3 minutes. Stir in half the Parmesan. Season with salt and pepper.

HEAT the remaining butter in a frying pan and fry the lobster over moderate heat for 2 minutes until lightly browned—take care not to overcook. Preheat the broiler.

DIVIDE HALF the sauce among the lobster shells, top with the lobster meat and then finish with the remaining sauce. Sprinkle with the remaining Parmesan and place under the broiler until golden brown and bubbling. Serve immediately.

Fry the lobster in butter until it is lightly browned, but take care not to overcook it or it will toughen. Spoon the lobster and sauce into the cleaned shells for serving.

Carefully remove the flesh from the lobster tails by cutting away the underside of the shells. Cook the tails by simmering on top of the sauce. To finish off, stir the lobster roe and livers into the sauce for a rich flavor.

LOBSTER A L'AMÉRICAINE

4 live lobsters
4 tablespoons olive oil
1 onion, finely chopped
4 shallots, finely chopped
1 carrot, finely chopped
1 celery stalk, finely chopped
1 garlic clove, crushed
1 lb. ripe tomatoes
2 tablespoons tomato paste
1/2 cup white wine
2 tablespoons brandy
1 cup fish stock
bouquet garni
4 tablespoons butter, softened
3 tablespoons chopped parsley

SERVES 4

PUT the lobsters in the freezer an hour before you want to use them. Cut off the lobster heads and remove the claws. Heat the oil in a large frying pan and cook the lobster heads, tails and claws in batches over moderate heat until the lobster turns bright red and the flesh begins to shrink away from the shell.

ALLOW TO cool slightly before cutting the lobster heads in half and scraping out the red roe (coral) and the yellowy livers. Keep these to add flavor to the sauce.

CUT DOWN each side of the underside of the tail, then remove the center piece of shell and carefully remove the meat from the tail.

ADD the onion and shallot to the saucepan with the lobster claws and head shells. Cook over moderate heat for 3 minutes, or until a golden brown, then add the carrot, celery and garlic and cook for 5 minutes, or until soft.

SCORE a cross in the top of each tomato. Plunge into boiling water for 20 seconds, then drain and peel the skin away from the cross. Chop the tomatoes, discarding the cores. Add the tomatoes, tomato paste, wine, brandy, fish stock and bouquet garni to the pan and bring to a boil.

ARRANGE the meat from the lobster tails on top of the sauce, cover and simmer for 5 minutes, or until the lobster is cooked.

REMOVE the tail meat, heads and claws from the sauce, cover and keep warm. Continue cooking the sauce until it has reduced by half.

MIX the reserved roe and livers with the softened butter and stir this into the sauce with the parsley. Season with salt and pepper and remove the bouquet garni. Slice the tail meat into medallions and divide among four plates. Spoon the sauce over the lobster and decorate with the claws to serve if you like.

MOULES À LA MARINIÈRE

GROWN ON WOODEN POSTS ALL ALONG THE COAST OF FRANCE, MUSSELS ARE REGIONAL TO MANY AREAS BUT ARE PARTICULARLY ASSOCIATED WITH BRITTANY, NORMANDY AND THE NORTH-EAST. THIS IS ONE OF THE SIMPLEST WAYS TO SERVE THEM.

4 lb. mussels
3 tablespoons butter
1 large onion, chopped
$1/2$ celery stalk, chopped
2 garlic cloves, crushed
$12/3$ cups white wine
1 bay leaf
2 thyme sprigs
$3/4$ cup heavy cream
2 tablespoons chopped parsley

SERVES 4

SCRUB the mussels and remove their beards. Discard any that are already open and don't close when tapped on the work surface. Melt the butter in a large saucepan and cook the onion, celery and garlic, stirring occasionally, over a moderate heat until the onion is softened but not browned.

ADD the wine, bay leaf and thyme to the saucepan and bring to a boil. Add the mussels, cover the saucepan tightly and simmer over a low heat for 2–3 minutes, shaking the saucepan occasionally. Use tongs to remove the mussels as they open, putting them into a warm dish. Throw away any mussels that haven't opened after 3 minutes.

STRAIN the liquid through a fine sieve into a clean saucepan, leaving behind any grit or sand. Bring to a boil and boil for 2 minutes. Add the cream and reheat the sauce without boiling. Season well. Serve the mussels in individual bowls with the liquid poured over. Sprinkle with the parsley and serve with plenty of bread.

Wash the mussels, taking care to discard any that are already open and don't close when tapped.

BROILED SARDINES

8 sardines
2 tablespoons olive oil
3 tablespoons lemon juice
$1/2$ lemon, halved and thinly sliced
lemon wedges

SERVES 4

SLIT the sardines along their bellies and remove the innards. Rinse well and pat dry. Use scissors to cut out the gills.

MIX TOGETHER the oil and lemon juice and season generously with salt and black pepper. Brush the inside and outside of each fish with the oil, then place a few lemon slices into each cavity.

PUT the sardines onto a preheated griddle and cook, basting frequently with the remaining oil, for about 2–3 minutes on each side until cooked through. They can also be cooked under a very hot broiler. Serve with lemon wedges.

BROILED SARDINES

MARSEILLES OLD PORT is still a thriving fishing port, even though the main fish market has now moved undercover. Fishing here is very much a local and family industry and "*Pêche le nuit, vendu le matin*" (fish the night, sell in the morning) is the saying—though in reality the men go out in the early morning, not all night. The fishing boats arrive back at the Quay des Belges at about ten in the morning, when their

SEAFOOD

BORDERED ON THREE SIDES BY WATER, THE CHOICE OF
SEAFOOD AVAILABLE IN FRANCE IS PROBABLY UNSURPASSABLE,
AND THE FRENCH CERTAINLY KNOW HOW TO EAT IT—THIS IS A
COUNTRY FAMOUS FOR ITS WONDERFUL FISH DISHES.

The seafood comes from the Mediterranean to the south, the Bay of Biscay and the Atlantic to the west and the English Channel to the northwest, as well as freshwater fish from rivers and lakes. What is not available in home waters is snapped up elsewhere, with long-distance trawlers fishing as far away as the waters of Newfoundland and Iceland.

FISH MARKETS

The fishing fleets bring their catch into *criées*, or wholesale markets, where the seafood is auctioned early in the morning and then distributed to the towns and cities before daybreak. The most important of these markets is at the channel port of Boulogne, which services Paris, and also the fishing ports of Brittany and Normandy. Some of the daily catch may also be sold on the wharf, where fishermen bring their boats alongside and sell fish that are still alive from containers running with sea water. Away from the coast, *poissonneries* and supermarkets sell fish.

REGIONAL SPECIALTIES

In the Northwest, oysters, scallops, Dublin Bay prawns, clams and whelks can all be found on Brittany and Normandy's *plateau de fruits de mer,* riches from an area that has some of France's most important fishing ports.

catch is unloaded, still wriggling, into blue trays. Usually a family member sells the catch while the fishermen clean up their boats and mend nets. As well as individual fish, mixtures of small fish are sold for frying and bonier fish for soup. The seafood, including octopus, is carried away live in plastic bags, though each stall also has a knife and chopping block, and fish can be gutted and filleted before being sold.

Brittany fleets fish for sardines and tuna, and the area also claims *lobster à l'américaine* as its own, while Normandy is famous for its *moules marinière,* stewy *marmite dieppoise* and its Dover sole, cooked as *sole normande.*

The center of the fishing industry in the North is Boulogne, which has wonderful local sole and mussels, as well as fishing boats bringing in catches from the Mediterranean to the Atlantic. Inland, freshwater trout, prepared "*au bleu*," is a specialty of Alsace-Lorraine. In the Southwest there are Atlantic tuna from the Basque ports and oysters from Bordeaux.

Sardines and anchovies are a southern favorite from Languedoc-Roussillon on the Spanish border, while Provence's Mediterranean catch, from rascasse, chapon, mullet, conger eel, sea bass to bream, is transformed into wonderful dishes such as *bouillabaisse* and *bourride.*

LOBSTER (*Homard*) there are two species, an American and European, with the European considered finer. Lobsters are usually dark-coloured when alive, then turn red when cooked.

SKATE (*Raie*) also called rays, these fish have no real bones or scales. All species can be used interchangeably. It is the sweet "wings" that are eaten, classically with a burnt butter sauce.

MUSSELS (*Moules*) grown on poles or ropes along France's coast. Buy live ones, discarding any open ones that do not close when tapped. Use small varieties for dishes like *moules marinière*.

FRITURE a mixture of small fish used for deep-frying. The smallest can be cooked whole without cleaning and eaten intact. When they are bigger, they are sold under their names.

WHELKS (*Bulots/Escargots de mer*) like a pointed snail, whelks are seawater shellfish. *Murex* are the most common variety in the south of France and are served as part of a seafood platter.

SPINY LOBSTER (*Langouste*) also called a crawfish or rock lobster, it differs from other lobsters in having no claws. Can be boiled, broiled or sautéed and used interchangeably with lobster.

OYSTERS (*Huîtres*) in France, *huîtres creuses* are crinkly Portuguese oysters while *huîtres plates* are rounder natives. The best French oysters are from Belon in Brittany and Marennes.

SQUID (*Encornet*) buy whole or as cleaned bodies or rings. Remove the insides, head and eyes before cooking, then broil or grill quickly, or stuff and braise slowly with wine and herbs.

WARTY VENUS CLAMS (*Praire*) these tasty clams have a ridged shell and can be eaten raw, steamed, cooked in wine and herbs or dipped in mayonnaise.

SEA URCHINS (*Oursins*) the tiny orange/yellow roe is all that is eaten—cut away the top with a pair of long scissors and scoop out. Eat raw or serve with scrambled eggs.

OCTOPUS (*Poulpe*) a whole octopus needs to be cleaned and skinned, then tenderized by beating. The flesh can be stewed, braised or broiled and goes well with lemon and herbs.

POISSONS DES ROCHES a mixture of rockfish sold as a kind of soup mix. Rockfish have bony bodies that are really only suitable for being cooked whole in soups and then eaten off the bones.

SOLE NORMANDE

12 shrimp
2 cups dry white wine
12 oysters, shucked
12 small button mushrooms
4 sole fillets
1 cup cream
1 truffle, thinly sliced
1 tablespoon chopped parsley

SERVES 4

PEEL and devein the shrimp. Put the wine in a deep frying pan and bring to a boil. Add the oysters to the wine and poach for 2–3 minutes, then remove with a slotted spoon, drain and keep warm. Poach the shrimp in the wine for 3 minutes, or until pink and cooked through. Take out and keep warm. Poach the mushrooms for 5 minutes, then take out and keep warm. Add the sole fillets to the poaching liquid and cook for 5 minutes, or until cooked through. Remove to a serving dish, cover and keep warm.

ADD the cream to the poaching liquid and bring to a boil. Boil until the sauce has reduced by half and thickened enough to coat the back of a spoon. Season with salt and pepper.

PUT a sole fillet on each plate and scatter with the shrimp, oysters and mushrooms, then pour the sauce over the top. Sprinkle with the sliced truffle and parsley and serve immediately.

Slash the fish in the thickest part of the body so they cook quickly and evenly and the basting liquid runs through the flesh.

GRILLED RED MULLET WITH HERB SAUCE

4 x 6 oz. red mullet
3 tablespoons lemon juice
3 tablespoons olive oil

HERB SAUCE
4 cups spinach leaves
3 tablespoons olive oil
1 tablespoon white wine vinegar
1 tablespoon chopped parsley
1 tablespoon chopped chives
1 tablespoon chopped chervil
1 tablespoon finely chopped capers
2 anchovy fillets, finely chopped
1 hard-boiled egg, finely chopped

SERVES 4

PREHEAT a griddle or barbecue. Make a couple of deep slashes in the thickest part of each fish. Pat the fish dry and sprinkle inside and out with salt and pepper. Drizzle with a little lemon juice and olive oil and cook on the griddle or barbecue for 4–5 minutes each side, or until the fish flakes when tested with the tip of a knife. Baste with the lemon juice and oil during cooking.

TO MAKE the sauce, wash the spinach and put it in a large saucepan with just the water clinging to the leaves. Cover the saucepan and steam the spinach for 2 minutes, or until just wilted. Drain, cool and squeeze with your hands to get rid of the excess liquid. Finely chop. Mix with the oil, vinegar, herbs, capers, anchovies and egg in a food processor or mortar and pestle. Spoon the sauce on a plate and place the fish on top to serve.

GRILLED RED MULLET WITH HERB SAUCE

BAKED TROUT WITH FENNEL AND CAPERS

PURISTS LIKE THEIR TROUT COOKED WITH A MINIMUM OF FUSS, PERHAPS DRESSED WITH A LITTLE BUTTER AND LEMON. THE FENNEL AND CAPERS, HOWEVER, COMPLEMENT THE TROUT PERFECTLY, THEIR FLAVORS PERMEATING THE DELICATE FLESH OF THE FISH DURING BAKING.

Stuffing the trout allows the flavors to permeate the flesh. Use the vegetables as a rack for the fish to lie on.

2 fennel bulbs, with fronds
1 leek, white part only, thickly sliced
1 large carrot, cut into sticks
2 tablespoons olive oil
2 tablespoons capers, rinsed and
 patted dry
1 shallot, finely chopped
1 x 2³/₄ lb. brown or rainbow trout,
 or 4 x 10 oz. trout, gutted and
 fins removed
1 or 2 bay leaves
2 tablespoons butter, cut into
 4 cubes
4 slices lemon
³/₄ cup fish stock
¹/₄ cup dry vermouth
2 tablespoons heavy cream
2 tablespoons chopped chervil

SERVES 4

PREHEAT the oven to 400°F. Cut off the fronds from the fennel bulbs and finely chop them. Thinly slice the bulbs and place in a roasting pan with the leek and carrot. Drizzle a tablespoon of olive oil over the vegetables, add salt and pepper and then toss well to coat them in the oil and seasoning. Bake on the middle shelf of the oven for 20 minutes.

MEANWHILE, mix the chopped fennel fronds with the capers and shallot. Season the inside of the trout and fill with the fennel and caper stuffing. Put the bay leaf, cubes of butter and the lemon slices inside the fish too. Mix together the fish stock and vermouth.

REMOVE the vegetables from the oven, stir well and reduce the oven temperature to 275°F. Lay the trout over the vegetables and pour the stock and vermouth over the fish. Season the trout and drizzle with the remaining tablespoon of olive oil. Cover the top of the pan with aluminum foil and return to the oven for 1 hour 15 minutes or until the fish is cooked through. The flesh should feel flaky through the skin and the inside will look opaque and cooked. Transfer the fish to a large serving platter.

TRANSFER the roasting pan of vegetables to the stove top and heat for a couple of minutes, until the juices bubble and reduce. Now add the cream and cook for 1 minute, then stir in the chervil and season to taste. Spoon the vegetables around the fish on the platter, pour over a little of the juice and serve the rest separately in a gravy boat.

Marseille fish market buildings.

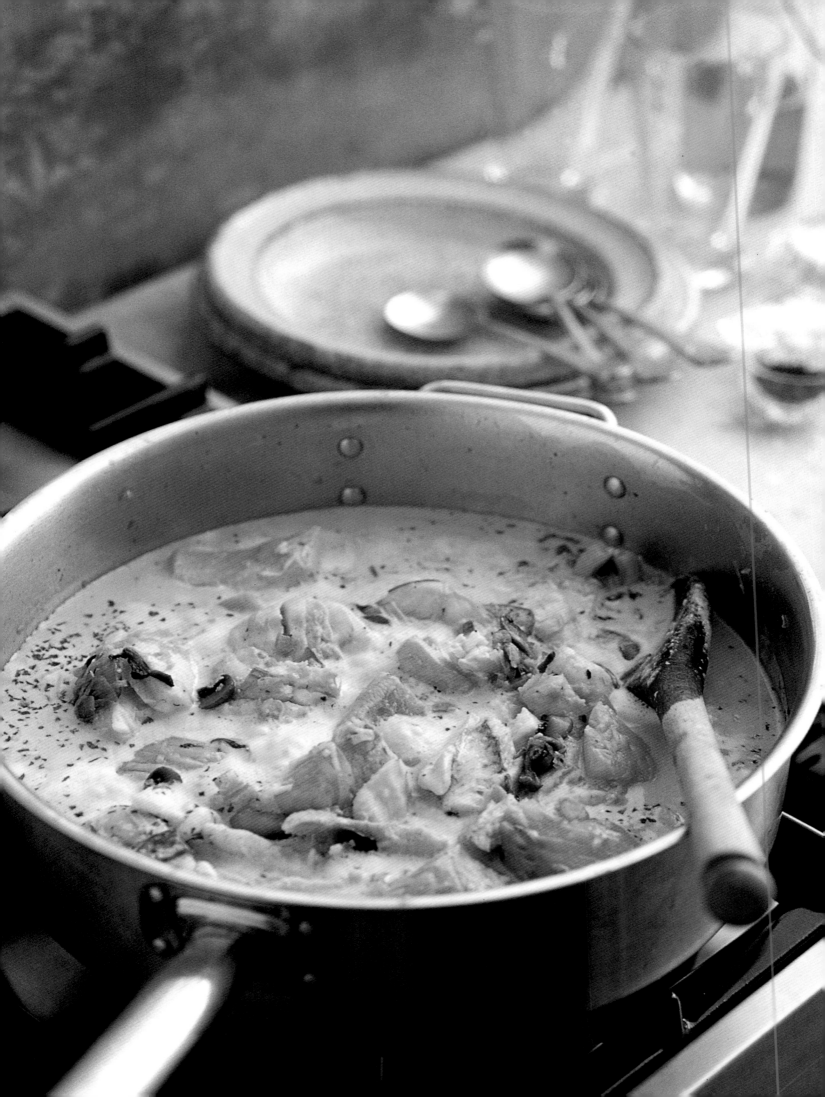

MARMITE DIEPPOISE

THIS RICH SOUPY STEW OF SHELLFISH AND FISH GIVES AWAY ITS ORIGINS IN THE NORMANDY REGION BY ITS USE OF CIDER AND CREAM. TRADITIONALLY TURBOT AND SOLE ARE USED, BUT THE SALMON ADDS A SPLASH OF COLOR.

16 mussels
12 large shrimp
1³/₄ cups cider or dry white wine
3 tablespoons butter
1 garlic clove, crushed
2 shallots, finely chopped
2 celery stalks, finely chopped
1 large leek, white part only, thinly
 sliced
3 cups small chestnut mushrooms,
 sliced
1 bay leaf
10 oz. salmon fillet, skinned and cut
 into chunks
13 oz. sole fillet, skinned and cut
 into thick strips widthwise
1¹/₄ cups heavy cream
3 tablespoons finely chopped
 parsley

SERVES 6

SCRUB the mussels and remove their beards. Throw away any that are already open and don't close when tapped on the work surface. Peel and devein the shrimp.

POUR the cider or white wine into a large saucepan and bring to a simmer. Add the mussels, cover the saucepan and cook for 3–5 minutes, shaking the saucepan every now and then. Place a fine sieve over a bowl and put the mussels into the sieve. Transfer the mussels to a plate, throwing away any that haven't opened in the cooking time. Strain the cooking liquid again through the sieve, leaving behind any grit or sand.

ADD the butter to the cleaned saucepan and melt over moderate heat. Add the garlic, shallots, celery and leek and cook for 7–10 minutes, or until the vegetables are just soft. Add the mushrooms and cook for another 4–5 minutes, until softened. While the vegetables are cooking, remove the mussels from their shells.

ADD the strained liquid to the vegetables in the saucepan, add the bay leaf and bring to a simmer. Add the salmon, sole and shrimp and cook for 3–4 minutes until the fish is opaque and the shrimp have turned pink. Stir in the cream and cooked mussels and simmer gently for 2 minutes. Season to taste and stir in the parsley.

Put the cooked mussels into a sieve and throw away any that haven't opened. Make a sauce of the vegetables and poaching liquid, then add the seafood to cook quickly at the end.

Salt cod on sale in a Paris market.

BRANDADE DE MORUE

THIS RICH GARLICKY PURÉE IS TRADITIONALLY MADE WITH *MORUE*, SALT COD PRESERVED BY THE SALT RATHER THAN BY DRYING. SALT COD IS ALSO SOLD AS BACALAO, ITS SPANISH NAME. YOU WILL HAVE TO PREPARE TWO DAYS IN ADVANCE, BECAUSE OF THE TIME NEEDED TO SOAK THE COD.

1¹/₂ lb. piece salt cod (also known as *morue*)
1¹/₄ cups olive oil
2 garlic cloves, crushed
1¹/₄ cups whipping cream
2 tablespoons lemon juice

SERVES 4

PUT the salt cod in a shallow bowl and cover with cold water. Refrigerate for 1 or 2 days, changing the water every 8 hours, to soak the salt out of the fish.

DRAIN the cod and rinse again. Put in a saucepan and cover with 8 cups water. Bring to a simmer and cook for 10 minutes (do not boil or the salt cod will toughen). Drain and rinse again.

REMOVE the skin and bones from the cod. Use a fork to flake the cod into small pieces. Make sure there are no small bones left in the cod, then finely chop in a food processor or with a sharp knife. (It will have a fibrous texture.)

HEAT ¹/₄ cup of the oil in a heavy-bottomed frying pan and cook the garlic over a low heat for 3 minutes without coloring. Add the cod and stir in a spoonful of the remaining oil. Beat in a spoonful of cream and continue adding the oil and cream alternately, beating until the mixture is smooth and has the consistency of fluffy mashed potato. Add the lemon juice and season with pepper (you won't need to add any salt). Serve warm or cold with bread or toast. Keep in the refrigerator for up to 3 days and warm through with a little extra cream before serving.

Add the cream and oil alternately, beating until the brandade has a fluffy consistency.

PIKE QUENELLES

PIKE QUENELLES ARE A SPECIALTY OF THE LYON REGION. QUENELLES ARE SMALL OVAL BALLS OF CHOPPED FISH OR MEAT, USUALLY COOKED BY POACHING. THEY CAN BE A LITTLE TRICKY TO MAKE—THE KEY LIES IN KEEPING THE MIXTURE CHILLED. IF PIKE IS UNAVAILABLE, SOLE WORKS WELL ALSO.

14 oz. pike fillet, bones and skin
 removed
2 tablespoons finely chopped
 parsley
3/4 cup milk
1/2 cup all-purpose flour
2 large eggs, lightly beaten
2/3 cup butter, softened and cubed
2 large egg whites
3/4 cup heavy cream
4 cups fish stock

SAUCE
3 tablespoons butter
1/3 cup all-purpose flour
1 2/3 cup milk
1/3 cup heavy cream
large pinch of grated nutmeg
1/2 cup Gruyère, grated

SERVES 6

POUND the fish to a paste in a mortar and pestle, or purée in a food processor. Transfer to a mixing bowl, stir in the parsley, cover and refrigerate.

PUT the milk in a saucepan and bring just to a boil. Take the saucepan off the heat and add all the flour. Return to a gentle heat and beat in the flour, then take the saucepan off the heat and allow to cool. Using electric beaters or a wooden spoon, gradually add the eggs, beating after each addition. Add the butter, piece by piece, then stir the mixture into the fish purée, cover and chill.

WHEN the mixture is very cold, put the bowl inside a larger bowl filled with ice cubes. Gradually and alternately, add the egg whites and cream, beating after each addition. Season generously, cover and chill again.

TO MAKE the sauce, melt the butter in a saucepan, then stir in the flour to make a roux. Cook, stirring constantly, for 2 minutes without allowing the roux to brown. Remove from the heat and gradually add the milk, stirring after each addition until smooth. Return to the heat and bring to a boil. Simmer for 2 minutes, add the cream and season with nutmeg, salt and pepper.

USING TWO tablespoons, mold the fish mixture into 30 egg shapes (quenelles) and put onto a buttered baking sheet and put in the refrigerator for 20 minutes. Heat the fish stock in a large frying pan until barely simmering and gently lower the quenelles into the liquid in batches. Poach for 5–7 minutes, or until the quenelles rise to the surface and feel firm to the touch. At no stage should the poaching liquid boil. Use a slotted spoon to gently place the quenelles into six lightly buttered gratin dishes. Preheat the broiler. Pour the sauce over the quenelles and sprinkle with the cheese. Broil until brown and bubbling.

Dairy herd in the Alpine foothills.

Pound the fish to a paste and then stir in the parsley.

Wrap the pieces of salmon in large circles of parchment paper as this will seal in the flavors while they bake.

SKATE WITH BLACK BUTTER

SALMON EN PAPILLOTE WITH HERB SAUCE

4 x 6 oz. salmon fillets, skinned
1 tablespoon butter, melted
8 thin slices of lemon, halved

HERB SAUCE
1/4 cup fish stock
1/3 cup dry white wine
2 shallots, finely chopped
1 cup heavy cream
4 tablespoons finely chopped herbs
 such as chervil, chives, parsley,
 tarragon or sorrel

SERVES 4

PREHEAT the oven to 400°F.

REMOVE ANY bones from the salmon fillets: you may need to use tweezers to do this. Cut out four 12-inch parchment paper circles. Fold each circle in half, then open out again and brush with melted butter. Place a salmon fillet on one half of each paper circle, lay four half slices of lemon on top, season, then fold the other half of the paper over the fish to enclose it. Seal the packages by folding the two edges of parchment paper tightly together. Put on a baking sheet and bake for 10–15 minutes (depending on the thickness of the salmon), or until the fish is firm to the touch.

TO MAKE the herb sauce, put the stock, wine and shallots in a saucepan and simmer until the mixture has reduced to a syrup (you should have about 5 tablespoons of liquid left). Add the cream and bubble for a few minutes to thicken slightly. Season and gently stir in the herbs. Serve each diner a package to unwrap at the table with the herb sauce in a separate bowl.

SKATE WITH BLACK BUTTER

COURT BOUILLON
1 cup white wine
1 onion, sliced
1 carrot, sliced
1 bay leaf
4 black peppercorns

4 x 1/2 lb. skate wings, skinned
1/3 cup unsalted butter
1 tablespoon chopped parsley
1 tablespoon capers, rinsed,
 squeezed dry and chopped

SERVES 4

TO MAKE the court bouillon, put the wine, onion, carrot, bay leaf, peppercorns and 4 cups water into a large deep frying pan, bring to a boil and simmer for 20 minutes. Strain the court bouillon and return to the cleaned frying pan.

ADD the skate and simmer for 10 minutes, or until it flakes when tested with the point of a knife. Take out the fish, drain, cover and keep warm.

HEAT the butter in a frying pan and cook over moderate heat for 2 minutes until it turns brown to make a *beurre noisette*. Remove from the heat and stir in the parsley, capers, salt and pepper.

POUR the sauce over the top of the fish and serve immediately. You can remove the fillet from each side of the fish first, if you prefer.

POULTRY, MEAT & GAME

COQ AU VIN

A DISH ALLEGEDLY PREPARED BY CAESAR WHEN BATTLING THE GAULS, WHO SENT HIM A SCRAWNY CHICKEN AS A MESSAGE OF DEFIANCE. CAESAR COOKED IT IN WINE AND HERBS AND INVITED THEM TO EAT, THUS DEMONSTRATING THE OVERWHELMING SOPHISTICATION OF THE ROMANS.

2 x 3$\frac{1}{4}$ lb. chickens
1 bottle red wine
2 bay leaves
2 thyme sprigs
8 oz. bacon, diced
4 tablespoons butter
20 pickling or pearl onions
8 oz. button mushrooms
1 teaspoon oil
$\frac{1}{4}$ cup all-purpose flour
4 cups chicken stock
$\frac{1}{2}$ cup brandy
2 teaspoons tomato paste
1$\frac{1}{2}$ tablespoons softened butter
1 tablespoon all-purpose flour
2 tablespoons chopped parsley

SERVES 8

CUT EACH chicken into eight pieces by removing both legs and cutting between the joint of the drumstick and the thigh. Cut down either side of the backbone and remove backbone. Turn the chickens over and cut through the cartilage down the center of the breastbone. Cut each breast in half, leaving the wing attached to the top half.

PUT the wine, bay leaves, thyme and some salt and pepper in a bowl and add the chickens. Cover and allow to marinate, preferably overnight.

BLANCH the bacon in boiling water, then drain, pat dry and sauté in a frying pan until a golden brown. Remove onto a plate. Melt a quarter of the butter in the pan, add the onions and sauté until browned. Take out and set aside.

MELT another quarter of the butter, add the mushrooms, season with salt and pepper and sauté for 5 minutes. Remove and set aside.

DRAIN the chickens, reserving the marinade, and pat them dry. Season. Add the remaining butter and the oil to the frying pan, add chickens and sauté until a golden brown. Stir in the flour.

TRANSFER the chickens to a large saucepan or casserole and add the stock. Pour the brandy into the frying pan and boil, stirring, for 30 seconds to deglaze the pan. Pour over the chickens. Add the marinade, onions, mushrooms, bacon and tomato paste. Cook over moderate heat for 45 minutes, or until the chickens are cooked through.

IF the sauce needs thickening, take out the chickens and vegetables and bring the sauce to a boil. Mix together the butter and flour to make a *beurre manié* and whisk into the sauce. Boil, stirring, for 2 minutes until thickened. Add the parsley and return the chickens and vegetables to the sauce.

Cooking the chicken with the skin on keeps the flesh moist.

CHICKEN WITH FORTY CLOVES OF GARLIC

THIS SOUNDS FRIGHTENINGLY OVERPOWERING BUT, AS ANYONE WHO HAS EVER ROASTED GARLIC KNOWS, THE CLOVES MELLOW AND SWEETEN IN THE OVEN UNTIL THE CREAMY FLESH THAT IS SQUEEZED FROM THE SKINS IS QUITE DIFFERENT FROM THE RAW CLOVE.

2 celery stalks, including leaves
2 rosemary sprigs
4 thyme sprigs
4 flat-leaf parsley sprigs
1 x 3^1/$_4$ lb. chicken
40 garlic cloves, unpeeled
2 tablespoons olive oil
1 carrot, roughly chopped
1 small onion, cut into 4 wedges
1 cup white wine
1 baguette, cut into slices
small herb sprigs, to garnish

SERVES 4

PREHEAT the oven to 400°F. Put a chopped celery stalk and 2 sprigs each of the rosemary, thyme and parsley into the chicken cavity. Add 6 cloves of garlic. Tie the legs together and tuck the wing tips under.

BRUSH the chicken liberally with some of the oil and season well. Scatter about 10 more garlic cloves over the bottom of a large casserole. Put the remaining sprigs of herbs, chopped celery, carrot and onion in the casserole.

PUT the chicken in the casserole. Scatter the remaining garlic cloves around the chicken and add the remaining oil and the wine. Cover and bake for 1 hour 20 minutes, or until the chicken is tender and the juices run clear when the thigh is pierced with a skewer.

TO SERVE, carefully remove the chicken from the casserole. Strain off the juices into a small saucepan. Use tongs to pick out the garlic cloves from the strained mixture. Spoon off the fat from the juices and boil for 2–3 minutes to reduce and thicken a little.

CUT the chicken into serving portions, pour over some of the juices and scatter with the garlic. Toast the baguette slices, then garnish the chicken with herb sprigs and serve with the bread to be spread with the soft flesh squeezed from the garlic.

Use a casserole into which the chicken and vegetables fit snugly so that the flavors mingle well.

CHICKEN CHASSEUR

CHASSEUR MEANS "HUNTER" AND IS USED FOR DISHES INCLUDING MUSHROOMS, SHALLOTS, TOMATOES, WINE AND BRANDY. THE NAME PROBABLY REFERS TO THE FACT THAT THIS WAS ORIGINALLY A RECIPE FOR COOKING GAME.

1 x 3$^{1}/_{4}$ lb. chicken
1 tablespoon oil
4 tablespoons butter
2 shallots, finely chopped
$^{1}/_{4}$ lb. button mushrooms, sliced
1 tablespoon all-purpose flour
$^{1}/_{2}$ cup white wine
2 tablespoons brandy
2 teaspoons tomato paste
$^{3}/_{4}$ cup chicken stock
2 teaspoons chopped tarragon
1 teaspoon chopped parsley

CROUTONS
2 slices bread
olive oil

SERVES 4

CUT the chicken into eight pieces by removing both legs and cutting between the joint of the drumstick and the thigh. Cut down either side of the backbone and remove backbone. Turn the chicken over and cut through the cartilage down the center of the breastbone. Cut each breast in half, leaving the wing attached to the top half.

HEAT the oil in a frying pan or saucepan and add half the butter. When the foaming subsides, add the chicken and sauté in batches on both sides until browned. Put on a plate and keep warm. Pour the excess fat out of the pan.

MELT the remaining butter in the pan, add the shallots and cook gently until softened but not browned. Add the mushrooms and cook, covered, over moderate heat for 3 minutes.

ADD the flour and cook, stirring constantly, for 1 minute. Stir in the white wine, brandy, tomato paste and stock. Bring to a boil, stirring constantly, then reduce the heat and add the tarragon. Season.

RETURN the chicken to the pan, cover and simmer for 30 minutes, or until the chicken is tender and cooked through. Sprinkle with parsley to serve.

TO MAKE the croutons, trim the crusts from the bread and cut the bread into moon shapes with a cookie cutter. Heat the olive oil in a frying pan and fry the bread until a golden brown. Drain the croutons on paper towels and serve hot with the chicken.

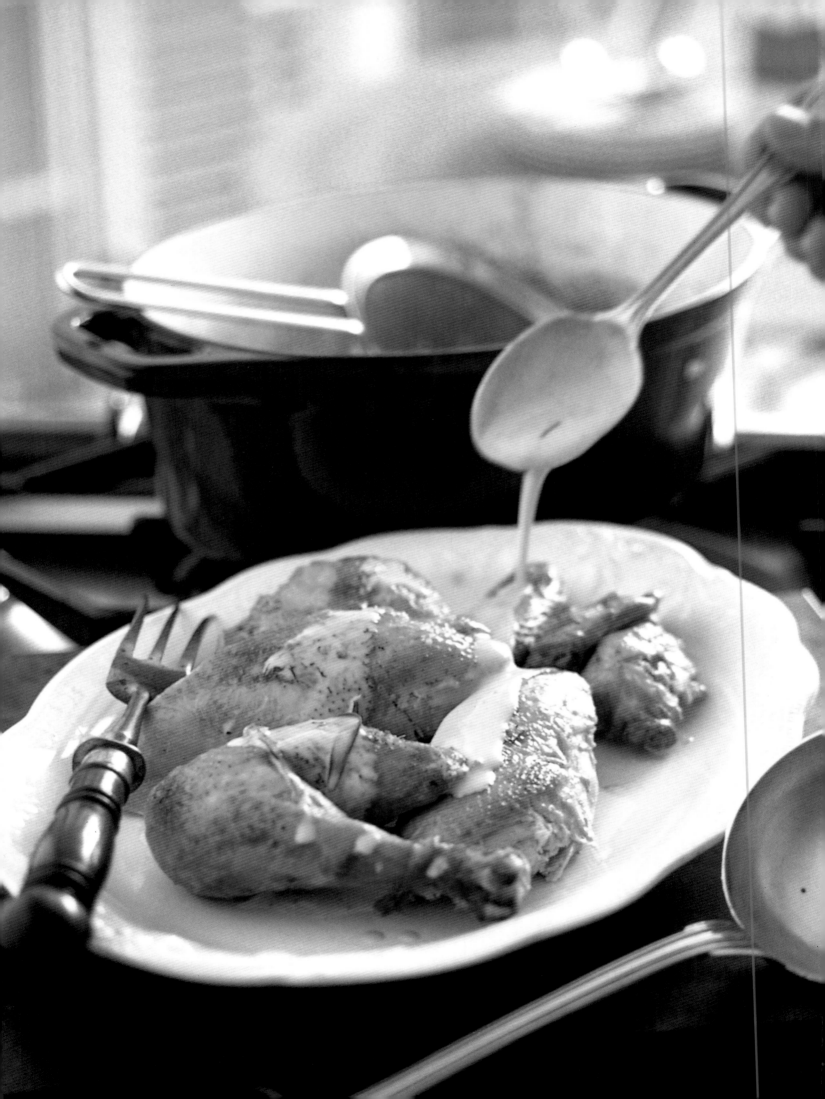

TARRAGON CHICKEN

TARRAGON HAS A DELICATE, BUT DISTINCTIVE, LICORICE FLAVOR AND IS ONE OF THE HERBS THAT GOES INTO THE FRENCH *FINES HERBES* MIXTURE. IT IS KNOWN AS A PARTICULARLY GOOD PARTNER FOR CHICKEN, WITH A TARRAGON CREAM SAUCE MAKING A CLASSIC COMBINATION.

1¹/2 tablespoons chopped tarragon
1 small garlic clove, crushed
3 tablespoons butter, softened
1 x 3¹/4 lb. chicken
2 teaspoons oil
¹/2 cup chicken stock
2 tablespoons white wine
1 tablespoon all-purpose flour
1 tablespoon tarragon leaves
¹/2 cup heavy cream

SERVES 4

PREHEAT the oven to 400°F. Mix together the chopped tarragon, garlic and half the butter. Season with salt and pepper and place inside the cavity of the chicken. Tie the legs together and tuck the wing tips under.

HEAT the remaining butter with the oil in a large casserole over low heat and brown the chicken on all sides. Add the chicken stock and wine. Cover the casserole and bake in the oven for 1 hour 20 minutes, or until the chicken is tender and the juices run clear when the thigh is pierced with a skewer. Remove the chicken, draining all the juices back into the casserole. Cover with aluminum foil and a kitchen towel and allow the chicken to rest.

SKIM a tablespoon of the surface fat from the cooking liquid and put it in a small bowl. Skim the remainder of fat from the surface and throw this away. Add the flour to the reserved fat and mix until smooth. Whisk quickly into the cooking liquid and stir over moderate heat until the sauce boils and thickens.

STRAIN the sauce into a clean saucepan and add the tarragon leaves. Simmer for 2 minutes, then stir in the cream and reheat without boiling. Season with salt and pepper. Carve the chicken and spoon the sauce over the top to serve.

Brown the chicken to seal before adding the stock and wine.

Buying cooked chickens and meat from a market rotisserie.

POULE AU POT

WHEN HENRY IV WISHED THAT ALL HIS SUBJECTS HAVE A CHICKEN FOR THEIR POT EVERY SUNDAY, THIS WAS PRESUMABLY THE MEAL HE HAD IN MIND. THE CHICKEN IS COOKED SIMPLY, SO IT IS IMPERATIVE TO USE A FREE-RANGE BIRD FOR THE BEST FLAVOR.

1 x 3^{1}/$_{4}$ lb. chicken
1 carrot, roughly chopped
1/$_{2}$ onion, halved
1 celery stalk, roughly chopped
1 garlic clove
4 parsley sprigs
2 bay leaves
8 black peppercorns
8 juniper berries
2 ham bones
1 teaspoon salt
12 baby carrots
8 baby leeks
8 baby turnips
12 small new potatoes

SERVES 4

SEASON the chicken and wrap it up in cheesecloth, securing with string. Put into a large saucepan. Tie the carrots, onion, celery, garlic, parsley, bay leaves, peppercorns and juniper berries in another piece of cheesecloth and add to the saucepan. Add the ham bones and salt, cover with cold water and bring to a simmer. Cook over very low heat for 40 minutes.

TRIM the baby vegetables, add to saucepan and cook for 10 more minutes. Take out the chicken and drain on a wire rack over a baking sheet. Cook the vegetables for another 10 minutes. Remove the skin from the chicken and carve, then serve with the vegetables. Strain the cooking liquid, discarding the ham bones, and serve as a broth to start the meal or freeze for soup stock.

Cook the chicken wrapped in cheesecloth to keep its shape.

POULET RÔTI

3 tablespoons butter, softened
1 x 3^{1}/$_{4}$ lb. chicken
1 tarragon or rosemary sprig
1^{1}/$_{4}$ cups chicken stock

SERVES 4

PREHEAT the oven to 400°F. Place half the butter inside the chicken with the tarragon or rosemary. Rub the chicken with the remaining butter and season. Tie the legs together and tuck the wing tips under. Put in a roasting pan, breast side down, and add the stock.

COVER the chicken loosely with aluminum foil and roast for 30 minutes, basting occasionally. Uncover, turn the chicken and roast for another 30–40 minutes, or until a golden brown and the juices run clear when the thigh is pierced with a skewer.

REMOVE the chicken from the pan, cover with aluminum foil and a kitchen towel and allow to rest. Put the pan on the stove top and skim off most of the fat. Boil rapidly until the juices reduce and become syrupy. Strain and serve with the chicken.

POULET RÔTI

POULET VALLÉE D'AUGE

THIS IS ONE OF THE CLASSIC DISHES OF NORMANDY AND BRITTANY, THE APPLE-GROWING REGIONS OF FRANCE. IF YOU HEAR IT REFERRED TO AS *POULET AU CIDRE*, THIS MEANS THE CHICKEN HAS BEEN COOKED IN CIDER RATHER THAN STOCK.

1 x 3¹/₄ lb. chicken
2 eating apples
1 tablespoon lemon juice
4 tablespoons butter
¹/₂ onion, finely chopped
¹/₂ celery stalk, finely chopped
1 tablespoon all-purpose flour
¹/₃ cup Calvados or brandy
1¹/₂ cups chicken stock
¹/₃ cup crème fraîche

SERVES 4

CUT the chicken into eight pieces by removing both legs and cutting between the joint of the drumstick and the thigh. Cut down either side of the backbone and remove backbone. Turn the chicken over and cut through the cartilage down the center of the breastbone. Cut each breast in half, leaving the wing attached to the top half.

PEEL and core the apples. Finely chop half of one apple and cut the rest into 12 wedges. Toss the apple in the lemon juice.

HEAT half the butter in a large frying pan. Add the chicken pieces, skin side down, and cook until golden. Turn over and cook for another 5 minutes. Remove the chicken and pour off the fat.

HEAT 1 tablespoon more butter in the same frying pan, add the onion, celery and chopped apples and fry over moderate heat for 5 minutes without browning.

REMOVE from the heat. Sprinkle the flour over the vegetables and stir in. Add the Calvados and return to the heat. Gradually stir in the chicken stock. Bring to a boil, return the chicken to the saucepan, cover and simmer gently for 15 minutes, or until the chicken is tender and cooked through.

MEANWHILE, heat the remaining butter in a small frying pan. Add the apple wedges and fry over moderate heat until browned and tender. Remove from the pan and keep warm.

REMOVE the chicken from the pan and keep warm. Skim the excess fat from the cooking liquid. Add the crème fraîche, bring to a boil and boil for 4 minutes, or until the sauce is thick enough to lightly coat the back of a wooden spoon. Season and pour over the chicken. Serve with the apple wedges.

Fry the chopped apple with the chicken and its sauce to give flavor and then fry the apple wedges separately.

POULET VALLÉE D'AUGE

DUCK BREASTS WITH CASSIS AND RASPBERRIES

"MAGRET" IS THE FRENCH NAME FOR DUCK BREAST, THE LEANEST PORTION OF THE DUCK. *MAGRET DE CANARD* IS USUALLY SERVED PINK WITH A VERY CRISPY SKIN. YOU CAN USE FROZEN RASPBERRIES FOR THIS RECIPE, BUT MAKE SURE THEY ARE THOROUGHLY DEFROSTED.

4 x 6 oz. duck breasts
2 teaspoons sea salt
2 teaspoons ground cinnamon
4 teaspoons Demerara sugar
1 cup red wine
1/2 cup crème de cassis
1 tablespoon cornstarch or
 arrowroot
1/2 lb. raspberries

SERVES 4

SCORE the duck breasts through the skin and fat but not all the way through to the meat. Heat a frying pan and fry the duck breasts, skin side down, until the skin browns and the fat runs out. Lift the breasts out of the frying pan and pour off most of the fat.

MIX TOGETHER the sea salt, cinnamon and Demerara sugar. Sprinkle over the skin of the duck breasts, then press in with your hands. Season with black pepper. Reheat the frying pan and cook the duck breasts, skin side up, for 10–15 minutes. Take them out of the frying pan and allow to rest on a carving board. Preheat the broiler.

MEANWHILE, mix together the red wine and cassis in a pitcher. Pour about 1/3 cup of the liquid into a small bowl and mix in the cornstarch or arrowroot, then pour this back into the pitcher.

POUR the excess fat out of the frying pan keeping about 2 tablespoons. Return the frying pan to the heat and pour in the red wine and cassis. Simmer for 2–3 minutes, stirring constantly, until the sauce has thickened. Add the raspberries and simmer for another minute to warm the fruit through. Check the seasoning.

BROIL the duck breasts, skin side up, for a minute, or until the sugar starts to caramelize. Slice the duck breasts thinly, pour a little sauce over the top and serve the rest separately in a gravy boat.

DUCK A L'ORANGE

DUCK CAN BE FATTY, WHICH IS WHY IT SHOULD BE PRICKED ALL OVER AND COOKED ON A RACK TO LET THE FAT DRAIN OUT. THE REASON THAT DUCK A L'ORANGE WORKS SO PERFECTLY AS A DISH IS THAT THE SWEET ACIDITY OF THE CITRUS FRUIT CUTS THROUGH THE RICH DUCK FAT.

5 oranges
1 x 4 lb. duck
2 cinnamon sticks
3/4 cup mint leaves
1/2 cup light brown sugar
1/2 cup cider vinegar
1/3 cup Grand Marnier
2 tablespoons butter

SERVES 4

PREHEAT the oven to 300°F. Halve two of the oranges and rub them all over the duck. Place them inside the duck cavity with the cinnamon sticks and mint. Tie the legs together and tie the wings together. Prick all over with a fork so that the fat can drain out as the duck cooks.

PUT the duck on a rack, breast side down, and put the rack in a shallow roasting pan. Roast for 45 minutes, turning the duck halfway through.

MEANWHILE, zest and juice the remaining oranges (if you don't have a zester, cut the orange peel into thin strips with a sharp knife). Heat the sugar in a saucepan over low heat until it melts and then caramelizes: swirl the saucepan gently to make sure it caramelizes evenly. When the sugar is a rich brown, add the vinegar (be careful as it will spatter) and boil for 3 minutes. Add the orange juice and Grand Marnier and simmer for 2 minutes.

BLANCH the orange zest in boiling water for 1 minute three times, changing the water each time. Refresh under cold water, drain and reserve.

REMOVE the excess fat from the roasting pan. Increase the oven temperature to 350°F. Spoon some of the orange sauce over the duck and roast for 45 minutes, spooning the remaining sauce over the duck every 5 to 10 minutes and turning the duck to baste all sides.

REMOVE the duck from the oven, cover with aluminum foil and strain the juices back into a saucepan. Skim off any excess fat and add the orange zest and butter to the saucepan. Stir to melt the butter. Reheat the sauce and serve over the duck.

A butcher's shop in Paris.

DUCKLING WITH TURNIPS

1 x 3³/₄ lb. duckling
bouquet garni
2 tablespoons clarified butter
1 carrot, chopped
1 celery stalk, chopped
¹/₂ large onion, chopped
2 teaspoons sugar
8 shallots
8 baby turnips
¹/₃ cup white wine
2 cups chicken stock
¹/₂ tablespoon softened butter
¹/₂ tablespoon all-purpose flour

SERVES 2

The white wine and stock in the roasting pan adds flavor and helps to keep the duckling moist.

PREHEAT the oven to 400°F and put a roasting pan in the oven to heat up. Truss the duckling by tying the legs together and tying the wing tips together behind the body. Prick all over, put the bouquet garni in the cavity and season.

HEAT the clarified butter in a large frying pan and brown the duckling on both sides. Lift the duckling out of the pan and pour all but a tablespoon of the fat into a pitcher. Add the carrot, celery and onion to the pan and soften over the heat, then brown. Remove the vegetables.

ADD ANOTHER 2 tablespoons of duck fat to the frying pan. Add the sugar and let it dissolve over low heat. Turn up the heat and add the shallots and turnips. Caramelize over high heat, then remove from frying pan. Pour in the white wine and boil, stirring, for 30 seconds to deglaze the pan.

PUT the carrot, celery and onion in the middle of the hot roasting pan, place the duckling on top and pour in the white wine and stock. Add the turnips to the pan and roast for 45 minutes. Baste well, add the shallots and roast for another 20 minutes. Baste again and roast for another 25 minutes.

TAKE OUT the duck, turnips and shallots and keep warm. Strain the sauce, pressing the chopped vegetables in the sieve to extract all the juices, then throw away the chopped vegetables.

POUR the strained sauce into a saucepan and boil rapidly to reduce by half. Mix together the butter and flour to make a *beurre manié*. Whisk into the sauce and boil, stirring, for 2 minutes until thickened.

PUT the duckling, turnips and shallots on a serving plate and pour a little sauce over them. Serve the rest of the sauce in a gravy boat.

DUCK CONFIT

A CONFIT IS THE TRADITIONAL METHOD OF PRESERVING MEAT FOR USE THROUGHOUT THE YEAR. TODAY IT IS STILL A DELICIOUS WAY TO COOK AND EAT DUCK. THE THIGHS AND LEGS ARE USUALLY PRESERVED, WITH THE BREAST BEING SERVED FRESH.

8 large duck legs
8 tablespoons coarse sea salt
12 bay leaves
8 thyme sprigs
16 juniper berries, lightly crushed
4 lb. duck or goose fat, cut into pieces

SERVES 8

PUT the duck legs in a bowl or dish in which they fit snuggly. Scatter the salt over the top, season with black pepper and tuck half the bay leaves, thyme sprigs and juniper berries into the dish. Cover and leave in the refrigerator overnight.

PREHEAT the oven to 350°F. Put the duck legs in a large roasting pan, leaving behind the herbs and any liquid that has formed in the bottom of the bowl. Add the duck or goose fat to the pan and roast for 1 hour. Reduce the oven to 300°F and roast the duck for another 2 hours, basting occasionally, until the duck is very well cooked.

WASH one large or two smaller canning jars and dry in the hot oven for 5 minutes to sterilize them. Use tongs to put the hot duck legs into the hot jar and add the remaining bay leaves, thyme sprigs and juniper berries. Strain the cooking fat through a sieve and into a large pitcher. Now pour the fat into the jar to cover the duck. Close the lid and allow to cool. The fat will solidify when cooled.

Use tongs to push the duck legs into the jars, then cover with the strained hot fat to seal.

DUCK CONFIT will keep for several months in a cool pantry or refrigerator. To use, remove as much duck as you need from the jar, returning any excess fat to cover the remaining duck. The meat can then be roasted in a very hot oven until really crisp and served with lentils, beans or salad. Or it can be used to make cassoulet.

Confit de canard is used to add richness to cassoulet.

Push a fresh tarragon sprig into each quail before cooking, so that the flavor infuses the flesh.

QUAILS WITH GRAPES AND TARRAGON

8 tarragon sprigs
8 x 5 oz. quails
2 tablespoons clarified butter
$1/2$ cup wine
$1^2/_3$ cups chicken stock
5 oz. seedless green grapes

SERVES 4

PUT a sprig of tarragon into the cavity of each quail and season well. Heat the clarified butter in a sauté pan or deep frying pan and brown the quails on all sides. Add the wine and boil for 30 seconds, then add the stock and grapes.

COVER the pan and simmer for 8 minutes or until the quails are cooked through. Lift out the quails and grapes and keep warm. Boil the sauce until it has reduced by two thirds and become syrupy. Strain the sauce and pour over the quails and grapes to serve.

PRUNE AND WALNUT-STUFFED POUSSINS

FRENCH AGEN PRUNES ARE SAID TO BE THE BEST IN THE WORLD AND THE COMBINATION OF PRUNES WITH WALNUTS IS A CLASSIC ONE, WITH BOTH THE FRUIT AND THE NUTS COMING FROM THE SAME AREA OF SOUTHWEST FRANCE.

PRUNE AND
WALNUT-STUFFED POUSSINS

STUFFING
1 tablespoon butter
4 shallots, finely chopped
1 large garlic clove, crushed
$2^1/_4$ oz. shelled walnuts, chopped
14 prunes, pitted and chopped

4 poussins (very young chickens)
4 bay leaves
4 slices bacon
3 tablespoons butter
juice of 1 small lemon
2 tablespoons honey
$1/4$ cup heavy cream or crème fraîche

SERVES 4

TO MAKE the stuffing, heat the butter in a frying pan, add the shallots and cook for 10–15 minutes. Add the garlic and cook for 1 minute. Remove the frying pan from the heat and stir in the walnuts and prunes. Season and allow to cool. Preheat the oven to 350°F.

SPOON an equal amount of stuffing into each poussin, then add a bay leaf. Tie the legs together and tuck the wing tips under. Arrange the poussins in a roasting pan and wrap a slice of bacon around each poussin breast.

PLACE the butter in a small pan with the lemon juice and honey. Melt together, then pour over the poussins. Roast, basting often, for 45 minutes, or until a skewer pushed into the center of the stuffing comes out too hot to touch.

TAKE the poussins out of the pan, cover and keep warm. Put the roasting pan on the stove top, heat until the juices bubble and stir in the cream or crème fraîche. Season the sauce, pour a little over the poussins and serve the rest separately.

VENISON WITH BLACKBERRY SAUCE

4 tablespoons clarified butter
12 pickling or pearl onions
1/4 cup blackberries or
 black currants
3 tablespoons red currant jelly
16 x 2 oz. venison medallions
1/4 cup red wine
1²/3 cups brown stock
1/2 tablespoon softened butter
1/2 tablespoon all-purpose flour

SERVES 4

HEAT half the clarified butter in a saucepan. Add the onions, cover with crumpled wet waxed paper and a lid. Cook gently for 20–25 minutes, stirring occasionally, until brown and cooked. Put the berries in a saucepan with the red currant jelly and 3 tablespoons water. Boil for 5 minutes until the fruit is softened and the liquid syrupy.

SEASON the venison, heat the remaining clarified butter in a frying pan and cook in batches over high heat for 1–2 minutes. Remove the venison and keep warm. Add the wine to the frying pan and boil for 30 seconds. Add the stock and boil until reduced by half.

MIX TOGETHER the butter and flour to make a *beurre manié* and whisk into the stock. Boil, stirring, for 2 minutes, then drain the syrup from the fruit into the stock to make a sauce. Stir well, season and serve with the venison and onions. Use the drained fruit as a garnish if you like.

Brown the venison in batches so that it fries without stewing. Drain the syrup from the fruit to add flavor to the sauce.

ROASTED PHEASANT WITH GARLIC AND SHALLOTS

1 x 2 lb. pheasant
1/2 teaspoon juniper or allspice
 berries, lightly crushed
a few parsley sprigs
2 tablespoons butter
6 slices bacon
6 shallots, unpeeled
6 garlic cloves, unpeeled
1 teaspoon all-purpose flour
1/2 cup chicken stock

SERVES 2

PREHEAT the oven to 400°F. Rub the pheasant with salt, pepper and the juniper berries. Fill the cavity with the parsley and butter, tie the legs together and tuck the wing tips under. Place in a small roasting pan and lay the bacon over the pheasant to prevent it from drying out. Scatter with the unpeeled shallots and garlic and roast for 20 minutes. Remove the bacon and roast for another 10 minutes.

REMOVE shallots, garlic and pheasant from the pan and cut off the pheasant legs. Put the legs back in the pan and cook for another 5 minutes, then remove and keep all the pheasant warm.

TO MAKE the gravy, transfer the roasting pan to the stove top. Stir in the flour and cook, stirring, for 2 minutes. Add the stock and bring to a boil, whisking constantly. Boil for 2 minutes to thicken slightly, then strain the gravy. Serve the pheasant, shallots and garlic with a little gravy poured over.

ROASTED PHEASANT WITH
GARLIC AND SHALLOTS

The easiest way to mix the venison with the marinade is to toss it together with your hands.

VENISON CASSEROLE

THIS WINTER CASSEROLE IS SERVED UP DURING THE HUNTING SEASON IN POPULAR GAME AREAS SUCH AS THE ARDENNES, AUVERGNE AND ALSACE. VENISON BENEFITS FROM BEING MARINATED BEFORE COOKING, OTHERWISE IT CAN BE A LITTLE TOUGH.

MARINADE
1/2 onion
4 cloves
8 juniper berries, crushed
8 black peppercorns, crushed
1 cup red wine
1 carrot, roughly chopped
1/2 celery stalk
2 bay leaves
2 garlic cloves
2 pieces lemon zest
5 rosemary sprigs

2 lb. venison, cubed
3 tablespoons all-purpose flour
1 tablespoon vegetable oil
1 tablespoon clarified butter
8 shallots
2 cups brown stock
2 tablespoons red currant jelly
rosemary sprigs

SERVES 4

TO MAKE the marinade, cut the half onion into four pieces and stud each piece with a clove. Mix together in a large bowl with the rest of the marinade ingredients. Add the venison, toss it well and put in the fridge overnight to marinate.

TAKE the venison out of the marinade (reserving the marinade), drain and pat dry with paper towels. Season the flour and use it to coat the venison (the cleanest way to do this is to put the flour and venison in a plastic bag and toss well).

PREHEAT the oven to 315°F. Heat the oil and clarified butter in a large casserole, brown the shallots and then remove from the casserole. Brown the venison in the oil and butter, then remove from the casserole.

STRAIN the marinade liquid through a sieve into the casserole and boil, stirring, for 30 seconds to deglaze. Pour in the stock and bring to a boil.

REMOVE the remaining marinade ingredients from the sieve onto a piece of cheesecloth and tie up in a package to make a bouquet garni. Add to the casserole with the venison. Bring the liquid to a simmer, then put the casserole in the oven. Cook for 45 minutes and then add the shallots. Cook for another 1 hour.

DISCARD the bouquet garni, remove the venison and shallots from the cooking liquid and keep warm. Add the red currant jelly to the liquid and boil on the stove top for 4–5 minutes to reduce by half. Strain the sauce and pour over the venison. Serve garnished with sprigs of rosemary.

RABBIT FRICASSÉE

THE NAME OF THE DISH COMES FROM AN OLD FRENCH WORD, *FRICASSER*, TO FRY. A FRICASSÉE IS A DISH OF WHITE MEAT, USUALLY CHICKEN, VEAL OR RABBIT, IN A VELOUTÉ SAUCE WITH EGG YOLKS AND CREAM. WILD RABBIT, IF YOU CAN GET IT, HAS A BETTER FLAVOR THAN FARMED.

4 tablespoons clarified butter
1 x 3 lb. rabbit, cut into 8 pieces
6 oz. button mushrooms
1/2 cup white wine
2/3 cup chicken stock
bouquet garni
1/3 cup oil
small bunch of sage
1/2 cup heavy cream
2 egg yolks

SERVES 4

HEAT HALF the clarified butter in a large saucepan, season the rabbit and brown in batches, turning once. Remove from the saucepan and set aside. Add the remaining butter to the saucepan and brown the mushrooms.

PUT the rabbit back into the saucepan with the mushrooms. Add the wine and boil for a couple of minutes before adding the stock and bouquet garni. Cover the saucepan tightly and simmer gently over very low heat for 40 minutes.

MEANWHILE, heat the oil in a small saucepan. Remove the leaves from the bunch of sage and drop them, a few at a time, into the hot oil. The leaves will immediately start to bubble around the edges. Cook them for 30 seconds, or until bright green and crispy. Make sure you don't overheat the oil or cook the leaves for too long or they will turn black and taste burnt. Drain the leaves on paper towels and sprinkle with salt.

TAKE the cooked rabbit and mushrooms out of the saucepan and keep warm. Discard the bouquet garni. Remove the saucepan from the heat, mix together the cream and egg yolks and stir quickly into the stock. Return to a very low heat and cook, stirring, for about 5 minutes to thicken slightly (don't let the sauce boil or the eggs will scramble). Season with salt and pepper.

TO SERVE, pour the sauce over the rabbit and mushrooms and garnish with crispy sage leaves.

While the rabbit is simmering, deep-fry the sage until crispy.

BEEF BOURGUIGNON

ALMOST EVERY REGION OF FRANCE HAS ITS OWN STYLE OF BEEF STEW, BUT BURGUNDY'S VERSION IS THE MOST WELL KNOWN. IF YOU CAN, MAKE IT A DAY IN ADVANCE TO LET THE FLAVORS DEVELOP. SERVE WITH A SALAD OF CURLY ENDIVE, CHICORY AND WATERCRESS AND BREAD OR NEW POTATOES.

If you have time, allow the beef to marinate overnight to deepen the flavors of this dish.

3 lb. beef blade or chuck steak
3 cups red wine (preferably Burgundy)
3 garlic cloves, crushed
bouquet garni
5 tablespoons butter
1 onion, chopped
1 carrot, chopped
2 tablespoons all-purpose flour
6 oz. bacon, cut into short strips
10 oz. shallots, peeled but left whole
6 oz. small button mushrooms

SERVES 6

CUT the meat into 1½-inch cubes and trim away any excess fat. Put the meat, wine, garlic and bouquet garni in a large bowl, cover with plastic wrap and put in the refrigerator for at least 3 hours and preferably overnight.

PREHEAT the oven to 315°F. Drain the meat, reserving the marinade and bouquet garni. Dry the meat on paper towels. Heat 2 tablespoons of the butter in a large casserole. Add the onion, carrot and bouquet garni and cook over low heat, stirring occasionally, for 10 minutes. Remove from the heat.

HEAT 1 tablespoon of the butter in a large frying pan over high heat. Fry the meat in batches for about 5 minutes or until well browned. Add to the casserole.

POUR the reserved marinade into the frying pan and boil, stirring, for 30 seconds to deglaze the pan. Remove from the heat. Return the casserole to a high heat and sprinkle the meat and vegetables with the flour. Cook, stirring constantly, until the meat is well coated with the flour. Pour in the marinade and stir well. Bring to a boil, stirring constantly, then cover and cook in the oven for 2 hours.

HEAT the remaining butter in the clean frying pan and cook the bacon and shallots, stirring, for 8–10 minutes or until the shallots are softened but not browned. Add the mushrooms and cook, stirring occasionally, for 2–3 minutes or until browned. Drain on paper towels. Add the shallots, bacon and mushrooms to the casserole.

COVER the casserole and return to the oven for 30 minutes, or until the meat is soft and tender. Discard the bouquet garni. Season and skim any fat from the surface before serving.

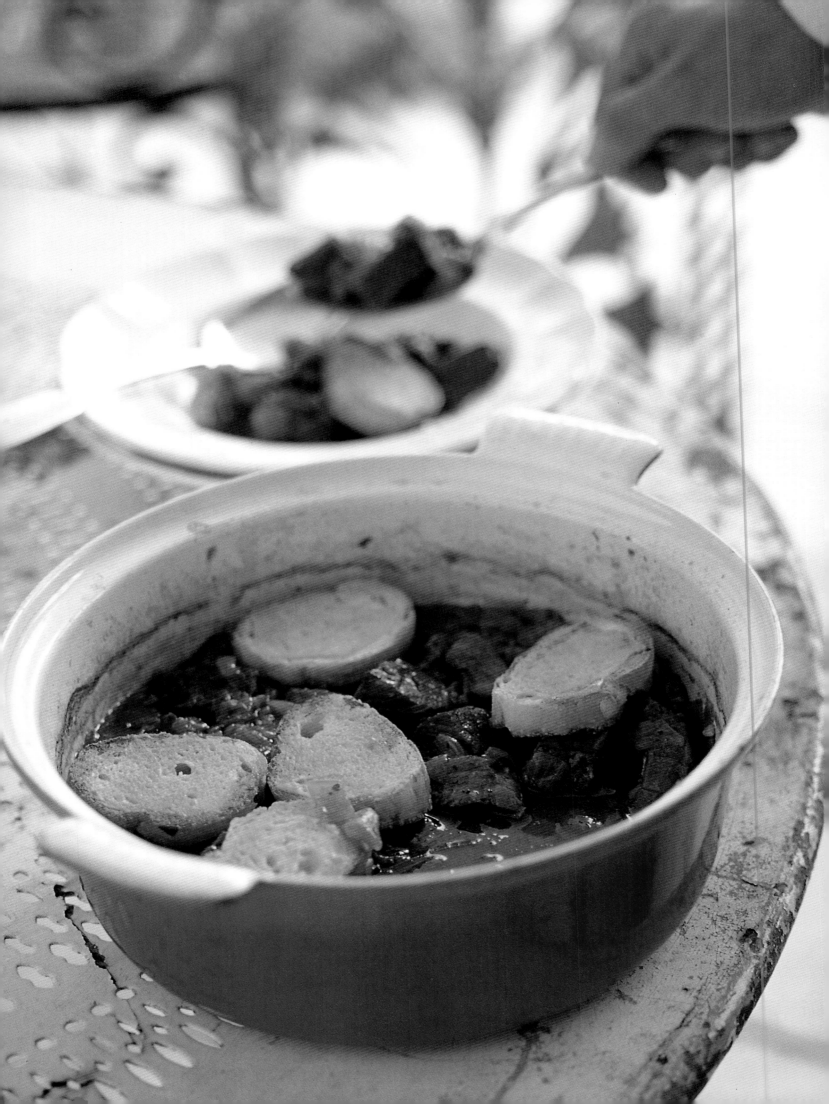

BEEF CARBONNADE

CARBONNADE A LA FLAMANDE IS, AS THE NAME IMPLIES, A FLEMISH RECIPE, BUT IT IS ALSO TRADITIONAL THROUGHOUT THE NORTH OF FRANCE. CARBONNADE MEANS "CHARCOAL COOKED" BUT THIS IS, IN FACT, A RICH OVEN-COOKED STEW OF BEEF IN BEER. DELICIOUS WITH BAKED POTATOES.

2 tablespoons butter
2–3 tablespoons oil
2 lb. lean beef rump or chuck
 steak, cubed
4 onions, chopped
1 garlic clove, crushed
1 teaspoon brown sugar
1 tablespoon all-purpose flour
2 cups beer (bitter or stout)
2 bay leaves
4 thyme sprigs

CROUTONS
6–8 slices baguette
Dijon mustard

SERVES 4

PREHEAT the oven to 300°F. Melt the butter in a large sauté pan with a tablespoon of oil. Brown the meat in batches over high heat and then remove to a plate.

ADD ANOTHER tablespoon oil to the pan and add the onions. Cook over moderate heat for 10 minutes, then add the garlic and sugar and cook for another 5 minutes, adding another tablespoon of oil if necessary. Remove the onion to a second plate.

REDUCE the heat to low and pour in any juices that have drained from the browned meat, then stir in the flour. Remove from the heat and stir in the beer, a little at a time (the beer will foam). Return to the heat and let the mixture gently simmer and thicken. Season with salt and pepper.

LAYER the meat and onion in a casserole, tucking the bay leaves and sprigs of thyme between the layers and seasoning with salt and black pepper as you go. Pour the liquid over the meat, cover with a lid and cook in the oven for 2¹/₂–3 hours, or until the meat is tender.

TO MAKE the croutons, preheat the broiler. Lightly toast the baguette on both sides, then spread one side with mustard. Arrange on top of the carbonnade, mustard side up, and place the whole casserole under the broiler for a minute.

Layer the meat and onion in the casserole, adding the herbs and seasoning between the layers, then pour the liquid over the top.

BEEF EN DAUBE

DAUBES ARE TRADITIONALLY COOKED IN SQUAT EARTHENWARE DISHES CALLED "*DAUBIÈRES*," BUT A CAST-IRON CASSEROLE WITH A TIGHT-FITTING LID WILL WORK JUST AS WELL. DAUBES HAIL FROM PROVENCE AND ARE USUALLY SERVED WITH BUTTERED MACARONI OR NEW POTATOES.

The pig's trotter (foot) will give a gelatinous texture to the daube, as well as adding extra flavor.

MARINADE
2 cloves
1 onion, cut into quarters
2 cups red wine
2 strips of orange zest
2 garlic cloves
1/2 celery stalk
2 bay leaves
a few parsley stalks

3 lb. boneless beef stew meat,
 such as blade or rump, cut into
 large pieces
2 tablespoons oil
2 oz. pork fat
1 pig's trotter (foot) or 7 oz. piece
 bacon
2 1/2 cups beef stock

SERVES 6

TO MAKE the marinade, push the cloves into a piece of onion and mix together in a large bowl with the remaining marinade ingredients. Season the beef with salt and pepper, add to the marinade and allow to marinate overnight.

HEAT the oil in a saucepan. Take the beef out of the marinade and pat dry, then brown in batches in the oil and remove to a plate. You might need to use a little of the marinade liquid to deglaze the saucepan between batches to prevent bits from sticking to the bottom of it and burning.

STRAIN the marinade through a sieve into a bowl and tip the contents of the sieve into the pan to brown. Remove from the saucepan. Add the marinade liquid to the saucepan and boil, stirring, for 30 seconds to deglaze the saucepan.

PLACE the pork fat in a large casserole, then add the pig's trotter, beef and marinade ingredients. Pour in the marinade liquid and stock. Bring to a boil, then cover, reduce the heat and simmer gently for 2–2 1/2 hours or until the meat is tender.

REMOVE the meat from the casserole to a serving dish, cover and keep warm. Discard the garlic, onion, pork fat and pig's trotter. Pour the liquid through a fine sieve and skim off as much fat as possible, then return to the casserole. Bring to a boil and boil until reduced by half and syrupy. Pour the gravy over the meat to serve.

Specialty award-winning meats for sale at a Paris butcher's shop.

BEEF A LA FICELLE

THE NAME MEANS SIMPLY "BEEF ON A STRING," WHICH DESCRIBES THE DISH VERY WELL. THE STRING ALLOWS THE PIECES OF BEEF TO BE LOWERED INTO AND REMOVED FROM THE COOKING STOCK. YOU CAN USE THE SAME METHOD TO COOK ONE LARGE PIECE OF BEEF.

1 x 1 lb. 10 oz. center-cut beef fillet
3¹/₂ cups beef stock
1 rutabaga, cut into sticks
1 carrot, cut into sticks
1 celery stalk, cut into sticks
2 potatoes, cut into chunks
¹/₄ cabbage, chopped
4 scallions, trimmed into long
 lengths
1 bay leaf
2 thyme sprigs
a few parsley sprigs

SERVES 4

TRIM the beef of any fat and sinew and cut into four even pieces. Tie each piece of beef around its circumference with kitchen string so it keeps its compact shape. Leave a long length of string attached to lower the beef in and out of the stock.

PLACE the stock in a saucepan, bring to a boil and add the vegetables and herbs. Cook over moderate heat for about 8 minutes, or until the vegetables are tender. Remove the vegetables with a slotted spoon and keep warm. Discard the herbs and skim the stock of any fat or foam that floats to the surface.

SEASON the beef with salt, then lower into the simmering stock, keeping the strings tied around the saucepan handle or a wooden spoon balanced over the saucepan. Cook for about 6 minutes for rare, or 10 minutes for medium-rare, depending on your tastes.

PLACE each piece of beef in a large shallow bowl and loop the end of the string onto the rim of the bowl. Add the cooked vegetables and ladle some of the cooking broth over the top to serve.

Tie a length of string around the beef. Leave long tails to lower the meat into the stock (tie them around the saucepan handle while you are cooking).

A Paris butcher delivers fresh meat by scooter.

STEAK AU POIVRE

4 x 6 oz. beef steaks
2 tablespoons oil
6 tablespoons black peppercorns,
 crushed
3 tablespoons butter
3 tablespoons Cognac·
1/4 cup white wine
1/2 cup heavy cream

SERVES 4

RUB the steaks on both sides with the oil and press the crushed peppercorns into the meat. Melt the butter in a large frying pan and cook the steaks for 2–4 minutes on each side, depending on how you like your steak.

ADD the Cognac and flambé by lighting the frying pan with your gas flame or a match (stand back when you do this and keep a pan lid handy for emergencies). Put the steaks on a warm plate. Add the wine to the pan and boil, stirring, for 1 minute to deglaze the pan. Add cream and stir for 1–2 minutes. Season and pour over the steaks.

Press the peppercorns firmly into the steaks, so they don't come off while you are frying.

STEAK BÉARNAISE

1 shallot, finely chopped
2 tablespoons white wine vinegar
 or tarragon vinegar
2 tablespoons white wine
3 tarragon sprigs
1 teaspoon dried tarragon
3 egg yolks
3/4 cup clarified butter, melted
1 tablespoon chopped tarragon
 leaves
4 x 6 oz. fillet steaks
1 tablespoon oil

SERVES 4

PUT the shallot, vinegar, wine, tarragon sprigs and dried tarragon in a saucepan. Bring to a boil and cook until reduced to 1 tablespoon. Remove from the heat and cool slightly.

WHISK the egg yolks with 1 1/2 tablespoons water, and add to the saucepan. Place the saucepan over very low heat or over a simmering bain-marie and continue to whisk until the sauce is thick. Do not boil or the eggs will scramble.

REMOVE the sauce from the heat, continue to whisk and slowly add the butter in a thin steady stream. Pass through a fine strainer, then stir in the chopped tarragon. Season with salt and pepper and keep warm while cooking the steaks.

RUB the steaks with the oil, season them with salt and pepper and cook for 2–4 minutes on each side, depending on how you like your steak. Serve with the sauce.

STEAK BÉARNAISE

ENTRECÔTE A LA BORDELAISE

SAUCE

3 tablespoons unsalted butter, chilled and diced
3 shallots, finely chopped
2 cups red wine (preferably Bordeaux)
1 cup brown stock
2³/4 oz. bone marrow
1 tablespoon chopped parsley

4 x 6 oz. entrecôte or sirloin steaks
1¹/2 tablespoons oil

SERVES 4

TO MAKE the sauce, melt 1 tablespoon of the butter in a saucepan, add the shallots and cook, stirring, for 7 minutes or until very soft. Pour in the wine and simmer until reduced by two-thirds. Add the stock and bone marrow and simmer until reduced by half, breaking up the marrow as it cooks.

WHISK IN the remaining pieces of butter. Season to taste with salt and pepper. Add the parsley.

TRIM and season the steaks and rub with some of the oil. Heat the remaining oil in a frying pan, and sauté the steaks for 2–4 minutes on each side, depending on how you like your steak. Pour the sauce over the top to serve.

BIFTECK HACHÉ

BIFTECK HACHÉ MEANS "CHOPPED" OR "GROUND STEAK," OTHERWISE KNOWN AS A HAMBURGER. GOOD HAMBURGERS NEED TO BE MADE WITH A TENDER MEAT BECAUSE THEY ARE COOKED QUICKLY. ADD THE SALT JUST BEFORE YOU COOK SO AS NOT TO DRAW THE MOISTURE OUT OF THE MEAT.

Bifteck haché has a better flavor and texture if you use ground steak rather than ground beef.

2 tablespoons butter
1 garlic clove, crushed
1 small onion, finely chopped
1 lb. ground lean beef steak
1 tablespoon finely chopped parsley
large pinch of grated nutmeg
1 large egg, lightly beaten
1 tablespoon oil

SERVES 4

MELT 1 tablespoon of the butter in a saucepan and gently cook the garlic and onion for 10–15 minutes, or until the onion is softened but not browned. Cool.

PUT the ground steak in a large bowl and add the onion mixture, parsley, nutmeg, beaten egg and plenty of ground black pepper. Mix together well, then divide the mixture into four and roll into four balls. Put the balls on a large plate and gently pat each one down into a burger shape. Cover and chill in the refrigerator for at least 1 hour.

MELT the remaining butter and the oil in a frying pan, slide in the burgers and season with salt. Cook for 10–12 minutes over moderate heat, turning them halfway through. The burgers should be crusty on the outside and slightly pink on the inside. Serve with salad and *frites*.

BIFTECK HACHÉ

Fold the beef tightly into the pastry package as the meat will shrink slightly when cooked.

Cattle farming is a major industry of the Alpine areas.

BEEF EN CROÛTE

FOR THIS DISH TO WORK REALLY WELL, YOU NEED TO ASK THE BUTCHER FOR A PIECE OF CENTER-CUT BEEF FILLET THAT IS AN EVEN THICKNESS ALL THE WAY ALONG. THE PASTRY CAN BE PUFF, FLAKY OR EVEN BRIOCHE DOUGH. IT IS ALSO KNOWN AS BEEF WELLINGTON.

PÂTÉ
3/4 cup butter
3 shallots, chopped
1 garlic clove, chopped
12 oz. chicken livers
1 tablespoon brandy or Cognac

1 x 2 lb. thick beef fillet
2 tablespoons drippings or butter
1 batch puff pastry (page 281)
1 egg, lightly beaten

SERVES 6

PREHEAT the oven to 425°F. To make the pâté, melt half the butter in a frying pan and add the shallots and garlic. Cook until they are softened but not browned.

REMOVE any discolored spots from the chicken livers, wash and pat dry. Add the chicken livers to the frying pan and sauté for 4–5 minutes, or until cooked but still a little pink in the middle. Let the livers cool completely and then process in a food processor with the rest of the butter and the brandy. Alternatively, push the chopped livers through a sieve and mix with the butter and brandy. Season.

TIE the beef four or five times along its length to keep its shape. Heat the drippings in a roasting pan and brown the beef on all sides, then put in the oven and roast for 20 minutes. Allow to cool and remove the string.

REDUCE the oven temperature to 400°F. Roll the pastry into a rectangle just big enough to cover the beef fillet completely. Trim the edges and keep them for decoration. Spread the pâté over the pastry, leaving a border around the edge. Brush the border with beaten egg.

LAY the fillet on the pastry and wrap it up tightly like a package, pressing the seams together firmly and tucking the ends under. Put the package, seam side down, on a baking sheet and brush all over with beaten egg. Cut pieces from the trimmings to decorate the pastry and brush with beaten egg. Bake for 25–30 minutes for rare and 35–40 minutes for medium. Allow the beef to rest for 5 minutes before carving.

PAVÉ meaning cobblestone, these are thick pieces of cured pork *saucisson sec*. The casing is made from pig's stomach and they are air-dried.

FAGOT thin, long air-dried pork *saucissons secs* that resemble the bundles of sticks they are named after. Single lengths of sausage are called batons.

CERVELAS a specialty of Lyon found on its *assiette lyonnaise*, this boiling sausage is cooked by poaching in water or red wine and is flavored with pistachio (*above*), truffle or mushroom.

BRIDE a rustic *saucisson sec* that is eaten thinly sliced. The white bloom is produced by yeast during the curing process. Eat thinly sliced with cornichons and butter.

BOUDIN BLANC an expensive northern specialty made from white pork meat or chicken, cream and seasoning. Precooked, they are heated up and often served with apples or in a cream sauce.

CONFIT DE CANARD pieces of duck that are salted, then cooked in their own fat until very tender. Used in dishes like cassoulet, goose is also traditionally prepared in this way.

JAMBON hams are produced all over France, with the most famous coming from Ardennes and Bayonne. This local ham from the South is salt-cured and sold on the bone. Eat thinly sliced.

CRÉPINE the white lacy caul-fat from pigs used to wrap packages of sausage meat such as crépinettes and caillettes. It helps keep the shape as well as baste it while it cooks.

SAUCISSE A CUIRE known as boiling sausages, these fatty sausages are usually poached. They are often served with a hot wine sauce.

JÉSUS an air-cured coarse pork and pork fat *saucisson sec* from Lyon. The name comes from the idea that the sausage looks like the swaddled baby Jesus. Eat thinly sliced.

JAMBON DE PARIS a cooked ham sold on or off the bone and unsmoked or lightly smoked. Produced all over France by artisans and commercially.

RILETTES a slow-cooked preserved meat traditionally shredded using two forks. They can be pork, goose, duck or rabbit depending on the region. Serve with bread or toast.

ARTISAN CHARCUTIERS are found selling their products in markets and charcuteries all over France, often made using traditional methods of drying, smoking and cooking. Each region has its own specialties, such as these myrtilles from Provence, many of which are not found outside the area, and are flavored with local vegetables, fruits, herbs and spices. Flavorings include garlic, though this is usually used in

CHARCUTERIE

IN FRANCE, ALMOST EVERY VILLAGE HAS A CHARCUTERIE SELLING FRESH AND AIR-DRIED SAUSAGES, HAMS AND PÂTÉS, AND THE ART OF THE ARTISAN CHARCUTIER LIVES ON IN A WEALTH OF SPECIAL LOCAL AND REGIONAL CHARCUTERIE.

Meaning literally "cured meat," the term charcuterie generally refers to cured or cooked pork products, though other meats can be used, from game and beef in sausages, to goose and duck in foie gras and pâtés. Traditionally horse and donkey meat were also used, but this is increasingly rare. Charcuterie is associated with pork more than any other meat as virtually any part of the pig can be transformed into something to eat. Pigs have traditionally been kept by rural families and slaughtered in the autumn, some meat eaten fresh and the rest made into items that could be preseved and eaten through the winter.

Charcuterie is made commercially and by artisan charcutiers all over France. In the Northeast, charcuterie from Alsace has been influenced by Germanic traditions, while the forests of the Ardennes have provided the game, such as wild boar, for hams and pâtes. The Northwest is famous for its rillettes from Tours and Vouvray, and the Southwest for its goose and duck foie gras and Bayonne ham. The East, specifically Lyon, is the acknowledged home of charcuterie and its andouillettes, Jésus, cervelas and rosettes are well known all over France. The South makes good *saucissons secs* and air-dried hams.

SAUCISSES
Saucisses, or fresh sausages, vary from the coarse pork saucisse de Toulouse to the hot dog-like saucisse de Strasbourg. Boudin noir, a kind of black pudding, and boudin

FOIE GRAS has been a great delicacy since ancient times, and in Castels in Périgord, Marc and Marcelle Boureau continue to produce it at their farm by traditional methods. Their geese are raised in warm barns where they listen to music to calm them (stressed birds do not eat or grow well), and they come outside during the day to feed and wander about. When they are from three to six months old, Marc begins the

fresh sausages rather than *saucissons secs* as it may turn rancid; caraway seeds (*carvi*), used in the charcuterie of Alsace; *quatre-épices* (cinnamon, pepper, nutmeg and cloves), added to sausages and pâtés; juniper berries (*baies de genièvre),* used to flavor game; sage (*sauge),* mixed with pork; and thyme *(thym),* added to sausages and pâtés, especially rabbit and chicken.

blanc are sausage-like charcuterie, while andouilles and andouillettes are sausages made from chitterlings or tripe. Fresh sausages are often poached rather than broiled and these *saucisses à cuire* (boiling sausages), like cervelas, are generally larger and fattier and used in dishes such as a potato salad, *choucroute garnie* or *cassoulet*.

SAUCISSONS SECS

Saucissons secs, or dried sausages, are like Italian salamis and are usually cured by air-drying. They need no cooking and are sliced and eaten cold. Most are made from pork, though some may include horse meat or beef. Spicing and flavoring vary by region and much of what is made is only sold locally. Lyon is a great center for this charcuterie, including rosettes and Jésus, and elsewhere other fine products include pork and beef saucisson d'Arles from Provence, French and German-influenced *saucissons* from Alsace, and rustic, coarse sausages, such as saucisson sec d'Auvergne, from Limousin and the Auvergne.

JAMBON

Hams have been made in France since before the Romans arrived. Jambon de Bayonne is one of the best-known *jambon cru* (raw ham), air-dried and sweet like Parma ham. Alsace and the Ardennes are famous for *jambon cru fumé* (smoked raw hams). Cooked hams are called *jambon* or *jambon cuit*.

PÂTES AND TERRINES

Originally meaning more a "pie" (now called *pâté en croûte*), pâté now refers only to the filling and is similar to a terrine. Other prepared items sold by charcuteries include *galantines*, *rillettes* and *rillons* (fried pieces of pork belly).

FOIE GRAS AND CONFITS

Fattened duck and goose livers, a specialty of southwest France, are sold on their own or made into parfait (mixed with a little chicken liver) or pâté (made with half pork pâté). Confit is made from pork, duck or goose meat cooked in its own fat and used in *cassoulet* and *garbure,* a hearty cabbage soup.

gavage, feeding them corn by hand through a funnel so that in a few weeks their liver becomes three or four times its normal size. The geese are killed on the farm and the foie gras prepared there, along with confit made from the meat by cooking it slowly in goose fat. Today, *foie gras d'oie* is increasingly rare as more farmers switch to ducks, which are less delicate to raise and take less time to fatten.

MEDALLION AUX AMANDES air-dried pork *saucisson sec* studded with almonds and pressed into a flattish shape. Eaten as part of an *assiette de charcuterie* (charcuterie plate).

TERRINE DE CAMPAGNE a cooked country terrine made from coarsely chopped pork, rabbit or game, flavored with garlic, herbs or spices. Generally made in an earthenware terrine.

SAUCISSE SÈCHE a coarse air-dried link of pork sausage set in a loop shape. A specialty of the South and usually smaller than *saucissons secs*, these garlic ones are from Provence.

JAMBON PERSILLÉ cured ham and pork shoulder set in aspic and flavored with wine, parsley and vegetables. This Burgundian specialty is thinly sliced to eat as hors d'oeuvres or on a picnic.

BOUDIN NOIR blood sausage made all over France, but a specialty of the Northwest. Often flavored with apples or chestnuts, this precooked sausage is fried or broiled before eating.

MYRTILLE coarse air-dried *saucisson sec*. It is named after bilberries (a relative of blueberries) that grow wild and are the same color as the sausage's skin.

ANDOUILLETTE made all over France, these vary regionally and can be made from calves' or pigs' intestines (chitterlings). Sold precooked, they are then fried or broiled and eaten hot.

SAUCISSE DE FRANCFORT a pork boiling sausage made in the style of hot dogs and poached before being eaten. Widely eaten all over France and used in casseroles and salads.

FROMAGE DE TÊTE "head cheese," or brawn, made from the meat of a pig's head, which is cooked and then set in a flavored aspic.

MERGUEZ a sausage originating in North Africa and made from beef, which has been adopted by the French. They are flavored with harissa and are often broiled and served with couscous.

SAUCISSON D'ARDÈCHE air-dried pork *saucisson sec* from the Ardèche flavored with garlic and wine. The wrapping implies this local sausage is an old family recipe. Eaten sliced.

ROSETTE one of France's, and especially Lyon's, great *saucissons secs*, it is made from seasoned pork and back fat in a natural case. Tied into long links, they are slightly fatter at one end.

PORK NOISETTES WITH PRUNES

PORK WITH PRUNES IS A TYPICAL DISH OF THE ORCHARD-RICH TOURAINE REGION. IT IS SOMETIMES SAID THAT THE FRENCH GENERALLY DO NOT COMBINE FRUIT WITH MEAT, SWEET FLAVORS WITH SAVORY, BUT PRUNES AND APPLES ARE BOTH ENTHUSIASTICALLY COMBINED WITH PORK.

8 pork noisettes (medallions)
 or 2 x 13 oz. pork fillets
16 prunes, pitted
1 tablespoon oil
3 tablespoons butter
1 onion, finely chopped
1/2 cup white wine
1 1/4 cups chicken or brown stock
1 bay leaf
2 thyme sprigs
1 cup heavy cream

SERVES 4

TRIM any excess fat from the pork, making sure you get rid of any membrane that will cause the pork to shrink. If you are using pork fillet, cut each fillet into four diagonal slices. Put the prunes in a small saucepan, cover with cold water and bring to a boil. Reduce the heat and simmer for 5 minutes. Drain well.

HEAT the oil in a large heavy-bottomed frying pan and add half the butter. When the butter starts foaming, add the pork, in batches if necessary, and sauté on both sides until cooked. Transfer the pork to a warm plate, cover and keep warm.

POUR OFF the excess fat from the frying pan. Melt the remaining butter, add the onion and cook over a low heat until softened but not browned. Add the wine, bring to a boil and simmer for 2 minutes. Add the stock, bay leaf and thyme and bring to a boil. Reduce the heat and simmer for 10 minutes or until reduced by half.

STRAIN the stock into a bowl and rinse the frying pan. Return the stock to the frying pan, add the cream and prunes and simmer for 8 minutes, or until the sauce thickens slightly. Put the pork back into the pan and simmer until heated through.

Sauté the pork on both sides, then keep it warm while you make the sauce.

Cervelas often contain pistachio nuts for extra flavor.

LYONNAIS SAUSAGES

3 tablespoons butter
1 lb. onions, chopped
large pinch of sugar
12 pork sausages with pistachio
 nuts (*cervelas* or *saucisses
 à cuire*)
2 tablespoons white wine vinegar
1/2 cup dry white wine
3 tablespoons finely chopped
 parsley

SERVES 6

MELT the butter in a large saucepan and add the onions and sugar, stirring to coat the onions in the butter. Cover the saucepan and cook the onions over low heat for 40–45 minutes, or until caramelized. Preheat the broiler.

PRICK the sausages and poach gently in boiling water for 15 minutes until cooked through. Drain and then broil until golden brown.

MIX TOGETHER the vinegar and wine. Increase the heat under the caramelized onions and add the vinegar and wine. Allow to bubble for a few minutes until about half of the liquid has evaporated. Stir in the parsley and taste for seasoning. Serve with the sausages.

ANDOUILLETTES

THESE TRIPE SAUSAGES ARE OFTEN BOUGHT PRE-COOKED AND DO NOT NEED TO BE BOILED. THEY CAN BE FOUND THROUGHOUT FRANCE, ALTHOUGH TYPES DO VARY A LITTLE BETWEEN REGIONS. SOME ARE MADE FROM PIG'S INTESTINES, OTHERS CONTAIN VEAL.

8 andouillettes

SERVES 4

IF YOU have bought andouillettes that are loosely wrapped rather than cased in sausage skins, slash them a couple of times across the top.

PREHEAT the broiler to moderate heat. Prick the andouillettes all over with a small skewer and arrange them in one layer on a baking sheet. Broil the sausages gently, turning them frequently until they are browned and cooked through. Serve with mashed potatoes or potato gratin and plenty of French mustard.

ANDOUILLETTES

SALT PORK WITH LENTILS

IT IS THOUGHT THAT THE DRY CLIMATE AND VOLCANIC SOIL AROUND THE TOWN OF LE PUY-EN-VELAY

IN THE AUVERGNE IS THE LUCKY COMBINATION THAT PRODUCES THE REGION'S SUPERIOR GREEN

LENTILS. THEY ARE MORE EXPENSIVE THAN OTHER VARIETIES, BUT HAVE A SUPERB FLAVOR.

2 lb. salt pork belly, cut into thick
 strips
1 small salt pork knuckle
1 large carrot, cut into chunks
1/4 lb. rutabagas or turnips, peeled
 and cut into chunks
1 cup leeks, white part only, thickly
 sliced
1 parsnip, cut into chunks
1 onion, studded with 4 cloves
1 garlic clove
bouquet garni
2 bay leaves
6 juniper berries, slightly crushed
11 oz. Puy lentils
2 tablespoons chopped parsley

SERVES 6

DEPENDING ON the saltiness of the pork you are using, you may need to soak it in cold water for several hours or blanch it before using. Ask your butcher whether to do this.

PUT the pork in a large saucepan with all the ingredients except the lentils and parsley. Stir thoroughly, then add just enough water to cover the ingredients. Bring to a boil, then reduce the heat, cover the saucepan and allow to simmer gently for 1¼ hours.

PUT the lentils in a sieve and rinse under cold running water. Add to the saucepan and stir, then replace the lid and simmer for another 45–50 minutes, or until the pork and lentils are tender.

DRAIN the saucepan into a colander, discarding the liquid. Return the contents of the colander to the saucepan, except for the whole onion which can be thrown away. Season the pork and lentils with plenty of black pepper, and taste to see if you need any salt. Stir in the parsley.

Use a saucepan large enough to fit all the ingredients comfortably. Unlike other varieties, Puy lentils keep their shape when cooked.

Braise the red cabbage slowly to bring out the sweetness.

PORK CHOPS WITH BRAISED RED CABBAGE

BRAISED RED CABBAGE
2 tablespoons clarified butter
1 onion, finely chopped
1 garlic clove, crushed
1 small red cabbage, shredded
1 eating apple, peeled, cored and
 finely sliced
1/3 cup red wine
1 tablespoon red wine vinegar
1/4 teaspoon ground cloves
1 tablespoon finely chopped sage

1 tablespoon clarified butter
4 x 6 oz. pork chops, trimmed
1/3 cup white wine
12/3 cups chicken stock
3 tablespoons heavy cream
11/2 tablespoons Dijon mustard
4 sage leaves

SERVES 4

TO BRAISE the cabbage, put the clarified butter in a large saucepan, add the onion and garlic and cook until softened but not browned. Add the cabbage, apple, wine, vinegar, cloves and sage and season with salt and pepper. Cover the saucepan and cook for 30 minutes over very low heat. Uncover the saucepan and cook, stirring, for another 5 minutes to evaporate any liquid.

MEANWHILE, heat the clarified butter in a frying pan, season the pork chops and brown well on both sides. Add the wine and stock, cover and simmer for 20 minutes, or until the pork is tender.

REMOVE the chops from the frying pan and strain the liquid. Return the liquid to the frying pan, bring to a boil and cook until reduced by two-thirds. Add the cream and mustard and stir over very low heat without allowing it to boil, until the sauce has thickened slightly. Pour over the pork chops and garnish with sage. Serve with the red cabbage.

PORK CHOPS WITH CALVADOS

2 tablespoons butter
2 eating apples, cored, each cut
 into 8 wedges
1/2 teaspoon sugar
11/2 tablespoons oil
4 x 6 oz. pork chops, trimmed
3 tablespoons Calvados
2 shallots, finely chopped
1 cup dry cider
1/2 cup chicken stock
1/2 cup heavy cream

SERVES 4

MELT half the butter in a frying pan, add the apples and sprinkle with the sugar. Cook over low heat, turning occasionally, until tender and glazed.

HEAT the oil in a frying pan and sauté the pork chops until cooked, turning once. Pour the excess fat from the pan, add the Calvados and flambé by lighting the pan with your gas flame or a match (stand back when you do this and keep a pan lid handy for emergencies). Transfer the pork to a plate and keep warm.

ADD the remaining butter to the pan and cook the shallots until soft but not brown. Add the cider, stock and cream and bring to a boil. Reduce the heat and simmer for 15 minutes, or until reduced enough to coat the back of a spoon.

SEASON the sauce, add the pork and simmer for 3 minutes to heat through. Serve with the apples.

PORK CHOPS WITH CALVADOS

BLANQUETTE DE VEAU

BLANQUETTES ARE USUALLY SERVED WITH PLAIN WHITE RICE OR BOILED NEW POTATOES. THEY CAN VARY FROM REGION TO REGION, BUT THIS ONE WITH MUSHROOMS AND ONIONS AND A SAUCE THICKENED WITH CREAM AND EGGS IS A CLASSIC RECIPE.

1 lb. 10 oz. boneless veal shoulder, cut into 1¹/₄ inch cubes
4 cups brown stock
4 cloves
¹/₂ large onion
1 small carrot, roughly chopped
1 leek, white part only, roughly chopped
1 celery stalk, roughly chopped
1 bay leaf
2 tablespoons butter
4 tablespoons all-purpose flour
1 tablespoon lemon juice
1 egg yolk
¹/₄ cup heavy cream

ONION GARNISH
¹/₂ lb. pickling or pearl onions
1 tablespoon butter
1 teaspoon superfine sugar

MUSHROOM GARNISH
1 tablespoon butter
2 teaspoons lemon juice
5 oz. button mushrooms, trimmed

SERVES 6

PUT the veal in a large saucepan, cover with cold water and bring to a boil. Drain, rinse well and drain again. Return to the saucepan and add the stock. Press the cloves into the onion and add to the saucepan with the remaining vegetables and bay leaf.

BRING to a boil, reduce the heat, cover and simmer for 40–60 minutes, or until the veal is tender. Skim the surface occasionally. Strain, reserving the cooking liquid and throwing away the vegetables. Keep the veal warm.

TO MAKE the onion garnish, put the onions in a small saucepan with enough water to half cover them. Add the butter and sugar. Place a crumpled piece of waxed paper directly over the onions. Bring to a simmer and cook over low heat for 20 minutes, or until the water has evaporated and the onions are tender.

TO MAKE the mushroom garnish, half-fill a small pan with water and bring to a boil. Add the butter, lemon juice and mushrooms and simmer for 3 minutes, or until the mushrooms are tender. Drain the mushrooms, discarding the liquid.

HEAT the butter in a large saucepan. Stir in the flour to make a roux and cook, stirring, for 3 minutes without allowing the roux to brown. Remove from the heat and gradually add the cooking liquid from the veal, stirring each time you add, until the mixture is smooth. Return to the heat and whisk until the sauce comes to a boil, then reduce the heat to low and simmer for 8 minutes, or until the sauce coats the back of the spoon.

ADD the lemon juice and season well. Quickly stir in the egg yolk and cream, then add the veal and the onion and mushroom garnishes. Reheat gently, without boiling, to serve.

Strain the cooking liquid from the veal and then use to give flavor to the velouté sauce.

Weekly markets offer commercial and homegrown produce.

ROAST VEAL STUFFED WITH HAM AND SPINACH

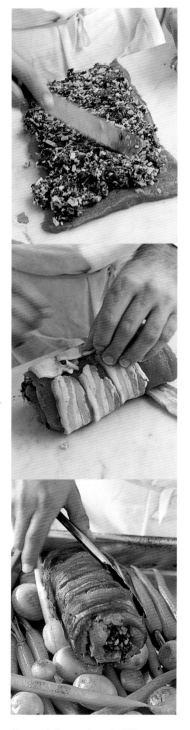

1/2 lb. spinach leaves
2 garlic cloves, crushed
2 tablespoons finely chopped
 parsley
2 teaspoons Dijon mustard
3 1/2 oz. ham on the bone, diced
finely grated zest of 1 lemon
1 x 1 1/4 lb. piece boneless veal loin
 or fillet, beaten with a meat mallet
 to measure 12 x 6 inches (ask
 your butcher to do this)
4 slices bacon
2 tablespoons olive oil
3 tablespoons butter
16 baby carrots
8 small potatoes, unpeeled
8 shallots
3/4 cup dry (*Sercial*) Madeira

SERVES 4

PREHEAT the oven to 325°F. Wash the spinach and put in a large saucepan with just the water clinging to the leaves. Cover the saucepan and steam the spinach for 2 minutes or until just wilted. Drain, cool and squeeze dry with your hands. Chop and mix with the garlic, parsley, mustard, ham and lemon zest. Season well.

SPREAD the spinach filling over the center of the piece of veal. Starting from one of the shorter sides, roll up like a jelly roll. Wrap the slices of bacon over the meat and season well. Tie with string several times along the roll to secure the bacon and make sure the roll doesn't unravel.

HEAT the olive oil and half of the butter in a large frying pan and add the carrots, potatoes and shallots. Briefly brown the vegetables and then transfer to a roasting pan. Brown the veal package on all sides, then place on top of the vegetables. Add 4 tablespoons of the Madeira to the frying pan and boil, stirring, for 30 seconds to deglaze the pan. Pour over the veal.

ROAST the meat for 30 minutes, then cover the top with aluminum foil to prevent from over-browning. Roast for another 45–60 minutes or until the juices run clear when you pierce the thickest part of the meat with a skewer. Wrap the meat in aluminum foil and allow to rest. Test the vegetables and return to the oven for a while if they're not yet tender. Remove them from the pan.

PLACE the roasting pan over moderate heat and add the rest of the Madeira. Allow it to bubble, then add the rest of the butter and season the sauce to taste. Slice the veal thickly and arrange the slices of meat on top of the vegetables. Pour over some of the Madeira sauce and serve the rest separately in a gravy boat.

Spread the spinach filling over the piece of veal, then roll up like a jelly roll. Tie with string to keep the bacon slices in place and prevent the veal from unrolling.

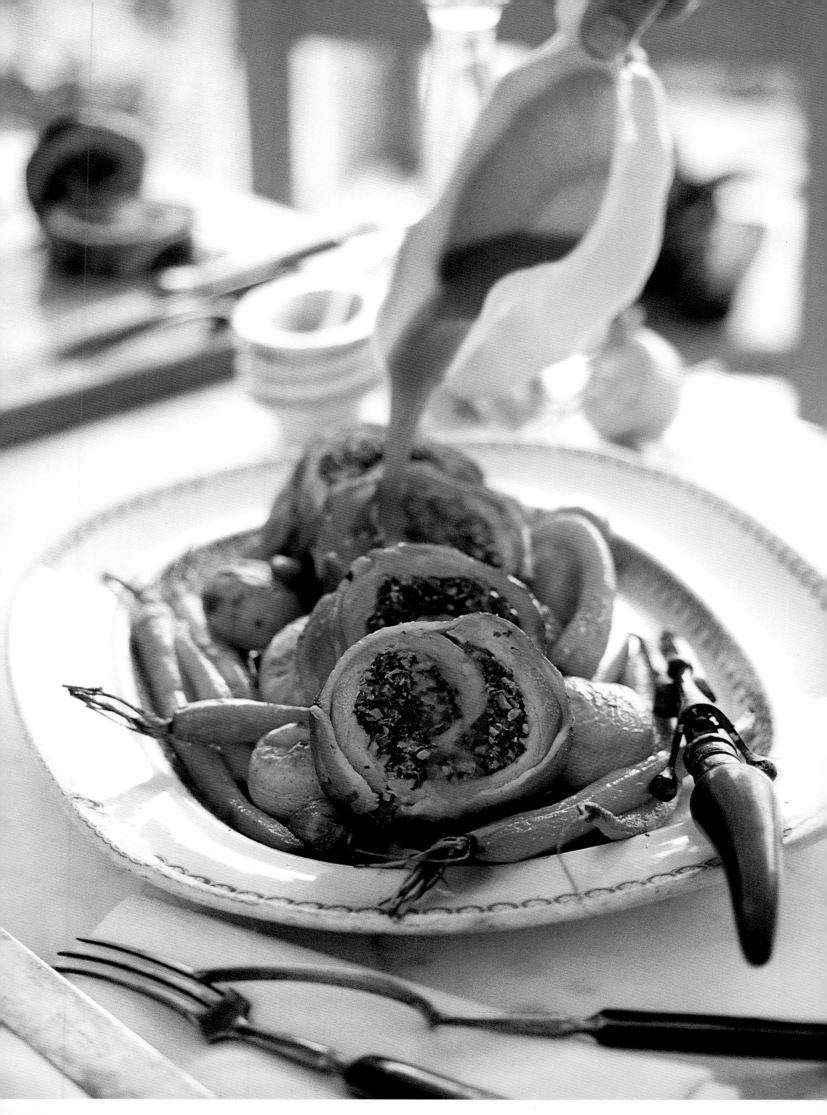

ROAST LEG OF LAMB WITH SPRING VEGETABLES

A POPULAR MEAT IN FRANCE, LAMB COMES IN VARIOUS GUISES. IN SOME AREAS IT FEEDS ON LUSH GRASSLANDS AND, IN OTHERS, ON WILD HERBS. IN NORMANDY, PICARDIE AND BORDEAUX, FLAVORSOME PRE-SALÉ LAMBS FEED ON SALT MARSHES AND ARE OFTEN SERVED WITHOUT ADDED FLAVORINGS.

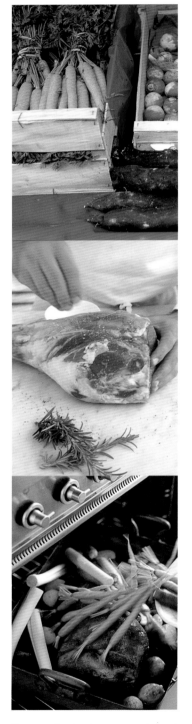

Season the lamb generously and roast with just the rosemary and garlic for 20 minutes. Add the vegetables in stages, depending on how long they take to cook.

1 x 4 lb. leg of lamb
3 rosemary sprigs
6 garlic cloves, unpeeled
1 lb. small potatoes, halved
1/2 lb. baby carrots
6 small leeks
1/2 lb. small zucchini
1 1/2 tablespoons all-purpose flour
1/2 cup red wine
2/3 cup brown stock

SERVES 6

PREHEAT the oven to 400°F. Rub the lamb all over with salt and pepper. Put the lamb in a roasting pan, lay the rosemary sprigs on top and scatter the garlic around the lamb. Roast for 20 minutes, then turn the lamb over.

ADD the potatoes to the roasting pan and toss in the lamb fat, then return to the oven for another 15 minutes. Turn the lamb again and cook for another 15 minutes.

ADD the baby carrots and leeks to the pan, toss with the potatoes in the lamb fat and turn the lamb again. Roast for 15 more minutes, then add the zucchini. Toss all the vegetables in the lamb fat and turn the leg of lamb again.

ROAST for another 15 minutes, then take the lamb out of the roasting pan to rest. The lamb will be rare—if you prefer, cook it for another 5–10 minutes. Remove the vegetables and garlic from the pan and keep warm.

TO MAKE the gravy, spoon the fat from the surface of the meat juices. Place the roasting pan over moderate heat on the stove top and stir in the flour to make a roux. Cook, stirring, for 2 minutes, then gradually stir in the wine and stock. Boil the gravy for 2 minutes, then strain into a gravy boat.

CARVE the lamb and serve with the spring vegetables and garlic. Serve the gravy separately.

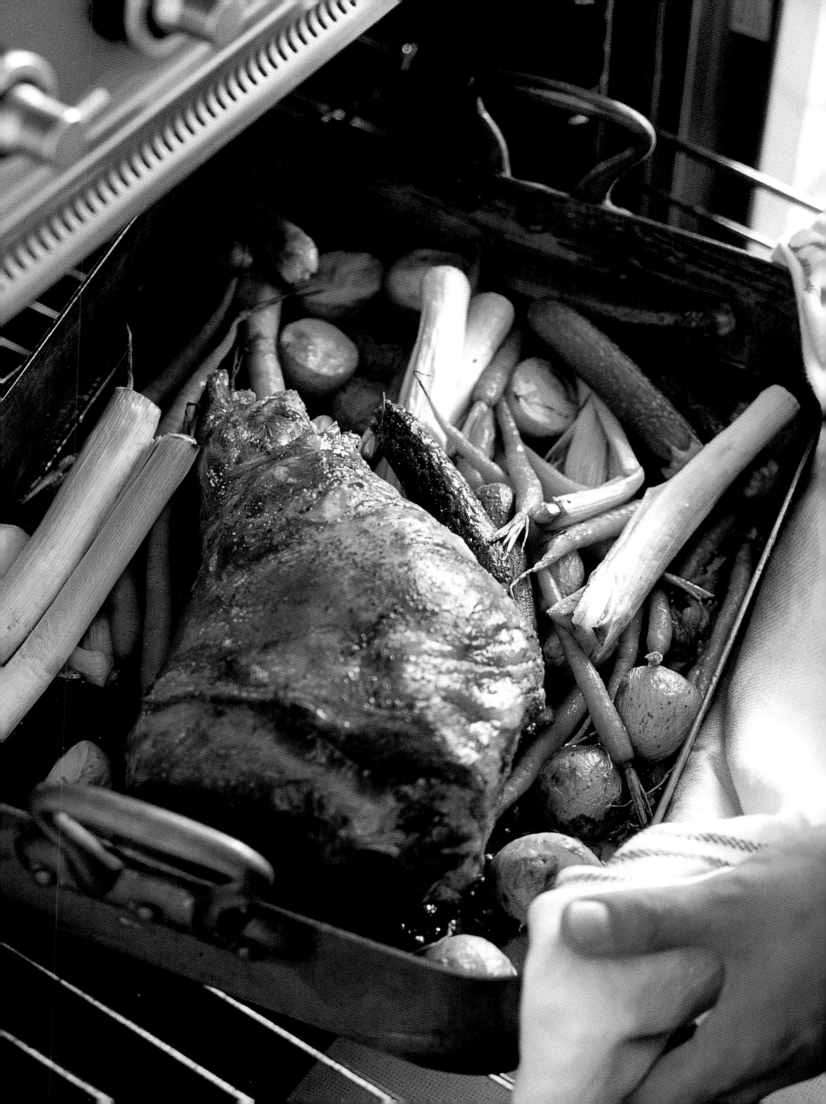

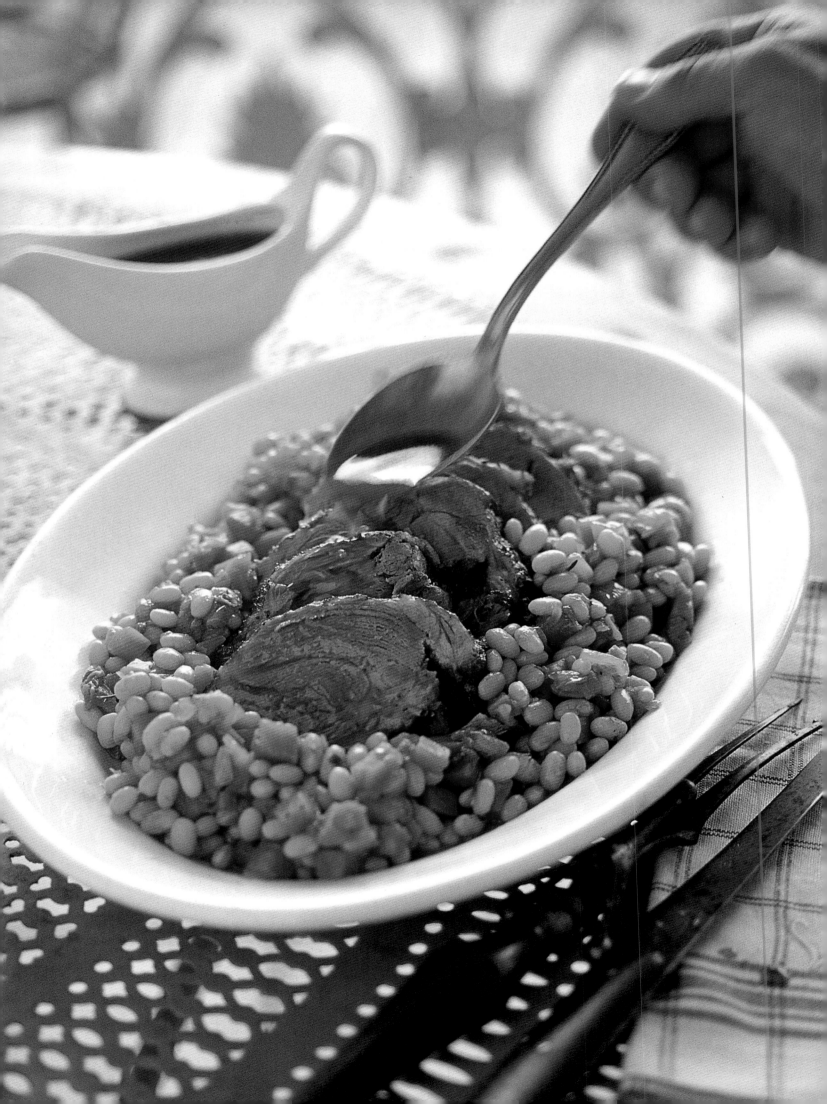

LAMB BRAISED WITH BEANS

2/3 cup dried haricot (white) beans
1 x 2 lb. boned shoulder of lamb,
 tied with string to keep its shape
2 tablespoons clarified butter
2 carrots, diced
2 large onions, chopped
4 garlic cloves, unpeeled
bouquet garni
1 cup dry red wine
1 cup brown stock

SERVES 4

PUT the beans in a large bowl and cover with plenty of water. Allow to soak for 8–12 hours, then drain. Bring a large saucepan of water to a boil, add the beans and return to a boil. Reduce the heat to moderate and cook the beans, partially covered, for 40 minutes. Drain well.

RUB the lamb all over with salt and pepper. Heat the butter over high heat in a large casserole with a tight-fitting lid. Add the lamb and cook for 8–10 minutes, turning every few minutes until well browned. Remove the lamb.

REHEAT the casserole over high heat and add the carrots, onions, garlic and bouquet garni. Reduce the heat and cook, stirring, for 8–10 minutes or until softened. Increase the heat to high and pour in the wine. Boil, stirring, for 30 seconds to deglaze the casserole, then return the lamb to the casserole. Add the stock.

BRING TO a boil, then cover and reduce the heat to low. Braise the meat for 1¹/₂ hours, turning twice. If the lid is not tight fitting, cover the casserole with aluminum foil and then put the lid on top.

ADD the cooked beans to the lamb and return to a boil over high heat. Reduce the heat to low, cover the casserole again and cook for another 30 minutes.

TAKE the lamb out of the casserole, cover and allow to rest for 10 minutes before carving. Discard the bouquet garni. Skim the excess fat from the surface of the sauce and, if the sauce is too thin, boil over high heat for 5 minutes or until thickened slightly. Taste for seasoning. Carve the lamb and arrange on a platter. Spoon the beans around the lamb and drizzle with the gravy. Serve the rest of the gravy separately.

Use the same casserole to brown the lamb, to soften the vegetables and then braise the meat. This will help to strengthen the flavor of the dish.

Fruit delivery at Saint-Rèmy produce shop.

Brown the lamb in a couple of batches so that you don't lower the temperature by overcrowding. Once all the meat is browned and coated with flour, slowly stir in the stock.

NAVARIN A LA PRINTANIÈRE

NAVARIN A LA PRINTANIÈRE IS TRADITIONALLY MADE TO WELCOME SPRING AND THE NEW CROP OF YOUNG VEGETABLES. NAVARINS, OR STEWS, CAN ALSO BE MADE ALL YEAR ROUND, USING OLDER WINTER ROOT VEGETABLES SUCH AS POTATOES, CARROTS AND TURNIPS.

2 lb. lean lamb shoulder
2 tablespoons butter
1 onion, chopped
1 garlic clove, crushed
1 tablespoon all-purpose flour
2 cups brown stock
bouquet garni
18 baby carrots
8 large-bulb scallions
6 oz. baby turnips
6 oz. small potatoes
1 cup peas, fresh or frozen

SERVES 6

TRIM the lamb of any fat and sinew and then cut it into bite-size pieces. Heat the butter over high heat in a large casserole. Brown the lamb in two or three batches, then remove from the casserole.

ADD the onion to the casserole and cook, stirring occasionally, over moderate heat for 3 minutes or until softened but not browned. Add the garlic and cook for another minute or until aromatic.

RETURN the meat and any juices to the casserole and sprinkle with the flour. Stir over high heat until the meat is well coated and the liquid is bubbling, then gradually stir in the stock. Add the bouquet garni and bring to a boil. Reduce the heat to low, cover the casserole and cook for 1¼ hours.

TRIM the carrots, leaving a little bit of green stalk, and do the same with the scallions and baby turnips. Cut the potatoes in half if they are large.

ADD the vegetables to the casserole, bring to a boil and simmer, covered, for 15 minutes or until the vegetables are tender. (If you are using frozen peas, add them right at the end so they just heat through.) Season with plenty of salt and pepper before serving.

LAMB STUFFED WITH COUSCOUS AND ALMONDS

THE ALMONDS GIVE THIS STUFFING A LOVELY CRUNCHY TEXTURE. WHEN YOU BUY THE MEAT, BE SURE
TO TELL THE BUTCHER YOU ARE INTENDING TO STUFF THE LAMB AND YOU WILL NEED THE HOLE IN
THE MEAT TO BE FAIRLY LARGE. SERVE WITH BOULANGÈRE POTATOES.

$1/3$ cup olive oil
1 small red pepper
1 small yellow pepper
$1/4$ cup whole blanched almonds
1 small onion, chopped
4 garlic cloves
4 oz. eggplant, diced
$14^1/2$ oz. can diced tomatoes
pinch of sugar
1 tablespoon thyme leaves
2 teaspoons capers, rinsed and
 squeezed dry
8 black olives, pitted and finely
 chopped
$1/4$ cup couscous
1 x 3 lb. butterflied leg of lamb
$1/2$ small onion

GRAVY
1 tablespoon all-purpose flour
1 teaspoon tomato paste
$1^1/4$ cups brown stock
$1/3$ cup red wine

SERVES 6

PREHEAT the oven to 400°F. Rub 1 tablespoon of
oil over the peppers and roast for 40–45 minutes,
or until blackened. Cool, then peel the peppers
and cut into long thin strips.

LIGHTLY TOAST the almonds in a dry frying pan,
then chop. Heat 1 tablespoon of oil in the pan and
cook the onion until softened. Crush 2 garlic
cloves, add to the onion and cook for 5 minutes.
Add 2 tablespoons of oil and the eggplant and
cook for 10 minutes. Add the tomato and sugar
and simmer until fairly dry. Remove from the heat
and mix in the thyme, capers and olives. Cool.

POUR $1/3$–$1/2$ cup boiling water onto the
couscous. Let sit for 5 minutes, then fluff the
grains with a fork. Add the couscous, peppers and
almonds to the eggplant mixture and season well.

INCREASE the oven to 450°F. Push as much
stuffing as you can into the cavity of the lamb.
(Put any leftover stuffing in a flameproof dish.) Fold
the meat over the stuffing at each end and secure
with skewers. Put the remaining cloves of garlic
and the half onion in a roasting pan and place the
lamb on top. Roast for 30 minutes, then reduce
the oven to 350°F and cook for $1^1/2$ hours
(cover with aluminum foil if lamb appears to be
over-browning). Bake any extra stuffing for the
last 20 minutes.

TO MAKE the gravy, remove the meat from the
pan, cover and allow to rest. Strain off all but
2 tablespoons of the fat from the pan, then place
over moderate heat. Stir in the flour and tomato
paste and gradually add the stock, stirring. Add
the wine slowly, stirring until the gravy reaches the
consistency you like. Season well. Slice the meat
and serve with the gravy and any extra stuffing.

The couscous and almond filling
should be fairly dry. Pack as
much as you can into the lamb
and cook the rest separately.

POT AU FEU

THE SIMPLICITY OF THIS DISH OF BOILED MEAT AND VEGETABLES MEANS YOU NEED TO USE THE VERY BEST QUALITY INGREDIENTS. REGIONAL RECIPES VARY, BUT POT AU FEU IS USUALLY SERVED WITH THE MEATS SLICED AND THE BROTH IN A SEPARATE BOWL.

1 tablespoon oil
1 celery stalk, roughly chopped
2 carrots, roughly chopped
$1/2$ onion, roughly chopped
$1^{3}/_{4}$ lb. beef shank with
 marrowbone
$1^{3}/_{4}$ lb. piece beef chuck
2 bay leaves
4 thyme sprigs
a few parsley stalks
10 peppercorns
$1^{3}/_{4}$ lb. beef short ribs

VEGETABLE GARNISH
1 large celery stalk
11 oz. small potatoes
10 oz. baby carrots, green tops
 trimmed
6 oz. baby turnips
11 oz. baby leeks

Dijon mustard and coarse sea salt,
 to serve

SERVES 4

While the pot au feu simmers, skim away the fat and foam that float to the surface.

HEAT the oil in a heavy-bottomed frying pan and cook the chopped celery, carrots and onion over moderately high heat for 10 minutes, or until they are browned.

REMOVE the meat from the beef shank and reserve the marrowbone. Tie the beef chuck with string so it looks like a package.

PUT 12 cups water in a large saucepan and bring to a boil. Add the browned vegetables, herbs, peppercorns, beef shank meat, ribs, and beef chuck to the saucepan. Return to a boil and skim off any fat that floats to the surface. Reduce the heat, and simmer for 2–$2^{1}/_{2}$ hours, or until the meat is very tender.

GENTLY REMOVE the meat to a clean saucepan and strain the cooking liquid over it. Throw away the vegetables. Season the meat with salt and pepper, add the marrowbone and simmer over moderate heat for about 10 minutes. Remove the marrowbone, gently push the marrow out of the bone and slice into six pieces.

MEANWHILE, to make the vegetable garnish, cut the celery into 2 inch lengths, then cut each piece in half lengthwise. Cook the potatoes in salted boiling water for 10 minutes, or until tender to the point of a knife, then drain. Add the celery, carrots, turnips and leeks to the meat and cook for 7 minutes. Add the potatoes and cook for another 3 minutes to heat through.

SLICE the meats and serve with the marrow and vegetables. Serve the broth separately in bowls, accompanied by plenty of mustard and sea salt.

CHOUCROUTE GARNIE

SAUERKRAUT (CHOUCROUTE), OR PICKLED CABBAGE, IS AN IMPORTANT INGREDIENT IN ALSACE CUISINE. THIS DISH CAN VARY ACCORDING TO THE NUMBER OF PEOPLE YOU WANT TO FEED— TRADITIONALLY, THE MORE PEOPLE THERE ARE, THE WIDER THE VARIETY OF MEAT USED.

Place the ham knuckle on top of the sauerkraut and add the other flavorings, then layer with the rest of the onion, sauerkraut and pork shoulder and belly.

2 1/2 lb. fresh or canned sauerkraut
4 tablespoons bacon fat or lard
1 onion, chopped
1 large garlic clove, crushed
1 onion, studded with 4 cloves
1 ham knuckle or hock
2 bay leaves
2 carrots, diced
8 juniper berries, lightly crushed
1 x 14 oz. piece pork shoulder
14 oz. salt pork belly, cut into thick strips
2/3 cup dry wine, preferably Riesling
12 small potatoes, unpeeled
3 boiling sausages (*saucisses à cuire*)
6 hot dogs

SERVES 8

PREHEAT the oven to 375°F. If you are using fresh sauerkraut, wash it under cold running water, then squeeze dry. If you are using a can or jar of sauerkraut, simply drain it well.

MELT the fat or lard in a large casserole, add the chopped onion and garlic and cook for 10 minutes, or until softened but not browned. Remove half the onion from the casserole and keep on one side. Add half the sauerkraut to the casserole, then place the whole onion and the ham knuckle or hock on the sauerkraut. Scatter the bay leaves, carrots and juniper berries over the top. Season.

NOW ADD the rest of the onion and the remaining sauerkraut and season again. Place the pork shoulder and strips of pork belly on top and pour in the wine and 1/2 cup water. Cook, covered, in the oven for 2 1/2 hours (check after an hour and add a little more water if necessary). Add the whole potatoes and cook for another 30–40 minutes, or until the potatoes are tender.

POACH the boiling sausages in simmering water for 20 minutes, then add the hot dogs and poach for 10 minutes longer. Drain and keep warm. Discard the studded onion from the casserole. Cut any meat from the ham knuckle and slice the pork shoulder and sausages.

TO SERVE, arrange the piping hot sauerkraut on a large dish with the potatoes, sausages and pieces of meat.

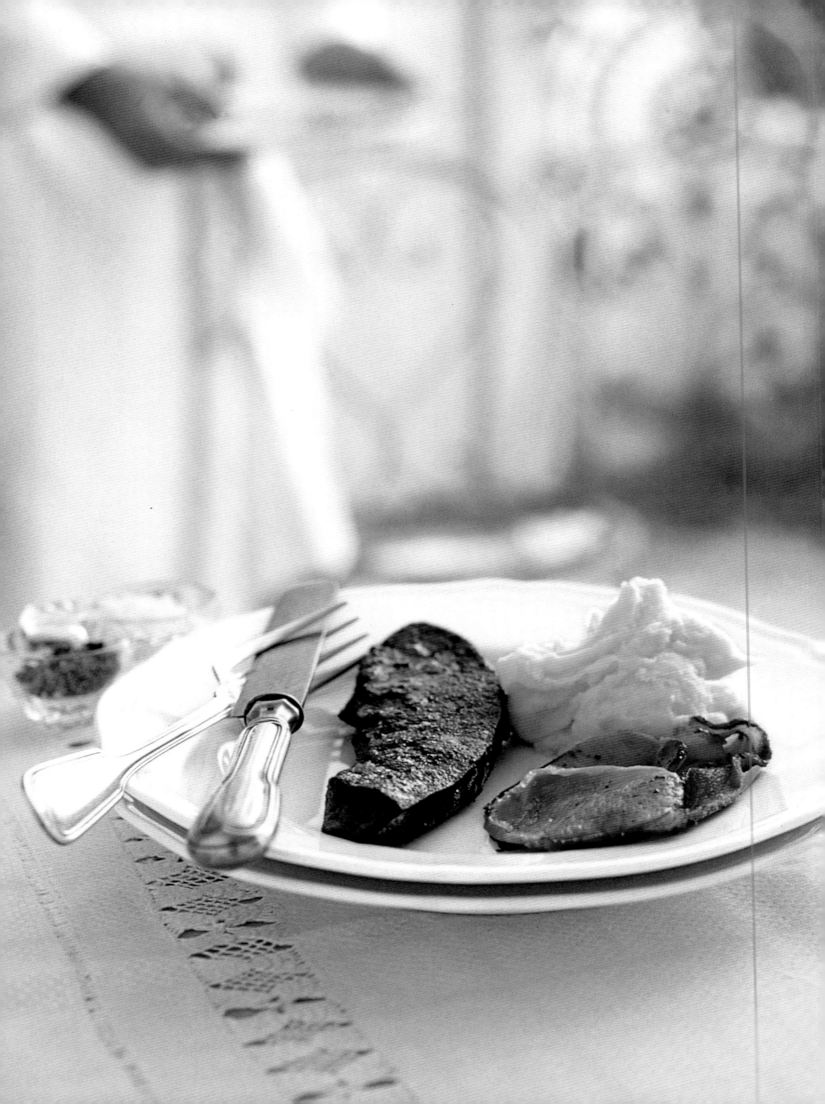

SAUTÉED CALVES' LIVER

4 bacon slices, cut in half
4 x 5 oz. slices calves' liver
³/₄ cup all-purpose flour
1¹/₃ tablespoons butter

SERVES 4

HEAT a frying pan and cook the bacon until browned and crisp all over. Remove bacon with a slotted spoon and keep warm. Don't clean the pan.

PEEL OFF any membrane from the liver and cut out any veins with a sharp knife. Season the flour with salt and black pepper, then spread out on a baking sheet or board. Coat the liver with the flour and shake off the excess.

HEAT the butter in the frying pan with the bacon fat. When the butter is foaming, add the liver and cook for 90 seconds on each side (the liver should still be pink in the middle). Serve the liver and bacon with mashed potatoes.

BOUDIN NOIR WITH APPLES

THERE ARE SEVERAL VARIETIES OF BOUDIN NOIR AVAILABLE IN FRANCE. RECIPES VARY REGIONALLY AND CAN INCLUDE INGREDIENTS SUCH AS APPLES, CREAM AND CHESTNUTS. ENGLISH BLACK PUDDING CAN ALSO BE USED FOR THIS RECIPE.

Fry the boudin noir, then keep warm while you caramelize the apples in the same pan.

2 boudin noir or black puddings
2 eating apples
2 tablespoons butter
1 teaspoon brown sugar

SERVES 4

CUT the boudin noir into ¹/₂-inch slices. Peel and core the apples, cut them into quarters and then into thick slices. Heat the butter in a frying pan and fry the boudin noir on both sides until browned and warmed through. Remove from the pan and keep warm.

FRY the apple in the same pan over high heat, sprinkling it with the brown sugar to help it caramelize. When it is browned on both sides, place on a serving plate and arrange the boudin noir on top. Serve with pan-fried potatoes.

BOUDIN NOIR WITH APPLES

Use the same frying pan for browning all the ingredients separately. Once the sauce is made, return the kidneys and cocktail sausages to the pan.

KIDNEYS TURBIGO

THIS STEW OF KIDNEYS, SAUSAGES AND ONIONS IS NAMED AFTER THE TOWN OF TURBIGO IN LOMBARDY, THE SITE OF TWO FAMOUS FRENCH MILITARY VICTORIES OVER THE AUSTRIAN ARMY IN THE NINETEENTH CENTURY.

8 lamb kidneys
4 tablespoons butter
8 cocktail sausages
12 small pickling or pearl onions or
 shallots
1¹/₃ cups button mushrooms,
 sliced
1 tablespoon all-purpose flour
2 tablespoons dry sherry
2 teaspoons tomato paste
1 cup beef stock
2 tablespoons finely chopped
 parsley

CROUTES
oil, for brushing
2 garlic cloves, crushed
12 slices baguette, cut on an angle

SERVES 4

TRIM, HALVE and cut the white membrane from the kidneys with scissors. Heat half the butter in a large frying pan and cook the kidneys for 2 minutes to brown all over. Remove to a plate. Add the cocktail sausages to the frying pan and cook for 2 minutes until browned all over. Remove to a plate. Cut in half on the diagonal.

LOWER the heat and add the remaining butter to the frying pan. Cook the onions and mushrooms, stirring, for 5 minutes until soft and golden brown.

MIX TOGETHER the flour and sherry to make a smooth paste. Add the tomato paste and stock and mix until smooth.

REMOVE the frying pan from the heat and stir in the stock mixture. Return to the heat and stir until boiling and slightly thickened. Season well with salt and pepper. Return the kidneys and cocktail sausages to the sauce. Lower the heat, cover the pan and simmer for 25 minutes, or until the kidneys are cooked. Stir occasionally.

MEANWHILE, to make the croutes, preheat the oven to 350°F. Mix together the oil and garlic and brush over the bread slices. Place on a baking sheet and bake for 3–4 minutes. Turn over and bake for another 3 minutes until golden brown. Sprinkle the kidneys with parsley and serve with the croutes on the side.

VEGETABLES

A vegetable stall in Lyon's market.

Crème fraîche is regularly used in place of cream in French kitchens.

PURÉE OF RUTABAGAS

IT IS EASIEST TO MAKE VEGETABLE PURÉES IN A FOOD PROCESSOR OR BLENDER BUT, IF YOU DON'T HAVE ONE, MASH THEM WITH A POTATO MASHER OR USE A FOOD MILL. NEVER PURÉE POTATOES IN A PROCESSOR OR BLENDER—THEY BECOME GLUEY.

2 lb. rutabagas, peeled and chopped
3 tablespoons butter
1 tablespoon crème fraîche

SERVES 4

PUT the rutabagas in a saucepan, half-cover with water and add 1 teaspoon salt and 2 tablespoons of the butter. Bring to a boil and then reduce the heat, cover, and simmer for 30 minutes or until tender. Drain, reserving the cooking liquid.

PROCESS the rutabagas in a food processor or blender with enough of the cooking liquid to make a purée. Spoon into a saucepan and stir in the remaining butter and the crème fraîche. Reheat gently for a couple of minutes, stirring all the time.

PURÉE OF JERUSALEM ARTICHOKES

1 1/2 lb. Jerusalem artichokes, peeled
1/2 lb. potatoes, halved
1 tablespoon butter
2 tablespoons crème fraîche

SERVES 4

COOK the artichokes in boiling salted water for 20 minutes or until tender. Drain and then mix in a food processor or blender to purée.

COOK the potatoes in boiling salted water for 20 minutes, then drain and mash. Add to the artichoke with the butter and crème fraîche. Season, beat well and serve at once.

PURÉE OF SPINACH

2 lb. spinach leaves
3 tablespoons butter
4 tablespoons crème fraîche
1/2 teaspoon nutmeg

SERVES 4

WASH the spinach and put in a large saucepan with just the water clinging to the leaves. Cover the saucepan and steam the spinach for 2 minutes, or until just wilted. Drain, cool and squeeze dry with your hands. Finely chop.

PUT the spinach in a small saucepan and gently heat through. Increase the heat and add the butter, a little at a time, stirring continuously. Add the crème fraîche and stir into the spinach until it is glossy. Season well and stir in the nutmeg.

PURÉE OF SPINACH

STUFFED GREEN CABBAGE

CHOU FARCI IS A TRADITIONAL DISH FROM THE COOLER REGIONS OF FRANCE—THE CABBAGE CAN COPE WITH A HARSHER CLIMATE THAN MANY OTHER VEGETABLES AND IN THIS DISH IT IS PADDED OUT WITH MEAT TO MAKE A FILLING MAIN COURSE.

STUFFING
4 ripe tomatoes
1/3 cup pine nuts
1 lb. pork sausage meat
5 oz. bacon, finely chopped
1 onion, finely chopped
2 garlic cloves, crushed
5 oz. fresh bread crumbs
2 eggs
1 tablespoon mixed herbs

1 Savoy cabbage, or other loose-
 leafed cabbage
lemon juice

BRAISING LIQUID
2 tablespoons butter
2 shallots, chopped
1 large carrot, chopped
1 celery stalk, chopped
1 potato, diced
1/4 cup medium-dry white wine
1 cup chicken stock

SERVES 6

TO MAKE the stuffing, score a cross in the top of each tomato, plunge into boiling water for 20 seconds and then peel the skin away from the cross. Chop finely, discarding the cores. Toast the pine nuts under a hot broiler for 2–3 minutes until lightly browned. Mix together all the stuffing ingredients and season with salt and pepper.

CAREFULLY separate the cabbage leaves, trying not to tear them. Save the cabbage heart for later use. Bring a large saucepan of water to a boil, add a little lemon juice and blanch the cabbage leaves a few at a time. Refresh in cold water, then drain.

SPREAD a damp kitchen towel out on the work surface. Place the four largest leaves in a circle on the cloth with the stems meeting in the middle and the leaves overlapping each other slightly. Spread some of the stuffing over the leaves as evenly as you can.

ARRANGE ANOTHER four cabbage leaves on top and spread with more stuffing. Continue with the rest of the leaves and stuffing, finishing with the smallest leaves. Bring the sides of the kitchen towel up to meet each other, wrapping the cabbage in its original shape. Tie into a ball with string.

TO MAKE the braising liquid, melt the butter in a large casserole or saucepan and sauté the chopped vegetables for a couple of minutes. Add the wine and boil for 2 minutes, then add the stock. Lower the cabbage into the liquid and cover tightly. Simmer for 1 1/4 hours, or until a metal skewer comes out too hot to touch when poked into the center of the cabbage. Take out, unwrap and drain on a wire rack for 5 minutes.

TO SERVE, place some of the braising vegetables and liquid into shallow serving bowls and top with a wedge of stuffed cabbage.

The neater that you are able to fill and layer the cabbage leaves, the more regular the shape of the finished dish will be.

POMMES ANNA

1³/₄ lb. waxy potatoes
¹/₂ cup clarified butter, melted

SERVES 4

PREHEAT the oven to 415°F. Grease a deep 8-inch round cake pan or flameproof dish with melted butter.

PEEL the potatoes and cut into very thin slices with a mandolin or sharp knife. Lay the potato slices on paper towels and pat dry. Starting from the center of the dish, overlap one-fifth of the potato slices over the bottom. Drizzle one-fifth of the butter over the top. Season well.

REPEAT the layers four more times, drizzling the last bit of butter over the top. Cut a circle of waxed paper to fit over the top of the potato. Bake for about 1 hour, or until cooked and golden and a knife blade slides easily into the center. Remove from the oven and leave for 5 minutes, then pour off any excess butter. Run a knife around the edge to loosen, then turn out onto a serving plate.

Mealy potatoes will soak up the liquid in the gratin dauphinois and give a softer, fluffy texture.

GRATIN DAUPHINOIS

THERE ARE A NUMBER OF VERSIONS OF THIS REGIONAL DISH FROM DAUPHINÉ, SOME WITHOUT THE TOPPING OF BROWNED CHEESE. IN FACT, THE WORD "GRATIN" ORIGINALLY REFERRED NOT TO THE TOPPING, BUT TO THE CRISPY BITS AT THE BOTTOM OF THE PAN.

2 lb. mealy (baking) potatoes
2 garlic cloves, crushed
¹/₂ cup Gruyère, grated
pinch of nutmeg
1 cup heavy cream
¹/₂ cup milk

SERVES 6

PREHEAT the oven to 325°F. Thinly slice the potatoes with a mandolin or sharp knife. Butter a 9 x 6¹/₂ inch flameproof dish and layer the potatoes, sprinkling the garlic, grated cheese, nutmeg and seasoning between the layers and reserving some of the cheese for the top. Pour the cream and milk over the top and sprinkle with the reserved cheese.

BAKE FOR 50–60 minutes or until the potatoes are completely cooked and the liquid has been absorbed. If the top browns too much, cover loosely with aluminum foil. Allow to rest for 10 minutes before serving.

GRATIN DAUPHINOIS

Saint Cyprien in the Dordogne.

PEAS WITH ONIONS AND LETTUCE

LETTUCE IS OFTEN THOUGHT OF AS PURELY A SALAD GREEN, BUT UNTIL THE EIGHTEENTH CENTURY IT WAS MORE OFTEN SERVED COOKED THAN RAW, AND IN FRANCE IT IS STILL OFTEN EATEN THIS WAY, PARTICULARLY IN THIS DISH.

3 tablespoons butter
16 small pickling onions or shallots
1 lb. shelled fresh peas
1/2 lb. iceberg lettuce heart, finely
 shredded
2 parsley sprigs
1 teaspoon superfine sugar
1/2 cup chicken stock
1 tablespoon all-purpose flour

SERVES 6

MELT 2 tablespoons of the butter in a large saucepan. Add the onions and cook, stirring, for 1 minute. Add the peas, lettuce, parsley sprigs and sugar.

POUR IN the stock and stir well. Cover the saucepan and cook over moderately low heat for 15 minutes, stirring a couple of times, until the onions are cooked through. Remove the parsley.

MIX the remaining butter with the flour to make a beurre manié. Add small amounts to the vegetables, stirring until the juices thicken a little. Season well with salt and black pepper.

VICHY CARROTS

1 lb. carrots
1/2 teaspoon salt
1 1/2 teaspoons sugar
3 tablespoons butter
1 1/2 tablespoons chopped parsley

SERVES 6

SLICE the carrots quite thinly, then put in a deep frying pan. Cover with cold water and add the salt, sugar and butter. Simmer until the water has evaporated. Shake the pan to glaze the carrots, then add the parsley, toss together and serve.

VICHY CARROTS

VEGETABLE TIMBALES

1³/₄ cups carrots, chopped
9 cups watercress, trimmed
9 oz. red peppers
³/₄ cup heavy cream
7 egg yolks
pinch of nutmeg

SERVES 4

PREHEAT the oven to 315°F. Steam the carrots until they are soft. Wash the watercress and put in a saucepan with just the water clinging to the leaves. Cover the saucepan and steam the watercress for 2 minutes, or until just wilted. Drain, cool and squeeze dry with your hands.

PREHEAT the broiler. Cut the peppers in half, remove the seeds and membrane and place, skin side up, under the hot broiler until the skin blackens and blisters. Allow to cool before peeling away the skin.

PURÉE EACH vegetable individually in a food processor, adding a third of the cream to the carrots to make a smooth purée. Pour the pepper purée into a saucepan and stir over moderate heat until thickened. Put each purée in its own bowl to cool, then divide the remaining cream between the pepper and watercress purées.

STIR 2 egg yolks into each purée. Divide the last yolk between the pepper and watercress purées. Season with salt, pepper and nutmeg.

GREASE FOUR timbale molds and divide the carrot purée equally among them. Smooth the surface. Spoon the watercress purée on top and smooth the surface. Top with the pepper purée. Put the molds in a roasting pan and pour in hot water to come halfway up the sides of the timbales. Cook in this bain-marie for 1¹/₄ hours.

TO SERVE, hold a plate on top of each timbale and then turn it upside down. Give the plate and timbale one sharp shake and the timbale will release itself. Serve with a salad and baguette.

Smooth each layer as you put it in the mold, so the timbale is neat and even when turned out.

To make the vegetable tian, arrange a layer of zucchini in the dish, then top with cheese, the tomato mixture and thyme.

VEGETABLE TIAN

FENNEL, TOMATO AND GARLIC GRATIN

2 lb. fennel bulbs
1/3 cup olive oil
1 large red onion, halved and thinly
 sliced
2 garlic cloves, crushed
1 lb. tomatoes

GRATIN TOPPING
3/4 cup white bread, broken into
 coarse crumbs
2/3 cup Parmesan, grated
2 teaspoons grated lemon zest
1 garlic clove, crushed

SERVES 4

PREHEAT the oven to 400°F. Grease an 8¹/₂-inch square gratin dish with melted butter or oil. Cut the fennel in half lengthwise, then slice thinly.

HEAT the oil in a large frying pan. Cook the onion for 3–4 minutes until softened but not browned. Add the garlic and cook for 2 minutes. Add the fennel and cook, stirring frequently, for 7 minutes until softened and lightly golden brown.

SCORE a cross in the top of each tomato, plunge into boiling water for 20 seconds and then peel the skin away from the cross. Chop roughly and add to the fennel. Cook, stirring frequently, for 5 minutes until the tomatoes are softened. Season well and pour into the dish.

TO MAKE the gratin topping, mix all the ingredients together, sprinkle over the vegetables and bake for 15 minutes, or until golden brown and crisp. Serve immediately.

VEGETABLE TIAN

1/4 cup olive oil
1 lb. zucchini, thickly sliced on the
 diagonal
4 garlic cloves, crushed
pinch of nutmeg
1¹/₄ lb. tomatoes
2 red onions, chopped
1/4 cup white wine
2/3 cup chopped flat-leaf parsley
1 cup Gruyère, grated
a few small thyme sprigs

SERVES 4

PREHEAT the oven to 350°F. Grease a 6 x 10 inch flameproof dish with melted butter or oil. Heat half the oil in a large frying pan and add the zucchini and half the garlic. Cook, stirring, over low heat for 8 minutes, or until just beginning to soften. Season well with salt, pepper and nutmeg. Spread evenly into the dish.

SCORE a cross in the top of each tomato, plunge into boiling water for 20 seconds and then peel the skin away from the cross. Chop roughly. Cook the onion in the remaining oil over low heat for 5 minutes, stirring often. Add the remaining garlic, tomatoes, wine and parsley. Cook, stirring often, for 10 minutes until all the liquid has evaporated.

SPRINKLE the cheese over the zucchini and spread the tomato mixture over the top. Scatter thyme sprigs over the tomato and bake for 20 minutes, or until heated through.

RATATOUILLE

THE NAME RATATOUILLE COMES FROM THE FRENCH WORD FOR "MIX" AND WAS PREVIOUSLY USED AS A FAMILIAR TERM FOR ANY STEW. THIS RECIPE FOLLOWS THE TRADITIONAL VERSION, WITH EACH INGREDIENT BEING FRIED SEPARATELY BEFORE THE FINAL SIMMERING.

4 tomatoes
2 tablespoons olive oil
1 large onion, diced
1 red pepper, diced
1 yellow pepper, diced
1 eggplant, diced
2 zucchini, diced
1 teaspoon tomato paste
1/2 teaspoon sugar
1 bay leaf
3 thyme sprigs
2 basil sprigs
1 garlic clove, crushed
1 tablespoon chopped parsley

SERVES 4

SCORE a cross in the top of each tomato, plunge into boiling water for 20 seconds and then peel the skin away from the cross. Chop roughly.

HEAT the oil in a frying pan. Add the onion and cook over low heat for 5 minutes. Add the red and yellow peppers and cook, stirring, for 4 minutes. Remove from the pan and set aside.

FRY the eggplant until lightly browned all over and then remove from the frying pan. Fry the zucchini until browned and then return the onion, peppers and eggplant to the pan. Add the tomato paste, stir well and cook for 2 minutes. Add the tomatoes, sugar, bay leaf, thyme and basil, stir well, cover and cook for 15 minutes. Remove the bay leaf, thyme and basil.

MIX TOGETHER the garlic and parsley and add to the ratatouille at the last minute. Stir and serve.

You can braise white chicory or the purple-tipped variety. Both should be pale yellow, rather than green and bitter.

BRAISED CHICORY

8 chicory heads
1 tablespoon butter
1 teaspoon brown sugar
2 teaspoons tarragon vinegar
1/3 cup chicken stock
2 tablespoons heavy cream

SERVES 4

TRIM the ends from the chicory. Melt the butter in a deep frying pan and fry the chicory briefly on all sides. Add the sugar, vinegar and chicken stock and bring to a boil. Reduce the heat to a simmer and cover the pan.

SIMMER GENTLY for 30 minutes, or until tender, turning halfway through. Take the lid off the frying pan and simmer until nearly all the liquid has evaporated. Stir in the cream and serve.

BRAISED CHICORY

Olives growing in Provence.

Frying the scallions and bacon slices for the dressing of the salade lyonnaise.

SALADE NIÇOISE

THE TERM "A LA NIÇOISE" REFERS TO DISHES, TYPICAL OF NICE AND ITS SURROUNDING AREA, THAT CONTAIN TOMATOES, OLIVES, ANCHOVIES AND GARLIC. A DEBATE RAGES OVER WHAT A SALADE NIÇOISE SHOULD CONTAIN—APART FROM THE EGG, PURISTS PREFER TO USE ONLY RAW INGREDIENTS.

4 waxy potatoes
1 tablespoon olive oil
$1^3/_4$ cups small green beans, halved
10 oz. canned tuna in oil, drained
6 oz. green lettuce leaves
$^3/_4$ cup cherry tomatoes, halved
20 black olives, pitted
2 tablespoons capers
3 hard-boiled eggs, cut into wedges
8 anchovies

VINAIGRETTE
1 garlic clove, crushed
1 teaspoon Dijon mustard
2 tablespoons white wine vinegar
1 teaspoon lemon juice
$^1/_2$ cup olive oil

SERVES 4 AS A STARTER

COOK the potatoes in boiling salted water for 15 minutes or until just tender. Drain, cut into small cubes and place in a bowl. Drizzle with the olive oil and toss well. Cook the green beans in boiling salted water for 3 minutes, then drain and refresh under cold water. Keep on one side.

TO MAKE the vinaigrette, whisk together the garlic, mustard, vinegar and lemon juice. Add the oil in a thin steady stream, whisking until smooth.

PUT the tuna in a bowl and separate into large chunks with a fork. Cover the bottom of a serving dish with the lettuce leaves. Scatter the potatoes, beans, tuna, tomatoes, olives and capers over the leaves, pour the vinaigrette over the top and decorate with the eggs and anchovies.

SALADE LYONNAISE

1 garlic clove, cut in half
oil, for shallow-frying
4 slices white bread, crusts removed, cut into $^1/_2$-inch cubes
$^1/_4$ cup olive oil
2 scallions, chopped
3 bacon slices, cut into short strips
$^1/_3$ cup red wine vinegar
3 teaspoons whole grain mustard
7 oz. frisée, mâche and dandelion leaves
4 eggs

SERVES 4 AS A STARTER

RUB the cut garlic over the bottom of a frying pan. Pour oil into the pan to a depth of $^1/_2$ inch and fry the bread for 1–2 minutes, or until golden brown. Drain on paper towels. Wipe out the pan.

HEAT the olive oil in the frying pan and cook the scallions and bacon for 2 minutes. Add the vinegar and mustard and boil for 2 minutes to reduce by a third. Pour over the salad leaves and toss to wilt a little. Arrange on serving plates.

TO POACH the eggs, bring a saucepan of water to a boil. Crack each egg into a ramekin, reduce the heat and slide the egg into the simmering water. Poach for 3 minutes, take out with a slotted spoon and drain on paper towels. Place on the leaves and sprinkle with the croutons. Serve immediately.

SALADE LYONNAISE

SALADE AUX NOIX

4 thin slices baguette
1 garlic clove, cut in half
1/4 cup olive oil
1 large crisp green lettuce or a
 selection of mixed lettuce leaves
11/2 tablespoons walnut oil
1/2 cup red wine vinegar
1 teaspoon Dijon mustard
1/2 cup walnuts, broken into pieces
5 oz. streaky bacon, cut into small
 pieces

SERVES 4 AS A STARTER

PREHEAT the broiler and rub the bread with the cut garlic to give it flavor. Drizzle a little of the olive oil on each side of the bread and then broil until golden brown. Allow to cool.

TEAR the lettuce leaves into pieces and arrange on a large platter. Mix together the remaining olive oil, walnut oil, vinegar and mustard and season to make a dressing.

PUT the walnuts in a bowl and cover with boiling water. Let sit for 1 minute, drain and shake dry.

COOK the bacon in a frying pan until crisp, then remove from the pan with a slotted spoon and sprinkle over the lettuce. Add the walnuts to the pan and cook for a couple of minutes until browned, then add to the salad. Pour the dressing into the pan and heat through.

POUR the dressing over the salad and toss well. Add the garlic croutons to serve.

Frying the sweetbreads before adding the creamy dressing gives them a crisp outer layer while the center stays soft.

SWEETBREADS SALAD

7 oz. sweetbreads (lamb or calves')
1 batavia lettuce or a selection of
 mixed lettuce leaves
1 tablespoon butter
1 shallot, finely chopped
2 tablespoons red wine vinegar
1 tablespoon Dijon mustard
1/3 cup olive oil
2 tablespoons whipping cream

SERVES 4 AS A STARTER

SOAK the sweetbreads in cold water for 2 hours, changing the water every 30 minutes, or whenever it turns pink. Put the sweetbreads in a saucepan of cold water and bring them to a boil. Simmer for 2 minutes, then drain and refresh under cold water. Pull off any skin and membrane and divide into bite-size pieces.

TEAR the lettuce leaves into pieces and arrange on a plate. Melt the butter in a frying pan and fry the shallot until tender. Add the sweetbreads and fry until browned and cooked through. Add the vinegar, mustard, oil and cream to the pan and stir well. Spoon over the salad leaves and serve.

SWEETBREADS SALAD

SALADE AU CHÈVRE

1/3 cup walnuts, broken into pieces
1 teaspoon sea salt
8 slices baguette
1 large garlic clove, cut in half
4 oz. chèvre, cut into 8 slices
2 oz. mesclun (mixed salad leaves
 and herbs)
1 small red onion, thinly sliced

DRESSING
2 tablespoons olive oil
1 tablespoon walnut oil
1 1/2 tablespoons tarragon vinegar
1 garlic clove, crushed

SERVES 4 AS A STARTER

PREHEAT the broiler to hot. Put the walnuts in a bowl and cover with boiling water. Let stand for 1 minute, then drain and shake dry. Toast under the broiler for 3–4 minutes until golden. Sprinkle sea salt over the top, toss lightly and allow to cool.

PUT the baguette under the broiler and toast one side until lightly golden. Remove from the heat and rub the toasted side with the cut garlic. Allow to rest for a few minutes to cool and crisp, then turn over and place a slice of chèvre on each one. Broil for 2–3 minutes, or until the cheese browns.

TO MAKE the dressing, mix together the olive oil, walnut oil, vinegar and garlic and season well.

TOSS the mesclun, onion and toasted walnuts together on a large platter. Arrange the chèvre croutons on top and drizzle with the dressing. Serve while the croutons are still warm.

For the salade au foie gras, cut the foie gras terrine into eight slices. Slice the truffle as finely as you can and place a slice on top of each piece of foie gras.

SALADE AU FOIE GRAS

1/4 lb. waxy potatoes such as Red
 Bliss or Yellow Finn, thickly sliced
12 asparagus spears, cut into short
 lengths
1 small black truffle, very thinly
 sliced into at least 8 pieces
1/4 lb. foie gras terrine, sliced into
 8 pieces
1 tablespoon butter
2 oz. mesclun (mixed salad leaves
 and herbs)

DRESSING
2 tablespoons olive oil
1 tablespoon walnut oil
1 tablespoon Armagnac
1 1/2 tablespoons red wine vinegar

SERVES 4 AS A STARTER

COOK the potatoes in salted water at a simmer for 15 minutes until tender. Remove with a slotted spoon, rinse in cold water and cool. Cook the asparagus at a simmer in the same water for 3–4 minutes until tender. Drain, rinse under cold water and chill.

TO MAKE the dressing, mix together the olive oil, walnut oil, Armagnac and vinegar. Season well.

PLACE a slice of truffle on the center of each slice of foie gras and press it in gently. Melt the butter in a frying pan, add the foie gras to the pan and brown lightly, turning after 30 seconds. The foie gras becomes quite soft as it heats, so use a spatula to turn it over and take it out. Drain on paper towels and keep warm.

PUT the potatoes, asparagus and mesclun in a bowl. Add the dressing and toss lightly. Top with the foie gras, truffle side up, and sprinkle with any leftover truffle slices. Serve at once.

SALADE AU FOIE GRAS

DESSERTS & PASTRIES

The crémets are spooned into cheesecloth-lined ramekins to make them easier to turn out.

COFFEE CRÉMETS WITH CHOCOLATE SAUCE

DARK CHOCOLATE (INCLUDES SEMISWEET AND BITTERSWEET) IS AVAILABLE IN A VARIETY OF DIFFERENT QUALITIES. FOR A REALLY GOOD CHOCOLATE SAUCE, YOU WANT TO USE THE RICH, ALMOST-BLACK, IMPORTED CHOCOLATE THAT IS LABELED "WITH 70% COCOA SOLIDS." YOU CAN FIND IT IN GOURMET AND SPECIALTY FOOD STORES.

1 cup cream cheese
1 cup heavy cream
4 tablespoons very strong coffee
1/3 cup superfine sugar

CHOCOLATE SAUCE
3 1/2 oz. dark chocolate
3 tablespoons unsalted butter

SERVES 4

LINE FOUR 1/2-cup ramekins or heart-shaped molds with cheesecloth, leaving some cheesecloth hanging over the side to wrap over the crémet.

BEAT the cream cheese a little until smooth, then whisk in the cream. Add the coffee and sugar and mix together. Spoon into the ramekins and fold the cheesecloth over the top. Refrigerate for at least 1 1/2 hours, then unwrap the cheesecloth and turn the crémets out onto individual plates, carefully peeling the cheesecloth off each one.

TO MAKE the chocolate sauce, gently melt the chocolate in a saucepan with the butter and 4 tablespoons water. Stir well to make a shiny sauce, then let the sauce cool a little. Pour a little chocolate sauce over each crémet.

PEARS IN RED WINE

1 tablespoon arrowroot
1 bottle red wine
1/3 cup sugar
1 cinnamon stick
6 cloves
zest of 1 small orange
zest of 1 small lemon
6 large pears (ripe but still firm)

SERVES 6

MIX the arrowroot with 2 tablespoons of the wine and set aside. Heat the remaining wine in a saucepan with the sugar, cinnamon stick, cloves and orange and lemon zest. Simmer gently for a couple of minutes, until the sugar has dissolved.

PEEL the pears, but don't remove the stems. Put the whole pears in the saucepan of wine, cover and poach gently for 25 minutes or until they are very tender, turning occasionally. Take out with a slotted spoon and place in a deep serving dish.

STRAIN the wine to remove the cinnamon stick, cloves and rind, then pour the wine back into the saucepan. Stir the arrowroot and add to the hot wine. Simmer gently, stirring now and then, until thickened. Pour over the pears and allow them to soak until they are cold. Serve with cream or crème fraîche.

PEARS IN RED WINE

CINNAMON BAVAROIS

THE NAME OF THIS CREAMY DESSERT IS A PECULIARITY OF THE FRENCH LANGUAGE IN THAT IT CAN BE SPELLED IN BOTH THE MASCULINE FORM, "BAVAROIS" (FROM *FROMAGE BAVAROIS*) AND THE FEMININE, "BAVAROISE" (FROM *CRÈME BAVAROISE*). HOWEVER, ITS CONNECTION TO BAVARIA HAS BEEN LOST.

1¹/₄ cups milk
1 teaspoon ground cinnamon
¹/₄ cup sugar
3 egg yolks
3 gelatin leaves or 1¹/₂ teaspoons
 powdered gelatin
¹/₂ teaspoon vanilla extract
³/₄ cup whipping cream
cinnamon, for dusting

SERVES 6

PUT the milk, cinnamon and half the sugar in a saucepan and bring to a boil. Whisk the egg yolks and remaining sugar until light and fluffy. Whisk the boiling milk into the yolks, then pour back into the saucepan and cook, stirring, until it is thick enough to coat the back of a wooden spoon. Do not let it boil or the custard will split.

SOAK the gelatin leaves in cold water until soft, drain and add to the hot custard with the vanilla extract. If using powdered gelatin, sprinkle it on to the hot custard, leave it to sponge for a minute, then stir it in. Strain the custard into a clean bowl and allow to cool. Whip the cream, fold into the custard and pour into six ¹/₂-cup greased bavarois molds. Set in the refrigerator.

UNMOLD by holding the mold in a hot cloth and inverting it onto a plate with a quick shake. Dust with the extra cinnamon.

Drape the warm tuiles over a rolling pin so that they set in a curved shape.

TUILES

2 egg whites
¹/₄ cup superfine sugar
2 tablespoons all-purpose flour
¹/₃ cup ground almonds
2 teaspoons peanut oil

MAKES 12

BEAT the egg whites in a clean dry bowl until slightly frothy. Mix in the sugar, then the flour, ground almonds and oil. Preheat the oven to 400°F.

LINE a baking sheet with waxed paper. Place one heaping teaspoon of tuile mixture on the baking sheet and use the back of the spoon to spread it into a thin circle. Cover the baking sheet with tuiles, leaving ³/₄ inch between them for spreading during cooking.

BAKE for 5–6 minutes or until lightly golden. Take the tuiles off the baking sheet with a metal spatula and drape over a rolling pin while warm to make them curl (or use a bottle or a glass). Allow to cool while you cook the rest of the tuiles. Serve with ice cream and other creamy desserts.

TUILES

CHOCOLATE MOUSSES

2 cups dark chocolate, chopped
2 tablespoons unsalted butter
2 eggs, lightly beaten
3 tablespoons Cognac
4 egg whites
5 tablespoons superfine sugar
2 cups whipping cream

SERVES 8

PUT the chocolate in a heatproof bowl over a saucepan of simmering water, making sure the bottom of the bowl isn't touching the water. Allow the chocolate to become soft and then stir until melted. Add the butter and stir until melted. Remove the bowl from the saucepan and cool for a few minutes. Add the eggs and Cognac and stir.

USING an electric mixer or wire whisk, beat the egg whites in a clean dry bowl until soft peaks form, adding the sugar gradually. Whisk one third of the egg white into the chocolate mixture to loosen it and then fold in the remainder with a large metal spoon or spatula.

WHIP the cream and fold into the mousse. Pour into glasses or a large bowl, cover and refrigerate for at least 4 hours.

PETITS POTS DE CRÈME

THE FLAVOR OF THESE PETITS POTS COMES FROM THE VANILLA BEAN USED TO INFUSE THE MILK. FOR CHOCOLATE POTS, ADD A TABLESPOON OF COCOA AND 1/3 CUP MELTED DARK CHOCOLATE INSTEAD OF THE VANILLA TO THE MILK. FOR COFFEE POTS, ADD A TABLESPOON OF INSTANT COFFEE.

1²/₃ cups milk
1 vanilla bean
3 egg yolks
1 egg
1/3 cup superfine sugar

SERVES 4

PREHEAT the oven to 275°F. Put the milk in a saucepan. Split the vanilla bean in two, scrape out the seeds and add the bean and seeds to the milk. Bring the milk just to a boil.

MEANWHILE, mix together the egg yolks, egg and sugar. Strain the boiling milk over the egg mixture and stir well. Skim off the surface to remove any foam.

LADLE the mixture into four 1 oz. ramekins and place in a roasting pan. Pour enough hot water into the pan to come halfway up the sides of the ramekins. Bake for 30 minutes, or until the custards are firm to the touch. Allow the ramekins to cool on a wire rack, then refrigerate until ready to serve.

PETITS POTS DE CRÈME

CHOCOLATE SOUFFLÉS

SOUFFLÉS ARE RENOWNED FOR BEING DIFFICULT TO MAKE, BUT CAN IN FACT BE VERY EASY. IF YOU ARE FEELING PARTICULARLY DECADENT WHEN YOU SERVE THESE CHOCOLATE SOUFFLÉS, MAKE A HOLE IN THE TOP OF EACH ONE AND POUR IN A LITTLE CREAM.

3 tablespoons unsalted butter, softened
$^3/_4$ cup superfine caster sugar

SOUFFLÉS
1 batch crème pâtissière (page 285)
$^3/_4$ cup unsweetened cocoa powder
3 tablespoons chocolate or coffee liqueur
$^1/_2$ cup dark chocolate, chopped
12 egg whites
3 tablespoons superfine sugar confectioners' sugar

SERVES 8

Beat egg whites in a clean dry bowl—any hint of grease will prevent them from aerating.

TO PREPARE the dishes, brush the insides of eight $1^1/_3$-cup soufflé dishes with the softened butter. Pour a little superfine sugar into each one, turn the dishes around to coat thoroughly and then pour out any excess sugar. Preheat the oven to 375°F and put a large baking sheet in the oven to heat up.

WARM the crème pâtissière in a bowl over a saucepan of simmering water, then remove from the heat. Whisk the cocoa powder, chocolate liqueur and chocolate into the crème pâtissière.

BEAT the egg whites in a clean dry bowl until firm peaks form. Whisk in the sugar gradually to make a stiff glossy mixture. Whisk half the egg white into the crème pâtissière to loosen it, and then fold in the remainder with a large metal spoon or spatula. Pour into the soufflé dishes and run your thumb around the inside rim of each dish, about $^3/_4$ inch into the soufflé mixture to help the soufflés rise without sticking.

PUT the dishes on the hot baking sheet and bake for 15–18 minutes, or until the soufflés have risen and wobble slightly when tapped. Test with a skewer through a crack in the side of a soufflé—the skewer should come out clean or slightly moist. If it is slightly moist, by the time you get the soufflés to the table, they will be cooked in the center. Serve immediately, dusted with a little confectioners' sugar.

RASPBERRY SOUFFLÉ

THERE IS SOMETIMES CONFUSION ABOUT THE DIFFERENCE BETWEEN A SOUFFLÉ AND A MOUSSE. TECHNICALLY, A SOUFFLÉ IS HOT AND A MOUSSE IS COLD. A MOUSSE IS HELD UP BY GELATIN AND EGG WHITE AND WON'T COLLAPSE LIKE A HOT SOUFFLÉ, WHICH IS HELD UP BY HOT AIR.

3 tablespoons unsalted butter, softened
3/4 cup superfine sugar

SOUFFLÉ
1/2 batch crème pâtissière (page 285)
3 1/4 cups raspberries
3 tablespoons superfine sugar
8 egg whites
confectioners' sugar

SERVES 6

TO PREPARE the soufflé dish, brush the inside of a 6-cup soufflé dish with the softened butter. Pour in the superfine sugar, turn the dish around to coat thoroughly and then pour out any excess sugar. Preheat the oven to 375°F and put a baking sheet in the oven to heat up.

WARM the crème pâtissière in a bowl over a saucepan of simmering water, then remove from the heat. Put the raspberries and half the sugar in a blender or food processor and mix until puréed (or mix by hand). Pass through a fine nylon sieve to get rid of the seeds. Add the crème pâtissière to the raspberries and whisk together.

BEAT the egg whites in a clean dry bowl until firm peaks form. Whisk in the remaining sugar gradually to make a stiff glossy mixture. Whisk half the egg white into the raspberry mixture to loosen it and then fold in the remainder with a large metal spoon or spatula. Pour into the soufflé dish and run your thumb around the inside rim of the dish, about 3/4 inch into the soufflé mixture, to help the soufflé rise without sticking.

PUT the dish on the hot baking sheet and bake for 10–12 minutes, or until the soufflé has risen and wobbles slightly when tapped. Test with a skewer through a crack in the side of the soufflé—the skewer should come out clean or slightly moist. If it is slightly moist, by the time you get the soufflé to the table, it will be cooked in the center. Serve immediately, dusted with a little confectioners' sugar.

When adding beaten egg white to a mixture, whisk in a small amount first to loosen it. This allows you to fold in the rest without losing the volume.

CHERRY CLAFOUTIS

IT IS TRADITIONAL TO LEAVE THE PITS IN THE CHERRIES WHEN YOU MAKE A CLAFOUTIS (THEY ADD A BITTER ALMOST-ALMOND FLAVOR DURING THE COOKING), BUT YOU'D BETTER POINT THIS OUT WHEN YOU'RE SERVING THE DESSERT.

3/4 cup heavy cream
1 vanilla bean
1/2 cup milk
3 eggs
1/4 cup superfine sugar
1/2 cup all-purpose flour
1 tablespoon kirsch
14 oz. black cherries, unpitted
confectioners' sugar

SERVES 6

PREHEAT the oven to 350°F. Put the cream in a small saucepan. Split the vanilla bean in two, scrape out the seeds and add the bean and seeds to the cream. Heat gently for a couple of minutes, then remove from the heat, add the milk and cool. Strain to remove the vanilla bean.

WHISK the eggs with the sugar and flour, then stir into the cream. Add the kirsch and cherries and stir well. Pour into a 9-inch round baking dish and bake for 30–35 minutes, or until golden on top. Dust with confectioners' sugar and serve.

Adding the unpitted cherries to the clafoutis batter.

PEACHES CARDINAL

4 large ripe peaches
3 1/2 cups raspberries
4 teaspoons confectioners' sugar,
 plus extra for dusting

SERVES 4

IF the peaches are very ripe, put them in a bowl and pour boiling water over them. Allow to rest for a minute, then drain and carefully peel away the skin. If the fruit you have is not ripe enough, dissolve 2 tablespoons sugar in a saucepan of water, add the peaches and cover the saucepan. Gently poach the peaches for 5–10 minutes, or until they are tender. Drain and peel.

LET the peaches cool and then halve each one and remove the pit. Put two halves in each serving glass. Put the raspberries in a food processor or blender and mix until puréed (or mix by hand). Pass through a fine nylon sieve to remove the seeds.

SIFT the confectioners' sugar over the raspberry purée and stir in. Drizzle the purée over the peaches, cover and chill thoroughly. Dust a little confectioners' sugar over the top to serve.

PEACHES CARDINAL

Dairy cows in Normandy.

Ladling the crème brûlée custard into the ramekins.

CRÈME BRÛLÉE

CRÈME CARAMEL

CARAMEL
1/2 cup superfine sugar

2 1/2 cups milk
1 vanilla bean
1/2 cup superfine sugar
3 eggs, beaten
3 egg yolks

SERVES 6

TO MAKE the caramel, put the sugar in a heavy-bottomed saucepan and heat the sugar until it dissolves and starts to caramelize—swirl the sugar in the saucepan to keep the coloring even. Remove from the heat and carefully add 2 tablespoons water to stop the cooking process. Pour into six 1/2-cup ramekins and allow to cool.

PREHEAT the oven to 350°F. Put the milk and vanilla bean in a saucepan and bring just to a boil. Mix together the sugar, eggs and egg yolks. Strain the boiling milk over the egg mixture and stir well. Ladle into the ramekins and place in a roasting pan. Pour enough hot water into the pan to come halfway up the sides of the ramekins. Cook for 35–40 minutes, or until firm to the touch. Remove from the pan and allow to stand for 15 minutes. Unmold onto plates and pour on any leftover caramel.

CRÈME BRÛLÉE

CRÈME BRÛLÉE HAS BEEN KNOWN IN ENGLAND SINCE THE SEVENTEENTH CENTURY BY THE NAME "BURNT CREAM." THE CREAMY CUSTARD IS SIMILAR TO THAT OF THE CRÈME CARAMEL, BUT THE TOPPING IS CARAMELIZED TO A HARD CRUST.

2 cups cream
3/4 cup milk
1/2 cup superfine sugar
1 vanilla bean
5 egg yolks
1 egg white
1 tablespoon orange blossom water
1/2 cup Demerara or turbinado sugar

SERVES 8

PREHEAT the oven to 250°F. Put the cream, milk and half the sugar in a saucepan with the vanilla bean. Bring just to a boil.

MEANWHILE, mix together the remaining sugar, egg yolks and white. Strain the boiling milk over the egg mixture, whisking well. Stir in the orange blossom water.

LADLE INTO eight 1/2-cup ramekins and place in a roasting pan. Pour enough hot water into the pan to come halfway up the sides of the ramekins. Cook for 1 1/2 hours, or until set in the center. Cool and refrigerate until ready to serve. Just before serving, sprinkle the tops with Demerara sugar and caramelize under a very hot broiler or with a kitchen torch. Serve immediately.

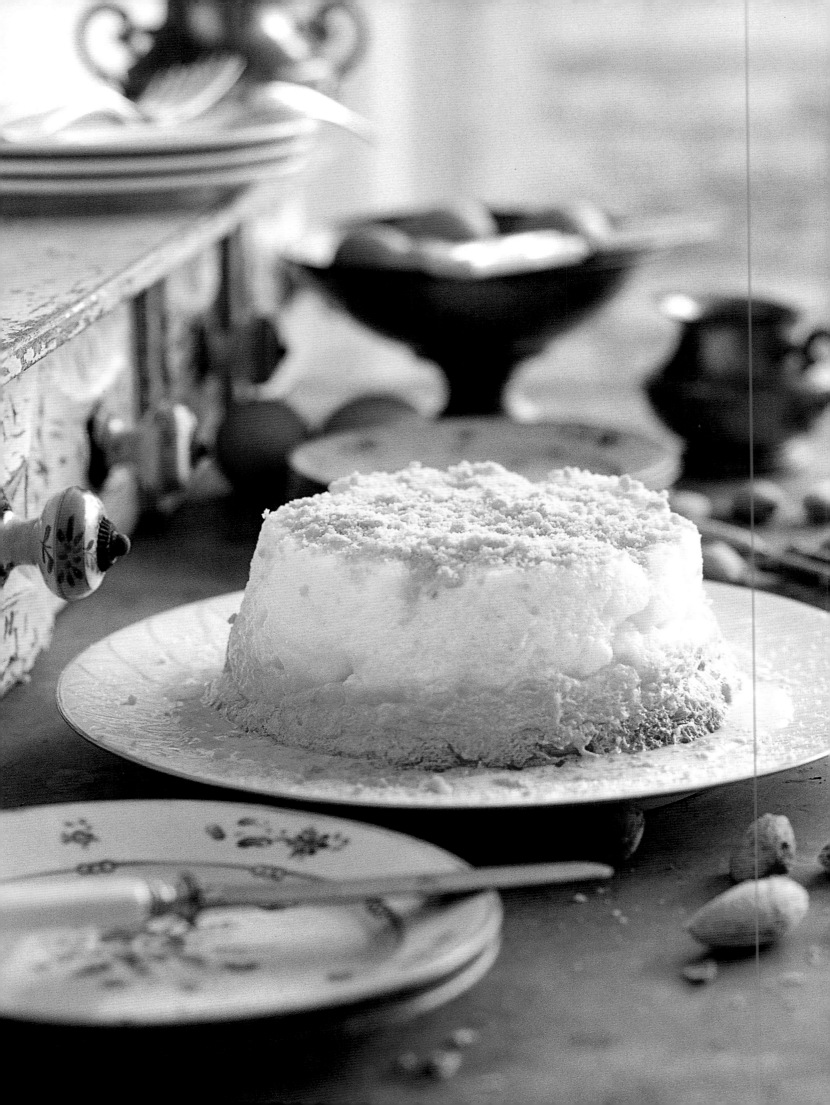

ÎLE FLOTTANTE

THIS ROUND ISLAND OF MERINGUE FLOATING ON A SEA OF CUSTARD IS OFTEN CONFUSED WITH

ANOTHER FRENCH MERINGUE DESSERT, *OEUFS A LA NEIGE*. "FLOATING ISLAND" IS ONE LARGE BAKED

MERINGUE, WHILE "EGGS IN THE SNOW" ARE SMALL POACHED MERINGUES ON CUSTARD.

MERINGUE
4 egg whites
$1/3$ cup superfine sugar
$1/4$ teaspoon vanilla extract

PRALINE
$1/4$ cup sugar
$2/3$ cup sliced almonds

2 batches crème anglaise
 (page 285)

SERVES 6

PREHEAT the oven to 275°F and put a roasting pan in the oven to heat up. Grease and line the bottom of a 6-cup charlotte mold with a circle of waxed paper and lightly grease the bottom and side.

TO MAKE the meringue, beat the egg whites in a clean dry bowl until very stiff peaks form. Whisk in the sugar gradually to make a very stiff glossy meringue. Whisk in the vanilla extract.

SPOON the meringue into the charlotte mold, smooth the surface and place a greased circle of waxed paper on top. Put the mold into the hot roasting pan and pour boiling water into the pan until it comes halfway up the side of the mold.

BAKE for 50–60 minutes, or until a knife poked into the center of the meringue comes out clean. Remove the circle of paper, put a plate over the meringue and turn it over. Lift off the mold and the other circle of paper and allow to cool.

TO MAKE the praline, grease a sheet of aluminum foil and lay it out flat on the work surface. Put the sugar in a small saucepan with 3 tablespoons water and heat gently until completely dissolved. Bring to a boil and cook until a deep golden, then quickly pour in the sliced almonds and pour onto the greased aluminum foil. Spread a little and allow to cool. When the praline has hardened, grind it to a fine powder in a food processor or with a mortar and pestle.

SPRINKLE the praline over the meringue and pour a sea of warmed crème anglaise around its base. Serve in wedges with the remaining crème anglaise.

Grease and line the charlotte mold and place greased waxed paper over the top after filling so that the meringue will not stick.

Once the crêpe starts to come away from the side of the pan, it is cooked enough to turn over.

CRÊPES SUZETTE

THE ORIGIN OF THE NAME CRÊPES SUZETTE HAS BECOME A MYSTERY, BUT THEY SEEM TO HAVE APPEARED SOMETIME AT THE END OF THE NINETEENTH CENTURY. TRADITIONALLY FLAMBÉED AT THE TABLE IN RESTAURANTS, IN THIS RECIPE THE CRÊPES ARE QUICKLY SET ALIGHT ON THE STOVE TOP.

CRÊPES
2 tablespoons grated orange zest
1 tablespoon grated lemon zest
1 batch crêpe batter (page 282)

$1/2$ cup superfine sugar
1 cup orange juice
1 tablespoon grated orange zest
2 tablespoons brandy or Cognac
2 tablespoons Grand Marnier
$31/2$ tablespoons unsalted butter, diced

SERVES 6

TO MAKE the crêpes, stir the orange and lemon zest into the crêpe batter. Heat and grease a crêpe pan. Pour in enough batter to coat the bottom of the pan in a thin even layer and pour out any excess. Cook over moderate heat for about a minute, or until the crêpe starts to come away from the side of the pan. Turn the crêpe and cook on the other side for 1 minute or until lightly golden. Repeat with the remaining batter. Fold the crêpes into quarters.

MELT the sugar in a large frying pan over low heat and cook to a rich caramel, swirling the pan so the caramel browns evenly. Pour in the orange juice and zest and boil for 2 minutes. Put the crêpes in the pan and spoon the sauce over them.

ADD the brandy and Grand Marnier and flambé by lighting the pan with your gas flame or a match (stand back when you do this and keep a pan lid handy for emergencies). Add the butter and shake the pan until the butter melts. Serve immediately.

CRÊPES SOUFFLÉS

CRÊPES SOUFFLÉS

1 batch crème pâtissière
 (page 285)
$1/2$ cup orange juice
grated zest of 1 orange
2 tablespoons Grand Marnier
8 egg whites
2 tablespoons superfine sugar
$1/2$ batch cooked crêpes
 (page 282)
confectioners' sugar

SERVES 6

PREHEAT the oven to 400°F. Warm the crème pâtissière in a bowl over a saucepan of simmering water and whisk in the orange juice, orange zest and Grand Marnier.

BEAT the egg whites in a clean dry bowl until firm peaks form. Whisk in the sugar gradually to make a stiff glossy meringue. Whisk half into the crème pâtissière to loosen the mixture, then fold in the rest with a large metal spoon or spatula. Place two big spoonfuls of soufflé on the center of each crêpe. Fold in half with a spatula, without pressing. Bake on a buttered baking sheet for 5 minutes. Dust with confectioners' sugar and serve immediately.

Saint Cyprien in the Dordogne.

CARAMEL ICE CREAM

ALTHOUGH WE ALL THINK OF ICE CREAM AS A FROZEN DESSERT, IT SHOULD IDEALLY BE SERVED WHEN

IT IS JUST ON THE VERGE OF MELTING. IF YOU SERVE IT TOO COLD THE FLAVOR WILL BE MASKED, SO

TAKE IT OUT OF THE FREEZER HALF AN HOUR BEFORE SERVING TO LET IT SOFTEN.

1/4 cup sugar
1/3 cup whipping cream
3 egg yolks
1 1/2 cups milk
1 vanilla bean

SERVES 4

TO MAKE the caramel, put 3 tablespoons of the sugar in a heavy-bottomed saucepan and heat until it dissolves and starts to caramelize—swirl the sugar in the saucepan as it cooks to keep the coloring even. Remove from the heat and carefully add the cream (it will spatter). Stir over low heat until the caramel remelts.

WHISK the egg yolks and remaining sugar until light and fluffy. Put the milk and vanilla bean in a saucepan and bring just to a boil, then strain over the caramel. Bring back to a boil and pour over the egg yolk mixture, whisking continuously.

POUR the custard back into the saucepan and cook, stirring, until it is thick enough to coat the back of a wooden spoon. Do not let it boil or the custard will split. Pass through a sieve into a bowl and place over ice to cool quickly.

CHURN in an ice-cream maker, following the manufacturer's instructions. Alternatively, pour into a plastic freezer container, cover, freeze and stir every 30 minutes with a whisk during freezing to break up the ice crystals for a better texture. Freeze overnight with a layer of plastic wrap over the surface and the lid on the container. Keep in the freezer until half an hour before serving.

Add the hot milk to the caramel, then pour over the egg yolk mixture to make a custard.

BLACK CURRANT SORBET

WE'VE USED GLUCOSE FOR THIS SORBET BECAUSE IT STOPS THE SUGAR FROM CRYSTALLIZING FOR A GOOD TEXTURE. TO WEIGH GLUCOSE WITHOUT IT RUNNING EVERYWHERE, MEASURE THE SUGAR INTO THE PAN OF THE SCALE, THEN MAKE A WELL IN THE MIDDLE AND POUR IN THE GLUCOSE.

$1/2$ + $1/3$ cup superfine sugar
1 tablespoon liquid glucose
$2^1/4$ cups black currants, stalks removed
1 tablespoon lemon juice
2 tablespoons crème de cassis

SERVES 4

PUT the sugar and glucose in a saucepan with 1 cup water. Heat gently to dissolve the sugar and then boil for 2–3 minutes. Cool completely.

PUT the black currants and lemon juice in a blender with half of the cooled syrup and mix to a thick purée. (Alternatively, push the fruit through a sieve to purée and then mix with the lemon juice and syrup.) Add the remaining syrup and the crème de cassis and mix well.

CHURN in an ice-cream maker following the manufacturer's instructions. Alternatively, pour into a plastic freezer container, cover and freeze, stirring every 30 minutes with a whisk during freezing to break up the ice crystals for a better texture. Freeze overnight with a layer of plastic wrap over the surface and the lid on the container. Keep in the freezer until ready to serve.

RED WINE SORBET

1 cup superfine sugar
$1/3$ cup orange juice
1 cup light red wine

SERVES 4

DISSOLVE the superfine sugar in 1 cup boiling water, stirring until it has completely dissolved. Add the orange juice and red wine and stir well.

CHURN in an ice-cream maker following the manufacturer's instructions. Alternatively, pour into a plastic freezer container, cover and freeze. Stir every 30 minutes with a whisk during freezing to break up the ice crystals for a better texture. Freeze overnight with a layer of plastic wrap over the surface and the top on the container. Keep in the freezer until ready to serve.

Stir the sugar until it is completely dissolved before adding the orange juice and wine.

MACARON a crisp, melt-in-the-mouth macaroon that comes in bright colors, including brown (chocolate) and green (pistachio), sandwiched with cream. Made of almonds, sugar and egg whites.

BABA AU RHUM a yeast sponge cake soaked in rum-flavored syrup and decorated with crème chantilly and fruit. Can be baba-shaped or made in a round savarin mold (pictured).

MIRLITON a puff-pastry shell filled with preserves and an almond cake mixture, decorated with almonds and an icing glaze. Mirlitons are a specialty of Normandy, especially Rouen.

ÉCLAIR a classic of French pâtisserie, this finger of choux pastry is filled with cream or a plain, coffee or chocolate pastry cream and dipped in chocolate or coffee fondant or caramel.

MERINGUE AUX NOISETTES a basic ingredient of pâtisserie, meringue is mixed here with hazelnuts to form a crisp but chewy ball of hazelnut meringue.

TARTE AUX PÊCHES fruit tarts are one of the most popular and varied pâtisserie items. Here a rectangular pastry shell is filled with pastry cream and peach halves, baked and glazed.

MILLEFEUILLE meaning a thousand leaves, this is made of layered puff pastry, pastry cream and preserves or another filling. The *quadrillage* pattern on top is made with piped icing.

MOUSSE AUX FRAMBOISES a raspberry mousse set on a sponge base and decorated with white chocolate. The piece of clear plastic holds the shape of the mousse until it is served.

GÂTEAU AUX PRUNES a cross between a cake and a tart, the plums are cooked in a brioche-type pastry and then glazed.

TARTE TATIN made famous by the Tatin sisters, this tart is cooked upside down in a special pan, then turned over to reveal a pastry base topped with halved or quartered caramelized apples.

TARTE AUX FRUITS a beautiful mixture of sliced fruit arranged on a pastry and pastry cream base and glazed. This is a creation from Gérard Mulot's pâtisserie in Paris.

PITHIVIERS a puff-pastry shell filled with a frangipane mixture. A version is made for Twelfth Night, when a token is hidden inside and it is decorated with a crown of gold posterboard.

PÂTISSERIE is one of France's most respected culinary arts, one that is even protected by its own patron saint, Saint Honoré. Pâtissiers can become members of several professional organizations, such as The National Confederation of Pastry Chefs and Relais Desserts International Professional Organization of Master Pastry Makers. One of these signs hanging above a pâtisserie shows a real commitment to the trade.

PÂTISSERIE

PÂTISSERIE, THE ART OF CAKE AND PASTRY MAKING, IS THE MOST DELIGHTFUL AND ELABORATE OF CULINARY ARTS—THE ONLY ONE WHERE BEAUTIFUL DECORATION CARRIES EQUAL WEIGHT TO THE FLAVOR OF THE FOOD.

Pâtisserie can be traced back to the simple cakes of the ancient world and the pastry-making of the Middle East, with its use of spices, nuts and sugar. From the Crusades onwards, these techniques and ingredients filtered into Europe, particularly Italy, and when Catherine de Medici arrived at the French court in the sixteenth century with her retinue of Italian chefs, they revolutionized French pâtisserie with their skills, such as the invention of choux pastry. In the early nineteenth century, Antonin Carême became the first of a line of great Parisian *pâtissiers* (pastry chefs). He was famous for his fantastical architectural creations, including croquembouches shaped as famous buildings.

BUYING PÂTISSERIE

Pâtisserie refers not only to the pastries, but also to the place where they are made and sold. Pâtisseries are sometimes solely shops, but often have a *salon de thé* attached where patrons can enjoy a pâtisserie in the mid-morning or afternoon, the favored times for indulging in such a treat. Pâtisseries also sell candied fruits, chocolates, beautiful items to finish a meal or present as a gift. They display their pâtisserie elegantly, and after carefully choosing, customers are presented with their purchases beautifully wrapped.

JOËL DURAND'S chocolates in his Saint Rémy shop are each numbered and described on a "menu." He flavors chocolate with Provençal lavender and herbs, green tea, Sichuan pepper and jasmine. The flavors change with the season—number 28 is perfumed with rose petals in summer and Carmargue saffron the rest of the year. Number 30, known as "Provence," is a mix of olives from Les Baux and praline.

REGIONAL PÂTISSERIE

Each area of France has its own pâtisserie specialties. In Alsace-Lorraine in the Northeast, there are Austrian-inspired Kugelhopf and strudels and wonderful fruit tarts, especially those using mirabelle plums. Paris is famed for its pâtisserie shops and dark, bitter chocolate is a northern specialty, especially in the cork-shaped *bouchons* from Champagne. In the Northwest, Brittany and Normandy's dairy farming and apples are used to create buttery Breton cookies and the finest *tarte aux pommes*. In the East and Center, Lyon is home to Bernachon, one of France's finest *pâtisseries-confiseries*, while *pain d'épices*, a spicy gingerbread, has been made in Dijon since the fifteenth century. The Southwest is known for its rural Basque cooking, which includes *gâteau basque*, as well as famous *macarons* from Saint Emilion and tarts made with Agen prunes. In the South, with its abundance of fruit, there are candied fruit and *marrons* (chestnuts).

FRUIT CONFITS are a specialty of Provence and were originally a way to store soft fruit through the winter. Lilamand Confiseur is one of the last independent producers of the jewel-like fruits, which must be made with fruits flavorful enough to be tasted through the sugar.

FRAISIER fresh strawberries in a crème mousseline (a rich butter cream) and sandwiched between two layers of almond genoise sponge.

DACQUOISE in this version of a southwestern specialty, two or three layers of nut meringues are sandwiched with strawberries and crème chantilly.

JALOUSIE a puff-pastry slice with a sweet topping and a lattice or slatted pastry top. *Jalousie* is French for a slatted window blind, though today the pastry tends to have a lattice top.

CANNELÉ a specialty of the Bordeaux region, these tall little rum-flavored cakes are baked in ridged molds, which gives them their fluted sides.

MAGIE NOIR a rich chocolate cake meaning "black magic" and decorated with pieces of praline. A specialty of Gérard Mulot's pâtisserie in Paris to be served on a special occasion.

PÊCHES two hollowed out brioche filled with pastry cream, sandwiched together and decorated with red currant jelly to look like little peaches.

PETITS FOURS here a selection of tiny pastries, each a miniature version of its larger namesake and bought by weight. Petits fours can also refer to cookies, such as tuiles and macaroons.

TRIANGLES a specialty of Le Petit Duc pâtisserie in Saint Rémy in Provence, these triangles have a pastry base with a topping of Provençal almonds and honey.

LE SUCCÈS two layers of an almond meringue cake filled and topped with praline or chocolate butter cream and decorated with sliced nuts. Each pâtisserie has its own version of this cake.

CALISSONS from Aix-en-Provence, these square- or diamond-shaped candies are made from almonds and candied fruit and are topped with a sugar icing.

GÂTEAU SAINT HONORÉ this ring of choux and buttery pastry is filled with pastry cream and topped with balls of choux and caramel. It is named after the patron saint of pastry chefs.

TARTE AUX FRAISES a tart of strawberries sitting on a *pâte brisée* (a classic French pastry) and crème pâtissière base. The strawberries are heavily glazed to give them a glowing shine.

PITHIVIERS

ORIGINATING IN PITHIVIERS IN THE LOIRE VALLEY, THIS PASTRY IS TRADITIONALLY SERVED ON TWELFTH NIGHT, WHEN IT IS KNOWN AS *GALETTE DES ROIS* AND USUALLY CONTAINS A BEAN THAT BRINGS GOOD LUCK TO WHOMEVER FINDS IT IN THEIR SLICE.

FILLING
1/2 cup unsalted butter, at room
 temperature
1/2 cup superfine sugar
2 large eggs, lightly beaten
2 tablespoons dark rum
finely grated zest of 1 small orange
 or lemon
3/4 cup ground almonds
21/2 tablespoons all-purpose flour

1 batch puff pastry (page 281)
1 egg, lightly beaten
confectioners' sugar

SERVES 6

TO MAKE the filling, beat the butter and sugar together until pale and creamy. Mix in the beaten eggs, little by little, beating well after each addition. Beat in the rum and the orange or lemon zest and then lightly fold in the almonds and flour. Put the filling in the fridge to firm up a little while you roll out the pastry.

CUT the pastry in half and roll out one half. Cut out an 11-inch circle and place the circle on a large baking sheet lined with waxed paper. Spread the filling over the pastry, leaving a clear border of about 3/4 inch all the way around. Brush a little beaten egg over the clear border to help the two halves stick together.

ROLL OUT the other half of the pastry and cut out a second circle, the same size as the first. Lay this circle on top of the filling and firmly press the edges of the pastry together. Cover and put in the refrigerator for at least 1 hour (several hours or even overnight is fine).

PREHEAT the oven to 425°F. Brush all over the top of the pie with the beaten egg to give it a shiny glaze—be careful not to brush egg on the side of the pie or the layers won't rise properly. Working from the center to the outside edge, score the top of the pithiviers with curved lines in a spiral pattern.

BAKE the pithiviers for 25–30 minutes, or until it has risen and is golden brown. Dust with confectioners' sugar and allow to cool. Cut into slices to serve.

Leave a clear border around the filling, then brush it with egg to help the two halves of the pastry stick together.

PARIS-BREST

THIS LARGE CHOUX PASTRY CAKE WAS NAMED AFTER THE PARIS-BREST BICYCLE RACE. IT WAS INVENTED IN 1891 BY A CANNY PARISIAN BAKER WHO OWNED A SHOP ALONG THE ROUTE AND HAD THE IDEA OF PRODUCING THESE BICYCLE WHEEL-SHAPED CAKES.

1 batch choux pastry (page 282)
1 egg, lightly beaten
1 1/2 tablespoons sliced almonds
1 batch crème pâtissière
 (page 285)
confectioners' sugar

PRALINE
1/3 cup superfine sugar
1 cup sliced almonds

SERVES 6

PREHEAT the oven to 400°F and put the choux pastry in a pastry bag fitted with a wide tip (about 3/4 inch wide). Draw an 8-inch circle on the back of a piece of waxed paper in a dark pen so that the circle shows through on the other side. Put the paper on a baking sheet, pen side down.

PIPE a ring of pastry over the guide you have drawn. Now pipe another ring of pastry directly inside this one so that you have one thick ring. Pipe another two circles on top of the first two and continue until all the choux pastry has been used. Brush the choux ring with beaten egg and sprinkle with the sliced almonds.

BAKE the choux ring for 20–30 minutes, then reduce the oven to 350°F and bake for another 20–25 minutes. Remove from the baking sheet and place on a wire rack. Immediately slice the ring in half horizontally, making the base twice as deep as the top. Take off the top and scoop out any uncooked pastry from the base. Allow to cool completely.

TO MAKE the praline, grease a sheet of aluminum foil and lay it flat on the work surface. Put the sugar in a small saucepan with 1/3 cup water and heat gently until completely dissolved. Bring to a boil and cook until deep golden, then quickly pour in the sliced almonds and pour onto the greased foil. Spread a little and allow to cool. When the praline has hardened, grind it to a fine powder in a food processor or with a mortar and pestle. Mix into the cold crème pâtissière.

SPOON the crème pâtissière into the bottom of the choux pastry ring and cover with the top. Dust with confectioners' sugar to serve.

Pipe a thick ring of choux pastry over the guide.

APPLE TART

1 batch sweet pastry (page 278)
1/2 batch crème pâtissière
 (page 285)
4 eating apples
1/4 cup apricot preserves

SERVES 8

PREHEAT the oven to 350°F. Roll out the pastry to line a 9-inch round loose-bottomed fluted tart pan. Chill in the refrigerator for 20 minutes.

LINE the pastry shell with a crumpled piece of waxed paper and baking beads (use dried beans or rice if you don't have beads). Blind bake the pastry for 10 minutes, remove the paper and beads and bake for another 3–5 minutes, or until the pastry is just cooked but still very pale.

FILL the pastry with the crème pâtissière. Peel and core the apples, cut them in half and then into thin slices. Arrange over the top of the tart and bake for 25–30 minutes or until the apples are golden and the pastry is cooked. Allow to cool completely, then melt the apricot preserves with 1 tablespoon water, strain to remove any lumps and brush over the apples to make them shine.

APPLE TART

TARTE AU CITRON

1 batch sweet pastry (page 278)

FILLING
4 eggs
2 egg yolks
1 cup superfine sugar
1/3 cup heavy cream
1 cup lemon juice
finely grated zest of 3 lemons

SERVES 8

PREHEAT the oven to 375°F. Roll out the pastry to line a 9-inch round loose-bottomed fluted tart pan. Chill in the refrigerator for 20 minutes.

TO MAKE the filling, whisk together the eggs, egg yolks and sugar. Add the cream, whisking all the time, and then the lemon juice and zest.

LINE the pastry shell with a crumpled piece of waxed paper and baking beads (use dried beans or rice if you don't have beads). Blind bake the pastry for 10 minutes, remove the paper and beads and bake for another 3–5 minutes, or until the pastry is just cooked but still very pale. Remove from oven and reduce the temperature to 300°F.

PUT the pan on a baking sheet and carefully pour the filling into the pastry shell. Return to the oven for 35–40 minutes, or until the filling has set. Allow to cool completely before serving.

Whisking the lemon filling for the tarte au citron.

MIXED BERRY TARTLETS

1 batch sweet pastry (page 278)
1 batch frangipane (page 285)
3¼ cup mixed berries
3 tablespoons apricot preserves

MAKES 10

PREHEAT the oven to 350°F. Roll out the pastry about ⅛ inch thick and use to line ten 3-inch-wide tartlet pans. Put the frangipane in a pastry bag and pipe into the tartlet pans. Put the pans on a baking sheet and bake for 10–12 minutes, or until golden.

COOL SLIGHTLY on a wire rack, then arrange the berries on top. Melt the preserves with 1 teaspoon water, strain to remove any lumps and brush over the berries to make them shine.

MIXED BERRY TARTLETS

PEAR AND ALMOND TART

1 batch sweet pastry (page 278)
¼ cup superfine sugar
1 vanilla bean
3 pears (ripe but still firm), peeled, halved and cored
3 tablespoons apricot preserves

ALMOND FILLING
⅔ cup unsalted butter, softened
⅔ cup superfine sugar
few drops of vanilla extract
2 large eggs, lightly beaten
¾ cup ground almonds
finely grated zest of 1 small lemon
3 tablespoons all-purpose flour

SERVES 8

PREHEAT the oven to 375°F. Roll out the pastry to line a 9-inch round loose-bottomed fluted tart pan. Chill in the refrigerator for 20 minutes.

PUT the sugar and vanilla bean in a saucepan. Add the pears and pour in just enough water to cover them, then remove the pears. Bring the water to a simmer and cook for 5 minutes. Add the pears, cover and poach for 5–10 minutes until tender. Drain and allow to cool.

TO MAKE the almond filling, beat the butter, sugar and vanilla extract together until pale and creamy. Beat in the eggs gradually and then fold in the almonds, lemon zest and flour.

LINE the pastry shell with a crumpled piece of waxed paper and baking beads (use dried beans or rice if you don't have beads). Blind bake the pastry for 10 minutes, remove the paper and beads and bake for another 3–5 minutes, or until the pastry is just cooked but still very pale. Reduce the oven to 350°F.

SPREAD three-quarters of the filling in the pastry shell and put the pears on top, cut side down and stem ends in the middle. Fill the gaps with the remaining filling. Bake for 35–40 minutes, or until the filling is golden and firm. Melt the preserves with 1 teaspoon water, strain to remove any lumps and brush over the pears to make them shine.

Arrange the pears cut side down in the pastry shell with the stems pointing to the center.

APPLES AND PEARS IN PASTRY

IN LATE SUMMER AND AUTUMN, WHEN THE ORCHARDS ARE OVERFLOWING WITH FRUIT, THE NORMAN COOK MAKES *BOURDELOTS* OR *DOUILLONS*. THESE PASTRY-WRAPPED APPLES OR PEARS COULD ALSO CONTAIN A DRIZZLE OF CALVADOS.

PASTRY
2/3 cup unsalted butter
1 3/4 cups all-purpose flour
2 tablespoons superfine sugar
1 egg yolk

HAZELNUT FILLING
1/4 cup hazelnuts, finely chopped
1/4 cup unsalted butter, softened
1/3 cup brown sugar
pinch of pumpkin pie spice

2 eating apples
2 pears (ripe but still firm)
juice of 1 lemon
1 egg, lightly beaten

SERVES 4

TO MAKE the pastry, rub the butter into the flour until the mixture resembles fine bread crumbs. Stir in the sugar. Add the egg yolk and 2–3 tablespoons water and stir with a knife to form a dough. Turn out the dough and bring together with your hands. Wrap in plastic wrap and refrigerate for at least 30 minutes. Preheat the broiler.

TO MAKE the hazelnut filling, toast the hazelnuts under the hot broiler for 1–2 minutes or until browned, then cool. Mix the softened butter with the sugar, hazelnuts and pumpkin pie spice. Peel and core the apples and pears, leaving the stems and trimming the bottoms of the pears if they are too big. Roll in the lemon juice and stuff with the hazelnut filling. Reduce the oven to 400°F.

ROLL OUT the pastry to make a 13-inch square, trimming off any uneven edges. Cut into four equal squares and place an apple or pear in the center of each. Brush the edges of the pastry with water and then bring them up so that the corners of each pastry square meet at the top of the fruit. Press the edges together so that the pastry follows the curve of the fruit.

CUT OFF the excess pastry and crimp the edges to seal the fruit packages thoroughly. Use the pastry trimmings to cut out leaves, then stick these onto the fruit by brushing the backs with water.

BRUSH the pastry fruits with the beaten egg to glaze and bake on a lightly greased baking sheet for 35–40 minutes or until the pastry is cooked and browned. Serve with cream.

Bring up the four corners of the pastry square so they meet at the top of the fruit.

Dinner in Saint Rémy.

Wedge the apples tightly into the pan—they shrink as they cook.

TARTE TATIN

THIS FAMOUS DESSERT IS NAMED AFTER THE TATIN SISTERS WHO RAN A RESTAURANT NEAR ORLÉANS AT THE BEGINNING OF THE TWENTIETH CENTURY. THEY CERTAINLY POPULARIZED THE DISH, BUT MAY NOT HAVE INVENTED IT THEMSELVES.

3 lb. eating apples
1/4 cup unsalted butter
3/4 cup superfine sugar
1 batch tart pastry (page 278)

CRÈME CHANTILLY
3/4 cup heavy cream
1 teaspoon confectioners' sugar
1/2 teaspon vanilla extract

SERVES 8

PEEL, CORE and cut the apples into quarters. Put the butter and sugar in a deep 10-inch frying pan with a flameproof handle. Heat until the butter and sugar have melted together. Arrange the apples tightly, one by one, in the frying pan, making sure there are no gaps. Remember that you will be turning the tart out with the apples on top, so arrange the apple pieces neatly underneath.

COOK over low heat for 35–40 minutes, or until the apple is soft, the caramel is lightly browned and any excess liquid has evaporated. Baste the apple with a pastry brush every so often, so that the top is caramelized as well. Preheat the oven to 375°F.

ROLL OUT the pastry on a lightly floured surface into a circle slightly larger than the frying pan and about 1/8 inch thick. Lay the pastry over the apple and press down around the edge to enclose it completely. Roughly trim the edge of the pastry and then fold the edge back on itself for a neat finish.

BAKE FOR 25–30 minutes, or until the pastry is golden and cooked. Remove from the oven and allow to rest for 5 minutes before turning out. (If any apple sticks to the pan, just push it back into its place in the tart.)

TO MAKE the crème chantilly, put the cream, confectioners' sugar and vanilla extract in a chilled bowl. Whisk until soft peaks form and then serve with the hot tarte tatin.

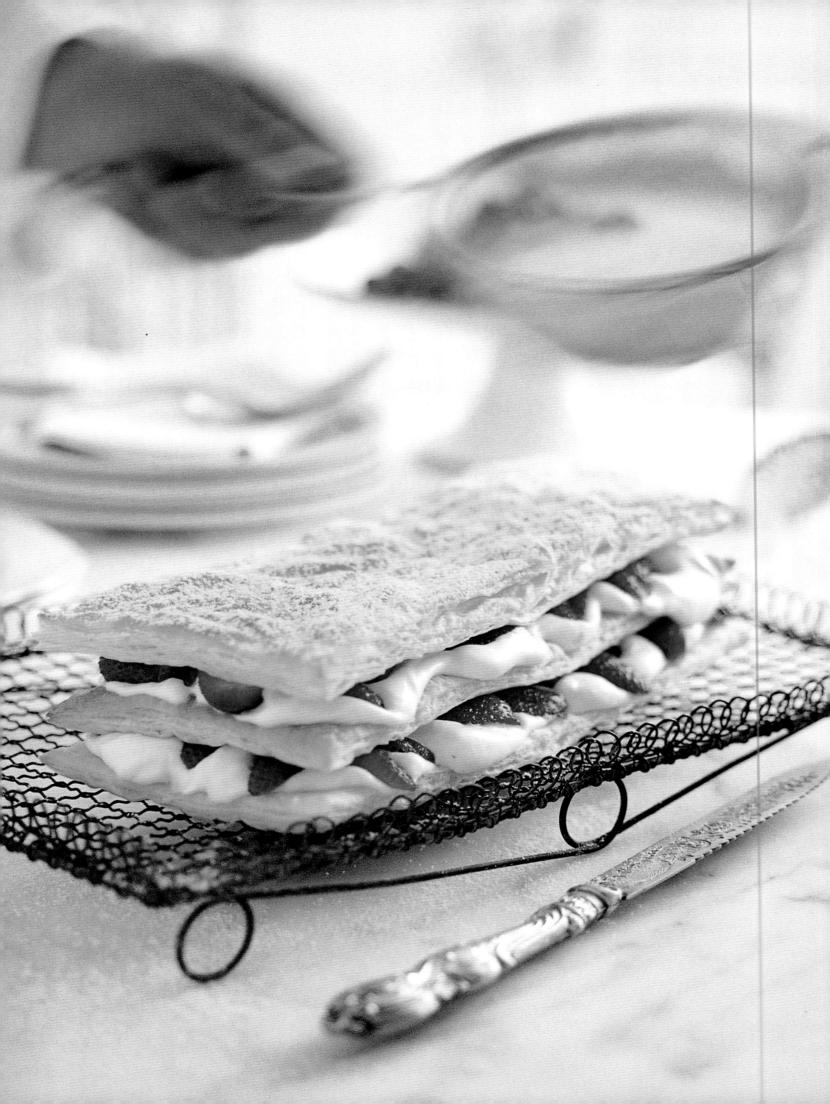

STRAWBERRY MILLEFEUILLE

1 batch puff pastry (page 281)
5 tablespoons sugar
1/2 batch crème pâtissière
 (page 285)
1/2 cup whipping cream
1 3/4 cups strawberries, cut into
 quarters
confectioners' sugar

SERVES 6

PREHEAT the oven to 350°F. Roll out the puff pastry on a lightly floured surface into a rectangle about 1/8 inch thick. Roll the pastry around a rolling pin, then unroll it onto a baking sheet lined with waxed paper. Put in the refrigerator for 15 minutes.

TO MAKE the syrup, put the sugar and 3/4 cup water in a saucepan and boil for 5 minutes, then remove from the heat.

CUT OUT three 12 x 5 inch rectangles from the pastry and place them on a large baking sheet. Prick with a fork, cover with a sheet of waxed paper and place a second baking sheet on top to prevent the pastry from rising unevenly. Bake for 6 minutes, then remove the top baking sheet and waxed paper. Brush the pastry with the syrup and bake for another 6 minutes or until golden on top. Cool on a wire rack.

WHISK the crème pâtissière. Whip the cream and fold into the crème pâtissière. Spread half of this over one pastry rectangle and top with half of the strawberries. Place a second layer of pastry on top and spread with the remaining cream and strawberries. Cover with the last layer of pastry and dust with confectioners' sugar to serve.

Madeleines are baked in small scallop-shaped molds.

MADELEINES

3 eggs
1/3 cup superfine sugar
1 1/4 cups all-purpose flour
1/3 cup unsalted butter, melted
grated zest of 1 lemon and
 1 orange

MAKES 14 (OR 30 SMALL ONES)

PREHEAT the oven to 400°F. Brush a tray of madeleine molds with melted butter and coat with flour, then tap the tray to remove the excess flour.

WHISK the eggs and sugar until the mixture is thick and pale and the whisk leaves a trail when lifted. Gently fold in the flour, then the melted butter and grated lemon and orange zest. Spoon into the molds, leaving a little room for rising. Bake for 12 minutes (small madeleines will only need 7 minutes), or until very lightly golden and elastic to the touch. Remove from the molds and cool on a wire rack.

MADELEINES

GÂTEAU BASQUE

THE BASQUE COUNTRY IS SQUEEZED INTO THE SOUTHWESTERN CORNER OF FRANCE, BORDERED BY THE SEA ON ONE SIDE AND SPAIN ON THE OTHER. JUST ABOUT EVERY BASQUE HOUSEHOLD HAS ITS OWN RECIPE FOR THIS BAKED TART, WHICH IS ALSO KNOWN AS *VÉRITABLE PASTIZA*.

ALMOND PASTRY
13 oz. all-purpose flour
1 teaspoon finely grated lemon zest
1/4 cup ground almonds
2/3 cup superfine sugar
1 egg
1 egg yolk
1/4 teaspoon vanilla extract
2/3 cup unsalted butter, softened

ALMOND CRÈME PÂTISSIÈRE
6 egg yolks
3/4 cup superfine sugar
1/2 cup all-purpose flour
1/3 cup ground almonds
4 cups milk
4 vanilla beans

4 tablespoons thick black cherry or
 plum preserves
1 egg, lightly beaten

SERVES 8

TO MAKE the pastry, mix the flour, lemon zest and almonds together, turn out onto a work surface and make a well in the center. Put the sugar, egg, egg yolk, vanilla extract and butter in the well.

MIX TOGETHER the sugar, eggs and butter, using a pecking action with your fingertips and thumb. Once they are mixed, use the edge of a flexible bladed knife to incorporate the flour, flicking it onto the dough and then chopping through it. Bring the dough together with your hands. Wrap in plastic wrap and put in the refrigerator for at least 30 minutes.

ROLL OUT two-thirds of the pastry to fit a 10-inch tart ring. Trim the edge and chill in the fridge for another 30 minutes. Preheat the oven to 350°F.

TO MAKE the almond crème pâtissière, whisk together the egg yolks and sugar until pale and creamy. Sift in the flour and ground almonds and mix together well. Put the milk in a saucepan. Split the vanilla beans in two, scrape out the seeds and add the beans and seeds to the milk. Bring just to a boil, then strain over the egg yolk mixture, stirring continuously. Pour back into the clean saucepan and bring to a boil, stirring constantly—it will be lumpy at first but will become smooth as you stir. Boil for 2 minutes, then allow to cool.

SPREAD the preserves over the bottom of the pastry shell, then spread with the crème pâtissière. Roll out the remaining pastry to make a top for the pie. Brush the edge of the pastry shell with beaten egg, put the pastry top over it and press together around the side. Trim the edge. Brush the top of the pie with beaten egg and gently score in a criss-cross pattern. Bake for 40 minutes, or until golden brown. Cool for at least 30 minutes before serving, either slightly warm or cold.

Use the best-quality preserves you can find to spread over the pastry shell. Spoon in the crème pâtissière over the top.

RAISIN RUM BABA

THE BABA IS THOUGHT TO HAVE ITS ORIGINS IN POLAND AND WAS INTRODUCED TO FRANCE BY A
PARISIAN PASTRY COOK AFTER A VISIT BY THE POLISH COURT. BABAS CAN BE MADE IN DARIOLE OR
PUDDING MOLDS OR IN A SAVARIN MOLD, AS HERE.

3 teaspoons dried yeast or $2/3$ oz.
 fresh yeast
$1/3$ cup warm milk
1 tablespoon superfine sugar
1 large egg
2 large egg yolks
finely grated zest of 1 small orange
$1^1/3$ cups all-purpose flour
$1/3$ cup raisins
$1/4$ cup unsalted butter, melted

ORANGE RUM SYRUP
1 cup superfine sugar
2 tablespoons orange juice
4 tablespoons dark rum

SERVES 8

MIX the yeast with half of the warm milk and
1 teaspoon of the sugar. Allow to rest for
10 minutes in a warm place until the yeast
becomes frothy. If the yeast does not bubble and
foam in this time, throw it away and start again.

WHISK together the egg, egg yolks and remaining
sugar and stir in the orange zest. Sift the flour into
a large bowl and make a well in the center. Pour
the yeast mixture and egg mixture into the well
and add the raisins. Gradually stir in the flour,
dribbling in the rest of the warm milk as you do
so. Once the ingredients are thoroughly mixed,
add the melted butter, little by little, mixing well.
Work the dough with your hands for 10 minutes,
raising it high and dropping it into the bowl, until
the dough is very soft. Cover with greased plastic
wrap and allow to rise in a warm place for
$1^1/4$ hours or until the dough has doubled in size.

TO MAKE the orange rum syrup, put the sugar in
a saucepan with $1^1/3$ cups water. Bring to a boil,
and boil for 3 minutes. Remove from the heat and
add the orange juice and rum. Set aside.

DEFLATE the dough by punching it with your fist
several times to expel the air, and then lightly
knead it again for a minute. Put it in a buttered
5-cup savarin mold. Cover with greased plastic
wrap and allow to rise in a warm place for
20–30 minutes, or until risen almost to the top
of the pan. Preheat the oven to 375°F.

BAKE the baba for 25–30 minutes, covering the
top with aluminum foil if it is over-browning.
Remove from the oven and, while still in the mold,
prick all over the top of the baba with a skewer.
Drizzle some of the syrup over the top of the baba
and allow it to soak in before drizzling with the
rest. Allow to stand for 15 minutes, before turning
out onto a large serving plate to serve.

Bake the rum baba in the
buttered savarin mold. Keep it in
the mold while you drizzle the
syrup over the top, letting the
syrup soak in completely.

BASICS

Because brioche dough has so much butter in it, you will notice that it is heavier to knead than bread dough.

BRIOCHE

BRIOCHE IS SO BUTTERY THAT YOU CAN SERVE IT UP FOR BREAKFAST WITH NOTHING MORE FANCY THAN SOME GOOD-QUALITY PRESERVES OR CURD. IF YOU HAVE ONE, USE A FLUTED BRIOCHE PAN, IF NOT, AN ORDINARY LOAF PAN WILL BE FINE.

2 teaspoons dried yeast or $^1/_2$ oz.
 fresh yeast
$^1/_4$ cup warm milk
2 tablespoons superfine sugar
1$^3/_4$ cups all-purpose flour
pinch of salt
2 large eggs, lightly beaten
few drops vanilla extract
$^1/_3$ cup butter, cubed
lightly beaten egg, to glaze

MAKES 1 LOAF

MIX the yeast with the warm milk and 1 teaspoon of the sugar. Allow to stand for 10 minutes in a warm place until the yeast becomes frothy. If the yeast does not bubble and foam in this time, throw it away and start again.

SIFT the flour into a large bowl and sprinkle with the salt and the rest of the sugar. Make a well in the center and add the eggs, vanilla extract and yeast mixture. Use a wooden spoon to mix all the ingredients together, then use your hands to knead the dough for a minute to bring it together. Transfer to a lightly floured work surface and gradually knead in the butter, piece by piece. Knead for 5 minutes, then put the dough in a clean bowl and cover with greased plastic wrap. Allow to rise in a draft-free place for 1–1$^1/_2$ hours or until the dough has doubled in size.

DEFLATE the dough by punching it with your fist several times to expel the air, and then lightly knead it again for a couple of minutes. Shape the dough into a rectangle and place in an 8 x 2$^3/_4$ x 3$^1/_2$ inch buttered loaf pan. Cover with greased plastic wrap and allow the dough to rise in a draught-free place for 30–35 minutes, or until risen almost to the top of the pan. Preheat the oven to 400°F.

ONCE the brioche has risen, use a pair of scissors to carefully snip into the top of the dough at regular intervals. Snip three times on each side and twice at each end. The cuts should only be about 1 inch deep. This will give the top of the loaf its traditional bubble shape. Brush the top with egg to glaze and bake for 30–35 minutes, or until the top is deeply golden. Turn the hot brioche out of the pan and tap the bottom of the loaf—if it sounds hollow, it is cooked. Put it back in the pan upside-down and return to the oven for 5 minutes to crisp the bottom. Transfer to a wire rack and allow to cool.

BREAD DOUGH

HAVE LUNCH WITH THICK SLICES OF THIS RUSTIC BREAD WITH UNSALTED BUTTER AND A GOOD CHEESE. THIS IS A BASIC BREAD DOUGH AND IS EASILY FLAVORED—YOU COULD ADD CHOPPED WALNUTS, FRESH HERBS, OLIVES OR CHEESE.

2 teaspoons dried yeast or
$1/2$ oz. fresh yeast
2 cups bread flour
$1/2$ teaspoon salt
3 tablespoons olive oil

MAKES 1 LOAF

MIX the yeast with $1/2$ cup warm water. Allow to stand for 10 minutes in a warm place until the yeast becomes frothy. If the yeast does not bubble and foam in this time, throw it away and start again.

SIFT the flour into a large bowl and add the salt, olive oil and the yeast mixture. Mix until the dough clumps together and forms a ball.

TURN OUT onto a lightly floured work surface. Knead the dough, adding a little more flour or a few drops of warm water if necessary, until you have a soft dough that is not sticky but is dry to the touch. Knead for 10 minutes, or until smooth, and the impression made by a finger springs back immediately.

RUB the inside of a large bowl with olive oil. Roll the ball of dough around in the bowl to coat it with oil, then cut a shallow cross on the top of the ball with a sharp knife. Leave the dough in the bowl, cover with a kitchen towel or put in a plastic bag and allow to rest in a draft-free place for 1–$1^1/2$ hours or until the dough has doubled in size (or put it in the refrigerator for 8 hours to rise slowly).

DEFLATE the dough by punching it with your fist several times to expel the air and then knead it again for a couple of minutes. (At this stage the dough can be stored in the refrigerator for 4 hours, or frozen. Bring back to room temperature before continuing.) Allow to rest in a warm place to rise until doubled in size. Place in a pan, on a baking sheet or use as directed in the recipe, then bake at 450°F for 30 minutes. When it is cooked, the base of the bread will sound hollow.

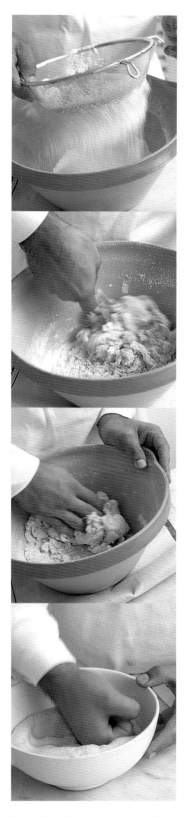

Use flour that is packaged as bread flour. You can also use all-purpose flour or a mixture of all-purpose and whole wheat, but the result won't be as good.

When making the sweet pastry it is easiest to work directly on the work surface.

TART PASTRY

1³/₄ cups all-purpose flour
pinch of salt
²/₃ cup unsalted butter, chilled
 and cubed
1 egg yolk

MAKES 14 OZ.

SIFT the flour and salt into a large bowl, add the butter and rub in with your fingertips until the mixture resembles bread crumbs. Add the egg yolk and a little cold water (about 2–3 teaspoons) and mix with a flexible bladed knife until the dough just starts to come together. Bring the dough together with your hands and shape into a ball. Wrap in plastic wrap and put in the refrigerator to rest for at least 30 minutes. You can also make the dough in a food processor, using the pulse button.

ROLL OUT the pastry into a circle on a lightly floured surface and use to line a tart pan, as directed in the recipe. Trim the edge and pinch around the pastry edge to make an even border raised slightly above the rim of the pan. Slide onto a baking sheet and put in the refrigerator for 10 minutes.

SWEET PASTRY

2³/₄ cups all-purpose flour
small pinch of salt
²/₃ cup unsalted butter
³/₄ cup confectioners' sugar
2 eggs, beaten

MAKES 1 LB. 6 OZ.

SIFT the flour and salt onto a work surface and make a well in the center. Put the butter into the well and work, using a pecking action with your fingertips and thumb, until it is very soft. Add the sugar to the butter and mix together. Add the eggs to the butter and mix together.

GRADUALLY incorporate the flour, flicking it onto the mixture and then chopping through it until you have a rough dough. Bring together with your hands and then knead a few times to make a smooth dough. Roll into a ball, wrap in plastic wrap and put in the refrigerator for at least 1 hour.

ROLL OUT the pastry into a circle on a lightly floured surface and use to line a tart pan, as directed in the recipe. Trim the edge and pinch around the pastry edge to make an even border raised slightly above the rim of the pan. Slide onto a baking sheet and allow to rest in the refrigerator for 10 minutes.

SWEET PASTRY

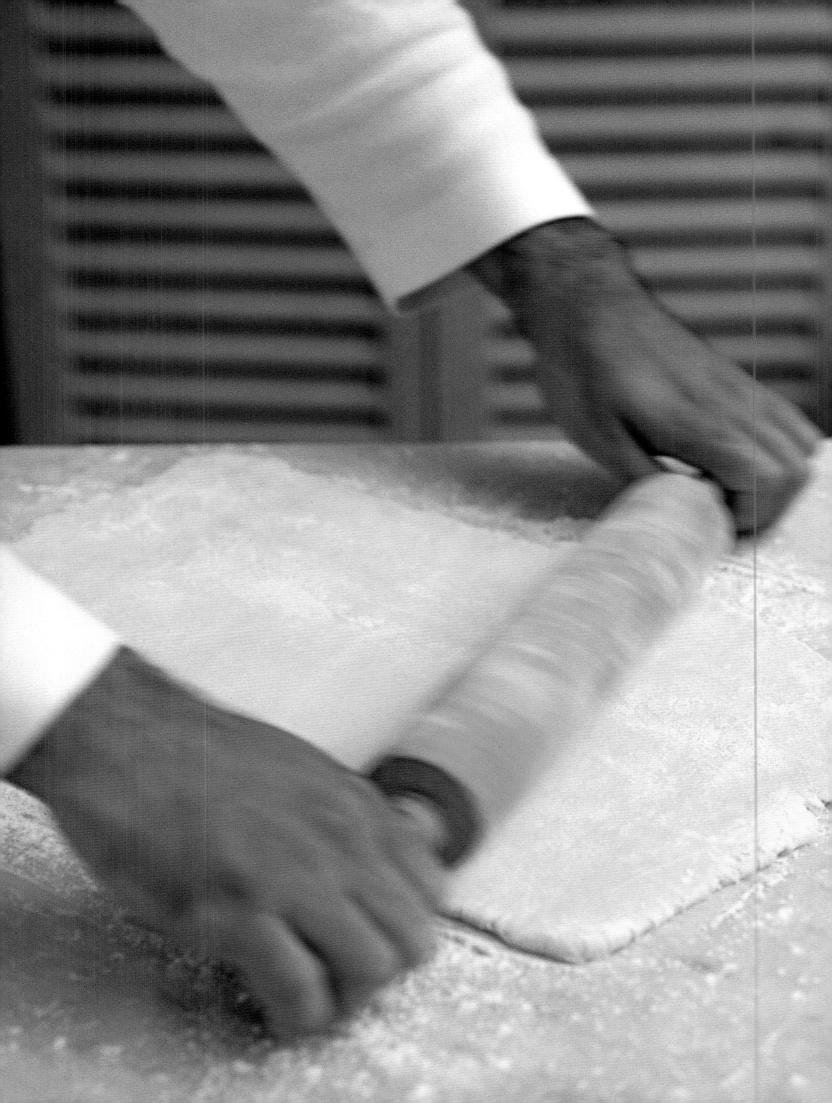

PUFF PASTRY

LIGHTNESS IS THE HALLMARK OF GOOD PUFF PASTRY AND THE MANY LAYERS SHOULD RISE WITHOUT
STICKING. THE KEY IS TO HAVE THE BUTTER AND PASTRY AT THE SAME CONSISTENCY WHEN YOU ROLL
THEM OUT, AND TO KEEP THE ROLLING AND FOLDING AS NEAT AS YOU CAN.

2 cups all-purpose flour
1 teaspoon lemon juice
1 teaspoon salt
2 tablespoons butter, melted
³/₄ cup butter, chilled

MAKES 1 LB. 5 OZ.

SIFT the flour into a bowl and make a well in the
center. Pour in ¹/₂ cup water, the lemon juice, salt
and melted butter. Draw in the flour with your
fingertips, little by little, until you have a rough
dough. Turn out onto a work surface and knead
with the heel of your hand until the dough is
smooth. Shape into a ball and cut a cross on
the top. Wrap with plastic wrap and refrigerate
for 1–2 hours.

PLACE the chilled butter between two pieces of
waxed paper and beat with a rolling pin to make
a square ¹/₂–³/₄ inch thick. Keep the butter cool
so that it doesn't harden again or melt any
further—it needs to be about the same softness
as the pastry or it will break up when you roll it.

ON A LIGHTLY floured surface, roll out the dough
in four different directions to form a cross large
enough to hold the square of butter in its center.
Put the butter in the center and fold the four arms
of dough over it, one by one, to enclose the
butter completely. Position the dough so that it
looks like a book with the spine to the left and the
open piece of dough to the right. Roll the pastry
away from you into a rectangle, keeping the
corners as square as you can, then fold the top
third down and the bottom third up to make a
package of three even layers. Turn the pastry
90 degrees to the right and repeat the rolling,
folding and turning, trying to keep the corners
neat and square—this will help make the pastry
layers even. Wrap in plastic wrap and chill for
30 minutes. (You can mark the pastry with finger
indents each time you refrigerate so you
remember how many turns you have made.)

REPOSITION the pastry as before, with the hinge
to your left, then roll out, fold, turn and chill twice
more. Allow to rest for 30 minutes, then make two
more turns as before. The pastry is ready to use.

Although it can be time-
consuming to make, homemade
puff pastry that uses butter will
always taste better than
commercial pastry, which is often
made with vegetable fat.

CHOUX PASTRY

2/3 cup unsalted butter
1³/₄ cups all-purpose flour, sifted
 twice
7 eggs
1 tablespoon superfine sugar

MAKES 1 LB.

MELT the butter with 1¹/₂ cups water in a saucepan, then bring it to a rolling boil. Remove from the heat and add all the flour at once and a pinch of salt. Return to the heat and beat continuously with a wooden spoon to make a smooth shiny paste that comes away from the side of the pan. Cool for a few minutes.

BEAT IN the eggs one at a time, until shiny and smooth—the mixture should drop off the spoon but not be too runny. Beat in the sugar. Store in a pastry bag in the refrigerator for up to 2 days.

Sift in the flour and stir until the choux dough comes away from the side of the pan.

CRÊPES

2 cups all-purpose flour
pinch of salt
1 teaspoon sugar
2 eggs, lightly beaten
1²/₃ cups milk
1 tablespoon melted butter
butter or oil, for frying

MAKES 12 SMALL OR
6 LARGE CRÊPES

SIFT the flour, salt and sugar into a bowl and make a well in the center. Mix the eggs and milk together with ¹/₃ cup water and pour slowly into the well, whisking all the time to incorporate the flour until you have a smooth batter. Stir in the melted butter. Cover and refrigerate for 20 minutes.

HEAT a crêpe pan or a deep non-stick frying pan and grease with a little butter or oil. Pour in enough batter to coat the bottom of the pan in a thin even layer and pour out any excess. Cook over moderate heat for about a minute, or until the crêpe starts to come away from the side of the pan. Turn the crêpe and cook on the other side for 1 minute or until lightly golden. Stack the crêpes on a plate with pieces of waxed paper between them and cover with aluminum foil while you cook the rest of the batter.

CHOUX PASTRY

CRÈME PÂTISSIÈRE

6 egg yolks
1/2 cup superfine sugar
1/4 cup cornstarch
1 tablespoon all-purpose flour
2 1/4 cups milk
1 vanilla bean
1 tablespoon butter

MAKES 1 LB.

WHISK together the egg yolks and half the sugar until pale and creamy. Sift in the cornstarch and flour and mix together well.

PUT the milk, remaining sugar and vanilla bean in a saucepan. Bring just to a boil, then strain over the egg yolk mixture, stirring continuously. Pour back into a clean saucepan and bring to a boil, stirring constantly—it will be lumpy at first but will become smooth as you stir. Boil for 2 minutes, then stir in the butter and allow to cool. Transfer to a clean bowl, lay plastic wrap on the surface to prevent a skin from forming and refrigerate for up to 2 days.

CRÈME PÂTISSIÈRE

CRÈME ANGLAISE

1 1/4 cups milk
1 vanilla bean
2 egg yolks
2 tablespoons superfine sugar

MAKES 1 1/4 CUPS

PUT the milk in a saucepan. Split the vanilla bean in two, scrape out the seeds and add the bean and seeds to the milk. (If you don't want the black specks of vanilla seeds, leave the vanilla bean whole.) Bring just to a boil. Whisk the egg yolks and sugar until light and fluffy. Strain the milk over the egg mixture, whisking continuously.

POUR the custard sauce back into the saucepan and cook, stirring, until it is thick enough to coat the back of a wooden spoon. Do not let it boil or the custard sauce will curdle. Strain into a clean bowl, lay plastic wrap on the surface to prevent a skin from forming and refrigerate for up to 2 days.

FRANGIPANE

FRANGIPANE

1 cup unsalted butter, softened
2 cups confectioners' sugar
1 1/3 cups ground almonds
1/3 cup all-purpose flour
5 eggs, lightly beaten

MAKES 1 LB. 10 OZ.

BEAT the butter until very soft. Add the confectioners' sugar, ground almonds and flour and beat well. Add the egg gradually, beating until fully incorporated. Transfer to a clean bowl, cover with plastic wrap and refrigerate for up to 24 hours.

CRÈME ANGLAISE

MAYONNAISE

MAYONNAISE

4 egg yolks
1/2 teaspoon white wine vinegar
1 teaspoon lemon juice
2 cups vegetable oil

MAKES 2 CUPS

PUT the egg yolks, vinegar and lemon juice in a bowl or food processor and whisk or mix until light and creamy. Add the oil, drop by drop from the tip of a teaspoon, mixing constantly until the mixture begins to thicken, then add the oil in a very thin stream. (If you're using a processor, pour in the oil in a thin stream with the motor running.) Season well.

VINAIGRETTE

1 garlic clove, crushed
1/2 teaspoon Dijon mustard
2 tablespoons white wine vinegar
6 tablespoons olive oil

MAKES 1/3 CUP

MIX TOGETHER the garlic, mustard and vinegar. Add the oil in a thin stream, whisking continuously to form an emulsion. Season with salt and pepper. Store in a screw-top jar in the refrigerator and shake well before use. You can also add some chopped herbs such as chives or chervil.

VINAIGRETTE

BÉCHAMEL SAUCE

1/3 cup butter
1 onion, finely chopped
3/4 cup all-purpose flour
4 cups milk
pinch of nutmeg
bouquet garni

MAKES 3 CUPS

MELT the butter in a saucepan, add the onion and cook, stirring, for 3 minutes. Stir in the flour to make a roux and cook, stirring, for 3 minutes over low heat without allowing the roux to brown.

REMOVE from the heat and add the milk gradually, stirring after each addition until smooth. Return to the heat, add the nutmeg and bouquet garni and cook for 5 minutes. Strain through a fine sieve into a clean pan and lay a buttered piece of waxed paper on the surface to prevent a skin from forming.

BÉCHAMEL SAUCE

VELOUTÉ SAUCE

1/4 cup butter
2/3 cup all-purpose flour
4 cups hot chicken stock

MAKES 2 CUPS

MELT the butter in a saucepan. Stir in the flour to make a roux and cook, stirring, for 3 minutes over low heat without allowing the roux to brown. Allow to cool to room temperature. Add the hot stock and mix well. Return to the heat and simmer very gently for 10 minutes or until thick. Strain through a fine sieve, cover and refrigerate until needed.

MINERVOIS red and white wines from Languedoc, France's largest wine-growing area. Good value, the reds are fruity and light with a typical Mediterranean grape blend, including Grenache and Syrah.

CORBIÈRES an *appellation* in Languedoc making good dry white wines and reds—mixing Grenache and Carignan (used in mass-produced wines but here used to give character).

CHÂTEAUNEUF-DU-PAPE great red wines from the papal vineyards of Provence, mixing up to 13 different grape varieties to produce a full-bodied wine that usually needs aging.

GRAVES famed Bordeaux area producing dry Semillon/Sauvignon Blanc whites and rich Cabernet Sauvignon reds. Split in 1987, the outstanding *crus classés* are now in Pessac-Léognan AC.

ALSACE dry white wines from the North. The area produces many varietal (single grape variety) wines that bear the name of the grape, here Pinot Blanc, rather than the region.

MÂCONNAIS a Burgundian district producing decent Gamay and Pinot Noir reds and white Chardonnays, especially the very good Pouilly-Fuissé. In Mâcon, Mâcon-Villages is a superior AC.

MÉDOC Bordeaux's outstanding wine area, producing Cabernet Sauvignon reds. Within Médoc, the greatest areas (Pauillac, Saint Julien and Estèphe and Margaux) have their own *appellations*.

SAUTERNES a Bordeaux region, classified in 1855 and producing the world's most prestigious dessert wines from Semillon, Sauvignon Blanc and Muscadelle grapes.

POUILLY FUMÉ one of the world's great Sauvignon wines, along with neighboring Sancerre. Made in the Loire Valley, it has an elegant gooseberry character and should be drunk young.

NUITS-SAINT-GEORGES situated in the Côte d'Or in the middle of Burgundy, this commune has a number of *premiers crus* producing classic Pinot Noir reds for aging.

BERGERAC east of Bordeaux, this area has the same climate and grapes as its neighbor. Fine reds centering on Cabernet Sauvignon, Franc and Merlot; dry whites based around Sauvignon.

BEAUJOLAIS a Burgundian area producing fruity reds from Gamay grapes to be drunk chilled and young (within weeks for Nouveau). Beaujolais-Villages is a superior *appellation* within Beaujolais.

CHÂTEAU MARGAUX is one of Bordeaux's *grands crus classés*, a classification dating back to 1855 when wines from Médoc, Sauternes and one from Graves were classified according to the prices they fetched. The five-tier classification, from *premiers* down to *cinquièmes* (fifth) *crus* (growths), is still used today, with Châteaux Margaux, Haut-Brion, Latour, Lafite-Rothschild and Mouton-Rothschild (elevated to

WINE

FRANCE IS INDISPUTABLY THE CENTER OF THE WINE WORLD, AND GREAT BORDEAUX, BURGUNDIES AND CHAMPAGNES CONTINUE TO SET THE STANDARD TO WHICH OTHERS ASPIRE.

The French were making wines from indigenous vines even before the Romans arrived. Over the centuries, wine-makers have cultivated a staggering number of grape varieties, eventually matching each one up to the right methods of production, the perfect climate and terrain, from the wet North to the cool mountains and the hot Mediterranean. This fact means that today France produces nearly every classic wine in the world.

CLASSIFYING FRENCH WINE

France's *appellation d'origine contrôlée* (AC) is the oldest and most precise wine governing body in the world. The French attach much importance to the notion of *terroir*, that there is a perfect environment in which to grow a wine and that every wine should demonstrate the character of that environment, so the smaller and more pinpointed an *appellation*, the more prestigious it is. Thus, within the broad Bordeaux AC, subregions, such as Médoc, and even individual communities within this, such as Pauillac, may gain their own *appellation*. The AC also defines grape varieties, yields and production methods.

Vin délimité de qualité supérieure (VDQS) classifies less distinguished regions standing between AC and *vins de pays* status. *Vins de pays* (country wines) can be great if they have a strong local character. *Vins de table* should be drinkable.

this level in 1973) all *premiers crus*. The fact that the classification remains in use reflects the suitability of the *terroir* for growing Cabernet Sauvignon, especially the mild climate and gravelly soil, and also the efforts of the châteaux to maintain standards. At Château Margaux, the land is still worked by hand and a cooper handcrafts the French oak barrels. The best of their elegant wines can be aged for at least 20 years.

READING FRENCH LABELS

CHÂTEAU a Bordeaux wine estate

CLOS on some Burgundies, meaning a walled vineyard

CRU meaning "growth," it refers to wine from a single estate

CRU BOURGEOIS an unofficial level of classification just below Bordeaux's *crus classés*

GRAND CRU CLASSÉ/CRU CLASSÉ a Bordeaux classified in 1855 and usually of a very high quality. Also used in other regions to signify their most prestigious wines

CUVÉE a blended wine from different grapes or vineyards

CUVÉE PRESTIGE a special vintage or blend

MILLÉSIMÉ vintage

MIS EN BOUTEILLE AU CHÂTEAU/DOMAINE estate-bottled, rather than a merchant or cooperative blend

NÉGOCIANT-ÉLEVEUR a wine merchant, often an international firm, who buys grapes to blend and age and finished wines

PROPRIÉTAIRE-RÉCOLTANT growers who make their own wine

WINES can be bought from a *marchand de vin* (wine shop), *négociant* (specialized wine merchant) or *en vrac* (unbottled wine sold by the liter at markets). In wine areas you can also buy directly from the vineyards or from a *cave coopérative* (wine cooperative).

CHAMPAGNE

THE CELLARS AT TAITTINGER, one of Reim's world-famous champagne houses, date back to the Benedictine monks who first created champagne. Champagne is a mixture of red Pinot Noir and Pinot Meunier and white Chardonnay grapes, carefully picked and pressed to prevent any red skin color leaking into the juice. First a *cuvée* is blended by adding previous years' harvests to the present one, creating a champagne in the house's style (their non-vintage brut; though a vintage may be made in exceptional years). A secondary fermentation is

initiated by adding sugar and yeast *(liqueur de tirage)* before bottling, sealing with a cap and aging slowly in the cold cellars. After a 3-month fermentation, aging continues *sur lie* from one to several years, and a yeasty, less acidic flavor develops. During this time, the upended bottles are turned periodically, called *remuage* (riddling), to slide the sediment into the neck. Finally, *dégorgement* takes place, with the sediment frozen into a plug and ejected when the bottle is opened. The plug is replaced by some sweet wine that determines the sweetness of the champagne.

TYPES OF CHAMPAGNE

VINTAGE this champagne is made only every 3 or 4 years, when an exceptional harvest produces a distinctive, fine wine that is not blended with previous vintages into a house style.

BRUT this is the most common champagne, a dry wine made every year from a mixture of Pinot and Chardonnay grapes, blended with a little wine from previous harvests to create a house style.

ROSÉ usually made from normal white champagne blended with 15% red wine (produced from the same red pinot grapes), rosé is a fruity wine not made in large quantities and good with food.

BLANC DE BLANCS meaning "white of whites" and made just from white Chardonnay grapes, a blanc de blancs has a fine, delicate taste and makes a great apéritif.

goose fat A soft fat that melts at a low temperature and is used a lot in the cooking of southwest France to give a rich texture to dishes. Duck fat can be substituted, although it needs to be heated to a higher temperature.

Gruyère A pressed hard cheese with a nutty flavor. French Gruyère is available as *Gruyère de Comté*, which can have large holes, and *Gruyère de Beaufort*, which has virtually no holes. Although French Gruyére does have a different flavor than Swiss, the two are interchangeable in recipes.

haricot beans The general French name for beans, though the term is also used just to mean a kind of small, dried bean. Dried haricot beans come in many different varieties, including cannellini, flageolet (white or pale green beans) and navy beans. When slow-cooked in stews such as cassoulet they become tender. They also break down very well when mashed to make a smooth purée.

julienne To cut a vegetable or citrus rind into short, thin "julienne" strips. Vegetables used as a garnish are often julienned for decorative purposes and to ensure quick even cooking.

juniper berries Blackish-purple berries with a resinous flavor. Used in stews and robust game dishes. Use the back of a knife to crush the berries lightly before use to release their flavor.

Madeira A type of fortified wine from the Portuguese island of Madeira. There are a number of different varieties of Madeira, from sweet (Malmsey or Malvasia and Bual), to medium (Verdelho) and dry (Sercial).

Maroilles A square soft cheese with an orange washed-rind and a strong smell but sweet flavor. As an alternative, you could use other washed-rind varieties, such as Livarot, or a cheese with a white-molded rind, such as Camembert.

Mesclun A salad mix containing young lettuce leaves and herbs such as arugula, mâche, dandelion leaves, basil, chervil and endive. Traditionally found all over the south of France.

mussels Grown commercially around the coast of France on *bouchots* (poles) driven into mud flats or in beds in estuaries, mussels can be eaten raw but are usually cooked in dishes such as *moules à la marinière*. French mussels have blue-black shells and vary slightly in size and flavor according to the waters in which they are grown. The mussels grown around Boulogne in northern France are of a very high quality.

olive Grown all over the South, the main varieties of French olives include the green pointed Picholines, purple-black Nyons and the small black olives of Nice, used in traditional Niçoise cooking. Fresh green olives are available from the summer and are picked before they start to turn black, while fresh black olives are available from the autumn through winter. Though green and black olives have a different flavor, they can be used interchangeably in recipes unless the final color is a factor.

olive oil Extra-virgin and virgin olive oils are pressed without any heat or chemicals and are best used in simple uncooked dishes and for salads. Pure olive oil can be used for cooking or deep-frying. Olive oil is made in the south of France, and after picking the olives in the autumn, each year's new oil is available in the winter.

orange flower water Produced when the flower of the bitter orange is distilled. Orange flower water is a delicate flavoring used in dessert recipes.

oyster Two main species of oyster are available in France. *Huîtres plates* are European oysters, or natives. They have a flat round shell and are better in the winter months when they are not spawning. The most famous are the *belons* from Brittany. *Huîtres creuses* are the much more common Portuguese (or Pacific) oysters, with deep, bumpy and flaky shells. Some of the best Portuguese oysters are grown in Marennes. *Fines de claires* are oysters grown in water full of algae, giving them a green colour and a distinct, iodine flavor.

poussin A baby chicken weighing about 13 oz–1 lb. Poussin are often butterflied and broiled or stuffed. Usually one poussin is served per person, though slightly bigger ones are adequate for two people.

Puy lentils Tiny green lentils from Puy in central France that are AOC graded. Puy lentils do not need to be presoaked and do not break down when cooked. They have a firm texture and go very well with both meat and fish. Traditionally they are cooked and served with a mustard vinaigrette.

saffron The dried dark orange stigmas of a type of crocus flower, which are used to add aroma and flavor to food. Only a few threads are needed for each recipe as they are very pungent (and expensive).

salt cod Brought to Europe as long ago as the fifteenth century, salt cod's popularity in France is a legacy of the religious need to eat fish on Fridays and feast days. Salt cod is cod that has been gutted, salted and dried, and is different from stockfish (dried cod), which is just dried but not salted. A center-cut fillet of salt cod tends to be meatier than the thinner tail end, and some varieties are drier than others so the soaking time varies.

saucisse à cuire A cooking, or specifically boiling, sausage that is usually larger than an ordinary sausage. *Saucisses à cuire* are poached in liquid, either as part of a dish like *choucroute garnie* or just with red wine.

sweetbreads The pancreas and thymus glands of calves or lambs, sweetbreads are white in color, soft in texture and have an irregular shape. Sweetbreads should be soaked in cold water to remove any blood before they are cooked.

Toulouse sausage A general term for meaty pork broiling sausages, usually sold in a coil.

truffles Considered an expensive delicacy, truffles are a type of fungus and have an earthy smell. The black truffles found in France, specifically around Périgord, are often considered the best black truffles in the world. Truffles are best eaten fresh, but can also be bought preserved in jars, and only need to be used in small amounts to flavor dishes.

vanilla extract Made by using alcohol to extract the vanilla flavor from beans and not to be confused with artificial vanilla essence made with synthetic vanillin. Vanilla extract is very strong and should be used sparingly.

INDEX

BIBLIOGRAPHY

Ayto, John. *The Diner's Dictionary Food and Drink from A to Z.* Oxford University Press, 1993.

Behr, Edward. *The Art of Eating*, no. 48.

Bissell, Frances. *Sainsbury's Book of Food.* Websters International Publishers, 1989.

Christian, Glynn. *Edible France: a Traveler's Guide.* Interlink Books, 1997.

Conran, Caroline and Terence, and Hopkinson, Simon. *The Conran Cookbook.* Conran Octopus, 1997.

Davidson, Alan. *The Oxford Companion to Food.* Oxford University Press, 1999.

Dominé, André, and Ditter, Michael. *Culinaria.* Könemann, 1995.

Dominé, André. *Culinaria France.* Könemann, 1999.

Editors of Time-Life Books. *Classic French Cooking.* Time-Life Books Inc, 1978.

Editors of Time-Life Books. *The Cooking of Provincial France.* Time-Life Books Inc, 1972.

Editors of Time-Life Books. *The Good Cook: Wine.* Time-Life Books B.V., 1982.

Grigson, Jane. *Charcuterie and French Pork Cookery.* Penguin Books, 1970.

Johnston, Mireille. *Complete French Cookery Course.* BBC Books, 1994.

Masui, Kazuko, and Yamada, Tomoko. *French Cheeses.* Dorling Kindersley, 1996.

Millon, Marc and Kim. *The Food Lover's Companion to France.* Macmillan Travel, 1996.

Sinclair, Charles. *International Dictionary of Food and Cooking.* Peter Collin Publishing Ltd, 1998.

Stobart, Tom. *The Cook's Encyclopaedia.* Grub Street, 1998.

Wells, Patricia. *The Food Lover's Guide to Paris.* Methuen London Ltd, 1984.

THE FOOD OF FRANCE

Published by Murdoch Books®

© Text, design, photography and illustrations Murdoch Books® 2000.
All rights reserved. Published 2001.
Reprinted 2002, 2003 (twice).
National Library of Australia Cataloguing-in-Publication Data
Food of France. Includes index. ISBN 0 86411 970 4.
1. Cookery, French. 641.5944
A catalogue record of this book is available from the British Library.

Publishing Manager: Kay Halsey
Food Editor: Lulu Grimes
Design Concept and Art Direction: Marylouise Brammer
Designer: Susanne Geppert
Editor: Jane Price
Photographer: Chris L. Jones
Stylist: Mary Harris
Stylist's Assistant: Ben Masters
Additional Photography: Howard Shooter
Additional Recipes: Ruth Armstrong, Michelle Earl, Barbara Lowery, Dimitra Stais, Jody Vassallo, Richard Young, Sophia Young
Map: Russell Bryant

Publisher: Kay Scarlett
Chief Executive: Juliet Rogers

PRINTED IN CHINA by Leefung-Asco Printers Ltd.
No part of this publication may be reproduced, stored in a retrieval system or transmitted in any form or
by any means, electronic, mechanical, photocopying, recording or otherwise without the prior written
permission of the publisher. Murdoch Books® is a subsidiary of Murdoch Magazines Australia Pty Ltd.

Murdoch Books® Australia
GPO Box 1203, Sydney, NSW 1045
Phone: + 61 (0) 2 4352 7000 Fax: + 61 (0) 2 4352 7026

Murdoch Books® UK
Ferry House, 51– 57 Lacy Road, Putney, London SW15 1PR
Phone: + 44 (0) 208 355 1480 Fax: + 44 (0) 208 355 1499

IMPORTANT: Those who might be at risk from the effects of salmonella food poisoning
(the elderly, pregnant women, young children and those suffering from immune deficiency
diseases) should consult their GP with any concerns about eating raw eggs.

ACKNOWLEDGMENTS

The Publisher wishes to thank the following for their help in making this book possible: Cour des Loges, Lyon; Gérard Ravet, Cour
des Loges, Lyon; Danièle Monterrat, Lyon; Michaël Leete, Boulangerie du Pont, Lyon; Jean Perroux, Lyon; Alain Duclot, Lyon;
L'Hotel les Ateliers de l'Image, St-Rémy-de-Provence; David and Nitockrees Carpita, Mas de Cornud, St-Rémy-de-Provence;
Gerard Driget, St-Rémy-de-Provence; Denis Censi, Fromagerie Du Mistral, St-Rémy-de-Provence; Josette Erard, St-Rémy-de-
Provence; Paul Bergese, St-Rémy-de-Provence; Joël Durand, Joël Durand Chocolatier, St-Rémy-de-Provence; Pierre Lilamand,
St-Rémy-de-Provence; Van Beeck, Le Petit Duc Patissiers, St-Rémy-de-Provence; Andre Rousson, St-Rémy-de-Provence;
Michel Nunes, Aix-en-Provence; Sofitel Marseille Vieux-Port, Marseille; M. Fromion, Marseille; M. et Mme. Delfino, Marseille;
M.-J Pichot, Mme. Bizard, Chateau Margaux; Monique Bodin, Christophe Conge, Château Lafite Rothschild; Bristol Hôtel,
Périgueux; Gérard Joly, Marchal & Pautet, Périgueux; Jean Paul Armaud, Pondaurat; François Rames, Carves; Angèlique Denoix,
St Mayme de Peyrerol; M. Barriere, St Laurent la Vallee; Eric Settbon, St Martin de Riberac; Marc et Marcelle Boureau, Castels;
Hotel de l'Université, Paris; Philippe Foulatiere, Hediard, Paris; Marie-Anne Cantin, Paris; Stéphane Nachba, Gérard Mulot, Paris;
Corinne Rosa, Paris; Claude et Catherine Ceccaldi, Paris; Vincent Rové, La Sablaise, Paris; Dominique Fenouil, Le Repaire de
Bacchus, Paris; M. Jean Luc Poujounan, Poujauran, Paris; Jean Paul Gardil, Paris; Mon Martin Boulangerie, Paris; Sébastien Lay,
U.C.L. Isigny-Sainte-Mère, Isigny-Sur-Mer; M. Claude Taittinger, Michèle Barbier, Champagne Taittinger, Reims; Kalinka, Sydney;
Camargue, Sydney; Mosaique, Sydney; Brian Allen Antiques, Sydney; McLeod Antiques, Sydney; Peppergreen, Sydney.
Rod Johnson and Kayell Photographic; Nicole Lawless and Kodak; Kylie Goodwin, Qantas; Simon Johnson, Sydney;
Sara Schwartz, Tasting Places, London; Mosaique Imports; Corso de Fiori; Will Studd; Max Pesch, Ilve Australia.